James Lord first went to France, aged twenty-one, as a member of the Military Intelligence Service during World War II. Since then he has spent the major part of his life in Paris, where he has been acquainted with many of the most prominent members of modern European art. Giacometti: A Biography was nominated for the National Book Critics Award. James Lord has subsequently published three volumes of memoirs. In recognition of his contribution to French culture he has been made an officer of the Legion of Honour.

By the same author

A Giacometti Portrait
Giacometti Drawings
Picasso and Dora: A Personal Memoir
Six Exceptional Women: Further Memoirs
Some Remarkable Men: Further Memoirs

Giacometti

A BIOGRAPHY

James Lord

A PHOENIX GIANT PAPERBACK

First published in the United States of America by Farrar Straus & Giroux Inc. in 1985. First published in Great Britain by Faber and Faber Limited in 1986. This paperback edition published in 1996 by Phoenix, a division of Orion Books Ltd, Orion House, 5 Upper St Martin's Lane, London WC2H 9EA

Copyright © 1983, 1985, 1986 by James Lord

Published by arrangement with Farrar Straus & Giroux Inc., 19 Union Square West, New York, NY 10003, USA.

The right of James Lord to be identified as the author of this work has been asserted by him in accordance with the Copyright, Designs and Patents Act 1988.

All rights reserved. No part of this publication may be reproduced, stored in a retrieval system, or transmitted, in any form or by any means, electronic, mechanical, photocopying, recording or otherwise, without the prior permission of the copyright owner.

A CIP catalogue record for this book is available from the British Library.

ISBN: 185799 501 5

Printed and bound in Great Britain by Butler & Tanner Ltd, Frome and London

In Memory of the Two Brothers

Contents

Preface xi GIACOMETTI 3

Acknowledgments 525
Notes on Sources 531
Bibliography 549
Index 567
Index of Works 575

1.0

STATE POPATO

April 10 con con con taxol

THE PROPERTY AND

of the State of the Augustic

Illustrations

between pages 178 and 179

The Giacometti family 1911
The Giacometti studio and residence in Stampa
Alberto in Rome
Alberto 1922
Alberto and Flora 1927
The studio complex in the rue Hippolyte-Maindron
Isabel
Diego in 1934
The passageway outside Giacometti's studio

between pages 306 and 307

Alberto, Annette and Diego c. 1952 Alberto and Annette c. 1954 Alberto and Caroline c. 1963 Alberto and Georges Braque c. 1952 Alberto and Annette c. 1960 Alberto and his mother at Stampa 1961 Alberto in his studio c. 1956 Alberto with Samuel Beckett 1961 James Lord and Giacometti 1965 Alberto in 1961 Alberto's tomb

Preface

One evening in February 1952, I wandered into the Café des Deux-Magots in Paris, looking for somebody to talk to, and chanced upon a friend. He introduced me to his companion: Alberto Giacometti. Like almost everyone meeting him for the first time, I sensed at once that the man before me was profoundly different from other people and felt a powerful attraction, which was all the stronger for being exerted by an artist whose work I knew already and admired greatly. Giacometti accepted with disarming simplicity and candor the unsought attentions, often gauche and indiscreet, of would-be admirers such as I. Nothing was easier than to fall into the habit of visiting him in his studio. He was always courteous, attentive, responsive. He introduced me to the persons who shared his life most closely—his brother Diego, and his wife. Annette. Occasionally we had dinner together, went to the movies. or visited an obscure bar late at night. I wrote a few articles about his work, and as I was fairly often on hand, or underfoot, he got me to pose for drawings now and then. When in the autumn of 1964 he painted my portrait, during the sittings I made detailed notes, which became the basis for a little book, A Giacometti Portrait, which was published by the Museum of Modern Art. New York, in 1965. I made notes at other times, too, both before and after the portrait, and these have also proved useful. Everything, indeed, about my acquaintance with Alberto has proved useful in the preparation of this book.

An acquaintance, though, is all it ever was. To suggest that we became close friends would be presumptuous and inaccurate. I was witness to certain aspects of Alberto's life, but no part of it would have been different if we had never met, and therefore I have no place in his biography. His biography, however, not to mention the gradual revelation of its significance, has affected my own life immeasurably. For one thing, I have devoted fifteen years to it. During this time I have solicited the encouragement, counsel, and help of a great many people. Only one declined to have any part in my undertaking and, in fact, from the outset opposed the very idea that the artist's life should be recounted at all. This person, though not the one whose own life was most affected by his, was the one who suffered most-after Alberto himself-from the implacable contact with genius: his widow. Her opposition was neither mysterious nor injurious. It will be understandable to even the casual reader. The attentive one, I hope, will feel, as I do, not only sympathy but compassion for Annette Giacometti's attitude. Genius, however, makes its own rules, and one of them is that it requires to be known, to be known as widely, as intimately, and as openly as possible. Alberto shrank from no disclosure. We owe it to him to follow his lead insofar as we can, and it behooves those to whom he has meant the most to go the furthest. Besides, every era is entitled to take the measure of its great men, and especially is this so when they are in short supply.

If Annette Giacometti's opposition was not injurious, it was nonetheless inconvenient. When the artist died intestate, his widow's legal rights as his principal heir gave her much power regarding the manner in which his artistic legacy was to be administered and perceived. She exercised this power with a will, and one consequence of it has been to prevent the appearance in her husband's biography of any unpublished writings by him of whatever sort: letters, journals, or random notations. This is a pity, because Alberto wrote copiously and wonderfully well. No paraphrase, gloss, or patchwork contrivance can catch the vivacity of his writing. The pity, however, will be neither profoundly nor permanently inhibiting. Concerned readers can consult published sources in extenso, while all the documents, letters, notes, and materials of every kind related in any way to the preparation of this book will be deposited in the library of Yale University at New Haven, Connecticut, where they will in perpetuity remain available to interested persons. And the power to censor happily has limits. Alberto not only wrote but also spoke wonderfully well and a lot. Many people who had the good luck to hear him had the common sense to record what he said. These words, at least, are in no danger of being censored.

Only one person could have laid legitimate claim to any moral jurisdiction concerning the contents of this book, because he helped Alberto's biographer just as selflessly as he always helped Alberto. A man whose nobility of spirit and indomitable forbearance were quite as legendary as his brother's, Diego, too, believed that nothing is better served by art than a passion for the truth.

Fuss about the writing or publication of his biography would have been greeted by Alberto with ridicule and scorn. He would have said that the life of any passerby in the street could provide a story just as interesting and extraordinary as his. He would have been right, of course. He usually was. But at the same time he was too fair-minded not to admit that he had delved very deeply into himself in order to see what it is that makes everyone extraordinary and had worked with indefatigable passion for half a century to produce evidence that what he had seen was interesting. He went about this in such a way that he became extraordinarily interesting to everyone who met him, or even set eyes on him, and so I have tried to find words sufficient to tell his story.

One

The Bregaglia Valley lies deep in a cleft of southeastern Switzerland. A meeting place between north and south, a place much traveled through since Roman days, it has nevertheless retained a character all its own. A telling evidence of this is the religion of Bregaglia's inhabitants, sternly Protestant amid surrounding Catholics. From the foot of the Maloja Pass the valley slopes steeply downward to the Italian frontier at Castasegna, a distance of twelve miles. It is a region of precipitous slopes, jagged peaks, icy streams, high meadows, and simple villages. Beautiful but austere. Before winter's snows first fall to the valley floor, the sun leaves it. From early November till mid-February, the sheer mountain walls cut off all sunlight, and the coldest time of day or night is high noon, when fiercest cold is driven down to the frost-encrusted depths.

"It's a sort of purgatory," Diego sometimes said.

However that may be, it was there that everything began for the sculptor and painter Alberto Giacometti. It was there that circumstances led him to become an artist, there that they assumed their fullest meaning, there that the allegory of his life pointed its most profound and valuable moral.

Life in Bregaglia was hard in the years before electricity and automobiles. Amenities were few, pleasures rare. The local men frequently left home to seek their fortune in less trying climates. If they often went away, they usually came back sooner or later, either for good or for regular visits. Austere and rigorous as it may be, and perhaps for that very reason, there is something about the valley which attaches itself to men's hearts and so dwells in their mind's eye that other places seem insipid by comparison. Therefore, it was not unnatural, after a stay in Warsaw and another in

Bergamo, that a young fellow named Alberto Giacometti returned about 1860 to the small Bregaglia village of Stampa. And there, on the 15th of November 1863, he married a girl named Ottilia Santi.

The Giacometti family had by then been a long time in the valley, having come originally from somewhere in central Italy, where the name is a common one. Prosperity, however, had so far eluded the Giacomettis. The Santis, on the other hand, were people of substance. Ottilia brought with her in marriage the prospect of material as well as emotional security. Among other things, her family owned the inn at Stampa, named after a ten-thousand-foot peak which dominates the northern side of the valley: the Piz Duan. Ottilia's husband became the innkeeper.

Whatever may have been his ability in other respects, Giacometti was a potent husband. He fathered eight children, of whom seven were males. The third of these, a son, born on March 7, 1868, was named Giovanni. He grew up to be a gentle, pensive boy and early showed an interest in drawing. While at school, he came to feel that he would like to be an artist. The innkeeper encouraged his son in this ambition, helped him with money when possible, and sent him to study in Paris.

Giovanni Giacometti was a man of medium height, robust, with red hair and beard, and blue eyes. Gentle, sensitive, sincere, he liked other people and was liked by them. His work resembles him. Neither adventuresome nor innovative, yet it shows spirit and imagination. His paintings are still pleasing today because he looked with incorruptible pleasure at life, and they have a certain nobility because he had.

The start of his career was beset by difficulty and hardship. His father helped occasionally if he could, but there were days when Giovanni went hungry. Having finished his studies in Paris, he went to Italy and stayed some time in a town on the Bay of Naples not far from Pompeii. This was the most painful period of his life, and in later years he spoke of it often. But he returned periodically to Bregaglia. Early in 1900, he suffered a profoundly troubling bereavement. His father died. The innkeeper who had understood and sustained the artistic aspirations of his son did not live to see them fulfilled, and this must have been a further cause

of distress to Giovanni. If so, it may not be coincidence that in the year of his father's death he made up his mind at the age of thirty-two to marry.

Annetta Stampa was not beautiful: She was handsome. The distinction already says something important about this forceful, extraordinary woman. She was about the same height as her husband, physically vigorous, with a prominent nose, dark eyes, and black, wiry hair. In her bearing there was something commanding, though at the same time outgoing and warm. Throughout her life, which proved to be an exceptionally long one, she made a powerful impression on others, and most of all on the members of her own family.

The Stampas were people of means. They owned houses and land. Thus, like his father, Giovanni Giacometti married a woman who was able to better his condition in life. An excellent cook, fastidious housekeeper, and vigilant holder of purse strings, she assured the family's well-being and comfort during the years before Giovanni's paintings began to sell. She was a woman of indomitable resolve and principle, went to church regularly, and held a stern view of propriety. Yet she was not provincial or narrow-minded. She read the newspapers and her house was well supplied with books. She loved talk, especially a good argument, and had a ready sense of humor. Knowing what she thought about most things, including art, she never hesitated to speak her mind.

Borgonovo, "the new village," lies along a gentle slope about a mile up the valley from Stampa. Annetta had been born there. Her parents lived there, and it was there in the Church of San Giorgio, where his father's funeral had taken place only eight months before, that Giovanni Giacometti was married to Annetta Stampa on the 4th of October 1900. And it was in Borgonovo that the newly married couple first settled. They rented an apartment on the second floor of a plain three-story house in the center of the village.

Giovanni may have been a mild-mannered, temperate, and unassuming man, but, like his father, he proved to be a potent husband. Three months after their wedding his wife became pregnant, and at one o'clock in the morning on the 10th of October 1901 their first child, a son, was born. The happy parents named him Giovanni Alberto Giacometti. Because his father's name was also Giovanni, the child was never called anything but Alberto by his parents or by anyone else, and the name certainly suited him, for it means illustrious through nobility. In time, everyone, and even he, may have forgotten that Alberto's first name was Giovanni, but the fact—and its significance—remained.

The first few months of the infant's life were those during which the valley lies in the shadow. It was not long before an event occurred in the lives of the parents and their child which may have affected decisively his way of looking at the world, and also—because he happened to be a genius—our way of looking at it.

The valley had hardly emerged from the shadow when Annetta Giacometti once more became pregnant. This new pregnancy caused her to wean her firstborn. Weaning at six months is not unusual. At any age, however, it may bring a loss of that sense of primal security, of physical certainty and delight, which every infant experiences through contact with his mother's body.

On the 15th of November 1902, a second son was born to Annetta and Giovanni Giacometti. He was named Diego, after Velázquez, whom his father admired. By a strange irony, this second son encountered at his mother's breast an experience contrary to the normal expectations of infancy. He was unable to accept her milk. It made him sick, and Annetta was compelled to substitute a vegetal formula. The aversion proved lifelong. Even when milk was prescribed many years later as treatment for an ulcer, Diego could not digest it.

The very earliest memory which in later life Alberto retained of his childhood was an image of his mother. Many years afterward he wrote: "The long black dress which touched the ground troubled me by its mystery; it seemed to be a part of the body, and that caused a feeling of fear and confusion; all the rest vanished, escaped my attention."

Alberto could not have been less than a year old, and probably he was rather more, when he formed this image. Annetta was thirty-two. The child's reaction is surprising. Confusion and fear are not feelings which most people associate with childhood memories of their mother. Of course, powerful psychic forces from later periods always shape and color the memories that seem to remain from childhood, and though children's memories do

retain what is important, a kind of symbolic representation often occurs which is not unlike the symbolism of fantasies or dreams.

Diego was not yet a year old when his mother once again became pregnant. This occurrence does not seem to have been charged for him with any traumatic effect. But it did create a practical family problem. On May 31, 1904, a daughter was born. She was named Ottilia, after her father's mother. Now the family numbered five. The lodgings in Borgonovo were no longer adequate. In the late autumn of 1904, Giovanni moved his family down the road to Stampa.

On the day of the move, an incident occurred which formed Diego's first memory; he was then not quite two. In the confusion, he wandered outside unnoticed. The street was full of milling sheep, and he became lost among them. All around him, the sheep's legs crowded close, stamping up and down. Alone, helpless, terrified, Diego began to scream and sob. A girl came to the rescue, lifting him up from the flock of sheep, and he saw his mother at the window, laughing. He was unharmed, but after those few minutes of fright the world never again seemed quite so safe or secure.

After a year and a half of temporary lodging at the Piz Duan Inn, the family moved across the road into an apartment on the main floor of a large, rose-colored house, with hay barn and stable immediately adjacent. They never moved again. The quarters were not spacious, consisting of two bedrooms, living room, dining room, and kitchen. As to modern "conveniences," there were none. Water had to be carried from a fountain by the roadway. The adjacent barn was converted into a studio for Giovanni. Only it and the living room were heated in winter. The windows faced north across the valley with its rushing stream toward the sharp summit of the Piz Duan. Fortunately for all the family, the father's studio served as a kind of extra living room, and the artist found his wife and children willing models. Alberto in particular seemed to enjoy the studio atmosphere, the smell of turpentine and paint, and the opportunity to pose.

He was a shy, gentle child. His dearest and most intimate companions were by his own account inanimate objects. "Between the ages of four and seven," he later wrote, "I saw only those things which could be useful to my pleasure. These were above all stones and trees." There was one stone, and above all the cave which erosion had formed beneath it, that became the principal hiding place and sanctum of Alberto's childhood. He was four years old when his father first took him there. The stone is an immense boulder in a meadow about 650 yards from Stampa. The cave beneath it is high enough for small children to stand upright. At the rear, a crevice narrows into the earth. The entrance, formed by an overhanging lip of the boulder, is long, low, and jagged, like an enormous open mouth.

This cave was well known to all the children of Stampa. But Alberto had an exclusive feeling for the place. To him, it had a meaning and an importance not shared by his brother or other playmates. Many years later, when he was over thirty, he felt impelled to describe the cave and the intensity of his attachment to it in a short memoir which he wrote for a Surrealist publication and entitled "Yesterday, Quicksand."

"From the first," he says, "I considered that stone a friend, a being full of good intentions toward me . . . like somebody one has known long before and loved, then found again with surprise and infinite joy." Every morning when he awoke, his first concern was to look out the window to make sure that the stone was still there, and even from a distance he seemed able to distinguish its tiniest details. Nothing else in the landscape interested him.

For two years, the cave was for Alberto the most important place on earth or, one should say, in the earth. His greatest pleasure, he says, came when he penetrated as deeply as possible into the narrow crevice at the rear of the cave. "I attained the height of joy," he wrote. "All my desires were fulfilled." The fulfillment, to be sure, was symbolic, but the desires were not. They are felt by all children, though in varying degree. Alberto's case was exceptional. It called for expression. One day, while curled up securely in the depths of the cave, the little boy thought that he might want some nourishment. So he stole from his mother's kitchen a loaf of bread, carried it to the cave, and hid it deep in the recess at the rear. Once he had done that, his satisfaction must

have seemed the greatest that life can give, for in a sense he never got over it.

Once, while playing near the cave, Alberto wandered a bit farther than usual. "I would not be able to remember by what chance," he wrote in "Yesterday, Quicksand." It's odd that he felt compelled to preface his account with a failure of memory and an element of chance. "I found myself on a rise in the ground. In front of me, a little below, in the midst of the brush, rose up an enormous black stone in the form of a narrow, pointed pyramid, of which the sides were almost vertical. I cannot express the emotion of resentment and confusion I experienced at that moment. The stone struck me at once as a living being, hostile, threatening. It threatened everything: us, our games, and our cave. Its existence was unbearable to me and I felt immediately-being unable to make it disappear-that I must take no notice of it, forget it, and speak of it to no one. Nevertheless, I did go close to it, but this was with a feeling of surrendering to something reprehensible, secret, improper. I barely touched it with one hand in disgust and fear. Trembling at the prospect of finding an entrance, I walked around it. No sign of a cave, which made the stone even more unbearable to me, and yet I did experience one satisfaction: an opening in that stone would have complicated everything and I already felt the desolation of our cave if it had become necessary to be concerned with another at the same time. I ran away from the black stone, I didn't mention it to the other children, I dismissed it and never went back to see it again."

A time came when Alberto no longer found the cave so irresistibly desirable or satisfying. In the natural course of things, he developed other desires and sought other satisfactions. "I awaited the snows with impatience. I was not content until I calculated that there was enough—and many times I calculated too soon—so that I could go by myself, carrying a sack and armed with a pointed stick, to a field at some distance from the village. (The work in question was to be secret.) There I attempted to dig a hole just large enough for me to penetrate into it. On the surface was to remain visible only a round opening, as small as possible, and nothing else. I planned to spread the sack in the bottom of the hole

and once inside I imagined the place would be warm and dark; I believed I should certainly experience great joy. I was entirely absorbed in the pleasure of having my hole completely installed and entering it. I would have liked to spend all winter there, alone, enclosed, and I thought with regret that it would be necessary to return home to eat and sleep. I must say that in spite of all my efforts, and also probably because external conditions were bad, my desire was never fulfilled."

In later life Alberto spoke repeatedly of his carefree, happy childhood. He often said that in many ways he felt himself to be still a young boy. And he was, though it took a lifetime of labor to become so. Perhaps his childhood had, in fact, been as happy as he always said. After all, the deep desires he felt and the satisfactions he craved were the same throughout his life. But they were strained and transformed by experiences to come, and so was he. As a child he was able to live with his longings, no matter what they were, in pleasurable, carefree compatibility, which is not a bad criterion for happiness.

Discord seems never to have entered the Giacometti family. Friends and relatives were impressed and attracted by the harmony and warmth that flowed between parents and children. The centripetal force which held all secure came from Annetta Giacometti. Her determination, her resourcefulness, and her love made all one and one all. To many people, especially in later years, she appeared as a kind of beneficent, invulnerable earth-mother, circumventing peril and sustaining pleasure. But she demanded as good as she gave. From those to whom she offered the security of her strength and love she expected to receive unconditional devotion in return.

The children seldom quarreled, the parents never. Alberto and Diego often said that no cross word had ever been known to pass between their parents. Such harmony is admirable, but it seems a bit unnatural, too. People who have strong feelings show them. No doubt the little Giacomettis appreciated the tranquillity of their home life, but it may at the same time have led them as they grew up to form a somewhat unrealistic concept of the relations which husbands and wives may be expected to enjoy.

On August 24, 1907, a third son, their fourth and last child, was born to Annetta and Giovanni Giacometti. They named him Bruno. To be his godfather they chose Ferdinand Hodler, the best-known Swiss painter of the time, a controversial but successful figure. Giovanni was, meanwhile, neither controversial nor very successful. He obviously was not motivated by a need or desire to capture the world's attention or to create a new vision of reality. His paintings were sensitive, beautiful, at the forefront of contemporary taste, if not of the avant-garde, and they had begun to

sell with sufficient regularity for him to support his family in modest comfort. He does not seem to have worried about immortality. He appreciated the present and his life in it. He had a happy disposition. Also, of course, he had his wife. She, too, had a cheerful nature and liked a good time, for which even in Stampa there was occasionally the opportunity.

The children also had good times. There were plenty of games to be played, innumerable tall trees to be climbed, and epic snowball fights in winter. Alberto did not take part in the fights. He had no taste for the rough-and-tumble companionship and competition that most boys enjoy. The other children of the village seemed to sense that he was different and never expected him to behave as they did. Thus, from the first, Alberto was made aware of a distance between himself and the rest of the world, a distance inviting and compelling him to observe the relative situations of persons and things, among which his own was perforce solitary. Even from those closest to him, Alberto received special treatment. The children were expected to perform routine household chores, for example, but often it was Diego who did Alberto's for him. It came naturally to the second son that he should help the first as best he could. When he might have been playing in the forest, he was willing to stay home and do extra work so that his brother could sit calmly in a corner looking at books. Exceptionally curious, eager, quick to learn, Alberto was an excellent student, and his schoolteachers also must have seen that this grave, curly-haired boy was exceptional. Diego, on the other hand, was at best a mediocre student. If he did not share his brother's enthusiasm for learning, however, he did respect it.

Siberia was the part of the world which most excited Alberto's imagination when he first studied geography. In "Yesterday, Quicksand" he describes the seemingly innocent fantasy by which he repeatedly traveled to that remote and forbidding land. "There I saw myself in the middle of a vast plain covered with gray snow: there was never any sun and it was always cold. The plain was bounded along one side rather far from me by a forest of pines, a drab black forest. I gazed at that plain and forest from the window of an isba (this name was essential for me) in which I remained and

where it was very warm. That was all. But very often I traveled mentally to that place."

He was no longer a child. The awareness and problems of sexuality had begun to assert themselves. It is no accident that he remembered this daydream so vividly or that he wanted to record it. A landscape as a symbolic representation is always feminine. The sexual interest of a child is directed primarily to the problem of birth, leading him to wonder what sort of intimacy exists between his parents. He wants to see what goes on when they are alone, and this impulse to see, the importance of it, the ability, the act of looking or watching, and all the circumstances of sight, are intensified by the longing to know what is at the basis of life. But the child's desire is conditioned by dread, because he is incapable of understanding what he wants to see. To his incautious eye the act which arouses such curiosity would forcibly appear to be one of violence, while a spot of blood on his parents' sheets or his mother's linen would look like evidence of injury inflicted by the man. In any case, a child would naturally be disturbed by the appearance of pleasure which prevails and might be prompted to view the woman's submission as a sign of something wrong or dangerous.

During these early years Alberto formed an obsessive habit which seemed odd, though innocent, to the other members of his family. Every night before going to sleep, he took particular care in the arrangement of his shoes and socks on the floor beside the bed. The socks were smoothed, flattened, and laid out side by side so that each had the appearance of a foot in silhouette, while the shoes were placed in a precise position beside them. This painstaking ritual, repeated without variation each night, amused Alberto's brothers, and sometimes, to tease him, they would disturb his arrangement, provoking outbursts of rage.

For the rest of his life, Alberto continued to be obsessively concerned with the arrangement of his shoes and socks before going to bed. His passion did not extend to other articles of clothing, however; only the shoes and socks. And only before going to bed at night. Once in bed, though, the young boy did not necessarily go straight to sleep. In "Yesterday, Quicksand" he states how over a period of months at this time he was unable to fall asleep before

enjoying the peculiar representations of a waking dream. "I could not go to sleep at night without having first imagined that at dusk I had passed through a dense forest and come to a gray castle which stood in the most hidden and unknown part. There I killed two men before they could defend themselves. One was about seventeen and always looked pale and frightened. The other wore a suit of armor, upon the left side of which something gleamed like gold. I raped two women, after tearing off their clothes, one of them thirty-two years old, dressed all in black, with a face like alabaster, then a young girl round whom white veils floated. The whole forest echoed with their screams and moans. I killed them also but very slowly (it was night by that time), often beside a pool of stagnant green water in front of the castle. Each time with slight variations. Then I burned the castle and went to sleep, happy."

Giovanni Giacometti occasionally made short trips to Geneva, Paris, and elsewhere to visit friends or try to further his career. During one of these periodic absences, Alberto suddenly found that he was unable to remember his father's physical appearance. This failure of memory seems especially surprising because the house in Stampa contained numerous self-portraits, portraits, and photographs of Giovanni. Upset by his incomprehensible amnesia, Alberto burst into tears and began screaming, "I can't remember my father's face."

Diego, to whom his brother turned for comfort, simply laughed and said, "You know, he's that little man with the red beard."

Diego's calm and matter-of-fact response to his older brother's anxiety was perfectly in character. Helping to do household chores was only one aspect of the fraternal reassurance and support that he was evidently expected, and prepared, to provide with equanimity. But this does not mean that he had no anxieties of his own. He seems from an early age to have felt a strange sort of dissociation from himself, as though cut off somehow from the natural expectation of life's unlimited possibilities. Such a feeling was in glaring contrast to his brother's self-confidence and studious sensitivity. Alberto held a whole world of beauty and delight at his fingertips. Diego, on the other hand, felt unhappy with his en-

dowments. Some intolerable discontent was at work, and it centered upon the most immediate, physical organs of his contact with the world: his hands. His fingers, their physical appearance, displeased and upset him. His childish mind was beset by a painful malaise, as if the ability of the hands to do what they are meant to do put him at unbearable odds with himself.

One summer's day in 1907, a bizarre "accident" occurred. The principal crop of Bregaglia was hay, and in those simple days all the able-bodied men and boys of the valley helped to bring in the harvest. Diego, ever willing and eager to please, needed no urging to lend a hand. His job that day was to help load freshly cut hay onto a conveyor belt that carried it through the rotating blades of a chopper, from which it fell into a bin where it was mixed with oats as feed for the horses. This agricultural machine was powered by a hand crank which turned a set of gears with interlocking teeth. The operator of the crank, a youth ten years older than Diego, stood halfway along the belt, cranking vigorously. The young helper was behind, on the other side of the belt, and as he lifted each armful of hay onto the belt he had to take care that none of it got caught in the gears. He was fascinated by the powerful motion of their teeth continually interlocking as the wheels went round and round. More than seventy years later, the old man would still remember the incident in all its detail with an awful intensity.

Lifting his right hand, he deliberately placed his fingers on one of the moving wheels and waited for the interlocking metal teeth to crush them. When the first finger was crushed, the pain was surprisingly slight. Then his second finger was seized and crushed by the sharp, interlocking gears, and the third one went in. He did not make so much as a murmur, because he knew that if he cried out the other boy would stop cranking before all his fingers had sufficiently suffered. But then the cranking did stop, as no more hay was coming along the belt, and even the slight interference in the smooth working of the gears caused by Diego's crushed fingers had been perceptible to the operator of the crank, who turned to see what had happened. Horrified, he immediately reversed the motion of his crank so that Diego's hand came free, and he shouted for help. The injured boy was quickly taken home, where his

family gathered round with shocked solicitude. They called a doctor, who was little better than a veterinarian. The pain, which had not initially been great, now became agonizing. The first finger was very seriously injured but still hung more or less together and could be saved, though it would always show signs of mutilation. Of the second finger less than half remained, the rest having been sliced cleanly off. The third finger had been crushed only at the tip.

It would be pleasant to pass on quickly from this excruciating incident to happier evocations of childhood. But if Diego was able to endure it, that was his way of making a point of it. At the time, everyone must have asked how such an accident could possibly have occurred. The answer was in the evidence of the injury, while the proof that this had been an accident was the presumption of common sense. As for Diego, all his life he knew better than anyone how to keep to himself what most concerned him, whether or not he grasped the meaning or good of it. Though right-handed, he always held his right hand in such a way as to conceal the fact that it was maimed.

On the 5th of August 1911, Annetta Giacometti reached the significant age of forty. To celebrate that event, she went with her husband and children on an outing to the border town of Castasegna. While there, they posed for a local photographer. His picture is a remarkable document. Each member of the family group seems to appear in it as he or she really was and would remain throughout life.

Diego, seated in the foreground, looks restless, obviously ill at ease in good clothes, his maimed right hand resting on his knee, partly hidden from view. His hair is cut short, though the luxuriant locks of his older brother are still long. Ottilia kneels between her father and mother, gazing outward with an expression both wistful and pensive, clasping her father's left knee. Giovanni is seated in the center of the group, but he does not dominate it. Holding his youngest son on his right knee, he glances downward, an expression of contentment on his gentle features. Bruno appears placid, almost impassive, accepting with composure the experience of the moment.

Annetta, dressed in black, with a flowered shirtwaist, is seated

to one side, but she is the largest figure in the group. She sits calmly, her hands joined, and looks at Alberto, who is staring at her with rapt fixity. It is the intensity, the quality and the meaning of their reciprocal gaze which dominates the picture. Of this the others are unaware, and they appear excluded not only from the knowledge but also from an understanding of it, as if Annetta and Alberto were in fact alone together. Everything about Alberto, his clothes, his posture, even his physical existence, seems subordinate to the spellbound gaze which he fixes upon his mother, her person combining absolute fascination and incommensurable mystery. She returns her son's gaze with equanimity, seeming utterly sure of herself and of him. Whatever his gaze may portend, she looks serenely satisfied with it and with the world. Upon her lips there is an enigmatic smile.

Annetta Giacometti was the niece of a man named Rodolfo Baldini, a baker who lived and worked in Marseilles but who, like other emigrants from the valley, had always maintained close ties with Bregaglia. He owned, for example, a good-sized house in the town of Maloja at the top of the pass. When he died in 1909, he left this house to his niece. Commanding a superb view of mountains, meadows, and the Lake of Sils, the house stands on a slope above the main road. Giovanni once again transformed the conveniently adjacent hay barn into a studio, which Alberto would put to good use later on. From 1910 onward, every summer was spent there. A third of each year. Maloja became a second home, separated by only ten miles of distance but by twenty-five hundred feet of altitude from the first.

When Alberto started to draw is impossible to determine. He later said, "I began to draw in my father's studio as long ago as I can remember." But at the age when he liked to spend all his free time in the cave, or even when he needed to fantasize about murder and rape in order to sleep, he seems not yet to have begun drawing. It was probably soon after.

He had grown up in the awareness that his father was an artist. There was plenty of talk about art in the Giacometti household, and his parents' conversation can have left no doubt in

Alberto's mind about the importance of art or the desirability of becoming a successful artist. However, he was not urged by his father to begin drawing. He started by himself. An instinct for emulation must have been a powerful part of the motive which led him to do so.

"There was no greater joy for me," he wrote later, "than to run to the studio as soon as school was out and sit in my corner near the window, drawing or looking at books."

If Alberto was not urged by his father to start drawing, he was encouraged and helped after he had done so. He appreciated the help and guidance, and after his father's death, after he had become an artist far more successful and celebrated than his father had been, he often expressed his gratitude. One may assume that he showed it at the time. Giovanni certainly realized early that his oldest son was extraordinary and that momentous things might someday be expected of him. There is no reason to suppose that such expectations gave anything but pleasure.

The drawing which Alberto later remembered as having been his very first was the illustration of a scene from *Snow White*, or, as it is called in Italian, *Bianca Neve*. It was the death scene: Snow White lying in her crystal coffin, surrounded by the seven grieving dwarfs. Of course, she is not really dead, but in order to neutralize her seductiveness she has been placed at an almost-insurmountable remove from life.

During his boyhood, most of the drawings which Alberto made were illustrations for the books he read. Many of them were scenes of battle, murder, torture. He was obsessed by thoughts of cruelty and violence. Nor was he a stranger to the pleasure which children often derive from tormenting small animals and dismembering insects. Sadistic impulses seem to have been present in the boy's temperament, though he must have repressed or sublimated most of them. Where sadistic impulses are present, there may also be a disposition to accept, even to seek, suffering as a natural or inevitable correlative.

In addition to drawings illustrating the books he was reading, Alberto drew many copies of the works of art that most pleased him in the albums and volumes of reproductions owned by his father. He was absorbed by art and by his own imagination. He drew with astonishing facility and virtuosity, yet the majority of the very early drawings which have survived suggest that he did not take great pains over them. The time came, though, when he wished to make a drawing as perfect and finished as he possibly could. It was the very first on which he worked with such industry and concentration. He was twelve years old.

Giovanni had recently acquired a volume of reproductions of the works of the great German master Albrecht Dürer. One of these so fascinated Alberto that he felt he must make an exact reproduction of it. It was the celebrated engraving entitled *Knight*, *Death*, and the Devil. It had been executed in Nuremberg exactly four hundred years before Alberto sat down to draw his painstaking and prodigiously accomplished copy.

This engraving is a representation of the ideal of manly virtue and self-reliance. The figure of the knight in armor on horseback embodies simultaneously the naturalistic style of the northern late Gothic and the classicism of the southern Renaissance, as if the mountain landscape through which he rides were a meeting place between north and south. He pursues his course despite the bland-ishments of flesh and the world and in defiance of death. Personifying determination and faith, he gazes at the road he must travel with an expression of heroic resolve. His dog is an embodiment of zeal and reason. Together they pass by the swine-snouted devil of carnal lust and a half-decayed cadaver symbolizing death.

It is evident that the knight will prevail over temptation and fear, but he may well have need of his weapons, which consist of a sword and a long, pointed stick or lance.

Alberto spent several days working on his copy. The result was a drawing of remarkable precision and finesse, and the artist, who was prone to casual destruction of his works, carefully preserved this one all his life. Alberto's father asked him whether he preferred Rembrandt or Dürer. After much hesitation, he said that he preferred Dürer. And for a time he even signed his own drawings in an imitation of the master to whom he felt most deeply responsive, and whose forename he happened to share, with a flattopped capital "A" and a small "g" between its legs.

Dürer was one of the first artists to look at reality with uncompromising objectivity and to record what he saw with unequivocal exactitude. He possessed a keen power of observation, and his perception of the natural world was unsentimental. At the same time, he conjured up visions of ominous fantasy. He was a profoundly neurotic man, shaken by portents, frightened by monsters, and preyed upon by nightmares and sexual obsessions. Deeply affected by the Reformation, he became a Protestant. He was the first artist to sign his drawings. He approached his profession in a spirit new to it, and which very few men since then have had the courage or competence to emulate.

Giovanni Giacometti possessed a considerable library of books on the works of artists of the past. By studying them and making copies from them, Alberto early formed a comprehensive familiarity with the art of the past. The young boy must therefore have conceived the purpose and activity of an artist to be part, and to take part, in a continuing tradition, of which the exemplification and the perpetuation were his privilege and responsibility.

Not one of the Giacometti children inherited the red hair and blue eyes of their father. Fair-haired in early childhood, they all turned out as they grew older to have the dark hair and eyes of their mother. Genes tell important truths. Alberto looked more like Annetta than any of the others.

In 1914, while half the world was plunged into catastrophe

and irreversible change, Alberto Giacometti reached the age of thirteen, the age when childhood is left behind, when profound psychic and physiological transformations are underway, and when it becomes apparent that things will never look the same again.

In 1914, he made his first sculpture. He had seen in one of his father's books a reproduction of some small sculptures on square bases and he immediately felt a desire to create one like them. His father bought him some Plasticine and he started in. For his model he naturally selected someone readily available who might be expected to submit patiently to the discipline of posing: Diego. The choice must have seemed obvious. His brother's features were so familiar and his presence so reassuring that Alberto could work without self-consciousness.

The making of that first sculpture proved to be one of the most satisfying experiences of Alberto's life. He always looked back on it with puzzlement and nostalgia. He had the feeling of being able to do exactly what he wanted to do, which was simply to reproduce what he saw. He succeeded without hesitation or inhibition, as if the work sprang spontaneously from his fingertips at the command of a vision so sincere and penetrating that reality obeyed it as easily as Diego did. This first sculpture shows an instinctive grasp of artistic form and a remarkable technical virtuosity, surpassing sensitivity but unsparing objectivity.

It was also at this time that he began to draw consistently from nature. "I had the feeling that I possessed such a command over what I wanted to do that I could do it exactly. I admired myself, I felt that with such a formidable means as drawing I could accomplish anything, that I could draw anything, that I saw more clearly than anyone else."

He drew everything around him. Stampa. The mountains. The houses. The people. He drew his brothers, his mother, the furniture in the rooms, the pots and pans in the kitchen. "I drew in order to communicate," he said, "and to dominate. I had the feeling of being able to reproduce and possess whatever I wanted. I became overbearing. Nothing could resist me . . . My pencil was my weapon."

The other members of the Giacometti family must have been

astonished by this sudden, aggressive burst of precocity. Especially Giovanni, who had more reason than the rest to view it with interest. But everyone seems to have been delighted. Alberto received enthusiastic and affectionate encouragement. He never had to fight for the freedom to do as he pleased.

On the 30th of August 1915 there was some excitement at the Evangelical Secondary School in Schiers. It was the start of a new term, and a personage of note and unusual appearance had arrived at the school. It was the painter Giovanni Giacometti, who was finally at the age of forty-seven beginning to receive the attention he deserved. A number of the students as well as members of the faculty had heard of him. They were impressed by his dignified bearing and red beard. He had come to the school to accompany his oldest son, enrolled as a new student.

Alberto was not obliged by his parents to go to boarding school. The idea was that he should give it a try and see what happened. He was not quite fourteen, and he thought that he didn't know what he wanted to do with his life.

Schiers is a pretty village standing amid fields in the valley of the Landquart River. The school is its principal establishment and had originally been founded to transform young boys into missionaries, though by 1915 few students were enrolled for that purpose. The prevailing atmosphere was nevertheless religious. There were prayers eight times a day. The director was a seriousminded man with a black beard named Jacob Zimmerli.

Alberto loved the life at Schiers. He seems never for a moment to have been homesick, which is interesting and even, perhaps, a little surprising. Maybe he felt at Schiers for the first time an exhilarating intimation of freedom and the challenge of a world beyond Stampa. Besides, home was only forty-five miles due south across the mountains, though the journey by post coach and train via Saint Moritz and Chur was not easy.

Giovanni and Annetta went quite often to see their son during

the four years he spent at the Evangelical Secondary School. Letters passed regularly back and forth. It was then that Alberto formed the habit of sending home long, lively letters in which he described his feelings, experiences, and activities. He continued to do so as long as his mother lived, for he obviously wished to assure himself of her concern and secure her involvement in most—but not all!—of the important happenings and feelings of his life. The schoolboy received packages of books from his father and food from his mother. In fact, she sent so much food that he sometimes had to tell her to send no more for the moment. He asked, instead, for shoes.

Outside his own home, where he had triumphed by the simple feat of being born, Schiers was the first province offered to Alberto to conquer. He was anxious to do so. He was young, with all the exuberance and expectations of youth. He wanted to receive admiration and to demonstrate that he deserved it. He wanted to enjoy his natural ascendancy over others. He wanted to charm, to fascinate, to dominate. He succeeded superbly, for he was intelligent, intuitive, independent. But the extraordinary sweetness of his nature saved him from seeming aloof or arrogant. Fifty years after his departure from Schiers, his schoolmates remembered him with an emotion enhanced not only by the realization of his greatness, which they had suspected from the first, but also by the fact that he had never asserted it to the detriment of anyone else.

Of all the means by which he rapidly gained the admiration and affection of his schoolmates and masters, it was his pencil, his trusted weapon, that served him best. No one could fail to be impressed by the ease with which he was able to bring people and things to life on a piece of paper, or to be moved by the sincerity and simplicity of his desire to do so. The world seemed to belong to this schoolboy because he found such delight in looking at it and such satisfaction in recording that delight. And it was the delight which counted for him more than the record of it. Then, as always, he was generous. He gave away his work without hesitation to those who liked it and to those whom he liked. The other pupils seem to have taken great pleasure in these gifts from their schoolmate. They competed to be his model, posing patiently in the small

studio which Alberto was permitted to fit out for himself in an unused attic room above the gymnasium. When the portraits were finished, fellow students and even the teachers came to inspect and admire them. Alberto painted, or drew, landscapes and still lifes, too, and even made a few sculptures. All are marked by the simplicity and happiness of those years and by the beautiful felicity with which art and life added to each other. No foreboding, no anxiety, no failure seems to have intruded upon this happy period.

Much as Alberto enjoyed life at school, he looked forward eagerly to vacations. The first vacation came in mid-December of 1915. Traveling by himself for the first time, the fourteen-year-old schoolboy proceeded from Schiers to Chur. There he was to take the train to Saint Moritz, where he would have to spend the night in a pension before going down the next morning by the post sleigh to Stampa. Finding that there would be a considerable wait in Chur, Alberto took a stroll in the town. He came to a bookstore and went in. A large volume of reproductions of the work of Rodin caught his attention.

Auguste Rodin was then still living and universally regarded as one of the titanic figures in the history of art, the greatest sculptor since Michelangelo. The book was expensive and Alberto had with him only enough money to get home. He didn't hesitate. He bought the book and returned to the railway station. Fortunately, he already had his ticket to Saint Moritz. But when he arrived there late in the evening, he had no money left for the pension. The last post sleigh had departed. He set out on foot in the dark, carrying his book and a bundle of clothes.

At midnight in mid-December in the Alps at five thousand feet it is cold. The road was deserted. It was ten miles to Maloja, where his mother's house stood dark. Alberto trudged on to the pass and started down in the icy blackness. Several times he slipped and fell. His book slid off into the snow and he had to hunt for it. Arriving in Stampa at five o'clock in the morning, he was half frozen but hugged the precious volume. One can imagine with what care the impetuous lad must have been taken in, warmed up, and fed. But perhaps parental afterthoughts may have included some wonder concerning the future of a son who was prepared to

subject himself to such an ordeal for the sake of a book about sculpture, albeit the work of the greatest sculptor living.

In 1916, no doubt during a vacation from Schiers, Alberto for the first time modeled a bust of his mother. It is strikingly unlike the one he had previously made of Diego. The act of the artist had formerly been subordinate to the presence of the model. No longer. It is the artist now, and he alone, who imparts life to the work of art. This evolution is evident in the use of the sculptural material, the texture of the surface, which in its strong but sensitive modeling resembles certain works of Rodin.

It is interesting that the sculpture in which Giacometti first seems to have asserted his dominance as a creative individual should have been a portrait of his mother. Just as the artist has come nearer to us, however, the model is placed at a distance, as if Alberto were not prepared or able to approach her any more closely than he allows us to. He has determined not only how we shall see the individual but also our relation to her in space. The early bust of Diego shows the child present at the very surface of the sculpture, but Annetta Giacometti in person is situated beyond the bronze integument of her effigy, and the ambiguous expression which Alberto has given to her eyes seems to imply that there may never be a way for anyone to cross that frontier.

Alberto as a boy, and even as a young man, apparently did not feel impelled to portray his father, though he made portraits of every other member of his family, not to mention friends and acquaintances. The first known portraits of the father by his son date from 1927, when Alberto had already spent five years in Paris and was on the verge of achieving his first successes there. Alberto was a brilliant student, excelling particularly in languages, history, literature, and, of course, art. He continued to read a great deal for his own pleasure, repeatedly asking for books to be sent from home. Novalis, Heine, Hoffmann, Hölderlin in German. The plays of Shakespeare in English. Not the kind of reading one would have expected from a boy of fifteen. He was capable of prolonged intellectual exertion, and he discovered that even when he seemed to be completely exhausted he could drive himself to still further efforts, from which he actually derived pleasure. Arbeit is a word which repeatedly appears in the notes Alberto wrote to himself while at Schiers, though his inclination to work was so ceaseless and compulsive that he hardly needed a reminder.

To have kept anything like a regular journal or diary would have been an activity too self-important for one of Alberto's temperament. However, his respect and taste for the written word gave him a need to confirm in writing his feelings, thoughts, and experiences. While at Schiers, he formed the habit, which he kept for the rest of his life, of making notes related to the events and preoccupations of his daily life. But because these notes were meant for himself alone, they were for the most part terse and abbreviated, scrawled on any scrap of paper that chanced to be at hand. Taken all together, they would have constituted a unique record demonstrating the diversity, depth, passion, humor, and nobility of a great intellect. Such a demonstration, however, would have seemed pompous to Alberto. He threw away the notes as easily and naturally as he turned his mind to another topic. Most of those surviving have survived by accident.

The First World War does not seem to have troubled the

young Giacometti deeply. He felt compassion for its victims but was too young and too preoccupied with school to identify himself seriously with the paroxysm of the outside world. The tranquillity of his life at Schiers was interrupted once. Not in a way that may have seemed serious at the time, but with enduring consequences.

He contracted mumps. This was in the latter part of 1917 or sometime during 1918, so he was well past the age of puberty, and not properly cared for, with the result that he suffered an acute attack of orchitis, inflammation and swelling of the testicles. The physical pain was intense, but the emotional discomfort may have been more difficult to bear. The swollen testicles must have seemed to present both physically and psychically a serious threat to manhood, and they did. Acute attacks of orchitis last for several days, and may have grave aftereffects, for they frequently destroy the capacity of the glands to fulfill their natural function and the patient is left sterile for life. That is what happened to Alberto.

Thus, while he was hardly more than a boy, one of life's most basic and far-reaching decisions was made for him by nature, as it were, rather than by himself. An important turning point in an individual's existence is reached when sexual experience is subordinated to the purposes of reproduction, and it is a characteristic common to all sexual abnormalities that, in them, reproduction as an aim has been set aside. That decisive turning point was eliminated from Alberto's future before he had had an opportunity to experience any normal sexual life whatever. He was condemned to a lifetime of equivocal activity in the most intimate realm of human experience, because the pursuit of physical gratification for its own sake was the most that his sexual capacity allowed. Since he could never be a father, he could never be fully a husband, and so he was deprived forever not only of a normal sexual life but also of a normal social life. It would have been surprising had this not caused some demoralization as regards fulfillment of the masculine role. A feeling of genital insecurity and the awareness of sterility can contribute very powerfully toward problems of impotence.

Meanwhile, the drawings and paintings produced by the student artist after his recovery were no less bright, spirited, and selfconfident than those he had done before. His schoolmates and teachers continued to be impressed by his mysterious power to imbue the products of his eyes and hands with so strong a stream of pleasure that they provided for others the surprise and consolation of an access to their own unconscious sources of delight.

With the passing of years, Alberto had grown less shy. He was pleased to inform his mother that he enjoyed long conversations with strangers as he traveled back and forth between Stampa and Schiers. Being curious and observant, he realized even as a boy that he possessed a personality to which others were exceptionally responsive. One of the characteristics which most struck them, and which impressed people as long as Alberto lived, was his uncanny ability to make them sense at once that he truly cared for them as individuals and to prove it by the passionate candor of his conversation. He used to say, "I'd give my entire lifework for one conversation."

Alberto liked Schiers so well that he was sorry Diego should not also have a chance to enjoy it. He urged his brother to give it a try, promising that he would have a good time. So Diego arrived at Schiers in the early summer of 1917. He hated it. Schoolwork was not delight but drudgery. It was Diego's misfortune as a schoolboy to be the second Giacometti, because allowances were made for the brother of a brilliant student and the son of a well-known artist. He was permitted to do as he pleased, which was nothing. Naturally, he was miserable. Alberto was sorry, and perhaps a little mortified. But there wasn't much he could do. His friends didn't take to Diego, or he to them. Being energetic and easygoing, and not in the least given to self-pity, Diego made friends of his own. And so it came about that while the brothers saw each other daily at school, they led separate lives there.

As a youth, Alberto was not handsome. He was shorter than most of the other boys his age, for, although never tall, he seems to have been peculiarly slow to reach full height. His head consequently, and his hands, seemed too large for his body. The pensive seriousness of his expression appeared in untoward contrast to still-boyish features. But if he was himself not handsome, he felt strongly attracted to those who were.

On the 27th of April 1917 a fourteen-year-old boy of exceptional beauty arrived at Schiers. His name was Simon Bérard. Tall and slender, with curly chestnut hair, high color, and a dazzling but diffident smile, he attracted attention. One of those most responsive was Alberto, who showed how impressionable he was by falling in love. During the fall and winter of 1918–19, when peace had finally returned to Europe, the two schoolboys became inseparable. Alberto took the initiative, but Simon was only too happy to find himself the favorite of a boy whose superiority was acknowledged by the entire school. They went for walks together, talked long hours alone, and shared the daily life of schoolboys. What they shared, perhaps, most powerfully was the unqualified adoration that each boy felt for his mother.

Of all the portraits Alberto executed in his lifetime, none is more marked by tenderness than those of Simon Bérard. He experienced no difficulty in imbuing the products of his hand and eye with the full force of his mind and heart. No aesthetic calculation, no personal inhibition has interfered with the expression of the two boys' feelings for each other. The only work done at Schiers which still remained in Alberto's possession forty-seven years later was a bust of Simon.

The friendship between them did not go unnoticed. There was talk. At times Alberto requested his friend to pose in the nude. This may have seemed desirable to the artist, and even to his model, but it was intriguing to the other students, who repeatedly came to the door of the studio and peeked in to see if anything was going on.

Whether there was or not we will never know, nor is it of great importance. What mattered was that Alberto was troubled by the overtly homosexual aspect of his feelings for Simon. The opprobrium attached to homosexuality was great; several boys had been expelled because of it. Alberto's longing for sexual expression was also great, and as he was both intelligent and courageous, he felt that it was cowardly of him not to seek the fulfillment he craved. Boys between fourteen and eighteen experience the craving for sexual gratification with overpowering intensity. If they have little opportunity to satisfy this longing and the romantic agitation

associated with it in the manner usually sanctioned by society, they may, and often do, seek other means of satisfaction. When this impulse is severely condemned and frustrated, the resulting inhibition may cause a profound, permanent mistrust, even a fear, of emotional impulses and commitments.

Life at Schiers, which had for so long been happy, began to seem intolerable. Because he could not foresee a viable resolution of the dilemma that tormented him, Alberto determined to run away from it. This was not the first time that he had run away from something that threatened him. It would not be the last. The destination to which he ran was always the same. The stratagem which Alberto chose in order to make good his escape seems touchingly naïve.

He went to Dr. Zimmerli and explained that for the purpose of deciding whether or not he might eventually try to become an artist he wished to take a leave of absence from school in order to devote himself entirely to painting and sculpture. The headmaster was not sympathetic. Not everyone can be Michelangelo, he observed, advising Alberto to continue his studies and graduate from Schiers, adding that later he could always paint pictures to decorate his home.

The stratagem which Alberto had chosen would, of course, have a far more decisive result than the one he anticipated. Stung by the sententious condescension of the headmaster, he insisted. He knew how to be persuasive, how to exercise charm and use to good effect the intellectual authority at his command. He had his way. It was agreed that he should be given a leave of absence from Schiers for three months, after which, if he wished to return, he might reenter the same class. Having received the consent of the headmaster, he had no difficulty persuading his parents.

It was on the 7th of April 1919 that Alberto left Schiers for the last time. Diego also left on that day, wondering how it happened that he had not been expelled long before, and no doubt Dr. Zimmerli did not urge him to stay. His formal education was finished, and he was delighted, little suspecting what a lifetime of learning lay in wait. In Stampa, it was spring. The steep meadows were flooded with wildflowers and Alberto promptly fell in love. The girl was only twelve, and attentions paid her caused gossip. He didn't care, and nothing would come of it, anyway. The threat of homosexuality seemed, after all, to have been slight. He was happy. He was free. He could draw and paint and sculpt. The world he saw and everything he saw in it still belonged to him with beautiful simplicity.

He worked in the studio of his father, and Giovanni was glad of an opportunity to observe the developing gifts of his son. It must have been a sobering experience. Alberto's ability sprang into being with such authority that it could brook no admonition or advice.

One day in the studio he began to draw a still life of pears on a table. He started by making the pears the same size he knew the pears on the table to be, as if a realistic appearance depended on the representation of known proportions. As he worked, he kept erasing what he'd done, until the pears had grown tiny. Giovanni observed this, and apparently assumed that the tiny pears were an affectation. He said, "Just do them as they are, as you see them." Starting again, Alberto ended up half an hour later with the same tiny pears. He was more concerned with representing reality than with representing pears, and therefore he identified the edges of his sheet of paper with the boundaries of his field of vision, in which the pears were naturally tiny. This instinct for phenomenological observation was inevitably in conflict with Giovanni's reliance upon the aesthetic convention that known reality is identical with perceived reality.

Paternal influence on the son's youthful work was superficial. Alberto sought to emulate, never to imitate. By the age of eighteen, he was artistically more mature than his fifty-one-year-old father. There was nothing left for the older to teach, and it is he who may have been influenced. His style of painting changed markedly after 1919, became less vigorous and authoritative. If, however, this was the effect of Alberto's development, it did not cause any rivalry between them. Their outward relationship was warm, generous, and affectionate.

Whatever the father may have felt about his son's emergence as an artist, one may assume that no misgiving ever troubled the mother. She must have been elated to observe the astonishing prowess of her son, for she could take pleasure and find fulfillment in Alberto's achievement far more naturally and completely than in Giovanni's. Her son was the flesh of her flesh, her firstborn, while her husband owed his life, if not his survival, to another woman.

Diego did not give his parents as much cause for satisfaction as his older brother. He had no desire or need to excel. The simple world, with its simple, worldly pleasures, proved quite satisfying to him as it was. He may have dabbled in painting and drawing because his father and brother were so occupied with art, but he felt no compulsion to become an artist himself.

Some occupation, however, had to be found for him, so he took a job in the office of a transport company in Chiasso, a town on the frontier between Switzerland and Italy. The work was monotonous and hard, and Diego didn't enjoy it. Not an artist, yet he had no taste for workaday routine. Of the eighteen months he stayed in Chiasso, only the first few were spent working for the transport company. He was a companionable young man, enjoyed drinking and talking in the town's cafés and taking the streetcar to Como, three miles away in Italy, to visit the bordello. Among the friends he made was a Sicilian, who must have been rather a madcap and something of a crook. Together they earned their living for a time traveling around the nearby countryside scouring with acid the copper cooking utensils of the peasants. They sold vacuum cleaners door-to-door. For a time Diego worked as an assistant to a stone carver who made monuments for the local

cemetery. He and his Sicilian pal also did a certain amount of smuggling.

The three months' respite from Schiers which Alberto had asked for passed all too quickly. At the end of that time, he felt no desire to return to school. "Do you want to become a painter?" his father asked.

"A painter or a sculptor," Alberto replied.

Giovanni agreed. His agreement seems natural, remembering the encouragement he had received from his own father. Annetta also agreed. Her motives and emotions may have been more complex, but the sincerity of her agreement was certainly wholehearted. "After all," Alberto later remarked, "she had married a painter."

Annetta was anxious that Alberto should not be overshadowed by the success and reputation of his father. She did all she could to ensure that he had every opportunity to prove and exercise his powers. Throughout her life, this was to be an abiding concern. At times it became a little oppressive, for Annetta was authoritarian. Stampa to Alberto signified the life-giving—but also the life-demanding—presence of his mother. He was not averse to leaving home in order to be on his own in the great world.

Giovanni advised his son to go to Geneva and enroll in the School of Fine Arts. Alberto took the advice. It was in the autumn of 1919 that he first went to live in the city of Calvin and Jean-Jacques Rousseau. He disliked it.

A room was found for him in the apartment of some family friends. He enrolled at the School of Fine Arts, where several professors were friends of his father. He felt dissatisfied immediately. He thought the instruction conventional and stupid. Having progressed so far by himself, he was not disposed to mark time in deference to the precepts of mediocre teachers. He informed his father that he would not remain at the School of Fine Arts. Giovanni was displeased, but he did not try to prevent his rebellious son from pursuing the path of his choice.

Alberto transferred to the School of Arts and Crafts, where attitudes toward instruction and work were more practical and less aesthetic. In later life he liked to say that he had remained at the School of Fine Arts for exactly three days. This is not true. During the entire time he remained in Geneva he went regularly to the School of Fine Arts to attend a course in drawing and painting.

Alberto was committed to truth as an abstract concept, but he was also a conscientiously truthful individual. Falsehood and deception were repugnant to him. Still, he perpetuated certain inaccuracies concerning himself and his life. In the case of this first one, it seems difficult to make out his motive. He was too intelligent to have been tempted to fool either himself or others by appearing bohemian. One can only suppose that if he persisted in saying he had left the School of Fine Arts after three days, when in fact he continued to go there for many months, he did so in order to satisfy an important need. His stay in Geneva represented his first major step toward his independence. He was obliged to make a show of rebellion, and that may have something to do with the liberty his memory took with the facts.

He was lonely. "I felt entirely alien to the life of that city," he said. His life was orderly and uneventful. Early to bed and to rise, he devoted himself to work, determined to go his own way, alone if need be, conceding nothing to the preferences and tastes either of his classmates or of his teachers.

One day in the drawing class a buxom model named Loulou was posing nude. Convention required students to draw the entire figure, but Alberto maintained that it was his prerogative to draw only what interested him. To the great irritation of the instructor, he stubbornly and repeatedly drew enormous studies of the girl's foot.

The teacher of sculpture in stone at the School of Arts and Crafts was a man named Bouvier. An incident occurred one afternoon during his class which made such an impression on the friend working beside Alberto that it remained as his most vivid memory of the young Giacometti fifty years later. In the midst of his work, Alberto inadvertently knocked from his sculpture stand the heavy iron hammer he had been using. It fell from a height of some four and a half feet directly onto his foot. A normal reaction would have been to "displace" the pain by some physical reaction, to cry out or jump up and down. Alberto remained absolutely motionless

and made no sound whatever. A grimace of pain passed over his features. Then he bent down, picked up the hammer, and went on working as if nothing had happened.

Girls were among the students in the classes Alberto attended. He was friendly with a number of them, but not with any one in particular. He does not appear to have fallen in love during the time he spent in Geneva. He concentrated energy on his work with a single-mindedness which must have left little doubt as to the authenticity of his creative drive. Money was no worry. Only eighteen, he was content to be supported by his parents. The satisfying material relationship between Alberto and his family, which prolonged the physical dependence of childhood, was to last many years longer.

After six months in the art schools of Geneva, Alberto was anxious to return home. In fact, he left Geneva even earlier than planned. Other travels, experiences, and opportunities beckoned.

In the first decades of the twentieth century, Italy still held out to artists much of the fascination which it had exerted since Dürer's first voyage there. For four centuries, its cities had attracted those who hoped to fulfill their creative ambitions in the perspective of an artistic heritage which reached back to Giotto, beyond him to Byzantium, Rome, Greece, and Egypt. Alberto felt the fascination. How he must have looked forward to his first long trip in that marvelous country, whose language was his mother tongue, and where the deepest roots of his heredity lay.

The opportunity came at the end of April 1920. Giovanni was a member of a commission to be sent to Venice by the Swiss government to inspect the Swiss pavilion at the great biannual international exhibition of art, the Biennale, which was then the most prestigious artistic event in the world. He decided to take his son with him.

Alberto was thrilled by the city, its light, its architecture, its art. Above all, by the art of Tintoretto. "During that stay in Venice," he wrote later, "I was excited solely by Tintoretto. I spent the entire month running around the city, worried that there might be one more painting by him hidden somewhere in the corner of a church. Tintoretto was for me a marvelous discovery, he opened the curtain upon a new world which was the very reflection of the real world that surrounded me. I loved him with an exclusive and fanatic love . . . Tintoretto was right and the others were wrong."

NX

The works of art exhibited at the Biennale also must have seemed wrong. Yet they included in the French pavilion a group of paintings by Cézanne, who had died only fourteen years before, and who in his own time had also felt a veneration for Tintoretto. This was the first group of Cézanne's works that the young Giacometti had ever seen, but because of his exclusive admiration for a painter deeply admired by them both he was unable to appreciate immediately the art of a man whose achievement was to become a major spiritual influence in his life. However, Tintoretto's absolute hold on Alberto's mind and heart was short-lived.

"The last day I ran to the Scuola di San Rocco and to San Giorgio Maggiore as if to tell him goodbye, goodbye to the greatest of friends. The very same afternoon, as I went into the Arena Chapel in Padua, I received a body blow full on the breast in front of the frescoes by Giotto. I was confused and lost, I immediately felt an immense pain and a great sorrow. The body blow struck Tintoretto, too. The power of Giotto asserted itself irresistibly upon me, I was crushed by those immutable figures, dense as basalt, with their precise and accurate gestures, heavy with expression and often infinitely tender. I rebelled at the idea of giving up Tintoretto; I had a deep feeling of losing in that way something irreplaceable, like a glimmer or a breath infinitely more precious than all the qualities of Giotto, though he was, I felt convinced, the stronger.

"The same evening all these contradictory feelings were thrown into confusion by the sight of two or three young girls who were walking in front of me. They seemed immense, beyond all conception of measurement, and their whole being and their movements were charged with a dreadful violence. I stared at them, hallucinated, invaded by a sensation of terror. It was like a hole torn in reality. All the meanings and the relationships of things were changed. The Tintorettos and Giottos became at the same time very small, weak, flaccid, and without consistence, like naïve stammerings, timid and awkward. And yet what I most prized in Tintoretto was like a very pale reflection of that vision and I understood why I wanted absolutely not to lose him."

What had happened? Why did the sight of two or three young girls so deeply disturb the feelings with which he had previously been preoccupied? It was a perfectly commonplace sight. Why did the girls seem immense and beyond all conception of measurement? Why did their movements and their whole being seem

charged with a dreadful violence? What was it that induced a sensation of terror and made Alberto feel as though he were having a hallucination? What was it that seemed to tear a hole in reality? Why were all the meanings and relationships of things changed in that one moment? And what exactly was the pale reflection of the sight of those girls, what was the glimmer or breath which Alberto did not want to lose? He says he understood why he didn't want to lose it. If he did, he understood the destination of his life, and that, certainly, would have been a shattering experience for youth of eighteen. Particularly, it may seem, if he happened at the time to be in the company of his father. If, in fact, he did understand what he says he did, he can hardly have realized where that understanding would lead him.

For more than ten years, Alberto had created and cultivated, with the aid of his trusted weapon, his pencil, and the other materials of the artist, a relation with reality which convinced him that he could control it and make it do his bidding. That reality, of course, was not only external and physical but also, and primarily, inward and psychic. He had developed a capacity for abstraction, a disposition to establish between himself and the objects of his perception a psychic as well as a physical distance. This leads to the propensity for creating symbols and activates the imagination by providing for a relationship with reality which does not depend principally upon reality itself.

In the weeks preceding the sight of the young girls, Alberto had encountered the most profound and exciting aesthetic experience of his life: the art of Tintoretto, with its frenetic movement, ghostly perspective, and supernatural sense of space. No other artist has ever demonstrated more persuasively the power of art to create a self-contained and self-sustaining universe, and the greatest masterpieces of that demonstration are all in Venice. On the very day, however, of his leave-taking from that city, where the spirit of Tintoretto had become so precious to him, Alberto encountered the genius of Giotto, and he was shaken by his recognition that the Florentine's greatness was more powerful even than that of his Venetian idol. Yet the purely artistic animus of Tintoretto retained for Alberto a vitality which Giotto could not dispel.

In the midst of this aesthetic crisis of his young life, an external, physical reality tore through and thrust itself upon his consciousness. "The sight of two or three young girls who were walking in front of me." There was nothing theoretical or ideal about the sight of them or about their existence. They were tangible, they might even have been touchable, though Alberto's only contact was visual. The evidence of his senses compelled him to acknowledge the existence of a world outside himself, limitless and immeasurable, a world outside his relationship with visible reality, a world completely indifferent to art and artists. Naturally, the agents of that compulsion seemed charged with a dreadful violence. Naturally, the experience seemed like a terrifying hallucination, transforming the meanings and relationships of things.

It was no accident that the sight which tore open reality happened to be of young girls, nor was it by chance that Alberto appears to have seen them very clearly yet from a distance. The crisis must have been physiological as well as psychological and phenomenological. His sexual experience till then had also been essentially, if not completely, imaginary. It, too, demanded acknowledgment and expression, and despite the blandishments of the imagination and the sublimations of the spirit, the sole fulfillment of sexuality is sexual experience.

During the late summer and early autumn of 1920, Alberto returned for a time to the art schools of Geneva. But the experiences of the previous spring had aroused feelings and desires which must have made that inhibited and inhibiting city seem tedious. He was anxious to return to Italy, and it was presently settled that he should go there alone to travel as he pleased for a period of several months. This trip was to have consequences even more momentous than the first.

In mid-November he left Stampa for Florence, where he hoped to attend an academy and find free painting classes. But all the academies were full and no free classes were available. So he painted busily on his own, exploring the city and visiting its museums. In one of them he discovered the first sculpture of a head which had ever seemed to him to have a true resemblance to a human head. In the city of Michelangelo, however, this sculpture

was not Italian, or even Greek, but Egyptian, a work on exhibit in the Archaeological Museum. The Egyptian collections of that institution are neither large nor-except for one item-remarkable. The head noticed by the young sculptor cannot have been a particularly fine example. However, the one remarkable item in the Florentine museum was very remarkable indeed, being at that time unique in the world. Not properly speaking a work of art, it was the only war chariot to have survived intact from ancient Egypt. Made to be drawn by two horses, it accommodated a single passenger on a fragile platform mounted between two wheels, each having four spokes. Alberto may not have realized how remarkable this exhibit was, nor is it likely he was then much interested in chariots, either ancient or modern. But no visitor to the museum could have failed to notice that one. Occupying the largest glass case in the building, it evokes an uncanny sense of forward motion. Alberto's attention, however, seems to have been taken up entirely by the head. It apparently embodied for him the same glimmering, the same breath which he had found six months before in the paintings of Tintoretto.

Florence was freezing cold. Uncomfortable, lonely, and disappointed to have found no academy or class he could attend, Alberto decided after a month to move on to Rome. There the presence of some cousins gave promise of more comfort and companionship, and he hoped to find a place in an academy. Arriving on the 21st of December 1920, he was delighted by his first view of the Campagna, trees covered with green leaves and sunny meadows in which sheep and oxen were grazing. He was excited. This would be the largest city he had ever visited, the oldest, the richest in art, history, and vestiges of civilization stretching back in time for more than two thousand years. Waiting to meet him on the station platform were two of his cousins.

Antonio Giacometti was a cousin both of Giovanni Giacometti and of Annetta Stampa. He had gone from Bregaglia to Rome in 1896 and set up a pastry shop. After prospering for some years, he returned home, married, and took his bride back to Italy. Like most other expatriate sons of the valley, however, he did not leave it altogether, for he kept a house in Maloja where he and his family

went for summer vacations. So the cousins waiting for Alberto at the station in Rome on that winter afternoon in 1920 were not strangers.

Antonio and Evelina and their six children lived in a comfortable house in the Monteverde section of Rome, a quiet residential neighborhood. There was plenty of room for everyone, and a spacious garden, dominated by an enormous cedar of Lebanon. Alberto felt at home. He visited St. Peter's, the Forum, the Colosseum. Thrilled by the profusion of things to see, he ran all over the city, trying not to miss any. But he did not forget Stampa. If he could be split into many pieces, he said, in order to experience life more fully, the largest piece would always be saved for Stampa.

The Roman Giacomettis were slightly embarrassed by the attire and manners of their country cousin. He had arrived wearing shabby, old-fashioned clothes handed down from his father. Gangly and awkward, he was not yet the wide-shouldered, muscular young man he would soon become. Initially shy and aloof with the Romans, he rapidly recovered his natural self-possession and was not at all averse to startling or impressing strangers.

Though he may not have realized that his father's old clothes would be unsuitable attire for a young artist in Rome, he was quite ready to get out of them when the realization dawned. He serenely informed his parents that one felt better when well dressed and enjoyed oneself more, provided the money held out. It obviously did, for Alberto does not seem to have had to skimp. He sent his parents a drawing of himself in a fashionable new outfit, asking whether it made them happy to have such a well-dressed son. More than his handsome new suit, fine overcoat, scarf, or gloves, it seems to have been Alberto's walking stick which pleased him the most in his emergence as a young man of fashion. As canes were no longer the staple of masculine elegance they had been twenty years before, it may have seemed a bit eccentric of Alberto to carry one. If so, that didn't trouble him, and he flourished it with a swagger of which he himself was humorously aware.

Having hoped to enter an academy and find a studio, he was disappointed at first. The academies were full, studios expensive. After some weeks, though, he became a member of the Circolo Artistico, where he was able to draw from live models every evening for two hours. "Drawing is the most important thing," he said. And before long he found a small studio in the Via Ripetta. He made friends with young artists of his own age: Arthur Welti and Hans von Matt, both Swiss, and an Italian youth named Murillo La Greca.

Bianca was the eldest of the six children of Antonio and Evelina Giacometti. Lively, saucy, and pretty, she was fifteen when her nineteen-year-old cousin from Stampa arrived in Rome. She didn't like him, and he quickly fell in love with her. It was the first overt, unhappy love of his adult life.

Everyone in the Giacometti family and among their acquaintances liked Alberto, admired him, and made much of him. Except Bianca. She was interested only in what could amuse and entertain her. Art didn't. Upon occasion, when it suited her fancy, she was willing to go out with Alberto or allow him to make her a present. She soon discovered that she could get almost anything from him if she went about it in the right way, which was by playing the innocent, and she slyly saw that he enjoyed being taken advantage of.

Alberto became Bianca's slave. He worshipped her, but from afar. The relationship was highly unsatisfying, Bianca indifferent or impatient, Alberto miserable. He tried to arouse her interest by going out with another girl. She took no notice. He bought her candy and ice cream and escorted her around the city. She would not offer him even an illusion of satisfaction. That was all she could have offered, in any case. Of course, it was all he wanted.

Evelina Giacometti was a warm-hearted, understanding woman. She liked Alberto, and in the absence of his own mother, she tried to be motherly to him. Wanting her daughter to be more considerate of the love-sick cousin, one day she ordered her to go out walking with him. Bianca protested and when her mother insisted she had a temper tantrum and burst out crying. Alberto

was present during this scene, but instead of being upset by it he sat down and made a drawing of Bianca in tears.

During the first eight weeks of his Roman sojourn, Alberto made no sculpture. Shortly after the middle of February, he felt a desire to do so. It was motivated in part, perhaps, by the hope that if he again paid attention to another girl, Bianca might become more interested in him. The model was a beautiful young woman named Alda, with fine features and lustrous hair gathered in a pompadour on top of her head, a sister-in-law of the Giacomettis' maid. She posed in a basement room of the Villino Giacometti, where Alberto had installed a makeshift studio. The sessions went well. The artist and his model talked and laughed constantly, and Alberto portrayed Alda with a smile on her lips. In a week, the small bust was finished and turned out to be an excellent likeness. The model declared herself delighted and added that she would be glad to receive the sculpture as a gift. Alberto was pleased, too. The clay was cast in plaster and Alda happily carried off her portrait.

If he had hoped to make Bianca jealous, he failed. She was not a bit interested in what was going on in the basement between her cousin and the maid's sister-in-law. Before the bust of Alda was finished. Alberto determined to make one of Bianca as well. Evelina must have prevailed upon her daughter to pose, for she had no desire to do so. Work began immediately, and one may assume that the relationship between artist and model was less carefree and merry than the week before. Alberto had allowed Bianca in other circumstances to twist him around her little finger. Now he demanded that she submit to the strict regime of immobility which he always demanded when working from a model. This can only have seemed intolerable to a capricious girl of fifteen who didn't care two straws either for the artist or for his art. She fidgeted and squirmed. Alberto must have been uncomfortable, too. How could he hope to see her with the necessary objectivity of an artist when every glance aroused the feelings of an unrequited lover? Under such conditions, it is easy to imagine that the bust which stood both literally and figuratively between them may have seemed to be more a representation of conflict and dissatisfaction than of Bianca.

At the same time, however, Alberto may have sensed that if he could succeed in making a portrait of Bianca as satisfactorily as he had made the one of Alda, his model might respond more favorably to his romantic yearnings. The work went badly from the beginning. Bianca sat before him, but she remained aloof, distant. So near, yet she was far. "For the first time I couldn't find my way," he said later. "I kept getting lost, everything escaped me." He was unable to reproduce what he saw. The sense of ineffectuality was devastating. It destroyed in an instant all his confidence and zest. "The head of the model in front of me became like a cloud, vague and boundless." He couldn't understand what had happened. He felt baffled. But he was tenacious. He refused to submit to this seeming impossibility. The sittings dragged on for weeks, the weeks became months.

Alberto's time and energies during that late winter and spring of 1921 were not solely devoted to the bust of Bianca, of course. He continued to paint landscapes and portraits, to make drawings from life at the Circolo Artistico, and to fill notebooks with copies of the works he admired in Rome's museums and churches. With none of these, moreover, did he experience the least difficulty. The bust of Bianca alone withheld satisfaction. In the basement of the Villino Giacometti, wrapped in damp rags to keep the clay from hardening, the sculpture stood like an incriminating witness.

Needless to say, there was no physical intimacy between Alberto and Bianca. Alberto felt trepidation at the prospect of sexual experience, because it was related to notions of love and personal commitment. The painful bout of orchitis had probably left him with some sense of genital inadequacy, and perhaps of sexual futility. But there was something more, some interdiction that made the sexual act seem not only intimidating but frightening. Desire, however, overcame apprehension.

"I took a prostitute home with me to draw her. Then I slept with her. I literally exploded with enthusiasm. I shouted, 'It's cold! It's mechanical!'"

This explosion, charged with the energy and release of a youthful orgasm, altered forever the configuration of Alberto's inner self. The sexual act was mechanical, it was cold. Therefore,

it need have, it could have, nothing to do with love. It was not to be feared. It entailed no commitment of one's identity. No dire consequences stemmed from it. A thrilling sense of freedom appears to have followed the cataclysm, and the enthusiasm with which Alberto greeted it can only be construed as a measure of the previous foreboding. He cannot, however, have imagined that the passion with which he embraced his liberation was in direct proportion to the dispassion with which he embraced his liberator. Yet that convenient fact bore with it the ironic possibility of an even more inhibiting servitude.

Alberto's first mature sexual experience established a pattern. Prostitutes became the simplest solution to a problem that had no solution. It was not yet necessary to justify this expedience. Physical deliverance did that. But the time would come when he felt constrained to explain repeatedly in public and private why whores made the most satisfactory mistresses. It was courageous of him to do that, because, while the reasons he gave were serious and sincere, none of them hinted at the true reason. But perhaps he was in no danger of being obliged to understand. His work fulfilled the function of understanding.

It was while in Rome that Alberto began to smoke cigarettes. He also embraced the pleasures of tobacco with passion. He even made a drawing of himself in the attire of a dandy, holding in one hand his cane and in the other a cigarette, and inscribed with a phrase attributed to Oscar Wilde: "The cigarette is the truest delight." However true the delight, Alberto remained an inveterate smoker for the rest of his life.

While in Italy, the young artist was anxious to visit Naples, Pompeii, and the Greek temples at Paestum. Traveling with a young English acquaintance, Alberto went south from Rome on March 31, 1921. He was delighted with Naples, which he found much more beautiful than he had expected. He visited the museum, where he was especially impressed by the Roman paintings and bronzes, and the two young men went for the inevitable boat ride on the bay.

From Naples they took the train to Paestum on April 3. In 1921 that site had not yet become a noisy attraction of organized tourism. The three Doric temples, as well preserved as any which

survive, stood in serene solitude among pines and oleanders. Alberto was very moved by that peaceful and forgotten spot. He felt more religious spirit there, he said, than in all the Christian churches of Italy, adding that Paestum would remain forever in his memory. It would, indeed.

After one night there, the two young travelers took the morning train for Pompeii. Alberto was reminded of his father, who had spent one of the most trying periods of his life nearby. They were not alone in the railway carriage, and presently got into conversation with one of their fellow passengers. This person was an elderly, white-haired gentleman, a tourist traveling alone and glad of a chance to chat with the high-spirited youths. The companionable interlude didn't last long, however, as Pompeii is only forty-five miles from Paestum. Alberto and his English friend got off there, while the solitary gentleman went on to Naples.

The city of Pompeii made a deep impression, too. Alberto paid particular attention to the paintings, and recognized at once the grandeur of those in the Villa dei Misteri, which he felt to be very modern in form and lighting. A little like Gauguin, he said, but more complete.

Bianca continued to pose, and Alberto to have difficulty. The bust didn't satisfy him. He couldn't finish it. It is curious and intriguing, this difficulty with the bust of Bianca. Nothing like it had occurred before. Till now he had been able to complete without difficulty whatever he began. Busts of Diego and Bruno, of his mother, Simon Bérard, and Alda had all been finished as simply and pleasurably as could be. Then something happened. The difficulty had materialized in the form of a sculpture, and it was in terms of sculpture that Alberto felt he must overcome it. He could easily have gone on making drawings and paintings. They gave no trouble. It was his need to do satisfactorily what it seemed that he could not do at all which determined the character of his resolve. This may in time have been affected, too, by the fate of the sculpture which caused it.

In the bust at which he had worked for so long and with such dissatisfaction, Bianca was represented life-size, braids of hair looped over her ears. Unlike Alda, she was not smiling. Her expression reflected her dislike of posing, of the artist, and of his work. One day this dislike grew to such an extreme that she knocked the sculpture from its stand onto the floor, where it smashed to pieces.

There was an angry scene. Alberto had a fierce temper. Bianca's mother came running. The recalcitrant model got a slap for her pains. Alberto was not placated. The damage was irreparable. Gathering up the pieces, he threw them into the trash bin and vowed that he would never again make a portrait of his ungrateful cousin. But he bore no grudge. Maybe Bianca's readiness to mutilate his work made him even more amorous.

Throughout the rest of his life, Alberto repeatedly spoke of

the difficulty he had experienced with the bust of Bianca, explaining again and again that it had been, as it were, his "expulsion from Paradise" and therefore the true beginning of his lifework. "Before that, I believed I saw things very clearly, I had a sort of intimacy with the whole, with the universe. Then suddenly it became alien. You are yourself, and the universe is beyond, which is altogether incomprehensible."

However, in the accounts of this experience there was another of those factual inaccuracies which point to the truth. He always stated that it was he who had destroyed his work because he was dissatisfied with it. He never said that the bust had been the portrait of a girl with whom he was in love or that it was she who had destroyed it. The difficulty he encountered had destroyed something, and he had to assume responsibility for it. There were times in later years when Giacometti seemed to be of two minds about the precise date and nature of the experience which precipitated his critical sense of difficulty and determined the course of his lifework. Not that there is any question about the events which took place in Rome in the spring of 1921. But he did encounter a similar difficulty four years later in somewhat similar but decisively different circumstances, and he seemed upon occasion to consider the two interchangeable in their character and effect.

Alberto continued to work at the Circolo Artistico, to go to concerts, the theater, and museums. But he didn't forget home. After more than seven months away, he looked forward with impatience to returning for the summer. Besides, Rome had become oppressively hot.

Bianca had been enrolled at a boarding school in Switzerland, near Zurich. So that she would not have to travel so far alone, it was arranged that Alberto should accompany her to Maloja, where his parents were installed for the summer, and after spending a night there she could take the train from Saint Moritz. As they set out together, he whispered to her, "It's like our wedding trip." She did not think of it in that way and was quick to say so.

There was some delay en route. By the time they reached the frontier, it had been closed till the next morning. They were obliged to go to a hotel for the night. After dinner in the hotel

dining room, they went into the garden, where Alberto pushed her back and forth in a swing till it began to grow dark. Then she went to her room, took off her dress, and in her shift sat down to write a letter to her mother. After a time, Alberto knocked on the door. Bianca was reluctant to open, but he insisted. Finally she opened the door a crack and said, "What do you want?"

"I want to draw your feet," he said.

Thinking the request ridiculous, Bianca did not hesitate to say so. Alberto, however, was again insistent. Realizing that it might be easier to acquiesce than resist, Bianca reluctantly consented, protesting all the while. But Alberto was in earnest. He came in with his paper and pencil and made drawings of her feet until midnight. Then he contentedly returned to his own room.

In the morning the two continued their journey by the post coach, proceeding directly to Saint Moritz, where Bianca was to catch the train after lunch. During the meal Alberto was despondent. For dessert, both ordered chocolate cake. Of all things to eat, chocolate was the one which Alberto liked most. But when the cake appeared, he said, "How can you eat chocolate cake? I'm too sad to eat anything."

"Then I'll eat yours," Bianca pertly replied, and she did.

A mysterious advertisement appeared in an Italian newspaper during the midsummer of 1921. The mystery is great, because the advertisement had very definite consequences, but years of diligent research have been unable to resurrect it from the morgues of the Italian press. It had been inserted by a Dutchman from The Hague and was addressed to the attention of an anonymous, Swiss-Italian art student whom he had met some months before while traveling by train from Paestum to Naples. The latter was requested to respond by mail. Every law of probability would have seemed to be defied by the chance that this advertisement might fall into the hands of the young man for whom it was meant. But Antonio Giacometti chanced to see the advertisement, chanced to suppose that it might be addressed to his young cousin, and took the trouble to send it on to Maloja.

Alberto was surprised and puzzled. However, he did recall having encountered an elderly man in a railway compartment the previous April. He thought that perhaps the man had lost something en route and hoped that a fellow traveler might help him to recover it. Since the request had by chance reached its destination, Alberto wrote to The Hague.

A reply presently came back from a man named Peter van Meurs, who wrote to say that although their previous meeting had indeed been brief, he had found the young artist an agreeable traveling companion. He proposed to renew the acquaintance. Enjoying travel, he explained, but being elderly and alone in the world, he preferred not to travel by himself. Therefore, it would give him great pleasure if Alberto should agree to accompany him on a trip, for which he would naturally pay all the expenses.

It was, to say the least, an astonishing proposal. It might have seemed more astonishing still if the recipient had known more about his would-be benefactor. Peter Antoni Nicolaus Stephanus van Meurs was born of Protestant parents at Arnhem in 1860, the first of six children. He studied law and obtained a degree but never practiced. In 1885 he accepted employment with the Central State Archives in The Hague, where his principal activity was to catalogue and conserve the municipal archives of southern Holland. and in 1913 he was appointed Keeper of the Public Records. In addition to professional duties, he assumed certain civic responsibilities, of which the most significant was as member of the board of directors of an organization formed to deal more humanely with delinquent young boys. He also belonged to the Society for the Furtherance of Sunday Rest and to the Dutch Alpine Society. He loved travel, especially in the mountains of Italy. He was a vegetarian, independently wealthy, and unmarried.

This was the man who after an hour's chance meeting in a train had gone to extraordinary lengths to renew contact with Alberto and now proposed to take him on a journey. It seems a surpassing understatement to observe that the nineteen-year-old youth must have made a deep impression on his fellow traveler of sixty-one.

The idea of taking a trip appealed to Alberto. At the same time he didn't know quite what to think of van Meurs's offer. Since Diego happened to be in Maloja for a visit, Alberto turned to him for advice. There was no doubt in Diego's mind. He felt sure that the older man was a homosexual who hoped to take advantage of the trip to have an adventure far from home with a young man unlikely to endanger his reputation. What other explanation, he argued, could there possibly be for the extravagant pains taken by this stranger to reestablish contact with someone he had known for an hour four months before? If his intentions had been innocent, why should he not have sought a traveling companion at home?

Alberto protested. He said that Diego had no right to make such discreditable assumptions, and he declined to take account of them. The fact was, however, that he had made the very same assumptions himself, but he did not choose to acknowledge them. By nature contradictory, not to say contrary, he obviously wanted to accept the offer despite his misgivings. In later years he explained his acceptance by saying that he had been anxious to travel but was too poor to do so on his own. The explanation is as poignant as the proposition.

He wrote to van Meurs and accepted. The Dutchman was evidently in a hurry to take advantage of his good luck, because it was agreed that they should set out together soon. The itinerary apparently decided upon seems to demonstrate that the older man was eager to prove to his young correspondent that the trip would be pleasant. Their destination turned out to be none other than Venice, the city to which Alberto had longed to return since leaving it more than a year before with his father.

What Alberto's parents thought of his plans we do not know. Perhaps they felt that Alberto was of an age to make decisions for himself and that they had best not interfere. But Alberto was not disposed to leave them out altogether. He took steps to make sure that if some difficulty arose en route he could count on parental assistance—not in person, of course, but symbolically. Before leaving Maloja, he took a thousand francs from his father's drawer.

"If things turn out badly," he said to himself, "if he becomes pressing, I'll be able to get home on my own!"

A thousand Swiss francs was not at the time a great deal of money. Alberto had spent far more on new clothes while in Rome, and his father might well have given him such an amount if he had asked for it. But he didn't. He made sure that he wasn't, so to speak, starting out unaccompanied.

Exactly where in northern Italy the two met is unclear, but wherever the meeting occurred, it must have been a strange moment, tense with curiosity and ambiguity, as the two came face to face: an impetuous youth of nineteen and a staid, though fanciful, gentleman of sixty-one.

Van Meurs was not handsome. He had thick, fleshy features, and pronounced pouches under small eyes, but his chin was strong and his mouth firm. His shoulders were rather stooped, no doubt as a result of the decades spent poring over archives. If he was homosexual, as seems likely, there is no reason to assume he was an

active or even a conscious one. If there was any sexual motive for his interest in Alberto, he may have been unaware of it. He had grown up in a time when homosexuals were still hounded by the police and despised by the public. People were not prone to acknowledge such a tendency either to others or, if possible, to themselves. Lacking evidence to the contrary, it seems fair to assume that van Meurs's attentions were innocent. Alberto never implied that the older man had attempted to have any kind of intimacy with him. Everything, in fact, that he subsequently said or wrote about van Meurs—and it was much—suggests that he regarded his companion as a kind and fatherly man.

The travelers set out on September 3, 1921, for a small village high in the mountains named Madonna di Campiglio. As no motorized transport yet existed in that rather desolate region, they took the post coach over narrow, twisting roads up the faces of cliffs and above precipitous gorges. Even in early September, it can get very cold up there. By the end of the day, when they had reached the little place in a fold of the mountains, van Meurs had caught a chill. They went to the Grand Hôtel des Alpes, a rambling structure built on the ruins of an ancient monastery.

The following day was Sunday. Rain was falling on the mountainsides, on the forest, and on the fields around the hotel. It was cold. Van Meurs awoke unwell and in severe pain. He suffered from kidney stones, he explained. He writhed from side to side on his bed, banging his head repeatedly against the wall. The hotel luckily had a doctor attached to its staff. He was called, examined van Meurs, and gave him an injection to ease the pain.

Alberto remained by the bedside of the elderly Dutchman. Having brought with him a copy of Flaubert's *Bouvard et Pécuchet*, he began to read the introductory essay by Guy de Maupassant. In it there is a passage which may have seemed striking to the impressionable young artist as he sat by the bed of this sick man whom he barely knew.

Speaking of Flaubert, Maupassant says: "Those people who are altogether happy, strong, and healthy: are they adequately prepared to understand, to penetrate, and to express this life we live, so tormented, so short? Are they made, the exuberant and outgoing,

for the discovery of all those afflictions and all those sufferings which beset us, for the knowledge that death strikes without surcease, every day and everywhere, ferocious, blind, fatal? So it is possible, it is probable, that the first seizure of epilepsy made a deep mark of melancholy and fear upon the mind of this robust youth. It is probable that thereafter a kind of apprehension toward life remained with him, a manner somewhat more somber of considering things, a suspicion of outward events, a mistrust of apparent happiness."

Outside the window, rain continued to fall on the wooden balcony of the hotel, on the few houses of Madonna di Campiglio, on the forest beyond. In the sickroom, occasionally van Meurs murmured, "Tomorrow I'll be better." But he showed no sign of improving. On the contrary. His cheeks had become sunken, and he was barely breathing through his open mouth.

Alberto took paper and pencil and began to draw the sick man: to see him more clearly, to try to grasp and hold the sight before his eyes, to understand it, to make something permanent of the experience of the moment. He drew the sunken cheeks, the open mouth, and the fleshy nose which even as he watched seemed bizarrely to be growing longer and longer. Then it suddenly occurred to him that van Meurs was going to die. All alone in that remote hotel, with rain pouring on the rocky mountaintops outside, Alberto was seized by blind fear.

Toward the end of the afternoon, the doctor returned and examined the sick man again. Taking Alberto aside, he said, "It's finished. The heart's failing. Tonight he'll be dead." There was nothing to be done.

Alberto waited by the bedside of the dying man. Nightfall came. Hours passed. Peter van Meurs died.

In that instant, everything changed for Alberto Giacometti forever. He said so, and never ceased saying so. The subsequent testimony of his lifetime showed that it was the truth. Till then he had had no idea, no inkling of what death was. He had never seen it. He had thought of life as possessing a force, a persistence, a permanence of its own, and of death as a fateful occurrence which might somehow enhance the solemnity, and even the value, of life.

Now he had seen death. It had been present for an instant before his eyes with a power which reduced life to nothingness. He had witnessed the transition from being to non-being. Where there had formerly been a man, now there remained only refuse. What had once seemed valuable and solemn was now visibly absurd and trivial. He had seen that life is frail, uncertain, transitory.

In that instant, everything seemed as vulnerable as van Meurs. Everything was threatened in the essence of its being. From the most infinitesimal speck of matter to the great galaxies and the whole universe itself, everything was precarious, perishable. Human survival above all appeared haphazard and preposterous.

"When I saw how that could happen, at the very instant when I saw how that person died, everything was threatened. For me it was like an abominable trap. In a few hours van Meurs had become an object, nothing. Then death became possible at every moment for me, for everyone. It was like a warning. So much had come about by chance: the meeting, the train, the advertisement. As if everything had been prepared to make me witness this wretched end. My whole life certainly shifted in one stroke on that day. Everything became fragile for me."

Alberto did not rest well that night. He did not dare go to sleep for fear he might never wake again. He was also afraid of the dark, as if the extinction of light were the extinction of life, as if the loss of sight were the loss of everything. All night, he kept the light burning. He shook himself repeatedly to try to stay awake. Now and again he drowsed. Then suddenly it seemed to him in his half-sleep that his mouth was hanging open like the mouth of the dying man, and he started awake in terror. Struggling against drowsiness, he kept awake till dawn.

His first impulse was to run away, to leave Madonna di Campiglio as fast as he could. He wanted to escape from the scene of terror, the sense of fate, to forget what had happened, to return to the security and innocence of his former life. But it was too late. If he did not fully understand what had happened, he understood, at least, that nothing would ever again be as it had been. His whole life had, indeed, shifted.

It seemed there might be something suspicious about the cir-

cumstances of the Dutchman's death. A strange inflammation had been found on his chest. Alberto was placed under police guard until the exact cause of death could be determined. To be sure, the authorities may merely have suspected that van Meurs had died of some seriously contagious malady and wished, if so, to make sure that his young traveling companion should have no opportunity to spread it. Perhaps they entertained other suspicions. For Alberto, in any case, after the sleeplessness and terror of the preceding night, to wait in the custody of a policeman surely added to the shock of his experience. Detention by the police always smacks of crime and imputes guilt.

Examination disclosed that van Meurs had died, as the doctor predicted, of heart failure. Having spent a day in police custody, Alberto was free to go. His foresight in having stolen a thousand francs from his father seems uncanny, but that was probably an element of chance which he preferred to disregard. Instead of returning directly to Maloja, he decided—"in spite of everything," he said—to go on to Venice, the destination planned from the start.

During this second Venetian sojourn, the young artist was not excited by the same exclusive and fanatic love which had so absorbed him sixteen months before. Instead of running from church to church to worship Tintoretto, he ran after prostitutes, spending his father's money on them and in the cafés. Always dutiful, however, he sent home a postcard the day after his arrival. It was a photograph of one of the most celebrated sculptures extant, the equestrian statue of that great Renaissance man of action, Bartolomeo Colleoni, by Verrocchio. Assuring his loved ones that Venice seemed more agreeable than ever, an enchantment, where one heard whistling and singing all day long, Alberto added that the bad memories were fading away. It was not so.

One evening, as if to his surprise, he found himself running through the narrow alleyways of the city, along obscure canals, across out-of-the-way squares, clutching in one hand a piece of bread that he wanted to dispose of. "I went through all of Venice," he wrote many years later, "looking for remote and lonely neighborhoods, and there, after several unsuccessful attempts on the darkest little bridges and along the most somber canals, trembling

nervously, I threw the bread into the stinking water at the dead end of a canal enclosed by dark walls, and I rushed away in a panic, hardly aware of what I was doing."

But he could not throw away what had happened. Bread could have filled the canals of Venice to overflowing in vain. No ritual act could grant the deliverance he sought. It would have to spring from his solitary understanding.

When the money he had taken from his father was all spent, Alberto returned to Maloja. One month later, he celebrated his twentieth birthday. "That trip I made in 1921 (the death of van Meurs and all the events surrounding it) was for me like a hole torn in life. Everything was transformed and the trip obsessed me constantly for an entire year. I talked about it tirelessly and often I wanted to write about it; that was always impossible for me."

The experience would demand other forms of acknowledgment for twenty-five years before Alberto was able to allude to it in writing. Conversation was only one of these.

At the time when Alberto returned from Venice to Maloja, he was sharing with Bruno a bedroom in the family's summer home. The fourteen-year-old boy was startled and annoyed to find that his older brother had acquired another nocturnal eccentricity while away. Not only did Alberto continue to arrange his socks and shoes with the same obsessive precision as before, but now he refused to sleep without a light burning in the room. Bruno protested, but Alberto would not give in. If a dispute ensued and was referred to Annetta for arbitration, the first son, as usual, had his way. In this case, perhaps, she sensed that as a mother she had cause to be more than usually sympathetic. The light in Alberto's bedroom remained burning.

It remained burning, wherever the bedroom happened to be, and whatever the circumstances, for the next forty-four years and four months. "It's childish, of course," Alberto was the first to acknowledge. "I know perfectly well that one is no more threatened in the dark than in broad daylight." But the light remained burning. It was symptomatic of anxiety, and where there is anxiety there must be something of which one is afraid. What had happened at

Madonna di Campiglio had happened in reality, not in the fantasy of a child or the dream of a grown man.

The cane which Alberto had carried with such pride in Rome, tapping it constantly around him, "always endangering someone's life," as he said, did not seem appropriate in Stampa. Nor did the fashionable clothes of which he had formerly been proud. He gave them up. His period of sartorial self-satisfaction had been brief. Once he had come home, simple, homely attire seemed suitable. He never again showed any interest in fine clothes. In fact, it sometimes appeared that he went out of his way to be dressed shabbily.

A decision had to be taken as to Alberto's future. It was clear that he was on his way to becoming an artist, but the course of his artistic formation remained uncertain. Everyone, in any event, realized that he could not remain in Stampa. Where was he to go? Rome? Paris? Vienna? What was he to do? Sculpture? Painting?

It must have been at this juncture that Alberto made up his mind to apply himself above all to sculpture. The decision itself had been made many months before in the basement of the Villino Giacometti.

"I began to do sculpture because that was precisely the realm in which I understood least. I couldn't endure having it elude me completely. I had no choice."

Giovanni suggested to his son that he should go to Paris and enter an academy where he could receive guidance and instruction from a recognized master. He recommended the class of Antoine Bourdelle at the Académie de la Grande-Chaumière.

On the 28th of December 1921, Alberto left Stampa and traveled by way of Zurich to Basel, where he would be obliged to obtain the visa for entry into France. He was met at the station by Diego, who by that time had moved on from Chiasso and found employment with a manufacturing company. Alberto was gratified to discover that his nineteen-year-old brother seemed to be applying himself conscientiously to the job, and had become something of a dandy, making a considerable impression on people in Basel. The impression may have been due in part to the fact that he had turned out to be strikingly handsome in the style of matinee idols of the twenties. This was the beginning of a dapper, even flashy,

period in Diego's life. As it happened, his industry was not devoted solely to the interests of his employers. The habits he had formed and the lessons he had learned while in Chiasso were not allowed to remain dormant in the frontier city of Basel, and so a bit of smuggling still went on. No doubt the proceeds from such operations helped the elegant, good-looking young man about town to impress the solid citizens.

Formalities delayed the delivery of Alberto's French visa. He looked forward impatiently to Paris. Two nights before his departure, he dreamed that he was already in the train and on his way, that everything was beautiful and the railway cars of fabulous size.

On the evening of January 8, 1922, his dream came true. Traveling alone, Alberto crossed the border from Switzerland into France for the first time. As the night train rolled westward through the Vosges, perhaps its railway cars did not seem so fabulous, after all. But their destination was.

Two

Dada

13 Surrealism

Giacometti invariably stated in later years that he had arrived in Paris for the first time on New Year's Day, 1922. In fact, he arrived on January 9. The inaccuracy is intriguing, because at first it seems so pointless.

To arrive for the first time in Paris was a signal event for a young artist in 1922. If his arrival coincided with the first day of a new year, the coincidence would probably have impressed him and might have seemed a good augury. But if he did not arrive on that day, then neither impression nor augury could have existed. By stating that he had arrived on the very first day, he was taking destiny into his own hands, demonstrating his disposition to live with experience in such a way that a mythical imperative can take precedence over mere fact.

Paris in 1922 was the world center of intellectual and artistic ferment. The chaos and devastation of the Great War had spawned movements which were intended to annihilate traditional concepts and practices. Of these, the most forceful was Dada, originated in 1916 in Zurich by the Rumanian poet Tristan Tzara, the sculptor Hans Arp, and others. Dada was based on deliberate irrationality, nihilism, and the systematic denial of all traditional canons of composition, form, and beauty. After the war, Tzara and the movement migrated to Paris, where the young poets André Breton and Louis Aragon and artists like Marcel Duchamp and Francis Picabia were attracted to it. Its ascendancy was not long-lived, for it came to an end as a movement in 1922, but some of its ideas and many of its adherents found an ampler field for expression two years later when the Surrealist movement was brought into being by André

Breton. Thus, a turmoil of artistic change was sweeping Paris when Alberto arrived there.

The proven masters of the previous generation had no part in it. After the extraordinary adventure of Cubism, Picasso was peacefully installed with a new wife and baby boy in the bourgeois repose of his classical period. Braque was turning out decorative still lifes. Matisse, the most authentically wild of the so-called wild beasts (les fauves) of 1905, had become a tame painter of graceful odalisques on the Riviera. Derain, Vlaminck, Rouault, Utrillo all had left their best work far behind. There was an open challenge for some young man to come along and prove his ingenuity and daring. Plenty were eager to try.

The center of all the creative excitement was Montparnasse, that area of Paris surrounding the intersection of the Boulevard du Montparnasse and the Boulevard Raspail. That was where everything interesting and inventive in the arts happened, or seemed to happen. There the young artists lived, studied, and worked. They sat in cafés drinking and arguing till all hours of the morning. And none doubted that Montparnasse was the hub of the universe. Its inhabitants, in any case, came from all over the world. From the Americas, from Asia, Africa, Australia, and every part of Europe.

The rue de la Grande-Chaumière is immediately adjacent to the Raspail-Montparnasse intersection, and it was in that street, at No. 14, that the academy of the same name was located, and still stands today. It was the best-known academy in Paris during the twenties, and its most celebrated teacher was the sculptor Antoine Bourdelle.

X

Then a man of sixty, Bourdelle had been a pupil of Rodin and for fifteen years his assistant. He conceived of himself as an epic figure, a creator on the scale of Beethoven, whose effigy he produced in more than a score of grandiloquent versions. His work presumed to be on a similar scale, turning for inspiration to archaic Greek sculpture and the rough-hewn carvings of medieval craftsmen. But his exaltation proved to be mediocre and his monumental sculptures are great in size only. It was Bourdelle's fate to be unaware of the crisis of his epoch, oblivious to the eventualities

inherent in European culture, and blind to the drift of his own career.

The most eminent sculptors of the time were Brancusi, Laurens, Lipchitz, and Maillol. All of them were older than Giacometti, the last having been born exactly forty years before him. All were more gifted than Bourdelle and well known in Paris before Alberto's arrival.

The Rumanian Constantin Brancusi had come to France in 1904, declined Rodin's offer of tutelage, and before long had been recognized as a leading abstract sculptor. His work is characterized by extreme simplification of form, which is frequently symbolic, and by a remarkably subtle exploration of the aesthetic potential of sculptural materials.

The early works of Henri Laurens illustrate with authority and refinement the fundamental principles of Cubism. In this style he created sculptures and bas-reliefs, often polychromed, more lyrical and less theoretical than the paintings of Picasso and Braque. In the mid-twenties, however, he returned to the human figure, the female figure almost exclusively. This return liberated unforeseen powers, and he developed a highly personal style, voluptuous, lyrical, and ideally suited to celebrate the mythical fruitfulness of womanhood.

Jacques Lipchitz, Lithuanian by birth, arrived in Paris at the age of eighteen. He soon came under the influence of Cubism, producing with brio and virtuosity a series of works which exemplified the then radical genre. After the First World War he evolved a more original style, but later became preoccupied with allegorical, symbolic themes, the results of which were turgid and bombastic.

The continuity of the classical sculptural tradition after Rodin is seen at its most obvious in the works of Aristide Maillol. His simple, massive figures of women were meant to proclaim a deep affinity with Greek sculpture. The style was idealized but stereotyped, and it produced works of ponderous plenitude.

Both Picasso and Matisse, as it happened, had done important work in sculpture prior to the First World War. However, it remained for many years nearly unknown. The day would come when Picasso was to be considered the potent progenitor of an entire new tradition in contemporary sculpture, a tradition which repudiated former concepts of the sculptural object and ushered in a new era of aesthetic discourse. But in 1922 that day was still more than a decade in the future.

Giacometti was vigilantly attentive to all the aesthetic happenings of his time. To scientific, political, and social happenings, too. He knew what was going on and he responded to it with such ardor that his life became important to the history of his century, of which it filled the first two-thirds.

All in all, and more or less, Alberto spent five years at the Académie de la Grande-Chaumière. There he could always work from a live model when he wished, and the presence of other students, some of whom were very skilled, obliged him to look at his own work more objectively and to take careful stock of the evolution of his creative ambitions. But there were many days, even weeks, and sometimes months, when he didn't go to the academy, preferring to work by himself.

During those early years, Alberto had no fixed residence. He lived here and there in hotels, moving frequently, as if reluctant to establish himself in a manner that might entail a commitment to permanence. Just as he avoided taking anything in life for granted, he avoided situations that could seem to take his presence for granted.

It was among the other students at the academy, naturally enough, that Alberto found his first friends in Paris. Most of them were foreigners like himself. There were a few Frenchmen, to be sure, but they tended to keep to themselves. Alberto was startled by the French reserve. "There's nothing more difficult than to make contact with Frenchmen," he said. "It's like a wall."

Among those unfriendly French students at the Grande-Chaumière was a young man of twenty-two who may have been even more unsociable and reticent than the others. Perhaps he had cause to be, for he was the youngest son of a painter who even then was world famous. His name was Pierre Matisse. His father had wished to make a musician of him, but he aspired to become a

painter. Though skilled, he was lacking in self-confidence, and the pursuit of an artistic career was abruptly interrupted when in 1923 he impulsively married a headstrong young woman whom he had met while staying with an aunt in Corsica. When the match promptly turned out to be an unhappy one, Henri Matisse, never a man of indulgent family feeling, dourly packed his son off to America and set about having the union annulled. In New York, Pierre found that he would have to do something about supporting himself, so creative aspirations were set aside to make way for the career of an art dealer, as it must have seemed obvious that in this profession circumstances could help him to make a name for himself. It was an activity, moreover, in which his father had occasionally engaged in order to support his family before Matisses started to sell. As an art dealer, at least, the son did eventually manage to outdo his celebrated parent.

Alberto's first friends in Paris were Yugoslavian, Swiss, American, and Greek. There was also a group of Italian painters he saw from time to time. They went to the movies together, to concerts, to the Louvre, and sometimes made excursions into the surrounding countryside on Sundays. Full of confidence for the future and elated by the new freedoms which had followed the war, they exuberantly enjoyed their youth and each other. However, like Alberto's schoolmates at Stampa and Schiers, they sensed from the beginning that their friend was different. He often kept to himself. There was something about him which seemed incommunicable. Perhaps this was in part the extraordinary passion with which he applied himself to his work. All of them were serious, of course; all had great aspirations; but Alberto was driven by a compulsion surpassing mere ambition, and everyone sensed it.

Giacometti's first three Parisian years were in reality little more than half years, if that, for he was continually making long visits home. Even after he had settled more permanently in Paris, he returned regularly to Stampa, as if there were two Albertos, one who lived abroad and another who never left home. From the latter the Parisian could receive reassurance but for his sake must periodically return to their birthplace. Its rocky soil nourished both. "One has to be born there to understand," he said. Every aspect of

Bregaglia was essential and indispensable. Above all, Annetta Giacometti. It was her concern and her love that most nurtured and fructified.

Bianca, too, was to be found during the summertime at Maloja. While in boarding school she had not forgotten her cousin, and she thought that her schoolmates might be impressed if she received love letters from a young artist in Paris. So she began to write, never imagining that the one most impressed by the correspondence might be herself. Alberto replied. Letters between them became frequent, and little by little Bianca perceived that she had understood nothing about her unusual cousin.

His letters were beautiful and original. They showed how deeply he cared for life, how compassionately he looked at the world, how vividly he saw all of its features. They were whimsical and carefree on one page, thoughtful and grave on the next. Above all, Alberto was intensely present and alive in each one. Bianca was surprised, and gradually she began to realize that her cousin had touched her heart. By the time she was eighteen, she found herself as deeply in love with Alberto as ever he could have wished during those difficult days when she had so reluctantly posed for him in Rome.

None of the girls Alberto met at the Grande-Chaumière or in the Parisian cafés caused him to forget Bianca. He must have been profoundly satisfied to find her indifference replaced by passion. Though he loved other women after her, he loved her, too, and the romantic emotions he had first felt for the saucy fifteen-year-old girl were never supplanted by apathy.

Of other girls with whom Alberto fell more or less in love

during those early years, Alice Hirschfeld was one of the more important. Her parents spent summers in Maloja. She was interested in art. The Giacomettis were cordial to callers. She and Alberto had long, serious conversations. He had been reading Hegel. She was able to appreciate his speculations and enjoy his dialectical turn of mind. Perhaps their parents imagined, or hoped, that the two young people might have intentions as serious as their conversations. But Alberto could not bring himself to make advances. He shied away from commitment. Perhaps he was content to let his mother see him as the irresolute admirer of a respectable girl. Annetta always considered him very well behaved in this regard.

Alberto never learned to dance. He was often called upon to attend dances, however, especially at Maloja during the summer. Diego and Bruno both danced well, but their elder brother never even tried to learn, as if the activity entailed some relation in which he could not bring himself to participate. Dance is rhythmic movement requiring no precise situation in space. It involves an identification with the abstract realm of acoustics. A lively tune is said literally to carry the dancer away, leading him to move in a way neither determined by nor directed toward any goal. It is not by chance that people dancing often do so with their eyes closed. Optical space is the realm of man's actions and the framework of his life history.

Alberto's failure to learn to dance appears significant, because he nonetheless longed to participate in the sensuous experience of acoustical space. Not being lame, he was technically able, but clearly suffered from some inhibition, as he came to terms with his longing in a way peculiarly his own.

The dances held at Maloja and Stampa were communal affairs. Everyone attended. Because Alberto could not dance, however, all he could do was watch. It sometimes happened that when he saw a girl with whom he would have liked to dance, he asked Bruno to dance with her instead, and the younger brother usually obliged. While Bruno danced with the girl of his brother's choice, Alberto would stand to one side, staring at them, his arms held stiffly at his sides and his fists tightly clenched. Often a single dance was not enough. He would insist that Bruno dance again and again with the same girl while he gazed at them. On one occasion, he even organized a dance in honor of a school friend of Ottilia whom he found attractive, paying all the expenses himself, though he could only watch her dance with others.

From August to October of 1922 Alberto did his military service. Stationed at Herisau in the canton of Appenzell, he took a basic training course in the Alpine Infantry. His penetrating eyesight stood him in good stead and he won a sharpshooter's stripe.

However, he had too clear a mind and powerful an imagination to participate in anything so spurious as military morale. The warlike simulacrum of maneuvers was particularly demoralizing to one who lived with a constant sense of life's frailty. To play at killing or being killed was more than his common sense could stand. Reacting impulsively but right in character, he ran away from the makebelieve battlefield and hid.

"He will either go very far or go mad" is what the other students in those early years at the Grande-Chaumière said about Alberto. They recognized that he was different, but not all of them were prepared to acknowledge that he was superior, especially since neither he nor Bourdelle encouraged them to think so.

The master and the pupil did not get along. Given the widely divergent character of their aspirations and temperaments, it was perhaps natural, even desirable, that there should be no respect or understanding between them. Alberto frequently kept his work covered during Bourdelle's weekly visits to the academy, though he did upon occasion report to Stampa that he had received the master's commendation, feeling no doubt, and rightly, that even if he did not need such encouragement, his parents did. But when he began to produce work which was seriously original, Bourdelle's comments turned to sarcasm. Neither praise nor criticism, however, had much effect on Alberto. On one occasion, Bourdelle admired a bust which the young artist had produced and advised him to have it cast in bronze. Giacometti refused. He felt that to accept the work as finished would be to admit that he could do no better. He had already surmised that failure, not success, is the way to fulfillment.

Alberto was never satisfied. His fellow students at the Grande-Chaumière were impressed by the effortless skill with which he could produce figurative sculpture. He was not. He constantly criticized and belittled what he had done, repeating over and over that it was impossible ever to achieve anything satisfactory. At the same time he praised the work of his classmates, telling them how much better it was than his own. He was always able to do this with

complete sincerity for the simple reason that most artists are principally concerned with producing works of art, while for him these were but a means to an end.

If Alberto's classmates were surprised by his severe self-criticism, they were also amused. To be an artist in Paris in the twenties was romantic and exciting. There was no reason for one solemn classmate to spoil the fun. Alberto's seriousness, in fact, could be part of it. The others deliberately provoked him to argument, then laughed at his answers. They called him "the crazy genius." They played practical jokes on him. But he took the banter and jokes in good part as a rule, for he had a sense of humor equal to his talent, and as he himself observed, "It takes a long time to reach my breaking point."

He was lonely, however. Despite his extraordinary charm, his intelligence, his powerful physical presence, despite his subtlety, his candor, and his uninhibited responsiveness to other people, an insurmountable distance seemed to separate him from them. Like his work, they could never satisfy him. Solitude, however, seemed to be in the natural order of things. He did not complain. Besides, he had a strong impulse to accept suffering. Yet he was not a pessimist. The deepest dissatisfaction combined with indomitable energy is a source of optimism, for together they generate the conviction that tomorrow everything must be better.

Many of the young people at the Grande-Chaumière had love and marriage as well as sculpture on their minds. Not Alberto. The girls looking for husbands who glanced in his direction did not find responsive eyes gazing back at them. He was shy and aloof. Occasionally he did invite a girl from the academy to go to a restaurant and seemed to be courting her, but if she gave any sign of becoming attached he would immediately stop seeing her and complain to the others that she was "clinging." His friends were men. It was evident that the one woman who counted in his life was his mother, for he spoke of her very often, repeatedly praising her extraordinary virtues. Some of his friends, considering the evidence, wondered whether Alberto might not be homosexual.

Yet he showed an unmistakable interest in women. He did so, however, in a way which people found peculiar. When attracted

to a girl, he would often stare at her with an almost hallucinated intensity, immobile, his arms held stiffly at his sides, fists clenched. This gazing impulse made a powerful impression. Alberto recalled it years later, at a time when, perhaps, he had at last come to viable terms with his overpowering need to stare at women. "From the beginning the human face interested me more than anything," he said, "and to such an extent that I remember when I was a young man in Paris I sometimes stared so hard at people I didn't know that they became incensed, as if I didn't see what I wanted to see, as if everything were so confused that one could not decipher what one wanted to see."

Alberto was not homosexual, though he had strong empathy for friends who were. However, his feelings toward women were violently ambivalent. He both adored and despised them. They were goddesses to be worshipped from afar, but they were also fallen women deserving to suffer. He entertained fantasies of rape and murder. The seemingly insurmountable distance which he saw between himself and others might, he felt, be overcome by violence. From a very early age he had conceived of the sexual act as a battle. "I thought that between a man and a woman there could be only incompatibility, war, violence. The woman would not submit till bodily resistance was exhausted; the man raped her."

Dreams of violence were not conceived to be carried out in real life, but their intensity no doubt derived in part from a sense of sexual inadequacy. "I always felt very deficient sexually," he said. The reason was not physiological, however. The mumps had left him sterile, but physically quite capable of sexual intercourse. And yet he could never be sure of achieving satisfactory completion of the sexual act, no matter how fiercely he desired it. Maybe that's why he preferred to stare at women from a distance and shyly avoid amorous entanglements.

The sense of sexual inhibition did not apply equally to all women, though. By a convenient but logical process of selectivity, whores were exempt. Ever since Rome, Alberto's partiality to prostitutes had become increasingly pronounced, and during the first years in Paris it was confirmed as a deeply ingrained proclivity.

"Whores are the most honest girls," he said. "They present

the bill right away. The others hang on and never let you go. When one lives with problems of impotence, the prostitute is ideal. You pay, and whether or not you fail is of no importance. She doesn't care."

The Sphinx was in its heyday during most of the years Alberto spent in Paris, and he responded to its lure. One of the most famous brothels in Paris, it stood behind the Montparnasse station at 31 Boulevard Edgar-Quinet. Luxuriously decorated, the downstairs rooms were a Parisian potpourri of Karnak and Pompeii, while the bedrooms above offered styles and contrivances calculated to appeal to the most varied tastes. The bar and the salon were open to the public, and anyone was welcome to while away an evening, drinking and talking. The girls, naked to the waist, mingled freely with the clients and tried to entice them upstairs. But no one was under an obligation to go up if he didn't feel like it. This freedom was especially appealing to Alberto, for he felt that the Sphinx would never put him to a test which he need fear. "It was for me a place more marvelous than any other," he said.

Alberto lived with the problems of impotence, to be sure, but they were sexual only in their practical application, so to speak. A prostitute seemed to be the ideal not because she relieved the discomfort and indignity of impotence but because the character of relations with her concealed the true ideal of womanhood to which Alberto aspired. Thus, in terms of the conflict which he believed to exist between men and women, he was running away from the real battle no less than he had run away from a simulated one during military maneuvers. And consistent with his concept of relations between men and women as war, Alberto spoke of marriage as surrender and was sternly hostile to the idea and institution.

Giacometti as a grown man was both more than handsome and less. His head was a little too large for his body, his hands were also outsized, and his arms too long. At the academy the other students used to make fun of him, saying that he could scratch his knees without bending them or leaning forward. Although his finely modeled features were strong and at the same time sensitive, his skin was sallow and his lips lacked color. His small teeth, set far apart, in later years grew stained with tobacco. His mother once

remarked that he looked as if he'd come from a land of dark fogs, and on another occasion said, "You'd never win a beauty contest."

Alberto probably concurred with pleasure in that tart judgment. Self-esteem based on his physical appearance or constitution was not in his nature. Indeed, he went out of his way to disregard the well-being of an unusually sturdy physique. He never engaged in sports of any kind, and got very little exercise. Though occasionally during a summer visit to Maloia he would go along on a mountain-climbing party, he felt that the peaks looked best when seen from below. He smoked too much, and already during the early years in Paris had begun to develop a cough. Despite the problematic pleasures which he derived from sexual experience. despite his craving for tobacco and a casual appreciation of food and drink, physical satisfaction did not count for much with Alberto. The body is the area in which subjectivity most easily controls a person's actions. The physical self often stands in the way of the intellectual and spiritual self. Alberto seems to have felt from the beginning that such interference must not be allowed to trouble him, and circumstances certainly did cooperate.

Of the three studios which Giacometti occupied in Paris during his lifetime, the largest and most pleasant was the first. It stood at 72 Avenue Denfert-Rochereau, but well back from the street, facing north onto the spacious gardens of the Observatory. Measuring thirty-three feet by nineteen, it had a very high ceiling and a vast skylight. The rent was only a hundred francs a year.

The efforts of the first Parisian years were almost all destroyed. Alberto did not think of himself as a professional artist. Wholly absorbed in scrutinizing appearances, he considered his works as exercises in seeing, by-products of a struggle with vision, not demonstrations of creative competence. It was the act, not its outcome, which gave promise.

He received a regular allowance from his parents. About a thousand Swiss francs per month, it was quite enough to live on without worrying. Still, a little more would have been welcome, too, and Alberto applied for one of the grants which the Swiss government routinely offered to meritorious young artists who had gone abroad to perfect their skills. His application was refused. Surprised and chagrined, the young Giacometti felt that he had been rebuffed by his homeland. He was resentful, and he did not forget. Six or seven years later, when invited to submit an example of his work for an official competition, he refused. Though he was devoted to his home itself, to Bregaglia and all that it represented, his relations with his homeland both practically and symbolically were something else, and in the future there would be further reasons to feel resentful. He would not forget those, either. As for the money that came from Stampa, he does not seem to have felt the least reluctance about accepting it. Perhaps he thought of it more as evidence of devotion than legal tender, and as such it *could* have been welcomed as perfectly natural.

Annetta Giacometti occasionally visited Paris to see how her eldest son was getting along. It seems likely that she felt he'd get along better if she kept an eye on him. Perhaps he felt the same way. One may assume, in any event, that during his mother's visits Alberto endeavored to create for her benefit an impression of orderly and decorous industry. He always tried to secure her approval and participation in the activities of his life which meant most to him. He liked to tell her about his work, his ambitions, and undoubtedly the future seemed fairer for her involvement in it. Having been ready with encouragement from the first, she never hesitated to express her opinions or to give advice.

Almost every Sunday, when there was no admission charge, Alberto visited the Louvre, the world's richest, most varied and encyclopedic museum. He filled countless notebooks with copies of the works which impressed him most. Preeminent among these, in addition to the Egyptian sculptures of the Old Kingdom, were the marble idols of the prehistoric Cycladic culture. This is an art characterized by extreme stylization, yet each work possesses a deeply felt, specific individuality. The majority of the idols represent a nude woman standing stiffly erect. Her feet are usually bent forward and down in a position which would have been physically painful and consequently calls undue attention to the feet but is at the same time aesthetically effective. The legs are straight, the sex suggested by an incised V, the torso rectangular, and the arms crossed just below the breasts. The head is held high, featureless except for a stylized nose. All the figures are frontal, appearing in profile fragile and thin. These idols were fertility figures, representations of the Earth Goddess or Great Mother. Throughout the Aegean world before the Classic period, she was of primary importance, symbolizing the act and power of creation. Her image was placed in tombs to preserve the defunct from harm and to guide him on the way to resurrection.

Classical sculpture never possessed for Giacometti the power and fascination which he immediately found in Egyptian art and the Cycladic idols. Though his own work seldom outwardly resembled them, there was an inward affinity which became more pronounced, more profound, and more provocative as the decades passed, and which the artist eventually went out of his way to emphasize.

When the young Giacometti arrived in Paris, Paul Cézanne was already a legendary figure regarded with veneration even by artists who did not presume or attempt to emulate him, and sometimes affectionately referred to as "Papa" Cézanne. Alberto had first known his painting from reproductions in Giovanni's library. He had seen originals in Venice, though he was distracted from understanding by his adoration of Tintoretto. Now he had an opportunity to study important exhibitions. They impressed him immediately and decisively. Cézanne's example encouraged Alberto to persevere in the thankless struggle for artistic fulfillment, but he was too intelligent to slip into the sterile mistake of trying to emulate the technique or style of his forebear.

Bourdelle was a personage of consequence in the Parisian art world and held positions of authority, among others as vice president of the Salon des Tuileries, an annual exhibition where many artists showed works in the various styles of the moment. His favorite students were invited to exhibit. Despite Alberto's ability, it was three years before Bourdelle asked him to show work at the Salon des Tuileries. Not that it matters. The lists of exhibitors are rosters of nonentity. But the injustice of his exclusion may have rankled at the time.

Thus, it was only in 1925 that Giacometti showed his work publicly in Paris for the first time. He exhibited two sculptures, one of them a head, which was probably quite conventional, and a torso, a forceful work influenced partly by Lipchitz and partly, perhaps, by the early Brancusi. It did not appeal to Bourdelle, who said to Alberto: "One can do things like that at home, but one doesn't show them."

There were moments of anxiety and doubt, but Alberto felt very sure of himself. At the Grande-Chaumière, in fact, there were those who thought him conceited and arrogant. Not yet humbled by the afflictions that go with genius, he sometimes seemed brusque and overbearing. He was intolerant of models who wanted to rest,

rudely shouting, "Hold the pose, please!" As a rule, however, he was remarkably good-natured. When he began to appear less often at the academy, his companions found that the place felt strangely empty.

Alberto's purpose in life was plain, but Diego kept drifting from one occupation to another. He left Basel. During the summer of 1922 he was summoned for military service in the artillery corps. Military discipline did not suit him; he was fined for wearing non-regulation items. When he returned to civilian life, a cousin in Marseilles found work for him as night watchman in a chemical-products plant. He didn't care for it. Returning to Switzerland early in 1924, he enrolled in a trade school at Saint Gallen. But he had no idea what he wanted to do with his life. He seemed perfectly satisfied to live for the moment, having a good time, drinking, and running after girls. His parents were concerned.

Alberto fretted. All his life he was vigilantly protective of Diego, worrying that harm might come to him, anxious that others should have a good opinion of him. For no other person except their mother did he ever show such care. If Diego did anything dangerous, his anxiety was immoderate, and as a youth Diego had a taste for scaling risky peaks and getting into tight scrapes.

In the summer of 1925, Alberto undertook to paint a portrait of his mother. It did not go well. He found himself overcome by the same sense of difficulty which he had encountered four years previously while trying to do the bust of Bianca. This time the experience seems to have been even more traumatic. In the first instance he had not felt that the nature of visible reality was challenged, only his ability to re-create it in satisfactory form. That challenge had been a grave threat to his relations with himself, but it had also been a powerful motivating force in his determination to master his art. The efforts to do so had since then continued in a mode not basically different from the one familiar to him before the difficulty. In short, in 1921 his situation had changed radically but be had remained the same.

Not now. "The human face had always interested me more than anything else," he said later. "But in 1925 I became convinced of the total impossibility of conveying even an approximation of the impression I had of a head, and I gave up the effort—I thought forever."

Annetta Giacometti was by 1925 certainly a practiced and patient model. A multitude of portraits by her husband and son testify to the fact. The difficulty which Alberto experienced in executing her portrait cannot have been caused, as in Bianca's case, by her reluctance to pose. At the same time, however, the difficulty had to do with the identity of the model. The likeness he wished to capture was of his mother. He had an extremely exacting concept of the model's proper role and behavior. Posing for Alberto entailed a profound commitment, because he demanded not only submission to long periods of immobility but also constant responsiveness to the intensity of his concentration. It was active passivity. In later years, many people spoke of the emotional involvement which accompanied posing for Alberto.

In that summer of 1925, he stood on the threshold of maturity as an artist. His years of initiation, education, and emulation were over. From 1925 onward, he spent less time than before in Bregaglia. He always remained deeply attached to the place, aware of its primordial importance, and he returned there regularly all his life. But Paris became his true home. It was in terms of Paris that he had to fashion a career. Eagerly ambitious, he was still young enough to be influenced by older, more successful contemporaries. An element of that summer crisis may have been his realization that representational work was not the mode in which a young artist might then expect most effectively to win admiration and honor.

The crisis of 1925 cut Alberto off from a significant part of his past, but this does not seem to have had inhibiting aftereffects. On the contrary, it may have been a liberating event, freeing for fuller expression important and complex aspects of the artist's nature. Speaking later of what had happened, he said, "If you want to jump as high as the moon and are stupid enough to believe you can, when one fine day you see it's pointless you abandon the idea. It's idiotic to be unhappy about it."

That is an admirably sensible attitude. The romantic imagery with which he chose to describe a frustrated aspiration causes one

to wonder whether he was quite as lucid about his experience as he thought he was. Forty years later he repeatedly spoke of the crisis of 1925 as if it had been gravely traumatic. For the artist it may have been a liberation, but the individual may have suffered a sense of loss. Once again we glimpse the power of the creative will to work with subtle effect toward the realization of its destiny.

Though he later insisted that he had, Giacometti did not entirely renounce all effort to represent the human figure. The inaccuracy may have been motivated by a desire to make his past seem orderly and simple while his life and art became increasingly complex. All through the following years he occasionally executed sculptures, paintings, and drawings which were representational. He even exhibited some of them. These works, to be sure, did not comprise for him, and do not comprise for us, the essential part of his creative effort at that time. This was concerned with elaborating a sculptural idiom ample enough and versatile enough to contain the forces activated by the crisis of 1925. And yet the very forms in which the effort found expression assume a different, deeper import when viewed with an awareness that the artist was still occasionally producing representational works.

Bianca and Alberto were constantly together during summer vacations in Maloja. Familiarity did not fatigue their passion. But it was of a peculiarly unimpassioned kind. Sexuality did not enter in. Not overtly, at least. That may have been a convenience which in part accounted for the duration of their feelings. They went for long walks together, hand in hand, and one of his particular pleasures during their walks was to persuade her to squeeze in with him beneath some overhanging bank or under low bushes, on the pretext that rain was imminent. A single dark cloud would do.

Annetta disapproved of the attachment between her son and Bianca, making no secret of her opinion that marriage between Alberto and his cousin was out of the question. The consanguinity between the cousins was too close, she felt, being on both sides of both families. Perhaps she also judged that Bianca would never make a good wife for an artist. She knew what qualities an artist's wife should have, and she may also have guessed that Alberto

would prove far more demanding and difficult as a mate than Giovanni. In any event, she would have had an exacting standard for the woman who was to become Alberto's wife, and it is possible that no one could ever have seemed quite acceptable to her. Or to him.

On the 16th of April 1925 a young woman from Denver, Colorado, arrived in Paris. Her name was Flora Lewis Mayo. Twenty-five years old, she had come to France in the hope of making a new life. Her past had given her good cause to long for a changed future.

Flora's father owned a large department store in Denver. Prosperous but busy, he had had little time for his daughter. Unhappy, she took refuge in romantic daydreams. She wanted to live for the moment and live every moment to the hilt. At school the headmistress said to her, "You're the kind of girl at whom the devil looks up from hell and says, 'I want you down here.'" When she went on to college, young men paid attention to her at dances and garden parties. Famished for affection, she responded with reckless gratitude. People began to talk. Gossip reached Flora's family, who believed it. She began to fear that her life was ruined before it had fairly begun, and dreamed that she was standing in the street watching a funeral pass by-her own. Her parents decided she should "marry and settle down." An amenable young man named Mayo was found and after the wedding he got a good position in his father-in-law's store. His bride despised him.

Having become a victim of convention, Flora presently supposed that she might have nothing further to lose by making fire where formerly, in fact, there had been only smoke. She took a lover. He was a White Russian who had recently escaped from the Bolsheviks by the simple expedient of walking eastward; when his shoes fell apart, he went on without any, crossing Manchuria barefoot. He, too, had suffered from fate. He sympathized with

Flora's plight. Perhaps the readiness of his sympathy was sustained by the fact that her father was a millionaire. They ran away to New York.

She took a job selling books at Macy's. She met the colony of Russian refugees, and all the erstwhile noblemen and their ladies said that she had a Russian soul, that she was like a character out of Chekhov. As a matter of fact, she was.

Mayo got a divorce. In the process of securing her freedom, Flora had sacrificed her prospects. Her lover did not propose. She didn't know what to do with herself. Return to Denver was out of the question. Living alone in New York had become intolerable. For some time she had been studying at the Art Students' League, as she had a facility for sculpture and enjoyed working at it when the impulse struck her. Paris was much in vogue just then as a place where romantic, artistic Americans could seek fulfillment. Flora advised her father that she wished to go to France. Mr. and Mrs. Lewis came on from Denver, and there was an unpleasant confrontation in the lobby of the Plaza Hotel. Flora's parents did not relish underwriting what they felt sure would be a sinful life in a sinful city, but they deemed it expedient to keep their daughter away from home. She was allowed to sail with the promise of a monthly allowance of two hundred dollars.

Paris thrilled her. It was spring. In a rapture she walked through the city and took an open carriage into the Bois. Here, it seemed, she could make a new life. Like most of her artistically inclined compatriots, she soon found her way to Montparnasse, where she took a spacious studio in the rue Boissonade and enrolled in Bourdelle's class at the Grande-Chaumière. The newcomer was welcomed to the academy. Anxious to be found likable and attractive, she responded with impulsive sociability. Too much so, perhaps. For one thing, she had never had an opportunity to form a moderate tolerance of alcohol, and drink made her even more impulsive. For another, her longing to be happy made her particularly vulnerable to the café Casanovas of Montparnasse, while her comfortable allowance made her particularly desirable. It wasn't long before some of the students at the Grande-Chaumière began to say that she was indiscreet, if not disreputable. Flora, of

course, aware that she was again the object of gossip, began to fear that her new life would never come. She started drinking more than she should have and longed more than ever for a strong, understanding man to fulfill her dream of happiness.

Alberto met her when she entered the academy. Perhaps he found her appealing from the first, but for some time they remained acquaintances. This period of casual meetings was long enough to allow him to assume that she was an unconventional girl, not one who might turn out to be "clinging." The gossip must have made her more attractive also, as he had an instinctive sympathy for those condemned by conventional society. One day when Flora, being sick, had not recently appeared at the Grande-Chaumière, Alberto went to the rue Boissonade to see her. He sat on the foot of her bed and looked at her, so it seemed to her, with such compassion that she held out her arms to him. He fell into them. It was not a lustful embrace. They held each other as if to express a boundless confidence. That was the beginning of their love affair. It was a very happy one—for a time.

While Alberto was finding happiness in life and fulfillment in his work, Diego still had found neither. Young Bruno, on the other hand, was growing up to be a responsible, attractive person and had already decided to become an architect. Ottilia, her education completed, remained at home with her mother. So the second son was the only child whose development caused concern. The dimension of the concern may be gauged in part by the step Annetta took in hope of ending it. She decided to send Diego to his older brother in Paris. Though reluctant to make Alberto assume a responsibility beyond his own activities, she knew his desire to protect the younger brother, and no doubt assumed that if anyone could help, it would be he. He suffered from no lack of purpose. Some of it, she must have hoped, might rub off on the irresolute sibling. Diego was not averse to going to Paris, where he may have foreseen that there would be plenty of opportunities for having a good time and getting into a bit of trouble. Alberto would gladly have welcomed the opportunity to try to help his brother while at the same time reassuring their mother.

Diego arrived on a cold, gray day of February 1925. He did

not find the dreary vista of the Boulevard de Strasbourg very inviting, but he probably cheered up when he reached Montparnasse. He had no thought of becoming an artist, but he found attractive the idea of a carefree, self-indulgent life.

Some time before his brother's arrival, Alberto had had to move from the studio on the Avenue Denfert-Rochereau to a new one at 37 rue Froidevaux, only six or seven minutes' walk from the former location and closer to Montparnasse. It occupied the entire second floor of a two-story building, reached by a narrow staircase, and consisted of the large studio room plus a very small kitchen. Measuring twenty-six by seventeen feet, the new studio was appreciably smaller than the other, with a much lower ceiling. As a working space it was less commodious, but it did offer more practical advantages as a lodging. The view, however, was not cheerful, for the two front windows looked directly onto the monument-cluttered expanse of the Montparnasse Cemetery. The brothers' nearest neighbors were, thus, the dead, and on hot summer nights they could see flickering above the tombs the blue luminescence of combustible gas which arose from decaying corpses.

Diego was introduced to Bourdelle's studio, but he showed little interest in what went on there. He got a job in the office of a factory in the suburb of Saint-Denis. That didn't interest him much, either. What interested him was dressing in flashy clothes, hanging around disreputable bars, and visiting the whorehouses. It wasn't long before he fell in with the sort of devious characters whose company he enjoyed, and who in due time would invite him to take part in their shady activities. He did not hesitate to do so. The nature and extent of these activities was obscure, as befitted their aim. Diego did not have a criminal disposition, but he was a bit irresponsible and had a casual attitude toward applied morality. An important aspect of those dubious doings in the early years is that they demonstrate a basic difference between the two brothers. Though worried about his safety, Alberto would not have been shocked by Diego's happy-go-lucky involvement in a bit of smuggling or some petty thievery. He was too intelligent not to make a distinction between moral expedience in an industrial society and the highest standards of ethical judgment;

it was with respect to the latter that he attempted, often with excruciating exactitude and self-denial, to determine the proper course of his own behavior. When he failed, as he often did, he blamed himself all the more severely because guilt was a fundamental assumption of his existence. Diego's behavioral frame of reference, on the other hand, was solely the domain of day-to-day morality, which he was temporarily disposed to disregard for reasons of which he probably had no inkling. It was this instinctive disregard rather than its outward manifestations which would have aroused in Alberto a deep concern, and strong protective need, because he could not help feeling, however unconsciously, that Diego's unwillingness or inability to come to terms with everyday reality had some relation to himself and to the means by which he was endeavoring to do precisely that. He would thus have tended to associate the realization of his own endeavors with his efforts to help his brother, and even in a practical manner to interrelate the best methods of obtaining those seemingly divergent objectives. This was a mistake. Preoccupied by youthful ambition and blind fraternal devotion, Alberto couldn't see it. Decades later he did, but by then the time for amendment had passed.

He bought a set of paints and some canvases and encouraged his brother to use them. Diego set to work with a modest show of industry. After a few days, he casually put down his brushes and said, "I'm going out."

"Where?" Alberto asked.

"To Venice," replied Diego.

Among the new pals Diego had made in Paris, the closest was a young fellow from Venice named Gustavo Tolotti. The two did a good deal of traveling together, most of it around northern Italy, and they got into quite a few scrapes. Their comings and goings were closely watched by the police. On several occasions they were ordered to leave within twenty-four hours the city or town where they happened to be. In Zurich, where Bruno was studying architecture, they were detained while trying to sell some diamonds of uncertain origin, and the well-behaved young student was alarmed by his brother's rash conduct.

Once Tolotti and Diego traveled as far as Egypt, on a slow

ship from Marseilles. They must have been a suspicious-looking pair, for the police had them under surveillance from the moment they stepped onto the pier at Alexandria. In Cairo they seemed with disconcerting frequency to encounter well-intentioned strangers who warned them to keep out of trouble. They prudently took the advice. Having visited the brothels and the pyramids and gazed upon the Sphinx, they returned to Alexandria and embarked on the next ship back to Marseilles.

Alberto can hardly have been gratified by the associates and indiscretions of his brother. But he had no promising alternative to offer. One may be sure, however, that not a hint of Diego's reckless doings ever reached Stampa. Still, Alberto couldn't help feeling for his brother some of the impulsive admiration which a contemplative youth may feel for a man of action. In later years he often spoke of Diego's early escapades, and particularly of the expedition to Egypt, with almost envious enthusiasm, as if they had in fact been deeds of daring and imagination. But by that time his need to think so had become nearly a condition of his survival.

If Alberto had every reason to consider Diego's behavior with indulgence as well as misgiving, Alberto's friends had none. They knew perfectly well what the younger Giacometti was up to. In the café and studio world of Montparnasse, everyone knew everybody else's business, and the colleagues of the promising young sculptor had no use for his brother. Alberto could not have changed their opinion, and would have been too proud to try. Nor would Diego have wished to ingratiate himself where he felt unwanted. The result of all this was that Alberto had one group of friends, while Diego had another, and the two groups had nothing in common except the presence of a Giacometti in each. The same had been true at Schiers, and this dichotomy may not have seemed surprising at first, when Diego was often away. In any case, there was nothing to be done about it. But it did establish a pattern, one which in time added another singularity to the beautiful but strange relationship of the two brothers.

The sculptures which Giacometti produced during the first few years of his artistic maturity, following the difficulty of 1925, are clearly the work of a powerful and original artist. Despite their formal strength and plastic invention, however, the lucidity of hindsight reveals that the young man was not yet ready for the tests by which genius determines whether or not its possessor can become a great artist. The most important sculptures of these years nonetheless embody characteristics which are present in the major works executed two or three decades later.

Of the pieces produced between 1925 and 1930, one of the most notable was executed in 1926 and is now generally called The Spoon Woman, though the artist himself was still referring to it as late as 1948 simply as Large Woman, which relates it more logically and closely to the later sculpture. The dominant feature of this work is a large, spoon-shaped form, convex at the top and concave at the bottom, suggesting an abdomen. This form is surmounted by a stylized thorax and small head; it stands upon a pedestal which makes no effort to represent human limbs. The interrelation between these features is subtle but powerful, showing for the first time how skillfully Giacometti was able to work with space as an integral element of the sculptural medium. He clearly expressed certain of the basic aspects of his lifework in this first Large Woman. Though only fifty-seven inches high, she creates an immediate impression of monumentality. Her commanding presence requires the viewer to face her squarely rather than from an angle or in profile. This ability to compel direct frontal contemplation also confers upon her a numinous and hieratic aura. She is a concept rather than an individual. The woman is a goddess,

the sculpture an idol. It possesses a profound formal and spiritual affinity with the marble sculptures of the Cyclades.

Another intriguing and significant sculpture of this period, executed shortly after the Large Woman, is entitled The Couple. Very different from its predecessor, less commanding both as an artistic accomplishment and as an imaginative statement, this work also is a prefiguration of things to come. Again the position is forcefully frontal. But the figures are neither remote nor hieratic. On the contrary, they are present, tangible, physical, and, above all, sexual. Highly but roughly stylized, the man and woman simultaneously symbolize and represent their specifically genital characteristics: the former cylindrical and erect; the latter, curvilinear and orificial. Together and close, still they stand rigidly apart, separated not only by space but also by irreconcilable dissimilarity of form and function. Each seems frozen in self-awareness, unable to acknowledge the presence of the other. The formal purpose of the piece seems intellectual rather than emotional, despite its explicit sexual character. It is an intimate revelation, as well as a manifest image, and in this respect it already demonstrates a disposition and a need which were to remain constant throughout Giacometti's life and work but which were to exact the most austere reckoning before they could infuse either the work or the life with its grandest meaning.

Alberto and Flora were romantically happy during the first months of their affair. Love seemed to eliminate from reality every necessity save its own. They went to the Bois and sat holding hands by the lake; they visited the Louvre, the Luxembourg Gardens, the zoo at the Jardin des Plantes, where they both found more pleasure watching children at play than watching animals in cages. Alberto never explained to Flora, however, that he was incapable of becoming a father. Though they talked about love and art, they never spoke of the future. Marriage was not mentioned. Flora would have liked nothing better and longed for Alberto to propose. When he didn't, she fatalistically made the best of it. After all, she was happy as things were, and her "Rus-

sian" soul disposed her to feel that if only she waited long enough, everything would eventually turn out as she hoped.

Alberto sculpted her portrait and exhibited it at the Salon des Tuileries. She, in turn, executed a bust of him, which proved to be surprisingly skilled and lifelike, though academic. A photograph has survived of the two young artists and lovers seated on either side of Flora's portrait of Alberto. He gazes at the world with forceful but sensitive self-confidence, an enigmatic half-smile upon his lips. Flora looks at her lover wistfully, as she had cause to do. She is attractive but not beautiful, and there is something weak in her face. It must have been apparent even then that she was one of those destined to be destroyed by circumstances. Between them stands her portrait of him. It appears to have been executed with love, for it is not only a sensitive likeness but an idealized image of the model as the sculptress must have wished him to be. Alberto is portrayed as a strong, dynamic, serious young man, which he was, but there is no sign of the elusive, hesitant, noncommittal disposition which Flora knew only too well to be part of her lover's character. So the portrait in the photograph may seem to stand between them not only as a concrete object but also as a symbol of the differences and misunderstandings which would determine the outcome of their dreams.

Flora could neither understand nor make allowances for the obscure dictates of an artist's nature. And Alberto could not be expected to give suitable consideration to the possibility that his behavior might seem perverse and selfish. It became evident that he was not the sort of man who could be counted on as a dependable lover or who was likely to assume the responsibilities of a husband, however unconventional. Sometimes without explanation, he would fail to appear for days at a time. Flora's sense of security was already precarious. Alberto's seeming indifference distressed her. She tried not to cling, but it wasn't easy. And there were difficulties even more troubling to a young woman in search of a mate. Alberto did not seem to find sexual satisfaction with her. Though ardent beforehand, he frequently turned out to be impotent when the time came to prove his ardor. Nor did he

attempt to compensate for his failure by increased demonstrations of tenderness. He refused to spend the night with her even when most of it had already passed. Something was wrong. Still, the two clung to one another. Flawed as it may have been, this was Alberto's first full experience of romantic love, and it would turn out to be Flora's last. Neither wanted to acknowledge that it was a failure.

Flora was not invited to visit Bregaglia. Alberto would never have accepted the presence in his mother's home of a woman whose reputation Annetta might question. Besides, Bianca was to be found in Maloja during the summers. Alberto's fondness for her was not affected by his knowledge that another woman was waiting in Paris. They continued to go for long walks, hold hands, and squeeze together into little hiding places. She was never his mistress, but he was prepared to go to unusual lengths to demonstrate that he was her master. One evening when they were alone together in her room he took a penknife from his pocket and told her that he wanted to carve his initial in her arm. She must have been startled, and had every reason to be alarmed, but he knew how to be persuasive. Bianca agreed. Alberto opened his knife and eagerly went to work on her left upper arm. He could not have cut too deeply, for although she bore a scar for many years, it eventually disappeared. Still, he cut deeply enough to cause blood to flow, and Bianca must have felt some pain, which she endured with calm-and perhaps with pleasure. He carved a small capital A. He was excited and proud. "Now you are my very own little cow," he told her, pretending that the incident was a joke. Bianca was pleased because Alberto was pleased. But it was not a joke. For years to come, Bianca had time to gaze with romantic conjecture at the place where the artist's knife had entered her flesh.

The families of the young sweethearts, having no reason to blink at implications, did not regard the incident as a joke. They blamed Bianca for agreeing to Alberto's request and him for taking advantage of her. Assuming that there was more to this than met the eye, whether they saw what it was or not, they disapproved. The pocket knife which Alberto used to carve his initial in Bianca's arm also served him to work at his sculptures. As always, he preferred to work with pocket knives rather than with conventional sculptor's implements. When he took his knife to carve Bianca in person rather than to struggle helplessly with her portrait, he encountered no resistance, no difficulty. She submitted to him as willingly as she had long before obstinately resisted in the basement of the Villino Giacometti. He was signing his name, as it were, to the model rather than to the portrait. And perhaps some uncertainty did exist in the mind of the artist as to where the most vital and convincing reality dwelt.

At the Grande-Chaumière, old friends began to drift apart. Carefree student days were coming to an end. Bourdelle had started to suffer from the heart attacks which in 1929 killed him. Studio jokes and happy-go-lucky dreams of fame gave way to knowledge that the world didn't care two straws for an artist until he was successful or—even better—dead.

The discoveries and great works of Cubism had all been made before Alberto's arrival in Paris. But no young artist anxious to make his mark during the twenties could afford to disregard the Cubist revolution, for it seemed to have destroyed the age-old concept of a work of art as a creation which embodied a meaningful human statement separate from its material existence. To be sure, the inventors of Cubism presumed to represent fragmented aspects of observable reality. However, their ultimate aim was not to depict reality but to create works of art. Their aesthetic principles generated an art of pure form, and they brashly attributed its paternity to Paul Cézanne, who would have recognized little of himself in such contrary offspring. Though most of the Cubists eventually turned away from the rigid strictures of their system, it remained an imposing influence, one to be reckoned with.

Giacometti felt compelled to test his sculptural power in Cubist terms. In 1926 and 1927, he produced a number of essentially abstract sculptures in the Cubist style, entitled Composition or Construction, though he was unwilling to acknowledge a complete abandonment of representation and gave the pieces subtitles such as Man, Woman and Personages. There are certain stylized elements which recall features of human anatomy, but they are

subordinated to the plastic imperative of the sculpture as a whole. Although these constructions are the work of a highly talented young man, it would be a mistake to see them merely as brilliant exercises in a style which was not fundamentally congenial. Alberto had something to learn—about sculpture and about himself—from Cubism; its history was enriched because he approached the lesson with enthusiasm and candor.

About sculpture he learned from Cubism that he could solve the formal plastic problem of creating an essentially abstract three-dimensional object of self-sustaining variety and interest. About himself he learned that the solution of such problems could not provide him with the kind of fulfillment he sought. As he was often to say in years to come, what interested him was not art but truth. Still, one regrets that he produced only ten or twelve Cubist constructions, for they possess a bluff beauty unlike any other works in Giacometti's production. The juxtapositions of convex and concave, of angle and line, of inert mass and animated space are so tensile and inventive that they leave no question as to Alberto's mastery of the Cubist idiom. It was not an original mode of expression, but with vigor and sincerity he made something personal of it.

Henri Laurens and Jacques Lipchitz were the two most visible influences on the young Giacometti. Both were older and both disposed, though in different ways, to foster the talents of younger artists.

Lipchitz was a vain self-seeker, gratified when beginners turned to him for guidance, which he gave in generous measure so long as no one, and especially the general public, took the work of the beginner too seriously. Giacometti knew him in the mid-twenties and visited his studio occasionally. The Cubist constructions of 1925 and 1927 frankly show his influence, though they are more straightforward and virile. Unfortunately, cordial relations between the two men did not survive the first promises of success for Alberto; and the greater fame in later years of the younger artist unhappily prompted the older to spiteful belittlement.

Henri Laurens, on the other hand, was a man of exquisite

modesty and creative integrity. He never sought to overawe younger artists and welcomed them with friendly interest to his studio. His candor and artistic rectitude were as inspiring to others as the subtle luxuriance and vigor of his sculptures. From the beginning of their acquaintance, Alberto admired both the man and his work without reserve, and never afterward found any reason to alter his high opinion of either. He expressed it not only in direct contact with Laurens and others but also in an essay of appreciation and praise published in 1945. The actual artistic influence of Laurens upon his admirer and friend appears to have been more spiritual than sculptural. A few of Alberto's Cubist works reflect some of the elegance and rhythm of Laurens's early style, but the curvilinear abundance of form so characteristic of his maturity is completely absent from Giacometti's sculpture. Unalike in their work, the two men were very similar in their uncompromising humility and their determination to work solely as they saw fit, however contrary that might be-and was-to the prevailing mode of the time.

Giacometti's studio in the rue Froidevaux was never completely satisfactory. The ceiling was too low, the light no more than adequate. But Alberto waited two years before deciding to look for another place. In those days, studios were easy to find. In the spring of 1927, a Swiss friend told him that something was available at 46 rue Hippolyte-Maindron. He went to see it. His first impression was that it was tiny. However, he decided on the spot to take it, and one warm afternoon in April the two brothers loaded onto a handcart their belongings and such early sculptures as Alberto wished to preserve. The move was not a long one, as the distance from one studio to the other is barely a thousand yards.

The rue Hippolyte-Maindron, ironically enough, is named after a nineteenth-century sculptor whose posthumous reputation has not justified the confidence of those who thought to celebrate his achievement by giving his name to a public place. As a thoroughfare, its most distinctive feature has always been its anonymity and insignificance. Running from north to south between the rue Maurice-Ripoche and the rue d'Alésia, it is only four hundred

yards long and does not provide an important means of access from one point to another. Fifty years ago it was lined with shabby, low buildings, small cafés and shops, a lumberyard, and a few of those nondescript little houses with a scrap of garden which the French call *pavillons*.

On a sizable plot at the southwest corner of the rue Hippolyte-Maindron and the rue du Moulin-Vert stands the jerry-built hodgepodge of studios and flimsy dwellings to which Alberto and Diego came on that spring day. It had been thrown together about 1910 by a single workman, a Monsieur Machin, using junk materials salvaged at little cost from the demolition of sturdier structures. The haphazard conditions of its origin made the ensemble look more like a number of separate buildings than like a single onesome parts of it being one story in height, others two, and yet others three-and together they gave the impression that only the presence of each unit next to its neighbor prevented the collapse of all. An open passageway provided access to the various studios and apartments. One corner of the property was occupied by a small garden, in which stood a couple of trees. All in all, the place had a certain derelict charm. It had nothing, however, of what might be called modern comfort, neither electricity nor running water nor central heating nor plumbing of any kind. Halfway along the open passageway was an outside faucet and adjacent to it a primitive toilet, its flimsy door open a foot at both top and bottom. All other amenities were to be provided at their own expense by the tenants. The best that most of them could manage was a small coal stove for heat and a gas jet for light. The fire hazard was of course flagrant, but poor artists were perhaps not supposed to worry about such contingencies.

Alberto's studio was the first to the left in the open passageway. His impression of its smallness was accurate enough, for it was appreciably less spacious than the other two he had occupied, measuring only about sixteen feet square. The ceiling was good and high, however, although at the back there was a narrow wooden balcony reached by a steep flight of stairs. A large window onto the passageway faced north, with a skylight above. Artificial illumination was provided at first by a gas jet, and there was never any other heating facility than an iron stove for coal. The furnishings were minimal, because there was no room for anything more than a bed, a table, a cupboard, a chair or two, and the necessary sculpture stands and easels.

An obscure, prosaic, shabby little place. No effort was made to improve its appearance during the next thirty-eight years. Alberto, of course, did not expect to remain there for the rest of his life. "I planned on moving as soon as I could," he said, "because it was too small—just a hole." During the thirties he and Diego occasionally looked at other places, but no change was seriously considered. In time, Alberto came to feel that it was quite spacious enough. "The longer I stayed," he said, "the larger it grew."

Life in the rue Hippolyte-Maindron was never comfortable. At first, it was frankly austere. Diego slept on the balcony at the rear of the studio, Alberto in the corner directly below. Winter and summer, they washed at the faucet in the open passageway. They took their meals in the cheap restaurants of the neighborhood or in Montparnasse, which was only a twenty-minute walk away. Later, when they had begun to earn a little money, Alberto often slept at an inexpensive hotel nearby named the Primavera. No such luxuries were ever indulged in by Diego.

The move to the rue Hippolyte-Maindron coincided with an important change in Alberto's work. In the new studio, he began to develop a sculptural style owing nothing to anyone else. In 1926, he had accepted a commission to sculpt the portrait of a Swiss collector and dilettante named Joseph Müller, producing a straightforward, vigorous sculpture and excellent likeness. The following year, Alberto executed another. Though personality traits are still apparent, the portrait is close to caricature, for the artist was now endeavoring to make an object which would offer to the beholder an artistic equivalent of visual experience. The second portrait of Müller is disproportionately flattened and asymmetrical. The features are only slightly in relief but emphasized by incising of the plaster. Not at all lifelike, still this sculpture is astonishingly alive. Art takes candid precedence over nature, yet conveys a powerful sense of a human individual.

Alberto executed another of these "flat" portraits using his

1 0 2

mother as the model. It also combines extraordinary vivacity with deeply felt veracity in a form which does not try to reproduce naturalistic appearances. Evidently the execution of this portrait—in a style now altogether his own—caused the young artist no difficulty. He never again had any trouble portraying his mother.

It was in a surprising series of portraits of his father that Alberto most forcefully pursued this new path. Oddly enough, these are the first portraits the son had ever executed of the father. The first is a highly skilled academic likeness, suggesting an effort by the artist to please, if not to flatter, his model. The effort failed. for it offers only an appearance, not the conviction of life. It was followed, however, by others, which grew gradually more distorted and abstract until all resemblance to Giovanni had vanished and there remained but the work of art itself. The front of the head became flatter and flatter. In one version it is a completely flat plane on which the recognizable but distorted features of the model are carelessly scratched-almost as an afterthought-and are, in any case, irrelevant to the validity of the sculptural object. A version in white marble is so close to abstraction that it is identifiable only because the roughly triangular shape of the face is similar to the completely "flat" portrait. Finally, there is a small sculpture which is in fact but a mask, and which presents the father's features in a violent, almost brutal caricature.

With this series of works, Giacometti evolved radically and in a very personal manner away from the traditional means of representing a human head: he separated the face from the physical form upon which it is, so to speak, superimposed. By a slow, difficult evolution, the "flat" portraits led in 1928 to a number of sculptures which are essentially thin, rectangular plaques with very subtle, non-figurative shapes engraved upon their frontal surfaces. A plastic image had now completely taken the place of straightforward representation: "I was working in an effort to reconstitute solely from memory what I had felt in the presence of the model." And yet the representational imperative was not repudiated. On the contrary, these plaques constituted Giacometti's first formal effort to bring new vitality and meaning to a sculptural

tradition which had begun with the Greeks and led to Rodin. But this tradition insisted that a sculpted head or figure must have the same physical configurations as a living figure or head. Giacometti, however, knew that sculpture need not be lifelike in order to generate a sense of life. The flat, slender forms of the Cycladic idols, vibrant with verisimilitude, had shown him that. The lesson of Cézanne had taught him that only absolute fidelity to psychic and visual experience, however surprising or unpredictable, can mark an artistic work with integrity. Moreover, he was beginning to learn that an artist can discover through arduous practice how to be true in creative terms to his deepest feelings without openly indulging them.

At this juncture, Giovanni told Alberto that the time had come for him to test himself as an artist. It was doubtless not meant as an ultimatum, but in effect the father was bidding his son to take a step which would influence the subsequent course of his life. Alberto was being asked not only to prove himself as an artist but to stand on his own feet as a man, respond to the challenge of Paris, and prove his powers.

At first, he hesitated. "I did not want to play the part of an artist or have a career," he explained later. "I had the position of a young man who's taking a chance on a few experiments, that's all, just to see. As long as my father supported me, I had no idea of playing the part of a professional artist." But now he had been admonished to take a step. To be sure, the thin plaques were a faithful expression of visual experience and an honest embodiment of deep feelings. But to the artist they were not satisfying demonstrations either of his ability or of his ambition.

"It was always disappointing," he said in reference to those works, "to see that what I could really master in terms of form boiled down to so little." However, Alberto did long to win the admiration, approval, and affection of others. Therefore, he determined to exhibit two of his plaques, a *Head* and a *Figure*.

On several occasions he had exhibited his work in group shows with Italian friends, of whom the most noted were Campigli and Severini. The former, as it happened, was just preparing to show recent works at the Jeanne Bucher Gallery when in June

of 1929 Alberto decided to exhibit his plaques. The gallery was well known. Madame Bucher had earned a reputation as a dealer of farsighted discernment. Her approval was a mark of prestige for a young artist. If she agreed, as she did, to exhibit along with Campigli's paintings the two sculptures by his friend Giacometti, it must have been because she saw the originality of his work and realized that it gave promise of finer things to come. At his father's behest he had taken a fateful step.

Within a week, she had sold the two sculptures Giacometti left with her. She offered to handle his work on a regular basis, and he agreed. His career had begun with a success. He was surprised, and perhaps in some way disappointed, because he had not expected it to be that easy. "How can people acquiesce so quickly?" he said to himself. "And for such foolishness?" Yet the questions he asked suggest that he had never doubted his ability to win admiration. Besides, as he willingly acknowledged, "I was pleased, because of my father."

Flora Mayo responded with mixed feelings to Alberto's success. It had become increasingly evident that their relationship would never be settled or permanent. Any change in Alberto's life could be seen as a threat to her place in it. True to his ambivalent disposition where women were concerned, Alberto made efforts to please her, but her expectations had become oppressive. "With her I had the feeling that I was suffocating," he said. "I wished that she would find someone else." Lying in bed with her at night in her studio, he felt a frightening sense of imprisonment. He wanted to get out, to run away. It was the dark, he thought, which caused his anxiety. By his own bedside, of course, the reassuring light would be burning.

On the frequent occasions when Flora found herself alone in the evening, she habitually sought consolation in alcohol and in the company of such casual drinking companions as could be met in the cafés of Montparnasse. One evening at the Dôme she met a handsome young Pole who offered her a drink. She accepted. He invited her to spend the night at his hotel. She agreed. They enjoyed themselves, and in that particular respect it must have been an agreeable change for Flora from the troubling uncertainties of relations with Alberto. But there was to be no sequel, even had she desired one, because the Pole left the next day for Warsaw and Flora never saw him again.

Her unfaithfulness troubled her. She naïvely imagined that if she confessed her transgression, forgiveness would follow. A week after her encounter with the Pole, she and Alberto went one afternoon to Versailles. They had a happy time strolling about

in the gardens. That evening, when they had returned to Flora's studio in Paris, she told him of her infidelity.

He was wounded and enraged. When upset, he was always prone to clamorous outbursts. He shrieked with anger and made such an uproar, lasting so long, that the occupants of adjoining studios complained of the disturbance. Flora was alarmed and astonished. She tried to reason with her obstreperous lover, telling him that a passing infidelity need not be of consequence, that there were, in fact, plenty of married people who were sometimes unfaithful yet remained together and loved each other no less for it.

Alberto replied that there were also couples who were never unfaithful, and that that was how it should be. One can guess what ideal couple he had in mind to validate such a categorical imperative, and the thought, not to mention the contrast, would have added to the anguish of the moment. But how is one to consider his attitude in light of the knowledge that he was himself all the while regularly frequenting prostitutes? Pure love had not been betrayed. Flora was not allowed to know this, however, for what had been threatened and offended was not a spiritual ideal but Alberto's emotional constitution. The ambivalence of his attitude toward women spared neither him nor the person he loved. Still, his suffering was genuine and can only have been compounded by the fact that it flowed from such deeply troubled and ambiguous sources.

"Something is broken between us," he told her.

It was. They stopped meeting, but they could hardly avoid seeing each other. Before long, Flora had a new lover, a handsome American gigolo. Alberto was furious. Though he did not want to continue their relationship, he couldn't help being jealous. To his surprise, he found that he could not put Flora out of his mind. He wrote long letters, outpourings of feeling, carried them to the nearby post office, but couldn't put them into the box. The longing of which Flora had been a temporary object was not appeased, but she could no longer serve it. He never again engaged in a relationship quite so overtly and unrealistically romantic. Henceforth, his love affairs, of which there were to be four

important ones, grew from needs more primal than any Flora could have hoped to satisfy, and they increasingly became embodiments of the destiny toward which his creative urges drove him. As for his work, it was at this juncture that Alberto entered the phase during which profound personal feelings and deeply buried desires were most powerfully and revealingly expressed.

In 1929, for the first time, there openly appeared in Giacometti's work the theme of sexual cruelty and violence. It would reappear in numerous sculptures during the coming years but was stated at the outset with an explicit force and trenchant purpose never afterward quite the same. Man and Woman is the only sculpture in Giacometti's oeuvre which shows one figure in active relation to another. The act is one of naked and violent aggression. Freely stylized, the figures of both male and female are concave, as if recoiling from one another, while from the center of the male protrudes a rapier-like implement which might either ravish or slaughter the woman, who appears about to collapse before its menacing thrust. Still, the male's rigid weapon does not quite touch the fragile orifice of the female. The two figures remain frozen forever in an image of fateful but poignant ambivalence. Man and Woman represents a decisive step in Giacometti's evolution away from the strictures of Cubism and the limitations of the "flat" sculptures. He was anxious to try to convey the visual experience, the "sensation," as Cézanne would have said, of a figure in space, making the perception of space itself an integral part of the sculptural object. Neither the sensation nor the resulting object therefore would need to have direct reference to the lifelike appearance of an actual figure. This apparent freedom imposed a radical constraint upon the artist. In order to demonstrate—to himself first, and then, perhaps, to others—that sculpture was a viable medium, he would be compelled to try to work as if he were the first man who had ever sculpted, while at the same time never neglecting to take account of the sculpture of the past. This seemingly contradictory imperative would oblige him to delve with infinite caution and perspicacity into the personal sources of his art, striving to distill from their essence the emotional content of his work in such a way as to both liberate and

obliterate the personal character of its origin. This necessity would soon make him ready to contribute to, and benefit from, the activities of an artistic movement dedicated to expression directed chiefly by the unconscious, freed from the inhibitions of conventional discipline and academic standards. Giacometti gravitated into the Surrealist group as simply and spontaneously as if it had been devised for him alone.

The Viscount Charles de Noailles and his wife, Marie-Laure, were the most prominent and generous patrons of art and literature in France between the two world wars. Their wealth was so vast as to be secure from the fluctuations of national economies or the panic of international crises. There was no limitation to their role but that of their taste, which proved to be as catholic as it was clairvoyant. From the time of their marriage in 1923, they began to form a collection of contemporary art, including representative works by all the artists of consequence of the School of Paris. To have a work acquired by them became a prestigious distinction. Jeanne Bucher's confidence in Giacometti's talent must have seemed well repaid when in June of 1929 the Noailles purchased from her gallery one of the thin plaster plaques he had left on consignment. Entitled Gazing Head (Tête Qui Regard), it is one of the most subtle of Alberto's early sculptures.

The art world of Paris between the wars was so cohesive and compact that a signal occurrence in one of its parts was soon registered in the others. It is especially appropriate that Giacometti's public emergence was early noted by a man whose lifelong care was that he should, if possible, be in the forefront of every artistic event. Jean Cocteau, a close friend of Charles and Marie-Laure de Noailles, wrote in his *Journal* for 1929: "I know of sculptures by Giacometti so solid and yet so light that one thinks of snow bearing the imprint of a bird."

Jeanne Bucher, though she had every reason to feel confident of her judgment, was in the habit of showing new work by unknown artists to men of recognized achievement in order to learn

Mosser

their opinions. So it happened that she had shown Giacometti's plaques to André Masson, a painter already in his mid-thirties. One of the early and more zealous members of the Surrealist group, Masson had quickly acquired an appreciable reputation, particularly for his so-called automatic drawings, in which the dynamic interplay of linear rhythms formed fantastic figures and arcane symbols. When Madame Bucher showed him the fragile plaster sculptures by an artist he had never heard of, he responded with immediate enthusiasm. "For once," he told her, "you've really got something."

A week or so later, Masson was seated by himself on the terrace of the Café du Dôme when an unfamiliar young man came to his table and said, "You're Masson, aren't you?"

He sensed at once that this was the artist whose sculptures he had recently admired. He said, "You must be Giacometti."

"I am," said Alberto. He sat down. They began talking, and it soon seemed to both that they had known each other for ages. Their friendship sprang full-grown from a passionate community of interest and the impressive awareness on both sides that the other was a person of compelling creative authority.

Masson introduced his newfound friend to the artists and writers of his acquaintance, who readily accepted him as one of them. Almost overnight, Alberto became familiar with the most talented, lively, and interesting young men of his generation. A number of them were to become his lifelong friends, and from the first these friendships seemed natural and inevitable. Giacometri overcame all at once the obscurity, loneliness, and solitude of his former life. To do so had needed only the unlooked-for prospect of success as a professional artist. After that, there was no going back. His father's admonition to take that fateful step had had its appointed result.

Max Ernst, Joan Miró, Jacques Prévert, Michel Leiris were, along with Masson, the new friends Alberto made in that early summer of 1929. All had been closely allied to the Surrealist movement, though Masson and several others had lately been drummed out of the ranks for insubordination. Acrimony was

plentiful and passionate on all sides. But the whole history of Surrealism had, of course, from the beginning been one of clamor, contention, and controversy.

The Surrealists aspired to rekindle in the human consciousness a sense of primordial wonder and to regenerate the integrity and immediacy of man's inner self. In order to achieve this aim, they realized from the first that artistic and literary innovations would not suffice. A radical transformation of human life was necessary. In short, a revolution. The young poets and artists thought of themselves in all seriousness as revolutionaries. However, they had neither doctrine nor strategy; they had only their furious belief in their own values, above all in the supreme importance of the unconscious and its expression through hallucinations and dreams. They scorned logic, religion, morality. They did not mean to waste their lives by earning their living. Surrealism was a new faith, a new order, an elite brotherhood in which all submitted to a common discipline and were joined in the exaltation of the same ideal.

The self-appointed leader of this utopian cohort was André Breton. It was he who had started the movement, formulated its theory, and recruited members. He was an individual of singular authority. Tall and majestically handsome, he had a noble, sober air of absolute self-confidence. Very few of those who came in contact with him were able, or wished, to resist the extraordinary magnetism of his personality and intellect. He had originally studied medicine, planning to specialize in neuropsychology, but his vocation and his disposition were at odds: the future advocate of anarchy couldn't stand the sight of blood and fainted during the first operation he was required to witness. Giving up medicine, he nonetheless remained profoundly interested in psychology, and had made a pilgrimage to Vienna to meet Sigmund Freud. Freudian theories were to be central in the development of Surrealism. Breton's friendship and approval were prized above all else by his fellow Surrealists, and their esteem was frequently put to the test, for Breton could be capricious and flighty, changing his mind on matters of theory from one day to the next and expecting the others to acquiesce without question. For a long time, no one presumed to challenge his authority.

Louis Aragon and Paul Eluard were, after Breton, the most high-ranking and conspicuous of the original Surrealists. Aragon was also of an imperious temperament, disposed to be autocratic and arbitrary. It is perhaps a significant coincidence that both he and Breton were the sons of members of the Paris police department and both had originally meant to be doctors. Eluard, too, ardently endorsed the revolutionary ideal, but with less fanatical vociferation, for he was above all a lyric poet of exquisite sensibility and a man of winning charm. These three were among the most remarkable and talented figures of their generation. It is not surprising that they should have galvanized the attention and secured the following of so many other talented and remarkable men.

At first, the young Surrealists occupied themselves with the publication of pamphlets and a review-aptly entitled The Surrealist Revolution-which proclaimed their scandalous, nihilistic opinions. Being young and exuberant, they also had a lot of perfectly ordinary fun and managed to get into plenty of trouble. They went to great lengths to provoke public outrage. No gesture was considered too offensive, no epithet too contemptuous to express their loathing of bourgeois society, but the insolent writings and turbulent escapades were not taken seriously as a threat to the existing order, because they had no political purpose. This significant lack was soon denounced as an emasculating deficiency by the Communists. They called the Surrealists ineffectual phrasemakers and naïve hypocrites. Thus, the conflict was joined. It was to be prolonged, as the Surrealists were in earnest, whereas the Communists shrewdly foresaw that so much energy and talent might one day be turned to advantage.

By 1928, Surrealism had come of age. Breton, Aragon, Eluard, and their friends were no longer treated in the press as irresponsible impostors and scoundrels but were publicly recognized as an authentic, even valuable avant-garde. The semblance of respectability proved treacherously alluring to certain of the erstwhile anarchists.

They, too, had come of age, felt the urgings of personal ambition, aspired to have careers and to receive recognition. Such inclinations were anathema to Breton, whose personal ambition, career, and glory were all conveniently embodied in Surrealism itself. The hour of estrangement and recrimination had come. Henceforth, the Surrealist movement was to be riven with conflict.

Most of Giacometti's new friends were men who had either deserted or been expelled from the Surrealist ranks. Alberto was warned to avoid Breton and never to be misled or duped by the false prophet. Though attentive to this advice, he must have been curious to see for himself what sort of man could arouse such passions.

Since 1926, the favored art dealer of the Surrealists had been Pierre Loeb, an astute, ambitious man whose gallery was located at 2 rue des Beaux-Arts. To both clients and artists, he presented himself primarily as a connoisseur and friend, only incidentally as a man of business. Likewise, his gallery was spacious but a little shabby, its atmosphere rather that of a studio than of a commercial establishment. All of this perfectly suited the Surrealists, who professed such contempt for personal ambition and worldly success. Pierre Loeb's supreme acumen was to grasp this nuance and turn it to profit. A man of exceptional aesthetic flair, he naturally took an interest in Giacometti's work as soon as it began to be talked about.

Jeanne Bucher had provided Alberto with the opportunity for his first success. They had made an agreement for her to continue handling his work. Not long afterward, Pierre Loeb sought out the sculptor and offered him a contract whereby he would receive a fixed monthly income in return for his entire production. His financial situation at that time was difficult but not precarious. The increased security represented by Loeb's offer would not in itself, one may suppose, have induced Alberto to accept. But the Galerie Pierre was more important and prestigious than Jeanne Bucher's. In addition to such younger men as Max Ernst, Miró, and de Chirico, Pierre Loeb was at times able to show works by Picasso, Braque, even Matisse. Further stock-intrade was the carefully nurtured mystique of Loeb himself as an

individual of almost infallible clairvoyance. For a young artist who had not long since been questioning his ability to have a professional career at all, the offer of a contract from Pierre Loeb must have seemed irresistibly auspicious. Alberto accepted.

His acceptance was at odds with the commitment to Jeanne Bucher, and we do not know how this conflict was resolved. On the face of things, it appears that Alberto behaved with opportunism. That would have been unlike him. In all his subsequent career, there was no instance when considerations of prestige or pecuniary advantage took precedence over a concern for ethical behavior, which was, to say the least, punctilious. Still, it is fair to add that at this particular time Giacometti's ambition, his will to achieve an impressive success, was at its most intense. Whatever doubts he may have entertained about himself as a professional artist, Alberto craved approval. He was ready to go to great lengths to obtain it.

The sculptures produced by Giacometti between 1930 and 1935 are all interrelated in that they are direct expressions of the artist's psychic character and emotional disposition. Neither before nor later did he produce work which so overtly referred to his own nature, to his deepest compulsions and desires. It is evident that the evolution toward fulfillment required that he be able to fuse psychic motive with aesthetic purpose, forming a whole which should appear to have come spontaneously into existence. The so-called difficulties of 1921 and 1925 were probably a result. at least in part, of his sense that to achieve such a synthesis was for him, as it must be for everyone, virtually impossible. Yet the acknowledgment of this impossibility is a fructifying incentive, for it compels the artist to identify his experience with a creative contingency forever in the future. His life and work become on every level a single thing, joined in the unity of what he wants to be with what he wants to do. Cause and effect are united in an identity which is simultaneously the artist and the work of art.

While not so frankly sexual or violent as the earlier Man and Woman, the Reclining Woman and the Woman Dreaming, both of 1929, include obvious phallic shapes in elusive but ambiguous relationship to equally obvious concave forms. Emotional content, however, has now become more completely integrated with plastic

effectively on their own terms, so to speak, than on the artist's. He was beginning to devise a vocabulary of expressive forms with which he could objectively formulate the profoundest aspects of his inner life. This imagery, though it may appear hallucinatory or haphazard, is in fact the product of a coherent emotional and aesthetic attitude. Giacometti's Surrealist period does not represent an incongruous parenthesis in his development or career. Though the sculptures of these five years may appear unlike those which preceded or followed, they were all produced by the same artist, whose creative imperative was served essentially in the same way by all the works he executed during his lifetime. Such underlying unity is, of course, the quintessence of every artist's adventure.

purpose, and consequently the structural elements blend more

5 of 7

Of Alberto's recently made friends, the one with whom he would remain most friendly the longest was Michel Leiris. Exactly the same age as Giacometti, Leiris came from a safely well-to-do bourgeois background, a mishap of birth for which a lifetime of literary atonement would never be adequate exculpation. He was consequently a belligerent young man, though of physical stature small, and the Surrealists seemed made to order to harmonize with his contentious turn of mind. He wanted to live dangerously. albeit ethically, to elevate by means of literature an "ordinary" life, a "normal" life, to the high level of a destiny. Meaning to explore his obsessions to their extreme end, however bitter, he found that what obsessed him most was the idea of death, and the parallel eventuality, or temptation, of suicide. His standards of personal responsibility and rectitude were far too exacting to make common cause for long with the Surrealist escapade, and he had gone his way alone well before he met Alberto. He became a professional ethnologist, made journeys to Africa, and attained distinction in this branch of human study. His principal endeavor, though, was a literary, especially an autobiographical one, by means of which he was willing to live with danger in a pursuit of truth so painstaking as to make analogies, allegories, and images the fabric of myth. Author also of considerable poetry and many critical pieces on art, Leiris was the first to publish an appreciative text devoted exclusively to the sculpture of Alberto

Giacometti. It appeared in 1929 in a small review named Documents, edited by the distinguished writer Georges Bataille. This was prestigious attention for an artist not yet thirty. The critic wrote: "There are moments which may be called crises and these are the only ones that count in life. Such are the moments when what is exterior seems abruptly to respond to the appeal which we make to it from the interior, when the outer world opens so as to establish between itself and our hearts a sudden communication . . . I like the sculpture of Giacometti because everything he does is like the petrification of one of these crises." It was prescient of Leiris to understand at the start of Giacometti's career the fundamental, generative effect of this recurrent sense of crisis. To be sure, those who knew Alberto were inevitably aware of his creative anxiety. In later years he would exalt the moment of crisis to such a degree that it became the very medium in which the creative act generated a material result.

Early in 1930, Giacometti executed a sculpture quite different from any he had made hitherto. Entitled The Suspended Ball, it was to have an important effect on the progress of his career. The original was in plaster, painstakingly copied in wood by a Basque cabinetmaker. Wood was more durable than plaster but less costly than bronze, and Pierre Loeb never missed a chance to spare expense. Within an open, cage-like framework of metal rods is suspended by a wire a ball the size of a large apple, from the underside of which a sizable wedge has been sliced out. On a platform immediately beneath this slice rises a large, crescentshaped form, its sharply ridged upper rim almost entering the slice in the ball, which, being suspended, seems by the juxtaposition of forms about to move either away from the crescent or into a penetrating contact with it. This uncertainty as to a resolution in the ambiguous relationship between the two forms, of which the sensual implications are strong but indecisive, creates an extraordinary sense of some occurrence incessantly on the verge of taking place yet forever frustrated. The placement of the sculptural elements within their cage-like framework adds an impression of inhibiting isolation.

In the spring of 1930, Pierre Loeb held an exhibition of

works by Miró, Arp, and Giacometti. Among other recent sculptures by Alberto was The Suspended Ball. It at once drew the attention of André Breton and Salvador Dali, a militant Spanish newcomer to the Surrealist movement. They agreed that Giacometti's work exemplified Surrealist principles and decided that he should be recruited forthwith. Breton went to call at the rue Hippolyte-Maindron. The warnings of the disaffected apparently had little effect against the famous charm and sublime self-assurance of the Surrealist leader. Alberto was impressed. He must also have been pleased by the praise of an older man whose aesthetic eminence was so widely acknowledged. Almost every artist or writer of distinction of the younger generation was, or had been, a member of the Surrealist movement. Alberto agreed to join, while Breton was immediately attracted by the intellectual intensity and conversational dynamism of the new recruit. Giacometti's allegiance to Surrealism lasted for four and a half years. * He attended meetings, participated in exhibitions, endorsed political and artistic principles, and published some of his writings in the newly retitled review, Surrealism at the Service of the Revolution.

The sculptor assured Breton that his works came into being, as it were, independently of himself, appearing in his mind's eye completely finished and taking shape without his conscious intent. The statement is perfectly in accord with orthodox Surrealist doctrine, and there is no reason to question its sincerity, as all of Giacometti's Surrealist sculptures are images of inner rather than outward reality. Any implication, however, that they sprang into existence almost by themselves, automatically, is false. Chance effects played no part in the elaboration of Alberto's Surrealist sculptures. They were created with painstaking diligence, and while some were executed quickly, others, including all of the most significant, were the outcome of weeks, even months, of meticulous work. An alert and vigorous sense of purpose seems to contradict the somewhat passive implications of the statement to Breton. Alberto thrived on contradiction; it was one of his most pronounced intellectual characteristics. André Breton's favorite color was green. In the elaboration of Surrealist doctrine and rites, it seemed logical that the leader's personal preferences should have the dominion of natural law. Breton at one time decreed that, insofar as possible, all members of the group should eat and drink only substances which were green. They complied. Alberto, however, one evening while the others were dutifully sipping chartreuse and crème de menthe, ordered cognac. There was a limit to the nonsense in which he was willing to participate. But Breton was singularly indulgent. The two men obviously took such pleasure in their friendship that they were prepared to make exceptional allowances.

Alberto fell ill only a few weeks after having become a member of the Surrealist movement, suffering from severe pains in the stomach. The doctor to whom he turned for consultation was a man named Theodore Fraenkel, who had been a schoolmate and chum of Breton's since the age of ten, had gone with him to medical school, and had remained on intimate terms ever since. Like many French doctors, Fraenkel was passionately interested in art; the men whom he met through his former schoolmate excited and satisfied a proclivity more profound than his concern for medicine. In return for satisfaction and excitement, he was more than willing to offer medical advice—frequently gratis—but it happened that he had, in fact, a greater aptitude for the appreciation of artistic talent than for the diagnosis of disease. After examining Alberto, he said that it was a case of acute indigestion, prescribed some simple remedy, and sent his patient home.

The pains did not abate. They became acute. Diego called another doctor, who quickly saw that the trouble was appendicitis. Medical opinion in France at that time did not consider surgery desirable for patients suffering from acute attacks. It was common practice to pack ice about the abdomen and wait till the acute phase had passed. Alberto was fortunate at that moment to be living at the Hôtel Primavera, where he was certainly more comfortable than in his nearby studio. Diego came frequently during the day with milk, soft foods, and the ice. The pains lasted more than three weeks. Meanwhile, Alberto decided that he would prefer to undergo the operation at home rather than in Paris. Shortly after June 15, he set out for Maloja. The operation was performed at the hospital in Samedan, a few miles beyond Saint

Moritz, and the surgeon said afterward that it had taken place in the nick of time. A few days longer might have proved fatal, because infection had, after all, spread beyond the appendix to the peritoneum. Alberto, aged only twenty-nine, had had a brush with death.

In the fashionable, artistic Parisian world of people like the Noailles, the most successful and innovative interior designer of the time was Jean-Michel Frank. A man of extraordinary charm, he won the loyalty and esteem of friends from dramatically differing social and intellectual environments. Devoted to the high society where his clients were to be found, he was also a thinker and an aesthete. He had reason to be unusually thoughtful. Jewish and homosexual, he had been cruelly bereaved: his two older brothers were killed in the First World War; his father had soon afterward in despair leapt to his death from a high window; and his mother went insane and died in an asylum, leaving her last child rich and alone before his twenty-first birthday. The young man was attracted by the most advanced intellectual and artistic movements. The Surrealists became his friends. He professed to admire, even to agree with, the principles of Communism. Since at the same time, however, he could not do without the life craved by the luxury-loving side of his nature, he compensated in part for contradictory self-indulgence by developing a rigorous, spare style of decoration. The idle rich whose company he enjoyed and whose ethical condition he deplored were to be installed in surroundings of stark, extremely expensive simplicity. The stylish elite of the period, having accepted Cubism and acknowledged Surrealism, were delighted. Frank's shop at 140 rue du Faubourg-Saint-Honoré became the haunt of the people whose insight and influence would largely turn out to determine the taste of the time.

Because he admired the work and enjoyed the company of gifted young artists, Frank determined to combine, whenever possible, their talents with his own. Of all those who collaborated with him, Giacometti was by far the most accomplished, prolific, and faithful. They were introduced to each other about 1929 by Man Ray, the American Surrealist photographer, and their association continued until the Second World War put an unhappy end to it. They became close friends, each no doubt appreciating in the other an almost obsessive disposition to take unlimited pains for the sake of spatial relationships which most people would never have noticed.

Alberto created for Frank in plaster and bronze a quantity of vases, lamps, sconces, candlesticks, decorative medallions, sculptured mantelpieces, andirons, and so forth. Though this work allowed the artist to assume greater responsibility for his livelihood, it should not, and cannot, be regarded merely as a moneymaking activity. Giacometti was incapable of applying himself to a job which did not engage his entire attention. The objects he made for Frank have an inherent beauty independent of their practical purpose. "I attempted," he said, "to make vases, for example, as well as I could, and I realized that I was working on a vase exactly as I did on sculptures." It was natural that the designing of all those objects should have an effect on his work. It was indirect, and it may have been less than he believed. The effect on his life, also indirect, proved to be great, and he was keenly aware of it, for it decisively altered his relations with the person who was, after his mother, closest to him.

The evolution of Alberto's existence had still not been matched by any similar development on the part of Diego, who was content to spend most of his time hanging around disreputable bars and taking part in shady escapades. If at first it had seemed possible to explain away such conduct as high-spirited impulsiveness, that wishful rationale became less credible as years passed. It began to seem that Diego had no other prospect, or ambition, than to spend the rest of his life as an irresponsible idler. Alberto worried. His fears may have been heightened by awareness of some essential relation between the negative character of Diego's existence and the affirmative character of his own. At the same time he could not have helped seeing that he represented one positive element, and perhaps the only one, able to prevent the probable

future from becoming a certainty. Thus, he would have tended hopefully to identify his own destiny with Diego's. If he expected to do anything for his brother, he could hardly do more than that. His intentions were selfless. He wanted to save Diego from what appeared to be an impending lifetime of slightly disreputable nonentity, that was all. Having to contend with personal imperatives, however, he could only help Diego within the context of his own activity.

Till now, there had never seemed to be any way of doing that. Suddenly something materialized, materialized when in every way it was needed most, and it was the very possibility which would ideally satisfy every need and all concerned, and which for thirty-five years would add to itself and to the lives of both Diego and Alberto until it seemed to have been from the first inevitable, which by that time it had had to be. It was simply that Diego should assist Alberto in his work.

So long as he was working only on his sculpture, it probably never occurred to Alberto that an assistant might be necessary. When he began to accept commissions from Jean-Michel Frank, it became evident that he could not fulfill all of these and continue unhampered with his own work unless in both realms someone helped him with manual tasks: making armatures, casting plaster, carving stone—all the necessary but laborious chores which, as it neatly happened, had always been those for which Alberto himself had neither aptitude nor liking. Diego was the obvious one. From early childhood, it had seemed natural to them both that he should help his brother. He possessed an exceptional degree of manual dexterity. The injury to his right hand had, perhaps, led him to compensate by acquiring remarkable skill with his fingers. Experience gained with the carver of cemetery monuments in Chiasso would be useful. Above all, he never doubted that Alberto was a great artist.

It must have seemed a kind of miracle that Alberto had worked: the problem of Diego's future was solved overnight. Though he continued for a time to see his old pals, he was soon too busy to take part in their activities, and before long made friends with Frank and the other men who were his collaborators.

Both brothers must have been pleased and happy. The need of one to protect and of the other to assist had been merged in order to serve the need of the artist.

The worlds of art and fashion being both intermingled and interdependent, success in one often goes hand in hand with success in the other. Alberto soon found himself launched in fashionable Parisian circles, to which he had entree not only as a promising artist but also as a collaborator of Jean-Michel Frank. and he was accepted immediately by the beau monde because its members could see that he was interested in them for themselves, not for the sake of social appearances. The Viscount and Viscountess de Noailles took him up. He became a regular guest in their palatial house on the Place des Etats-Unis. Having bought another of his sculptures, this one from Pierre Loeb, they proposed early in 1930 that he execute a large stone sculpture to be placed in the gardens of an enormous villa which they had recently built on a hilltop overlooking the Mediterranean at Hvères. He agreed to make preliminary studies. Munificent advance payments were forthcoming.

Among the friends Alberto had made in the circle of Jean-Michel Frank and the Noailles were Jean Cocteau and a painter named Christian Bérard. A creative self-server of exceptional talent, Cocteau was known as the most captivating conversationalist of his time, and he certainly had a prodigious way with words. It may have been his undoing, however, as he became so fascinated by his capacity for fascinating others that he sacrificed much talent to the blandishments of great fame. The paintings of Christian Bérard were neither original nor important, but they were supremely stylish and found appreciative buyers. Bérard also had a distinguished career as a designer for the theater and, after the Second World War, contributed considerably to the brilliant success of the couturier Christian Dior. Like Jean-Michel Frank, who was a friend of both, Cocteau and Bérard adored high society and its luxurious style of living. Also like Frank, they were homosexual. They were regarded by the Surrealists with disapproval and distrust, especially Cocteau, who was rightly suspected of being a narcissistic climber who coveted the kind of official consecration which they abhorred.

Homosexuality was denounced by the Surrealists as a reprehensible defect. Such rigid discrimination may seem a bit frivolous on the part of these self-appointed followers of Freud who were fanatically committed to the regeneration of human experience through the free function of the id, especially since Freud himself had declared that homosexual tendencies were in some degree common to all creative personalities. But Breton was inflexible. One member of the group, however, and not one of the least, was homosexual: René Crevel. Handsome, appealing, a poet of vivacious originality, Crevel was a romantic idealist. He believed in the principles of Communism, yet he was the son of rich parents and enjoyed the luxurious life of the fashionable world. Robust and muscular, he suffered at the same time from tuberculosis, and had been obliged to undergo lengthy treatment in a sanatorium. Crevel was devoted to Alberto, who returned the affection without reserve, and one of the sculptor's first etchings was an illustration for a volume of Crevel's writings.

The intimacy of men like Cocteau, Bérard, Frank, and Crevel again caused some of Alberto's friends to wonder whether he might not be homosexual himself. Again, they were wrong. Still, Alberto felt for homosexual men an empathy which went beyond an understanding of their problem. He was drawn to them by some need of his own and derived enjoyment from participating by way of conversation in their experiences. But it went no further than that.

Of the women who played determinant roles in Giacometti's life, there is only one about whom we know next to nothing. Her name was Denise. They met in Montparnasse and their relationship began around 1930. She was beautiful, dark-haired, about the same age as Alberto. What her occupation may have been, if any, remains, like almost everything else about her, unknown. But the obscurity of her origin and subsequent history, plus Alberto's proclaimed penchant for prostitutes, does allow for conjecture.

We know that Denise sniffed ether, had a fierce temper, and that concurrently with Alberto she had another lover: a man called Dédé le Raisin because he sold fruit in the street from a barrow. Alberto, Dédé, and Denise apparently got along well together, and upon occasion, it is said, enjoyed together the conclusive demonstrations of intimacy. Complicated consequently, the relationship with Denise was from the beginning a tempestuous one, and a radical change from Flora.

Considering the large amounts of information available about all other persons important in Alberto's life, it seems surprising that there should be so little about Denise. He made no effort to hide her. Their liaison was public and she was readily introduced to his friends. The very lack of information may be what is most telling. Women who were important in Alberto's life were also important in his work. Only in the case of Denise does a lack of information prevent us from judging the effect she may have had. This lack, however, coincides with the period when the artist provided both in his work and in published writings the greatest abundance of candid information about himself. Like so many other coincidences in Giacometti's life, this one may not be altogether coincidental. Denise, though present, left almost no trace of her presence. What we do not know about her, however, is richly compensated for by what we shall learn during this period about Alberto.

Intimations of cruelty and violence, sexual anguish, and spiritual alienation suffuse the sculptures which Giacometti produced during his affiliation with the Surrealist movement. They reveal a state of continuing crisis and grim contingency. Ever since his difficulty in 1925, the artist had been engaged in a struggle to fuse personal and creative experience so as to free himself for creative fulfillment in terms of its initial causes and aspirations. One might say that he was striving to recapture the innocent sense of mastery which he had felt as a youth. Before he could even start to do that, however, there were conditions to be satisfied, obstacles to be overcome.

Speaking of his Surrealist sculptures, he said he had made them "without asking myself what they might mean. In the finished work I have a tendency to rediscover—transformed and displaced—images, impressions, and events which had profoundly moved me (often without my knowledge), forms which I feel to be very close to me, though I am often unable to identify them, which makes them for me always more disturbing."

What are these images, these forms? To what impressions and events do they refer? How is it that the sculptor should have produced works so highly and specifically evocative without wondering what they meant? Such questions, it seems, refer directly to obstacles to be overcome and conditions satisfied.

The Cage of 1931, executed first in plaster, then reproduced in wood by the convenient cabinetmaker, employs the same device as The Suspended Ball, but to different effect. In no way ambiguous, still this work is troubling by virtue of its aggressive, naked, but indecisive eroticism. The freely juxtaposed elements-two balls, two phallic forms, two rods at right angles to each other, three concave forms, and a five-pronged claw-hang within their cage as an image of impending sexual brutality, and the tremulous immediacy of violence seems more overt as one moves around the sculpture. But nothing happens, after all. The claw does not tear, the suggestive forms do not touch, the inherent violence never materializes. The sculpture stands before us with serene selfsufficiency, a work of art which asserts its artistic character independently of the artist's psychic motives. Thus, he was able to invest it fully with his fantasy while at the same time fashioning an objective creation to provide for others-of whom he himself was one—the delight of unexpected access to their deepest sources of longing and satisfaction.

Giacometti, of course, was not the only artist during this period to produce works of art which openly refer to private, hidden aspects of human experience. All of the Surrealists were dedicated to that purpose, and the common cause no doubt disposed each of them more freely to realize highly individual works.

"There was clearly a Surrealist atmosphere that influenced me," Alberto later said. "I wanted my sculptures to be interesting, mean something to other people. I had this need of other people, and was very conscious of reaching them or not."

The need for approval is striking. It appears at no other time in Giacometti's life, and he later proved that he could work without respite and without disappointment for ten years or more, unsustained by the approval or understanding of anyone. Therefore, we may wonder whether the expressive content of his Surrealist work demanded acceptance of a kind determined by its character. The Surrealist group was in a sense a large family, upon whose members the autocratic paterfamilias. André Breton. bestowed blessing or blame according to his inclination. Alberto must have been pleased to receive Breton's approval of his Surrealist works, because they fulfilled, as he said, "the need to complete myself by making something outside myself." What he made, we can see. How, by doing so, he completed himself, one may only guess. In any event, he did demonstrate his ascendancy to the world by proving it on his own terms in the microcosm of the Surrealist movement.

Giovanni Giacometti did not like or approve of the Surrealist works of his son. In terms of the paths that each was resolved to pursue, they had come to a point which must have looked like a challenge. Giovanni declared that Alberto had "lost his way." Such a radical departure from every criterion he honored was potentially an affront, a refusal to acknowledge his achievement and standing. But relations between father and son remained outwardly affectionate.

Annetta Giacometti's opinion of her son's Surrealist works we do not know. She had her ideas about art, many of them probably taken from Giovanni. It seems unlikely that she would have glimpsed the underlying significance of Alberto's Surrealist work. Whatever she may have thought of it, she was no doubt pleased by the progress of his career, having been fearful that the son might be overshadowed by the achievements of his father. It was clear that that danger had been averted. Alberto had proved that he was quite able both materially and professionally to take care of himself.

The Château Saint-Bernard at Hyères is an enormous folly of reinforced concrete. Designed for the Viscount and Viscountess de Noailles by Robert Mallet-Stevens, it was conceived as a Cubist extravaganza and the rooms were hung with works by the best-known artists of the School of Paris. The gardens were decorated with contemporary sculpture. Laurens, Lipchitz, and Zadkine as well as Giacometti were commissioned to design important pieces for the Riviera estate. Charles de Noailles had suggested that Alberto execute for Saint-Bernard a sculpture which would be "neither Cubist like the Laurens nor contorted like the bronze of Lipchitz." During the first few months of 1930, a number of tentative models were made in plaster, but none of them seemed satisfactory. The finished sculpture would have to be larger than anything Giacometti had ever produced and in a material which could remain out of doors.

An acceptable model was produced in December of 1930. Alberto, after consulting with Henri Laurens, decided that the finished sculpture should be carved in gray, granular stone from quarries near the little town of Pouillenay in Burgundy, whither Diego was promptly dispatched with the model to begin preliminary work. He spent most of the winter of 1931 at Pouillenay. Alberto made the trip a few times to see how work was progressing, drew guidelines on the stone, then returned to Paris. He trusted his brother to transpose into a different material on a much larger scale the concept which was suggested rather than stated in the small model. Diego did the great majority of the work which resulted in the finished sculpture. He could hardly be considered a mere manual helper now. Nor, on the other hand, may it have

seemed quite accurate to consider him an active collaborator. After all, he was only Alberto's younger brother, who helped with his work when necessary, received a fair share of the money that came in, and for the rest was a handsome, agreeable young man who liked to wear flashy clothes and have a good time. In short, he was not an artist. He never pretended to be one. However, he had become greatly helpful to the creative activity of his brother, who was without question an artist. What, then, did that make Diego? The question did not as yet, perhaps, seem particularly pressing. A certain ambiguity was nonetheless imminent in the drift of Diego's status.

The Figure for the Noailles' garden was not installed there and entirely finished until the early summer of 1932. Alberto himself spent three weeks in Hyères in June, adding last touches to the sculpture with Diego's help. From conception to completion it had occupied them, albeit not exclusively, for the better part of two years. It is a curious work. Standing eight feet tall, it approximately suggests a massive figure, with right hip and left shoulder outthrust, topped by an overlarge, square, featureless head. The precise place in the terraced gardens where this sculpture originally stood, selected by Alberto and the Noailles together. was such that it could best be seen from the terrace above. In front of the viewer, below him, in the midst of the garden plants, rose the stone monolith, suggestive of a living being but ambiguous. brooding. It seemed out of place in the lush gardens, an intruder. as it were, from some harsher clime. It is the only large work in stone of Alberto's entire production.

The professional agreement between Giacometti and his dealer, Pierre Loeb, had not turned out to be to the artist's liking. The aura of connoisseurship which the dealer created about himself made it easy for him to maintain to artists that sordid material considerations should hardly enter into their relationship, but by the same token he felt free to charge his clients a premium for the privilege of access to his discernment. When the term of their one-year contract had ended, Alberto was eager to be relieved of its constraints and the recovery of his freedom was an occasion for celebration. Another dealer, one more equable than Loeb in

his relations with artists, named Pierre Colle, also a man greatly appreciated by the Surrealists, soon made acquaintance with Giacometti and offered to give him a one-man exhibition whenever the adequate number of sculptures should be ready. Alberto welcomed the prospect.

Like many of his fellow Surrealists, though never actively militant, Giacometti in the early thirties believed that Communism offered the most effective and rational remedy to the ills of mankind. He held to this idealistic conviction for a number of years. although his own character and way of life were inseparable from the concepts and practices of a democratic capitalistic society. His political convictions were passionate, but it was to their passion rather than to their practical application that he committed himself. Not once in his lifetime did he cast a ballot. Retaining Swiss citizenship, he never resided long enough at home to satisfy the requirements for voting. He never became a member of any political party. Still, he took strong stands on the moral and social issues of his time. He identified himself with those who were oppressed by the inequity of human circumstances. He admired the vagabonds and beggars of Paris, felt a kinship with them, an obscure sense of alienation and affliction, and at the end of his life, world famous, rich, he lived and looked very like one of them. Concerning Communism in Stalinist Russia, before the purge trials and terror of the thirties, neither Alberto nor any of his Surrealist friends can have known the truth. Later, when the truth was out, he said, "I think that the best way for an artist to be a revolutionary is to do his work as well as possible."

Denise remained the central feminine figure in Giacometti's life, and the relationship continued to be stormy. Turbulence may have been added by the fact that she was not the only woman to receive the artist's attentions, and knew it. He did not regard fidelity as a male responsibility. Though susceptible to the torments of jealousy, he condemned the emotion as degrading. His nature was not free from perversity. He struggled against it, but, of all the struggles of his life, that was one he had been born to lose.

Flora Mayo reappeared one day, destitute. Her father had gone bankrupt. Once again, her life was falling to pieces while

she looked on, helpless. Not knowing where to turn, she appealed to Alberto for advice. He told her to go back to the United States. The heyday of American expatriation was over, anyway. Before leaving, she destroyed all the sculptures she had made while in Europe, including the bust of Alberto.

Diego always remembered the period between 1925 and 1935 as the happiest of his life. It was also the time of greatest change, for during that decade he ceased to be a happy-go-lucky youth and became a responsible adult whose maturity would be devoted to the fulfillment of another man's genius. The symbiosis of need, help, and protectiveness began to assume a character of its own which would independently act upon the evolution of the fraternal relationship. In addition to doing most of the manual work required by the commissions from Jean-Michel Frank, Diego was making all the armatures for Alberto's sculptures, even the most complex, and assisting in the execution of some of them. The artist supervised and decided, but Diego's hand in things became more and more indispensable. The gradual change also expressed itself in ways less predictable.

It had come about—with an irony of truly exquisite relevance—that Diego did not always approve of the company Alberto kept. He himself continued to spend an occasional evening with shady pals of the past, though he no longer took part in their ventures, but, as always, he made a distinction between Alberto and himself. If he was prepared to dedicate himself to Alberto's art, then it followed that he could do no less for the artist. Not a discriminating analyst of human motives, Diego nevertheless grasped the complexity of his brother's nature in terms of day-to-day cause and effect. Knowing Alberto to be a man of genius, he also saw that in relation to others he could be amazingly naïve and therefore exposed to undesirable eventualities. In this he was right, but brotherly concern was no match for creative ingenuity.

One evening early in April of 1932, both Diego and Alberto were at the Café du Dôme, seated, as was so often the case, with different people at different tables. Diego did not like the look of his brother's companions. There were four men and two women. The poet Tristan Tzara, founder of Dada, was one. The others were Jacques Cottance and Georges Weinstein, both in their early twenties, acolytes of the Surrealist movement, and a young artist aged twenty-three named Robert Jourdan. The women were Denise Bellon (not to be mistaken for Alberto's mistress of that time) and her younger sister, Colette, who was engaged to Jacques Cottance; they too were friends of the Surrealists. It seemed to be a lively group out for an evening of drink and talk, nothing more. But Diego did not feel reassured.

He left the Dôme that evening before Alberto. Having recently rented at 199 rue d'Alésia a studio-lodging in a complex no less ramshackle and spartan than the one in the rue Hippolyte-Maindron, he returned there and went to bed. His sleep was troubled. He dreamed that he saw Alberto trapped, half submerged in a black, slimy morass from which he could not escape, while from a distance he, Diego, could only look on with dismay,

powerless to help.

At the Dôme, in the meantime, Jacques Cottance and Georges Weinstein had also gone home, leaving the others to talk on. The conversation turned to drugs. Robert Jourdan was an exceptionally handsome and gifted young man. As much for his looks, perhaps, though he was not homosexual, as for his talent, he had been taken up by Jean Cocteau and Christian Bérard. It was they who prompted him to take opium. His father was a high official in the Department of the Seine, and Robert was still living at home, where he could hardly indulge his habit with the necessary sense of security. He suggested to his friends that they go somewhere together and take dross, the gummy substance left over after opium has been smoked. He had plenty of it with him. They agreed.

Denise Bellon, who had recently separated from her husband, was living in a small apartment in a pension in the rue Faustin-

Hélie. Though she knew that her two young daughters were in one of the bedrooms asleep, she offered the other bedroom for the party, and the five set out by car. When they reached the pension, Tzara begged off, after all, leaving Denise, Colette, Alberto, and Robert to go upstairs together. In order to reach Denise's bedroom, they were obliged to pass through the one where the children lay asleep, but they managed to do so without waking them. Robert produced his dross. The two men and two women gulped it down. The effects, whether pleasurable or merely stupefying, were soon felt. Everybody drowsed.

Toward morning, Alberto came to himself. He gradually realized where he was and remembered what had happened. He lay fully clothed on the bed. Beside him lay Robert. It was not yet daylight. Robert lay without moving. The two women were somewhere nearby. Slowly Alberto became more conscious of his surroundings. Robert lay still, so still that it seemed he could hardly be breathing. He was not breathing. Alberto turned violently on the bed. Robert's body was no longer warm. It lay there with a terrifying stillness, dead.

Once again, suddenly, unaccountably, Alberto found himself in a strange room at night beside a corpse. Once again, as in the rainy mountains of northern Italy, chance had brought him face to face with death. Was it by chance? He had never before taken drugs, never took them again. He had hardly known Robert Jourdan. If there was a necessity, where was it? In him or in the circumstances?

He could not face it. His first thought was to run away. Getting up from the bed where the dead man lay, he went quickly to the door, passed through the room where the two little girls slept, hurried downstairs into the street. It was cold and raining. Though the neighborhood was deserted, Alberto found a taxi and returned to the rue Hippolyte-Maindron.

Jacques Cottance was summoned from bed by a horrified telephone call. His fiancée and her sister had discovered the corpse of their friend soon after Alberto's departure. Cottance went immediately to the rue Faustin-Hélie. Robert had clearly absorbed

a lethal overdose. In the interest of all concerned, it was evident that the circumstances of his death should insofar as possible be concealed. The young man guessed that Robert's father would be only too anxious to use his influence. The police, of course, would have to be called. Reluctant to have such an embarrassing corpse found on his premises, the pension's proprietor suggested carrying Robert's body outside, where they could pretend to have come upon it by chance. In the adjoining bedroom, the little girls miraculously had not been awakened by all the coming and going, nor were they roused when the corpse was carried through. It was bundled around the nearest corner and left on the sidewalk in the Place Possoz.

The police, when they arrived, if fooled by the story they heard, were not fooled for long. The truth soon came out, and all concerned were taken to the police station at 2 rue Bois-le-Vent. A van was sent to bring Giacometti from his studio.

So it was that Alberto found himself once more detained by the police because of a death in which his involvement seemed to have been accidental. If detainment by the police entails a sense of guilt, the extent of its presumption need not derive from a rational judgment of the facts. He had kept the light burning at night in his bedroom for years, but it had averted nothing.

The formalities at the police station turned out to be no more than formalities. Cottance had been right. The dead boy's father was anxious to conceal the truth, and Maurice Jourdan was in a position to do so. The witnesses were released. No report was prepared. The death certificate was issued six days later, after the funeral had taken place; it omitted to state the cause of death and declared only that this had occurred in the street in front of 5 Place Possoz.

When Diego arrived at the studio that morning, he was surprised to find Alberto absent. Remembering his unpleasant dream of the previous night, he felt apprehensive. It was midmorning before Alberto returned, distraught, to tell his brother what had happened. Diego was upset. The coincidence of his dream with Alberto's experience, though subject to more complex interpretations than the one which he can have been expected

to make, certainly increased his disposition to feel that Alberto needed help and protection. This can hardly be counted in the score of chance.

No More Play, a sculpture executed in 1932, is one of the most telling of this period. Death is its theme, invoked with more powerful allusiveness and ambiguity than in any other work of Giacometti's oeuvre. A flat, rectangular slab of white marble, the sculpture is concretely emblematic of its deeply buried meaning. The carved surface is divided into three oblong fields, of which the middle one, the smallest, contains three coffin-graves with removable lids. A tiny, stylized skeleton reposes in one of these. The fields at either side are pitted with oval or circular holes of varying size; standing in two of them are upright figures, each separated from the other by the field of graves, to the right a rigid hieratic woman, to the left a headless personage with arms upraised in a gesture of veneration or surrender. As an elegiac inscription, the title is engraved in the right front corner of the stone. A funerary symbol, No More Play is at once the embodiment of a metaphysical concept and an expression of existential irony: death exists but is the negation of existence, while art provides for immortality, but, in order to do so, entails the death of the artist. The title in French is On ne Joue Plus, which means literally that one is no longer playing. Giacometti was thirty years old when he made this sculpture—an age at which life has had plenty of time to prove that it is not a game. When asked why he was a sculptor, Alberto sometimes said, "So as not to die."

Another important sculpture of the same year, *Point to the Eye*, alludes to similar preoccupations, though in different terms. Fixed upon a rectangular wooden slab, two sculptural elements stand in a deadly confrontation. A club-shaped form tapering to a stiletto point is thrust across the slab directly toward an eye socket in the skull-like head of a stylized skeleton. The point does not quite touch the socket. But has it not already done so? The figure is an image of death, and the point to the eye clearly the representation of a fatal occurrence. Its cause and character convey the expressive sense of the sculpture. For an artist, vision is equiva-

lent to life, and the natural outcome of their union is a work of art. Creation is procreation. To be blinded is to lose creative power, to be made impotent in a way which goes beyond artistic capacity, to have met with a living death. So our attention is directed to the nature of the lethal instrument. In *Point to the Eye* the point is not, as it were, the point itself but the whole form: the weapon is a club as well as a stiletto, suggesting by its shape the consummation of other acts which may entail fatal consequences. Thus, sex may seem to threaten what is most precious in life. Alberto's nature worked upon his art with relentless subtlety. Reflecting psychic causes and embodying their effects, *Point to the Eye* is also a work of exquisitely conceived sculptural authority. Its power is inseparable from its frailty and the two relate to each other in haunting evocative balance.

A third significant sculpture produced by Giacometti during 1932 is entitled Woman with Her Throat Cut. The dominant theme of death is here subordinated to the artist's recurring preoccupation with psychic anguish and sexual violence. The genesis of this work is especially revealing of its intent and relevant to its meaning, while both meaning and intent explicitly anticipate a strange, troubling concatenation of experiences which were still fourteen years in the future: a dream, a disease, a death. The open-work composition of stylized anatomical forms in Woman with Her Throat Cut is related to two earlier sculptures, the titles of which suggest similar symbolic intentions. The first of these had been executed three years before and was entitled Woman in the Form of a Spider. Although it is possible to visualize the various elements of this work as approximately suggestive of female and arachnid forms, the title seems arbitrary, as if Alberto had been determined to see, and to have us seek, in this sculpture an allusion which does a certain violence to its plastic integrity. Woman in the Form of a Spider was made to be hung on the wall. An inkling as to its possible significance for Giacometti may be gained from the fact that for some years he kept the original plaster version hanging on the wall directly above his bed. If this is a spider, however, it is one which has clearly been mangled. Its identification with a woman, not to mention the fact that the artist chose

to hang it directly above his bed, thus seems all the more revealing. The Tormented Woman in Her Room at Night, a sculpture executed two or three years later, is a tentative, transitional work in a semi-Cubist manner which owes something to both Lipchitz and Laurens. Less powerful, original, and effectively realized than either the Woman in the Form of a Spider or the Woman with Her Throat Cut, it is interesting above all in terms of the sculptural and symbolic transition. The disjointed, convulsive representation of a mangled woman-insect has been superseded by an elegant, intellectual creation meant to convey the anxiety of a woman alone at night threatened by a murderous intent which has been brutally carried out in the final sculpture. The spider woman, by nature menacing, is first mangled, then threatened, and at last slaughtered. The conclusive act is depicted in a sculpture of formally harmonious, original, and organic forms. As a representation of violence and bestiality, the Woman with Her Throat Cut is almost abstract and could not conceivably arouse horror. It is elegant, intellectual, aesthetic. The suggestive shapes are interrelated with extraordinary rhythmic subtlety, while the effect of creative self-assurance is masterful, and the work is among the most compelling of Giacometti's Surrealist period.

Another peculiar and intriguing sculpture is entitled Hand Caught by the Fingers. It shows a human hand, made of wood, with the fingers outstretched toward several interrelated wheels or gears, which can be set in motion by turning a crank. The motion is arrested, however. Nothing happens. Danger is imminent, but no injury has as yet occurred. This sculpture has been interpreted as representing the predicament of men in relation to machines they can no longer control. It may have had a more profound, personal meaning, however, related to an incident which would have been recalled to the sculptor's memory whenever he looked at his brother's right hand. But he did not yet know the truth about that accident which had occurred a quarter of a century before. It was biding its time. The sculpture, perhaps, was one way of demonstrating that it—and the artist—had something to wait for which would make the wait worth all the time it needed.

In May 1932, the first exhibition devoted solely to recent works by Alberto Giacometti took place at the Galerie Pierre Colle, 29 rue Cambacérès. It was not, however, the introduction of an unknown artist to Paris. Sculptures by Giacometti had been included in more than a dozen group exhibitions during the previous few years. The Pierre Colle exhibition came as public consecration of a talent already recognized and praised. On the opening day, one of the first to arrive was Pablo Picasso, alert as ever to the latest artistic innovations and ready to turn them to advantage in his own work when possible. He and Alberto had made acquaintance in the context of the Surrealist group, but they were not yet friends. Other visitors to the exhibition included most of the younger artists and writers important at the moment, plus elegant members of society like Charles and Marie-Laure de Noailles.

Informed critical comment in the press was farsighted and admiring. At that time, the world's most influential journal devoted to contemporary art was Cahiers d'Art, edited in Paris by Christian Zervos. Of Alberto's exhibition he wrote, in part: "Giacometti is the first young sculptor to profit extensively from the example of his elders (Brancusi, Laurens, Lipchitz). The newness of his work, as we have seen, lies in its very personal expressiveness, in its taste for adventure, in the spiritual curiosity of the artist, and above all in the primordial power which always triumphs. Giacometti is at present the only young sculptor whose works confirm and expand new directions in sculpture."

Despite such appreciation, and the unstinting esteem of his peers, Alberto sold little from this first one-man exhibition. The market for avant-garde art was not flourishing in the midst of economic crisis. However, commissions from Jean-Michel Frank continued to provide the Giacometti brothers with a dependable, if modest, livelihood, and financial assistance from Stampa could be counted on in a pinch. Besides, none of the Surrealists had money, and none of them cared much about it.

Ten years had passed since Alberto's arrival in Paris. He had achieved some success. A challenge had been met. He had proved the value of his art. It would have seemed natural for the artist to

accept the pleasures and rewards appropriate to this achievement, if not with pride, at least with a sense of receiving his due. He did not. A puzzling inhibition persisted, an inability to partake of normal enjoyments. Though his human relationships and professional experiences were predominantly successful, Giacometti felt very much alone, compelled to search for satisfaction and communion almost entirely through his work. So much self-absorption suggests a touch of hubris, the will of the individual to overstep himself, but that is a commonplace of the creative predicament.

The summer of 1932 brought romance to the Giacometti household in Maloja. Not to Alberto, but to several of those close to him. Too close for comfort in one case.

Bianca had long since reached marriageable age. Attractive, vivacious, she liked a good time, laughter, parties. Young men paid attention to her, and she enjoyed it, but she still felt an intense attachment to her brilliant cousin. However, it was clear that nothing more positive than conversations or an occasional caress would ever exist between them. Alberto may have been resolved to remain unmarried; Bianca was not. She became engaged to a warmhearted Neapolitan, an enthusiastic supporter of Mussolini, named Mario Galante. They were married the following year.

Bruno Giacometti had begun the practice of architecture in Zurich, where he met and became engaged to an attractive young woman from Lausanne named Odette Duperret. The marriage turned out to be a particularly long and happy one. Odette was a good-natured, affectionate wife, attentive to the needs of her energetic and sensitive husband. Bruno possessed neither the creative genius of Alberto nor the bohemian temperament of Diego. His life was orderly and relatively uneventful, his career distinguished. In time he would design a number of buildings of ingenious beauty. He and Odette, like all members of the family, recognized the uniqueness of Alberto among them and were usually prepared to make allowances for it. Sometimes he put their patience to severe tests, but he never failed to repay it with gratitude and love.

The reputation of Giovanni Giacometti in Switzerland had by 1932 become so widespread that uninvited admirers often presented themselves at his home to pay their respects. One of these was Francis Berthoud, a young doctor from Geneva. Not only a lover of art but also a passionate mountain climber, he had come to scale some of the more difficult neighboring peaks. He urged the young Giacomettis to accompany him. As Diego always enjoyed a risk, he and Francis went for quite a few climbs, while Alberto stayed home and fretted for fear that his impetuous brother might have a fall. So it was that Dr. Berthoud became familiar with the Giacometti household. Ottilia was then twenty-eight, pretty, sociable, and unmarried. The two took to each other quickly. Their intentions proved serious. The Giacometti family was pleased. An engagement was soon announced.

While the lives of persons close to him were being adapted to the comfort of social norms, Alberto continued to feel that he was not living fully and that he must make a life for himself more and more through his work. The Palace at 4 a.m. is one of the most eerie and enigmatic of all his sculptures. Made of wood. wire, and string, with a small rectangle of glass dangling in midair, it looks like the maquette for a stage setting in which some dramatic action may have occurred, may be occurring, or may be about to occur. At the rear rises a tower, unfinished, it would seem, or in ruins, brooding above the scene below. To the right, framed in a window, hangs the skeleton of a flying creature, and below it, inside a cage, a spinal column. Mounted on a slab in the center is an erect phallic shape, while to the left a stylized female figure stands before three upright panels. The whole structure has an air of being suspended in space, and if it is actually a palace, and the hour 4 a.m., then the concept is a dream. It conveys a sense of mystery, of strange foreboding, and Giacometti meant it to. because he published a text purporting to describe its genesis and hint at the significance of its cryptic iconography.

We are told that *The Palace at 4 a.m.* is related to a period of the artist's life which had come to an end one year earlier, when he passed six entire months hour by hour with a woman who made each instant a marvel for him and with whom he spent every night constructing a fantastic palace of matchsticks, beginning it over and over again as it repeatedly collapsed. During all this time, he writes, he never once saw the sun. The woman in ques-

tion was Denise, but his relationship with her had in fact not ended at all, and he saw the sun regularly. He had not yet begun to work till dawn, as he was to do later. Why a spinal column in a cage should appear in this palace, he declared, he could not say, yet he goes on to associate it with Denise. The skeletal flying creature is no more explicable, though it is "one of those she saw the very night before the morning when our life together collapsed." It is in respect only to the stylized female figure that Alberto was able to be explicit. This was intended to represent his mother as he remembered her from earliest childhood, wearing the long black dress which had upset him because it seemed to be part of her body. The three panels behind her are supposed to depict a brown curtain which the artist claims to recall from infancy. The object in the center, erect and phallic, is also one concerning which it proves impossible to speak plainly. Alberto identified it with himself. In short, we have learned only that he and Denise are symbolically united in this fantasy structure where his mother, being the only specifically represented human figure, presides with serenity over the present and the past. Time and life seem to be suspended like the little pane of glass, fragments of emotion and experience trapped and caged forever. Ambiguity, if not ambivalence, prevails, and that, perhaps, is the troubling point.

Between 1933 and 1934 Giacometti executed two almost-life-size figures strikingly anomalous in comparison to the other sculptures of his Surrealist period. Headless, armless, slenderly stylized, these figures are straightforward representations of a young woman's body. One of them has a shallow, heart-shaped declivity just below the breasts, a singularity which emphasizes the delicate naturalism of the rest. Both figures have the left leg and foot placed slightly in front of the right and stand poised as in barely arrested forward motion. It is the precise, subtle placement of the feet, though they are of normal size, which determines the uncanny animation of these works. Each, indeed, is entitled Walking Woman. By their posture as well as by the power of their presence, they recall the sculptures of ancient Egypt.

The two Walking Women are openly alien to the spirit and purposes of Surrealism. Straightforward representationalism was heresy, and many had been excommunicated for less flagrant lapses. But Breton continued to be indulgent. Though he occasionally complained that Alberto was "undependable," Giacometti continued to participate in the activities of the Surrealist group. An illustration of his readiness to do so may be found in one of his replies to the question asked by Breton in the course of a published dialogue. "What is your studio?" Breton asked. Alberto replied: "It is two feet that walk."

In the month of May 1933 appeared the final issue of Surrealism at the Service of the Revolution. The demise of the movement's evangelical publication may have been a symptom of impending decline. Alberto, who had contributed only a single text to previous issues, at the end contributed four. That fact may also have some terminal significance. Three of these are poems in the orthodox Surrealist mode, which is to say that it would be difficult, if not tendentious, to assign specific meanings. The first two, entitled "Poem in Seven Spaces" and "The Brown Curtain," are short and virtually opaque. The third, "Ember of Grass," is longer and more intelligible. One or two passages will illustrate with what evocative grace and refinement Alberto could write.

"I seek, groping in the void, to catch the invisible white thread of a throbbing marvel from which facts and dreams break out with the sound of a scream upon precious and living pebbles.

"It gives life to life and the gleaming play of needles and turning dice alternately fall and follow each other, and the drop of blood on the milk-white skin, but a strident cry suddenly rises, making the air throb and the white earth tremble." In "Poem in Seven Spaces," one space is given entirely to the phrase "a drop of blood." The image apparently held special significance.

The last text by Giacometti which appeared in the concluding pages of that final issue of the Surrealist review was the invaluable document relating to his earliest memories, entitled "Yesterday, Quicksand." The precision and vividness with which as an adult he describes the events, sensations, and fantasies of childhood might

r

lead one to wonder about their accuracy. The prevailing Freudian atmosphere of the Surrealist movement, moreover, might also prompt some question, because the revelations of the text fairly beg for Freudian interpretation. But the experiences described, and all of their implications, are so demonstrably and evocatively relevant to the nature of the mature Alberto that the issue of their fastidious fidelity to fact is beside the point, since the man, after all, is not the father of the child, and therefore could not counterfeit a credible likeness of himself.

What is apposite and strikingly significant about "Yesterday, Ouicksand" is that the author cannot have failed to grasp the underlying meaning of what he had written. Thus, the text represents an important step forward in his career. To have written and-even more!-to have published it is further evidence that he was increasingly able to live with himself in full view of selfknowledge. But the fruits of self-knowledge, however vital to the growth of an individual, are not necessarily palatable to others. One cannot but wonder how they may have tasted in Stampa, for it is unlikely that such a public affirmation of their son's prominence would have failed to receive his parents' notice. Alberto's memories of the cave, of the black rock, of the burrow in the snow, of the cozy hut in Siberia-all these could have seemed the innocent effusions of a poetic temperament. But what of the detailed fantasy of murder and rape with which the young boy found it necessary to regale himself before falling asleep? Devoted as she may have been to the advancement of her son's career, Annetta Giacometti was not a woman who could have learned with equanimity that her young son had enjoyed such lurid imaginings. As for Giovanni, already convinced that Alberto's Surrealist work was a mistake, this public declaration of a taste for violence and murder, however literary, can hardly have been pleasing.

Giovanni Giacometti was sixty-five years old. Recognized and admired as one of the leading painters of Switzerland, he had come a long way from the hardship and despair of his youth. Maturity had not been accompanied by creative fulfillment of the highest order, but perhaps he was unaware of this. His paint-

ings were widely exhibited and purchased. Maybe that brought satisfaction enough. Besides, he found himself growing tired. He looked older than his age. Prolonged physical effort had become increasingly difficult. A doctor of his acquaintance named Widmer, who had bought a number of his paintings and who owned a sanatorium at Glion in the mountains above Montreux, suggested that the weary artist come there for a rest. Giovanni agreed. A rest, however, was all that seemed necessary. The doctor assured the family that there was no reason to worry. Annetta accompanied her husband to the sanatorium. After a short time, feeling improved, he asked her to go to Maloja and open the house there for the summer.

On the 23rd of June 1933, Giovanni suffered a cerebral hemorrhage and lapsed into a coma. Annetta hurried back at once from Maloja, Bruno from Zurich, Ottilia from Geneva. They arrived at Glion the following day. Though the patient remained unconscious, there appeared to be no immediate danger. Hoping for improvement, the three decided not yet to alert Alberto and Diego.

The next day was a Sunday. Rain was falling on the mountainsides, on the forests, and on the fields around the sanatorium. At the bedside of the sick man, Annetta, her daughter and youngest son waited. As the hours passed, it became clear that Giovanni, who had never regained consciousness, was dying. Bruno notified his brothers in Paris. No such convenience as a telephone existed in their studio, but the message got through. They took the night train from the Gare de Lyon.

Alberto felt unwell as the train rolled eastward toward Switzerland. His malaise was an indefinite feeling of infirmity and fatigue, rather than a specific symptom of illness. He cannot have been in doubt concerning what awaited him in the rainy mountains above Montreux.

Bruno was at the station in the morning. He told his brothers at once that their father had died during the night. Then the three of them drove together up into the mountains. It was still raining. When they arrived at the clinic, they were greeted by Annetta and Ottilia. All five together, the mother, her three sons, and her daughter, went to the room where Giovanni Giacometti, their husband and father, lay dead.

Alberto soon announced that he felt sick, feverish, and would have to go to bed. A nearby room was available and Dr. Widmer came and made an examination. It disclosed that the patient did, indeed, have a fever, though this was due to no discernible infection or assignable malady. Rest seemed to be the only sensible prescription. Alberto remained in bed.

More practical and less emotional than his brothers, Bruno was the one to make arrangements for the removal of their father's body to Stampa, the funeral and burial in the churchyard of San Giorgio at Borgonovo, where Giovanni's own father and many relatives already lay. These arrangements had to take account of considerations beyond the feelings of the family, for the death of Giovanni Giacometti was an event of national importance. Newspapers were prompt to print eulogistic accounts of the artist's career, and his passing was noted as a loss to the cultural life of the country. It was proper to expect that his funeral would be an occasion to express national pride as well as to pay homage to the dead man. The family was notified that a government representative would be present at the ceremony.

While Alberto remained in bed, Bruno went several times to his room to consult him about the arrangements. The older brother would have no part in them. Lying rigidly outstretched under the bedclothes, he did not respond. This apparent refusal to be concerned in an event of major importance to the family was surprising, especially as the eldest son by tradition took the place of the father upon the latter's death. However, Alberto's illness could be assumed to explain his strange behavior.

The following day, the family prepared to leave Glion with Giovanni's remains for the journey back to Bregaglia. Alberto said that he was as yet too ill to travel. The others had no choice but to go on as planned. He would join them as soon as he was physically able. This, it turned out, was not for a number of days. Not until after Giovanni's funeral. So Alberto was not present to honor the artist or make the final gesture of piety as a son. One

cannot but wonder about the nature of the illness which confined him to bed during those critical days, and speculate concerning his thoughts while he lay there alone, separated from the central figures of his life, who were busy performing the rites appropriate to one of its crucial events. The continuity of days had a therapeutic effect. Alberto rejoined his family in Maloja. But he chose not to remain with them for long. His work, he said, required that he return to Paris. What this work may have been, however, we do not know. He produced almost nothing during the remainder of that year. Perhaps he destroyed whatever he did, as he was to destroy almost everything produced during the next decade. Being a man of indefatigable, one might almost say incorrigible, industry, however, it can be assumed he did not remain idle. The work may have been of a kind which produces no tangible result. A radical transformation of Giacometti's creative outlook seems to have begun at this time.

One year after his father's death, he executed a design for Giovanni's tombstone. The decision to make the design was his own. It seems obvious. He was the eldest son, a sculptor. What more natural than for filial gratitude and piety to find expression in a tangible and enduring memorial? The funerary monument is sober, discreet, and impressive. It was carved by Diego, working from his brother's design, out of a block of local granite. Only two feet high, it conveys an extraordinary sense of energy and mass. The front bears the name of the dead artist, and above it are carved in low relief a bird, a chalice, a sun, and a star. A bird with a chalice is the Christian metaphor for the certainty of eternal life; sun and star are age-old symbols of rebirth and permanence. Thus, it would seem that Alberto meant to consecrate his father's memory with an assurance of immortality. To do so would no doubt have seemed appropriate.

The years 1930, 1931, and 1932 had been richly productive, establishing Giacometti as the most authentic Surrealist sculptor.

The first six months of 1933 indicate a weakening of the artist's commitment to Surrealism; and in 1934 he executed but a single sculpture which can be described as Surrealist. So the effective end of Alberto's Surrealist period appears to have come in June 1933. More than a year would pass, though, before a confrontation confirmed what had, in fact, already taken place.

The large sculpture begun in the spring of 1934 was the largest Giacometti had undertaken since the carved monolith for the Noailles' garden and the first he had ever attempted as a representational image of an entire human figure. Even before it was finished, this sculpture fascinated Alberto's Surrealist friends. and in particular André Breton. Haunting, hieratic, arcane, it represents a woman, almost life-size, but not the literal image of a female figure. The legs and torso are slenderly stylized, reminiscent of the two recent Walking Women, the arms tubular, and the hands like attenuated claws held in front of the breasts. The head is stark, staring, open-mouthed, a mask. This mysterious figure is perched upon a high, open-backed chair or throne, the seat of which slopes obliquely forward. Beside her lies the head of a long-beaked bird. The lower legs of the figure are hidden by a small plank which weighs directly upon the feet. Two titles were alternatively used by the artist to designate this sculpture, and their interplay contributes to its esoteric aura. The Invisible Object is one title, Hands Holding the Void the other. Accordingly, the focus of one's attention, and of the sculpture's significance, is placed precisely in the space which separates the raised hands. But the two titles are conceptually contradictory, for the existence of an object, however invisible, precludes the principle of a void. The conceptual contradiction is thus compounded by the metaphysical opposition of being and nothingness. Given the high intellectual acuity of the artist, it is legitimate to assume that the tension of this opposition contributed to the genesis of the work and influenced its expressive purpose. Contemplation has taken the place of revelation. This would account for the woman's haunted stare and totemistic appearance.

Giacometti experienced acute difficulties while executing this sculpture. They were personal as well as aesthetic, symptomatic

of the work's own character as well as of its importance for his life and career. The greatest difficulty, as one might expect, concerned the precise placement of the hands in relation to each other, since the significance of the whole sculpture stems from the evocative power of this relation. The difficulty was compounded by the fact that for some years the need—the compulsion—to discover a perfect placement for various objects in relation to each other had become increasingly pronounced. Nor did this apply solely to elements used in the making of sculpture. For example, there had been a time when Alberto spent sleepless nights because he could no longer decide exactly how to place his shoes and socks after taking them off. This passion for placement extended also to things of less obvious ritual importance.

"In my room," he explained, "I found myself unable to do anything for days on end because I could not discover the exact and satisfying arrangement of the objects on my table. On it, for example, there were a pack of cigarettes, a pencil, a saucer, a pad of paper, a box, etc. The shapes, colors, and volumes of these objects maintained between themselves intimate and precise plastic relations which determined for each one its sole proper placement. The search for this order, either by reflection or by trial and error, was a veritable torment for me. So long as I had not found it, I was as if paralyzed, unable even to leave my room to keep an appointment. Thus, I would move the box to the left side of the table, turn the pad of paper slightly, place the pack of cigarettes at an angle, etc., but that didn't work. I would change the position of the box and it seemed to me that that was better, but then the pad was too near the center. I would push it away, but the saucer all alone became too important. I moved the pencil closer. Was I free? No, for in this imperfect equilibrium there persisted an element of approximation which was intolerable to me. So I would always and tirelessly start over again and spend interminable hours on this disappointing task."

Surrealism had helped Alberto to make personal and aesthetic progress. When it was done, it was done. His nature was too eager, too intransigent to accept the mere continuity of achievement, however distinguished. He grew impatient of the constraints and

compromises, hypocrisies, recriminations, jealousies, and conflicting ambitions common to any utopian movement. A parting of the ways had become inevitable. Even to Giacometti, however, the actual event was difficult to contemplate. Life for him had an ever-renewed but never-ending continuity. No part, no person could be relinquished without diminishing the whole. Almost all of his friends were members of the Surrealist movement. In addition to Breton, they were Max Ernst, Miró, Yves Tanguy, Eluard, and René Crevel—to name only the most notable.

In the autumn of 1934, Alberto was busy with preparations for an exhibition of his sculpture in New York. It had been arranged some time before with an American art dealer named Julien Levy, who specialized in Surrealism and had already exhibited works by other members of the group. Giacometti himself selected the eleven works which were shipped to New York, the earliest being the Gazing Head of 1927, the most recent The Invisible Object-Hands Holding the Void. The exhibitionentitled, a little inaccurately, Abstract Sculpture by Alberto Giacometti-took place in December. The United States, then mired in the adversity of the Great Depression, was in no mood for Surrealism. Though Giacometti's prices were low, nothing sold. On December 9, 1934, the critic of The New York Times wrote: "For five minutes I have stared blankly at my typewriter, trying to think of something to say about the abstract sculpture by Alberto Giacometti at the Julien Levy Gallery. If you want the blunt truth of the matter, Mr. Giacometti's objects, as sculpture, strike me as being unqualifiedly silly."

Sometime during that autumn, Alberto began work on two sculptures markedly different from those he had executed before. Both were heads, seemingly of women, though it is difficult to be sure. Both were sculpted entirely in the round and both were life-size. That seems significant, for they convey a sense of human resemblance struggling to emerge from the matrix of evolving form, the effect of a generic image wrested from a space in which there was no original likeness.

One day Alberto decided to take a model, feeling that it would help him to work from nature for a while. "I knew," he

said later, "that no matter what I did, no matter what I wanted, I would be obliged someday to sit down on a stool in front of a model and try to copy what I saw. Even if there was no hope of succeeding. I dreaded in a way being obliged to come to that, and I knew that it was inevitable . . . I dreaded it, but I hoped for it. Because the non-figurative works I was doing then were finished once and for all. To go on would have been to produce works of the same kind, but all adventure was finished. So that didn't interest me a bit."

He expected that work with the model would take a week, that he would see clearly what he wanted and be able to proceed without difficulty. The expectation was a snare. "After a week I wasn't getting anywhere at all! The figure was much too complicated. I said, 'All right, I'm going to begin by doing a head.' So I began a bust and . . . instead of seeing more and more clearly, I saw less and less clearly, and I continued . . ."

Alberto was never one to make a secret of his thoughts or doings. Word of both soon made the round of the Surrealist group. It was received with consternation. Yves Tanguy said, "He must be insane." Max Ernst sadly concluded that his friend was discarding the best part of himself. André Breton contemptuously declared, "Everybody knows what a head is!" He had been indulgent, had been patient. But even in the case of an intimate friend he was compelled to condemn failures of faith which denied doctrinaire hegemony.

Sometime in the month of December 1934, Benjamin Péret, a young poet and Surrealist zealot, asked Alberto to dine with him and Breton. During the meal, conversation naturally turned to Giacometti's preoccupation with the possibility of sculpting from life a head which would not only be lifelike but embody the artist's visual experience. Breton, and by definition Péret, regarded such an ambition as aesthetically frivolous and historically redundant. No argument, however, could sway Giacometti's resolve, and he had the intellectual authority to defend it. By the time dinner was over, the conversation had become heated. This was just what Péret and Breton had expected, and they had arranged in advance for a group of Surrealist henchmen to witness Gia-

cometti's recalcitrance. George Hugnet, another poet and courtier, was the fellow conspirator at whose home they waited. Alberto suspected nothing when Péret suggested, after leaving the restaurant, that they drop in on Hugnet. The discussion continued en route and had become almost acrimonious by the time they joined the others. In addition to Hugnet and his wife, there were Yves Tanguy, Madame Breton, and two or three more.

Giacometti was not easily intimidated, especially when his ongoing purpose in life was opposed. Attack from another flank therefore became necessary. Breton proclaimed that his work for Jean-Michel Frank was contrary to the spirit of Surrealism, that no true artist would debase his creative powers by devoting them to the production of utilitarian objects. How an artist might make ends meet if his artistic work did not suffice was a problem largely disregarded by Breton, who, incidentally, often made his own ends meet by the discreet sale of works of art, many of which had been gifts from his friends, Alberto among them. Giacometti replied to Breton's charge by asserting that he had attempted to design objects beautiful in themselves which would also add to the comfort and convenience of people's lives. Care for the comfort and convenience of people's lives smacked of bourgeois leanings, blasphemous to the Surrealists, and Breton retorted that the objects-beautiful or not-were luxury items sold to the rich in a fashionable shop. So Giacometti's activity was not only anti-Surrealist but anti-revolutionary, unworthy, and degrading.

This was too much. "Everything I've done till now," Alberto exclaimed, "has been no more than masturbation."

Breton saw at once the threat to himself. Imperiously he replied, "We'll have to clear this up once and for all."

"Don't bother," said Alberto. "I'm going." He went without ceremony. Behind him, he left a room full of former friends and an important period of his life.

From one day to the next, Giacometti found himself a virtual outcast in the Paris he had known and conquered. He had been made much of, honored. Now it was as though some secret shame were suddenly public knowledge. Men who had been his close friends refused to speak to him, turning their backs in the

NB

street. The power of the Surrealist leader was certainly great. This ascendancy, indeed, of one man over the judgment and conduct of others, who happened to be among the most gifted and intelligent of their generation, is astonishing. It illustrates the peculiar phenomenon of group behavior, which even then was assuming horrendous proportions in the two large nations neighboring France, an occurrence violently condemned by the Surrealists.

Giacometti had chosen to follow a solitary path. It went contrary to the dominant direction of the times. To follow it demanded a kind of rage of determination, a will, it might eventually seem, to mortify the spirit and punish the flesh.

Speaking of his Surrealist years, Alberto declared that reality was what he'd been running away from. The Surrealist works, however, exist with an aesthetic and psychic authority which Giacometti himself could neither diminish nor explain away. When one considers such sculptures as The Suspended Ball, The Cage, Point to the Eye, and Woman with Her Throat Cut, it seems curious that the artist should have characterized the work of those years as masturbation. The sexual allusiveness of his early sculpture is pronounced, but we know that for him the sexual act was never a simple matter. Masturbation is in its own way a flight from reality, an acceptance of facility and fantasy. This, apparently, is what Alberto had determined to put behind him.

The Surrealist revolution had failed. No radical change in the conduct of human life had come as a result of it. The exaltation of the irrational had not bettered society. As a matter of fact, the irrational side of human nature was soon to bring about worldwide devastation and tragedy.

The Communists were quick to diagnose the ineffectuality of the Surrealists, and a Soviet confidence man called Ilya Ehrenburg denounced them as fetishists, exhibitionists, and homosexuals. André Breton did not take disparagement lightly. Meeting Ehrenburg in the street, he saw an opportunity to vindicate his honor and struck him in the face. The incident stirred up a hullabaloo. This was especially troubling to René Crevel, who had long aspired to be the agent of reconciliation between friends of differing ideology, and who alone among the Surrealists made them

liable to the sexual slur. Troubled by all this, and by continuing ill health, Crevel went home and swallowed two bottles of sleeping pills, shut himself in his kitchen, and turned on the gas. Before lying down to die, and as a final, rather macabre gesture of Surrealist whimsy, he attached to his big toe a label inscribed René Crevel, so that there would be no mistaking his identity at the morgue.

The suicide of this personable, talented young man was deeply grieving to Giacometti. A particularly affectionate friendship had united them. Crevel had not turned his back on Alberto after the excommunication. He was the one Surrealist whose good humor never failed, whose sincerity went unquestioned, and whose tact often served to resolve misunderstandings. It is a sad, odd coincidence that Alberto's exclusion from the Surrealist group should have followed so closely upon the suicide of one of its most dedicated members and the revelation that the movement itself was also dead.

Three

On the 10th of July 1912, in a modest brick house facing an unpretentious square in East London, a baby girl was born. Her name: Isabel Nicholas. She grew up amid circumstances which could not possibly have led anyone, least of all the girl herself, to suppose that she might become a person of consequence in the cultural history of her time. Her father was an officer in the merchant marine. Prolonged absences at sea made him a semi-stranger to his child, but she was reminded of him by the exotic animals which he brought back from faraway countries and left with his family as pets. When Isabel was twelve, her mother took her to Liverpool, where the father's ship then occasionally put in, and there a brother was born, named Warwick. It was not long afterward that Captain Nicholas died of unknown causes in a remote corner of the world, leaving his widow alone with two children.

Young Isabel grew into a spectacular beauty. Tall, lithe, superbly proportioned, she moved with the agility of a feline predator. Something exotic, suggesting obscure origins, was visible in her full mouth, high cheekbones, and heavy-lidded, slanting eyes, from which shone forth a gaze of exceptional, though remote, intensity. Beauty, however, was not Isabel's sole resource. Added to it was a prodigal exuberance, a fierce, animal confidence in her right to do as she pleased. The zest with which she participated in life seemed to make it for others more exciting and meaningful. Her voice was metallic, almost strident, yet musical in its own way, like music from a strange country played on an unfamiliar instrument, and her laughter was a kind of wild, indomitable

shriek. Then there was something else about her, indefinable, elusive, aloof, which made her fascinating to men.

She attracted attention while still at school in Liverpool. Particularly interested in drawing, for which she showed talent, she was able to obtain a scholarship at the Royal Academy in London. Her mother, meanwhile, had emigrated to Canada, taking along the vounger brother, who later became a biologist and settled in Australia. Isabel found herself alone in London at age eighteen. Life was not easy, and perhaps the strict regimen of study did not appeal to a high-spirited young woman. She decided to leave school, to continue drawing and painting by herself and earn her living as an artist's model. One of her teachers was shocked by this decision, mindful of the scandalous reputations of many female models. He could not have guessed that Isabel would eventually become the model of several of the most important artists of the century. She was not intimidated by the Royal Academician's warning. If anything, it might have been she who was intimidating. She later seemed so to more than one man. Far from being alarmed by the possibility of scandal, it would have been perfectly in character for her to relish the prospect. As a model, she managed to make her way, and the ways of the world would have been strangely awry if an individual of such exceptional parts had not soon met with an opportunity to make the most of them.

Mrs. Jacob Epstein, the wife of the noted sculptor, appears to have had a rare appreciation of the means by which an artist's wife may best accompany him along the tortuous paths of self-expression. For example, she kept on the lookout for beautiful young women who might serve as models for her husband, and if a care for tactile attributes sometimes led the sculptor's hand to stray from the model's effigy to her person, then Margaret Epstein seems to have been prepared to look the other way. It was she who introduced Isabel to her husband. The artist found this new model very much to his liking. She posed for numerous works. One of the last was considered by Epstein to be among his finest creations. Not long after its completion, the sculptor became the father of a son. The newcomer altered Epstein's relations with his model, and he proposed that she go to Paris, where she would

be able to pursue her artistic inclinations in appropriate and pleasurable surroundings. She agreed, departed, and never had anything further to do with Epstein or his family.

Late in September 1934, traveling with two other young women, Isabel arrived in Paris. She and her friends promptly found their way to Montparnasse, where they took a table at the Dôme and prepared to enjoy their first evening abroad. At a nearby table sat a tall young Englishman, the well-known foreign correspondent of the London Express, Sefton Delmer. Intrigued to hear English spoken nearby, he observed the three women. One of them in particular attracted his eve, for it seemed to him that she resembled a sculpture by Jacob Epstein entitled Isabel which had aroused romantic reveries when seen at an exhibition some years before. He stood up and spoke to her. Isabel acknowledged with a shriek of delight that she was indeed the "original" of the sculpture by Epstein, and added that by an extraordinary coincidence she had intended to call Delmer the very next morning, because she had a letter of introduction to him from a mutual friend. Thus encouraged, the foreign correspondent helped the three young women to make their first evening in Paris a merry one.

That chance meeting with the flesh-and-blood Isabel led to others. Romantic reverie led to practical passion, passion to marriage. Mr. and Mrs. Delmer set up housekeeping in a luxurious apartment overlooking the Place Vendôme. The life of the foreign correspondent was agitated, exciting. Isabel sometimes accompanied her husband on his trips abroad, helping him in social and political contacts by her exuberance and charm. However, she did not forget that she had meant to be an artist. She installed a studio off the courtyard of the apartment building, attended classes at the Académie de la Grande-Chaumière, and became a habituée of Montparnasse. Having learned to speak passable French, she could talk, laugh, smoke cigarettes, and drink red wine half the night with tireless verve. Poets, musicians, and painters made much of her. She responded in kind, for she thrived on demonstrations of her power to attract men.

Alberto observed her from a distance. Her beauty, vivacity,

and appeal to men intimidated as well as attracted him. For her part, insofar as she was drawn to men at all by their physical appearance, Isabel would have liked his sturdy looks. In the cafés, where decorum was hardly the rule, they had plenty of opportunity to make acquaintance. But some months passed before Alberto spoke, and even then the acquaintance was very casual. From the first, an appreciation of their relationship entailed a precise perception of the distance between them.

Giacometti had resolved to make a new beginning in his art, resuming work directly from nature. The visual point of departure for this effort must have appeared self-evident. He asked his brother to pose. His first sculpture had been a bust of Diego, executed more than twenty years before with an ease and assurance which at the time had seemed a thrilling demonstration of his ability to do as he pleased with nature. It was that same sense of power and clarity of vision which he wished to recapture now. But the "difficulties" of 1921 and 1925 had intervened, followed by the works of the Surrealist years, of which he said: "I can't repudiate them because it is thanks to them that I was able to begin my work again in a different light." The difference was determined by his discovery that an artist's innermost nature may become the medium of his creative activity. Now he would have to seek a way to fuse subjective, symbolic perception with the immediacy and innocence of a child's vision of nature.

Diego posed each morning for several hours. So began a further, more complex involvement of the younger brother in the life of the older. Having become indispensable as a manual assistant, Diego was now to be committed in perpetuity to the conceptual development of Alberto's work. For thirty years, the metamorphoses of his features came and went as an enduring image of artistic purpose, binding forever in the autonomous products of

the creative act the two Giacomettis.

Every afternoon, while Diego devoted himself to further commissions from Jean-Michel Frank, Alberto worked with a female model named Rita, a small, sharp-nosed young woman

gris?

who lived in the neighborhood. The work with both models went badly from the start.

"The more I looked at the model," he explained, "the more the screen between his reality and mine grew thicker. One starts by seeing the person who poses, but little by little all the possible sculptures of him intervene. The more a real vision of him disappears, the stranger his head becomes. One is no longer sure of his appearance, or of his size, or of anything at all. There were too many sculptures between my model and me. And when there were no more sculptures, there was such a complete stranger that I no longer knew whom I saw or what I was looking at."

Art had become an obstacle in the way of the artist's effort to look at reality and translate his vision into art. From this dilemma there was only one way out. If art prevented him from making a new beginning, then he would have to begin as though art had never existed and see how it might be reinvested with the primitive power of reality perceived as if for the first time. In order to see this, he would, as it were, have to blind himself to the whole history of art. Difficult as this might be, it would be made more so by a further difficulty, compared to which those of the past would seem but a mild foretaste. The underlying assumption of representational art takes for granted that representation is possible. For Giacometti, it seemed not to be. But his failure to achieve what he wanted to achieve did not diminish his desire to achieve it—on the contrary!—and therefore his purpose was not primarily to produce works of art but to demonstrate that the possibility existed.

Day after day, morning and afternoon, Alberto worked at heads of Diego and Rita, always dissatisfied, destroying most of them as he went along. "I just wanted to make ordinary heads," he said. "That never worked out. But since I always failed, I always wanted to make a new attempt. I wanted to be able once and for all to make a head as I saw it. Since I never succeeded, I persevered in the effort." And he did not lose heart. He assured his mother that he took a new step forward each day, adding that he looked forward to the work of the morrow with the same

eagerness and delight he had felt as a child when looking forward to the Christmas tree. And rather like a child who breaks up his toys to see how they are made, Alberto kept on destroying most of his work.

The artist's dissatisfaction was fruitful for him. It produced works of art which are satisfying to others. There is nothing tentative about the few sculptures of this period which have survived. They are evidence of development toward a more and more personal means of representation. The texture is dynamic, the inner structure clear. The problem of vision for Giacometti was to find the style which would most amply and truly embody it. That is the problem, of course, of all art, and it is the cruelest problem of all, for it tests the personal resources of the artist beyond the limit of his capacity. The expression of truth is an effect of style, and that pitiless fact only increases the difficulty of the search for a true style.

Alberto knew this. He once observed: "The truer a work of art is, the more it has a style. Which is strange, because style is not the truth of appearances, and yet the heads which I find most like those of the people one sees in the street are the least realistic heads, the heads of Egyptian, Chinese, or archaic Greek sculpture. For me, the greatest inventiveness leads to the greatest likeness." In the light of such knowledge, it is not surprising that Giacometti was perpetually dissatisfied or that he destroyed his work so willingly.

He continued to see Isabel Delmer, and still from a distance. She had made her way in the art world of Paris. Not as an artist, to be sure, but as a woman of formidable allure. Her adult life had begun under the active influence of an artist, and henceforth she would often find herself intimately involved with creative men. She was never dominated by them, though. If anyone dominated, it was she. A number of the men who knew her well felt her disposition to hold and to control those with whom she was most intimate. Some, as a matter of fact, suspected that the strongest appeal of intimacy for her lay in the possibility of demonstrating yet again—but never too often—her power to draw men to her

and do with them as she pleased. Perhaps that was what made her so attractive to Alberto but, even as it lured him toward her, caused him at first to be so wary.

André Derain was another of the noted artists with whom Isabel became intimate and who executed a number of portraits of her, works outstanding, among those in his vapid later style. for their freshness and feeling. Born in the same year as Jacob Epstein, Derain was also a figure of self-assertive authority. As a young man he became friendly with Matisse and Vlaminck and was one of the iconoclastic innovators of the Fauve style. This period of violent, admirable originality was short-lived. By the twenties, the "wild beast" of 1905 had been tamed, was turning out chic landscapes, still lifes, and nudes, and had become a fashionable success. By 1935, almost all serious critics, and many artists as well, felt that Derain had failed to fulfill his promise and that his recent work was lifeless and imitative. As a result he began to withdraw from social life and to live and work at his country estate. He was in no sense a recluse, however. He enjoyed the company of beautiful women like Isabel Delmer, who were ready to pose for him, while a group of serious younger artists looked up to him as a model of creative constancy. Foremost among these was Giacometti.

Alberto's admiration and friendship for Derain date from the time when he determined to resume work directly from nature. The senior artist was surely in part a symbolic figure for the younger, and to some extent in this sense he may have replaced André Breton in Alberto's life. Neither admiration nor identification, however, could cloud Giacometti's clarity of vision. He knew perfectly well that Derain's late work was almost all bad, and that even in his best pictures there was, as he said, "always something that grates." In fact, it was what grated most that he liked best, for the pictures he claimed especially to admire were the least successful, those in which the borrowing from mediocre works of the past was most overt. What he cherished in Derain's activity as an artist must have been precisely that it failed, and what he admired, the passion with which Derain embraced that failure.

Fauer

It was not all gloom and despair. Plenty of spirited talk and a lot of good times were enjoyed by Derain and his young artist friends. He was an accomplished raconteur, and one of the anecdotes he repeatedly told to great effect concerned his marriage. As a young man he and Georges Braque had been close friends. Both were living with women whom they had not married but who hungered for matrimony and urged their lovers to wed them. Consenting at last, the two artists decided to have a double ceremony. On the appointed day, as the two couples prepared to leave Derain's studio, his bride-to-be suddenly declared that she must have a new pair of shoes, as the old ones were too shabby. Derain replied, "Oh, Alice, that's not necessary. In a crowd, nobody will notice your shoes." Alberto especially relished that story. Every time Derain told it, he laughed uproariously, and said, "That's perfectly true. Nobody notices shoes. They're not important."

Of the young artists who surrounded Derain toward the end of his life, the most interesting and promising after Alberto was a painter of Polish extraction who called himself Balthus. His real name was Michel Balthasar Klossowski, but he had preferred to retain as the adult appellation of his artistic career the nickname he had been given as a child. Other mutations of identity were to follow. The Klossowskis were a family of the minor aristocracy who had emigrated to France in the mid-nineteenth century, and both parents were painters, working with distinction in the Impressionist style. Their son grew up in an atmosphere congenial to artistic gifts and also, it would seem, to reverie. He later said of himself: "When I was young, I always felt like a little prince."

By the age of twenty-five, Balthus had been recognized in Paris as an artist of exceptional gifts. Pierre Loeb gave him a one-man exhibition, and the Surrealists bestowed their approval. His work was resolutely representational. It remained so, evolving very little either in subject matter or in style during the decades to come. His preferred subjects, portrayed with obsessive diligence, were pubescent young girls, often nude, and sometimes in situations of overt eroticism from which an element of the sadistic is not absent. An eerie stillness pervades all of Balthus's paintings.

The figures in them seem to exist outside of time, outside of everyday reality. One can understand that the Surrealists found him intriguing.

Balthus, however, was not interested in joining the Surrealist group. By nature haughty, rather morose, he was a loner who made an aristocratic principle of his determination to go his own way. He was essentially alone in his private life, too, because the objects of intimate longing portraved so lovingly in his paintings were incapable of fully developed adult relationships. Slender and handsome, he conceived of himself as a personage like Heathcliff, the proud, brooding hero of Wuthering Heights, who was encouraged to frame high notions of his birth in order to compensate for its obscurity. Balthus, indeed, made a series of illustrations for the novel, in which he depicted himself as the melancholy Heathcliff. He was a full-fledged Romantic in the spirit of Lord Byron, to whom, as luck would have it, he maintained that by some farfetched familial coincidence he was related. Unfortunately, he had no title, no fortune, and no fame. By dint of indefatigable diligence, he would eventually contrive to gain all three.

The title came easily. Though without legitimate claim, the artist superbly announced himself to be none other than Count Balthasar Klossowski de Rola, Balthus's artist friends sneered at him behind his back, while authentic aristocrats like the Noailles could afford to smile indulgently. But snobbery is no adequate explanation for such an overt idiosyncracy on the part of a man so sensitive and subtle. The aristocratic pose did not signify vulgarity of spirit. Aristocracy seems to have represented for Balthus a rather austere distinction of personal bearing, one which he apparently felt he could not achieve solely through his art. If it was necessary to his creative fulfillment to be a count, the necessity sprang from a determination to live and work according to criteria no longer instrumental in the modern world and which, therefore, Balthus could not hope to satisfy either as a man or as an artist. His fantasy fed upon itself with such an appetite that it inevitably became self-consuming.

His paintings from the outset showed a decisive affinity, a potent and irresistible nostalgia, for the art of the past. Remini-

scences of long-dead artists abound. Piero della Francesca, Velázquez, Seurat, and above all Courbet are unmistakably the models to whom Balthus referred when conceiving his own works. His sources of inspiration were of the highest, but they compel one to judge the outcome with a severity from which it suffers. Giacometti often spoke with asperity of Balthus's "Velázquez complex." But Balthus was able to relate himself to tradition through the power of an obsessive, almost perverse relation to his subject matter, the passionate detachment with which he depicted young girls, and even landscapes, as elements of a fantasy world. It is the uncanny, haunting vividness of this world which saves Balthus as a contemporary artist from the drawbacks of his preoccupation with the past.

Balthus soon became, and remained, the artist to whom Alberto was most bound in friendship and in a mutual commitment to aesthetic purposes opposed to contemporary taste. Yet the two were very different as artists and very, very different as men. Alberto had turned to the art of the past in order to seek a way into the future, whereas Balthus immersed himself in the past for its own sake. Alberto was preeminently a man of his time, responsive to its philosophical, political, and cultural climate, whereas Balthus had little use for the present. Alberto desired to live and work in circumstances of austere simplicity, whereas Balthus yearned for pomp. Alberto once said, "I want to live in such a way that if I became destitute tomorrow it would change nothing for me." Balthus said, "I have a greater need for a château than a workman has for a loaf of bread." Alberto wanted to be left alone to pursue his work as best he could, convinced in advance that his best would probably turn out to be evidence of failure. Balthus desired not only the homage due to a successful artist but also the deference due to an accredited aristocrat. Alberto endeavored in his most intimate relationships to live up to a high standard of human responsibility, though he could hardly help using those close to him, as he used himself, to serve his art. Balthus used the persons closest to him as the fantasy objects they clearly appeared to be in his paintings.

Considering such differences between the two men, one can-

not help asking what inspired their fast friendship. It began with the admiration of a young, unproved artist for an older one who had already shown his worth. It continued with ambivalence on both sides for thirty years. Many people believed that Balthus was envious of Alberto's talent, integrity, and intelligence, and felt impelled, as impressionable young men often are, to cultivate what he could not emulate. Part of Alberto's distinction was his uncompromising respect for the individuality of others, and that precluded his turning away from those who sought his company and friendship. But it did not blind him to flaws or keep him from forming judgments. Giacometti had no trouble holding two opposing ideas in his mind at the same time and retaining his ability to function. He disapproved of Balthus as a person but enjoyed his company. He did not admire his work but was sincere in his esteem for the artistic resolve which engendered it. This esteem was well deserved. Balthus was no less intractable, and no less courageous, than Alberto in his determination to defy the contemporary distaste for living forms and living beings as objects of aesthetic attention. The same standard of integrity prevailed for both. It would have drawn them together, even if nothing else had. But each man in his own way was also contradictory and perverse enough to enjoy what was perverse and contradictory in the enduring ups and downs of their friendship.

Giacometti and Balthus, though by far the most original, were not the only younger artists committed to direct representation of nature. They formed something of a group, though their styles and aims were quite different. Alberto, being the oldest, the most talented, was its center. The others, in addition to Balthus, were principally Francis Gruber, Pierre Tal Coat, Francis Tailleux, and Jean Hélion.

Son of a well-known designer of stained-glass windows, Francis Gruber was born in 1912. An artistic vocation declared itself early and was encouraged by his father. The Giacometti brothers were close neighbors, and Alberto became the principal influence on Gruber's work until the artist's early death from tuberculosis. In both purpose and outcome, however, the art of the two men was quite different. Gruber's paintings reflect the

melancholy but defiant attitude toward life of an artist who must have sensed that he had not very long to live. The draftsmanship is expert but cold, showing a care for virtuosity as an end in itself. Color relationships are stark and harsh. The search for style led to a rigid and somewhat empty stylization, with a corresponding limitation of expressive content. Gaunt, almost emaciated figures in awkward postures are seen in cheerless surroundings. It is neither a happy nor a profound view of the world.

Tal Coat, Tailleux, and Hélion, lesser talents, lesser personalities, added to the group principally by adding to its number. They were sincere and dedicated artists, each with an individuality of his own, but it was their role and their fate to be the minor figures who helped create an environment favorable to the achievements of a major one. If Giacometti dominated the little group, it was not from a desire for ascendancy but simply because genius confers dominion, and all concerned, including the genius, must make the best of it.

In those anxious years before the war, Giacometti preached purity of vision and primacy of nature. A zealous champion of his beliefs, he exhorted his friends to look with passion and to see without preconception. Balthus once said of him: "Alberto could look at his teacup and see it forever as if for the first time." It is that ability which drives an artist to try to reproduce what he actually sees rather than what he knows to be before his eyes.

For all his aesthetic preoccupations, Alberto was not blind to the dangerous drift of events in the world around him. "If only one could be left in peace for a few more years to do one's work," he said. It was not to be. Fascist Italy attacked and conquered Ethiopia. Hitler defied his neighbors by remilitarizing the Rhineland. The Spanish Civil War began. The story of European civilization was not headed toward a happy ending. Art, it seemed, was destined to become the orphan of history, seeking confirmation of its necessity and value in the efforts of the isolated individual. Giacometti was the archetype of that individual.

A pretty young woman could make her living in Montparnasse without a specific occupation. She could encourage the clients in a bar to do a bit more drinking, or strike up acquaintance with potential admirers who might be glad to give a girl a helping hand without expecting much more than a handshake in return. An easygoing, senseless sort of life. One of the girls who lived that way in the mid-thirties was called Nelly.

Diego met her at the Café du Dôme. He was about the same age as the century, handsome, experienced; she was only nineteen, but self-sufficient and beautiful. They were attracted to each other, and one may suppose that an affair began soon after they met. He asked her to come and live with him in the rue d'Alésia, though he called the place a hovel. Not quite that bad, yet it was certainly not the kind of place young couples usually dream about to set up housekeeping. But the housekeeping dream of most young couples had nothing in common with the expectations or desires of Diego and Nelly, for she turned out to be quite as casual as he was about bourgeois comforts, both moral and material.

She was not a girl like the others. Strangely apathetic, it sometimes seemed that she was immune to most of the emotions which ordinarily determine people's lives. She was fond of animals, even of insects, but rather indifferent to humans. A little while after moving into the rue d'Alésia, she made a confession. It was all the more surprising—and unpleasant—for having been delayed rather longer than its importance could conveniently explain. She had a child, a baby boy, at present in the care of an aunt in the suburbs. Who the father had been remained obscure

and was probably irrelevant. Though Diego can have had no illusions about Nelly's innocence, and may have been attracted to her in part for that reason, he had hardly expected to find himself a man with a family because he had asked a girl to live with him. The prospect was not appealing. Still, he wanted to do the right thing and knew that a child should not be separated from its mother. He proposed that the boy be brought to Paris. Nelly was, if possible, less interested in playing the role of mother, albeit to her own child, than Diego in playing the role of father. But they tried it for a time. The experiment did not work. Nelly had no patience with infantile behavior; she tied the baby to the top of a table in an effort to keep him out of trouble. Before long, he was sent back to the suburbs.

After the pseudo-parental interlude, Diego and Nelly continued to live together as before, but their lives remained strangely separate. Diego's daily existence was entirely occupied by his work with Alberto. Nelly can never have had any inkling of what that was all about, and her visits to the rue Hippolyte-Maindron were rare. Diego seemed to feel that, for social purposes, a woman's place was in the home, however humble, and Nelly was apparently willing to stay there. They almost never went together to a café, to the movies, to a restaurant. Many friends of both Alberto and Diego remained for years unaware of Nelly's existence. Still, Diego had occasion to complain of her apathy. He tried to persuade her to work, even found prospective employment for her in the Guerlain perfume shop. But Nelly declared that she would never consent to do anything so bourgeois. Though that argument might well have won his sympathy in other circumstances, Diego was annoyed. In a peculiar way, he was something of a misogynist. He enjoyed women but could not help finding them irritating. "There's always something the matter with them," he would say. Still, he and Nelly cared for each other. They even contemplated marriage.

No such step, however, could conceivably have been made without taking account of Stampa. Diego went about this with characteristic circumspection. He knew his mother's stern view of morality. Before risking an introduction, he wrote a letter in which he enclosed a photograph of Nelly. One may surmise that he made no mention of maternity. Annetta Giacometti was not one to mince words when it came to the conduct of her sons' lives. She wrote to Alberto: "That is not the sort of woman I could approve of."

Diego never married. Despite his raffish past and indifference to appearances, nothing meant more to him than his mother's approval. All the same, he would live with Nelly for twenty years.

Alberto was now the only one of the Giacometti children who had not yet found someone with whom to settle down and share his life. To settle down, of course, was the very last thing he meant to do. As for sharing his life, he knew only too well that it was not really his to share. He and Denise had drifted apart. And yet he had hopes of a kind. For the moment they were turned toward Isabel Delmer. The sculptor and the journalist's wife had gradually become better acquainted. There was no lack of opportunity. The metallic shriek of her laughter had become familiar in the cafés of Montparnasse and at artistic parties on Left Bank and Right. Sustained by plenty of drink, she easily held her own with the most spirited companions. Admirers were numerous. She welcomed them. If her husband was often called away to report on ever more alarming crises, Isabel did not lack for persons anxious to entertain her in his absence. Lots of lively gatherings took place in the luxurious apartment. Actresses and aristocrats mingled with ballet dancers and police inspectors. Giacometti was often present, adding largely to the fun, for he always knew how to make people laugh and could see the comic inside the dramatic.

Isabel was pleased by Alberto's interest. A shrewd judge of male potential, she realized that the artist's attention might offer significant gratifications while never inhibiting her prerogative to behave as she pleased. Though not herself a true artist, Isabel instinctively understood a great deal about men who were.

For his part, Alberto seems to have grasped very soon that Isabel might represent not only the tangible person, who could be touched and desired, but also an idol, to be adulated and adored from a distance. This may have lent enchantment; it also made for safety. She was the first woman to present Alberto with an authentic challenge. Part of her spell may have come from the sense that she could compel him—not by caprice but by her very nature—to expose himself completely to contingent aspects of experience.

One evening in 1937 at midnight, Alberto happened to be on the Boulevard Saint-Michel. Isabel also was there but stood at a distance. His impression of her identity was exceptionally powerful, with buildings beyond and an immensity of darkness above. It may have been determined in part by the state of relations between them at the time. She was the most important person in his emotional life, but her importance had not been affirmed by any act or commitment. He never knew quite where he stood. She went her own way, lived her own life, did not take account of his desires. These, on the other hand, may not have been made explicit. If he did not know where he stood with Isabel, he did not know quite where he meant to stand, either. He, too, went his own way and lived his own life, a fact which he was too honestand perhaps too perverse—to conceal. He made it a point to let Isabel know that there were other women, though he maintained that they were no more than "shadows." So both contributed to the distance which characterized their relationship. It must have seemed at times that the distance and the relationship were the same thing.

An approximation of intimacy nonetheless prevailed. It was confirmed in the most fitting way: Alberto sculpted two portraits of her—the first in 1936, the second two years later. Both were characteristic of the working style of the moment, and neither appears to have caused difficulty. But they are very unalike.

The first is sometimes called *The Egyptian*, because its smoothly modeled features, purity of line, dynamic interaction of forms, and lifelike immediacy are all reminiscent of Egyptian portraiture. A pleasing but forceful likeness, it appears to have been executed with ease, as if to show what authority the artist could command if he chose simply to reproduce what his mind knew to be before his eyes. The second portrait is something else altogether. No sign of ease. The likeness of the model has vanished.

In its place is the evidence of a prolonged struggle with looking. A victorious struggle, since â work of art is the outcome. The sculptural surface is roughly textured, granulated, striated; it gives a sense of matter on the verge of animation, almost aquiver, of the artist striving to maintain the integrity of his act. The model's likeness merges with the work of art as a conjecture concerning the riddle of human appearances; the portrait is like her but does not look like her; her gaze and expression are inscrutable.

The heads of Diego and Rita which Giacometti was sculpting at the same time as this second portrait of Isabel are akin to it in treatment and effect. All these sculptures, few of which survive, were important steps toward the development of a visual self-discipline capable of infinite persistence and infinite renewal. For that reason, they are satisfying as works of art. For the same reason, they were for the artist dissatisfying evidence of his inability to create a sculptural equivalent of what he saw.

Since he had begun to feel that he might never succeed in sculpting a head to his satisfaction, Alberto decided to try making a complete figure. Working directly in plaster, he started with a figure about eighteen inches high, representing a nude woman standing with her arms at her sides. As he worked, he found to his amazement, and to his consternation, that the sculpture grew smaller and smaller. The smaller it grew, the more troubled he became; yet he could not keep it from shrinking. The sculpture itself seemed to have determined in advance its appropriate size, would accept no other, and compelled the sculptor to comply. After several months of work, the figure had shrunk to the size of a pin, standing in precarious isolation upon a pedestal several times its own height. Those dimensions were intolerable to the artist, but the likeness he sought seemed somehow attached to the tiny size of the sculpture.

Bewildered, alarmed, he began again with a figure the same size as the first. Again it shrank while he worked on it, growing smaller and smaller despite his reluctance and distaste, finally ending as tiny as the first. Again he began. Again the outcome was the same. However, he could not stop. Sometimes the figure grew so

minuscule that a last touch of the sculptor's knife would send it crumbling into dust. He was working at the limit of being and on the frontier of non-being, confronted with the sudden passing of existence into nonexistence, a transition which took place in his hands but over which he had no control. For twenty years, he had been obsessed with life's frailty. Now it presided over his work. In a very real sense, it *became* his work. "I always have the impression or the feeling," he said, "of the frailty of living beings, as if at any moment it took a fantastic energy for them to remain standing, always threatened by collapse. And it is in their frailty that my sculptures are likenesses." It is fitting that very few of those tiny figurines survived. Their impermanence was their importance.

Giacometti had wanted to renew his vision, to see with original freshness what stood before him. He had not foreseen that the creations which embodied his vision would be symbols of regeneration. The sculptor's problem had become anthropological. Having determined to make a new beginning in his art by trying to work as though art had never existed, he made works which evoke the origins of creativity, its mysteries and rites. The tiny sculptures have something of the talisman, charged with anthropomorphic vitality and magical feeling. So they ask to be seen as inhabitants both of actual space, the space of the knowable and the living, and of metaphysical space, the space of the unknowable and the dead.

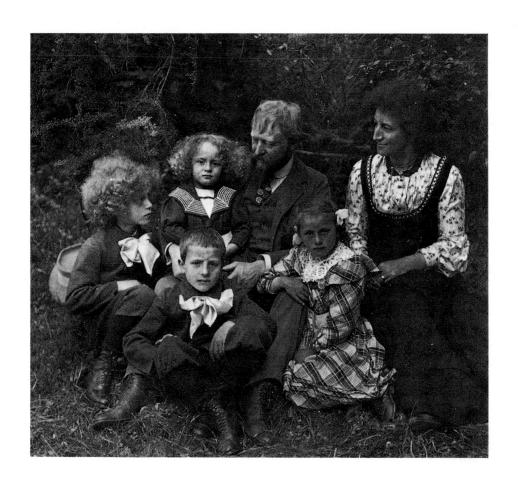

The Giacometti family in 1911; Alberto, Bruno, Giovanni, Annetta, Ottilia, Diego (clockwise from left)

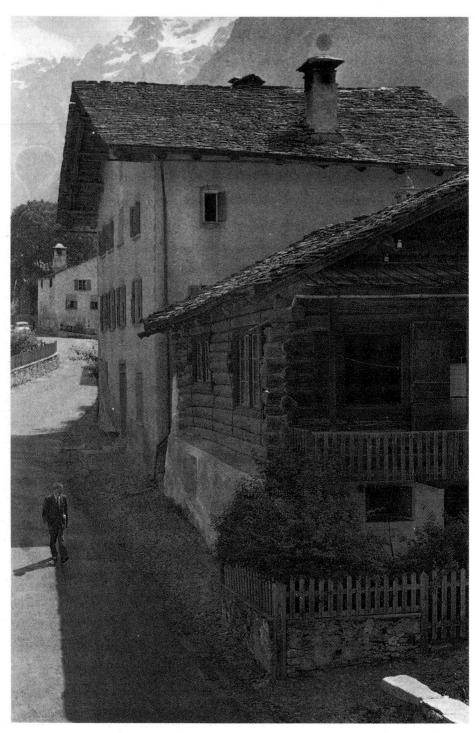

The Giacometti studio and residence in Stampa (Ernst Scheidegger)

Alberto in Rome

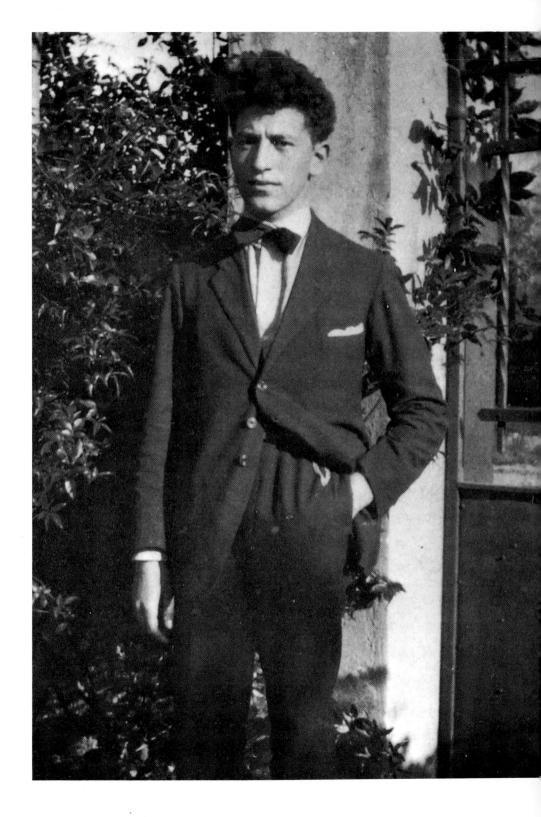

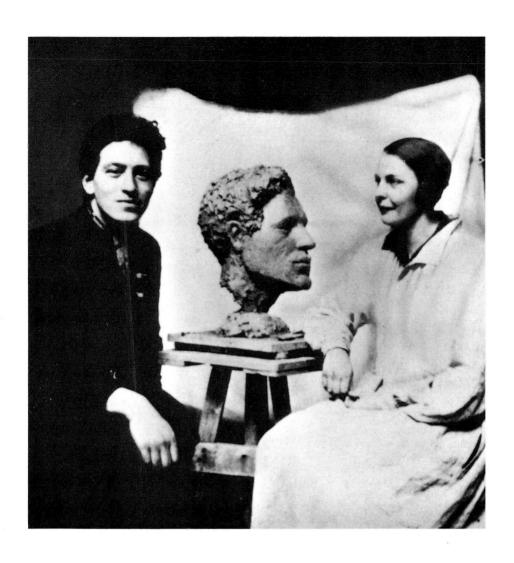

Alberto and Flora in 1927, with her bust of him (Flora Mayo)

The studio complex in the rue Hippolyte-Maindron (Sabine Weiss)

Isabel Nicholas (Isabel Rawsthorne)

The passageway outside Giacometti's studio in Paris (entrance at left). (Jean-Régis Roustan, L'Express)

Pierre Matisse, having fled from marital misadventure in France, had done well as an art dealer in New York. He had given up hope of becoming an artist himself, but he became creative in his own way by recognizing the creativity of other men and giving them the opportunity to experience an important aspect of its fulfillment. Cautious, secretive, parsimonious, Pierre was not a person prone to openhanded or warm relations with other people—in this, rather like his father. Still, he had beautiful manners and a suave charm which could be mistaken for companionable warmth by casual arquaintances. He was without close friends. However, he had a passionate care for art, for the art particularly of his own time. He had the courage and resolve to devote himself wholly to the vindication of his taste, and he believed with fierce conviction in the value of doing so. Thus, he served the interests not only of his ambition but also of great talent and great achievement, and rendered an outstanding service to the culture of his time.

Pierre's approach to Giacometti and his work was tentative, unhurried. He was perfectly aware of what went on in the Paris art world, knew both Pierre Loeb and Pierre Colle, and by 1935 had become the American representative of Miró, Yves Tanguy, and Balthus, all of whom were Alberto's friends. He was well acquainted with Giacometti's sculptures, having seen them not only in Paris but at the Julien Levy exhibition in New York. It was not, however, until the autumn of 1936 that he began to think about buying. The piece he selected was a Walking Woman of 1933–34 in plaster, the more naturalistic of the two. This was a significant choice, for, of all the early works, it suggests most clearly what was to come. The mysterious aura of its presence, the uncanny sense of

forward motion, and the haunting evocation of ritual objects of the remote past all relate to the works created by Giacometti during the last twenty years of his life.

The artist was pleased by the dealer's choice. Neither can have foreseen what was to come of it for them both, because it came only after years spent under the constant threat of failure. Still, the purchase seemed to augur well. "This statue is not at the end of its career," Alberto announced. Nor, to say the least, was he. In fact, he stood at the outset of his great adventure, and Pierre Matisse was to play an important part in it.

On April 26, 1937, German and Italian planes flying for the Fascist forces of General Franco attacked and destroyed a Basque town called Guernica. This atrocity, together with the failure of the Western democracies to denounce it for what it was, brought the coming catastrophe a good deal closer. Alberto foresaw it, and the constant talk of war made him nervous. One night he dreamed that hostilities had broken out, that he had been called to arms and thought of deserting because he was so afraid of bullets. But he was even more afraid of being thought a coward. "I can't imagine anything more terrible than going off with a rifle on my shoulder," he said. He need not have worried.

The atrocity of Guernica roused the fury of Picasso, who im-

mediately began making sketches for the enormous painting that he would complete in just five weeks. Picasso was already the most famous living artist in the world. Giacometti had met him while still a member of the Surrealist group. The two were impressed by each other. Few men of any period can have been more impressive than they were. Perhaps for that reason, their friendship got off to a slow start. Giacometti, in any case, was incapable of the kind of fawning admiration to which Picasso became increasingly susceptible as he grew older. At an exhibition of Picasso's recent works, he had pointedly neglected to compliment the artist, who was present, and later commented: "So he sees that everyone is not on his knees before him." Maybe Picasso admired the self-reliance of those who

would not kowtow, or craved the company of men whom he recognized as peers. By the time he had started work on Guernica,

Giacometti was one of the few welcomed to his studio in the rue des Grands-Augustins to observe the progress of the huge painting. Before it was finished, Picasso made a public declaration of solidarity with the Republican forces fighting in Spain. Among other things, he said, "My whole life as an artist has been nothing more than a continuous struggle against reaction and the death of art." In fact, the struggle was far deeper and more terrible than that.

Picasso was twenty years older than Giacometti. His career had been a prodigious success from the beginning. In later life, when he was world famous, he used to say he had known true fame only as a young man in Montmartre, where the habitués of his favorite café invariably rose to salute him as he entered. Thirty years later, he had grown accustomed to the homage of aristocrats and men of state, poets, beautiful women, and many other artists. He found his vitality stimulated by the comings and goings of admirers who vied with one another to enjoy his company. "They recharge my batteries," he said. It amused him to see how their admiration might be used to manipulate them. The effects were frankly dramatic, and he knew it. "Sometimes," he observed, "even my best friends don't get past the box office." One may wonder whether he paused now and then—when the box office was closed—to ponder the pitfalls of identity which the greatest roles present to great performers.

Picasso's private life, which eventually became more public than that of a movie actor, was less successful than his career as the richest, most famous artist of all time. The abrupt changes of style and violent about-faces of his art were accompanied by equally radical vicissitudes of personal experience. He had many mistresses, but all his relationships with women were profoundly troubled. As with his friends, he was wont to play them off against one another. At the time when he was painting *Guernica*, he permitted the mistress of the moment, Dora Maar, and a former one, Marie-Thérèse Walter, to engage in a fistfight in his studio, while he peacefully continued to work on the enormous canvas conceived to decry the horrors of human conflict. In Picasso's nature, the urge to create seems to have been inseparable from a will to destroy. "Every act of creation is first of all an act of destruction," he said. But he was probably thinking only of art.

That the real friendship between Giacometti and Picasso began at the time of Guernica is appropriate. Picasso's work and life in many ways reached their zenith during this period. Judgments may vary as to the relative importance of his large compositions, but none can contest that after Guernica he never painted another that came close to it in power or originality. It was executed almost exactly at the midpoint of his career; everything that came before may be seen as gradually building toward it, everything that came after as a gradual decline. By its formal inventiveness, its aesthetic dynamism, its moral and cultural implications, its dramatic imagery and symbolism, its overpowering emotion, and by its very size, this one work seems like no other to have engaged Picasso's whole being as an artist, as a Spaniard, and as a mortal man.

While Guernica was creating sensation and controversy, Giacometti was considering the progress of his own work. Two years had passed since his withdrawal from the Surrealist group. He had labored hard to model from life a head which would be convincingly lifelike; he had begun the series of figures in plaster which, to his consternation, became tinier and tinier as he worked on them. Nothing satisfied him. The impotence so often experienced in intimate relationships seemed to have become a condition of creative life as well. Anxiety ensued. His mother grew worried. Annetta felt herself concerned, as she had good cause to be. But Alberto was at the same time secure in the possession of a strength which nature herself could not allow him to doubt, and even less to question.

He assured his mother that he knew very well where he was going, which road was his, and that every day he advanced a little. He knew what he wanted to do for years to come, he told her. It was no use trying to arrive quickly; that, on the contrary, would be a way of remaining at a standstill. One could only advance step by step. But inevitably he would arrive where he wanted to go. It no longer depended on him, he declared, but on the years he had ahead of him. His craft happened to be one which was more than difficult, and that, he explained, is why there are so few sculptors. But above all one must not shirk any of the difficulties, because those would be just the ones liable to catch up with you later. What could you do?

It was like war. But, he concluded by way of setting things straight once and for all, he couldn't help being right.

As if to prove that he knew what he was talking about, and that he had no reason to be shy about being right, Giacometti painted two pictures in the summer of 1937. Both masterpieces, they may be seen as demonstrations of progress toward a resolution of the difficulties he had set himself as a sculptor. Very different, yet in their differences expressing an aesthetic unity, they are also masterly examples of two time-honored modes of Western painting. One is a portrait of the artist's mother; the other, a still life representing a single apple placed on a sideboard in the family dining room at Maloja. Both are conceived and executed in the straightforward representational idiom which had been in disfavor, if not discredit, for a full generation, and which no artist since Cézanne had been able to infuse with the renewed vitality of an original vision. Giacometti succeeded in doing so. His success proved that it was still possible to work with spirited originality in the context of a tradition which had seemed exhausted. As evidence of cultural continuity, this came at a desperately appropriate time.

Apple on a Sideboard is a work deceptively simple in appearance. It shows a single yellow apple posed on a wooden sideboard which stands against wainscoting similar in color, while above the wainscoting is a strip of bare wall of the same hue as the apple. That one spherical form, which occupies but a four-hundredth part of the pictorial area, focuses attention on its solitary presence. It alone is specifically depicted, it alone determines the structure of environing space, and it alone confers upon the whole its complex texture of meanings.

Giacometti was too honest and lucid an artist to have been unaware of the implications inherent in his choice of subject matter. He had begun the picture with several apples on the surface of the sideboard, but soon saw, as he said, "There was more than enough to do with one." He had good reason to be intimidated. The apple as a subject of still-life painting had become a mythic symbol in the art of Cézanne, who painted more than a hundred compositions in which apples appear and who declared that he wanted to astonish Paris with an apple. The astonishment turned out to be worldwide

and changed the history of Western art. But Cézanne never painted a still life consisting of a single apple. In Giacometti's painting, the perfect solitude of that one apple enhances its appleness, calling to mind other mythic, erotic, ethical, and metaphysical associations, of which the artist cannot have been unaware.

Apple on a Sideboard does not resemble a painting by Cézanne. The evocation of the father figure of twentieth-century art is nevertheless clear. Giacometti had been striving for two years to look at nature as if art had not existed, to see reality with an eye innocent of preconception. Cézanne had also expressed the wish to paint nature as if no one had ever painted it before. But no man can see the world now as it appeared to Adam in the light of the first morning, an artist least of all. It is yet another paradox of his calling that in order to see nature as if art had never existed, he must have such a disciplined and comprehensive knowledge of art that it becomes second nature to him, can consequently be "forgotten" and thus fructify the search for a personal style by which to render his own sense of visual experience. This search became Giacometti's style itself. We can see it fully for the first time in Apple on a Sideboard. The apple alone is delineated. The sideboard, wainscoting, and wall are not. The artist has left clearly visible traces of his repeated attempts to define their forms. His hesitations, rectifications, reexaminations, and amplifications are made part of the visual product and of the experience of which that product is both origin and outcome. The quest for form is a ceaseless questioning of form.

The apple in Giacometti's painting is bathed in the space which its presence creates. For five centuries the suggestion of space by means of artificial perspective had been central to the evolution of Western art. Pictorial space was meant to be an imitation of real space, and the quality of the work of art depended on the effectiveness of the illusion. Cézanne appeared to be the last artist for whom this interdependence was possible. He said: "There are two things in the painter, the eye and the mind; each of them should aid the other. It is necessary to work at their mutual development, in the eye by looking at nature, in the mind by the logic of organized sensation which provides the means of expression." Giacometti was to labor at that mutual development for the rest of his days, and by

doing so he became the truest heir of the intimidating father figure of twentieth-century art.

Portrait of the Artist's Mother is not so explicit in its evocation of Cézanne's legacy, because the human presence overshadows the aesthetic. Yet it cannot be by chance that the apple which so openly evokes the paternity of Cézanne was painted at the same time as the portrait which more powerfully than any other conveys the indomitable character and imposing personality of Annetta Giacometti. The strong-minded matriarch sits squarely before us, a figure larger than life. Clothed in black, stocky, white-haired, she gazes outward with composure. The entire painting is concentrated in her gaze, which is powerfully expressed but hardly defined. The expression flows from the ambiguous interaction of lines and shapes, themselves meaningless but invested with such force that ambiguity is replaced by vitality. This is the same searching, probing, hesitant, repetitive style of Apple on a Sideboard, and one may speculate that it was affected by the experience of the sculptor who had lately found the image in his hands taking form as if by a will of its own.

Far from experiencing "difficulty" with this portrait, Giacometti seems, on the contrary, to have used it, so to speak, as a means of developing the style which, though it required great concentration, liberated his expressive powers and allowed him to make a direct response to the personality of his model. A change had occurred. It was part of the all-embracing change that came with the end of the Surrealist experience. Annetta in person may not have been the monumental, awe-inspiring figure her son portrayed. But perhaps she was pleased by evidence that he saw her so.

Changes had occurred in her life, too, since the death of Giovanni. He left no will, but the Giacometti family was not given to disagreements over money matters. The estate was amicably divided, almost all of it going to Annetta. She found herself in comfortable circumstances, for Giovanni's paintings continued to sell, slowly but steadily increasing in price. So she was able when necessary to go on helping her eldest son, which undoubtedly gave pleasure to both, and she continued to mother him, as always, when he arrived at Stampa or Maloja, washing his hair, brushing his clothes, darning his socks. She never gave up trying to get him to

be more neat and orderly and to keep more regular hours. At mealtimes he always had to be summoned with special insistence from the studio. "Alberto, come and eat," she would call. "Come eat, Alberto!"

Annetta was not a person to dwell with melancholy on the past. Soon after her husband's death, she moved out of the large bedroom which she and Giovanni had always shared and took the smaller one on the other side of the living room. The bedroom of his parents now became Alberto's. Though never to be a father himself, he was head of the family, and he slept in the big bed with the carved headboard, the one in which he had been conceived.

The summer of 1937 was a time not only of important work for Alberto but of rejoicing in the Giacometti family. Ottilia was pregnant at last. Though content in her marriage, she had not enjoyed life in dour Geneva and had longed for a child. Alberto was especially pleased at the prospect of becoming an uncle. On vacation in Maloja, he delighted in pressing his ear to his sister's belly, crying, "I can hear it! I can hear it!" The harbinger he seemed to hear, however, did not turn out to be joyful.

As the time for the child's birth approached, it became apparent that delivery might be difficult. The doctor in attendance suggested birth by Caesarian section, and Francis Berthoud urged it. But Ottilia was determined that her child's birth should be natural. Labor began on the 8th of October; the doctor's expectations proved to have been well founded. The pains lasted for forty-eight hours. On the 10th of October, a boy was born. The family was relieved and delighted. Perhaps it seemed a happy augury that the child's birthday was the same as Alberto's, who had turned thirty-six on that same day. Ottilia held her son in her arms. And that moment, as Alberto later said, may have been the happiest of her life. Desperately weakened, the young mother died five hours after the birth of her child.

Husband and family were stricken. But this bereavement did not provoke so puzzling a reaction from Alberto as the death which had occurred in the mountains above Montreux four years before. He sat by the deathbed and made drawings of Ottilia's profile in a schoolboy's notebook, seeking as always to equate sight with experience. The drawings, of course, are strikingly lifeless.

The tragedy had left a survivor, however, in whom life and the family went on. He was named Silvio. None knew it then, but this baby boy was to be the only grandchild of Annetta Giacometti, and as such he became the living testimony to a certain strangeness in the destiny of that strong-willed and possessive mother. She believed that she would have enjoyed having a large brood of grandchildren to enliven her old age. It was not to be. Of her three sons, the firstborn, as everyone knew, could never father a child; the two others, who presumably might have, never did. All three were creative in other ways, but though they all spent their lives with women, not one of them produced offspring. Only the female child went out from the family, took a mate, and gave life to another being. Perhaps Alberto understood what had happened when he said that the happiest moment of his sister's life had come with death.

Annetta doted on her grandson. By her attentiveness and care she tried to compensate for the fact that he had no mother. She adjured his uncles to care for him, too, never forgetting his tragic loss and remembering their own, happier childhoods. They all did their best to live up to that admonition.

Giacometti kept on trying to sculpt a head or figure which would satisfy him. None did. The heads never seemed lifelike, while the figures kept on getting smaller and crumbling to dust in his fingers. The results baffled him, but he was not discouraged. What he saw had ceased to be as important as how he saw, and therefore the whole purpose of creativity had changed. In the search for a vision uniquely personal, it must eventually seem that the works of art which embody that vision can never be quite equal to the expressive potential of the aesthetic experience. A search for the absolute entails a clear-eyed recognition that its destination is failure-or death. In those terms, the principal reason for creating works of art will be to demonstrate the continuing possibility of that which as a basic premise is acknowledged to be impossible. No wonder Alberto could go on working with such constancy and assurance. He had reached the state of mind which was to become the very substance of his eventual fulfillment.

Alberto was not the only man in Paris at that time to whom such a singular, contradictory state of mind was beginning to seem the basis for creative fulfillment. There was at least one other: an unknown Irish writer in his early thirties named Samuel Beckett. No less—but no more—than Giacometti, Beckett had found his contradictory artistic faith in the confusion and incongruity of his life experiences.

"I have little talent for happiness," he said. He grew up with an awareness of being different from those who are altogether happy, strong, and healthy. But he was an excellent student and, after taking his degree, received a two-year fellowship for further study in Paris, returning afterward to become a professor at home. However, he soon became oppressed by a sense of the absurdity of trying to teach others what he felt unsure of himself, and resigned. In the last week of July 1933, his father died of a heart attack. For the twenty-seven-year-old son, the death was shattering. Thereafter, a kind of apprehension toward life remained with him, a suspicion of outward events, a mistrust of apparent happiness. He became a voluntary exile from his homeland, a foreigner in the countries where he chose to live, and a writer who finally elected to write in a language not his mother tongue. Further to complicate his alienation from everyday life, there was a difficulty in sustaining significant relationships, especially with women. In one of his earliest works, Beckett speaks of the "morbid dread of sphinxes." Such a dread was apparently a real and active aspect of his imaginative life, for the theme of impotence recurs throughout his work, coupled with the motif of sterility. Tall, handsome, with piercing but benevolent blue eyes, Beckett was attractive to women and not a few became infatuated with him, but he was unable to make a positive commitment.

The first several years of Beckett's exile were spent miserably in London, walking the streets, oppressed by the contempt of the English for the Irish. Later he went wandering through Germany, but the persecution of Jews and preparations for war made life there unbearable. In the autumn of 1937 he returned to Paris, where, except for the interruption of the war years, he was to make his home for the rest of his life. He met some of the artists and authors who frequented the cafés of Montparnasse and Saint-Germain-des-Prés. He started writing poetry in French. It seemed that Beckett's life was about to become stable and harmonious. But an incident soon occurred made to order to symbolize the absurd vanity of such an expectation.

While walking with friends along the Avenue d'Orléans, Beckett was accosted by a stranger, a pimp, who made his proposition with such tenacity that the writer pushed him away, whereupon the man plunged a knife into Beckett's chest. The wound came close to the heart, without injuring it, but perforating the layer of tissue surrounding the left lung, requiring some time in hospital. When recovered, he was obliged to be present at the trial of his

bulit

assailant and had an opportunity to ask him why he had committed such a senseless crime. "I don't know, sir," the prisoner replied.

Beckett's art reveals deep sympathy for the injuries of every-day experience. It deals with solitude, with man isolated, alone, lonely, alien, out of touch with anyone. It is steeped in a sense of mortality, of the frailty and impermanence of life. Early in his career, Beckett stated his stark artistic creed: "The expression that there is nothing to express, nothing with which to express, nothing from which to express, no power to express, no desire to express, together with the obligation to express." Art is not the way out of the artist's dilemma. To be an artist is to fail, and the embrace of failure is his main spur in striving to succeed. Beckett's career became a veritable apotheosis of this forbidding belief.

Giacometti and Beckett met casually at the Café de Flore. They could hardly have been better made to appreciate and respect each other, and it seems inevitable that they should have become friends. It was a friendship very gradual in growth, for neither man was looking for solace or reassurance. On the contrary, what they eventually found in each other's company was an affirmation of the supreme value of a hopeless undertaking. They met most often by chance, usually at night, and went for long walks, the only destination of which was the conclusion that, having, as it were, nowhere to go, they were compelled to go there. It was a very private, almost secretive, and secret friendship. However, it did not exist in the vacuum of austere speculation. It came to be recognized by others as a confirmation of something which—even if they did not understand it—they could recognize as valuable. Many years later, when both men had become famous, a prostitute who knew them both saw them seated together on the terrace of a café. Going inside, she said to the proprietor: "It's your luck to have two of the great men of our time sitting together right now on your terrace, and I thought you ought to know it."

Efstratios Eleftheriades was a wily Greek who came to France during the First World War to study law but very shortly discovered that he was more interested in art than in jurisprudence. Ambitious to make a name for himself, he began by adapting his own to the Gallic tongue and called himself Tériade. He soon made the acquaintance of another Greek, equally wily, named Christian Zervos, also interested in art, and together they founded the influential art review Cahiers d'Art. The two Greeks, however, did not prove compatible. Perhaps they found each other a little too wily. They parted company, Zervos keeping control of Cabiers d'Art. The years following were lean ones for Tériade. Determined, however, to make his way as a publisher in the field of contemporary art, he eventually had the good luck to meet Albert Skira, a young man from Switzerland with the same ambition. Together they produced a review of art and literature called Minotaure. It was handsome and avant-garde, but Tériade wanted to put out something of his own. Verve was the result. Neither innovative nor adventuresome, this review did achieve and maintain for almost twenty-five years a level of quality in content and presentation which no other review had before attained or has since equaled. It was via the pages of Verve, perhaps, that the School of Paris showed its most splendid, though final, flowering. However, it was to be as a publisher of sumptuous books illustrated by the outstanding artists of the time that Tériade made his most distinguished contribution to cultural history. Matisse, Picasso, Bonnard, Miró, Chagall, Léger, Le Corbusier, Laurens were among the many who collaborated with Tériade to produce books which as creations in their own right are masterpieces. Of them all, however, none is more important or impressive than the one created by Giacometti. It occupies a place apart in his oeuvre, and in his life. Appearing posthumously, it became a kind of testament. Tériade was a fitting person to publish it.

Giacometti had attracted his attention when the young artist's early sculptures were first shown by Pierre Loeb, but they did not become friends until Alberto resumed work directly from nature. That was appropriate, as Tériade's taste was decidedly for figurative art, and each was able to stimulate and strengthen the conviction of the other. Both loved to talk, especially about art. Their long conversations lasted late into hundreds of Montparnasse nights. Giacometti's art and Tériade's publications matured together.

There were several photographers in Paris at that time who

seemed likely to have brilliant careers. Man Ray, the American Surrealist from Philadelphia, was the oldest and best known. Then there were two Rumanians, Gyula Halasz and Elie Lotar. The former changed his name to Brassaï after arriving in Paris, where he soon became friends with painters, writers, and prostitutes, all of whom he made memorable in photographs. Lotar was the illegitimate son of a famous Rumanian poet named Tudor Arghezi. He suffered much from the overshadowing celebrity of his father, and that may have motivated his early expatriation. Highly talented, charming. Lotar was also inclined to take life as lightly as possible. Though he had worked with Luis Buñuel on several films and published photographs in Verve, his career never seemed destined to come to much; at the very end of it, though, he managed with Alberto's help to make a success of failure and slip rather furtively through the back door of history. Henri Cartier-Bresson took the main entrance in stride. Youngest of the brilliant photographers, he came from a rich family, had meant originally to be a painter, associated himself with the Surrealist group, and made his first important photographs during long voyages throughout the world. Numerous artists were among the people of whom he caught images which crystallize experience with uncanny precision; those of Giacometti at the end of his life are some of the most telling.

If it seemed that Alberto was acquainted with almost every artist and writer of consequence of the time, not to mention a host of other people who never had any claim to fame, he was. Genius attracts people. Alberto attracted more people than most, because he was himself so irresistibly attracted by others. He responded to them with an eagerness all the greater for his awareness that, even as genius attracts others, its uniqueness is a barrier which keeps them at a distance. That, in part, is why Giacometti felt a deeper kinship with the great, anonymous mass of people than with some of the intellectuals who were his close friends.

As events in Europe drifted toward catastrophe, the drift of Sefton and Isabel Delmer's marriage seems to have been going the same way. The assignments of the foreign correspondent led to prolonged absences from Paris. It became impractical to maintain an expensive

apartment. Besides, Delmer seems to have wearied of Isabel's bohemian companions. More than once, he came home to find a party in progress and ordered the guests to get out. The Delmers moved to London. Isabel was not pleased by the change. Loath to forgo the company of her artist friends, she still spent much time in Paris, living in hotels. Alberto's relationship with her continued as inconclusive as the outcome of his work in sculpture. Both were his principal preoccupations. He kept working with stubborn persistence on the heads and tiny figurines, destroying almost everything. He did not cease relations with other women, but none of them compared for him with Isabel, and he took care to let her know it.

It was a disturbing time. And things far more troubling than frustration with work or with Isabel were happening in the world. On the last day of September 1938, the representatives of England and France, meeting in Munich with the leaders of Germany and Italy, surrendered to the demands of Hitler for occupation of a part of Czechoslovakia. War was now a matter of time. On October 10, Giacometti celebrated his thirty-seventh birthday. More than half his lifetime had already gone by. One of its critical events was to occur just eight days later.

38

That afternoon was cloudy and cool. Isabel happened to be in Paris, staying at a hotel on the Right Bank. She came to Alberto's studio to pose. While she remained motionless, he walked back and forth, observing her. He said, "Look how well one can walk with both legs. Isn't it wonderful? Perfect equilibrium." He shifted his weight from one foot to the other, turning abruptly, marveling at the ability. However, his sense of inner equilibrium was neither confident nor marvelous. Isabel was there before him, yielding to the artist's gaze; but to the man she remained remote and intimidating. He still did not know where he stood with her. Their relationship had gone on for almost three years, and nothing had come of it. He was in love with her, but they were not lovers. To be sure, this was largely his own fault, as he could not bring himself to make overt gestures or commitments.

That evening Alberto and Isabel went to dinner, and afterward to Saint-Germain-des-Prés, where they ran into Balthus, his wife, and a few other friends. At midnight, Isabel decided to return to her hotel. Alberto accompanied her. They went on foot. As they walked, Alberto felt that the inconclusiveness of relations had become so demoralizing that he would have to break with her once and for all. Trying to explain his feelings, he said, "I've absolutely lost my footing."

To walk from Saint-Germain-des-Prés to the rue Saint-Roch, where Isabel's hotel was located, cannot have taken more than fifteen or twenty minutes. That length of time was evidently too short to accommodate the consummation for which Alberto wished. When he left Isabel at the door of her hotel, he was unable to make

the advances which might have led him upstairs to her room, but he could not bring himself to make a definite break, either. As he turned away in the chilly dark, it must have seemed that his predicament was virtually crippling.

The rue Saint-Roch at its southern end gives into the rue de Rivoli. Turning left under the arcade, Alberto came to the Place des Pyramides. This is a small square, opening toward the Tuileries Gardens. It was created by the greatest man of action in French history. Napoleon, and named to commemorate his recent victory in Egypt. In its center, on a high pedestal, stands the life-size equestrian statue of another unhesitant molder of the French destiny and spirit, Joan of Arc. Of gilded bronze, it is the work of a plodding nineteenth-century sculptor named Emmanuel Fremiet, now forgotten. The virgin-warrior visionary-martyr is seated astride her war horse, clad in armor, holding aloft a banner. Despite its academic execution, the group conveys an unusual sense of forward motion. Round the base of the pedestal is an oval sidewalk barely six feet wide. It was to this spot, charged with such a variety of associations, that Alberto came in the middle of that October night. He stood on the narrow expanse of sidewalk directly in front of the statue.

Suddenly an automobile came speeding along the rue de Rivoli, swerved toward him, careened onto the narrow width of sidewalk, and grazed him. He fell. The car hurtled onward. There was a shattering crash. Alberto lay on the pavement. He felt calm, peaceful, looking at the scene—the car had gone in under the arcade and smashed through a shop window—and his right foot, which had a peculiar shape, and his shoe lying at a distance. He didn't know what had happened. He felt no pain. Still, he realized that something was wrong with his foot.

People came running. A police van arrived, siren blaring. Alberto retrieved his shoe. Seizing his strangely shaped foot, he forced it into its normal position. It began to hurt. The driver of the car, extricated from the wreck, turned out to be a woman, an American. Alberto thought she seemed half-crazy. In fact, she was drunk. He wanted to go home, but the police insisted that he and

the woman must both be taken to the emergency room of the Bichat Hospital to see whether either had sustained serious injury. They were escorted to the van.

It drove very fast through the night streets. The police had some difficulty finding the hospital. The ride lasted longer than it need have, long enough for Alberto to have a vivid but strange impression of the woman whose careening vehicle had injured him. She asked him for a cigarette. The request can scarcely have seemed improper, especially to Alberto, who smoked incessantly and was never without cigarettes. But he was taken aback by it, did not comply, and concluded that the woman must be a prostitute. At the same time he felt strongly attracted to her, as if he were falling in love. It was a bizarre moment, fraught with imponderable feelings and meanings.

When they arrived at the hospital, the woman, who was named Nelson and came from Chicago, was found to be uninjured, though drunk, and required no medical attention. Alberto, however, seemed to have sustained an injury which might be serious. His foot was swollen. Only X-rays could show whether this was due to a sprain or a break. The foot was tightly bandaged and the patient put to bed in a ward on the second floor. He could not sleep. Toward four or five o'clock in the morning, he began to feel considerable pain. When daylight came, he found that he was one of twenty men in the ward. He was reminded of his appendix operation, and felt strangely pleased to be in the hospital again, though worried about his foot. Wanting to get word to Diego, he persuaded one of the nurses to call Jean-Michel Frank with news of his accident. Later that morning, X-rays were made.

Diego arrived in the early afternoon with an associate of Frank's named Adolphe Chanaux. The hospital may have pleased Alberto, but his visitors were unimpressed and urged that he should move as soon as possible to a private clinic where he would receive the best care. Frank, who appears to have known in almost every realm who and what was best, made the arrangements. Promptly the next morning, Alberto was transferred from the Bichat Hospital to the Rémy de Gourmont Clinic in a quiet residential street of the

same name near the Buttes Chaumont, an out-of-the-way area close by a charming park in the 19th arrondissement. The man in charge of this establishment was one of Paris's most eminent surgeons, Dr. Raymond Leibovici.

The metatarsal arch of Alberto's right foot had been crushed, with breakage at two points, but the displacement was not so important as to require surgery. Dr. Leibovici determined that a plaster cast would be perfectly sufficient to ensure normal healing of the breaks in their proper alignment, and he declared that within ten or twelve weeks the injury would be entirely healed, leaving no aftereffects. The broken bones were set and the cast applied without complication. By the next day Alberto was feeling well, rested, eating with appetite, very pleased with the clinic and the good-looking nurses. There seemed no cause for worry. But Alberto was worried about his mother. Always anxious to protect her from knowledge that might be troubling, he thought first of how to reassure her. But it may have been he, in fact, who needed reassurance. Annetta was far more sensible than her highly imaginative son.

Isabel came to the clinic as soon as she learned of Alberto's accident and whereabouts. We do not know whether they talked about the topic which had concerned them just before the accident. If they did, it was with a marked change of heart on Alberto's side. He no longer felt tormented by the inconclusiveness of the relationship. The elusive or menacing aspect of Isabel appears henceforth to have lost its troubling power. The injury to his foot made the difference. Isabel came daily to the clinic. She brought a present, a translation of Moll Flanders, and news of Montparnasse: what Tzara had said to whom, what someone else had said to Tzara, Gruber's opinion of Balthus's latest, and plenty of other gossip, all of which they laughed about for hours with newfound delight. So much merriment in a clinic was unusual, and the nurses were impressed by their patient's ability to accept his misadventure with such happy nonchalance. Alberto went out of his way to make the best of what had happened, and with some insistence declared, "I feel better than before this adventure," though he failed to say why.

When not laughing with Isabel, reading, or seeing other visi-

tors, Alberto drew. Diego had brought paper and pencil. What the artist found most interesting to draw while at the clinic was a cart or wagon used for carrying medicines, wheeled from room to room by the nurses. A curious, intriguing vehicle, a kind of chariot, it had two large, fixed wheels at the back and two small, mobile ones in front. When propelled by one of the women in white, it was accompanied by the clanking, tinkling noise of bottles and glasses in their metal racks. A number of drawings of this peculiarly wheeled vehicle were made. None have survived, unfortunately.

When the swelling of Alberto's right foot had subsided, the first cast was removed and replaced by a heavier one, which would remain for several weeks until the broken bones were knitted. Dr. Leibovici informed his patient that he would be able to return home shortly, repeating that there would be no aftereffects.

Meanwhile, consequences of the experience were not confined to psychological conjecture, aesthetic perception, or good times with Isabel. There were practical considerations. It was all very well to feel that the accident had had beneficial effects. There were costs, too-monetary costs-and these would have to be paid. Alberto was not legally responsible for what had happened. It seemed logical to seek financial compensation. As nothing further had been heard from the woman who had driven the car, he retained a lawyer, a well-known attorney named Gaston Bergery. Investigation disclosed that although the woman from Chicago may not have been, as Alberto supposed, a prostitute, she was not a lady, for she had unceremoniously absconded from the scene of her misdemeanor, leaving Paris the next day. A number of letters were eventually sent to her, claiming damages, but none of them ever brought a reply, much less a remuneration. It turned out that the car had been rented from a local garage, which had allowed its insurance to lapse, soon declared bankruptcy, and went out of business. Gaston Bergery was an efficient lawyer, but there was nothing he could do in the absence of anyone to assume legal responsibility. Despite all efforts, Alberto never received any compensation for his injury. Financial compensation, that is. If the injury could be seen as beneficial, then it would have to be its own reward.

A week after entering the clinic, Alberto was released. On crutches, he returned to the rue Hippolyte-Maindron. Though he cannot have foreseen the future, he was right in thinking that his life had taken a decisive turn, for the manner in which he was to make his way through it had changed forever.

Walking with crutches was a lark. It was like having three legs instead of two. Alberto enjoyed swinging along the sidewalk, stretching his strides far beyond those he could have taken unaided, experimenting with a novel sense of equilibrium and an altered view of his situation in space. A month after the plaster cast had been applied, it was removed. Dr. Leibovici was pleased to find his prognosis confirmed. The bones had knit perfectly. Though some swelling and stiffness remained, these would disappear after a month or six weeks of therapeutic massage and muscular reeducation. Alberto would have to remain on crutches for a time. Its length depended on him, on the frequency and conscientiousness with which he would pursue reeducative treatment. Dr. Leibovici dismissed his patient with the conviction of having done a good job. In any event, they were not to meet again for twenty-five years.

Autumn passed, winter set in, the old year came to an end. It was 1939. Alberto remained on crutches. Never one to watch his step when it came to his health, he repeatedly put off the necessary treatment. The delay may have been due in part to his enjoyment of walking with crutches. Maybe the enjoyment was a symptom of more fundamental causality. Time would tell. Meanwhile, there was work to be done. The fact that he was lame was no reason for Alberto to stop working.

It seemed that his desire, his need, to accomplish something in sculpture had become more compelling than ever. The injury to his foot appeared as a benefit not only to his emotional life but to his creative activity. He may have felt that the continued use of crutches would give continuity to the benefit. The crutches pointed

quote

to the sense of it. Its sense was important, and what was most important to Alberto was his work.

He had been attempting to make a new beginning in his art by working as though art had never existed. For three years and more, he had worked at a series of heads, trying to produce at least one that seemed a truthful counterpart of what he saw. None did. This labor had led to the figurines which shrank to infinitesimal dimensions while he worked on them, as if the pursuit of the real must begin with the elementary particle of the visible. It was an utterly personal venture, because what matters to an artist is not the nature of the world but the nature of his reactions to it. Seeing is a search for meaning.

Alberto's injury had made it clearer even than before—if possible—that fulfillment must come to him through his work. No wonder he felt an increased need to try to achieve something in sculpture. The need was urgent, but the achievement could come only in its own good time. Having learned to live with the contingency of failure, Alberto had no reason to fear for the future. He saw that the way would be hard, long, and lonely, but it was to be of his own making. Nor would the injured foot hinder his progress. So he kept after the figures which brought him repeatedly to the frontier between being and nothingness. It was there that vision compelled him to situate the proof that sculpture was a continuing possibility.

One night Alberto found himself late at the Café de Flore. Most of the other customers had left, but at an adjacent table sat a man alone. Presently he leaned toward Alberto and said, "Pardon me, but I've often seen you here, and I think we're the sort of people who understand each other. I happen to have no money on me. Would you mind paying for my drink?" That was the kind of request Alberto could never have refused. He promptly paid for the stranger's drink. A conversation ensued, and it did seem that the two men were the sort of people who understood each other. Twenty-five years later it would be worth recalling that their friendship had begun with such an optimistic assumption. The man who made it was Jean-Paul Sartre.

Alberto had certainly heard of him, and he of Alberto. The sculptor and the writer would inevitably have met sooner or later. Once they had met, it was inevitable that they should be attracted to one another.

Four years younger than Giacometti, Sartre was short and stocky, plain, if not ugly, with heavy glasses and a nearly sightless right eye, which had the unfortunate effect of making it seem that he avoided giving you a straight look. Reared in comfortable bourgeois circumstances, he began to write at an early age and became a brilliant student of philosophy at the Sorbonne. In the spring of his last year there, he met a young woman, also a student of philosophy, also a person of exceptional intellect and like him the product of a bourgeois background. Tall and pretty, she had such an industrious devotion to hard work that she already bore the nickname which would stick to her for life: the Beaver, From the first, there was no doubt on either side that Sartre and she were people who understood each other. Her name was Simone de Beauvoir. It was one of those rare meetings of minds which make the matings of the herd seem lamentably bestial. They saw eye to eye, it appeared, on everything, including marriage, which they spurned, repudiating en masse all bourgeois standards and conventions, confident of their ability to distinguish good from evil, right from wrong, and truth from falsehood. Despite their devotion to the sole dictates of reason, Sartre and the Beaver liked a good time. They acquired plenty of friends, with whom they enjoyed long evenings of talk in the cafés of Montparnasse and Saint-Germaindes-Prés. They even found it possible upon occasion to make fun of each other, showing in the process that their extraordinary powers of discernment were indeed objective and that neither of them could be explained without reference to the other. For example, Sartre called the Beaver "a clock in a refrigerator," while she said that "Sartre only associates with people who associate with Sartre."

Of those who associated with Sartre only because he associated with them, one of the most welcome was Giacometti. Like everyone who met him, Sartre realized at once that the bushy-haired sculptor was an extraordinary personality. As a trained

philosopher, he also knew how to recognize a first-rate mind and understood that one man's contemplation of reality may benefit the vision of another. Alberto's intellect was not made for neat and systematic thought. He was a master of quirky intuitions, unpredictable shifts of point of view, contradictory logic, speculative leaps of imagination. His conversation was exceptional and fascinating because the same passion which drove him to work drove him to pursue every topic as if it had never before been broached. Extraordinary as Alberto's conversation was, perhaps the quality of his silences was even more remarkable. He had a way of listening to other people with such complete absorption that they felt more fully themselves as a result. Sartre was impressed. What impressed him most was Alberto's uncompromising commitment to experience as a search for the absolute, admittedly doomed to failure, but more imperative for that very reason. This was how Sartre expected to live his own life. This was how he expected the Beaver to live hers, and how he expected everyone who associated with him to live. He was nothing if not all of a piece.

So the friendship between the sculptor and the philosopher got off to an auspicious start. Mutual friends were awed by the brilliance of their talk. Alberto had an important influence on Sartre's thought. It was abstract influence, because Sartre trusted only in abstractions to lead him safely through the treacherous world of appearances. Yet Alberto was not given to abstractions. Both in his work and in his life, he came to grips as closely as he could with raw materials. Besides, he never believed that sculpture could save man—or the artist—from himself, whereas Sartre was convinced that words could, should, and would.

Giacometti's work was disconcerting to his new friends. They didn't know what to think of the minuscule figurines or heads. But they were willing to learn, and the lesson—for Sartre—proved essential. Though Alberto saw where he was going only gradually, step by step, he knew what he was doing and knew how to say so. Sartre listened. What he heard seemed of phenomenal relevance to the philosopher who was soon to write a treatise entitled *Being and Nothingness*.

At the time of their meeting, Alberto may no longer have been

on crutches, for he gave them up after a few months and got himself a cane. Limping noticeably, though, he surely talked about his accident, as it was his lifelong practice to talk openly and repeatedly about intimate concerns. No one who knew him at all well can have failed to know that he had once sat by the deathbed of an old man in the Italian mountains or that his foot had been seriously injured by a woman at the wheel of an automobile as he stood on the sidewalk in the Place des Pyramides at night. It was not long before he started telling his friends, as he told them again and again in later years, that he had been glad when he realized that he would remain permanently lame.

In March, the Nazis invaded Czechoslovakia. Mussolini attacked Albania. Switzerland, anxious to safeguard its immemorial neutrality, saw the moment as opportune for a reaffirmation of traditional values. A National Exhibition was organized to take place in Zurich during the summer of 1939. Bruno Giacometti, a young architect of promise who had already received favorable attention, was selected to collaborate on the design of a pavilion for the display of Swiss textiles. The architects responsible for the various pavilions were expected to select works of art to be exhibited in or around them, and Bruno saw an opportunity to give a little help to his brother's career. From the viewpoint of Zurich, it cannot have seemed to be getting along very famously. He proposed that Alberto be invited to exhibit a sculpture in the central courtyard of the textile pavilion. His associates agreed. Alberto accepted.

The artist arrived in Zurich well in advance of the opening of the exhibition. A man in charge of installations told him that a truck was ready to go to the railway station to fetch his sculpture. Alberto said, "There's no need. I have it with me." From one of his pockets he produced a largish matchbox and took from it a tiny plaster figurine not more than two inches high. The architects, including Bruno, were surprised—unpleasantly. They argued that a sculpture so small on a large pedestal in the center of a large courtyard made no sense visually, since it would be virtually invisible. The virtuality of the visible, of course, being the very point of the sculptor's purpose, Alberto, too, was unpleasantly surprised. Bruno tried to reason with his brother, but succeeded only in having himself roundly

berated not only for his failure to understand but also for his even more lamentable failure of faith.

Alberto insisted that the sculpture should remain. The architects insisted that it must not. One of them tactlessly added that, if it did, the other artists invited to exhibit would be offended. Alberto became angry. He had a strong temper. When aroused, which was relatively often, he would grow red in the face, shout, stamp his feet, wave his arms, and pound on a table if one was handy. He could be very plainspoken. A virtue, at least, of his tempers was that they were usually short-lived, rarely left rancor, and were often followed by remorse. In this case, though, there may have been a bit of rancor. The architects had their way. Though compromise in matters of work was never Giacometti's practice, he accepted one this time, and we may assume it was to spare Bruno further embarrassment. A bronze cast of an abstract sculpture of 1934 was shipped to Zurich and placed in the courtyard.

Officialdom in Switzerland may have been blind to Giacometti's vision, but there were men in Paris who saw very well what he was looking for. Picasso was the most perceptive. Himself a sculptor whose works were to have decisive influence, he recognized that Alberto was engaged in an attempt to conceive and create sculpture of a completely new essence. Although their artistic ambitions, not to mention their characters, were profoundly different, almost in opposition, they were also very alike, sharing the selfdoubt, familiarity with failure, and fear of impotence which haunt all artists. Giacometti was one of the rare persons never overawed by Picasso, because the essential condition of his respect for others forbade the notion that any person should, by virtue of no matter what accomplishment, be the object of special consideration. Picasso, however, in his life as well as his art, was protean and polymorphous, different things to different people, and with Alberto he assumed an almost filial attitude, though he was himself old enough to be the father. Friends observed that he was impressed by Alberto as by very few people, paid close attention to what he said, and deferred to his judgment. Always quick to seize upon the inventiveness of others, he adopted many of Alberto's brilliant observations, repeating them as if they were his own. There was no

other artist save Matisse whom he sought out so readily or talked to so willingly about art, explaining his own intentions and trying to understand those of a colleague. He did more. He asked Alberto to criticize whatever sculpture he happened to be doing at the moment, and when the criticism had been given, he often altered his work in accord with it. Alberto was able to express his aesthetic convictions with an authority detached from personal feelings because he was the first to point out the inconclusiveness of his own work and to suggest that a contrary point of view might be more convincing.

Picasso was neither so modest nor so candid. He accepted Giacometti's criticisms but at the same time resented having done so, and the perverse side of his nature—always powerful—led him to make fun of Alberto behind his back. Though he understood very well why the tiny figurines which his friend sometimes carried about with him in large matchboxes were momentous innovations in the history of sculpture, he could not resist insinuating that their importance might, after all, be in proportion to their size. Making light of the sculptor's anxiety and frustration, he said, "Alberto tries to make us regret the works he hasn't done."

If such sarcasms ever got back to Giacometti, he would have been quick to say that there might be something to them. Picasso's penchant for sardonic mockery, however, also expressed itself in ways regarded by the sculptor with less indulgence. He was highly critical, for example, of the painter's parental behavior, which he considered scandalous. Picasso's older child, a boy called Paulo, was a problem, and chiefly because his father could not accept the idea that he had sired an exceptionally commonplace son. He wanted Paulo to be a Picasso not only in name but in effect. It was no good. But the lad was subjected to obscure compulsions, anyway. On one occasion his father took him by the hand and led him up and down the Champs-Elysées for hours while he begged the passersby for money. The gesture was a fine Picassian illustration of the artificial status offered by a materialistic society to an artistic genius, especially one who happens to be the richest artist of all time. But it meant something else to a lonely boy who lived at home

in luxury and wanted only to remain there in peace, playing with his toy cars. Picasso père did not believe in spoiling his offspring. Paulo had little spending money, went poorly dressed, and later got into trouble with the police. His father got him out of it. Giacometti said that Picasso, not Paulo, was the one who ought to go to prison. But it was the boy who was presently shipped off to a retreat near Geneva where rich people with a penchant for trouble could be kept out of it. Alberto was indignant.

Picasso probably sensed the disapproval. He was uncannily intuitive, and Alberto not good at hiding his feelings. Though Picasso always took unkindly to criticism of his private life, there were a few men whose friendship he valued so highly that exceptions could be made. Giacometti was one, Paul Eluard another. As a token of his affection and esteem, Picasso gave Alberto a large drawing. Such tokens were not handed out casually. Still, Picasso would not have been Picasso if perverse, capricious behavior had not followed. He had a certain genius, too, for picking occasions.

Alberto and Isabel went often to the Brasserie Lipp at Saint-Germain-des-Prés. Picasso and Dora Maar also were regular customers. Picasso formed the habit of staring intently at Isabel. He was a famous admirer of beautiful women, and it seemed clear that his stare was intended to annoy. To prove it, he stopped at their table one day and said, "I know how to make her." This assertion of ability and skill presumably referred to the making of Isabel's portrait only. But Alberto's readiness to talk about his difficulties both as an artist and as a lover stood in contrast to Picasso's celebrated facility in those roles. The Spaniard's taunt, however, was not an idle one. He made several portraits of Isabel. All were painted from memory, but Picasso's visual memory was so precise that he could produce without a model a likeness more lifelike than a photograph. In this case, however, the model's features were violently distorted in the style characteristic of Picasso's work from the time of Guernica until the end of the war. Isabel is unrecognizable; only the slant of her eyes survives as an approximate reminder of the real person. Despite his assertion that he knew how to make her, the artist had not attempted to portray the visible Isabel, making instead a series of savage representations of women as ominous, predatory creatures. He used to say, "Women devour you!" What he made of Isabel showed how he saw they might be capable of it.

Giacometti himself had for several years created memorable images of sexual cruelty and erotic apprehension, expressed fantasies of carnal mayhem, and published writings affirming his ambivalence toward emotional commitment. A sublimation of such feelings seemed to have occurred since. It may have been due to the evolution of the tiny figurines which led in time to his most memorable achievements. Still, the relationship with Isabel continued inconclusive. On the eve of a conflict soon to engulf the whole world, his own was no nearer resolution than ever.

In August 1939, Alberto went from Paris to Maloja to be with his mother. On arrival, he felt exhausted. Too much, he said, had happened since the past autumn. His life had taken a critical turn. Every step he took was proof of it, and he had good reason to feel that the time had been too short for him to live through the change or its meaning. At the moment he wanted rest, nothing more. He arrived in Maloja determined to look at neither painting nor sculpture for a good month. Two days later, he left to make a trip through northern Italy to Venice.

Perhaps the sudden change of mind was due in part to the urging of Diego, who was also in Maloja, and of Francis Berthoud, their brother-in-law, who had a car and would act as chauffeur. Neither of the brothers ever learned to drive. It is not the change of mind, however, which attracts our attention so much as the itinerary. Venice occupies a place apart in the geography of the human spirit, a place where death and the passing of time are unforgettably present but where the potential of art to defy time and death is fulfilled as in no other place. Venice was the first foreign city Giacometti had visited, the only one to which he so regularly returned throughout his life. It must have had something vital to tell the tired artist in those final days before the worldwide disaster.

After a week, the travelers returned to Maloja, where they spent the days playing chess, nervously waiting for the bad news. It came soon. German troops attacked Poland on September 1. At six o'clock in the morning of September 2, Alberto and Diego set out from Maloja to report to the military authorities in Chur. Though officially resident in Paris, both were liable for duty. There was no question of Diego's being fit; he was promptly assigned to a

transport battalion. The case of Alberto, however, was different. He was lame. As a result of his failure to undertake the necessary reeducation, he would limp slightly for the rest of his life. His right foot was permanently misshapen, swollen above the instep. The military doctors declared him unfit. Their decision was not surprising, since the candidate presented himself walking with a cane. Still, Alberto was relieved to be saved from a situation which he had always contemplated with dread. It was far from certain at the time that Swiss soldiers would not have to do any fighting and dying.

Returning alone to Maloja, Alberto remained for some time with his mother, working obstinately at the heads and tiny figurines. Autumn came, weighted with uncertainty and foreboding. It rained. Mist obscured the mountains and hung over the Lake of Sils. Alberto felt unwell. He tried to smoke less. He longed to go back to Paris, but now he would have to apply for a visa, which might or might not be of limited duration. Besides, he hardly wanted to be in Paris if Isabel was absent, and she was stuck for the present in London. He did not return until mid-November.

Montparnasse and Saint-Germain-des-Prés were still there. People sat in the cafés and talked interminably about the same topic. It was the winter of the drôle de guerre, and some were fooled into believing it would never grow serious. But many familiar faces were absent. Sartre had been posted to a meteorological station near Strasbourg. Balthus had also spent some time at the inactive front, where the Germans held up signs saying: "Don't shoot. We won't if you don't!" Picasso had established an alternate residence in a remote coastal town named Royan. Beckett was in Paris but morose. Isabel arrived from London, her challenging exuberance undiminished by the apprehensions of men afraid for the future. Jean-Michel Frank, whose business had fallen off dramatically as the war approached, and who was well aware of the Nazis' plans for the Jews, began to talk about taking refuge in America. As for the Surrealists, they quickly rallied to the defense of the mother country, put on uniforms, and shouldered arms.

Alberto kept on working, unsatisfied. Plaster dust and detritus

accumulated in his studio. The time was not ripe for successes. Meanwhile, failure was promising and exhilarating—but lonely. If loneliness was aggravated by his brother's absence, the separation was not prolonged. As a Swiss citizen whose legal residence had for many years been France, Diego was entitled to request permission to return there. It was granted, and he arrived in Paris in time for Christmas.

Never one to shirk the hard job, Diego seems to have welcomed chances to prove that his importance to others was his importance to himself. Not only for Alberto, but also for Nelly. As the business of Jean-Michel Frank fell off, he found work designing perfume bottles and fashion accessories. He had become increasingly skillful with his hands. Alberto urged him to perfect his dexterity at making plaster casts, as he himself had never troubled to master that delicate and painstaking part of the sculptor's craft. When working in clay, it was good to have plaster casts in a hurry, for sculptural nuances were clearer. The tiny heads and figurines made directly in plaster did not require casting, but the alternative of clay was always at hand. Diego found an expert willing to teach him, and soon learned to cast delicate objects without a flaw. He welcomed complicated tasks as a challenge to his skill. Miró once asked him whether he could cast a plum tart, and he did it. The perfected dexterity was put to good use by both Giacomettis. Diego assured their mother that he felt "proud to be the object of so much faith."

Annetta, too, must have been proud. Proudest of all, probably, was Alberto. It was he who had worked the change. Fifteen years had passed since Diego's arrival in Paris. Little by little, they had brought in the brothers' relationship the inversion of roles which became increasingly pronounced as both grew older. Alberto never stopped worrying about Diego—and he worried more than usual during the war years—but the character of his concern underwent a strange transformation as it became apparent that, in fact, he had nothing to worry about. He ceased to fear that Diego might in some way bring harm to himself and began wondering whether harm might not come to him from the one most anxious to avoid it.

No person as alert as he to the ethical nuances of human behavior can have failed to foresee that an eventual detriment to his brother might be the counterpart of a benefit to himself.

The dilemma would be permanent and painful. It proved the nobility of the brothers' devotion to each other and of their dedication to art. Having already identified the contingencies of his brother's destiny with his own, it was natural for Alberto to hope that Diego might find fulfillment in the same way. Manual habits become second nature. Over the years, Diego had had a hand in the making of so many works of art and decorative objects that he may have come to feel that the creative act dwelt at his fingertips, too. Alberto urged him to try his ever more experienced hand at works of his own. Eventually he did. Always attracted to animals, he made small sculptures of a horse, a leopard, and various other creatures, which Alberto was quick to praise when he wrote to the family. Thus, having become indispensable to his creative brother, Diego hesitantly took a step or two on his own. These would lead at length to very appreciable fulfillment, though it would not—and probably could not-come while Alberto was living.

The drôle de guerre lasted through the winter. In May the Nazis invaded Holland, Belgium, Luxembourg, outflanked French defenses, and cut off the Allied Expeditionary Force at Dunkirk. French troops were powerless to resist. The civilian population, terrorized and embittered, fled. In Paris, people heard the news with consternation. A sense of doom set the scene for panic. People began preparing to flee. Jean-Michel Frank invited Alberto and Diego to dinner and told them that he was leaving for Bordeaux, where he would embark for the United States. They had worked together and been friends for ten years. He urged them to come with him. The brothers, hesitant, said they would think about it. There was little time.

Alberto took a single precaution in those desperate days. He buried his recent works. Having dug a sizable hole in a corner of his studio, he secreted there, carefully wrapped and protected, all the minuscule heads and tiny figurines which had survived from the labors of the past several years. He made no effort to safeguard any of the earlier works that were stored in the overhead loft,

though he cared for them enough to preserve quite a number until the end of his life. It was only for the sake of his latest creations that he carried out the ritual interment, and it may have seemed that his care was not so much to safeguard as to consecrate their existence.

Isabel was still in Paris. So was her husband, and he managed to wangle a place for her on the last commercial flight to leave for London, Alberto urged her not to go, and she didn't. True to form, she seems to have felt that she had nothing to fear from men at war. However, occupation of the city was inevitable within a few days. People feared the worst, and those able to leave began to do so in ever-increasing numbers. Isabel finally agreed to join them. The last day she was in Paris, Alberto went to her hotel to say goodbye. He asked her to pose for him. She lay outstretched on her bed, nude. He made several drawings. And it was then, when they were about to be separated, when their own future and the whole future had become unpredictable, that Alberto found the will to make a decisive gesture, to commit himself to the act which for so long he had both feared and craved. It had taken a war to bring him to it. When he and Isabel parted on that day, one may assume—no matter how the act itself turned out—that their relationship meant more to both of them than it ever had before. She left Paris the next morning.

Alberto and Diego hesitated. As Swiss citizens they would presumably have nothing to fear from the occupying troops. But who could tell how things would go? The future was uncertain, the rumors ugly. Most of their friends had gone. Having waited till it was almost too late, they decided to follow. Luckily, they had the means: by bicycle, a tandem for Diego and Nelly, a single-seater for Alberto. But at the last minute Alberto discovered an obstacle. "What am I to do with my cane?" he exclaimed. He couldn't very well take it along on his bicycle. People were dying, governments collapsing. Friends had fled. Alberto worried about his cane.

Diego had no time for the theoretical. "Leave it," he said.

Alberto did as he was told. He could walk perfectly well without the cane, though he limped. The three set out on the afternoon of June 13 for Bordeaux, hoping to take ship from there and join Jean-Michel Frank in America. By running away from the war, as things turned out, they were to see much more of it than if they had remained behind.

It was a fine day. An occasional burst of antiaircraft fire exploded in the sky as planes droned overhead. They headed south. Though the main swarm of refugees was ahead of them, the roads were crowded and they could not go fast. The first night, they slept in the woods near Longjumeau, only thirteen miles from Paris.

In the morning, while enemy troops were occupying the capital, they set out in the direction of Etampes. Above them passed German planes, preparing to attack the town. Alberto, Diego, and Nelly arrived just as the attack ended. Buildings were in ruins, burning. A human arm, severed at the shoulder, lay in the road, and they realized it must have come from a woman's body, because a bracelet of green stones still circled the wrist. Farther on, they came to a wide, shallow crater where a bomb had recently fallen; around it lay several bodies, torn limbs, and the severed head of a bearded man. The street was running with blood. People were screaming. A bus had exploded and the passengers, most of them children, were burning alive. There was nothing to do but keep on pedaling.

Beyond Etampes, the highway was fearfully crowded. In addition to fleeing citizens, there were retreating units of the French army, tanks, trucks, command cars. Toward midafternoon there was a thunderstorm. German planes came over and dove to strafe the road with machine-gun fire. The refugees rushed for the ditch. Alberto was terrified as bullets poured through the foliage of a tree overhead. When the raid was over, they had to get up and move on, leaving behind the dead. Later there were more planes. Again everybody rushed for the ditches. The sun had come out, though the sky was still half filled with clouds and in the distance occasional rumbles of thunder were audible. Beneath a nearby tree, French soldiers had set up a machine gun and were firing at the planes. As Alberto lay there in the ditch, with other refugees crowded around him, he stared up at the sky and suddenly to his great surprise he realized that he was no longer afraid. It was in part the thrilling beauty of the June day, in part the presence of the other people, which gave him heart. He thought that if anyone was to be killed he was willing

that it should be he instead of one of the others. Always preoccupied by death, he was not afraid of dying. That was as close as he ever came to death by violence.

The exodus went on with panic-stricken momentum. Alberto, Diego, and Nelly went with it. In four days they went only 180 miles. Far off the road to Bordeaux, they reached Moulins, a good-sized town on the Allier River, on the evening of June 17. The Germans arrived the next afternoon.

Alberto said, "We must return to Paris as quickly as possible."

They set out in the morning. It was a gruesome trip. The roadsides were littered with abandoned cars and abandoned corpses, heaps of abandoned luggage, garbage, wreckage, the bloated carcasses of dead horses. The stench was monstrous. The roads themselves were crowded with columns of German tanks and troops, advancing unopposed or guarding woebegone French prisoners. The first night Alberto, Diego, and Nelly spent in a field not far from the road, but the smell of decomposing corpses was so oppressive that they could not sleep. They arrived in Paris on Saturday, June 22, the same day that the armistice between France and Germany was signed, and found safe everything they had left behind.

Those ten days were Alberto's entire experience of the war. What he had seen never faded from his memory, and remained present even in his dreams for months afterward. But he wrote to his mother that he was happy to have seen the war so close. He had participated in an experience essential to his era and generation.

Occupied Paris was a fusion of the grotesque and the abominable with the commonplace business of getting along. Life as usual, business as usual was what most people craved, and considerable sacrifices were in order for the sake of that illusion. But dire departures from the usual became daily routine all too quickly.

Alberto had managed perfectly well without his cane while the war was before his eyes. As soon as he returned to Paris, however, he took it up again. And then he went on working, at heads no larger than a pea and figures the size of a pin, and night after night he destroyed most of what he had done during the day.

The war had made a hiatus in Diego's customary activities, and Alberto urged him to enroll at an academy for practical instruction in sculpture. It seemed a plausible step. One cannot help wondering, though, whether Alberto actually believed that his brother might someday turn out to be an artist in the same sense that he was. No misconception concerning the differences between artisan and artist can have clouded Alberto's vision, or his expectations. Genius had its way with him as a brother no less than as a man. It is marvelous, though, to contemplate the determinism by which art finally did make a true artist of the one who humbly let it do with him as it would.

Diego enrolled in the beginner's course at the Académie Scandinave, where he was required to make studies from life. The results were unpromising, as the human figure did not appeal to him. The only subjects for which he felt a true affinity were animals. Nonetheless, he continued going to the academy, partly to please Alberto but also for his own satisfaction: pleasing Alberto had become second nature to him.

Annetta worried about her sons in Paris. Two years had passed since she had seen either of them, and letters were a poor substitute for the regular visits to which she had become accustomed. The sons also missed their mother, especially Alberto, Swiss nationals with papers in order were entitled to travel permits. There can never have been much question about which son would go. Practical considerations, too, made Alberto the natural choice. Diego could not leave Nelly to fend for herself in circumstances so uncertain, whereas Alberto had no obligation to remain in Paris. The work he was doing could be done wherever he had a sack of plaster. Diego felt that the privations of life in occupied Paris, with its curfew and severe rationing, were less trying for him than for his brother, who was in the habit of prowling about the city late at night and of consuming large quantities of coffee along with innumerable cigarettes. Alberto, however, was not concerned to evade hardship. Paris had been his home all his adult life and he did not like the idea of leaving it in time of trial.

But there was his mother. Her peace of mind was essential to his own. Though in excellent health, she was seventy-one years old. No one could tell how long the war might last, or how it would turn out. Alberto applied for the necessary permit. Valid for departure within twenty-one days, it was delivered on December 10, 1941. He planned to be away for two months, perhaps three, in Geneva, where Annetta helped with the upbringing of her motherless grandson, Silvio Berthoud. As travel plans for Alberto were always subject to last-minute revision, it was only on the last day of his permit's validity, December 31, 1941, that he reluctantly left occupied Paris, promising Diego and Francis Gruber that he would try to bring back with him some sculptures "of less ridiculous size."

The reunion of mother and son was joyful. They had never before been separated for so long. Being together again came as a relief as well as a confirmation. Alberto was happy to find her looking so young, and Annetta to discover him still the youngster who needed looking after. What a lot they had to talk about! She was no less eager and indefatigable a talker than he. All the news of Stampa and Paris. And more than anything else they naturally delighted in talking to each other about each other.

Annetta was not one to mince words, however, if something displeased her, and she did not like to see her son walking with a cane. She had seen it before, of course, but that had been shortly after the accident. Two years had passed since. Alberto walked with a slight limp, but he could not have been called lame, and had no need of a cane. Still, he clung to the age-old symbol of infirmity. His mother protested. Paying no heed for once, Alberto went right on using his cane. It made for a certain tension between mother and son at the outset of a sojourn which would be long and bring graver problems.

Dr. Francis Berthoud lived with his five-year-old son and his mother-in-law in a spacious apartment at 57 Route de Chêne, which was then at the eastern edge of the city, though within walking distance of the center. Geneva in 1942 was not a big city. When Alberto first arrived, he stayed for a time at his brother-in-law's apartment. He was amazed by the opulence of Switzerland, the abundance of meats and pastries in the stores, the plentiful American cigarettes. A scene from *The Thousand and One Nights* could not have seemed more fantastic, he said. Yet he also felt that the Swiss were too far removed from the reality of the war

to understand it, and that despite the relative hardship of life in Paris, it had, in fact, been a privilege to be there. His intention, repeatedly reaffirmed, was to return to France as soon as the visit with his mother had lasted long enough to allow for renewed separation.

Meanwhile, he wanted to get on with his work and resume a way of life as similar as possible to the one he had left behind. He couldn't expect to work in the orderly apartment of his brother-in-law, nor could he presume to live as he pleased under the indulgent but critical eye of his mother. He would have to find a place of his own. The place he found was, of course, exactly what he was looking for.

Of the several cheap hotels in Geneva which rented rooms to women who made a profession of entertaining chance acquaintances, the Hôtel de Rive was the smallest and shabbiest, also the cheapest, being farthest from the area where such acquaintances were made. Business cannot have been good, since Alberto had no trouble obtaining accommodation at a monthly rate of sixty francs. Cheerless and comfortless as well as disreputable, the Hôtel de Rive was a small, three-storied building at the northwest corner of the rue de la Terrassière and the rue du Parc, thus on the main thoroughfare about halfway between the center of town and the apartment of Dr. Berthoud. On the ground floor was a homely café, while on the floors above were crowded a dozen small rooms, plus a few even smaller in the garret. Access to these rooms was conveniently provided by a back doorway. Alberto's room on the third floor, at the top of the circular stairway, measured ten by thirteen feet. It had a single window facing south above the thoroughfare: its sole furnishings were an iron bed in one corner, an ancient and inoperative porcelain stove, a rough wooden table which served as a washstand, and a couple of chairs. Cheap flowered paper covered the walls; the wooden floor was bare. One toilet and one faucet (supplying cold water only) were located outside in the corridor. No heating facilities existed, with the result that overnight residents in cold weather had to sleep fully dressed, and in the morning the water in pitchers or basins would be frozen.

Such was the dwelling, and working, place Giacometti chose for the duration of his stay in Geneva. With visionary resource-fulness, he had contrived to install himself in an abode even smaller and, if possible, less comfortable than the rue Hippolyte-Maindron. He thought of the accommodation as temporary, for he expected after a few months to return to Paris. Having been allowed to leave France, however, he was unable to obtain permission to return. How hard he tried we don't know. But we do know that he was not a man given to evading hardship or material deprivation, of which he would find plenty during three and a half years at the Hôtel de Rive.

Geneva had been familiar to Alberto since the age of eighteen, but it was not a place he ever found congenial. It offered few of the amenities of a capital like Paris. The only part of the city that could pass as a substitute for Montparnasse or Saint-Germain-des-Prés was the neighborhood around the Place du Molard. A poor *pis aller* in time of war, it would have to do.

Giacometti's arrival in Geneva did not go unnoticed. Among those interested in contemporary art the sculptor was welcomed with respect, as his Surrealist work was not forgotten. One of the most eager to greet him was Albert Skira, the publisher. He had known Alberto in Paris and introduced him now to the painters and writers who met regularly in his office or at one of the nearby cafés. Though the artist's essential solitude remained entire, Alberto never had trouble making friends. Before long, he found himself at the center of a small group of young artists and intellectuals.

No time was wasted before getting to work. Change of scene had not changed the sculptor's predicament. His figures kept on shrinking, as if by a will to become the least common denominators of the visible. Sack after sack of plaster was hefted up the circular staircase, but neither the size nor the number of acceptable works increased, while the accumulating residue gradually transformed the little room into a bizarre wilderness. Chunks and crumbs and flakes and dust of plaster settled upon every surface, clogged every crevice, filled every crack, seeped through every seam of the room itself and of everything in it, including the man

whose efforts had brought into being this weird, ancillary spectacle, by which he himself was transformed. His hair, his face, his hands, his clothes were so penetrated with plaster dust that no amount of washing or brushing could eliminate it, and for five hundred yards around the Hôtel de Rive the streets bore the ghostly imprints of his footsteps. Alberto became a living image of the interdependence between the artist and his art, and from this period dates the physical resemblance which eventually came to identify the sculptor with his sculptures.

Days were spent at the Hôtel de Rive, working. Toward the end of the afternoon, Alberto would go on foot or by streetcar to the Route de Chêne to visit his mother, nephew, and brother-in-law. Before his arrival, Annetta Giacometti took care to spread newspapers across the floor and on the armchair where her son habitually sat, so that the apartment should not be dirtied by traces of what went on at the Hôtel de Rive. She may have guessed that the tiny figurines responsible for all that dust were to cause her far more trouble than inconveniences of housekeeping. Concerning the dust, however, as well as the cane, it can be said that if Alberto did not succeed in pleasing his mother all the time, his failure may have signified precisely that the desire to please was too strong.

The artist's daily visits to the Route de Chêne were happy and animated. He and his mother were too important to each other for estrangements. Alberto's family ties were a lifelong source of security and pleasure. He grew fond of his nephew, and young Silvio became devoted to his extraordinary uncle. An important aspect of the satisfaction Alberto found in family relationships may have been his freedom to enjoy them largely on his own terms. Unmarried, unencumbered by any obligation, he could come and go as he pleased. After his visits to the Route de Chêne he would head downtown to meet his friends at Skira's offices or across the square at the Café du Commerce. There they would sit for hours, drinking coffee or an aperitif, talking about the war, arguing about politics, discussing poetry, painting, philosophy.

Between the Place du Molard and the Place Longemalle, a distance of no more than one hundred and fifty yards, there is a street called the rue Neuve du Molard. It was here that local

ladies loitered, waiting to make acquaintance in the propitious dark of the blacked-out city. They also frequented a number of bars in the vicinity: Chez Pierrot, La Mère Casserole, or Le Perroquet, where gentlemen had no trouble engaging them in conversations that might, if understanding ensued, lead to the nearby Hôtel Elite. Alberto and most of his friends were enthusiastic habitués of these establishments. The Perroquet was the one he preferred. The walls were black, hung with dozens of paintings of parrots, and the artist was prone to discourse at length on their aesthetic merit.

Man's inclination to sin was accepted with dour tolerance in Calvinist Geneva, but righteousness called for a modicum of expiation. The ladies lingering in the rue Neuve du Molard, Chez Pierrot, or at the Perroquet were occasionally rounded up by the police, along with some of their gentlemen friends, who might prove to be illegally resident in Switzerland, and carted off to the station, where they were held until their papers could be examined, a formality which invariably lasted till dawn. The officers in charge of these roundups knew by sight, if not by name, almost all of those whose turpitude might, in fact, be commensurate with the performance of duty, so that the ones carted to the station were almost always the same. Alberto was never one of those chosen. It became a feature of these periodic disturbances for the officiating policeman to call out above the clamor, pointing at the dusty sculptor: "Not that one!"

Failure to pass muster for a night's detention by the police cannot have caused Alberto regret. But there may have seemed in the circumstances a symbolic allusion to ineffectiveness in other things. As always, he continued to experience difficulty in the pursuit which led him to find the Perroquet such a congenial place. This was the time of Giacometti's life when he had to live most intimately with failure. At every step of his way, failure was with him, not only as a daily principle of work but also as the social and material context of it.

He was forty years old. There had been a time when he sought success, when he wanted to win admiration. He had attained it only to see that it was profitless. Then he had set out to

find new purpose in renewed vision. The years had passed. What had he to show for his pains? A few tiny figurines and a room full of dust. It was not much. Nor had he any assurance that there would ever be more. Yet he was prepared to risk his future on the chance that someday there might be. To him, the risk seemed natural. Those who will not risk much have little worth risking. Meanwhile, he cannot have failed to realize that in Geneva he was conspicuous, that most people saw him as a caricature of the half-mad but amiable and harmless genius, wandering about leaning on his cane, shabby and dusty, with a few minuscule sculptures in his pocket, a figure not only laughable but pathetic because the power of his intellect and the charm of his personality were spent to so little effect.

Even Annetta Giacometti had her doubts. As weeks and months passed, while empty plaster sacks accumulated at the Hôtel de Rive (or in the studio at Maloja during the summer), producing more and more detritus but, if possible, less and less sculpture, his mother began to lose heart. She had been proud of the successes in Paris, the exhibitions, articles in the press, praise by fellow artists. Then had come the abrupt turnabout, for which there was so little to show that it seemed worse than nothing. Unable to understand, she criticized. She conceived a violent dislike of the tiny figurines. "You don't know how much they displease and trouble me," she said. "Your father never did things like that!"

It was a bad time, made worse by a precarious material situation. Alberto had no money and no way of earning any. He could hardly expect to find buyers for the few figurines which escaped destruction. He tried making decorative objects, vases and the like, but without Diego as a helper or Jean-Michel Frank as a salesman, his endeavors brought little cash. He appealed for loans to several wealthy acquaintances, who refused, thereby aggravating latent feelings of resentment against the artist's homeland. Albert Skira helped with an occasional advance, but he was in no position to provide continuing support.

The only person to whom Alberto could logically turn was the one most logical. But her logic was not his. And yet he had no choice. His needs were far from extravagant. He had to have plaster, rent, and the minimum of pocket money for a meal at the Brasserie Centrale and a few drinks at the Commerce or Perroquet. In short, he needed enough to live as he pleased. That was the problem. The way he pleased to live did not please his mother. It would, needless to say, have pleased her less if she had known more. Alberto's Geneva friends were never permitted to meet Annetta, which they thought a little odd, because he was forever talking about her, extolling her character, and calling her "my pal." But his pal was kept carefully out of sight. They also thought it odd that such an exemplary parent should do so little to help her son, whose resources were obviously of the scantiest.

Annetta Giacometti held tight to her purse strings, a habit formed in years when her diligent husbandry had helped keep the family solvent, allowing Giovanni to go about his work and the children to pursue their bents. Alberto had certainly pursued his. It had been rewarding for a time. Now things were different. His needs could be seen as self-indulgence, his work as proof of impotence. That is how Annetta appears to have seen things, which surely increased her son's frustration. He was not indifferent to the facts of his situation, and his anxiety about it may have made him more than ordinarily eager to receive money from his mother. At the same time, he was the first to assert that his work was, indeed. a self-indulgence, because its sole purpose was to see how it would turn out-not to his satisfaction, of course, since he knew that in the absolute there could be none, but simply for the sake of the vision itself-to see, in short, how he saw. As for impotence, he affirmed it in more ways than one, though surely not to his mother. The crux of the problem was precisely that to his mother he had never, could never, and would never show himself entirely as he was, with the result that although she was the central figure in his life she was strangely remote from it, near and far at once, a beloved but intimidating figure which her indomitable character and forceful personality had perfectly prepared her to be.

It was an unhappy predicament. While Annetta could not allow her son to starve, she was reluctant to make it possible for him to continue such a wayward life. Besides, he had gone on disregarding her express wishes in the matter of the cane. She did not stop giving him money, but gave only a little at a time, compelling him constantly to appeal for more, to acknowledge his dependence while at the same time asserting his will, but showing his gratitude and even, perhaps, in the labyrinthine tangle of contradictory emotions, making a kind of tacit admission that she was right because he could not do without her. The creative compulsion, however, was beyond the reach of reason; it dictated the conditions of his life, however troubling, and it was for him the justification of everything his mother deemed unreasonable. She did not agree. "You don't have to tell me what art is!" she exclaimed.

Alberto fell prey to a sort of desperation, which expressed itself at least once in a manner so rare and singular as to be almost unbelievable. He provoked an open quarrel with his mother, demanding a large amount of money to be paid over all at once. She balked. He insisted, asserting that the demand was legitimate, that he was asking for no more than his birthright, since he had never received any inheritance, to which he was rightfully entitled, after the death of his father. The basis of the argument was too shaky to be bearable, which made things worse for them both, because they could hardly face each other in the open knowledge of what it meant. Annetta refused her son's demand.

The tiny figurines which stood, as it were, between Alberto and his mother during the years in Geneva may seem emblematic of what existed between them always, a bond so powerful that disregard or disapproval could never break it, a barrier so strong that compassion could not overcome it. The power of the bond and the strength of the barrier contributed to the dedication of the artist and the devotion of the son. In the end, dedication and devotion turned out to have been the same thing. Alberto and Annetta may never have been so united as when they felt separated by the difficulty to which it seemed that each had brought an irreconcilable difference. The symbolic figurine stands as a kind of monument, commemorating the need to surpass human limitations by achieving what is impossible.

Isabel had stood one night in the Latin Quarter, with dark buildings and darkness looming above, while from a distance Alberto had observed her. Years later in Geneva he began to realize that his creative compulsion was bound to the vision he had had of her that night on the Boulevard Saint-Michel. She was the figurine. It was meant to stand for her, but it also represented abstract womanhood. Its conceptual essence dwelt in this ambiguity, and in the correlative condition of being both present and inaccessible, a duality perfectly suited to the artist's nature. Touching the plaster figurine, he did not touch a real woman. Remoteness was the prerequisite of the figurine's being, enhanced by placement upon a pedestal, which Giacometti saw as essential to his vision of Isabel. He told a friend that if he could only succeed in making his figurine satisfactorily tiny, then it could exist in any dimension and would assume the aspect of a goddess. The thing he touched when he touched the figurine had an existence of its own. It controlled his life, but he could control it. He could destroy it, because it never satisfied him. His dissatisfaction, however, was its power, compelling him to create it again and again.

The figurines of this period—as well as the standing female figures of later years—were all conceived as nudes. This may not seem immediately apparent, but it is central to the importance and meaning of a major portion of Giacometti's work. The nude is the most serious of all subjects in art, for it provides the most ample opportunities to express the greatest variety of attitudes concerning the significance of human life. The greatest artists of the Western world have all created great works with the nude

as subject, and in all of them an awareness of the sexual is present. The desire to touch and to be united with another body is such a primal part of human nature that it can interfere with the detachment essential to aesthetic pleasure. Sexual desire, however, has from time immemorial sought sublimation in images, which remove the object of desire from the province of the physical and place it at an inviolable distance in the realm of the imaginary.

Giacometti's figurines—and the later works which grew out of them—are archetypes of such transcendence. Every artist of true originality creates a "type," and the characteristics of its style correspond to fundamentals in his nature which determine the constitution of his art.

As a youth in Rome, Alberto had found that sexual relations were most satisfactory with prostitutes. He never altered that view. Real relations with an illusion remained irresistibly compelling for him till the end. "When I am walking in the street," he said, "and see a whore from a distance, all dressed, I see a whore. When she is in the room and naked before me, I see a goddess."

Truth in art and truth in life are not the same. But the two must unite in the creative act if it is to have significant consequences, which is to say that a work of art will be "true to life" when its existence, and its very form, embodies the truths of the artist's life. A work of art can then serve the ancillary purpose of revealing those truths. The artist himself, however, exists inside his truth: he can see what he is only by seeing what he does. What he does remains eternally potential rather than actual, so that he can truly become himself only by dying. No one knew this better than Giacometti. That was one of the sources of his tireless compulsion to work. It was also part of the existential dilemma which made the tiny figurines so elusive and troubling. The measure of their greatness is one of feeling, not size, and by that measure they restored to sculpture something of its traditional monumentality.

All the sculptures made by Giacometti during the wartime years in Switzerland were tiny save one. That one is almost lifesized. It alone withstood diminishment to the least common de-

nominator of the visible. It also withstood the destructive impulse which reduced most of the others to dust. Its survival as well as its exceptional size single it out for special attention, an attention, moreover, by which the artist can only have meant to indicate special significance. The tiny figurines expressed much, but they could not express everything.

The Chariot is the name which the sculptor gave to this work. The figure is, as usual, of a nude woman, standing erect, her arms pressed to her sides, feet close together, poised upon a massive pedestal. The pedestal itself rests on a platform just large enough for it, with a wheel at each corner. The sculpture was executed in the studio at Maloja during the summer of 1943, made in plaster like its diminutive relatives. The wheels obviously gave the work its name and were therefore essential to its purpose. How essential they were we know from an incident which occurred when the resculpture was cast in bronze twenty years later. A friend of Alberto found the wheels and platform superfluous and removed them from the cast in his collection, so that the pedestal rested directly on the ground. When Alberto saw the sculpture in this state, he became furious, insisting that it be restored immediately to its original condition. By placing his female figure on wheels, Giacometti had determined her identity. She was herself only insofar as she was capable of motion. The importance of the figure was the importance of the wheels, and the unwonted largeness of her size was the necessary expression of an essential relation. If she had been tiny, the effect of her power to move would have been diminished. And yet this figure is like a magnified figurine, posed with hieratic detachment upon her pedestal. One can almost see the goddess Alberto had prophesied. But are wheels indispensable to the demonstration of divinity? Giacometti had not lost the power to invest his work with the significance and authority of his profoundest experience. He was beginning to see how that capacity could add formal power to the traditional expressive purpose.

Painting was only an incidental occupation of the artist during his war-enforced stay in Switzerland. He executed a few portraits of family and friends. Drawing, however, became an increasingly important part of his work. Most of the drawings of the war years were copies of works of art of the past, made from reproductions in books. This lifelong practice of copying was a means not only of seeing other artists' work more closely but also of establishing more explicitly his relation with them in respect to the tradition of which he meant to be part. Cézanne also had been a lifelong maker of copies. Nearly a third of his extant drawings are copies, and of these it is significant to note that the great majority are copies of sculpture. Alberto made many a copy of "Papa" Cézanne. And he later said that he had spent the war years meditating on Cézanne's ambitions and achievements.

Sometime in the autumn of 1943, when the tide of war had begun to go against the Nazis, a friend of Alberto's brought with him to dinner one evening a young girl from the suburbs of Geneva. She was said to be interested in things artistic and to be in revolt against her bourgeois background. Slender, with fine dark eyes, dark hair, and a clear complexion, she was exceptionally pretty and had the awkward charm of one whose eagerness for novelty and excitement has not yet been put to the test of experience. She was just twenty years old. Her name was Annette. She was wearing that evening a coat with a fur collar, which she had turned up to cover the lower part of her face. So it was mainly by the look of her dark eyes that she made her first impression on those to whom she was introduced. Alberto was struck at once by the quality of the gaze. As the evening passed, he became intrigued by the person. She took little part in the conversation, but her presence was neither passive nor indifferent. She had extraordinary cause to be attentive, for her intuition had led her to realize that she had attracted the interest of the most remarkable person present. When the better part of the evening had passed, she said that in order to catch the last bus back to the suburb where she lived with her parents she would have to leave. Alberto remarked that if she elected to stay she could later spend the night with him at the Hôtel de Rive. She elected to stay. But she would have to telephone her mother with an explanation. Alberto accompanied her to the telephone, overheard the conversation, and was impressed by the ease with which a girl so young could tell a convincing lie. The remainder of the evening was spent in talk. When it was over, the artist seemed a little startled to find Annette still there, expecting to go home with him. But he was as good as his word, and the two went off together in the blacked-out street, he leaning on his cane, the young girl beside him. His friends were surprised.

Isabel, meanwhile, in wartime England was busy having a good time. London beneath the bombs was far more entertaining than safe but monotonous Geneva. Sefton Delmer had important secret work in the Psychological Warfare Branch. It kept him in the country. Isabel preferred London, where she spent her time in the company of artists, writers, and musicians. She had a feeling for music and came to know quite a number of musicians, some of them eminent. One of these was the composer and conductor Constant Lambert, a man of exceptional ability and charm. Older than Isabel, he was lame and walked with a cane. His talent as a musician was matched, if not surpassed, by an aptitude for hard drinking. Isabel was well able to hold her own, and the two presently began living together. That was the finish of her first marriage. Laughing and drinking with the recent conquest in London, though, she never forgot that an exceptional man in Geneva remained spiritually present.

Diego, on the other side of the Channel—the other person continually present in Alberto's thoughts—was not having such a good time. Food was scarce, fuel scarcer. Enemy soldiers sat in the cafés and at night patrolled the empty streets. Jews were arrested and shipped off to destinations rumored to be unthinkable. As the Resistance movement became bolder, reprisals became more brutal. Hostages were taken and shot, suspects were tortured, and ghastly atrocities were committed by ordinary men in broad daylight.

Diego often awoke in the morning wondering how he was going to scrape together enough money to see him and Nelly through the day. He continued making decorative objects, perfume bottles and jewelry, but the market had dwindled drastically. When possible, he borrowed, though it went against the grain. He sold the drawing Picasso had given to Alberto; it didn't bring

much. He took a job at a small foundry in the nearby rue Didot, and became skilled in working with bronze and especially adept at producing fine patinas.

Every day, whether working there or not, Diego went to the rue Hippolyte-Maindron to make sure that the studios were safe. These were now two in number, because shortly before the war Diego had been able to rent for his own use a somewhat smaller space than Alberto's directly across the passageway. Most of I the others stood empty, the ramshackle complex almost abandoned. To be sure, the absent landlord had left a caretaker in charge, but this individual had found more profitable things to keep him busy. He was also Swiss; his name, Tonio Pototsching. He lived with a woman called Renée Alexis, and it was she who lackadaisically did her lover's work while he was off collaborating with the Germans. Pototsching had obtained an administrative post in the organization responsible for constructing defenses on the Norman coast. His life and career were squalid and insignificant. His death should have been likewise, but chance intervened to make it a remarkable event and save his name from oblivion.

One spring morning Diego found that during the night a spider had spun its web near the door to his room, in front of the gas meter. It gleamed in the morning light. Awed by the airy perfection of form, Diego searched for the architect capable of producing in a single night this exquisite construction. He was amazed to discover a tiny yellow creature hardly larger than a grain of rice. Such industry and ingenuity seemed to deserve a recompense, and Diego determined to help the spider make the most of its web. All that spring and summer, holding up saucers of severely rationed jam, he shooed the flies attracted to it into the threads. This abundance was more than the lucky arachnid could devour all at once, and the surplus flies were bound in silk, carried up to the ceiling, and suspended there for future consumption like so many hams from the rafters of an Italian salumeria. When the inspector from the gas company came to read the meter and prepared to brush away the web, Diego persuaded him to spare it. However, the beautiful thing he had wished to preserve was eventually ruined as the outcome of his care. He could supply subsistence for the spider, but he could not ensure the perfection of the web. As its creator grew fatter and fatter, accumulating more and more "hams" in reserve, it had less incentive to maintain a facility for entrapping victims. The web grew ragged and dusty, while its obese architect dwelt complacently in the ruins. At last, the spider died of old age. Diego preserved the delicate skeleton in a little box until it crumbled to dust, but thirty years later he still recalled the spider with affection, and spoke with wonder of the gleaming structure it had woven in one night in his drab room.

In the meantime, in Geneva, something surprising had happened. To say that Alberto had fallen in love might be saying too much, but it would be equivocal to assert that he had not. The girl named Annette whom he had met one October evening at the Brasserie Centrale had become his constant companion. Friends observed that he was quite taken with her. As for her, to say that she had fallen in love seems perfectly credible, because everything indicates that her emotions had been seriously engaged from the very first evening. That was surprising, for it suggested that those dark eyes which had drawn Alberto's attention were capable of discerning far more than might have been expected of a young girl from a bourgeois background in the suburbs of Geneva.

Annette was the only daughter of a schoolteacher named Henri Arm and his wife, Germaine. The second of three children, she was born on October 28, 1923. Monsieur Arm taught at the primary school in a modest locality called Grand Saconnex on the western outskirts of the city, and his family occupied lodgings within the school. Conscientious and industrious, Arm was also known to be narrow-minded and conventional; his wife resembled him. Not poor, they were far from rich. Family life was mediocre and monotonous, diversions infrequent and prosaic. Annette as a girl was more sensitive and intelligent than her brothers. Like the majority of sensitive young people constrained to grow up in straitlaced and inhibiting circumstances, she was deeply troubled by the agitations of puberty and adolescence. Apparently she did

not find in her family milieu the sympathy and understanding needed to help adjust to these changes, and thus became passionately anxious to break away from her conventional background. The passion, and rashness, of her anxiety may be measured by the fact that while making the break she more than once attempted to commit suicide; this unhappy information was later confided to a Japanese professor of philosophy with whom she fell in love and he pensively recorded it in his diary. Whether she actually meant to take her life we do not know. But she did demonstrate, at least, that life was for her a desperately serious affair, and that she was determined to be taken seriously. Her youthful acts of desperation served notice that she was a person out of the ordinary and suggested that the ordinary was precisely what she had resolved to keep out of. If so, she could not have encountered a person more ideally suited to sustain her resolve than Alberto. No doubt she felt this, and it must have been an important part of his attraction for her. Thus, perhaps, Alberto appeared at first to the young woman in some sense as a providential alternative to oblivion-if not oblivion in fact, then in spirit. If so, for that matter he was ideally suited, too.

Compared with such expectations, it cannot have seemed very important that he was old enough to be her father, that he was evidently penniless, or very close to it, that his interests and pursuits were entirely foreign to anything she had ever known, and that he was clearly not looking for a wife. Indeed, it may appear that all the differences between them were what most determined her desire for a relationship with him. This was a deliberate choice. The suicide attempts may have been irrational reactions against an incompatible environment, but the means she took to assert her freedom from it were a declaration of free will and an assumption of responsibility for her future. That might have given her pause if she had paused to think about it, but Annette was not by nature a cerebral or circumspect person. She longed to live without restraint or inhibition. Good luck had given her an opportunity to do that in the company of a great man. She seized it with such alacrity that some of her friends thought it was what she had been looking for all along.

Alberto seems to have welcomed the romantic newcomer into his life with pleasure. She was young, pretty, vivacious, impressionable. She took to him with enthusiasm, not to say ardor, and her inexperience was the guarantee of her sincerity. He apparently took to her in the same way, but he was far from inexperienced. However, he was sincere. He was kind. He made an issue of ethical probity. So we may assume that from the outset he made clear to Annette that the present, however enjoyable, was not to be taken as a pledge for the future. His distaste for clinging women was inveterate, as was his predilection for those whose profession forbade them to be so. He concealed from no one-except his mother—the kind of life he led or his determination to lead it as he did. He must have believed that Annette understood and accepted the tentative character of their relationship, because before long he allowed her to come and live with him at the Hôtel de Rive. a move unthinkable had it been accompanied by the slightest intimation of a lasting commitment.

Annette no doubt accepted whatever it was necessary to accept in order to maintain the relationship. What she understood was another matter. Young people in love project their temporary feelings into the expectation of a changeless future, and that tendency is far more compelling than any amount of sensible admonition. Alberto was in a better position to know this than most people. He had had ample experience of the unpredictable interactions of heart and mind, and good opportunity to take stock of his ambivalent emotional disposition. He was self-analytical and honest. Still, he encouraged Annette to enter into a relationship which he ought to have known might lead to a situation he would be unwilling to accept. That was an ill-considered, irresponsible thing to do, and one wonders why he did it. Perhaps he was tired and lonely. Years of toil in the dusty hotel room had brought neither material nor moral increment. Annette may have seemed to him, with her girlish laughter and charm, a kind of daughter on whom he could imaginatively lean, whose vitality and devotion would be comforting as he made his way through a figurative wilderness in symbolic exile. Then, too, there was the magic evocativeness of her name.

and live in open sin, right there in Geneva, with a man of whom they knew next to nothing. Even as it was, they knew more than enough. They had a slight acquaintance with Dr. Berthoud, and talk is never dear in towns like Geneva. What they knew was that Alberto Giacometti was a shabby, unsuccessful, eccentric, povertystricken artist well into middle age whose only source of support was an aged mother, the widow of Giovanni Giacometti, who, unlike his son, had made a name for himself and achieved a respectable success. Esteem for intellectual distinction or deference to creative power, whether consecrated by public opinion or not, loomed little in the Arms' view of things. The schoolmaster made

up his mind to have a confrontation with Giacometti.

Learning of the indignant father's intentions, Alberto made serious attempts to avoid him. When meeting Annette in public, he asked friends to scout the vicinity in advance. Sooner or later, however, the meeting had to take place. Monsieur Arm had legitimate paternal prerogatives and Giacometti knew it. Annette was a minor, and though her formal education had ended, she was still attending a secretarial school and receiving financial support from her family. Her father felt he had a right, and a duty, especially in view of past imprudence, to protect her, albeit from herself.

The Arms were aghast. Like most well-intentioned but unimaginative parents, they had no doubt fancied that their daughter's adolescent problems would pass with adolescence. Their worst fears had not prepared them for the fact that she might run off

The meeting was arranged to take place in a café one evening before dinner. Alberto was apprehensive, being more vulnerable than most men to charges of moral misconduct, and the moment Arm arrived he started talking to camouflage his nervousness, discoursing on some abstract topic which had nothing to do with Annette. The schoolteacher had never encountered anyone like Giacometti. He was impressed, and seems to have understood at once that such a person could not be the hurtful ne'er-do-well whom he had been prepared to forbid further association with his daughter. That does not mean he was instantly converted to approval. The two men no doubt discussed the problem of

Alberto's relationship with Annette, but the discussion was peaceable, even friendly, for they went off together and ate a spaghetti dinner, parting afterward without ill feeling on either side. Alberto's summing up of the encounter was concise: "Nothing to worry about."

The Arms henceforth did not attempt to interfere. Annette went on living as she wished. It may have appeared that there was a streak of willfulness in her nature, a stubborn determination to do as she pleased. If Alberto perceived beneath her girlish charm a vein of headstrong self-will, that may have added to her appeal. At the same time, she was dutiful and docile. Life at the Hôtel de Rive was far from comfortable, but she never complained.

She idolized Alberto. People noticed that she began to talk like him, with a Bregaglia accent, though she had never set foot in the valley. At the Perroquet she made amateurish efforts to emulate the women for whom it was primarily a place of business, thinking apparently to please her lover by exhibiting a flair for the wiles he liked. She had no gift for that sort of thing, however, and Alberto laughingly remarked, "You just don't know how to go about it." But his lack of approval may have been precisely the incentive needed to make her keep on seeking it. So much suggestibility seems to indicate a character that wants to be molded, and this might also have appealed to the sculptor. But at the same time friends observed that Alberto was upon occasion deliberately disagreeable to Annette, teasing her with such insistence that she could no longer maintain the pretence of fun and completely lost her composure. People were puzzled. The power of Alberto's personality gave to his behavior a semblance of natural law, and nature can be perverse.

He called her "La Petite." In the street, when they were walking together, he often tapped her playfully on the legs with his cane and cried, "Forward march!" They seemed quite happy. She spent as much time as she could at the Hôtel de Rive. It had recently changed hands. The new proprietress was an Italian woman who had no intention of running the place as an accommodation for brief visits by anonymous clients. She transformed the

ground-floor café into a restaurant but allowed Alberto and a couple of his friends to remain upstairs. She even offered free of charge a small attic room where Annette could stay while Alberto was working. It was as well that Annette could keep out of the way and out of the dust while Alberto worked, for she had no part in what he was doing. She was never asked to pose, and apparently that suited them both.

Having finished secretarial school, Annette found work in an office of the Red Cross. By a curious coincidence, another employee in that same office was young Paulo Picasso, on "parole" from the retreat where he had been put to keep him out of harm's way. Paulo worked as an office boy, and it greatly amused his fellow employees to be able to say, "Hey, Picasso, run out and get me a pack of cigarettes." Regular employment did not keep him from trouble, however, and once again his father's far-reaching influence was needed to avert punitive consequences.

Annette was not a career girl. Though she had been brought up to respect material accomplishments, she does not seem to have felt that she should devote her life to earning a living. She evidently anticipated that someday the responsibility for her well-being might be assumed by someone who would never expect her to be a bourgeois housewife, because she spent many office hours leaning over her typewriter wondering whether or not she should marry Alberto. That she looked forward to marriage is not surprising, since the blindness of love can account for any anomaly of vision. What is surprising is that at the same time she questioned the suitability of the match. What is astonishing is the cause of her uncertainty. It was not induced by the fact that Alberto was so much older than she, by his apparent lack of prospects, or by his evident aversion to the married state. She hesitated because he was lame.

It was only a foolish concern for appearances, no doubt. Annette was never a lucid, analytical person. And yet what she saw as a possible stumbling block was precisely what a person of oracular lucidity would have seen. However obscure and latent her perception, it added to her relationship with Alberto a dimension which neither of them could foresee, or control, because it

would measure them both by the heartless yardstick of the symbolic. Alberto, to be sure, was not really a cripple. His limp was neither pronounced nor disabling, and sometimes, in fact, was almost imperceptible. Still, he walked with a cane, which was proof he had been the victim of a serious and authentic accident. He often spoke of it, recalling the painful weeks in hospital but emphasizing the benefits he felt his injury had brought. These, perhaps, were for the time being just what made it so difficult for him to get along without the conspicuous cane.

At dawn on June 6, 1944, Allied troops landed on the Normandy coast. Ten weeks later they were at the gates of Paris. Those who had collaborated with the Germans became fearful for their safety. One of these was Tonio Pototsching, absentee caretaker of the rue Hippolyte-Maindron. He showed up there with a satchel full of money, lamenting the disastrous turn of events and wondering what he should do. Diego advised him to go into hiding. But Pototsching decided to cut and run, hoping that in the confusion he could avoid unpleasantness until his wartime errors of allegiance were forgotten. Leaving Renée behind, as usual, he took off for the east with his satchel, and nobody in Paris expected ever to see him again.

On August 24 came news that Allied troops were advancing from the south and southwest and could be expected to reach the city at any moment. The next morning Diego rose early and went to the Porte d'Orléans. A large crowd had gathered, for it was said that French forces were to liberate their capital. Toward midmorning the first vehicles arrived. German gunners positioned on the roofs of surrounding buildings opened fire. The crowd scattered. Diego dove under a table on the terrace of a nearby café. The French returned the fire. There were some casualties, but the column kept moving. Diego got away down a side street. By evening the fighting was virtually over.

In Geneva, Alberto and his friends stayed close to the radio, elated but anxious. Alberto kept saying over and over: "That fool is going to get himself killed." He knew his brother, and he was right to worry.

Following the liberation of Paris, the campaign to clear France

of German forces proceeded rapidly. The tremendous task of rehabilitating a shattered, humiliated nation could then begin, and it concerned not only the French people but every person to whom France was an indispensable idea as well as an important place. Giacometti was preeminently such a person. It was to France, to Paris, that he had been drawn at the age of twenty-one. Switzerland, Stampa, his mother, had also been essential to his pursuit of achievement, but while they may have determined its course, Paris represented its goal. Paris was the place where the enactment of his destiny could attain the status of a creation in its own right. Having longed for three years to return there, he applied for the necessary visa and waited impatiently for it to be delivered. As soon as it was, he announced his departure and said goodbye to his mother and friends. Albert Skira gave a farewell dinner. But Alberto did not leave. Some compulsion kept him in Geneva. It was strange, because the main reason for delay was closely related to the desire for departure. What kept him in Geneva was one more of his tiny figurines.

Isabel had sent word that she would join him in Paris as soon as he returned there. He replied, saying that for months and months he had waited for the moment when he could tell her that he had "to some extent" finished his work, living with that idea as he had from week to week for years, preoccupied by the need to attain "a certain dimension" that dwelt for the time being only in his mind's eye. The ideal dimension, however, cannot have been simply in the size of his figurine, and certainly had to do with his own stature as a man and an artist. It was not enough that he should impose order upon the complexity and novelty of his works; he had to order the life of their maker in a way consistent with their existence and meaning. He assured Isabel that each day there was a little progress. When measured against the absolute, a hairsbreadth of progress can seem limitless. In this perspective, Alberto's resolve begins to seem heroic. But there is something more. All that work, that struggle, the solitary confinement and hard labor at a task interminably resumed with no assurance of satisfactory completion: it seems almost too punishing. But, of course, genius implies a commitment to truth. One begins to wonder whether the

difficulty may not have been in Geneva as well as in the work. He had come there to see his mother. Though happy to have him there, she had been unhappy with what he did. For years he had longed to return to Paris, where he would find Isabel. But that had been impossible. When it became possible, he put it off.

Whatever the ambiguities and uncertainties of other relations. with Annette Arm they appear to have been simple. If she was content with things as they were—and she seems to have been then he was, too. But there was to be no equivocation about the future. When Alberto finally went back to Paris, he would go alone. Annette was not to expect to join him there. She appears to have accepted this prohibition with equanimity. Strongly attached though she was, she had contrived never to give the fatal impression that she was "clinging." Having won her independence from the inhibiting background, she may have found life so enjoyable in the free and easy milieu to which Alberto had introduced her that she was willing to let the future take care of itself. Besides, Alberto was exceptionally kind. He cannot have failed to realize that a prolonged attachment to him would probably not turn out to be for Annette's good. Part of his aversion to the married state was surely due to his awareness that a man devoted to art is unlikely to devote himself very well to a wife.

Though he lingered on in Geneva, Alberto continued to worry about Diego in Paris. If he imagined, however, that his presence was indispensable for the well-being of the younger brother, he was mistaken, and his mistake may have had something to do with the facts being rather the other way around. Diego had come through the years of hardship and deprivation very well on his own. And as if in symbolic acknowledgment of his self-reliance, the war had brought him from its worst hell a little playmate: a fox from Auschwitz.

One of Diego's neighbors had been a member of the Resistance, arrested by the Gestapo, tortured, and deported to the infamous concentration camp. Contrary to reasonable expectation, he not only survived but somehow in that pit of inhumanity managed to catch, tame, and feed a baby vixen. Repatriated after the liberation of the camp, he brought back his pet to Paris, where

he kept her on a chain in his apartment. It was there that Diego first saw her. Outraged, he angrily demanded how a man who had endured-and survived!-the horrors of a concentration camp could bring a wild animal eight hundred miles from home only to keep it chained in a dark apartment? Chagrined, the former prisoner offered his pet to Diego, who gladly took her back to the rue Hippolyte-Maindron. He named her Miss Rose for the color of her fur. She had the run of the two studios and passageway, but Diego took great care that the door into the street should always remain closed, fearful of what might happen to her if she ran off into the city. Alone with Diego, Miss Rose was tame and playful. He delighted in her slyness and intelligence. Sometimes she would play dead, lying on her back on the floor, eves closed and jaws slack. He could roll her over or pick her up by the tail and shake her without a sign of life. If he turned away, feigning indifference, she would spring onto his shoulders and nip the nape of his neck. He trained her to jump back and forth across a broom handle. She would run to him immediately if he called. But when strangers came to the studio, she would flee to the burrow she had made in a back corner under a pile of plaster. For all the pleasure of her presence, however, Miss Rose was not as agreeably fragrant as her namesake. The vulpine odor was intense, permeating everything, made worse by her habit of hiding in her burrow the scraps of meat Diego gave her, which then rotted and stank. He was not bothered by the smell. He understood that a studio was a poor substitute for the fields and forests of Poland, and he bore in mind what she had lived through. The war, it is true, had uprooted many millions from their homes and swept them to terrible destinations. Of these millions, Miss Rose was but one, and one of the least, yet for those sensitive to the animal spirit perhaps her very insignificance gave her singular meaning, while a sense of animal virtue as contrasted with human bestiality was fostered by knowledge of the place from which she had come. Diego was by nature unworldly and self-effacing, aloof, reticent, secretive, not one to commit himself impulsively to any attachment, but during the months of waiting for his brother's return he became very attached to Miss Rose.

Alberto several times sent word of imminent arrival. Diego went to the station only to find that he wasn't on the train. Not overly surprised, accustomed as he was to his brother's unpredictability concerning travel, he waited patiently.

The summer came to an end. In Geneva, Alberto once again made his farewells. He burned most of the drawings done during the three previous years and packed up his tiny figurines in the convenient matchboxes. But there was a final problem. As usual, he didn't have enough money. Instead of turning to his mother, however, he asked Annette for a loan, and she gave it. On both sides, the business strikes one as odd. By asking Annette for a loan to leave Geneva, Alberto was soliciting her help in putting an end to their relationship, which was the last thing she wanted, and by accepting it, he was contracting an obligation toward the future, which was the last thing he wanted. If it had been irresponsible to embark on an affair in the first place, it was worse to bring it to a conclusion not quite conclusive. The inconclusive and the ambiguous, however, not to say the ambivalent, were inherent in Giacometti's nature. On September 17, 1945, in any event, when he left Geneva, neither Alberto nor Annette can have supposed that they would in future see much of each other.

He took the night train for Paris. Twenty-three years before, he had departed by train for the first time toward this destination. It had changed since. The destination, that is, as well as the city. He had changed, too, and the cumulative virtue of the change now hung in the balance.

Four

It was an ordinary day, cloudy and none too warm. Diego had gone yet again that morning to the Gare de Lyon, having received another telegram. Once more, nobody turned up. In the middle of the afternoon, Alberto calmly walked into the studio, carrying his suitcase. There had been some inexplicable delay. But here he was. After three years and eight months! It was the longest separation they ever knew until the final one. It had changed nothing for either, of course. It didn't take Alberto long to feel as if he had never been away. That pleasure, too, was largely thanks to his brother. He found his studio exactly as he had left it. The penknife lay in precisely the place where he had put it down in December 1941.

Pleased, surprised, reassured as Alberto may have been to find his studio intact, he did notice something different: a smell, unfamiliar and unpleasant: Miss Rose's pungent spoor. The little vixen had kept shyly out of sight during the fraternal reunion. Diego had to explain. Alberto had never shared his brother's fondness for animals. The brothers habitually went from one studio to another all day long, and the olfactory inconvenience would remain as long as the fox did. Still, on the very day of his arrival, Alberto would not have wanted to make an issue of such a minor annoyance. He said nothing.

When evening came, the brothers parted, as usual, Diego going to dine with Nelly or with cronies, while Alberto went his own way. When they said good night, Diego emphasized that the door from the passageway to the street must remain securely closed to keep Miss Rose safe from the dangers of the city. The next morning he came early to the rue Hippolyte-Maindron. The door to the

street stood ajar. Miss Rose had disappeared. He never saw her again.

He was unhappy, and angry. The door had been left ajar by Alberto, who presumably had forgotten his brother's warning. He no doubt expressed regrets. But regrets could not bring back Miss Rose, and the trouble was that Diego found it nearly impossible to believe that the door had been left ajar out of mere forgetfulness. He suspected an irresistible temptation to provide the opportunity for an inconvenient presence to become a welcome absence. The suspicion rankled, and rankled doubly because there was nothing to be done but forget about it. No overt quarrel ever came between the two brothers, but the disappearance of Miss Rose caused something unhappily akin to bad feeling. It passed, of course, but six years later the pinched features of a little fox came peering from the base of a baroque candelabrum which Diego had made to celebrate his brother's fiftieth birthday.

Isabel had arrived in Paris already, leaving behind in London her friend Constant Lambert and the others with whom she had whiled away the war. More than five years had passed since that June day when she and Alberto had said goodbye. She—no more than he—could not have forgotten what had happened that afternoon. It seems clear that both of them had since then thought of the future in terms of the possible promise of that moment.

Their first meeting was charged with romantic expectation. It took place in a café on the Champs-Elysées, unobserved by others. They were all to themselves, and that was well, for it gave them time to see how they had changed. In the first place, physically. Though Isabel was but thirty-three, the sheen had already gone from her beauty. Five years of hard drinking had made her face puffy. Her Parisian friends had been shocked by the change. As for Alberto, he was a decade older than she and had never been one to care either for his appearance or for his health. If anything, neglect was his propensity. Deeply incised lines had begun to show in his face and forehead. But neither of them was blinded by the physical. They had more significant contingencies to contend with, and these had also been subject to change during the war.

The inconclusiveness of the past seems to have been left behind

in Geneva. Alberto was no longer the same man who had said good night to Isabel seven years before in an anguish of indecision at the door to her hotel. Though he still walked with a cane, it was with a difference, which may have had something to do with what he'd done in the meantime. He asked Isabel to come and live with him. She said she would.

The ramshackle complex at the corner of the rue Hippolyte-Maindron and the rue du Moulin-Vert gave onto a small garden shaded in the summer by a couple of sycamore trees. The rooms facing this patch of greenery were reached through a separate entrance from the rue du Moulin-Vert. Exceedingly modest, they nevertheless offered a little more amenity than those on the other side. There was at least a communal bathroom. Soon after Alberto's return to Paris, he moved into one of these rooms, adjacent to the one occupied by Madame Alexis, who had stayed on after the disappearance of Pototsching. It was there that Alberto asked Isabel to join him.

This was the first time he had lived with a woman in even a semblance of marital stability. It was not a situation for which he had any aptitude. Nor had Isabel ever shown much inclination to become a conscientious spouse. However, theirs was not a frivolous relationship. They had not waited five years for the sake of a casual dalliance. We don't know what was said, left unsaid, or taken for granted. What we know is that for close to ten years Isabel had played a vital part in Alberto's life and work, that that part still demanded its due, and that both were willing to take account of it.

Isabel was not the only person who had occasion to notice that Alberto had changed. The more perceptive of his friends also sensed a difference. Before the war, it had been evident to everyone that his was a singular and imposing personality, with the assumption of genius thrown in to point up the singularity. At the same time, however, he was one artist among many: Miró, Max Ernst, Tanguy, Masson, Balthus, not to mention the eminent elders, Matisse, Picasso, Braque, Laurens, et al., plus the entourage of writers: Breton, Eluard, Leiris, Sartre, and so on. This was impressive company, in which Giacometti had easily held his own. After the war, however, people saw that something had been added. A

Southe

special aura seemed to mark him as a man apart. It was the onset of that massive accretion of creative and spiritual power which gradually made him a legendary figure. Meanwhile, he had not ceased to be entertaining, brilliant, and highly appreciated by the friends who welcomed him back to Paris.

Sartre at the outbreak of war had been an obscure professor, known as an author only to a few. By the time Alberto returned from Geneva, he was famous. His philosophical position, defined as Existentialism, had set the dominant intellectual and literary trend of the period and become a fashionable craze among the postwar young. He was a celebrity, and with him Simone de Beauvoir. Their determination to be in the forefront of current events would lead to many a twist and turn of itinerary. For the moment, the most significant course was the one which might, or might not, lead a man of integrity to be a fellow traveler of the Communists. Many consciences were to be baffled by that issue.

Pablo Picasso-great celebrator of the corrida-seized the bull by the horns. Having managed to live through the war untroubled -even by the occasional visit of a Nazi admirer in uniformthe painter seems to have viewed the future after the end of hostilities with a strange misgiving and to have felt a pressing need of partisan goodwill. An anti-Fascist of long-proven conviction, he had nonetheless kept securely aloof from the active political fray. Now he got caught up in it. He was not a citizen of France, but in 1944 he became a member of the French Communist Party. The announcement created a stir, coinciding providentially with the first exhibition of his wartime works, which also occasioned a well-publicized ruckus. Picasso's fame—and prices—skyrocketed. Expert in the arts of personal mythology, he asserted that his decision to become a Communist expressed no more than the emotional need of an exile for a homeland and the spiritual response of a revolutionary artist to a rightful revolution. In the past, however, Picasso had always been a leader, often rebellious and defiant, but he allowed his newfound comrades shamelessly to use him, an about-face which tallied only too well with his passion for unpredictable shifts in style. Having acquired a new allegiance. Picasso also went about acquiring a new mistress. At sixty-four, he

Set !

wasn't getting any younger. Neither was Dora Maar, then almost forty. He determined to replace her with a girl of twenty-four named Françoise Gilot. Since nothing concerning Picasso could now take place in becoming privacy, this change was accompanied by considerable public titillation.

Thus, the friend Alberto found on his return from Geneva was not quite the same Picasso he had known before. But the two were happy to rediscover one another. The happier was probably Picasso, because he found himself more and more exclusively surrounded by people whose admiration he craved but whose perspicacity he was too intelligent to trust. No uncertainty ever prevailed concerning the candor or acuity of Alberto's judgments. Anxious to show him recent work, Picasso expressed relief when the younger artist said that it was evidence of progress. For some time after his return from Geneva, Alberto was a frequent visitor to the rue des Grands-Augustins. When Picasso occasionally returned the visits, the two artists often went to a nearby café to talk, drink coffee, or while away an hour giggling like schoolboys as they looked at the pornographic magazines Picasso sometimes brought with him.

Giacometti's concern with the political aspect of human experience had been increased by the war. Despite the detachment and isolation of his own existence, and in part, perhaps, because of it, he never lost sight of the realities of other people's lives, and never lost faith in the value and importance of human life in general. At the same time, however, he saw clearly through the confusions and duplicities common during periods of international turmoil. While he was in Switzerland, a group of Communist intellectuals had invited him to participate in their activities. He said, "Everything that I am and want to be and care about is considered decadent by the Communists. Why should I take a stand that eliminates myself?" He never did. For that matter, he never took a stand that eliminated anyone.

André Derain had not come through the war with as much ingenuity and panache as Picasso. His prestige as an artist had already lost its luster. Now his good name as a man grew tarnished. It was widely alleged that he had collaborated with the enemy during the Occupation. In reality he had only allowed contemptible

opportunists to puff up his reputation for their own ends, but there was no denying that his hunger for homage had got him to swallow the side dish of dishonor. Many erstwhile friends treated him with contempt as a "collabo." Alberto was not one of them. The ardor with which he expressed his admiration for Derain never failed. In fact, it became quite aggressive as the years passed and the older artist's glory continued to dim, as if Alberto could not forgive others for failing to see that what was moving and valid in the art and example of Derain was the dimension of his failure. Alberto went frequently to his house in the country, where they talked, joked, and argued as though nothing had happened. But something had, and what it brought out was the virtue of friendship.

Balthus, Gruber, Tailleux, Tal Coat, and the others in the group of figurative artists who had gathered around Alberto in the late thirties had all survived the war with their ambitions and energies intact. The least talented, Tailleux, had even attained a brief celebrity. The rest labored on in obscurity, looking forward to a time when their efforts would bring recognition. Welcoming Alberto back to Paris surely made that time seem more likely to come. because there had never been any doubt that for him it was certain to come sooner or later, though he labored in obscurity as humble as theirs. They, at least, had something to show for their labor, while Alberto had next to nothing, only a handful of slivers and mites of plaster supposed to be sculptures. Some of his friends may have felt that nothing would have been better than those. The need for all those figurines and minuscule heads would only be clear when they had proved their necessity by producing issue. Meanwhile, the sculptor went on working, and his studio began to look like the hotel room in Geneva.

Diego was worried. His brother had promised not to come back until he could bring with him a sculpture less "ridiculous." Here he was, four years later, doing the same little things as before, destroying the majority, with no prospect of change. Diego's position was difficult. His part was to help, not to hinder, and help had to be given wholly on the recipient's terms. But it was ironic, not to say hard, that his brother didn't have to worry about the out-

come, because he was the instrument of it, and therefore saved by definition from futility, whereas Diego, depending on the outcome to prove the value of his part in it, could do nothing but worry. It wouldn't do a bit of good, but that was its point.

His part was not to interfere, but he could intervene. He tried to preserve as much as possible from destruction. He was on the side of the creative, opposed to the destructive, and he managed to save a lot of sculptures from dusty ends. His efforts coincided with the one consideration which, in fact, did worry Alberto: money. If there was never anything to sell, how would it be possible for him to go on making and destroying his infinitesimal sculptures?

They had no Jean-Michel Frank to fall back on now. Their faithful friend had not survived the war. Unhappy and unappreciated in New York, despondent over a love affair with an American boy, he had watched the war from afar with increasing horror. He would have been more horrified still if he had known the eventual fate of his fellow Jews in occupied Europe, including his grand-niece Anne, whose posthumously published *Diary* would impress the world. But Frank already had been horrified enough, and in 1941 he had, in despair, leapt to his death from a high window of the Hotel St. Regis. His sense of stylish refinement had epitomized a brief moment in the history of fashion. The moment had passed, taking him with it.

Times were hard, elementary staples of food and clothing difficult to come by. Alberto and Diego were faced with the possible collapse of the life they had led together for twenty years. They got along mostly on borrowed money, and there were those who wondered whether they weren't throwing it away by lending it to an artist who seemed incapable of finishing anything.

Alberto was only too aware of his predicament. Nor can it have been very heartening for him that Isabel should witness his inability to earn a living by his work or even bring the work itself to a satisfactory culmination. The inconclusiveness of personal relations had changed for the better, but the change did not extend to what went on in the studio. Often the sculptor awoke in the middle of the night, terrified that he might run out of money permanently.

XI di

Frank goe Judy He would lie there for hours, wondering what would happen, with Isabel asleep next to him, the inevitable light burning by the bedside.

Yet he seems never to have doubted that he was pursuing the right course. He believed absolutely that the next day or next week would bring progress. No matter how often the proof of it might be deferred, he never doubted that it would come in time. Whether anybody else, including Diego, and even Isabel, could see the very smallest part of that proof made no difference.

As for Isabel, she was about to do something which would abolish forever the issue of inconclusiveness. Henceforth, Alberto would know definitely how he stood with her.

On Christmas Day, 1945, Francis Tailleux's wife gave birth to a baby girl in Brittany. The artist, who had remained in Paris, decided to celebrate the event that very evening by giving a party at his mother's apartment in the rue du Bac. Alberto and Isabel were there, of course, along with a host of artists, writers, musicians. There was plenty to drink, and everyone made the most of it. The hour grew late. Suddenly Isabel and a handsome young man stood up, made their way through the room together, and without a word to anyone left the apartment. "Well, what about that!" exclaimed Alberto. He returned to the rue Hippolyte-Maindron alone.

Isabel did not reappear for several days, and then came only to take away her clothes and other belongings. She had decided to go and live with the young man met at Tailleux's party. How Alberto took this news we do not know, but we may remember that he had not welcomed the revelation of Flora's infidelity fifteen years before.

The young man was a musician named René Leibowitz. A conductor, musicologist, and champion of avant-garde music, he would later attain fleeting prominence. While living with Isabel he was surprised to find himself snubbed by Giacometti, with whom he had previously been on cordial terms, and he was distressed. This naïveté may have been a counterpoint to intriguing disingenuousness on the part of his mistress. She wrote Alberto long letters, appealing for tolerance based on the understanding that her principal purpose in remaining with Leibowitz was to destroy him.

Thus, her attitude toward both men appears dangerously ambivalent, while her motives seem to have been the stuff of destruction for herself as well as for others.

Alberto was not beguiled. The love affair ended for good on that Christmas Day of 1945. Though he later proved his lucidity by describing Isabel as a "devourer of men," she had added much to his life and art.

printe

A day came when Alberto stopped using his cane. He saw this as a great occasion, and called it to the attention of his friends. Henceforth, he would go his own way with a difference.

In Geneva, Annette Arm was thinking about going with him. Apparently, it no longer mattered that he was lame. All she wanted was to join him in Paris. Nor did it seem to matter, either, that he had expressly told her she couldn't. She wrote anxious letters, and they may have borne the ominous implication that the docile young thing might still turn out to be "clinging."

Alberto replied, telling his correspondent that she had better stay where she was. So long as he was living with Isabel, he could hardly have told her otherwise. Annette, however, did not welcome the prospect that her role as a woman of passion should be played out on a provincial stage with a supporting cast of unproven competence. She kept on writing. Meanwhile, she was not exactly a prototype of lovelorn despair. Having been initiated by Alberto into a certain way of life, she kept on living it and may have sustained the hope of rejoining him by being the sort of woman whose company he enjoyed. She went out regularly with a couple of friends, Madeleine Repond and Manon Sachot, to the cafés, bars, and nightclubs where he had so often taken her. The three girls had plenty of good times.

When Isabel ran off with René Leibowitz, things were different. The artist found himself face to face with himself in a way he had not been for a long time. Remembering the dusty years in the little hotel room, he must have remembered the person whose company had given him comfort and refreshment. He asked her to do him a favor, and he would hardly have done that unless he had been

prepared to let her take a step in his direction. He asked her to send him a pair of shoes.

It was a thoughtless and irresponsible thing to do. Borrowing money had been bad enough. This was worse. But perhaps it merely seemed practical. Shoes of decent quality were hard to get in Paris. Alberto recalled having seen in a shop window in Geneva a pair especially to his liking. Why he felt Annette to be the right person to provide him with those shoes, when others on the spot, beginning with his mother, could have done so, we cannot tell. It may have had something to do with the likelihood of her being, in fact, the wrong person. He wrote a lengthy, detailed letter, describing exactly the shoes he wanted, that pair and no other, giving his size, the location of the shop, and instructions as to how the package should be forwarded to him. It was to pass from hand to hand, beginning with Albert Skira in Geneva and ending with a young painter in Paris named Roger Montandon.

Having followed its appointed itinerary, the package was delivered one evening to the rue Hippolyte-Maindron. Alberto opened it. Immediately he started to shout and sputter with rage. These were not the shoes he'd wanted. Annette was an idiot. She would never understand anything about anything. Rushing outside, he flung the shoes furiously into the garbage bin without even having tried them on. Montandon was astonished. Having known Alberto for several years, he had witnessed many irascible outbursts, but never one like this. It seemed doubly incomprehensible because the sculptor, who had so little money, had not hesitated to throw away a valuable and sorely needed pair of shoes. But the soreness of the need cannot have proceeded from a realm accessible to common sense.

One evening Giacometti went to the movies. While seated in the theater, without forewarning, he experienced one of those miraculous instances of self-creation in which the present abolishes the past even as the future abolishes the present. It caused a radical change in the artist's view of the world and of his art. He saw this at once and later he spoke of it repeatedly.

"The true revelation," he said, "the real impetus that made me

Reveloped want to try to a I was watching

want to try to represent what I see came to me in a movie theater. I was watching a newsreel. Suddenly I no longer knew just what it was that I saw on the screen. Instead of figures moving in three-dimensional space I saw only black and white specks shifting on a flat surface. They had lost all meaning. I looked at the people beside me, and all at once by contrast I saw a spectacle completely unknown. It was fantastic. The unknown was the reality all around me, and no longer what was happening on the screen! When I came out onto the Boulevard Montparnasse, it was as if I'd never seen it before, a complete transformation of reality, marvelous, totally strange, and the boulevard had the beauty of the Arabian Nights. Everything was different, space and objects and colors and the silence, because the sense of space generates silence, bathes objects in silence.

"From that day onward I realized that my vision of the world had been photographic, as it is for almost everybody, and that a photograph or film cannot truly convey reality, and especially the third dimension, space. I realized that my vision of reality was poles apart from the supposed objectivity of a film. Everything appeared different to me, entirely new, fascinating, transformed, wondrous. So there was a curiosity to see more. Obviously I wanted to try to paint, or to make a sculpture of what I saw, but it was impossible. Still, at least, there was a possibility of trying. It was a beginning.

"I began to see heads in the void, in the space which surrounds them. When for the first time I clearly perceived how a head I was looking at could become fixed, immobilized definitively in time, I trembled with terror as never before in my life and a cold sweat ran down my back. It was no longer a living head, but an object I was looking at like any other object, but no, differently, not like any other object, but like something simultaneously living and dead. I gave a cry of terror, as if I had just crossed a threshold, as if I was entering a world never seen before. All the living were dead, and that vision was often repeated, in the subway, in the street, in a restaurant, in front of my friends. The waiter at the Brasserie Lipp became immobile, leaning toward me, with his mouth open, without any relation to the preceding moment, to

the moment following, with his mouth open, his eyes fixed in an absolute immobility. And not only people but objects at the same time underwent a transformation: tables, chairs, clothes, the street, even the trees and the landscapes."

The instant of revelation came like the gift of sight to a blind man. Giacometti's exultation brings back memories of the sixteen-year-old artist in the first glory of his powers. In some vital way he seems virtually to have been reborn. But bliss was now conditioned by somber insights into the nature of vision, for the innocence of youth had been lost long since. Still, somber insights could contribute to clarity of purpose. Having seen that he had been blind, Alberto saw that looking, not thinking, gave access to reality. By concentrating his vision for nearly ten years on what was aesthetically next to nothing, though at the same time humanly almost everything, he had purified perception to such an extent that the act of seeing could become the basis of a style.

When Giacometti entered the theater, he was committing himself to a situation set apart from direct experience of reality but devised for the credibility of the visible. This comes easily to most people in the blind belief that things are not only as they appear but can remain stable in an uncertain world. Giacometti had long been peering beyond stable appearances in order to analyze, if possible, the sensory process itself, and adapt its means to the end of his creative purpose. This effort, of course, would never be done, and had to be sustained by conceptual confrontations with the unknown. These could not be commanded by the artist but came in their own good time, turning to account his visual vicissitudes with a will of their own. The movie theater was the perfect place for an encounter of this kind, because the seeming credibility of the visual challenges the power of vision to make use of illusion not only as an aspect of reality but as an access to further perception. There is a lovely logic in the fact that the images which suddenly appeared unintelligible to Giacometti remained perfectly intelligible to his neighbors, who were by the same token so transformed in the sight of the artist that only the full resources of illusion could hope to register his vision of their reality. For years he had been making and remaking minuscule sculptures which to

most people looked like meaningless specks. Now a convulsion within the matrix of appearances would compel him to make his sculptures lifelike by making them look only like themselves.

Night is the title of a sculpture which represents first evidence of the breakthrough into a new realm. Fragile, skeletal, it represents a solitary figure in the arrested act of walking, feet apart, hands raised, body bent slightly forward, featureless, immobile, poised upon a rectangular pedestal. Night is the entire work, not the figure alone. As in all of Giacometti's sculpture, the pedestal is not only an aesthetic device but also a conceptual necessity, for it represents the world in which the figures stand on their own. This slender, attenuated being was a direct descendant of the tiny figurines, isolated in space as they had been, but now clearly on the way to a more positive destination.

The sculptor set to work with exuberance. After a decade of baffling labor, he had seen how to fuse the rediscovered energy of youth with the disciplined vision of experience in order to activate —again, but not in the same way—the expressive potentialities of his innermost self. He worked from his imagination and memory but also directly from life. That, too, was a change, and all in all, in every way, it seemed that change begot change.

As usual, Alberto turned to those close to him. Diego first. He posed for paintings and drawings, and it was just like old times. The artist also made drawings of Sartre and Aragon. He worked on a bust of Simone de Beauvoir, painted the portrait of his friend Tériade, editor of *Verve*, began a bust of Marie-Laure de Noailles and one of Picasso. In addition, he kept working on sculpture of less specific inspiration and fought its old tendency to grow tiny. "I swore to myself," he said, "no longer to allow my statues to shrink even an inch." He could not have made that vow with much conviction a few months before.

by by by

At Easter, 1946, Alberto returned to Geneva for a visit with his mother. In the perspective of what had meanwhile happened in Paris, things looked different, and so did he. The one most concerned by changes in point of view would have been Annette Arm. She had not left off looking forward to joining Alberto in Paris, and there was, among other things, a monetary debt outstanding. Then, perhaps, the artist may have welcomed an opportunity to scold her for not having sent the right shoes.

The point of view from which they saw each other *had* changed. Annette now posed for Alberto for the first time. The fact looms large upon the vista of mutual expectations, because it invited her into his world while appearing contrary to all logic. But that was the logic of Alberto's nature: unpredictable, perverse, impulsive. They talked about her desire to come to Paris. She didn't beat about the bush but asked outright. He cannot have been surprised, and his answer must have been in the making even before he beheld her as a focus of the creative act. He agreed.

Suddenly the entire geography of Giacometti's life is seen to shift, creating new perspectives and casting shadows where there had been none. This was the one and only time he submitted to the desire of another person to enter his life. An unlikely thing, to say the least, its improbability grew into a kind of artless virtue which eventually saved from human inadequacy something, at least, like love.

One good measure of altered terrain was Alberto's warning that his life would not be altered in any way by Annette's presence. The warning should have been addressed to himself, cautioning against evasions of a responsibility which he was ill-prepared to assume. He knew more than enough about the destructive power of the creative compulsion. Creativity does not necessarily require exercise of that power, but few men have the strength of character to resist such easy corruption. That the struggle to do so may be essential to an artist's integrity, however, Alberto knew and believed. And yet, at the midpoint of his adult life, he was entering into a commitment which gave fair promise of leading to exactly the kind of entanglement he had for so long avoided. Maybe he believed that Annette's presence would not change his life. Maybe he believed that it would not change her. No matter what he believed, he was not merely mistaken, he was at fault.

For Annette, the view of things to come was very different. The terrain of her life being still terra incognita, she could neither foresee nor forestall what would happen as a consequence of her initiative, nor did she care. There would come a time when she said that she had fallen in with an artist's way of life by chance, and it would be a convenient thing to believe. If Alberto had to some extent led her on, she had followed with a will. She cannot have known what she was getting into, but she knew fairly well what she would be getting out of. She was determined to discard the standards that had governed her background, though these would inevitably take the measure of her fulfillment, as she was a woman of emotion, not of reason. Her dearest desire would consequently be to possess what she was unable to have. For that gratification, Alberto gave promise of being an ideal partner. If he was, she would be, too. Lest such relations seem to have come about by accident, it will be well to stress again the element of premeditation on Annette's part. True, she was heedless-and so was hebut that is not to be blameless.

Back in Paris, Alberto began to have second thoughts. He wondered especially how Annette would fit in. Her presence would look like a deliberate choice. But such a choice was opposed to convictions he had held and reiterated for years.

Alberto's friends in Paris were a more selective and critical lot than those he had frequented in Geneva. Annette had learned to hold her own with them, but getting along with Picasso, Sartre, and Simone de Beauvoir would be another matter. In addition, Alberto belonged to a special little group that didn't like outsiders. It included Balthus, the writer Georges Bataille, the psychiatrist Jacques Lacan, and a few others, as well as their wives and/or mistresses. One of these others was a Chilean painter, a latecomer to Surrealism named Roberto Matta, married to an American heiress, Patricia O'Connell. The young Mrs. Matta was beautiful, high-strung, headstrong. She had an eye for art and artists. She took an especial liking to Alberto, and he to her. He confided in her. Later she would have her own part to play in his life.

The question of providing a suitable home for a young woman did not present itself to Alberto as a serious one. Annette had taken happily to the Hôtel de Rive, and could be expected to do likewise in the rue Hippolyte-Maindron. Anyway, lodgings were extremely difficult to find, and people willingly made the best of bad things. The ramshackle complex of studios has always been one of those, and was now worse. Seven years had passed without repairs, nor was urgently needed work likely to be undertaken soon, though by some miracle the person responsible for seeing to it had recently reappeared.

One spring day Tonio Pototsching came home from the war. His return had tactfully been delayed until there was little danger that opportunism in the service of the erstwhile enemy would get him into trouble. Besides, he was now taking care to portray himself as a victim rather than an accomplice. After fleeing from Paris, Pototsching was borne eastward, kept going by his satchel of money, and finally came aground in Vienna. Hiding out in a room above a jewelry store, he waited for events to take a definite turn. One morning he heard a commotion in the street below, the sound of shattering glass, shouting, and the clatter of horses' hoofs. From his window Tonio saw Russian soldiers looting the jewelry store downstairs, and thought he'd be better off where he'd come from than where the Soviets might send him. Managing to drift back westward, he presented himself to Allied authorities as a displaced person. Not impatient to be repatriated, he took on the character of a genuine DP all the better for believing sincerely that he was a bona fide victim of circumstances. When he finally reached home, he looked like a man come back from death's door, wasted, haggard, and sallow. Taking at once to his bed, he received the sympathetic attentions of Renée Alexis and the brothers Giacometti.

If the question of a suitable home for his young mistress did not trouble Alberto, financial insecurity did. Annette had agreed to be responsible for her support, but there was no reason to think that she had any idea what that responsibility meant. Alberto, on the other hand, knew that money worries were an integral part of every artist's need to justify his way of life. The crucial question was whether he could go on living as he wished by doing only what made him wish to go on living. After the war, the market for works of art was sluggish. Merchandise of Giacometti's manufacture was not in demand. Ten years had passed since he had shown anything in public. His work now was very different, and that was likely to prove a disadvantage because the trend of post-war taste was plainly toward abstract art.

The only Parisian dealer ready to handle Alberto's recent works was Pierre Loeb. True to form, however, he meant to invest a minimum of cash in the artistic venture which profited so much anyway from the prestige of his good taste. Alberto agreed, because he needed money. He was always inclined to put himself in a position where unfair advantage might be taken of him. Though he forgave such treatment with difficulty, he continued to provide opportunities for it. These sometimes aroused resentful outbursts of anger, directed in part, no doubt, against himself. But it soon became clear that Pierre Loeb's days as a maker of taste were past, and that Giacometti could not expect him to be effective as the champion of a middle-aged artist with no reputation. The arrangement fell through.

Other possible dealers in Paris were few. Pierre Colle, who had given Giacometti's first one-man show in 1934, was preparing to go to America, but he died before leaving. Jeanne Bucher was already dead. One possibility briefly presented itself in the person of a young admirer of Giacometti's work named Louis Clayeux, then employed as an assistant at the fashionable gallery of Louis Carré in the Avenue de Messine. Clayeux persuaded his employer to visit the rue Hippolyte-Maindron; it was not a fruitful errand, as Carré cared only for the established values of contemporary art.

abstarl

In Paris, that left only Kahnweiler, Picasso's dealer. But he had never shown interest in Alberto's work, or, for that matter, in the work of any first-rate artist younger than those who had originally made his fortune. Only a single possibility remained, and this was a dealer not even in Paris: Pierre Matisse. After his purchase of the Walking Woman in 1936, he had kept more or less in touch, though he made no further acquisitions. To Pierre's wary eye, nothing since had appeared worth buying. On sociable terms with everybody in the Parisian art world, Pierre knew Giacometti's situation. When he came to France early in 1946, he went to the rue Hippolyte-Maindron to see whether anything negotiable had accrued. What he saw aroused neither acquisitive nor entrepreneurial resolve. Never one to be effusive, Pierre could be insufferably smug when unimpressed. He told Giacometti to make his sculptures a bit larger and left.

The dealer's recommendation was superfluous as well as supercilious. The same advice had already been given by Alberto to himself. He had sworn not to allow his sculptures to shrink. He succeeded. But to his surprise he found that he was able to preserve their height only by making them extremely thin. The taller they were, the thinner they became, while the feet grew disproportionately large, as if the human resemblance he had sought in the tiny figurines refused to conform to "normal" proportions. This evolution toward the tall and slender was the start of what came to be seen as Giacometti's mature style. The development of a strikingly personal style, however, insofar as it fosters a preconceived manner of expression, was not the artist's aim. That he must have a style went without saving, but the essence of style is its cause, not its effect, and Giacometti had long ago been obliged to see that if his work was ever to embody his view of reality, then he would have to accept on its own terms the appearance it assumed. Though surprised by the advent of the tall, thin figures, he accepted their existence as a counterpart of his own. He had begun to put to good use the phenomenological lessons winnowed from years of dust in Geneva. The benefit was enormous.

Drawing was essential to it. Drawing is the most immediate, most revealing, and most universal of all creative acts. It had been

the first by which Alberto had attempted to assert himself, and from now till the end of his life it would be the basis of his activity. It also led to renewed interest in painting. "Perhaps I'm more at ease with painting," he speculated. "Besides, I began that way." The sense of ease was to prove illusory. But sculpture for the time being continued to dominate.

Giacometti would soon be forty-five. His health was good, though troubled occasionally by one complaint or another. The smoker's cough had grown worse, seizing his body at times with uncontrollable spasms. Fatigue troubled him, too, a consequence of more and more frequent nights spent at work.

Annette Arm left Geneva by train on July 5, 1946, a romantic girl from the suburbs, daughter of an obscure schoolteacher, on her way to a rendezvous with history and fame. What she may not have considered, however, is that satisfactions have consequences. Had she had an inkling of those, she might have gotten down from her train at the first stop and gone back as quickly as possible to the place and life from which she wanted Alberto to free her forever. On the other hand, alas, she might very well have gone right on her way.

Alberto was at the station to meet her. His greeting was not what young women in love usually look forward to after several months' separation. He was casual, matter-of-fact. No romantic excitement transfigured the drab platform of the Gare de Lyon. To have agreed to Annette's request in Geneva had been one thing. To find her expectantly in Paris was another. It would have been very unlike Alberto not to wonder what he had let himself in for. Heretofore she had not been clinging, but how could she be otherwise now? The question would have seemed all the more irksome for being provoked by the very person who feared the answer.

Alberto was fascinated by the opposite sex. His fascination, however, had always been fraught with a sense of peril and menace, and those who are apprehensive tend to be aggressive. Because he allowed people to take advantage of him, while repressing resentment in order to avoid unpleasantness for everybody except himself, sometimes he behaved as if with hostility toward others when in fact he was taking advantage of an opportunity to become his own enemy. For him to live with himself was not easy. Living with someone else may have seemed impossible.

When Annette first saw her lover's studio and lodgings, the picturesque dilapidation of the place probably appeared congenial. Concerning material circumstances, she was prepared to accept whatever need be for as long as necessary. Concerning other circumstances, she could thus afford to be expectant. The meeting with Diego went well. She thought him handsome. He found her pretty, pleasant, unassuming. That they should be compatible was cardinal for Alberto. In this regard, at least, the advent of Annette seemed promising.

Alberto took her to Saint-Germain-des-Prés, where they spent the evening at the Café des Deux-Magots with Picasso and Balthus. So her Parisian career started at the top. Before long, she had been introduced to all of Alberto's friends. They found her silly and uncultivated but eager to be liked and ready to please. The contrast to Isabel must have come as a surprise. But even Annette had no idea of what she was capable.

Tonio Pototsching had not improved. Cancer of the liver was the trouble. He was in and out of the hospital, though the eventual denouement was beyond the help of medicine. Increasingly cadaverous, his skin the color of yellow ivory, he lay in the room adjacent to the one occupied by Alberto and Annette, complaining and cursing, tended by Madame Alexis, visited occasionally by his neighbors. Death came at three o'clock in the morning. The date: July 25. Alone, distraught, the bereaved mistress went for help to a person she was sure to find awake, the sculptor working in his nearby studio.

So Alberto found himself again face to face with the paltry impermanence of human life. "No corpse," he said later, "had ever seemed to me so null, a miserable debris to be tossed into a hole like the remains of a cat. The limbs were spare as a skeleton, outstretched, spread apart, cast away from the body, the enormous swollen belly, the head thrown back, the mouth open. Standing motionless in front of the bed, I looked at that head which had become an object, a little box, measurable, insignificant. At that moment a fly approached the black hole of the mouth and slowly disappeared inside.

"I helped to dress Tonio as well as possible, as if he were to appear before a brilliant gathering, at a ball perhaps, or leave for a long journey. Raising, lowering, moving the head like any other object, I tied his necktie. He was strangely dressed, everything seemed as usual, natural, but the shirt was sewn onto the collar, he had neither belt nor suspenders, and no shoes. We covered him with a sheet and I went back and worked until morning.

"When I went into my room the following night, I found that by a curious chance there was no light burning. Annette, invisible in the bed, lay asleep. The corpse was still in the adjoining room. The absence of light was disagreeable, and as I was on the point of going naked across the dark corridor to the bathroom past the door of the dead man's room, I was seized by a veritable terror. Although I didn't believe it, I had the vague impression that Tonio was everywhere, everywhere except in the lamentable corpse on the bed, that corpse which had seemed so insignificant; Tonio had become limitless, and, though terrified of feeling an icy hand touch my arm, with an immense effort I crossed the corridor, went to my bed, and, keeping my eyes open, I talked with Annette till dawn. What I had just undergone was in a way the opposite of what I had experienced a few months before with the living."

The former experience had been the instant of revelation in the theater. It was not an opposite, however, so much as an affirmation of the same awareness, induced by an inversion of the same experience. He had seen death in the faces of the living; now he had seen once more that the dead reveal the truth about life. Sight begot terror in both cases. The man schooled in terror is a man prepared for possibility, because he will expect nothing and therefore be ready for everything. A man familiar with anxiety will look at the world with awe, because each day duplicates the miracle of birth. Inured to absurdity, he will become more and more free to assert the significance of life.

Times continued hard, money scarce. Annette had pledged to earn her keep and was expected to do so. Secretarial work being the only kind for which she was fitted, Alberto found her a position as secretary to an old friend from Surrealist days, a writer named Georges Sadoul, a critic and historian of the cinema. She

worked for him every afternoon and the money earned came in handy not only for her expenses but for some of his as well. Still, it was not enough. They were obliged to keep on borrowing and to take advantage of kindnesses which may sometimes have been mortifying. Annette had inadequate clothes. Alberto could not afford to buy her any, so she had to accept coats and dresses handed on by Simone de Beauvoir and Patricia Matta. There were nights when they had nothing to eat but bread and Camembert cheese. At other times Alberto would go off by himself to dine with friends, leaving Annette to shift for herself. On one such occasion, when he and Diego were sitting at the Café de Flore with Bianca, her husband, and her brother, who were visiting Paris, Annette appeared and said that she hadn't enough money for dinner. He told her to borrow it, naming a possible lender, but she had already tried that person, whereupon he named another, whom, as it turned out, she had also tried. At this Alberto irritably said, "Well, I'm going to have dinner with my cousins, and I can't do anything about it now."

Chagrined, Annette turned away, half in tears, and went off alone. Bianca said, "You can't just send her away like this without a penny." Whereupon Alberto reluctantly went after her, limping.

To Bianca it seemed that Alberto's limp was much more noticeable when the sympathy of others might be called for. So his infirmity could, if necessary, be a source of strength. Its importance, in any event, was great, for he spoke of it often, and everyone who knew him knew that one of the great events of his life had occurred in the Place des Pyramides, followed by many painful weeks in hospital.

People thought Alberto was sometimes deliberately disagreeable to Annette, making fun of her naïveté in front of friends, criticizing her for trifles, sending her curtly off to bed when she became drowsy in cafés. But she did not seem to resent it. She accepted his hardness with her just as she accepted the hard life they lived together. Her endurance was evidently her pleasure. By being unkind to her, perhaps Alberto was doing her a kindness. What he was doing for himself may have been something of the same sort. He was not a callous or cruel person. And he was pro-

foundly attached to Annette. If he had been indifferent, he would have been polite. There was great reciprocal affection and tenderness in their relationship despite its underlying strangeness. Of that strangeness there were strange illustrations.

Albert Skira had founded in Geneva a monthly review of art and literature called Labyrinthe. It, and other publishing projects, brought him often to Paris, where he was pleased to find friends who had been intimates of the Place du Molard, Alberto among them. One October Saturday in 1946, a convivial group invited by Skira gathered at a restaurant for lunch. During the meal, which was accompanied by plenty of wine, talk turned to the topic of keeping a daily journal and of everything that might prevent this. To his surprise, Alberto felt a desire to begin such a journal at once, starting that very moment. Taking quick advantage of an opportunity, Skira asked him to write for the next issue of Labyrinthe the story of Pototsching's death, which he had recently heard. Though skeptical of success, Alberto agreed.

At six o'clock the same afternoon he learned that the Sphinx was about to vanish. The famous brothel, along with its lesscelebrated sister establishments, had been voted out of business by the municipal council. Virtue profited. The prostitutes paid its price. Deprived of the protection of madames, driven into bars or onto the sidewalks, they would henceforth pursue their profession at the mercy of pimps and racketeers. Alberto was dismayed, Prostitution would survive, but not in the context he had for so long extolled and enjoyed. The Sphinx had been for him a marvel surpassing all others. It was intolerable to think that he would never again see the place where he had spent so many spellbinding hours. He ran to the Boulevard Edgar-Ouinet, Having had too much wine at lunch, he was a little drunk and this last time he did not hesitate to take advantage of the opportunity for which the place was made. It proved to be a memorable farewell, and the artist seems to have assumed at once that significant consequences would come from his final encounter with the Sphinx.

Assuming that he had contracted a disease, he began to watch for symptoms of infection. They came late in the night the following Friday in the form of ivory-yellow pus. He was troubled at once by what seemed at first sight to have been an involuntary paralysis of mind, which had prevented him from putting an end to the threat of disease. That would have been easy. Nothing, however, led him to believe in a kind of self-punishment. So he insisted, at least, when he wrote an account of these events shortly afterward. "Rather," he said, "I obscurely felt that the disease could be useful to me, give me certain advantages, though I didn't know what kind." The obscurity of his feelings about the usefulness of the disease conveniently obscured the nature of the advantages. As to the possibility of self-punishment, mentioned only in order to deny it, experience would determine the applicability of his candor.

That same night in bed Alberto told Annette of his disease. Laughing, she asked to be shown the symptoms. It seems natural, and necessary, that Annette should have known of her lover's malady. Considering the unusual conditions of their affair from the beginning, she can have been expected to take this news without indignation, and, perhaps, without aversion. Even without surprise. Mirth, however, gives pause, bringing a somber intimation of ambivalence. The obscurity of Alberto's feelings called for the obscurity of Annette's. She responded as an abstract but cruel personification of womanhood.

Presently, with the bedside light inevitably burning, they slept. Alberto dreamed. His dream was bizarre, bewildering. It stayed insistently in his mind after he awoke. It would not leave him. The following day, he wrote an account of it.

"Terrified, I saw at the foot of my bed an enormous, brown, and hairy spider, and the thread to which it was clinging led to a web stretched just above the pillow. 'No, no,' I cried, 'I can't endure a threat like that all night just over my head, kill it, kill it,' and I said this with all the repulsion I felt about doing so myself in the dream as well as when awake.

"At that moment I woke up, but I woke up in the dream, which went on. I was in the same place at the foot of the bed and at the very moment when I was saying to myself, 'It was a dream,' I noticed, even as I involuntarily searched for it, I noticed, as if spread out on a mound of earth and broken dishes or flat little stones, a yellow spider, ivory yellow and far more monstrous than

the first but smooth, and as if covered with smooth vellow scales and with long, thin, smooth, hard legs which looked like bones. Terror-stricken, I saw the hand of my mistress reach out and touch the scales of the spider; apparently she felt neither fear nor surprise. Crying out, I pushed her hand away and, as in a dream, I asked for the creature to be killed. A person I had not yet seen crushed it with a long stick or shovel, striking violent blows, and, eyes averted, I heard the scales cracking and the strange sound of the soft parts crushing. Only afterward as I looked at the remains of the spider gathered onto a plate did I read a name clearly written in ink on one of the scales, the name of that species of arachnid, a name I can no longer state, which I have forgotten. I see only the separate letters now, the black color of ink on the ivory yellow, letters such as one sees in museums on stones, on seashells. It seemed evident that I had just caused the death of a rare specimen belonging to the collection of the friend with whom I was then living. This was confirmed a moment later by the complaints of an aged housekeeper who came in, searching for the lost spider. My first impulse was to tell her what had happened, but I saw the inconveniences of this, the displeasure of my hosts toward me; I should have realized that the creature was a rare one, have read its name, warned them, and not killed it, and I decided to say nothing about it, to pretend to know nothing and hide the remains. I went out into the grounds with the plate, taking great care not to be seen, for the plate in my hands might have seemed strange. I went to a stretch of plowed earth hidden by thickets at the foot of a mound and, sure of being unobserved. I threw the remains into a hole, saving to myself, 'The scales will rot before anyone can find them.' At that very moment I saw my host and his daughter pass on horseback above me; without stopping, they said a few words to me, words which surprised me, and I awoke."

Awake, he looked at his room with terror. A cold sweat ran down his back. His towel was hanging over a chair. He saw it as if for the first time, as if suspended in a terrifying silence, a towel without substance in a stillness never before seen. It no longer had any relation, he felt, to the chair or the table, the feet of which seemed to rest no longer on the floor, or barely to touch it, and

there was no longer any relation between objects separated by incommensurable gulfs of emptiness. He was experiencing again the simultaneous perception of being and non-being, of the living and the dead, which he had experienced after the revelation in the movie theater. It was the same material and metaphysical anguish, and not only of visual origin, but also summoned from the farthest depths of his being by the dream.

The dream obsessed him. It had, in fact, been a nightmare, for it was concerned with matters of life and death, with the earliest. most profound and inescapable anxieties and conflicts to which human beings are subject. Its traumatic effect would persist, precipitating significant consequences. Alberto had lunch that day with Roger Montandon, to whom he related his dream in detail. By a curious coincidence, the dead spider's burial suddenly reminded him of a childhood experience: he saw himself in another clearing. surrounded by thickets at the edge of a forest, brushing away the snow with his feet, gouging a hole in the hardened earth and burying a partly eaten piece of stolen bread. Nor was that all, though by the association of images and ideas it would already have seemed more than enough. The stolen, buried piece of bread reminded him of another one. He saw himself passing through remote and lonely neighborhoods of Venice, clutching a bit of bread that he wanted to be rid of and which at last, after several unsuccessful attempts on the darkest little bridges, trembling nervously, he managed to fling into the stinking water at the dead end of a canal. He remembered all the events which had led up to that moment, and told Montandon about them: the chance meeting in the train to Pompeii, the newspaper advertisement which had reached him by chance, the journey with the fatherly Dutchman, the death in the rainy mountains. Alberto and Montandon also talked about the dimensions of heads, the dimensions of objects, the relationships and differences between objects and human beings, which led back—as though by an itinerary which compels every man to rediscover incessantly the landscape of his lifetime-to the dream.

After lunch, Alberto went to consult Dr. Theodore Fraenkel, who lived on the other side of the city in an ugly building at 47

Avenue Junot. The two had become close friends. Fraenkel was exceptionally timid, and would sometimes sit for hours in a group without uttering one word. Alberto gave him confidence, drew him out, enabled him to become expansive and talk about himself. This tonic effect was the basis of the friendship between the artist and the doctor, who was more than ready to repay the kindness with advice and medicine when necessary, which was rather often. Despite Fraenkel's failure in 1930 to have diagnosed an obvious attack of appendicitis, Alberto continued to believe in his competence and proclaimed him the very best doctor in Paris. A perceptive observer might have concluded that such enthusiasm on Alberto's part could suggest that he was one of the worst. For the complaint which had brought his friend to the office on this day, however, the doctor's skill was adequate, and he prescribed treatment with sulfa drugs.

Leaving Fraenkel's office, Alberto crossed the street and walked downhill under the trees to the Pharmacie Centrale de Montmartre, which faces a small square. A stone statue stands in this square, a memorial to Eugène Carrière, the mediocre painter of misty pictures who had once been the teacher of Alberto's friend Derain. On the base of the statue is inscribed, among others, the phrase: "It is art which renews language by rediscovering the source of our emotions." Coming out of the pharmacy, holding the medicine in his hand, Alberto hesitated on the doorstep, gazing across the square, and the first thing he saw was a small café on the far side with its name on the awning in bold letters: The Dream.

On his way home, thinking about his dream, about the memories it had aroused during his conversation at lunch, he recalled that just one week previously, before his final visit to the Sphinx, he had had lunch with Skira, who had asked him to write for Labyrinthe an account of the death of Pototsching. As he walked along, he remembered that wretched event, which coalesced in his mind with more recent memories and images, and he felt that he would be able to write something. What he wanted to write about, however, was not so much Tonio's sorry end but the dream of the night before, which still obsessed him. It was the dream that seemed to lead to everything else but back to which and through which

Jode uf

simultaneously everything else seemed to lead. It was the dream he determined to write about, and it was for the sake of the dream that he published the text which he began to compose when he reached home that same afternoon. Its title: "The Dream, the Sphinx, and the Death of T." Of some two dozen texts written by Giacometti for publication, this is one of the most autobiographically important and provocative, along with "Yesterday, Quicksand." That it should have been written for Labyrinthe is fitting, as it is intrinsically labyrinthine, repeatedly turning inward upon itself, leading from the dream to other topics but returning via their significance to the dream, which leads to still other topics and eventually to the conclusion that in nothing is there either definite ending or sure meaning, as everything in time and space has simultaneous but elusive being within an incomprehensible continuum, which is, of course, life itself.

Dreams have been considered of great moment in human existence since the remotest time and have recently come to be considered virtually essential to it. Regarding their significance and interpretation, there have been innumerable theories—both before and after Freud—but that the significance is profound there has never been any question. The importance of Giacometti's dream is affirmed by its persistence in his consciousness and conversation, by his having written it down, and above all by his having published it. He took, in short, the trouble to make certain that nobody interested in his life and work should disregard that dream.

It is generally accepted that in the symbolism of dreams a spider is a representation of the vagina; and a fearsome, threatening spider, of the dangerous, devouring vagina. This symbolism is significantly substantiated by the fact that female spiders are well known to have cannibalistic tendencies. Owing to the smaller size of the male and the greater voracity of the female, the male makes his advances to his mate at the risk of his life and is not infrequently killed and eaten by her after pairing. Aware of the danger, he pays his addresses with caution, often waiting for hours in her vicinity before venturing to come to close quarters. In this context, it is worth recalling that Alberto had made many years before a sculpture he called *Woman in the Form of a Spider*, which he hung for

some time directly above his bed and which in his creative development led to the Tormented Woman in Her Room at Night and then to the Woman with Her Throat Cut, a trio of works spectacularly contrived to convey, though at the same time to sublimate, psychic anguish, sexual violence, and ferocious hostility to women. In his dream, Alberto is unable to carry out himself his desire to kill the spider. He is, in a word, impotent. The dream then becomes a dream within a dream, suggesting that the anxiety caused by the situation is so great that the dreamer must assure himself it is "only a dream." An even more monstrous spider appears, though it is not frightening to Annette, who caresses it, whereupon Alberto calls for someone else to kill the creature. He wants a surrogate, a third person, someone more powerful and less fearful than he, someone more potent. But when the deed has been done, realizing that he has caused the destruction of something precious, he hopes to do away with evidence of guilt through the ritual of interment, as he had buried stolen bread in his youth and flung bread into a Venetian canal after the death of van Meurs.

When attempting to grasp the meaning of a dream, it is important to know, if possible, what events came before it in the dreamer's waking life. Alberto went out of his way to provide the information. He had just discovered that as a consequence of relations with a whore he had contracted a venereal disease and had revealed this condition to his mistress, who laughed and asked to be shown the symptoms, a response one might assume to have been humiliating, if not insulting.

Nightmares frequently occur at times of critical developmental progress and express conflicts associated with these changes. One of the essential characteristics of a dream, however, is that it shall seem meaningless or incomprehensible to the dreamer. If Alberto had understood the significance of his dream, he would never have been prepared to talk about it, write it down, and publish it. He specifically stated that the dream had liberated within him certain long-repressed impulses—such as the desire to write about the death of the Dutchman. He had a powerful urge to see, and to tell, the truth. He needed to reveal himself, to show what he was and why, but always in such a way that full understanding

was deferred, one revelation calling for another, ad infinitum. Creativity is an alternative to the conflicts which cause nightmares. The same mechanism which in dreams governs the elaboration of our strongest though most carefully concealed desires, desires often repugnant to consciousness, also governs the elaboration of works of art.

It would be unthinkable to end the consideration of Alberto's dream, of which the connotations are anyway all but endless, without wondering what impression "The Dream, the Sphinx, and the Death of T." may have made upon the author's mother when it appeared in the December issue of Labyrinthe. Maybe, to be sure, she never saw it. But that possibility cannot have been discounted by her son. Annetta was still in Geneva, where the review was published and for sale. Knowing of Alberto's association with it, she could very well have bought a copy. Alberto was aware of this. A readiness to accept consequences is presupposed by an author's willingness to publish. It was perhaps predictable that Annette should laugh and be curious when informed of Alberto's disease. Even more predictable would have seemed to be Annetta's consternation if confronted with such a fact and its implications. As to the significance of the entire text, if she had, perhaps, been surprised or shocked by "Yesterday, Quicksand," the highprincipled lady would have been stunned at this latest exercise in self-revelation. How, one must ask, when he knew the risk and yet had always gone to exceptional lengths to keep from his mother any worrisome awareness, bow could he have taken the chance? The answer must be that the knowledge, and nature, of the risk made taking the chance inevitable, made it, perhaps, desirable, so that it, too, could be united with the fear, fascination, and fructification of the dream.

Giacometti's sculptures continued to be tall and slender, their feet lumpish and long. His initial surprise at these radically altered proportions seems quite soon to have become a pleasurable familiarity, for there was no reversion to the dimensions of the figurines. These had been devised to convey the veracity and intensity of a vision by reducing the human image to an extreme which could be perceived at a glance in its entirety. But this extreme entirety, though it succeeded in creating a truthful and imposing image, failed at the same time to radiate the whole expressive power of a human presence. The problem then was how to achieve this wholeness of expression without any loss of perceptual immediacy. It could not be done by simply enlarging the figurines; their essence had been their tininess, and accordingly an equivalence had to be found which would provide for largeness but preserve the essence. This was thinness. It allowed the eye to embrace the entire figure all at once and to receive an impression of appropriate human stature, while at the same time emphasizing by its style that the impression issues from a work of art. It does more. Whereas in the figurines the dynamism of the image is their whole justification, in the tall, thin figures the dynamism of the material generates a vitality of its own. Giacometti made energetic marks on his materials from this time onward, more vital, visible marks than before, indicating in a tactile, recognizable way how the artist's fingers were governed by his eyes, which were governed equally by his creation and his vision. Rough, rippling, gouged, granular, the texture of his sculptures, though unlike any human integument, has a glimmering animation all its own. This mobile aspect of the sculptural surface amplifies the appearance of volume by more actively engaging the spectator's eye, and by concentrating attention on its own vitality it effectively situates the human image at a fixed distance. While becoming larger, Giacometti's figures, almost all of which are women, have not come any closer, nor have they gained the deceptive solidity of everyday life; size notwithstanding, they are prototypes of physical frailty, unapproachable in their hieratic remoteness.

"What is important," Alberto said again and again, "is to create an object capable of conveying a sensation as close as possible to the one felt at the sight of the subject."

That is no simple matter, for the sensation caused by the subject cannot be likened to the one created by the object—and yet must be its *likeness*—just as the object and subject are of absolutely unlike essence. A drama of conflicting imperatives presides over the perceptual process, in which the subjective view must be recon-

ciled with the objective. In this context of metaphysical give and take, drawing and painting continued to be increasingly important to Giacometti. The linear, two-dimensional mode made it possible for him to experience and explore more directly the uncertain outcome of every undertaking. From that very uncertainty, he forged a style of paradoxical authority. Nervous, fragile lines, tracing and retracing shapes, are charged with a sense of the artist's skepticism about the outcome. Giacometti's drawings convey neither the certainty of forms nor the credibility of appearances but rather the importance of an achievement which is confirmed by the evidence, so to speak, of its failure. In this world there can be no final view of things. Those who claim it are asking for tragedy. Disavowing all probabilities, Alberto undertook each work as a fresh assault on the impossible.

The winter of 1946–47 was severe. There were days when Alberto could not work because he had no fuel to heat his studio, barely enough to eat. Still, he assured his mother that she need not worry. By doing what he did, he insisted, by being ready always to start over and over again, each time as if from the beginning, he would eventually earn all the money he could need. Maybe. He himself was not sure. He felt paralyzed and vaguely unhappy. Under such circumstances, the future could not easily be viewed with the kind of conviction that makes creative anxiety productive.

Patricia Matta and her husband continued to see a good deal of Alberto and Annette. They bought some early Surrealist sculptures, and more recent ones, too, which helped the Giacometti pocketbook. Feeling creative urgings of her own, Patricia had turned to photography, and took many pictures of Alberto and his work. Meanwhile, her marriage to Matta having begun to turn out badly, she felt disposed to have someone else take an interest in her. A man of suitable means and milieu was ready: Pierre Matisse. His marriage had also taken a dissatisfying turn. Patricia's beauty, youth, and money made her appealing, while a highspirited enthusiasm for art and artists added a practical incentive. As for her, she evidently found the Franco-American art dealer a happy change from the Chilean artist. Matisse was a name far more prestigious than Matta. Though old enough to be her father, Pierre was an urbane gentleman, impeccably dressed, capable of enjoying a good joke as well as a good drink, and ready to spend money lavishly when his own gratification called for it. He knew how to make himself seem warm and engaging. The prospect of marriage was soon in the air.

Spoiled, selfish, and basically silly. Patricia had estimable qualities as well. One of these was a genuine concern for the welfare of her friends, especially her artist friends. Devoted to Alberto. she spoke persuasively of his merit to her suitor, who would just then have been an easy man to persuade. It was partly in view of Patricia's admiration therefore that Pierre returned sometime early in 1947 to the rue Hippolyte-Maindron for a second look at the contents of Giacometti's studio. He was unquestionably predisposed to see things differently, as his whole outlook had recently undergone a radical alteration. The things he saw, moreover, were different, very different, from the ones he'd seen the previous year. He must have been surprised, was certainly pleased, and may have felt flattered at the sight of those tall, slender sculptures which incorporated so nicely the departing advice of his last visit. Such was his satisfaction, in any event, that an informal arrangement was soon concluded by which the Pierre Matisse Gallery in New York undertook to exhibit and sell the works of art produced by Alberto Giacometti so long as both should feel a common interest to be well served.

This arrangement came at the right time. It did not make for a quick change in difficult material conditions, because Pierre was loath to let go of money, but there was promise of better days to come. What changed at once was the artist's relation to his work. his way of looking at it, and his sense of its own outlook, because plans were made immediately for an important one-man exhibition in New York. Giacometti had exhibited next to nothing for more than ten years. A few recent works shown here and there in group exhibitions plus some photographs reproduced in Cabiers d'Art did not give any comprehensive or coherent idea of the momentous evolution of the sculptor's art. That would come, if it was to come at all, only through a large exhibition in a great world center. Such an exhibition would take clear measure of the artist's stature, because a man who has done no distinguished thing by the age of forty-five is unlikely to do it later. Though not worried, Alberto was of two minds about the prospect of exhibiting after so long. He felt no uncertainty as to the value of his accomplishments, but at the same time he knew that to exhibit a work is to assert that it

represents a final affirmation. To him, nothing was ever final. The act of creation was endless and unpredictable, starting anew each day, if not each hour. However, he had made progress. Results existed. Sooner or later they would have to be given their chance.

Those tall, slender women with large lumpish feet had freed Giacometti to make sculptures of radically differing form and content. Liberation of a fundamental kind also came from the challenge of an exhibition after such a prolonged interim. To have labored all those years in obscurity had taken strength. To demonstrate that the labor had been worthwhile called for another kind of energy. The year 1947 was a wondrously productive one for Giacometti. He made several life-size sculptures of women, one of a man walking, another of a man pointing, both also life-size, a quantity of smaller figures, some busts on pedestals, a head of a man with his mouth open stuck onto a rod, a grotesque sculpture of a small grimacing head, with an extravagantly elongated nose, suspended inside a cage, as well as numerous paintings, portraits of Diego and of his mother, plus studies of heads related to the busts and, as usual henceforth, a quantity of drawings. When the end of the year approached. Matisse came to select works for the New York exhibition. There were plenty.

Dominating all the rest were those slender, large-footed women. Fresh from the sculptor's hands, they must have looked very mysterious. Though vaguely reminiscent of certain Etruscan figures, they are not derived from them, being far closer in spirit to Egyptian deities. The great religious art of the world has always been concerned with the female principle, and its masterpieces are possessed by a profound stillness. They do not stir or strive. They simply are. The law of their being is to do nothing but be. Giacometti's sculptures live by the same law. In ancient Egypt, a sculptor was called "one who keeps alive." His works were created to represent the idea of eternity, detaching both past and future from the flux of time. They were "true" to life in order to reveal the "falsehood" of death. They made no comment on the how or why of human circumstances but only on the timeless and empirical what. The same may be said of Giacometti's women.

In 1947, for the first time, the entire male figure came forth in

the artist's mature style. Though specific sexual attributes are almost always vague in Giacometti's sculpture, his men are unmistakably male, and they are most often to be distinguished from women by the fact that they do something. They act. They especially walk. A first, very tentative step in the direction of depicting movement had come fifteen years previously with a female figure. But she cannot be said to have gone very far, whereas the life-size man of 1947 is definitely making a move forward. His stance is the onset of an impetus, and the numerous walking men who followed in his footsteps positively stride. This movement, with men in motion, could lead to the conjecture that the artist was motivated by the fact that his own walk was unlike that of most other men. There may be something to it, but it seems a bit too pat, too obvious. In short, too easy. Alberto was never taken in by what was easy, or even very much by what was possible. He knew that simple problems ask for complex solutions, and was by nature attracted to the insoluble. To have expected him to sublimate, or solve, the problem of his injured foot by making sculptures of men who stride. albeit with strangely swollen feet, would have been to put the aesthetic cart before the spiritual horse, and no artist with any common sense would do that. The riddle of the maimed foot would be with him until the end. If he knew the answer, maybe that's why he came to be so mistaken in his accounts of what happened.

Man Pointing is the English title of a sculpture executed in this same year, 1947, though the name given by the sculptor in French is more prosaic, and perhaps more meaningful: Man with Finger. The act of pointing is self-evident. Widely and rightly considered to be one of the artist's most important and evocative, the work is life-size. The man stands erect with superb self-assurance, his large feet set apart on a small base, right arm upraised and forefinger outstretched, head held high and turned in the direction of the pointing finger, as if to obey its signal by gazing outward. The left arm is also upraised but bent at the elbow to make an encircling gesture. It has been said that the sculptor once considered the addition of an accompanying figure, which would have stood within the protection of that gesture. But the space remained empty, the man stands eternally, though expectantly, alone. His gesture and

signal summon no response save our own, which turns back upon itself to the mystery of the man's origin and purpose. In the world to which he points with one hand, while shielding with the other a void, he stands naked, and naked with a nakedness unique in all of Giacometti's oeuvre, for he possesses an explicit penis. It must be said that the member adds little to the sculpture, but Alberto obviously felt that the sex of his *Man with Finger* was too important to be left to anybody's imagination, including his own. As we scrutinize the bronze countenance, it begins to seem—to those, at least, who knew him—that the sculpture resembles the sculptor. It is true that Giacometti's works often looked like him, while he came more and more to look like them, with his high shock of hair and craggy, furrowed face. The *Man Pointing* points to the problem of his own existence, and beyond it to that of his maker, which is just as it should be.

The tall, thin figures of women, the walking man, and the Man Pointing were accompanied by a quantity of other works, of which three attract particular attention. In addition to aesthetic power, they yield proof that Giacometti still drew originality and conviction from experiences profoundly important to him, and remind us that the purely artistic part of a work of art need not be quite everything that one's discrimination is entitled to.

The first of these three intriguing sculptures is called *Head on a Rod*. Neckless, wracked backward in a grisly rictus, it is set on its rod as on a pike, the mouth agape, a soundless black hole, eyes bulging but sightless, a death's-head. In all Giacometti's oeuvre there is no other work so overtly meant to show that man will be made into dust. Given the artist's well-known preoccupation, plus his readiness to dwell on the aftereffects of a particular, long-ago experience, *Head on a Rod* has often been seen as a memento mori identifiable with that event. More likely, however, would seem its reminder of the less remote though no less pitiful demise of Tonio Pototsching.

The second of these sculptures does, perhaps, refer back to the vigil by the bedside of the Dutchman, which had been renewed in memory not long before by the nightmare. Alberto pointedly recalled his attempt to draw the tragic profile, the sunken cheeks,

open mouth, and the nose that seemed to grow longer and longer as he watched. The Nose is, indeed, the sculpture's title, its principal part and haunting image. Like a long, tapered, dangerous skewer, this preposterously proportioned proboscis sprouts from a head proportionately small and misshapen, shrunken as a trophy of the Jivaro Indians, its gaping mouth the only other recognizable feature, with a withered, pitted, bulbous neck. This weird, humanoid thing is suspended like a trophy in a cage. For the first time since Surrealist days, the sculptor reverts to an architectonic device used then to provocative effect. No fanciful, abstract elements, however, obscure the significance of The Nose. It is in dead earnest. Nothing is intended to hide the hideous immediacy of its meaning.

The third sculpture, called *The Hand*, seems at first unlike the other two. It is actually an entire arm, emaciated, almost skeletal, bent slightly at the elbow, one end a rounded stump, the other a hand with splayed fingers. Fixed in midair to a rod, it looks like an anatomical study. That is how we might always have seen it save for the chance survival of a few scrawled phrases in which Alberto speculated with himself concerning capital aspects of his existence and experience. As to what mattered to him most, he debated the relative importance of, first, the eye. Then the foot. Or the open mouth of the old man from Amsterdam stretched out dead in the Italian mountains. Rather, he thought, the foot—his foot crushed at the Place des Pyramides in Paris. "Or the arm-hand in bronze with burned fingers? . . . and shrunken . . . and stinking . . ."

(We may observe once again that no man's care for accuracy is immune to error: van Meurs was a native of The Hague, not Amsterdam.)

What is the bronze arm-hand with burned fingers which asked for an accounting on a par with the Dutchman's death or the accident? A disembodied arm, shrunken, stinking, its fingers burned. It had lain in Alberto's path one beautiful June morning seven years before in the town of Etampes. The sculpture assumes searing significance as a haphazard item from the inventory of human horror. It shows again how Giacometti worked to fuse the personal with the universal.

Pierre Matisse was pleased with the products of so much

creativity. He sent complimentary telegrams. Alberto never liked to be told that he had done well, and his dislike of praise had deeper roots than knowledge that satisfaction is the artist's enemy. Without false modesty, he told Pierre not to pay him compliments. He would undoubtedly have preferred to be paid cash, but the dealer remained chary of disbursement, as usual. Despite telegraphic amenities, he intended to consider, and manage, this newcomer to the stable with a firm hand until his worth had been demonstrated at the finishing post.

As for the artist, Giacometti meant to stake not only his future but also his past on what took place in faraway New York. The intent is clear in his choice of works, which included examples from almost every phase of his career, beginning with the Torso of 1925 and continuing through the Surrealist period. The decision to commit his lifework to a public confrontation in a foreign city of which he knew nothing may strike one at first as odd. Nobody in 1947 could have foretold that New York would presently replace Paris as the center of contemporary art. To be sure, European dealers were not clamoring to exhibit Giacometti, and he was constrained to welcome the opportunity that came along. Still, the wholeheartedness with which he welcomed the American opportunity seems prescient. Genius presupposes a knowledge of what's best. Alberto loved Paris. He never for a moment contemplated living anywhere else, and yet he saw it, as he saw himself, as the end of something rather than the beginning. He compared Paris in spirit to the only other city which figured largely in his life and imagination: Venice, the cemetery city par excellence. Though he may have accepted himself as one of the last representatives of a vanishing tradition, nonetheless Giacometti wanted his work to live up to it. By choosing New York, the greatest city of the New World, as a place to renew after long absence the relation of his art to other lives, he was holding out his hand toward the unknown.

Practical preparations proceeded apace. Pierre Matisse was partial to bronze, though parsimony precluded his paying for large quantities of it prior to certainty of sale. Eight or ten sculptures were nonetheless cast at a foundry in the nearby suburb of Malakoff. Most of the works chosen for exhibition remained in plaster,

which could always be cast in bronze later on if acquisitive collectors proved forthcoming. Of all the sculptures which might have been included, there was one of more than aesthetic note: the bust of Picasso. Pierre wanted to show it. Picasso was the contemporary artist most exciting and controversial, especially in America, where the war had stimulated rather than stifled artistic interests, and the association of his name would have added prestige to one little known. That likelihood occurred to Giacometti. It would be very, very disagreeable, he declared, if anyone should think (and there would be people to think it) that he had exhibited a bust of Picasso to make a kind of publicity for himself. In any case, that would ruin all pleasure in the exhibition. So the bust was not shown, and the artist's pleasure in his exhibition, though he was not on hand to see it, presumably went unimpaired. As for the bust, it eventually perished, and so did the friendship.

No consideration of compromised integrity entered—as yet—into Alberto's relations with Jean-Paul Sartre. Not, admittedly, as famous as Picasso, the philosopher was nonetheless an international celebrity, whose prestige could also bring associative benefit in the public eye. Nobody, however, seems to have thought it would be in the least inappropriate for him to extol the merit of his friend's accomplishments, and Sartre accordingly penned a four-thousand-word essay as a preface to the exhibition catalogue. Entitled "The Search for the Absolute," it is a brilliant, intellectual edifice erected upon the scaffolding of Giacometti's own ideas, interpreting the sculptor's endeavors as a felicitous example of Existentialist commitment.

Giacometti never meant his work to express or illustrate any system of thought, and yet it was widely seen as "an art of Existential reality," a formal effort to depict man's solitude in a precarious, incomprehensible universe. Such interpretive license was, perhaps, in keeping with the post-war climate of anxiety, but Alberto was never motivated by anything so obvious as a desire to represent the contemporary psyche.

The Giacometti exhibition at the Pierre Matisse Gallery in New York opened on a Monday, the 19th of January 1948. It included more than thirty sculptures, two-thirds of which were recent, including The Nose, The Hand, Man Pointing, plus a selection of both large and small standing female figures. Also shown were the two major paintings of 1937, Portrait of the Artist's Mother and Apple on a Sideboard, and a number of drawings. The exhibition certainly looked impressive, especially with so many recent sculptures in pristine plaster, some of them painted. It must have looked strange and surprising, too, because nothing like it had ever been seen before. But those who saw it were probably not many. Pierre was always better at showing to advantage the private aspects of an artist's work than at promoting the public strategy of a career. Besides, the excited attention of the New York art world was concentrated at that precise moment on another exhibition.

The coincidence is intriguing. Alberto's sense of propriety had made him refuse to exhibit a bust of Picasso. The exhibition then focusing all interest was "the first world showing" of Picasso's most recent paintings. Picasso was news. His works and personality fascinated even those who were outraged and scandalized. The papers were full of pro and con—political, ethical, pictorial—while talk of high prices titillated both connoisseurs and philistines. No other artist of modern times had so seized upon the public imagination. Nor was that a coincidence, either. About Picasso's person and career there had from the start been an aspect of legend, and now it had begun to assume the identity and activity of the artist himself. Giacometti's perspicacity in taking care to disassociate himself from this ambiguity was characteristic and astute. No Faustian aspirations or delusions ever distracted him from the task at hand.

Albeit unadvertised and uncelebrated, the Giacometti exhibition was a success. Influential collectors, curators, and artists came to see it, talked about it, and proclaimed its importance. Things sold fairly well, though Pierre was not a shrewd or spirited salesman. More artful and farsighted, perhaps, as a collector than as a dealer, he bought for himself a number of the best pieces. Patricia Matta bought a painting and two sculptures. What the exhibition altogether owed to her flair and charm as well as to her talent with a

camera was coyly implied on the first page of the catalogue by a statement that the photographs therein had been taken by "Patricia." Maybe, too, that was another way of saying how deeply the dealer appreciated the photographer. They were married not long after.

Annette did not enjoy working as a secretary. She had come to Paris to be Alberto's mistress and did not want any other occupation. Regular employment smacked of the bourgeois background. She had agreed to pay her own way, but she preferred to do so by putting up with less rather than providing for more. Hardships apparently did not upset her. They were shared. And it was natural enough—it was, in fact, all too natural—that she should look to Alberto as a provider—if not in the present, then in the future and that she should make the best of the present, which was not always a very good thing, in expectation of better times to come. Everything considered, Alberto and Annette got along well. She was spirited, good-natured, easygoing. She could not take seriously the things which were most serious to him, and that was of advantage to them both. Alberto does not seem to have felt for her the kind of passion he had felt for Isabel. That, too, was to their advantage. From the years of passion for Isabel, not many masterpieces remained. The years with Annette were replete.

Their relationship was nonetheless exceedingly complex, because he was. She had no choice but to conform as best she could to the complexity. In spite of his ambivalent teasing or occasional truculence, Alberto obviously liked the role of paternal lover. Annette was happy to do, and be, whatever he liked. Adaptability, in any event, was a sheer necessity. But there may have been stirrings of bewilderment, even of shock, when it began to appear that her lover's willingness to accept a diversification, so to speak, of her affections might not have been occasioned solely by mistrust of his ability to prove himself adequate for their normal satisfaction, might, as a matter of fact, have been sustained by a need to

find in the repeated proof of others' desires the most satisfying affirmation of his own. The surmise remains a surmise—informed, however, and prompted by Alberto's well-advertised and continuing predilection for prostitutes.

It is axiomatic that what takes place between two people when their bedroom door is closed should remain between them. But a different kind of tact is required when the door remains ajar, ajar, moreover, for the admission not only of perceptions but of persons. When a company of two becomes a crowd of three, gregarious instincts abrogate the prerogatives of privacy. Men of great stature cast such deep shadows that murky corners will always be found in their vicinity. Candor can only clarify, and clarity has a claim on our prospects which Alberto would have been the first to acknowledge. He was difficult to live with, if only because the few persons who shared his life were compelled to share the whole of it, which took a lot of doing. The commitment which he expected of himself, however, he did not ask of anyone else. For that, he knew he must go it alone. He tried to respect the integrity of others. He tried as hard as a man can, and failed, of course, but the effort made a mark. It marked Annette, too, though in a different way, because a woman may find it hard to see why the proof of a man's desire need be given by another.

Her position was not easy, either, between two brothers who for twenty years had been inseparable. Diego found women neither as capable nor as companionable as men. He lived with Nelly, but she was kept, and remained, in the background. Gladly or not, she knew her place and stayed in it. But she remarked with feeling that she had never been accepted by the Giacometti family. Annette was. Alberto accepted her and installed her in the midst of his life. Diego, Bruno, and Odette acknowledged her right to be there. The most important member of the family was less accommodating. Annetta inevitably learned of the liaison between her favorite son and a young woman from the suburbs of Geneva. She did not approve. Annette suggested sending a photograph of herself to the finicky matriarch, but Alberto said that Diego had tried the same tactic with unhappy results. He was obliged to visit his mother alone. A state of affairs probably pleasing for both.

The shadow months in Stampa, when sunlight never touched the valley floor, were those Alberto preferred. "Alas," Annetta told him, "you like the shadow." It was so. His mother, however, had no inkling of what dwelt in the unlighted places of her son's life. If she regretted his preference for the shadow season, she was always glad when it brought him back to Bregaglia, where she could care for him and mother him as she always had, calling him to eat and trying to keep him to a regular routine. If he lay too late abed in the morning, she did not quite dare intrude on the bedroom itself but made a terrific racket in the house, slamming cupboard doors and rattling chairs on the wooden floor, so that he could not ignore her summons. But she cared for him best by the mere fact of being there. Her wonderful permanence was the guarantee of her good. Sometimes she felt twinges of conscience because for her sake he had to leave behind his work in Paris, but was consoled by the thought that with her he got proper rest and food, led a regular life. Besides, he could work while there. Both in Stampa and Maloja, his father's studios stood waiting, with Annetta ready to pose, though she occasionally complained that her son's portraits made her look like a witch.

People were sometimes startled by expressions of the care of mother and son for one another. In that winter of 1948, for example, they went together to Bern, where an exhibition of contemporary sculpture of the School of Paris included among its hundred and forty-four items six sculptures by Giacometti, along with pieces by Arp, Laurens, Pevsner, etc. Alberto was famed for fussiness over the installation of exhibitions of his work. On this occasion his mother told him how to go about it, and he surprised the onlookers by heeding her advice like a schoolboy who has come in from play to do his homework. The exclusive tie binding Annetta and her favorite son was taken for granted by everyone, and it is a famous fact that a mother's favorite often keeps for life that confidence in success which can induce real success.

Diego made a vocation of his care for that success. Nobody knew better than he how difficult his brother could be. Living with that knowledge was a life work in itself. Diego did better than live with it. He added. His practical assistance became ever more important. He not only prepared the armatures for sculptures but saw to the last touches of the finished product, the patinated bronze. He gave much-needed counsel about sales and prices, with a realistic common sense his brother lacked. He posed for innumerable portraits. He even managed to do a bit of work for himself, which was not the least of his contributions to fraternal success. He got along amicably with his brother's young mistress, though he felt that she made no effort to improve on difficult living conditions. But neither, for that matter, did Nelly. Diego kept criticisms to himself. Being closemouthed helped him to help his brother.

Sometime in 1948 the studio next door to Alberto's on the Hippolyte-Maindron side became available, and he seized the opportunity to have the place where he slept adjacent to the one where he worked. The unity was accomplished at some sacrifice, for on this side there was no bathroom, and the primitive communal toilet was across the open passageway, a remove inconvenient in the best of weathers. The new bedroom had a large window facing north, a couple of cupboards and shelves, a sink in one corner with cold running water, electricity, a gas burner for cookink, a coal stove for heat. Alberto and Annette added a double bed, a chest of drawers, three tables, and as many chairs. That was all, and it wasn't much. Having no choice, Annette, as usual, adapted herself to these austere circumstances, and did the minimum of housewifely work necessary. It was enough, because a housewife -indeed, a wife of any kind-was the very last thing Alberto wanted. Precious few meals were ever prepared at the rue Hippolyte-Maindron. The irony is that Annette's guiding dream was of established domesticity with Alberto at its center. Nothing could have been less likely to come about. But the dream was selfsustaining, and as such could not have been expected to do anybody any good. Meanwhile, she was amenable and filial, and there were frequent good times for her and the two brothers.

In the rue d'Alésia, not far from the studio, there was a brasserie called Les Tamaris run by an ex-convict from the Bastille called Jacques. The petty crooks and roughneck youths of the neighborhood hung out there, and it was the first place visited by the police if anything went wrong in that precinct. A couple of shabby artists with plaster in their hair and clay under their fingernails attracted no attention at Les Tamaris. The food, though not very good, was inexpensive and nourishing, served at any hour of the day or night, and customers were welcome to linger at their tables as long as they liked. Alberto, Diego, and Annette ate hundreds of meals at Les Tamaris, and Alberto made hundreds of superb drawings on the paper table covers, all of them thrown away afterward by the waiters.

In the meantime, Francis Gruber, at the age of thirty-six, was dying of tuberculosis in the Boucicaut Hospital. He was the best friend Diego ever had, an intimate of Alberto, too, and closely associated with him as a colleague for more than ten years. The burial took place in a country cemetery near the village where the Grubers owned a house. Alberto was beside himself, and his friends were taken aback by the show of emotion. Later he drew designs for Gruber's tomb, and journeyed twice to the little town of Thomery to see that his friend's grave was all right.

Loss of one friend could never be offset by acquisition of others. However, Giacometti came by new friends easily. It was about the time of Gruber's death that he met one of the more unusual among his many unusual friends. The name was Olivier Larronde. Born in the South of France, only son of a journalist, he was taken during the war to a small town near Paris, where he grew up. Gifted with a flair for language, he began early to write poetry of remarkable ingenuity and was equally accomplished as a talker. In addition to these endowments, he was extraordinarily handsome, with honey-colored hair and an enchanting smile. Somber foreshadowings, however, had also fallen upon this brilliant young man. He was obsessed by the memory of a younger sister named Myriam who had taken her own life at the age of fourteen. He had a morbid fear of being trapped, intruded upon, or diminished by others, though he longed to be found appealing. People willing to appreciate his poetry, and person, were forthcoming, and one of the first was a man of exceptional magnetism and talent, then little known and not very long out of prison, called Jean Genet. He happily took the young poet for a while under his hardened wing.

Not long afterward a romantic, free-spirited young fellow named Jean-Pierre Lacloche came along and fell in love with Olivier. Also strikingly handsome, though dark, he was not a poet but lived in an aura of idealistic chivalry, for during the war he had run away from safety in America to join the Free French as a parachutist and proved his valor in action. Peacetime called for other kinds of gallantry. He and his brother François came to the attention of a gentleman named Georges de Cuevas, a South American boulevardier who had wed John D. Rockefeller's granddaughter, and a trickle of Standard Oil munificence was thenceforth diverted to the benefit of the Lacloche boys. Luxury was not adventure, however, so a soothing substitute was sought and promptly found in opium. The attraction of Jean-Pierre and Olivier to each other, and the addiction of both to the drug, was immediate and lasting.

The two young men made a striking couple. They settled in a spacious apartment opening onto a garden and filled it with ornate, outsized pieces of furniture, brocade draperies, the pelts of tigers and leopards, antique tapestries, and large paintings in gilt frames. Then they acquired a bizarre assortment of pets. Devoted as they were to each other, they cared greatly for monkeys, too, and over the years kept a number of them, large and small, male and female. Snakes also appealed to them, so they had a few of these as well, while in a glass aquarium they kept several large and extremely venomous scorpions. In the high, cluttered, stuffy rooms, the clinging effluvium of monkeys mingled with the odor of opium. The luxurious profusion of expensive appointments was none too clean. Thus, it was in a rarefied, fin de siècle, slighty decadent atmosphere that the young lovers elected to live. That was fitting, for Olivier Larronde sought his poetic precedent in models influential at the end of the previous century, especially in the works of Stéphane Mallarmé, whose obscure, elliptical verse dispensed with conventional syntax and intelligibility. Larronde's poetry is precious and euphuistic, characterized more by complexity of form than by significance of content. His first volume, The Mysterious Barricades, was published in 1948, when he was twenty-one. Another, entitled Nothing There Is Order, appeared ten years later with illustrations by Alberto Giacometti.

Prospects at first glance would have looked poor for close friendship between the poet and the sculptor. Aside from a casual community of interest and a readiness for bohemian conviviality. there seemed little to draw them together. But the tie was deep. Its nature and its depth became more apparent as the years passed, as Olivier's life and personality deteriorated into baleful disorder. He did not possess the resources of character, the resilience of mind. even the physical stamina to make of decadence a kind of moral virtue and spiritual strength. He clung to the memory of his dead sister as a source of purity and goodness. It did not help. He was attracted to Giacometti by the older man's ability to do exactly what he found himself unable to do: to save from the slightest taint of triviality or corruption the vital principle of his existence. Alberto was profoundly touched by Larronde's failure. The friendship, which puzzled some people, was really invested with the richest of prospects, and the proof of their value, perhaps, was that they were of no avail in the end.

Whether or not Isabel actually meant, as she had alleged, to make short work of René Leibowitz, that is what happened. Their affair lasted little more than a year. She went back to London, where in 1947 she married her wartime crony and drinking companion, the composer and conductor Constant Lambert, a man more famous than Leibowitz. She came over to Paris frequently, though, and sat about in the cafés with Alberto, Balthus, and others, laughing her head off and drinking far more than was wise. Despite his description of Isabel as a devourer of men, Alberto was glad to share with her that privileged but sometimes slightly perverse kind of intimacy which former lovers oftentimes share. Constant Lambert didn't object. He, too, kept on drinking, and after four years of marriage died at the unbecoming age of forty-five.

Before long, Alberto started asking Annette to pose for him, though at first for paintings only. They are very recognizable as portraits. She appears both clothed and nude, seated and standing. There is an intriguing dichotomy between the nude figures and the clothed ones. The latter look a bit awkward or ungainly, with an ungainliness which seems specifically girlish, and one may think that that was how it satisfied Alberto to see her. He saw in her what he sought in his work, anyway. The nude portraits are very different. Here she is entire as a woman, replete in the self-possession, power, and awareness of her sex, motionless but vibrant, visible but untouchable. In mastery of execution and confidence of vision, these works show Giacometti for the first time fully mature, at the apogee of his powers as a painter.

Posing for Alberto had not gotten any easier. His demands for absolute immobility became relentless as sessions grew longer and longer. The amount of time devoted to a single painting could extend indefinitely without relation to a possible conclusion. Like Cézanne, Giacometti never felt that anything was definitely finished, and he was irritably intolerant of distraction arising from a model's failure to match his own concentration. There can be no mistake about it: posing for Alberto was hard work. Annette stood up to the stress with creditable patience and composure. It was quite worth her while to do that, because it allowed her to beg off from the secretarial work she found tedious and a little demeaning -and at which she was but moderately proficient-in favor of an occupation which, while demanding, also raised her status to the dignity of vicarious participation in a calling of high honor. That was the end of her short-lived career as a professional person, and the start of her initiation into an employment which no woman is likely to think that she was made for.

"In a burning building," Alberto once declared, "I would save a cat before a Rembrandt." That order of priority expressed a reverence for life. It also spoke for an awareness that art amounts to little in the balance of living and dying. However, the artistic work demanded submission to its needs even as their fulfillment seemed to entail a kind of disregard of himself, in the first place, and, in the second, of those whose proximity, and feelings, made them most vulnerable to disregard. He had no choice but to live as best he could with this contradiction, but he did not expect anyone else—except Diego—to do so. "What I am looking for," he said, "is not happiness. I work solely because it is impossible for me to do anything else." That was all very well, and all to the good, for him. But one who has little care for his own happiness is ill suited to provide for the happiness of anyone else, and if he is a man of conscience, he will take pains to avoid becoming responsible for it.

Annette had longed to be set free from the lacerating anonymity of a bourgeois background. To that end, and to just the extent necessary for seeming entitled to it, she was ready to suffer. In fact, it may be that that is what she was best, and most, prepared to do. Putting one's background effectively behind one takes intellectual resolve and a character of solid rock. Annette had only her longing, which perversely but constantly put the background into the foreground. Five years with Alberto had only intensified her desire for a domestic setup that would satisfy the standards of Grand Saconnex. The case was complicated rather than eased by their devotion to each other. Love, however, cannot save lovers from their faults.

Annette wanted to get married. That should have been un-

thinkable. But she didn't think. Having become important to her lover in his work as well as in his life, she must have assumed that she could risk putting her importance to the test. It was too bad, because that test in the long run could have only one result, and the risk for her was final. She appreciated his importance greatly, since she loved him, and her appreciation seemed to be the logic of her claim, but she understood very little about his significance, since it had nothing to do with love. The grounds for union were, consequently, shaky. And yet she was tenacious in pursuit of matrimony. Her lover turned evasive. The thing was difficult for both.

Alberto knew that the maker of decisions must accept responsibility for them. And he knew that nobody has ever been entirely free to make choices, to measure prospects for satisfaction, or to judge accurately the wisdom of decisions affecting not only himself but others. In addition, the institution of marriage as a symbol of right human relationships put an intimidating weight on the mind of someone who knew that he could never wholly fulfill the natural expectations of a wife. Moreover, being a husband would be a damn bother, because he had work to do which admitted no other right to his time or energy, and it did not ask for anybody's approval or affection. He hesitated. He said, "The easiest thing in the world is to take a wife, and the most difficult is to get rid of her." But there was his mother to be considered, and Alberto never needed urging to do that. Annetta had come to favor her son's marriage because she deemed that state fitting. He knew that he could never bring his mistress to his mother's home as long as they remained unwed. And now that she had become his model he would have liked to take her along to Bregaglia, where she could continue to pose. He would also have liked to please his mother. And, as a matter of fact, he would have liked to please Annette. But how was he to reckon the needful balance between doing as others wished and being as he must? No wonder he hesitated.

Hesitation led to crisis. Alberto resolved it, with the sanction of creativity and genius, by saying yes. He had always said yes to life. "Yes" was the answer of the artist, the response of a man dedicated to doing, proof of his devotion to the positive. By agreeing to marry, he agreed to give a fuller measure of his humanity, and his

decision reflects an appreciation of the contribution Annette had already made to that measure. The forty-seven-versal experienced a rehimbal should not be astonishing that in his personal life he found himself prepared to accept the adoration and companionship of a woman twenty-two years younger. However, he wanted it clearly understood that nothing would be changed. He insisted on it: Annette was not to assume that the formality of marriage would in any way alter their relationship or make a difference in their behavior. He had insisted that her coming to Paris should make no difference. Here, nonetheless, was prima facie evidence to show how different everything had become. But she could easily agree that nothing would change, in the knowledge that her own metamorphosis was to be so radical. One day the issue of their sincerity would weigh heavily in the balance.

Alberto's betrothal came as a stunning surprise to his entourage. For those who had been treated to his tirades against everything marital, to his scorn for conjugal sentiment as wishy-washy compromise and his paeans in praise of prostitution, the news was a rude shock. Even Diego was taken aback; years later, in enduring bemusement, he occasionally said, "She really must have worked him over to get him to marry her." And indeed the business presents a puzzle. "Yes" may have been the artist's answer to life. but Alberto's life was wed to art; it asked questions to which workaday experience held no reply; its commitments needed no formal vow to be binding. Contradiction, however, is at the core of an artist's being, because he thrives on the infinite multiplicity of possible choices. But only his being is at stake in this ceaseless confrontation of alternatives. Allowing someone else to come into it can be perilous. But that is just what Alberto agreed to do. People wondered why. An explanation of sorts was given a decade or so later by the artist himself to the woman who replaced Annette in the center of his life and became for him the climactic incarnation of feminine allure, mystery, and divinity. When she asked how he had come to marry, he said that his agreement had finally been given when Annette declared that otherwise she would kill herself. If so, how serious she was we can never know. The

chances are she didn't either. As she saw her hopes continually deferred, there arose, perhaps, a sense of despair all too familiar from the past, proving yet again its inescapable dominance. By declaring that she would do away with herself if Alberto refused to marry her, she may merely have affirmed her conviction that the self with which she could do as she would was so completely dependent on him that his refusal must bring an act of total negation.

No matter what Annette said, thought, or felt, the positive commitment to marriage was made by Alberto alone. He knew that, and knew he had the resources to stand by it. Whatever the cost, he could, and would, meet it. But he had no way of knowing whether he could count on the resources of the one who had solicited his commitment. In fact—and this is just where he went wrong—by asserting with such insistence that the marital state must never be construed to have altered anything between himself and his wife, when he cannot have failed to expect that it would alter everything. Alberto seems to have needed to emphasize that he was taking a step directed toward destiny more than matrimony. And so he set foot on terrain where neither wisdom nor caution could guide him. He had been at fault in permitting Annette to join him in Paris. He compounded the fault by consenting three years later to marry her. But the fault-like the knowledge of his commitment -was entirely his, and he never tried to shift or shirk it. He met the cost, which turned out to be almost as great as the value added to his art.

There was a legal nicety. Marriage in France means that both parties, citizens of another country or not, are subject to French marital law. It stipulates that all property is held jointly by the couple unless at the time of marriage they sign a contract specifying that each is the sole owner of his, or her, property. In other words, without such a contract, Annette as Alberto's wife would take legal title to half his work. Displeased by that prospect, he insisted that the contract be part of the marriage act. He obtained the necessary document. But then, as so often when a prudent decision called for practical application, he didn't bother to pursue it.

Needless to say, anything remotely resembling a ceremony was out of the question. The event itself would be more than ceremonial enough. Alberto did make one concession. He got out of bed early. It was Tuesday, July 19, 1949. In midmorning, the bride and groom walked to the nearby town hall of the 14th arrondissement, accompanied by their witnesses, Diego and Renée Alexis (who had stayed on as concierge after the death of Pototsching). So Annette Arm and Giovanni Alberto Giacometti were married. When it was done, they went with Diego to lunch in a restaurant. Then Alberto returned to the rue Hippolyte-Maindron and got back into bed.

A honeymoon would have been laughable, but later in the summer the artist took his bride to Maloja, where she was presented to his mother. The two Madame Giacomettis were predisposed to like each other. Annetta thought Annette "a nice girl," though she observed that her son treated his wife like a daughter.

The years 1949 and 1950 were anni mirabiles for Giacometti, wonderful in the wealth, diversity, and mastery of works produced. One after another, the most extraordinary productions emerged from his studio. They include at least a dozen of those by which he remains most vitally present among us. To try to say how this came about would be, perhaps, to do away with an essential part of it. The artist himself, though, deserves to be heard. In this context, as in so many others, Giacometti found penetrating observations to be made. "In every work of art," he said, "the subject matter is primordial, whether the artist is conscious of it or not. A greater or lesser degree of plastic quality is no more than evidence of the degree to which the artist is obsessed by his subject matter; form is always the measure of this obsession. But it is the origin of the subject and of the obsession which should be sought..."

Thus, the artist would have us seek in the rationale of creativity a meaning to which he can accede only through the medium of our perception. It stands to reason. By that same token, we are bidden to look into his life and work as deeply as we can, and by

whatever means, in order to see the truth he forged. If we are perceptive enough, we may also catch a glimpse of ourselves.

There are too many extraordinary sculptures of 1949 and 1950 to allow for discussion of each. Among them all, however, there is one, perhaps, more extraordinary than the others by reason of having required him to be extraordinary. It asks the beholder to be extraordinary, too.

The town hall of the 19th arrondissement stands in an out-ofthe-way corner of northern Paris. Thrown up during the reign of Napoleon III, it is distinguished mainly by an air of bogus majesty, and only the portico is reminiscent of architecture favored by the first and more forceful Bonaparte. The building faces a square, opening on its southern side toward a public garden, the Parc des Buttes Chaumont. The center of this square had been occupied before the Second World War by a pedestal bearing the bronze statue of an obscure French pedagogue named Jean Macé. During the Occupation, the Germans collected many statues throughout France to melt them down, and that of Jean Macé was one of these. The post-war plethora of empty pedestals was seen as a symbol of national shame. Sculptors were solicited to supply replacements. The memorial to Jean Macé cannot have had a high priority, but the authorities got around to it in time. Partly at the behest of the ever more influential Aragon, and with the support of a minor Surrealist named Thirion, the sculptor selected to submit a project for that particular pedestal was Alberto Giacometti. It was a preposterous choice, and that should have been evident to all concerned. But no. Everybody seems to have found the project perfectly natural.

Alberto set to work. The memorial to the forgotten pedagogue must have been on his mind, but his creative faculties were clearly not disposed to entertain such a trivial prospect. What seized upon his imagination and held it without a qualm was the unique opportunity of executing a public monument for a square in the city of Paris. That opportunity produced the work of art, and its supernatural likeness to the conditions reigning over its creation. That likeness drove the sculptor to make a work incapable of seeming

acceptable to anybody but himself. He began with a female figure. which showed from the start how little he cared about Jean Macé. This figure is much like others executed at the time, large-footed. tall, and slender. But there is an important difference. Her long. spidery arms are held well away from the body, giving her a surprising air of movement, enhanced by another dramatic innovation: she stands poised upon a chariot. It is a real one this time, a true chariot, not the small-wheeled contraption added to the sculpture of 1943. This Chariot is not an idea but a fact. Its two high wheels are as important to the figure as the figure is to them. The wheels are joined by an axle from which two struts rise to support a platform where the passenger stands surprisingly still and straight. Being two-wheeled, The Chariot also bears the associative significance of antique counterparts and mythological intimations. Each wheel has four spokes: an apt aesthetic choice, it seems, until we remember the similar vehicle from ancient Egypt that the young artist had run into thirty years before in an Italian museum. The adaptability of his memory can be assumed to have had more effective uses than our own.

Of all the works executed by Giacometti, The Chariot may be the most hieratic and mysterious. Poised in midair, the delicate but dynamic figure appears to command our attention as much by her unapproachable majesty as by the serene equilibrium with which she remains motionless and upright, while at the same time suggesting to an uncanny degree headlong motion. How different she is from the earlier sculpture of the same name, of which the wheels were negligible in size. This later, greater mounted woman is infinitely more ambiguous and arcane. The first could conceivably be grasped in her suggestive purpose, while in approaching the second, every step must be measured with prudence. She seems to beckon just as she bids one to stay safely at a distance. It is the wheels, their size and their form, together with the position of her arms, which make and maintain the mystery. Because, in fact, she cannot move, though it is by the evocation, the threat, the menace of movement that she is so powerfully present. Immobile, she is motive. Inert, she nevertheless acts. Her identity is concealed even

as it is revealed. Naked, she is clothed in an aura of taboo. She wears her femininity like armor. Mounted on a warlike vehicle, she is above the encounters and accidents of everyday life, to which, though they are in her path, her indifference is absolute.

This was the sculpture Giacometti intended to place in a public square in Paris to serve a commemorative purpose. Only he could have taken the idea seriously. The men from the 19th arrondissement were shocked. The artist and his work were sent packing. Unabashed, Alberto returned to his studio. The opportunity had been all. The outcome could take care of itself. The plaster sculpture was soon carted off to the foundry to be cast in bronze. Six casts were eventually made, and it is worth noting that most of them have a gold patina, though he ordinarily favored dark bronze. The Chariot called for association with the metal most prized by man, the first to be worked in the pre-dawn of history, the one most often used to make or to enrich the effigies of heroes, saints, and deities.

But this was not all. The artist felt constrained to make an explanatory statement. The Chariot was exhibited for the first time at the Pierre Matisse Gallery in New York in November of 1950, along with a score of other sculptures, plus paintings and drawings. In an effort to make more clear the titles given to various works, Giacometti sent illustrated notes, some of which were reproduced in the catalogue. "The Chariot could also be called The Pharmacy Cart," he wrote, "because this sculpture comes from the tinkling cart I marveled at when wheeled through the rooms of the Bichat Hospital in 1938." Maybe. The cart, however, of which he had made drawings was the one in the Rémy de Gourmont Clinic. But the little lapse of memory could be only a coincidence, and he went on to say: "In 1947 I saw the sculpture as if it existed before me and in 1950 it was impossible for me not to make it, though situated for me already in the past. That is not the only reason which drove me to make this sculpture. The Chariot was executed from the necessity once more of having a figure in empty space in order to see it better and to situate it at a precise distance from the floor."

If the explanatory statement was really provided for our per-

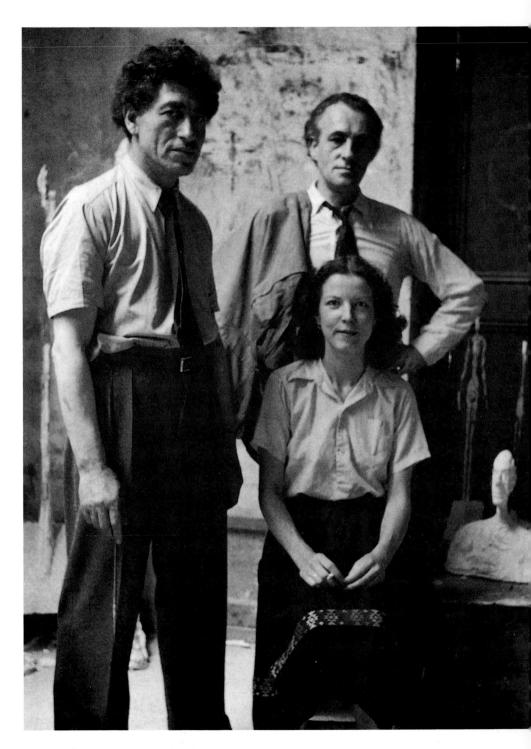

Alberto, Annette and Diego in the studio ε 1952 (Alexander Liberman)

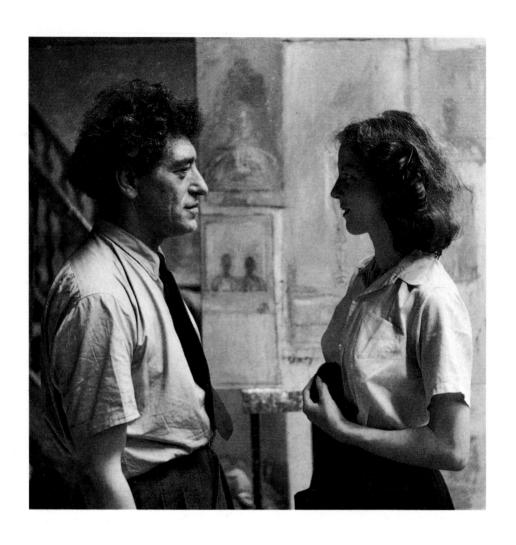

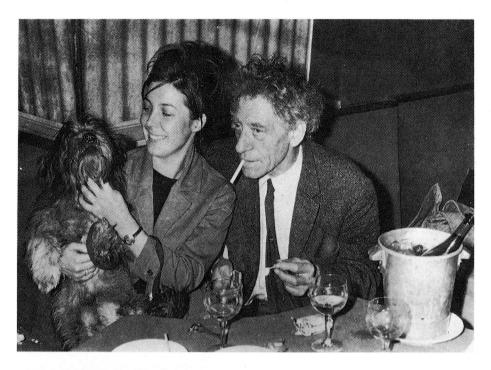

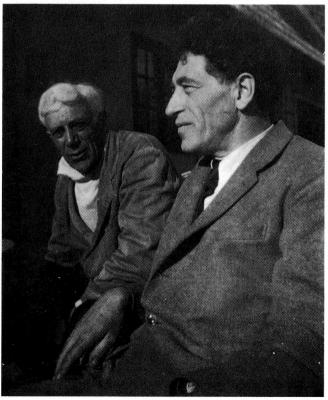

Alberto and Caroline with her dog Merlin c 1963

Alberto and Georges Braque c 1952 (Mariette Lachaud)

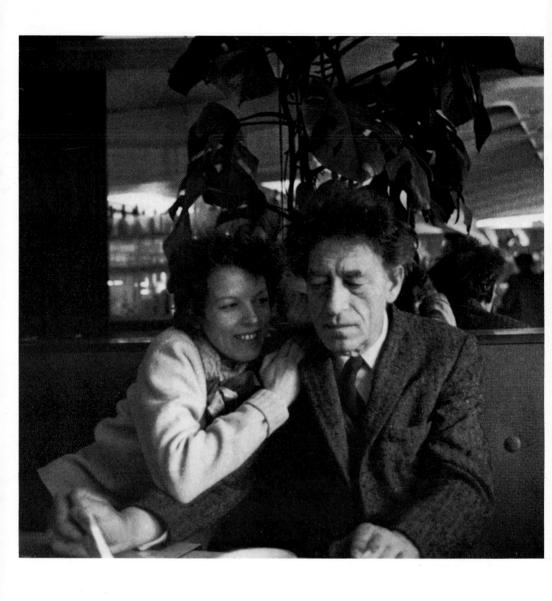

Alberto and Annette in the café at the corner of the rue Didot c 1960 (Henri Cartier-Bresson, Magnum)

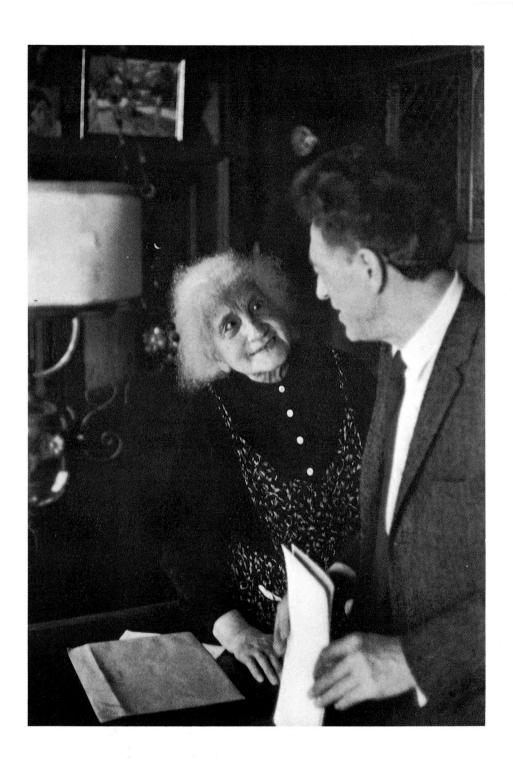

Alberto and his mother at Stampa in 1961 (Henri Cartier-Bresson, Magnum)

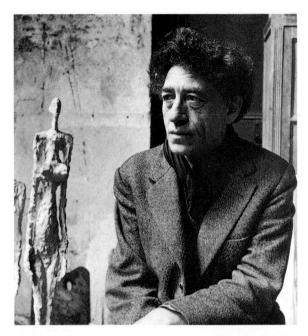

Alberto in his studio c 1956 (André Ostier)

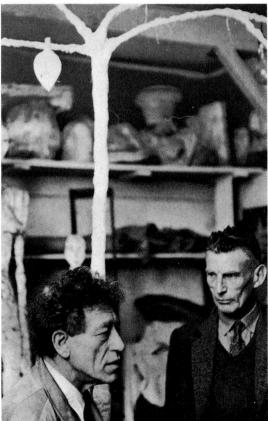

With Samuel Beckett and the tree for *Waiting for Godot* 1961 (Georges Pierre)

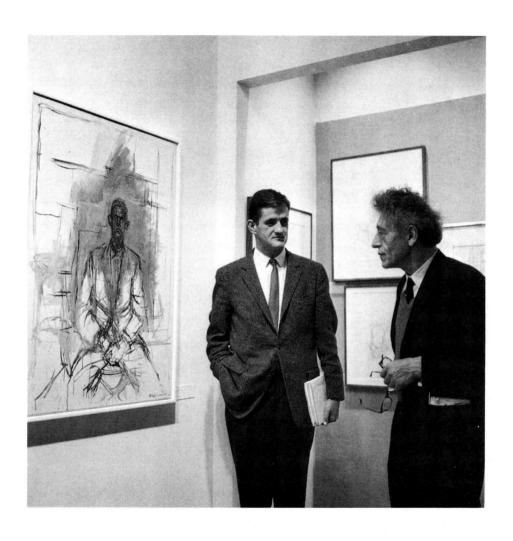

James Lord and Alberto Giacometti, with Giacometti's portrait of Lord, at the Museum of Modern Art, New York, October 7, 1965 (James Mathews)

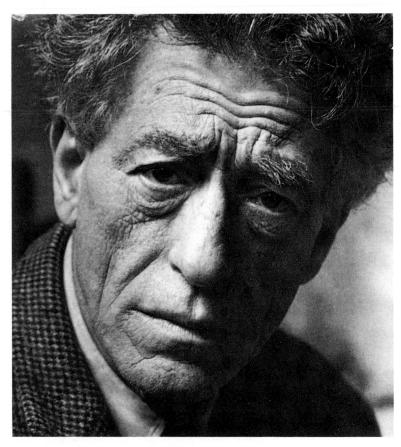

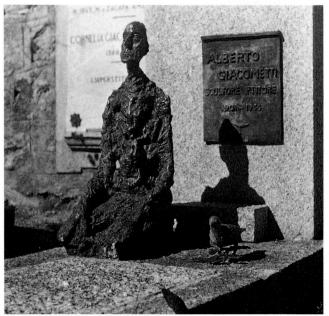

Alberto in 1961 (Jean-Régis Roustan, L'Express)

Alberto's tomb in the graveyard at Borgonovo, with the final bust of Lotar (Michael Brenson)

ception, and if we are really meant to take the measure of form through the intensity of the artist's obsession, then the pharmacy cart by itself would not go far. Farther, and faster, would proceed an inkling that emerges from the roots of language, for we find that in French a two-wheeled metallic vehicle without a body. carrying one person, is called a spider. Like a dream, The Chariot moves inward upon itself even as it seems to rush ominously forward, and in our perspective this motion signifies that the sculpture was not created by accident. Art uses life, and the extent of the use gives the moral of the work. The Chariot leads us to look more closely than usual at this interaction. It is fascinating but frightening. Where first there was nothing, suddenly there is everything. Giacometti was right in bidding us to seek in his work meanings recognizable only insofar as we can discern them to be evidence of our discernment. That was why, and how, he could say, "Art interests me very much, but truth interests me infinitely more." His interest was to be richly repaid, especially on the second score. So will be ours, albeit fortunately not in the same currency.

"The motor that makes one work," Alberto once observed, "is surely to give a certain permanence to what is fleeting." He then went on to remark that the impulse was effective for everyone. even for those who do no more than relate the events of a commonplace day to friends or family, since in the narration the events are re-created, perpetuated, and given a new reality. So, he said, everyone makes art in a way, every story being created anew each time it is told. The outcome for most of us is nothing but a lifetime, of which the significant events are in a state of ceaseless flux as we relate them to others and to ourselves. Even men who once ruled the world, whose acts are the fabric of history, even Caesar, even Napoleon, have felt bound to give accounts of themselves, knowing better than most men that yesterday's fact is not necessarily tomorrow's truth. Alberto knew that, too, and in his way he gave definitive accounts. An ability to recognize as such the significant events of his life helped. It helped the accounts, that is, not him. For him a great deal of the significance dwelt in the difficulty of making the account definitive. What helped him, perhaps, was that the greatly significant events were few, so few we can practically

say that they were just two, allowing for the supposition that the smallness of their number also makes for the immensity of their significance.

About the death of the Dutchman, Alberto published an account, about the accident never, although toward the end of his life, when others had taken it upon themselves to do so, he is reported to have written a twenty-eight-page narrative to set the record straight. Just how straight the record could possibly have been set by Alberto is a tantalizing question. The document, if it exists, is not at our disposal. What we may lose by way of evidence is unlikely to be more than corroboratory, however, because Alberto had the record constantly in mind and often at the tip of his tongue. As if for fear that his lameness might escape notice—his own, perhaps he went out of his way to talk about the night in the Place des Pyramides, repeatedly telling the story of painful months spent in hospital, all the while threatened with amputation of his maimed foot. Though he talked about the accident almost as if he had brought it upon himself, he was clear about his satisfaction with the outcome.

The Chariot was not the only masterwork of these years. By virtue of its extraordinary connotations, it seems the most extraordinary. But it may not be, and some of the others need mention. There were several sculptures of men walking, either singly or in groups. One of these, called The City Square, shows four men walking separately in various directions and one woman standing immobile, her arms pressed tightly to her sides. Several groups of standing female figures are set upon platforms, some with heads of men placed behind or to one side of them. The artist named one The Glade, another The Forest. The concept of trees as sensible beings is age-old, and vestiges of worship of tree spirits have persisted to the present day in various localities, including the English village where Isabel Lambert later went to reside. Other sculptures of these years show women standing alone or in groups on massive pedestals, the latter identified by the artist as prostitutes he had seen either at the Sphinx or in a small hotel room, where in the first case he perceived them to be unapproachably remote, though desirable, and in the second very close, hence threatening. So, too, they appear to us. Distance was not the loan of enchantment but the gift of passion. None of these works was conceived as an effort to depict the artist's immediate visual experience. Rather, they were made to be outward embodiments of inner states, whether conscious or unconscious, and as such they serve further notice that, while the expressive means and formal powers at Giacometti's command had been greatly developed and deepened, yet certain essential themes of the creative discourse remained constant after twenty years.

Simultaneous with this prolific production, and obviously impelled by newly evolving aesthetic intentions, Alberto pursued his efforts to make convincing representations while working from life. His wife, mother, brother, or an occasional friend posed for him. This pursuit was pressed principally in the direction of painting and appears to have proceeded without great difficulty. Numerous paintings of these years show increased boldness of vision and growing mastery of execution. The artist's progress was divided almost equally between visionary introspection and objective visual concentration. The dichotomy may have arisen from the nature of what was to be expressed or from the expressive resources available. A single creative culmination would be the outcome of two techniques made to fuse in the representational unity of insight and intent.

The paintings of this period show the artist's models integrated with their surroundings, neither isolated physically nor impaired spiritually. They cannot be taken for models of existential alienation or anxiety, as critics increasingly believed Giacometti's sculptures to be. Alberto often found his efforts being described in terms of ideas and attitudes taken from his friends Beckett and Sartre. He protested occasionally. "While working I have never thought of the theme of solitude," he said. "I have absolutely no intention of being an artist of solitude. Moreover, I must add that as a citizen and a thinking being I believe that all life is the opposite of solitude, for life consists of a fabric of relations with others.

NB

The society in which we live in the West has made it necessary in a sense for me to pursue my activities in solitude. For many years it was hard for me to work isolated from society (but not, I hope, isolated from humanity). There is so much talk about the malaise throughout the world and about existential anguish, as if it were something new. All people have felt that, and at all periods. One has only to read the Greek and Latin writers!"

marchit

The last major manifestation of the Surrealist movement took place during the summer of 1947 at the recently opened gallery of Aimé and Marguerite Maeght in a fashionable neighborhood of the Right Bank. When Madame Maeght saw what the Surrealists had done to her premises, she shrieked, "We're ruined!" In fact, it was the making of their fortune. Monsieur and Madame Maeght had recognized the rightness of the moment and the fitness of the place; they can never have felt a doubt concerning their own fitness and rightness, for, of course, there they were. At the end of the war, nobody in Paris had ever heard of them. Twenty years later, their doings would be extolled by ministers of state.

In school at Nîmes, young Maeght had shown artistic leanings and an exceptional aptitude for the meticulous craft of engraving. After a stint in the army he found himself in Cannes, where he met an attractive young woman named Marguerite Devaye, whose parents were in the grocery business. Going by the funny nickname of Guiguite, she had a temperament as sunny as the Riviera and also such an instinct for profit that she could later without false modesty say of herself: "If I were cast up naked on a desert island, I'd make money." Handsome and ambitious, Aimé had been on the lookout for a good thing. He and Guiguite got married and went into business, opening a small shop where they sold radios and electrical appliances. The shopkeeper didn't entirely forget about art, but he was unacquainted with the idea that much money might be made of it. The Second World War brought inspiration and opportunity.

Many Jews unable to flee abroad had sought refuge in the South of France, where for a time they were safe from persecution,

and some had brought along works of art they needed to sell discreetly. Maeght was privy to some of these transactions, where-upon paintings immediately replaced appliances in his view as the most promising stock-in-trade. But he had no secure supply. Fate promptly provided one. Having continued sporadically to practice his talent for engraving, Aimé was wont to display his handiwork in the shop window alongside the radios and toasters. One day a diffident, poorly dressed old man with a wispy mustache and steel-rimmed glasses came into the shop. He had noticed in the window an engraving, admired the technical proficiency, and asked who the artist was. Aimé introduced himself. The stranger said that he, too, was an artist and made prints but needed some technical assistance. The shopkeeper agreed to give it. The old man was delighted. His name: Pierre Bonnard.

Maeght went frequently up the hill to Bonnard's modest house, where masterpieces were carelessly stuck onto the walls with thumbtacks. He gave help but refused to accept payment, suggesting that instead, perhaps, he might choose something to buy. The artist said, "Why not?" Looking for further helpful opportunities, Aimé saw that while Bonnard's walls were overcrowded with works of art, his kitchen cupboards were sadly undersupplied with provisions, a commonplace plight in wartime. But Guiguite's parents had access to plenty of groceries, so that presently the artist's dining table as well as his walls overflowed with pièces de résistance, while the Maeghts stocked up on Bonnards. And then one day the kindly old painter said that his thoughtful friends might like to make the acquaintance of a colleague who lived not far away in Vence: Henri Matisse.

The pleasure proved to be mutual. Lately recovered from a grave operation, Matisse welcomed the attentions of the Maeghts, and the good things they brought with them. The walls of his villa overflowed with even more masterpieces than those of the little house in Le Cannet. As the war had interfered with his customary channels of sale, keeping his son Pierre at a distance, he was open to the appeal of interim arrangements. He saw no reason not to let the Maeghts acquire a certain number of Matisses.

With good provisions of Matisse and Bonnard in the larder, the couple felt fortified by the war's end for a foray to Paris. They didn't stint. The splendid premises they engaged would have been suited to the most important gallery in the capital. Aimé had pretensions. He also had imagination and daring, though the authenticity of his care for art would always be debatable. But it took some panache for an entrepreneur fresh from the provinces to turn over his place of business to the Surrealists, men with long-standing reputations for disorder and truculence. Maybe he thought that a little succès de scandale might give the Galerie Maeght a good start, and it did. What was needed to keep things going was a self-sustaining supply of masterworks. Maeght had the wit to guess that he alone could not assure it, and he also had the acumen to find the right man to do that.. This was Louis Clayeux.

Like so many of those who deal in art, Clayeux as a young man had had creative aspirations of his own. He wrote poetry. His forte, however, was for the spoken word. He cared keenly for art, enjoyed the company of artists, and knew how to talk to good effect about the topic they found most interesting: their work. For a time after the war he had been assistant to Louis Carré, with whom he had once fruitlessly visited Giacometti's studio. But he grew restive. Living alone, his personal life occupied principally by devotion to an aged mother, he was readier than most men to commit himself to an artistic enterprise holding out promise of rich fulfillment. Maeght came along just then. The two took to one another. Clayeux responded with warmth to the vigor and authority of the older man, who offered him the post of artistic director. Guiguite gave her blessing. The three together were to form a redoubtable team.

The young director moved fast. He got commitments from Braque, Miró, Chagall, and many other notables. Nor had he forgotten about Giacometti. The exhibition in New York had been seen as a significant event. There were stirrings of interest in France. The energetic entrepreneur went again to the rue Hippolyte-Maindron, accompanied by his new employer. The studio was crowded with sculptures, almost all of them in plaster,

large and small—Man Pointing, The Chariot, City Square, The Forest, The Glade, etc., etc., etc.,—plus quantities of paintings and drawings. The dealers were excited. Maeght proposed at once that Giacometti should join the gallery, undertaking to purchase at prices mutually acceptable one half of the artist's production, the other being reserved for Pierre Matisse. Prices were no worry to Alberto. What concerned him was the commitment Maeght would make to the work itself. He remembered Pierre's reluctance to stand the expense of casting in bronze more sculptures than the token few. Alberto liked bronze, not only for its durability, but because it is a noble substance, having played an essential role in the development of the human imagination. Of the numerous works in his studio, therefore, Giacometti wanted to know for how many Maeght would be ready to pay the costs of casting. "All!" said the dealer.

It may have been a gesture meant to flaunt the munificence of a latter-day Medici, or the gamble of an artful man in the art business. In either case, it was a gesture that counted. It counted to the considerable number of thirty-seven sculptures waiting to go to the foundry. Diego, who knew about costs, was impressed. As for Alberto, he never forgot Maeght's readiness to cast all at once the whole contents of his studio. That memory would serve the dealer well in time to come, when the artist's tolerance was often strained. What moved Giacometti to make a commitment he would honor for fifteen years, however, was not only the ebullience or lavishness of Maeght. It was also the presence of Clayeux. He sensed that this discreet, alert, self-assured man was a person of authentic sensitivity. He felt immediate sympathy and trust. Clayeux felt the same. In time, Alberto became the touchstone of his conscience. Their friendship withstood every test that it needed to, and some were severe.

So Alberto's financial status became increasingly secure. Little cash came in at first, but there were no more dinners of Camembert cheese or nights wakeful with anxiety. The changed situation was exciting for a moment. The first time Alberto received a substantial amount, payment for a batch of drawings, he and Annette and

Diego went out together and spent half the sum for a fine dinner. What pleased him most was the ability to pay his debts, demonstrating that all those years of apparent impotence had had issue, after all.

The sudden increase of cash on hand brought no change whatever in Alberto's way of living. No amount of money could have done that. Diego had always lived with little care for comfort, not to mention luxury. He was much interested in money but indifferent to things it could buy. Not so Annette. She had been brought up in awe of a rich uncle, and in the belief that one's dearest desire, if not determined by wealth, should be well provided for by its possession. Therefore, she contemplated the change in her husband's financial outlook with an expectation of change suited to the wants of his wife. Trouble was in the making.

Giacometti's prestige and renown were also growing. They, too, permitted repayment of debts. His brother Bruno had been asked by government officials in Bern whether Alberto would agree to be one of the artists representing Switzerland in 1950 at the Biennial Exhibition of International Art in Venice, the famous Biennale. Bruno inquired. Alberto refused, saying, "They should invite a Swiss artist."

As a son of Switzerland—to be counted one day among the most honored—Giacometti still felt hostility to his fatherland. Old vexations, enduring resentments had not been sublimated. Maybe they needed to be overt before they could be forgotten. Reconciliation would come in its own time, though just barely in his, and would efface unhappy memories. Meanwhile, a distinction could be made between hard feelings toward Switzerland and the appeal of friendship. Alberto was faithful to the affections of the past. Of his oldest friends, the closest were two he had known while at Schiers: Christoph Bernoulli and Lucas Lichtenhan. He had kept contact with them for thirty years, while losing it with the one for whom at the time he had cared most: Simon Bérard. His instinct usually led him to stay in touch with all the experiences of his lifetime, but in this case, perhaps, the memory was more than enough. He and Simon met but once after Schiers, shortly after the war.

Of the romance, and of Simon's good looks, nothing remained. He and Alberto found little to talk about, and they never saw each other again.

Lucas and Christoph lived in Basel, where in addition to professional occupations, both took part in civic activities, especially those devoted to the arts. They were anxious to arrange in their city an exhibition of the work of their old friend. Giacometti agreed, though with the proviso that the exhibition should be shared, because he felt that a one-man show would be suggestive of conceit and ambition/He asked that another artist be invited to exhibit with him, proposing André Masson, the first of his friends among artists of the School of Paris. Nobody objected. The choice of a co-exhibitor is interesting. Though still friendly, Alberto and André now saw each other seldom. While the former's artistic fortunes were rising, the latter's were waning. Through the thirties, Masson had continued working in the Surrealist style. During the war he took refuge with his wife and two sons in America, adopting an insipid semi-figurative style. The contrast with his previous productions was disconcerting. The contrast with Giacometti's work was such that no basis for comparable appreciation existed. Alberto never agreed to exhibit important selections of his work with artists whose aesthetic aims resembled his. Not that there were any who made a strong case for the resemblance! However, it may be worth noting that he apparently meant to risk no odious comparisons.

The Basel exhibition in the spring of 1950 was not a commercial success. Alberto had sent fifteen sculptures, among them many of his most important recent works, ten paintings, and twenty-five drawings. Prices were low, but only a single sculpture and two paintings were sold. Giacometti's work did nevertheless attract attention. One of the admirers was a young man named Ernst Beyeler, who would later take advantage of an exceptional opportunity to rally the admiration of his countrymen.

What Giacometti refused to Switzerland he was perfectly ready to offer France. Invited by the French to exhibit at the Venice Biennale, he accepted. His acceptance was all the readier as one of the other sculptors invited was his old friend Henri Laurens,

whose work Alberto had admired for twenty-five years, knowing it to be misunderstood and underrated. Affection and admiration made trouble. When he arrived in Venice and went to the French pavilion, Alberto found that Laurens's sculptures had been installed in the background, giving the fore to the work of Ossip Zadkine, a facile third-rater to whom the prize for sculpture was promised. Outraged, Giacometti declined to have any part in the exhibition and departed from Venice in protest. Loyalty meant more to him than prestige.

Pierre Matisse had not been pleased by the spectacular emergence of competitors from Cannes. To his icy eye, the Maeghts looked like upstarts. He was going to have to see a good deal of them through the years, however, and he didn't like it. They had begun by getting a foothold in the paternal preserve, and Henri Matisse continued occasionally to sell them his work. Then they had taken over Miró. Now it was Giacometti. But one had to acknowledge that they were enterprising. They got results. Pierre would never on his own initiative have raised Miró's prices to the Maeght level. He willingly followed their lead. And it was a fact that no other Parisian dealer had been eager to take on Alberto. The Maeghts were ready to pay, and the extent of their readiness probably didn't appeal to Pierre, either. If they did well, it would profit him nicely, and a prince, albeit of the merchant order, is not pleased to see—and most especially to have others see—his pocketbook fattened by a parvenu.

The second Giacometti exhibition at the Pierre Matisse Gallery would take place, anyway, before the first one at the Galerie Maeght. Nobody could question the part played by Pierre in cultivating public appreciation of Alberto's genius. His belief in it was probably nobler than Maeght's, but the issue made no difference in their professional resolve, of which at all events a common motive was to make money. The capacity of Giacometti's art to do that was established in the United States, and confirmed there, well before European dealers and collectors had realized what a good thing it was. Alberto's position as one of the major artists of his era was established by that second exhibition in New York in November 1950. Critical as well as commercial affirmation came quickly

and conclusively. All the great sculptures of the recent years were shown. All were sold, plus several paintings and numerous drawings. It was only proper that consecration should have come to Giacometti in America before Europe, because by 1950 the center of creative excitement in the arts had crossed the Atlantic. The productions of the New York School were not of a sort to engage Alberto's sympathy. The American artists, on the other hand, though committed to a radical break with the past, recognized and respected the authenticity of an undertaking which would have seemed to compromise their own future. There was something about Giacometti's work especially appealing and apparent to the American eye, some purity and power reminiscent of aspirations that had borne men and women in defiance of common caution across a great wilderness. The Giacometti legend was at home in the New World. Those radical young painters, who considered Picasso passé and figurative art effete, were not much given to encomiums. However, they found respectable figures of speech for Giacometti, Barnett Newman, one of the most intractable of abstractionists, said, "I take off my hat to him."

When the Korean War broke out, the world reacted with fear of global conflict. In Paris, people were frightened of waking up to find their city occupied by the Red Army. On the Riviera, Picasso debated the desirability of transferring family and funds to Switzerland. Giacometti tried to see the significance of events. It had seemed easier, however, when he was younger. Now he felt that to give his life for the right cause he had best remain in his studio.

The first Giacometti exhibition at the Galerie Maeght opened in the early summer of 1951. Nineteen years of difficulty and doubt had passed since Alberto's last one-man exhibition in the city where he had by that time spent more than half his life. He had known how to wait. He had known how to find in failure the resources essential to success. The exhibition contained forty pieces of sculpture, three dozen executed in the past three years, also a score of paintings and a quantity of drawings. Save for those who regularly frequented the rue Hippolyte-Maindron, and they were few, the exhibition came as an eye-opener. Even to those who

NO

misinterpreted what they saw, who were looking for existential theory or contemporary angst, it was evident that they were called upon to look as they had not formerly been accustomed to. Some were confused and annoyed. Others saw in Giacometti's work images possessing a metaphysical virtue, reflecting man's ability to perceive his experience in a realm apart from the physical. As for the artist, his sole concern was to get on with the business of seeing whether works of art were possible.

As Giacometti grew older, he took to living and working later and later in the night. He disliked the dark, but he loved the hours of darkness. With increased prosperity, he was more able to frequent haunts that cater to people whose desires don't like the light of day. In Montparnasse there was no lack of these. Alberto knew them all, and they became very familiar with him. In addition to large cafés like the Dôme and the Coupole, there were numbers of smaller bars. The one most favored by Alberto was called Chez Adrien. In a side street off the boulevard, it had opened during the war, a shady time for going into business. Its decoration was baroque and ostentatious, with torsade columns and a curvaceous bar. Prostitutes who preferred, or were privileged, not to work directly from the sidewalk were welcome Chez Adrien. There were quantities of nightclubs as well, places like La Villa, tawdry and noisy, where vulgar simulacra of the high life were obtainable for a high price. There were also a number of obscure little hotels that catered to anonymous clients and transient tastes.

From his nocturnal wanderings Giacometti returned home late, when Annette would already have been asleep for hours with the light burning beside the bed. He did not necessarily join her even then. Having worked through the beginning of the night, he would now sometimes work until the end, waiting for dawn before going to bed, exhausted. The work that kept him from his rest was almost always sculpture. It consisted of redoing, reshaping, re-creating sculptures already in the process of creation. All were works made from memory or imagination. No model sat or stood before him during those solitary sessions at five or six o'clock in the morning. He was alone with his work, absolutely in touch with it, not only

through his eyes but especially through his fingers. His fingers traveled up and down, back and forth upon the surface of those sculptures as if with a will of their own. Every touch made every work at every moment different, a thing not necessarily better, but new, which had never existed before and which by its metamorphosis embodied the principle of creation. The sense of touch, of being in touch with reality, of having the feeling of things as they are, the tactile experience in all its implications, is at the basis of our relation with ourselves and with the world. All these implications were joined in the contact of Giacometti's fingers with his clay. Kneading, gouging, pressing, caressing, carving, smoothing, the artist activated and liberated his most profound urges and feelings. He transmitted them to the texture of his sculptures so that in addition to being images these would exist as surfaces, because the surfaces of works of art open directly upon their most obscure but illuminating depths. In those lonely dawns, while his fingers coursed interminably over the clay, Giacometti was at one with his self.

At 7 a.m. sometimes Diego came into the studio and found his brother still at work, wan with fatigue, wreathed in the smoke of innumerable cigarettes, so absorbed in what he was doing that he seemed to be elsewhere, having left behind him only the sculptor's fingers to go on and on with their solitary task. Diego would say, "What are you doing? Go to bed." Alberto would seem surprised, as if wakened in the course of a dream that turned out to be true, which it did. Come back to himself, he would wearily do as his brother bid him.

A routine like that was far from healthy. The artist suffered from ill-defined complaints and pains. Some, though, were too easy to diagnose, especially the hacking smoker's cough. He warned himself: Smoke not so much! But by the early fifties he was smoking forty cigarettes a day. He began to be troubled by chronic fatigue, consequence of late nights exacerbated by little rest. Luckily, however, he had an exceptionally robust physique, inherited from forebears used to climes more trying than Montparnasse. Still, the punishing routine took its toll. At fifty, Alberto could have passed for sixty. The lines of his face grew deeper, and his flesh was the color of clay.

The answer to all complaints was a visit to Dr. Theodore Fraenkel. An incompetent physician, Fraenkel intended to be an efficient friend. He probably discerned the cause of Alberto's various ailments, and saw that they were too serious to be taken seriously by a medical man. He prescribed aspirin and let it go at that, taking the opportunity to treat himself to some of Giacometti's tonic conversation.

If Picasso had been uneasy during the summer of 1950, when it looked as though the conflict in Korea might turn into another world war, his nerves were steadied before the end of the year. In October, he attended a Congress for Peace organized in England by the Communist Party. In November, he was awarded the Lenin Peace Prize. In January 1951, he painted a good-sized picture entitled Massacre in Korea. A political statement intended to decry American intervention in that country, it was meant to depict the slaughter of innocent and defenseless civilians by inhuman men at arms, bringing to the cause of rightful compassion the prestige of great art. It is a far cry from the humanitarian grandeur and enraged creativity of Guernica, and by comparison seems but a faint bleat in the pandemonium of political propaganda. As a formal production, it makes facile use of aesthetic devices long since done to death by the painter. That is its truest image of violence. Something had happened to Picasso. He was now a changed man, and artist. This was not the first time he had allowed himself to be manipulated, and his art to be used for political purposes. Posters of his so-called Dove of Peace had been plastered onto half the walls in Europe. Common sense might have warned that so conspicuous a display of principle could come home to roost one day. But Picasso had set out to soar above every storm, and his flight could not be renegotiated in midair lest he be brought low like a common mortal. His comrades in high places, however, were not his equals in the sphere of art. He surrounded himself with mediocre sycophants and thirdrate artists, none of whom could remind him that moments of major attainment were no longer at hand. Georges Braque, who had shared such moments forty years before, was heard to say: "Picasso used to be a great artist, but now he's only a genius." In 1953, when Stalin died, Aragon asked Picasso to make a commemorative portrait of the deceased dictator. He complied. The portrait was published, along with reams of ignominious lamentation, beneath a hortatory headline: What We Owe to Stalin. But the party regulars didn't like it, and Picasso was rudely rebuked for want of respect. The uproar must have sounded brazen to ears addicted to adulation, but the artist kept his peace.

Giacometti's visits to the studio in the rue des Grands-Augustins had become progressively less frequent, and then stopped. Whereupon Picasso began appearing regularly, though always unexpectedly, at the rue Hippolyte-Maindron. His preferred hour was noon, when Alberto would just be awakening, not yet prepared to face the day, much less a challenging, crafty visitor. Too shrewd to expect obsequiousness from the sculptor but too dependent on it to go without, Picasso seems to have come to Giacometti's studio to test his welcome in a place where, in fact, he must have known it was no longer valid. He had stopped laughing behind Alberto's back, and spoke of his efforts with sharp-eyed admiration, saying that they represented "a new spirit in sculpture." When he came to the rue Hippolyte-Maindron, however, the works he chose to admire were invariably the worst, the ones half-finished or nearly destroyed, which he would praise with great gusto, crying, "The best thing you've ever done!" If Alberto was annoyed, it can only have been by the artlessness of the ploy. Knowing Picasso, though, he would not have expected him to let bad enough alone.

One day when the two men were together in Giacometti's studio, Christian Zervos arrived unannounced, bringing with him an Italian collector named Frua de Angeli, whom he hoped to coax into buying some of Alberto's work. This was at a time when a sale could still be important. Having been for years intimate with both artists, the Greek editor thought to turn to advantage the presence of the world's most prestigious painter by having him express before a tentative purchaser his admiration for the works of their mutual friend. Pointing to one of the pieces in the studio, he enthusiastically expanded on its merits, then turned to Picasso and said, "Isn't that so?" Picasso kept mute. Zervos tried again. Again Picasso kept silent. A third and yet a fourth time the surprised but

persistent editor attempted to extract a testimonial from the painter. To no avail. Picasso sat in stony silence, and his ostentatious refusal to accord his endorsement had the predictable effect. Zervos should have known better. Picasso, too.

In November of 1951, having had a good visit with his mother in Stampa, Alberto went on to the South of France with Annette to visit his friend Tériade, the other Greek editor, who owned a modest villa at Saint-Jean-Cap-Ferrat. Thrilled by the profusion of flowers so late in the year, he wanted to make drawings of them all, but there were calls to be made. They went to see Matisse, who received them in bed but ebulliently kept them for three hours of enthralling conversation. The next day they went to see Picasso, now living with his mistress and their two young children in a small, ugly house on a hillside set back from the coast. Picasso also received his callers in bed, as he was suffering from an attack of lumbago. The similarity to Matisse stopped short of his humor, which was bad. He picked Alberto as the target for his petulance, saying, "You don't like me as much as you used to. You never come to see me anymore." Alberto protested that the frequency of his visits was no fair gauge of friendship, since he did not live on the Riviera and traveled little. Picasso didn't care. If his friends were true, they came to see him. If not, what were they? Alberto's presence in Picasso's bedroom at that moment being apparently irrelevant, Picasso glared sullenly at his visitors, who were nonplused. Alberto made protestations, Picasso shrugged. An altercation ensued. It was the first open dispute ever to have occurred between the two artists. Both had violent tempers. The onlookers didn't know where to look.

Then Picasso performed one of those abrupt, unpredictable pirouettes of style so typical of him. He extended an invitation. What a lovely thing it would be, he said, if Alberto came to stay with him there in Vallauris. That would be proof of friendship. A wonderful idea. Why not begin the visit at once? Tériade could go straight back to Saint-Jean and fetch Alberto's suitcase. As for Annette, if her presence was required, she could go to some hotel in Cannes, which was only a few miles away, or Antibes, which was even closer. Alberto's own lodging, though he may never have

known this, would have been a dank room in the basement, where Picasso had recently lodged the newly remarried Eluard and his ailing bride. The invitation, of course, was the crudest kind of taunt. Picasso gleefully pressed Alberto to accept. Twenty years before, when they had first met, Alberto had wanted to make sure Picasso saw that he was not on his knees. Picasso had seen, had appreciated, but his craving to see people in that posture had not yielded to the years but only become more arrogant, and now he wanted a show of force to prove he could make Giacometti comply with a condescending caprice. It would not do. Though easy to anger, Alberto possessed immense reserves of self-control. He excused himself from accepting Picasso's invitation, and the visit lamely concluded with a poor pretense that amicable entente remained unimpaired.

The friendship between the two artists ended on that day. They had had strong feelings for each other, however. These did not automatically go away when friendship went. Picasso was too prodigious a phenomenon for anyone who knew him to become indifferent to him. Alberto did not stop talking about him, though what he said was severely critical. A year before the imbroglio at Vallauris, for example, after a visit to the Museum of Modern Art in Paris, he had had this to say: "Picasso altogether bad, completely beside the point from the beginning except for Cubist period and even that half misunderstood. French artist illustrator journalistic. Dubout,* etc., but worse. Ugly. Old-fashioned vulgar without sensitivity horrible in color or non-color. Very bad painter once and for all."

This was his judgment. It was final, and through the years to come he repeatedly confirmed it. One day, for example, he declared: "Picasso is certainly very gifted, but his works are only objects. If Picasso discovered African masks, that is because his origins were in the world of masks, that is to say, objects. Certain masks or dolls from Africa are very beautiful, but that is all. They are, so to speak, stagnant. There is no evolution in them. It is the same for the painting of Picasso. That is why—without pursuing a

^{*} Albert Dubout (1906-78) was a well-known illustrator and cartoonist of the thirties, heavy-handed and vulgar.

single course of work to develop it—Picasso constantly changes his course. There is no progress in the world of objects. It is a closed world."

The sculptor and the painter still saw each other occasionally, however, when Picasso came to Paris. Alberto tried to avoid the meetings, and went out when he sensed that Picasso might be planning to find him in. But he was vulnerable, having only Diego to protect him. Something drove Picasso to seek out the other artist, something, perhaps, akin to a suspicion that what he sought was a virtue which no man can procure from a mere mortal. If so, that was why Giacometti put upon their rare encounters as good a face as he could. Some years later, when Picasso exhibited recent work at Kahnweiler's gallery, Alberto politely attended the opening. A number of sculptures were shown. Picasso asked Giacometti's opinion of them. They were fine, all fine, Alberto said. Suspecting the reply to be a politesse, Picasso insisted, pressing particularly for appreciation of a painted bronze of a goat's skull and a bottle. He had guessed shrewdly. Alberto admitted that he didn't admire it. Picasso asked why. Alberto tried to explain, while Picasso tenaciously defended his work. Creative ideals so divergent could never be reconciled, especially now that friendship had gone out of the equation. But the two artists talked hard, though courteously, for close to an hour. Then Giacometti pleaded urgent business elsewhere and left Picasso in the company of his acolytes. The one stray from the flock, though, being the most precious, who should Alberto find on his doorstep when he reached home but Picasso. It is sad to think what he may have expected to gain by carrying his argument onto the home ground of the unbeliever. But he insisted. And it must have been hard to say no to a man whose insistence seemed to implicate him in the undoing of his own faith.

The two saw each other rarely thereafter.

The wildest dreams of Annette Arm as a young girl could hardly have led her to fancy that she would one day become the wife of a great artist, immortalized by him as a model for masterpieces. Now that she was Madame Alberto Giacometti, her dreams grew even wilder. She wanted to become a mother. The woman who had, by her own husband's account, threatened to do away with herself if she could not be married to a man incapable of fathering children blithely expected him to help her bring a new life into the world. The issue of her husband's incapacity was a trifle in view of wifely desire. By being as he was, he deprived her of fulfillment. Nor did it make one speck of difference to evoke her agreement that the formality of wedlock should change nothing about the status of their relationship.

The matter was even more complex than this. Alberto did not like, or want, children. On that score he had come to a comfortable accommodation with nature. Besides, Annette herself, being quite young enough and silly enough, was very like a daughter. They openly acted the parts. He called her "Ma Zozotte," meaning a woman who lisps slightly, and by extension a person both endearingly girlish and foolish. She treated him with due respect, at least in the beginning. Assuming the paternal role, Alberto could all the better condone his conduct both as a man and as an artist, and consider Annette's compliance natural, because she was his creation, and any artistic offspring would be the descendants of them both. He was perspicacious enough to see that that was, indeed, how it would turn out.

However, if the experience of maternity was in fact her dearest desire, then nothing could be simpler. She could have a child

by another man. He urged it. There was considerable discussion of the possibility, which coincided nicely with Alberto's willingness for Annette to respond to attentions other than his. It seemed to some who knew them well that this willingness positively provided the incentive for hers, and that the desire most set on satisfaction was his. At the same time he appears to have resented what he conceded, as if that justified keeping at a safe distance from women while indulging a fascination for everything they represented. Thus, the shadow of imperfection fell upon their married life, and they began to quarrel.

Diego, too, was beset by difficulty in his domestic life. Nelly had become disgruntled and irritable. She resented the failure of the Giacometti family to find a place for her in its framework of affections, though she herself had little to offer by way of family feeling. She spent her nights in Montparnasse and slept most of the day. Diego rose early to go to the studio, where he had more and more to do. The two saw little of each other. When they did, arguments grew acrimonious. It went on that way for a few years longer. Then one day Nelly walked out of Diego's life as casually as she had come into it. The arguments were finished forever. He henceforth could live in peace with his feeling that women were more of a nuisance than a pleasure, but he found after a timeprobably much to his puzzlement—that he rather missed the nuisance and felt a bit forlorn without it. A sheath of solitude began to form around him, almost transparent at first, but gradually taking substance from itself and becoming an armor that protected and imprisoned his secretive heart. If he was lonely, he sought solace in his solitude, for heaven knows he was not demonstrative or outgoing, and nobody was ever less likely to have uttered a murmur of complaint. Besides, he had Alberto.

Alberto was the pole and pivot of his existence, the guarantee of his value as an individual, and the redeeming feature of his selflessness. Alberto remained, Alberto sustained. Alberto was reason united with emotion. But thereby also hung a growing tangle of complexities, as in any relation which by the intricacy of its involvements limns the structure of a lifetime. Diego had become, if possible, more and more indispensable to his brother as the

passing years brought more recognition and more demand for Alberto's work. All his skills were put to use and to the test. Only he could have fashioned from piano wire the fragile armatures for the figurines that are part of works like The City Square, The Glade, or The Forest. Only he could have cast in plaster such delicate sculptures. He had worked hand in hand with his brother for more than twenty years. He had an instinctive feel for what the sculptor wanted, so instinctive, in fact, that it was he, not Alberto, who "finished" certain sculptures by making the bases or pedestals upon which they stood, and in certain cases—The Forest, The Glade—by helping to fix the positions of the figures among themselves. His hands touched every sculpture that came from Alberto's. That kind of help needs the trust generated by a lifetime of understanding, and by being essential to the end, it becomes necessary to the beginning. What has grown indispensable may seem to have been inevitable. The childhood model, the happy-golucky helper of the years with Jean-Michel Frank, was now transformed into a full-fledged collaborator. Neither brother had meant to bring this about. But there it was. It stood before them like a creation in its own right, which they both served. By the same token, it could be seen as something that stood between them.

That Alberto could not do without his brother's assistance was no secret. He repeatedly told their mother how necessary Diego had become to him, and Annetta was well pleased with the way things had worked out. Writing to Diego about Alberto in June 1952, she said, "He remains always his same anxious self, but fortunately he has a brother who is more calm and understands him well." It may not have occurred to their mother, however, that the good fortune of one brother did not by definition ensure that of the other, and that perhaps things had worked out too well. It is true that Diego understood Alberto, and stood by him throughout his career with a steadfastness that was part of its texture, moral as well as material, even when the prerequisites of the career became toward the end both incomprehensible and incompatible. He never faltered. He never failed. Even beyond the end, he kept faith with the spirit that had made his dependability-and dependence-indispensable.

Alberto's increasing financial security and growing reputation could not but point to the anomaly of Diego's status. For who was the indispensable collaborator but the wholly dependent brother? This situation certainly made for the gratification of Alberto, and both of them had to make the best of it. Their salvation as men and as brothers lay in believing that the best for one was the best for both. They were not always able to act on the belief. A few failures made the lasting success more moving.

Alberto continually urged Diego to do work of his own, and the urging seemed to grow more urgent as the opportunities for such work grew less. Diego was too busy with pressing tasks for Alberto, making armatures, plaster casts, patinating bronzes that poured in increasing numbers from the foundry. Alberto was so absorbed in making sculptures in clay or plaster that he had no time to supervise the production of bronzes, but he kept a severe eye on the outcome. The patina, in particular, had to be just right, though his view of what was right could vary unaccountably from day to day. Diego's past experience was put to unremitting use. Alberto was hard to please, and a cast that failed to reproduce the original exactly could put him into a rage. Being obsessive where his work was concerned, he saw no reason why others should be less so. Many, many sculptures had to be patinated, repatinated, then patinated again before the artist was satisfied. "Oh, he's impossible," Diego occasionally said with a sigh. "There's no denying it. Alberto is very difficult."

So there wasn't much time for Diego to do work of his own. Still, Alberto insisted, as if Diego's vocation as a creator in his own right was vital to the satisfactory performance of all tasks. It was, to be sure. But not to Diego. The proof of the importance came, unfortunately, from the older brother. Diego managed to do a little work of his own, making the occasional sculpture for a publicity display or decorative arrangement. Alberto praised his brother's work to the sky, taking visitors into his studio to admire the latest effort, repeatedly exclaiming, "Diego has talent to burn! Oh, yes, Diego has talent to burn!" The truth is that he did. But neither the proof nor the flame would come till it was too late to prove anything, though it would warm a few hearts. Meanwhile, Alberto

kept on saying, "Diego has talent to burn." It was sometimes embarrassing, and the one most embarrassed must have been the one whose embarrassment it would have been tactful to spare.

Alberto was in a better position than anybody to appreciate the benefits of his brother's hands. The appreciation of others. however, was not necessarily a welcome adjunct of those benefits. Alberto knew that Diego was indispensable. Diego knew it. Their mother knew it. Annette knew it. A few others supposed it to be so. But they were few, and few of them paid much attention to what was actually being done by Diego. As far as Alberto was concerned, that was all to the good. It was also rather to the bad. because Diego unmistakably did something. Genius is as jealous of its singularity as of its secret. Alberto was no exception. He desired it to be definitely understood that Diego's part in his work was that of a technical assistant, nothing more. It was he alone, he said, and not his brother, who made the works of art. Diego did nothing that a technician of comparable competence could not do. and the artist sometimes pointed out to inquiring critics that when writing about the art of Alberto Giacometti, no account was to be taken of the assistance provided by his brother.

If any echo of ambivalence came back to Diego, he could take it. The one prepared to maim his own hand is unlikely to shirk his share of pain. As for Diego's purpose in life, nothing could cast doubt on the daily affirmation of it that came from the person whose presence was its proof. Diego knew very well where he stood with Alberto, and with Alberto's work. The knowledge was not always easy to live with. Neither was Alberto. The difficulty developed the virtue.

It was in the early fifties that Diego began making the bronze furniture for which he would finally be famous. At first he was hesitant. The objects made for Jean-Michel Frank had never included tables, chairs, large items. These, however, were what he now diffidently started designing. Alberto, as ever, was quick with admiration and encouragement. Having little time, Diego produced little. The incentive at first was largely financial, anyway. Far in the future were the days when it became impossible to cope with demands for furniture signed Diego. It was at

NB

Alberto's insistence that Diego signed his work with his forename only. An expedient avoidance of confusions, certainly, but another evocation of the intricacies of fraternal devotion. Because Diego had little work of his own to sell, he had few clients. His friends told their friends. The first happy few advertised their satisfaction. Gradually a clientele began to grow, with the result that one day a perfect stranger in search of an authentic Diego presented himself unannounced, since there was still no telephone, at the rue Hippolyte-Maindron. In the passageway he chanced upon Diego himself, who inquired his business. The stranger said, "Are you Monsieur Giacometti?" To which Diego replied, "No. You will find him in the café at the corner of the rue Didot."

Customers eager for works by Alberto, on the other hand, were not wanting. Maeght and Pierre Matisse pressed the artist for merchandise. Among the numerous collectors on both sides of the Atlantic who had started buying Giacometti's work, there was one who singled himself out for special attention. His name was G. David Thompson, a self-made millionaire from Pittsburgh, Pennsylvania. His passion was money, his obsession art. He amassed extraordinary quantities of both. His collection of twentiethcentury masters was outstanding, and a singularity of it was that the two artists most abundantly represented were both Swiss: Paul Klee and Alberto Giacometti. Having begun to buy Giacomettis from Matisse, Thompson found that the more he had, the more he wanted, and presently thought it would be a profitable idea to make the acquaintance of the artist. In Paris in the spring of 1954, he sent an emissary to the rue Hippolyte-Maindron to announce that he would be coming to pay his respects and buy some sculpture. A few days later the collector arrived with his emissary, a stout German lady who acted as interpreter, since Thompson spoke no language but his own. Finding the door to Alberto's studio shut, the pair approached Diego's, which stood open, whereupon Thompson, who had never seen either brother before, rushed forward, embracing Diego with warmth, pressing upon him a carton of Camel cigarettes and a cashmere scarf, effusively blurting exclamations as to the honor and happiness of the occasion. A moment passed before the German lady could explain to her employer the case of mistaken identity. At that, the millionaire snatched back from Diego's hands the scarf and cigarettes and bolted from the studio. Much was to be seen, and heard, of Thompson by the brothers Giacometti subsequently. He never again addressed a cordial word to Diego. Alberto, on the other hand, was the object of incessant solicitations and ostentatious attentions, all of which would have seemed made to order to alienate him. He responded to them with goodwill, even with a kind of docile compliance. On his side, the industrialist made great promises, of which he kept none.

An affront from the likes of Thompson could be considered funny. Less amusing was the occasional indignity that came from Diego himself. To be true to his brother's trust entirely—entirely true, that is, to himself—perhaps it was essential for him to be capable of the rare failure which also proved that he was only human, that he, too, had feelings and felt pain and was entitled to show it and even, if need be, to inflict it. There were times when his identity as Alberto's brother became almost unbearable. In order to save himself from himself, as it were, maybe he had to deny the fraternal virtue he had worked so hard to confirm. "What are Alberto's sculptures," he sometimes unexpectedly demanded, "those spindly, skeletal blobs of bronze?" It was likely to be late at night, when he had had a bit too much to drink. "They are nothing!" he would exclaim. "They are nothing and less than nothing! Anybody could do as much." And the proof of it was that he himself, if he wanted to, if he could be bothered to, was perfectly capable of doing what Alberto did, just as well as he did it, because God knew he had learned by heart over the years exactly what went into the making of a Giacometti sculpture. He was in a better position than anybody to know that it didn't amount to much, was he not? As for the portraits of himself, he added, those hideous objects, squashed, distorted, pitted, and lacerated, any student at the Beaux-Arts could turn out a better likeness after one sitting ... while he, Diego, had already posed for half a lifetime! Distressing silence seemed the only possible response to such outbursts. They were extremely rare, but their rarity made the point more poignant, because in the fullness of time Diego, too, would have

to pass the test of great achievement. When it came, he showed that he was up to it by saying, "Alberto was my luck."

Sometime during these years—four decades and more after the event—Diego found the moment opportune to tell his brother the truth about the "accident" of that summer's day in 1908. He had never told another living soul, nor would he unburden himself again until his brother had been dead for fifteen long years. Alberto was astounded. He must also have been shattered. One so exceptionally intuitive and intelligent cannot have failed to see the truth and measure its significance in terms not only of his brother but of himself. The little boy of six had had to wait for more than forty years before he could acknowledge his real injury and show his suffering. For Alberto, always so protective, the wait must have seemed intolerably cruel. The composure of the child at the time of the accident had been an easy thing compared with the selfcontrol of the adult. The length of the wait made every imaginable allowance for ambiguous motives. The timing of the truth was right. Concerning himself, Alberto's lucidity had numerous means of sublimation. Concerning Diego, it had none. Thus, the brothers' mutual experience attained a further dimension of reliance and understanding.

If ambiguity sometimes teetered on the brink of ambivalence, or expedience went over the edge of exploitation, vet these were energetic and happy years. Lots of laughing went on in the rue Hippolyte-Maindron. Alberto was fond of jokes and bawdy songs, knew how to be funny, and took sly pleasure in showing it. He and Diego and Annette had good times together. Memories of the difficult years were still vivid enough to make the change enjoyable. They didn't have to think twice about going to good restaurants or taking taxis whenever they cared to. The dealers came and went. Matisse, Maeght, and especially Clayeux, who had become a close friend. They were all increasingly attentive as the prices kept on rising. Journalists and critics started turning up, and their articles appeared in papers and reviews both local and foreign. In Paris, Alberto had been a well-known figure for twenty-five years, but this was the beginning of fame. It brought a gratifying sense that what had gone on in those ramshackle studios was starting to live in the world beyond. Alberto may have been the least gratified, because he thought mainly of work to be done. He was pleased, nonetheless, and he took care to be sure that Diego was pleased. When bundles of bank notes were delivered by the dealers or their messengers, the younger brother got a generous share. He frugally salted it away, investing in gilt-edged securities, much to the amusement of Alberto, whose attitude toward cash was aloof. In all negotiations concerning the conduct of Giacometti's career, Diego was invariably consulted. About the works which created the career, his advice was always asked. If it appeared that the artist's brother was an inconspicuous adjunct to the activities of genius, Alberto was careful to compensate. Woe to any obtuse acquaintance who might inadvertently be lacking in regard for Diego's feelings. The paroxysm of outrage sure to follow was a devastating experience.

Alberto's meticulous care for the patina of his bronzes was not a finicky self-indulgence. He had tried painting sculptures as a boy. Since then, he had made similar experiments, even painting a roughhewn stone sculpture in 1927. Often he added touches of color to his plaster casts. But he had seldom painted his bronzes, preferring to experiment with varieties of patina, gold, green, brown, black. When none of these quite satisfied him, he tried paint. Immediately he felt that the painted sculptures were a new departure toward the fleeting visual sensation he sought. He was delighted by enthusiastic reactions from the first to see what he had done, the technicians in the foundry where his work was cast, who responded with new excitement. The first painted sculptures were the figurines composing such works as The Cage, The Forest, The Glade, Four Figurines on a High Base, etc. He also painted at least one version of The Chariot. The breathtaking vivacity and finesse of the painted sculptures gives them a place apart in Giacometti's oeuvre. The paint added power, and added it precisely in the direction in which the artist had for fifteen years been trying to go, the direction of heightened representation of human appearance. Not that the unpainted bronzes are diminished. But the painted ones benefit from a further attainment of feeling.

On the evening of January 4, 1953, two talkative derelicts put on a peculiar performance in Paris. They raved and rambled, complained of hard times and sore feet, looking forward to things no better while waiting for someone to keep an appointment which nobody was sure had ever been made in the first place. Their carryings-on were puzzling but made a hit and drew the world's attention, for they were the principal characters in the first performance of Waiting for Godot by Samuel Beckett.

The war years had been for Beckett a time of transit even more desolate and trying than for his friend Giacometti. Leaving Paris two days before the Germans arrived, he wandered through France for several weeks, largely on foot, cadging food, sleeping in alleys or on park benches. For more than a year and a half, in constant danger to himself, to his mistress, and to his friends, he engaged in espionage. Members of his group fell into the hands of the Nazis, were tortured and deported. Beckett went into hiding. For many days he hid under the false floor of an attic, then in a secluded room, from which a fellow fugitive, his sanity undone by the ordeal, leapt out the window to his death. Eventually he escaped southward on foot with his mistress. They found refuge in the wild country of northern Provence, where they lived in discomfort for two and a half years.

Beckett came near spiritual collapse. Though never alone, though physically safe, he seems to have felt that the circumstances of survival were desperately uncertain. He went on arduous, aimless tramps through the surrounding country. Having no destination, it may have been precisely their point to attain one beyond the reach of awareness. He spent many hours voluntarily laboring

in the fields of a local farmer. He forced himself to write. In work he found a means of asserting his sanity amid the madness of a war that left him in peace to write.

As soon as possible after the end of hostilities, Beckett returned to Paris. The novel written in hiding appealed to nobody. Publishers advised the author that a "realistic" account of his wartime experiences would make him a fortune. To which Beckett retorted, "I'm not interested in stories of success, only failure." He wrote several novels and plays, all of which are peopled with characters on the extreme outskirts of organized society. The author himself seemed to his mistress and friends to have become one of them. Always remote, withdrawn, he became increasingly so. His financial situation was desperate. Sleeping by day, he worked mostly at night. When he had written all he could, he would go out to roam the streets or to haunt late-night bars. Inevitably, he ran into Alberto. The two would sit or, more likely, walk together for hours, talking about the absurd predicaments of artists. These conversations fed to the full the shared appetite of both men for metaphysical anxiety and became at once the symbol and substance of their friendship.

Giacometti and Beckett, each in a deeply individual way, personified the pure commitment of the creative man. Driven beyond the conscious self by a need to express what defies expression, they found the strength to sustain that need in the ironic authority derived from a mortifying acknowledgment of failure. Beckett had learned that words are powerless to convey an idea or a feeling, just as Giacometti had found that neither paint nor clay can possibly embody the experience of vision. But both were infatuated with the expressive possibilities which baffled their passion for self-expression. It was the futility of the pursuit that made it fascinating and saved the effort from becoming monotonous. Its purpose was not to produce works of art but to wrest from the process of perception its utmost resources. A thankless, well-nigh ridiculous task, performed with humility as an act of pride. If the outcome happened to be fame and fortune, no rightminded man would have interpreted it as a symptom of success.

Isabel Lambert, though a widow, had never ceased laughing. Merry and indomitable, she went on drinking and even found time once in a while to paint a still life of a few dead birds or desiccated vegetables. Soon she came up with another musician to marry, a distinguished though obscure composer named Alan Rawsthorne, he too an enthusiastic celebrant of the bottle. And she still got over to Paris occasionally, keeping up her acquaintance with artists and cafés. In London, where she had long since become a fixture of the art world, one of her closest friends was a then-little-known painter named Francis Bacon. Compulsive gambler, prodigious drinker, lover of low life and the young men who lived it, Bacon had a powerful, morbid, but attractive personality. Like Isabel, he was a great laugher, though the timbre sometimes sounded hideously ambiguous. He painted quantities of portraits of Mrs. Rawsthorne, many of them quite appalling as likenesses.

Henri Laurens was the only sculptor of the previous generation with whom Giacometti had been from the first, and stayed till the end, on terms of close friendship. No rivalry, no misunderstanding ever came between them. In 1945, Alberto had published a homage to Laurens in Labyrinthe; in 1950 he withdrew his own work from the Venice Biennale when he felt the older artist had been slighted. Mutual respect remained constant and untroubled for a quarter of a century. Laurens's career was, like him, modest. He was, and has continued to be, an artist for the happy few. Aged only sixty-nine, he died on the 5th of May 1954. Alberto was indignant because the event was not made much of. France's finest sculptor, he said, had disappeared and nobody seemed to realize the extent of the loss. Vital resources of tradition were slowly slipping away. Alberto foresaw a day when only memories would remain.

In the month of Laurens's death, as if in ironic reaction, Giacometti's career took a decisive upward turn. The occasion was his second one-man exhibition at the Galerie Maeght. It included a considerable number of paintings as well as many recent sculptures and drawings. The majority were works done from life, mostly portraits of Annette and Diego. Even for those well acquainted with Giacometti's work, it must have been surprising to see the

Barr.

Zamera

Les Las of

emergence of a painter comparable in authority to the sculptor. As a youth the artist had applied himself more to sculpture than to painting because the problems posed by the added dimension demanded the greater self-mastery. Having achieved it, he could now bring to both undertakings the force of faculties concentrated in each medium by the resolution of their seeming incompatibility.

Giacometti had longed for recognition and acclaim as honestly as any other young man with an obsession for self-discovery. His flirtation with fame had been justified just enough, which was little, to let him throw it over for the grand passion of failure. But the enticements of celebrity were now to begin. Alberto resisted them with ingenuity. The perils of acquiescence were clear in the case of Picasso. His old friend Derain had become a sad example of acquiescence spurned. Ingenuity nonetheless advised that resistance should be coy, while respect for others enjoined polite tolerance of their enthusiasm. Alberto sometimes remarked that the best way to attain success was by running away from it. However that may be, he did nothing to attract it and knew it was a threat to the ethical center of the self.

The demonstration of Giacometti's importance and the promotion of his career were not, however, determined by his acts alone. Many of his admirers were eminent men of letters. Sartre, Leiris, and others published persuasive tributes. For the Maeght catalogue, Sartre produced an essay devoted principally to his friend's paintings, which he described with subtle ingenuity as representations of the existential void where a human figure endures rather than creates the illusion of spatial being. Intellectual testimonials were all to the good, providing a creditable basis upon which values less intrinsic to civilization could skillfully be settled. With these in place, there would be no limit to the heights profitably scaled by down-to-earth entrepreneurs. That was where the expertise of art dealers came in. There could be no doing without them, nor did Giacometti try. By way of atonement, however, he let them do with him, if not with his work, much as they wished.

The Galerie Maeght was a grandly going concern. Aimé, Guiguite, and Clayeux had a formidable way with artists, collectors, other dealers, museum curators, critics, journalists, and connois-

Macely

seurs. Carrying all before them, they were themselves borne toward great horizons. What other gallery in Europe, or in the world, could better their initiative and rewards? Braque, Chagall, Miró, Giacometti, Calder, Kandinsky were their stock-in-trade. On the strength of their prestige as the dealers of the great, they were also able to make a market, and a packet, with the output of minor talents. It must be said that if the concern went grandly, that is the way Maeght did things. He was a braggart, a liar, and something of a bully, but he was not a miser. He was prepared to spend just as prodigally to promote the glory of Bazaine as of Braque. His motive may have been to prove his competence in the role of modern Medici while making a lot more money, but that point was lost on Bazaine, who needed prestige, and on Braque, who appreciated homage. Maeght went the limit, and there seemed no limit to how far he would be prepared, or able, to go.

Clayeux was content. If Maeght was a latter-day Lorenzo, then he, perhaps, might be something of a Pico della Mirandola: an ideal man of the new Renaissance fostered by his employer's grand designs and his own more provident devices. It could almost have been. He admired Maeght greatly, responding with emotion to the older man's flamboyant drive and lavish ambition, characteristics he himself did not possess. They were constantly together, sharing the excitement of artistic and economic achievements. If Maeght was proud of what he had accomplished in less than ten years, Clayeux was convinced that his discrimination had been essential to the achievement. The intimacy of the two men was no doubt nourished by this sense of happy identification.

It was Clayeux who operated behind the scenes, content to leave public relations and posturings to Maeght, who reveled in them. Friendship with the artists was the director's province. He visited their studios, talked to them with perspicacity about their work, gave practical help, paid attention to their wives—and brothers—and, by making himself both likable and useful, encouraged the supposition that he was indispensable. In his role as impresario, Clayeux had Alberto almost entirely to himself. Pierre Matisse was far away in New York, appearing in Paris but twice a year.

matisse

The direct relation of Monsieur Maeght with the artists of his gallery was mostly concentrated on fixing the prices paid for their work. Given to grand gestures of largesse, especially if they were public, Maeght was like most men of business when it came to acquiring merchandise: he tried for minimum outlay, hoping for maximum income. So it went with Alberto, who was the easiest of marks, since in his heart he feared and despised money, and because he had an interest in being treated unfairly. Afterward, when it was too late, he could, and did, complain. To hear his tirades of resentment he strangely chose Clayeux, who heard them, oddly enough, with sympathy, advising the indignant artist that he had only to stand up for his rights in order to obtain from Maeghtand from Pierre Matisse—the prices he deserved instead of sums shamefully disproportionate to profits. The artist would be mollified by these assurances. But they never affected his peculiar habit of inviting the dealers themselves to fix his prices, though he knew pretty well what their prices would be and might later weep with rage at having been so easily had. Then Claveux would agree with him that it was shocking, though his own fault, and Alberto would admit that that was the truth. He came to have absolute faith in Claveux's judgment, good faith, and word. And the dealer came to feel that Alberto represented the noblest personification of man's noblest pursuit.

Henri Matisse was aged eighty-four and in uncertain health in the summer of 1954. Thirteen years previously, he had fallen ill, suffering from acute abdominal pain. The doctors found a malignant tumor, requiring major surgery. Though he had done his best to make ready for death, the artist sensed a quickening of powers. Five more years, he told his doctors, he wanted five more years to bring to a climax the work of half a century. He got what he wanted. "My terrible operation has completely rejuvenated and made a philosopher of me," he said. "I had so completely prepared for my exit from life that it seems to me I am in a second life." Proof of it stemmed indirectly from the fact that his recovery was never complete, leaving him bedridden. It was in part as an accommodation to the state of semi-invalid that he began to work with

W

scissors, snipping from great sheets of colored paper the so-called cutouts of his last decade. Few artists since Titian have enjoyed such felicitous old age.

Old age, however, it was, and could not go on forever. This came to the attention of the French authorities, who decided to commission someone to execute a medallion bearing an effigy of the aged painter. Matisse agreed. But the choice of a sculptor acceptable to him posed a problem, as he had from the start of his own career produced an important quantity of sculpture. Giacometti, he felt, was a man for whom he could accept the constraint of posing. Alberto admired Matisse without reserve. Matisse was the only artist whose work he respected so much that he, who feared possessions, went out of his way to acquire both a sculpture and a painting from his hand. Alberto agreed to attempt a portrait and asked to make from life a series of preparatory drawings. On the last day of June 1954, having traveled via Stampa and Genoa to Nice, where the heat was stifling, he found the old man weary and withdrawn, as if all his attention were turned inward. Very dignified, however, he received his young colleague with courtesy, and conscientiously applied himself to the effort of posing. Each session was brief, as Matisse tired quickly, but Giacometti returned several times over a period of a week. The two artists talked little, both concentrating on the shared task. One day, though, when conversation came to the subject of drawing, Matisse suddenly grew more animated than Alberto had ever seen him and exclaimed, "Nobody knows how to draw!" After a silence, turning to Giacometti, he added, "You don't know, either. You'll never know how to draw." It was a judgment in which the younger man wholeheartedly concurred. Shortly thereafter, Matisse announced that he felt unwell and must discontinue the sessions.

Two months later, the sculptor received a message: Matisse was prepared to resume posing and wished to do so as soon as possible. Alberto found him much changed. The drawings made in July show a man unmistakably old but one whose intellectual vigor and spiritual fortitude survive. The drawings made in September, on the other hand, show a man at the doorstep of death, an exhausted octogenarian whose gaze has gone vague and whose

features are ravaged already by loss of self. They are majestically pathetic, these drawings, fraught with the tragic insight and tenderness of the late Rembrandt. One afternoon while Matisse was posing he was seized by an agitation that was felt also by Giacometti. "I was drawing," he said later, "and at the same time observing what cannot be captured by drawing." The old man gasped for breath. He called for help. His companion came quickly from an adjoining room. Then the seizure seemed to have passed. Matisse attempted to resume the pose. He who had spent a lifetime drawing from life struggled to make himself once more fit for the gaze of the portraitist. But neither model nor artist could go on with the work. Hence they took leave of one another. Sixty days later, the great painter lay dead.

As for the medallion, Giacometti worked from his drawings to model in clay two small studies of Matisse's profile. They caught the intensity of the momentous encounter. Perhaps for that very reason, the sculptor was dissatisfied, and bronze casts of his studies were not made before he, too, had died.

André Derain enjoyed no rejuvenation. On the contrary, old age confirmed loss of vitality, loss of talent, loss of prestige. Of all the artists he had known, and he had known them all, only two of note stayed faithful: Giacometti and Balthus. Sunday lunches at the estate in Chambourcy grew steadily more morose. Derain was not granted even the modest consolation of a dignified farewell to failure. One day he was run down by a careless motorist. The injuries at first did not seem serious. Alberto went several times to see him in the hospital at Saint-Germain-en-Laye. Then his mind seemed to go, and he lingered for some weeks in a vagueness. Asked as he was failing if there was anything he wanted, he said, "A bicycle and a piece of blue sky." Two hours later he died, the date September 8, 1954. Few people took the trouble to attend his funeral. Only a single artist of stature: Alberto Giacometti. It was a sorry end to the wild venture that had started off with such colorful exuberance half a century before.

Balthus had gone right on saying he needed a château more than a workman needed a loaf of bread. It was a bon mot, of course, but most people thought it in pretty bad taste. Besides, it wasn't a joke. Alberto, whose style of living remained stoic in the face of good fortune, was outraged. The one who needed the château, however, wasn't Balthus. It was the Count de Rola. The genuine artist was compelled to follow the make-believe nobleman, since they were the same person. Châteaus were a dime a dozen in France in the early fifties. Balthus, however, hadn't even a dime. His paintings weren't selling, and he subsisted with difficulty and resentment on the dole provided by a consortium of dealers and collectors. Nonetheless, while his friends smirked and looked askance, he searched the country for a residence at a cut-rate price that would still be imposing enough to house his self-esteem. What he found wasn't exactly what the nobleman had craved, but the artist also had desires, and the place he chose was very much the sort in which he could hope to satisfy them. Given an inclination to seek romantic parallels in unexpected settings, one could easily have taken the Château de Chassy for a Gallic version of Wuthering Heights.

As châteaus go, it didn't amount to much. Standing on the down slope of a small hill, overlooking a perfectly ordinary little valley on a side road somewhere between Paris and Lyons, it was just a very large house with massive towers at each corner, in quite a mediocre state of repair. There was no garden, no park, not a single fountain or stately vista, and the approach was marred by a vulgar farmyard. The interior was unfurnished and unheated. Breezes whistled under loose-fitting doors. The roof leaked.

There was no telephone. The nearest village was several miles distant. What Chassy had was space in which to look at works of art with an eve free from the constraint of twentieth-century confusions and preconceptions. The grandeur of the Count de Rola's château was very much a state of mind, and for an artist prone to morose reverie and dour hauteur the setting seemed made to order. If it looked like Wuthering Heights, and he like Heathcliff, all that was needed now to bear out the evocation was some girl prepared to play the unhappy part of Cathy. Alberto Giacometti would have seemed the last person in the world likely to procure the right young woman. He not only denounced the pretentions of the bogus count but condemned his obsession with pubescent girls, exclaiming, "We're sick of Balthus and his little girls!" And yet by an exquisite zigzag of irony, it was he who procured for the Count de Rola the first mistress of the Château de Chassy.

Léna Leclercq was her name. Her parents had been farmers, though unconventional ones, freethinkers, who refused to kowtow to convention, with the result that their offspring were born out of wedlock. Such intransigent idealism cannot have made them popular in the French provinces prior to the Second World War, and it must have bred lonely, unhappy children. As soon as she was able. Léna set out for Paris, arriving there aged eighteen. She was bright, sensitive, anxious to make a mark in life, and she was pretty. Alberto met her in a café. A bit of a friendship developed, and it came out that Léna wanted to make her mark as a poet. The sculptor introduced her to his friends, and she did her best to make a good impression. She succeeded, but she also unfortunately had to make a living. It was just then that Balthus was preparing to set himself up at Chassy, where his station and the size of the house called for servants. But he had little money. Alberto suggested that Léna might do as a housekeeper. Then she could write poetry while Balthus painted pictures. It was an exceptionally bad idea, and everybody concerned thought it grand.

Léna was a little old for Balthus, being at that time around twenty-five. Perhaps Alberto assumed that the housekeeper would never be exposed to the wiles of the finicky count. That was proof of how naïve a man of formidable intuition can be. Alone together in the gloomy château, the handsome, haughty artist and the sensitive, idealistic poet seem to have found life quite congenial. The artist in the meantime painted some splendid pictures, one of them one of his finest, an immense canvas called Le Passage du Commerce-Saint-André. The poetess, who also did a bit of cooking and dusting, wrote a collection of verse sadly—because so inappropriately—entitled Unvanquished Poems. Balthus once asked her what historical person she might have liked to be. "Trotsky," she said. He tartly rejoined, "You might have chosen Lenin. He, at least, succeeded."

After a while the observant painter noted that the wife of his older brother, Pierre, had a very attractive teenaged daughter from a previous marriage, by name of Frédérique, and it seemed to him that she might do beautifully to preside over the Château de Chassy. For reasons which only they can pretend to understand, all parties found the plan pleasing. All, that is, except Léna. There were scenes. The count was unconcerned about the opinion of his housekeeper. Frédérique's girlish gaiety made the place seem less like Wuthering Heights. Maybe that came as a delightful change for the middle-aged artist. The distraught housekeeper made an effort to end her suffering by ending her life. Her initiative was unsuccessful. An ambulance came in time to take her to the hospital in Nevers, and the keen eye of the artist observed with sardonic merriment as the vehicle departed that the name of its proprietor printed on the door was Sépulchre.

Alberto and Annette were summoned from Paris to provide support in the time of crisis. The sculptor may have been mindful that some responsibility for the contretemps could appear to be his. He did what he could. For Balthus it was little, because the artist failed to see that anything needed doing, while the nobleman did not deign to notice. For Léna, on the other hand, there was a good deal. Both Alberto and Annette continually befriended and helped her in years to come, which did not bring much happiness, either personal or professional. She retreated to a small and tumbledown house in remote, mountainous country near the Swiss border. There she wrote poetry, kept bees, planted a garden,

watched the weather. Alberto paid the cost of a new roof for her house, and afterward executed a series of lithographs to illustrate a volume of her verse, entitled *Apple Asleep*, which never otherwise would have found a publisher.

The Château de Chassy brought out the best in Balthus. During his years there—less than ten, unfortunately—he reached the climax of his career and painted many of his finest works. He did numerous portraits of Frédérique, who obligingly remained adolescent till long after her twenty-first birthday. Of the ordinary little valley where the château stood, he painted a remarkable series of radiant visions. The public slowly began to realize that an artist of extraordinary powers was hidden away in that nondescript locality. People started buying. The Museum of Modern Art in New York put on a retrospective exhibition in 1956, though Balthus could not be bothered to leave his château in order to attend. Collectors and critics started coming to call. They were greeted by a butler in a white jacket with gold braid who said that the count was in his studio and could under no circumstances be disturbed. Fine furniture filled the rooms and Oriental carpets lay on the floors. Alberto and Annette returned once or twice, but grand airs were not made for Giacometti. In Paris, where he came occasionally. Balthus received his admirers and friends on the premises of an official in the government's cultural ministry. Then he contrived to have his old crony André Malraux name him director of the French Academy at Rome, housed in the magnificent Villa Medici, one of the noblest landmarks of the Eternal City. Chassy was left behind. In Rome the craving for grandeur got more satisfaction than anybody could have hoped for. Princes and princesses, cardinals, ambassadors dined at the count's table. The artist did not do so well, because the nobleman had little time for painting. He had himself become a creation commensurate with his ambition to carry on traditions of an erstwhile order. The pictures he produced were increasingly decorative, self-indulgent reminders of the achievements of a simpler time. Balthus had been the most talented of Alberto's contemporaries and friends. Though never comparable in vision or purpose, yet amid the decline of the School of Paris they had both upheld valuable and profitable

aspects of tradition. Now Giacometti was left alone to do that. When Balthus went to Rome, he went out of Alberto's life, and in time it seemed that he had lost his old power to create a convincing world for the obsessive inhabitants of his imagination.

Giacometti and Jean Genet had never met. Alberto preferred to see his friends separately, tête-à-tête, if possible. They recognized this preference and respected it. Olivier Larronde had been Genet's lover before becoming Alberto's friend, but he had never introduced the two. Sartre, the champion of Genet's literature, had in 1952 brought out a 573-page treatise entitled St. Genet, Actor and Martyr. But neither had Sartre introduced Genet to Giacometri.

Yerst

Born in Paris in 1910, Genet was abandoned by his mother at birth to the custody of a state institution. He received her name but never saw her. The identity of his father remained unknown. As a small child he was handed over to a peasant family in a mountainous region of central France. Industrious, pious, he led a life untroubled by any problem save the embarrassing obscurity of his birth until he was ten. Then catastrophe befell him. He was accused of stealing. Though claiming to be innocent, he was sent to an institution for delinquent boys. In the French provinces in the twenties, reform schools were prisons. Punishment was the rule. Love came into the boys' lives by the furtive or brutal exactions of homosexuality. After six years of this regime, Genet experienced a kind of infernal epiphany. Trapped in the ignominy of his life, he determined to defy it by making it the touchstone of his freedom. Accused of theft, cast among thieves, he would become a thief and make theft a moral imperative. Confirmed in homosexuality by all-male confinement, he would exalt the love of men for one another.

Released from reform school well-studied in lessons of debasement, he drifted for fifteen years through the underworld of pre-war Europe, in and out of prison, living by petty thievery and looking for love in the arms of lonely sailors, fellow crooks, and drifters on the tide of the underworld. It was in the world of the dead that Genet began his life as an artist. In 1939, in the prison at Saint-Brieuc, a drab industrial town on the north coast of Brittany, he was present when a young assassin aged twenty was taken to the guillotine. None of the millions of deaths so soon to come could ever compare for the poet in terror and pity with that rite in the prison courtyard. Three years later, in another prison, he composed his first literary work, a long poem entitled "The One Condemned to Death," celebrating the memory of the decapitated youth.

Nothing on earth could have seemed less likely than the transformation of a semi-literate delinquent into a master of language. Lest it be the crucial knowledge that led from prison to poetry. A tragic recognition of life's impermanence and frailty is the central theme of Genet's writing. His characters are denizens of the underworld, criminals and traitors, pimps, prostitutes, and perverts, pariahs of contemporary society. The underworld of Genet is as real as the symbolic world above. His writings are addressed as much to the dead as to the living, and he once said that he could conceive of no authentic art that did not express the relation to death.

One day Giacometti came back in a state of considerable excitement to the rue Hippolyte-Maindron. He had seen Jean Genet in a café and been so impressed by his appearance that he was eager to do his portrait. It is not surprising. Genet had gone bald early. Alberto was especially attracted to bald heads, because absence of hair shows the structure of the skull. In Genet's case it was fine, giving the face a density which concentrated to great effect his tough but gentle gaze. Alberto was an admirer of the writer's work, and soon arranged to meet him. They proved immediately congenial. Genet agreed to pose. It was not unusual for a kind of romantic intimacy to develop between Alberto and his models, men as well as women, and perhaps with the men more easily if they were prone to love other men. Between Giacometti and Genet the bond quickly grew strong.

Alberto painted two portraits of Genet and made a number of drawings, all of them powerful representations of the confrontation between two extraordinary personalities. Genet later composed a portrait of the portraitist, which he published, entitled *The*

Studio of Alberto Giacometti. Intuitive and impressionistic, Genet's description of Giacometti is of a very different order from the brilliant intellectual postulations of their mutual friend Sartre. The latter is all thought, the former mostly feeling. But the feeling is very thoughtfully expressed, its significance searching and profound. Genet's text is one of those rare instances in art where the nature of one man's creativity has successfully become the material of another's creation. Much was written about Giacometti during his lifetime, but no other text meant more to him than the little book of forty-five small pages by Jean Genet. Picasso, never at a loss where intuition was called for, said that Genet's book was the best one about an artist that he had ever read. A few quotations selected at random, though to some purpose, will suggest why:

Every work of art, if it is to attain the grandest of dimensions, must with infinite patience, infinite application from the first moments of its development descend throughout the millennia to rejoin if it can the immemorial night peopled by the dead who are to see themselves in that work.

His sculptures give me the feeling that they seek refuge at the last in some secret infirmity which acknowledges their solitude.

Confronted by his sculptures, still another feeling: they are all very beautiful people, yet it seems to me that their sadness and their loneliness are comparable to the sadness and the loneliness of a deformed man suddenly stripped naked, who would see revealed a deformity which at the same time he would offer to the world as evidence of his solitude and his glory.

As for the time being his sculptures are very tall—in brown clay—he stands before them, his fingers rise and fall like those of a gardener grafting or trimming a climbing rose. The fingers play along the length of the sculpture. And the whole studio moves and lives. I have this curious feeling that by his presence the previous sculptures, already completed, change and are transformed without his touching them because he is working at one of their sisters. This studio, moreover, on the ground floor is going to collapse at any moment. It is made of worm-eaten wood, of gray powder, the sculptures are of plaster, showing bits of string, stuffing, or ends of wire, the

canvases, painted gray, have long ago lost the repose of the art supplier's shop, everything is stained and ready for the dust-bin, all is precarious, on the verge of disintegration, everything tends to decay and is adrift: well, all of this is possessed as if by an absolute reality. When I have gone away from the studio, when I am outside in the street, then nothing round about me seems real. Shall I say it? In that studio a man is slowly dying, consuming himself, and before our eyes he has by his own hand been made into goddesses.

Giacometti is not working for his contemporaries, nor for the future generations: he is creating statues to at last delight the dead.

The understanding between Genet and Giacometti was so deep that the writer's grasp of the artist's purpose had no need of an intellectual structure to support it. The friendship was so close that for a time one of their favorite amusements while sitting in cafés was for the heterosexual to select among the young male passersby those the homosexual found desirable. The choice never failed to be accurate.

The writer decided after a time that he had had enough of posing. He felt that he was being transformed into an object. Alberto said that he found Genet's attitude very literary, which may suggest that he did not want to understand his friend's reasons. To say that they were literary was to say that for Genet they were vital.

There was no overt break or misunderstanding. The friend-ship went untended. Maybe after the years of bitter vagabondage and imprisonment, Genet was not capable of the kind of attachment that took for granted any social underpinning. He believed that betrayal was akin to death in the absolutism of its beauty, and such a credo does not make friendship easy. Alberto lived closer than Genet to a conventional social structure, though never within it. Genet was deeply attached only to the world that had made him what he was, and to the beings who dwelt there. It was not a realm of easy access. As yet, Giacometti had had no need to suppose that the underworld and the netherworld might be the same place or that their inhabitants might be the same. The supposition would come to him when it had to. Perhaps his

friendship with Genet was good preparation against the need of that hour.

In the early morning of November 1, 1954, All Saints' Day, armed attacks against local constabulary and settlers broke out in the wild mountains of central Algeria. They marked the start of the Algerian War. Nobody living in France during this period was able to remain unconcerned by the national crisis of conscience. Sartre and Simone de Beauvoir were among the fiercest critics of national policy. As usual, they did not mince words. "Colonialism is in the process of destroying itself," Sartre wrote. "Our role is to help it die."

Giacometti kept his opinions to himself. But they were no less forceful for being private. He knew that his sphere of responsible action was his studio, and that his contribution to the discourse of the era should be made by seeing, not speaking. There were moments when he wearied of the intellectual hair-splitting of friends like Leiris, Sartre, and the Beaver, whose sympathy and understanding were basically theoretical. "What concerns me is to go forward," he said.

He went forward alone. Sometimes there is a kind of panic in the isolation of genius. Alberto needed no one to talk to about the metaphysical facts of life. For the rest, he was content to laugh with Olivier Larronde and Jean-Pierre Lacloche, whose exotic way of living much intrigued Annette, or to chat about the weather with the bartender at the corner café.

One day an old woman of the neighborhood came in and stood at the bar. Noticing Alberto, she said, "Who's that poor bum? I'll buy him a cup of coffee." The bartender told her that this was a well-known artist, no bum, and quite able to pay for his own coffee. The woman was unconvinced. "Hey, you poor old thing," she called, "you'd be glad to have a cup of coffee, wouldn't you?" Alberto replied that he would, yes, be very glad and thanked her warmly. She, at least, had seen him for what he was.

The artist's daily life had now grown into a routine that it would follow till the end. At one or two o'clock in the afternoon,

having slept six or seven hours, he would get out of bed, usually still tired from the work of the previous night. After washing, shaving, and dressing, he would walk to the café at the corner of the rue d'Alésia and the rue Didot, five minutes away, drink several cups of coffee, and smoke six or eight cigarettes. Consumption of cigarettes constantly increased as he grew older, and so did the cough that went with them. After breakfast he would go back to his studio to work till six or seven, when he returned again to the café for a couple of hard-boiled eggs, a slice of cold ham with bread, a couple of glasses of wine, several more cups of coffee, and a lot of cigarettes. If alone, he would read a paper or review, often making drawings and notes in the margins. If with Annette or friends, he would talk, joke, and lament his inability to draw, paint, or sculpt as he wanted to. Returning again to the studio, he would work until midnight or later, then try to clean himself up a bit and take a taxi to Montparnasse. There, usually at the Coupole and often alone, he would eat a decent meal, afterward going to one of the nearby bars or nightclubs, more often than not Chez Adrien, where he found faces familiar enough to while away an hour or two. The girls knew that he could be counted on for a few drinks and a bit of lecherous banter that need not lead to anything. They even knew that he was good for the occasional loan against a day that was sure to be rainy. Well before dawn, he would take a taxi back to the rue Hippolyte-Maindron—all the taxi drivers of the vicinity knew him and many called him by his first name-and there he would work until in the tipe of ... daylight.

Giacometti was well known and honored abroad long before official attention was paid him in the country where he lived all his adult life. No French museum mounted any exhibition of his work during his lifetime, nor did the Museum of Modern Art in Paris own more than a couple of sculptures from his hand at the time of his death. Alberto did not lust after honors; he tended to avoid them. But an artist honest with himself does not hunger for neglect, either.

In 1955, three large and important retrospective exhibitions of Giacometti's works were organized in foreign museums, one in New York at the Solomon R. Guggenheim Museum, one in London at the gallery of the Arts Council of Great Britain, and the third in the museums of three important cities of West Germany. These three foreign exhibitions brought added confirmation that Alberto Giacometti was one of the foremost living artists. Art critics and commentators on contemporary culture wrote at length about the inventiveness and originality of his achievement, though there was still a tendency to interpret it as an expression of twentieth-century angst and existential solitude.

One interesting aspect of the three foreign exhibitions is that they took place simultaneously, all in June or July of the year, which means that the artist had been far more prolific than he liked to admit. He was given to saying that his studio was empty, that there was nothing in it worth seeing, when it was often so crowded that little space was left for him to work in. The crowd would have grown still more inconvenient if he had been less destructive. What he prized was the experience of the instant, not the evidence of it. He was fearful of facility. The ease and

rapidity with which he could fashion a lifelike image in clay, paint, or pencil was prodigious. He was afraid of that power. Looking for what was impossible, he could expect to benefit from his failure to find it. Each effort was thus enriched by a concern for discovery rather than a craving for achievement.

Official indifference in his country of adoption cannot have pleased Alberto. It must have seemed peculiar then, and particularly French, when in the autumn of 1955 he received an official invitation to exhibit a selection of his works not in France but in the main gallery of the French Pavilion at the Venice Biennale the following June. In his letter of acceptance he said that no invitation had ever given him such pleasure, and we may assume that it was in proportion to the significance of representing his adopted country in a place that represented for him personally such an extraordinary complex of associations. He had refused to represent his real homeland in Venice, implying that he wished to be seen only in the perspective of an international viewpoint. His mother country could be constraining, like his flesh-and-blood mother. But Switzerland was not going to be slighted by her celebrated son. He proved it by agreeing that a large retrospective exhibition be held in Bern at the same time as the Biennale. This would oblige him to reserve numerous works which might otherwise have been shown in Venice, and so he declined to be a candidate for any prize awarded by the Venetian jury.

The famous Women of Venice, so-called because they were executed with the Biennale expressly in mind, ten in all, were created in a single sustained rush of energy during the first five months of 1956. Working with the same clay on the same armature, as he often did, Giacometti concentrated on a single rigidly erect figure of a nude woman, her body slender, attenuated, head held high, arms and hands pressed to her sides, feet outsized and rooted to the pedestal. She was modeled after a female figure in his mind's eye, not from a living woman. In the course of a single afternoon this figure could undergo ten, twenty, forty metamorphoses as the sculptor's fingers coursed compulsively over the clay. Not one of these innumerable states was definitive, because he was not working toward a preconceived idea or form. If pleasantly sur-

prised by the look of what his fingers had done, he would ask Diego to make a plaster cast, the business of a few hours. Alberto's purpose was not to preserve one state of his sculpture from amid so many. It was to see more clearly what he had seen. In plaster, the revelation was more luminous than in clay. Once a figure existed in plaster, however, it stood apart from the flux in which it had developed. It had achieved an ambiguous permanence and made an apparent claim for survival. If the artist allowed it to survive, to be cast in bronze, this was by reason of curiosity and comparison, not as potential evidence of achievement.

That is how the ten Women of Venice came into being. They were directly descended from the tall, slender female figures that Giacometti had been making for nearly a decade. Although he was to make many more such figures in the years to come, and some of them very much larger, these ten may be seen as a summation of his findings in this particular form. It is unlikely that their Venetian destination had anything to do with their appearance. Though they were not modeled directly from life, they are characteristic of Alberto's effort to make sculpture lifelike. To him, the most important part of a figure was the head. "When you think of a person, you think of the face," he said. The heads of the female figures are disproportionately small, their bodies elongated, and the feet, as always, disproportionately large. Aesthetically, the two disproportions make for a single effect of ascending vitality. When a spectator's attention is fixed upon the head of one of these figures, the lower part of her body would lack verisimilitude were it not planted firmly upon those enormous feet, because even without looking directly at them, one is aware of their mass, which counterbalances the smallness of the head, and between the two poles the remote but proximate body springs to life with an instantaneous surge. The eye is obliged to move up and down, up and down, while one's perception of the sculpture as a whole image becomes an instinctual act, spontaneously responding to the force that drove the sculptor's fingers. Comparable to the force of gravity, it kept those massive feet so solidly set on the pedestal that they affirmed the physicality of the figure as the one aspect of his creativity which the artist could

absolutely count on, all the rest being subject to the unreliability of the mind's eye. On the score of those outsized feet, Giacometti was sometimes asked why, in fact, he made them so large. "I don't know," he replied, and the answer was good, because the strength of the artistic effect lay not in knowing but in doing.

Jean Genet, whose intuition Alberto honored, understood that and said as much, maybe more, when he wrote: "Strange feet or pedestals! I will return to this. Quite as much (in any case, at first sight) as to any requirement of sculpture and its laws (understanding and rendition of space) it seems here that Giacometti—and may he forgive me!—performs an intimate ritual by virtue of which he will give the sculpture an imperious, earthly, feudal basis. For us the effect of this basis is magical... (One may tell me that the whole figure is magical, yes, but the apprehension, the bewitchment which comes upon us from that fabulous clubfoot is not of the same order as the rest. Frankly, I hold that there is a cleavage here in the workmanship of Giacometti: admirable in both regards, but contrary. By the head, the shoulders, the arms, the pelvis he enlightens us. By the feet he enchants us.)"

Lifelike, though not meant to be likenesses, the Women of Venice represent one more step in the artist's evolution toward work based on the direct experience of life. He was becoming increasingly conservative in his outlook as he became more and more uncompromising in his ambition. Works such as The Chariot, The Cage, The Forest, The City Square, which he had made only six or seven years before, works which corresponded to an inward view of man's experience and which expressed the artist's relation to his innermost self, were no longer necessary to his development. With the entire accumulation of his stylistic skill—wrought from a sheer disbelief in its efficacy—Giacometti was moving toward a greater and greater simplicity of means, which showed that he was going, as he had always meant to go, toward a confrontation with what was most difficult. When the going got hardest, he found help in drawing. From these years date scores of superb drawings, studies of interiors in Stampa and Paris, chairs, tables, pots and bottles, portraits of Diego, Annette, his mother, all executed with quick, dazzling, but skeptical mastery.

Painting was on the way to becoming interchangeable with sculpture as a means of responding to the visible. Advantages and adversities of one activity were brought to bear with enhanced insight upon the other. It would be tendentious to say which gave the fullest measure of his greatness. The paintings of the mid-fifties plainly marked the trend toward more exacting figuration, especially in portraits, where the search for definitive form generated greater verisimilitude. The same search in sculpture coincided with a series of busts of Diego, some very distorted, thin, and elongated, with salient features accentuated, in order to strike a likeness by way of what was most striking. Seen in succession as subliminal images of an ideal Diego, these busts appear to form a schema ever more profound and far-reaching, inasmuch as the sculptor's very first bust had been a portrait of his brother.

Early in June, Alberto and Annette traveled together to Stampa. After a few days there, Alberto left his wife and mother in each other's company and went on to Venice, where a number of his Women already stood waiting in the French Pavilion. In his suitcase he had brought along a few of their more recent, smaller sisters, and he was present to make sure that each one should be placed in relation to the others in a position as nearly perfect as possible. Placement as a physical and metaphysical problem had never ceased to obsess him. The search for the perfect situation obviously involved infinity, but that was just the challenge Alberto wanted. After a week, though, he hurried from Venice before the Biennale opened. His eye was wanted elsewhere.

The retrospective exhibition in Bern numbered forty-six sculptures of all periods, including five plaster casts of the latest female figures, plus twenty-three paintings and sixteen drawings. Of the works exhibited, the earliest had been executed almost forty years before. So it was a comprehensive survey of the artist's career to date, the most comprehensive that he had yet had occasion to see. Seeing it, he cannot have failed to perceive from what a distance, from what a radically different point of departure, he had come. It must have looked like something of a watershed.

Annette had come from Stampa to Bern to be with her husband for the opening of the exhibition. The man who had organized it was a young art historian and curator named Franz Meyer, whose wife, Ida, was the daughter of Marc Chagall. Both had been friends of Alberto for years and gladly seized the opportunity for a public demonstration of esteem. Though Giacometti disliked honorific occasions, he recognized the need for ceremonial formalities which had their social benefit in the deceptive virtue of seeming natural. Also, to be sure, there must have been satisfaction in the knowledge that any honor done him would give pleasure to his mother, and that her pleasure was vital to his own, which meant that for her sake he must be entitled to a fair amount of admiration. He gladly agreed to attend the opening of the exhibition and go afterward to the party which Franz and Ida Meyer were planning to give in their apartment.

Annetta Giacometti was not present that June evening to preside over the display of her son's genius. Her traveling days were done, and she would never leave Bregaglia again. But she presided over the exhibition. In the Kunsthalle hung four portraits of her to prove it. Annette, on the other hand, was present to enjoy her husband's success. The question, however, of her readiness to enjoy it had not yet been put to the test. This was just the beginning of public recognition of Alberto as an artist of worldwide stature. We can assume that Annette had hoped for such recognition, and that her hope may have been part of her dowry. But there is no reason to believe she foresaw that Alberto's success might ever tax her endurance. In being Madame Giacometti, to be sure, there was little, if anything, that the girl from Grand Saconnex could have foreseen.

The mood of the Meyers' party was buoyant. The exhibition had been superbly installed. People were impressed, excited. A small nation had brought forth a great artist, and in 1956 that fact could still seem to project upon the future the promise of the past. Alberto was enjoying himself. Though he did not look for opportunities to shine, he knew that he could be brilliant and entertaining. When the occasion offered, he sometimes enjoyed

outdoing everything it offered by way of high-spirited exuberance. Being Giacometti, in short, was something he had always looked forward to, and to have succeeded in becoming Giacometti brought moments of joy. So his response was wholly in character when in the course of the evening an attractive young woman made her way to his side to congratulate him and express her heartfelt admiration: he impulsively kissed her on both cheeks. Whereupon, to the consternation of all, Annette started shrieking with rage, rushed to an adjoining room, and remained there for the better part of an hour, while the guest of honor endeavored to placate her. The party was ruined.

Friends of Alberto and Annette had seen for some time that their marriage was falling short of perfection. This was one of the first public demonstrations of that fact. Everything about the evening had been conceived for, or by, Alberto, and artists were said with some reason to be motivated by a longing to attain honor, power, riches, fame, and the love of women. To seal the triumph with a kiss, however, chance had not chosen the cheek of the artist's wife. He, however, had never made a secret of his resolve to live as he saw fit, marriage or no marriage. That resolve, indeed, had been the condition of his troth.

Annette's tantrum may have been irrational. But was the appeal to reason to be made solely on Alberto's grounds? He had led her on. He had led her specifically into his studio, where she had surrendered entirely to his demands, albeit transfigured by them. It was as a woman, though, that she longed to be made much of, not as a work of art. And there were material grounds for grievance, too. Of these, the most appreciable was money. Alberto feared it. Leonardo da Vinci once said: "As for property and material wealth, these you should ever hold in fear." Alberto did. He refused to be compromised by the triviality of ownership and possessions, and felt constrained to live by an ascetic scruple so pure as to look almost saintly.

The hard fact was, though, that he had begun to have a great deal of money. Clayeux and Maeght brought envelopes full of it. Pierre Matisse's agent in Paris brought more. The accumulation became positively embarrassing. Alberto didn't

know what to do with it. He gave a lot to Diego, who continued to squirrel it away. He gave handfuls to the girls he met in the bars and nightclubs of Montparnasse. To his mother he sent more than enough, lovely reminder of the days when his tiny figurines had seemed to promise so little. To Annette, however, he gave the bare minimum, which is odd. As her husband he apparently assumed that he could see her needs with a view to what best suited her condition, and what he appears to have seen was that it should suit his wife to live as he did. Annette didn't see it that way at all. Having made the best of things when the going was poor, why should she not expect to do the same when it got rich? She didn't want much, only to live in a good semblance of comfort as her parents and relatives and friends lived, as people lived, in short, in the background from which she had so earnestly longed to escape. She couldn't get away from that, nor did she want to. Why, even Sartre and the Beaver, those ferocious loathers of the bourgeois, were set up in perfectly respectable comfort.

What Annette wanted was a household, nothing elaborate, but decently comfortable. She wanted a kitchen, bath, an indoor toilet, hot and cold running water, automatic heat. The kind of lodging which could reasonably be called a home. That could never be said of 46 rue Hippolyte-Maindron, with its coal stoves, cold water, and outdoor toilet. It happened about this time that a little yellow house of three or four rooms and a bit of garden came up for sale directly on the other side of the street. Annette begged her husband to buy it. He refused. She pleaded and insisted. He was adamant.

Annette would also have liked fine clothes. Though no longer constrained to wear hand-me-downs from Patricia Matisse or Simone de Beauvoir, she dressed inexpensively and simply, while Patricia wore exquisite Chanel suits and even the once-dowdy Beaver was to be seen in elegant frocks and fur coats. It is possible that Annette's personality might have shown to less advantage had she been able to appear as a woman of fashion. The American industrialist and collector, G. David Thompson, assiduously cultivating the artist while amassing his works, once gave Annette a bolt of costly brocade to make a gown. Alberto took it and nailed

it to the wall of their bedroom. He was determined that his wife should be modestly attired, although he cannot have expected her to dress with an indifference to comeliness as absolute as his.

Alberto's apparel was so much a part of his personality as to seem almost a state of mind rather than an outfit of clothes. It was always the same: a tweed sports jacket, gray or brown in color, with a pair of gray flannel trousers, the latter usually too long and always baggy, held up by a worn leather belt. Never, or almost never, was he to be seen without a necktie. Whether he was in the studio or out, the necktie was at his collar. When the weather turned chilly or rainy, he wore a gabardine raincoat. He did not own a hat, but sometimes in the rain he would pull up the back of the coat to cover his head. Painting or sculpting, eating hard-boiled eggs in the café, or dining at expensive restaurants with Pierre Matisse or Dave Thompson. Alberto always wore the same clothes. They usually looked as if he'd slept in them on a park bench the night before. Still, he made efforts to be neat. Before going out of an evening, whether to the Coupole or to Lasserre, he would brush his clothes, give attention to his shoes, and at the sink in the corner of the bedroom scrub hands and face. The efforts were in vain because unmotivated by genuine care for the outcome.

Annette complained. With little money to spend on her wardrobe, she was neat, clean, and becomingly, if simply, attired. Alberto was hopelessly untidy, and his finances no longer excused it. She scolded. It was another issue of contention. When his hair grew too long, she cut it. To do anything about the clothes was less easy. Still, every now and then, once a year on average, Alberto would reluctantly get into a taxi and drive to the Boulevard des Capucines near the Opéra to a shop called Old England. After half an hour he would come out wearing a brand-new outfit—jacket, trousers, raincoat, necktie, scarf, all identical to the cast-off things left behind. A few weeks later, only the most diligent observer could see the change.

Monsieur and Madame Arm had continued for some time to disapprove of Alberto, and of their daughter's relationship with him, despite the accommodation of marriage. They had felt that no good was likely to come of it and deplored the artist's failure to father children. What altered their point of view, and radically reversed their displeasure, was fame. When they began to read about Alberto Giacometti in the newspapers, when the neighbors started making inquiries about the celebrated artist, when it became evident that their little girl was the wife of a great man, the parental attitude was altered as if by magic. The shabby, dusty good-for-nothing who had been Annette's undesirable lover was transformed by fame into an admirable and enviable son-in-law. The Arms began to feel properly proud of their daughter's marriage, and the prosaic irony was that their pride coincided with much of what had begun to trouble it.

Even in a position of financial, professional, and artistic success, Alberto obstinately persisted in the posture of failure. Maeght, Skira, and others wanted to publish books about his work. He put them off. When admirers grew persistent, he became evasive. Proposals for exhibitions went unanswered. Diego turned away would-be interviewers and photographers. Annette could not understand why success should be spurned. Other artists weren't so contrary. Picasso lived in luxury on the Riviera, and was driven about by his son Paulo in a Hispano-Suiza the size of two taxis. Braque had a mansion in Paris, a country estate, and rode in a Rolls-Royce. Max Ernst owned a large establishment in the Loire Valley. Likewise, Calder. André Masson had a fine apartment in Paris and an attractive summer home at Aix-en-Provence. Balthus had his château. Why should Alberto Giacometti-and his wifehave to live in seeming penury and genuine discomfort? She could not understand. She could only criticize and complain. What Annette failed to see was that Alberto's self-denial was a quest for affirmation. His preference for privation was a resolve to enjoy life's greatest luxury: spiritual freedom. To Annette, the quest looked like self-indulgence, the resolve like pride. They were looking at different objectives from different points of view. Conflict ensued.

The relationship between husband and wife began to seem entirely polemical. Alberto's hostility toward women—long since incorporated into memorable works of art—showed itself in violent

denunciations of Annette's foolishness, pettiness, and blindness. She retaliated as best she could, which was by rage or tears. There were loud, painful scenes, often in public. When beside himself with vexation, Alberto forgot his whereabouts and remained unaware of startled glances from neighboring tables. This only made his harsh criticism more wounding and embarrassing. Annette cried often. But she held her own. If she sensed that there might be something irrational in her husband's antagonism, that it might even in some obscure way be directed against himself, she was able to turn such awareness to advantage. In their altercations there was no sign of indifference.

Annette, however, was not the only one who wept. Despite his ruthless lucidity, Alberto was neither a blackguard nor a fool. Though he saw women as creatures to be feared even as they were worshipped—preferably from afar—he recognized each one as a human being whose integrity deserved to be kept inviolate. Then, perhaps, he hated them, and himself, even more because he had accepted the compromise of marriage to one of them. There, however, he was. He could not blind himself to what he had done. He knew Annette had been used by him, by his work, by his ambition. Even more ruthless than his lucidity was his remorse at having been used himself in his willingness to use her. Forgiveness did not come with knowledge. He shed real tears, and as he wept he would murmur over and over again, "I've destroyed her, I've destroyed her, I've destroyed her." Maybe that assumption made him less forgiving toward them both. He accepted the entire responsibility for what had happened. Upon occasion, his acceptance could be almost unbearable. For both.

One day Alberto and Annette and a couple of their friends were sitting in the café at the corner of the rue Didot, chatting, when the conversation brought forth the self-evident notion that an artist is a person condemned to be alone in the world.

"Like me," said Alberto.

"What about me?" Annette protested.

"Oh, you," Alberto said. "I only married you because you're named Annette like my mother."

A terrible thing to say. And to hear. But it was more terrible

still to *have*, and be *able*, to say it. It took for granted a burden of awareness that few men can bear. But Annette had never been made for that burden. Alberto lived for his art. He had no choice. Annette had chosen. She, too, lived for his art, if only because that was the way to live for him, and so the day of reckoning had to be even more thankless for her than for the artist.

She also complained about being indispensable to her husband's work. She had reason. For more than a decade, she had been posing for him incessantly, a cruelly punishing routine. He insisted on the immobility of the model, who sometimes had to stand naked for hours in the drafty studio, where it was in addition her duty to tend the stove. Indispensable, however, she was. She not only provided him with a model always at hand, patient and submissive, but offered the complete, uninterrupted familiarity with a naked body which is essential to true originality in its representation. Still, the work was exhausting. The model could confuse her person with the picture or sculpture as a cause of the artist's frustration and rage when he found himself unable to reproduce the figure before him exactly as he saw her. Sometimes he would scream in fury or groan in despair. But even as the model was essential to the effort, she was expendable. The figure and features of another person could do as well, producing the same frustration and rage, presenting the same problems. The model was everything and nothing, an appearance rather than a person, required on both counts to accept with composure the outcome of the artist's pursuit. It was a predicament made to test the selfpossession of strong personalities, and one to which Alberto sometimes added peculiar twists.

He disliked hair. "Hair is a lie," he used to say. It distracted one's attention from the essential, the head, the expression, the gaze. One day he declared that he could no longer endure seeing Annette with hair. She would be obliged to shave her head. Dismissing the suggestion as absurd, she exclaimed, "Oh, Alberto!" with a mixture of girlish amusement and feminine annoyance. Just that reaction was needed to pique Alberto's tenacity. He set about insisting that Annette shave her head to please him, advancing reason after reason to show that it was normal and impera-

tive for her to agree, ridiculous and wrong for her to refuse. He promised to buy the most sumptuous and expensive wigs. He enumerated other alluring inducements. She resisted. The more she resisted, the more he insisted. It was no fair match, and as it went on, the weaker of the two seemed to be physically wilting away. "All right, Alberto, all right," she said wearily at last. "If you want me to, I'll have my head shaved." She seemed utterly spent. But Alberto did not hold her to her word.

Their marriage had become like a sea of ambivalence, with deeps and shallows, uncharted currents, whirlpools, and tides, upon which arose sudden tempests, where squalls could come and go in a minute. It offered fair winds, too, zones of sunlit calm, and occasional isles that looked like paradise to passersby. In short, it was like many a marriage. It would have been, that is, if Alberto had not been Alberto Giacometti.

Diego watched what was happening between his brother and sister-in-law with concern, though for the time being with equanimity. Annette seemed a tolerable wife for Alberto. When there were storms, he did not ask anybody else to endure the inclemency of the weather. Occasionally the three Giacomettis still went to a nearby restaurant to talk and eat and joke and smoke, while Alberto made marvelous drawings all over the paper table covering. Then it could still seem like old times.

Change, however, had come, was irreversible, and would grow greater as they grew older. One of its principal agents was a newcomer to their lives, and as if to demonstrate the far-reaching extent of his role, he came from the other side of the world.

Five

Isaku Yanaihara was born in May 1918 on the Japanese island of Honshu, son of an impressive and eventually celebrated figure. The elder Yanaihara had graduated at twenty from the Imperial University, where he went on to become a distinguished professor of economics. With the rise of imperialism, however, his liberal teachings were frowned upon, and he was dismissed. Only a man of rare rectitude would have dared to defy accepted codes of patriotism, and his children may well have been predisposed to see themselves as persons set apart.

Isaku received an elite education, specializing in philosophy, and graduated in 1941. Before the end of that year, Japan was at war on the side of Germany and Italy. The twenty-three-yearold Yanaihara was drafted into the navy. At the war's end he returned to a homeland where the humiliation of defeat was compounded by the horror of having been a first proving ground for mankind's urge to tinker with the possibility of total selfdestruction. Independent of mind, bearing a name that called for some living up to, Yanaihara decided to follow in the paternal footsteps by becoming a university professor. He also became a husband, and presently the father of two daughters. His own father in the meantime had made good harvest of courage and integrity, being reinstated with honor to Tokyo University, of which he was named president in 1951. Isaku taught first at Gakushuin University, then at the University of Osaka, later at Doshisha and Hosei. This rhythm of professional change is unusual in a society where the patterns of men's careers tend to be sternly monotonous. It suggests a restless, headstrong, eccentric temperament.

The post-war climate of feeling in Japan fostered radical change and repudiation of the rigid attitudes of previous generations. Yanaihara was deeply influenced by this climate and contributed to it. The mode of thought he found most persuasive and congenial happened to be Existentialism, and he was one of those who introduced to his countrymen the ideas of Kierkegaard and Sartre. He translated into Japanese the novel that made Albert Camus famous, The Stranger. Attracted as he was by concepts and attitudes that came from France, it is not surprising that he should have been attracted by the country itself and felt that a sojourn there would contribute to personal and professional fulfillment. If it were to take him far from home and family, such was the existential necessity. Everybody concerned, including himself, must make the best of it.

He found life in Paris pure pleasure. Being there in 1954 was perfectly delightful, especially for a foreigner who had a bit of money to live on and nothing to do but see to his own enjoyment. There was plenty of fine, inexpensive food to eat, excellent wine to drink, and the French had grown more forthcoming since Alberto's arrival. Yanaihara had a scholarship from the National Center for Scientific Research, allowing for two years' study of philosophy at the Sorbonne. As months passed, his enjoyment led him less frequently to the lecture halls and more and more regularly to cafés, theaters, museums, restaurants, and the apartments of newly made friends. He particularly enjoyed and sought out the company of writers and artists. Among the most notable—and most inevitable—people he came to know in his first Parisian year were Jean-Paul Sartre and Simone de Beauvoir.

One day he received a letter from a friend in Japan, a writer who had published a magazine article on the art of Alberto Giacometti, asking whether Yanaihara would interview the sculptor to obtain more information about his work. Yanaihara wrote to the rue Hippolyte-Maindron. Alberto replied. They met for the first time at the Café des Deux-Magots on November 8, 1955. Unlike most people encountering Alberto for the first time, Yanaihara was not bowled over. But he was impressed, and before they parted, he asked to visit the studio. Alberto agreed. Yanaihara fell

into the same habit as most of Alberto's friends and admirers: he would drop by the studio unannounced or appear at the café on the corner of the rue Didot. If random visits were inopportune, Alberto was seldom coy about saying so, though careful to do it with tact. A friendship grew between the Japanese professor and the Parisian sculptor. Alberto's outgoing curiosity and sympathy helped, because Yanaihara was not an impulsive man. Watching Giacometti work, however, and hearing him talk—and how he did talk!—the philosopher began to feel that he was in the presence of a remarkable man. They started having meals together, accompanied usually by Annette but rarely by Diego, often joined by Olivier Larronde and Jean-Pierre Lacloche. Occasionally they went to the theater or a concert.

The winter passed, then the spring, and Yanaihara began planning his return to Japan, with a stop en route in Egypt, where he longed to visit the monuments and museums. Giacometti chose that moment to suggest that his new friend pose for a portrait, a painting. Yanaihara had some idea of what it meant to pose for Alberto, as he had also become friendly with Jean Genet and had often been present when Annette was sitting, or standing, for her husband. He realized it was not a commitment to be taken lightly. He felt swayed, however, not only by friendship but also by his conviction that Giacometti was a great artist. Posing for a great artist is participating in the process of civilization. Alberto was fond of saying that Philip IV of Spain could have done nothing better for mankind than to pose for Velázquez.

The visit to Egypt was postponed. Yanaihara began posing in September 1956. It is not difficult to see why Giacometti had asked him to do so. With a large head, strong jaw, broad, high forehead, and small but piercing eyes in well-defined sockets, he was not handsome but imposing. As a model he came close to being ideal, because in addition to the striking singularity of his features and the lively concentration of his gaze, he was capable of remaining for long periods absolutely motionless. The essential aspect of his suitability was friendship, as Giacometti needed the emotional participation of his model in an act which called for extraordinary unselfishness but offered a rare measure of intimacy. The artist's

idea was to make a rapid sketch on canvas, working no more than a week or so, leaving his model soon free for the homeward journey. A routine was set. Yanaihara had moved from his student room to the Hôtel Raspail in Montparnasse. It was an easy walk to the rue Hippolyte-Maindron. In the early afternoon, work began. Giacometti started painting the portrait of the Japanese professor.

Forty years of portraits lay behind him. Since the age of thirteen, he had sculpted and painted scores of portraits, many of them masterpieces. Portraiture per se, however, with its implications of concern for the individuality of the model and care for a convincing physical and psychological likeness, had not been his guiding purpose as he sought to develop a style all his own. Portraiture as a genre, moreover, had been in decline for half a century. But it was precisely by the painting of portraits that Giacometti began the final phase of his creative adventure. It coincided with the countenance of a man from another race and another world, and in the contemplation of his features the artist found himself embarked upon an experience as extraordinary as any voyage of discovery. At first, it went well. Alberto never had trouble making a convincing image. But his artistic temperament led him to seek tasks by which mastery is baffled.

Yanaihara's appearance came and went, inexplicably elusive. A face emerged from nothing in almost no time as Alberto's brush whisked across the canvas. It came so fast it had the quivering immediacy of breath. But the brush lost it again just as quickly, as if the material thing itself could not sustain the effort of imitation. To make a likeness was not the same thing as making an image lifelike, equivalent in feeling to the presence of the model. The impossibility was identified with Yanaihara because the image was his. The fleeting similarity to it was his portrait. He was extraordinarily patient. It became apparent that the enterprise to which artist and model were committed had no relevance to time. Yanaihara began to pose in the evenings as well as the afternoons, and Alberto took another canvas for the painting made by electric light. Now there were two portraits to contend with.

Weeks passed. The intimacy between the two men grew intense. It began to have the aspect of a passionate attachment. It spilled over from the studio to the adjoining room. Annette was drawn into it. Between sessions of posing, there were meals in Montparnasse, hours of conversation in cafés, excursions to night-clubs.

Diego did not share Alberto's enthusiasm for the newcomer, finding Yanaihara taciturn, aloof. But he had never been as outgoing as his brother, nor would he have presumed—as yet—to question the artist's right to take as model and friend whomever he pleased.

Annette was amused and intrigued by Yanaihara, with whom she found herself sometimes left alone when Alberto had appointments with dealers, critics, or other friends. The lilt of the Japanese language pleased her, so Yanaihara taught her a few words, which she proudly repeated to Alberto. The artist remarked to his friend, "I'm sure Annette adores you."

Yanaihara's homeward trip had now been postponed several times, and there had begun to arrive from Japan reminders of obligations and responsibilities difficult to ignore. Still, he lingered in Paris. The reasons for his delay could not be easily explained to those waiting at home. Having come to France to ponder man's freedom and responsibility, he had something to think about.

One afternoon early in November, Alberto told his model that they would be unable to work that evening. He had an engagement. Yanaihara was pleased at the prospect of a free evening. Annette proposed that they spend it together at a concert, and they went to the Salle Gaveau to hear the Fisk Jubilee Singers, a group of black Americans who specialized in spirituals. Afterward, they had arranged to meet Alberto at Saint-Germain-des-Prés. On the way, crossing the Seine in a taxi, Yanaihara kissed Annette's shoulder. Their embrace grew passionate. At the Café de Flore, Alberto was waiting. The three went to Montparnasse, where Alberto excused himself, saying that he had letters to write, and left the two together. Annette said, "I'm coming to your room." The hotel was only a few steps away. After an hour she said, "Alberto will

get worried." Having dressed and put on her coat, she held out her brassiere and stockings, laughing slyly, and said, "I'll have to show these to Alberto."

The next day, on his way to meet the artist, Yanaihara felt apprehensive. One may wonder at his naïveté, but the desire to please must have been genuine. When asked whether he was angry, Alberto said, "Not at all. I'm very pleased."

That evening, after the sessions of posing, Alberto again left his wife and model alone together, saying that he had letters to write. Yanaihara suggested going for a drink to a nearby bar. Annette said she would prefer to go directly to the hotel. Later she returned to the rue Hippolyte-Maindron. The following night it was the same; the night after, likewise.

Alberto claimed to be delighted. No emotion, he said, was more foreign to him than jealousy. He asserted that if Annette had fallen in love with a man undeserving of her devotion, who would make her unhappy, he would have advised her to give him up. But if the man was someone he liked and admired, then he himself could be pleased. "See how happy she looks," he said. "Since I love her, isn't it natural that I should be glad?"

Perhaps. His protestations ring a rather discordant note when one recalls past reactions to similar situations. So this one must be supposed to have been different. Much was to hinge on the true nature of Alberto's feelings about the intimacy between his wife and their Japanese friend. On the score of responsibility there was certainly large room for tolerance on the part of the husband, as he had never ceased to have a private life of his own. This, however, could not be taken to suggest that he did not love his wife. He proved it both in life and in art. Perhaps he proved it most by being so tolerant. The ambivalence of Giacometti's nature was too intricate to make things easy for anybody, especially himself. He could be sincerely gratified by the newfound happiness of his wife and also enjoy it as a stimulus to renewed ardor of his own. Still, friends who were close witnesses felt that despite his protestations Alberto was a jealous husband. This was the first time that Annette had shown serious interest in another man, and the situation was further complicated by the extraordinary intimacy between artist and model, which itself seems to have attained an aspect of passion.

Alberto's work began to go badly. Nothing would ever again be quite the same. He could see the difference. "It had seemed to me," he said later, "that I'd made some progress, a little progress, until the time when I started working with Yanaihara. Since then, things have been going from bad to worse." It was like the "difficulty" in 1925 when he had been trying to paint the portrait of his mother. The same sense of impotence tormented him now. The leitmotiv of the years to come was his baffled cry: "I'm right back where I was in '25!" Thirty years of labor, however, had not been for nothing. As he said, "It's not enough to do what I can do, but I must do what I cannot do."

Once again Giacometti set out to repudiate the apparent uncertainties of style and to learn how to look. Success had taught him that the appearance of a person or thing cannot be relied upon to inform one of its reality. The renewed lesson of failure would bring a richer result. Scrutiny of appearances reveals that seeing is not believing. Vision is inference infinitely reviewed. An artist works with innumerable alternatives, each one different but true, and in order to create a self-sustaining image he must be creatively aware of the largest possible number of relationships. Giacometti had extended this awareness to an extraordinary degree. Still, it must have come as something of a shock to have to prove himself the legitimate possessor of his powers at the age of fifty-five.

Annette was happy. Having discovered with delight that she could love two men without losing her own sense of wholeness, she patiently accepted their attentions to art. Yanaihara wrote poems for her, describing her as a smiling angel alongside her artist husband. The poet had no illusion about the quality of his verses, but they were transfigured by emotion in the mind of the recipient. He remarked to Alberto that he thought her a bit naïve. The husband protested. His wife was not at all naïve, he said. He'd known her for fifteen years and found her just the reverse of a naïve person, a woman with a strong will and the ability to act on it, one who always got what she wanted. Sweet and nice, then, yes, but not naïve.

act 55

Her happiness was about to be rudely interrupted. Yanaihara had received from Japan more and more peremptory reminders of home and duty, warning that further delay would entail grave consequences. A waiting wife and two daughters may also have inclined him to take leave of extraordinary experiences in Paris. The date of departure was set for mid-December, and Annette began to grieve.

Alberto was also dismayed. He was losing more than an asset of emotional life. He was losing the person who represented his changed rapport with visual reality. Because of Yanaihara, he had begun to see people as he had not seen them before. He saw them now stripped of all relation to the aesthetic, but he was compelled to come to terms with them on that basis. Yanaihara's presence coincided with this necessity, and he was about to lose it. "Certainly," he admitted, "I'll continue work with Diego or Annette in place of you. But it's your portrait I'd like to paint, not another, and which would benefit by the progress I've made thanks to you. Otherwise, I fail you." Nothing, in short could, or should, be so like Yanaihara as Yanaihara.

He seemed indispensable to the artist, the husband, and the wife. He was urged to return to Paris the following summer during his vacation, and it would be impossible to tell whose feelings were most at stake. Alberto would arrange for air fare, and the visitor would have no expenses once arrived. Fairness undeniably argued that he earned far more than his keep by being present. Yanaihara did not need to be pressed. It was agreed. The model and friend would return. Everything for everyone would begin again.

The Chase Manhattan Bank, one of the world's largest, was preparing in 1956 for the construction of a new building to house its headquarters in New York City. Plans called for a monolithic structure of sixty stories to stand in downtown Manhattan but also allowed for a spacious plaza facing Pine Street. Something proportionately impressive was wanted to decorate this space. The principal architect was a man named Gordon Bunshaft, a bumptious individual who knew what was what in the art world and owned a considerable collection, including works by Giacometti. A committee was formed to select a sculptor who could produce something grand enough for the Chase Manhattan Plaza. The men first asked to submit preliminary designs were Giacometti and Alexander Calder, whose large-limbed, decorative "stabiles" had recently won recognition.

That Giacometti should have been considered for such a project is surprising. He was not known for the large size or decorative character of his works. Perhaps the architect and committee members fancied that any artist worth consideration would gladly magnify his vision to suit the site. What is more surprising is that the artist should have taken the project seriously as a fit challenge to his ambition and imagination. He had never set foot in New York and knew nothing about life in a rapidly evolving metropolis. Nor had he ever laid eyes on an actual skyscraper. Moreover, he had a fear of heights, of empty space, of the void. He liked to keep his feet planted firmly on the ground. But he was immediately responsive to the American proposal. It is true that he felt a keen nostalgia for the idea of executing a sculpture to be placed in a city square, and that the theme of people seen either

singly or in groups in urban environments had long been important to him. It is also true that he had always been accustomed to seeing figures that looked no larger than pins below the towering peaks of Bregaglia. And crucial turning points in his development had come from the vision of female figures in city streets at night, once in Padua, once in Paris. Alberto wrote to his mother of the project. It interested him passionately, he said.

There was talk of a quick trip across the Atlantic to view the site. But since Yanaihara's departure, Alberto had begun painting a portrait of Annette, who posed four hours a day and more, and he was anxious to start yet another bust of Diego. He had no time to go to New York even for the sake of a prospective client as imposing as the Chase Manhattan Bank. Therefore, he was provided with a tiny scale model of building and plaza, allowing him to toy, as it were, with sculptural possibilities. As he was no stranger to the minuscule, this seemed perfectly practicable, and he quickly had an idea. He saw the plaza populated by three sculptures, each one an embodiment of his main aesthetic preoccupations: a head, a female figure, and a man walking. He would do much work with the Chase Manhattan Plaza in mind, but only the idea mattered, of course, not the place.

While Alberto was preparing to see what could be done at the behest of the New York bank, another manipulator of American wealth was at his door. G. David Thompson of Pittsburgh had gone on amassing Giacomettis. His aim was to own the largest, best collection extant. In pursuit of it he was prepared to be as ruthless as in the pursuit of cash, though disposed to part with the littlest amount of the latter as possible. He bought from Maeght. He bought from Pierre Matisse. He bought at auction. He bought from anybody who had a good Giacometti to sell. The one who obviously had the most and best was the artist.

Alberto was a man of principle. He had never entered into a formal contract with Maeght or Matisse. He had undertaken a moral commitment. He meant to repay with interest investments both personal and material made in order to further his career. That the investments were repaid with thumping interest by the dealers to themselves made no difference. Alberto liked to be better than

8 Hoomer of

his word. When the dealers took advantage of him, for which he provided continuing opportunities, he was at pains to see them in the right. Though often solicited by people who wanted to buy from him directly, bypassing regular channels and current prices, he always refused. Almost always.

Thompson was the great, egregious exception. He was shameless and sly. If he could not bully or buy people, he would wheedle and whine. Alberto was far too shrewd to have wool pulled over his eyes by a rascal of Thompson's ilk. And yet he let himself be had. Again and again. Just as if he had been on the lookout for somebody to make a bad joke of everything he believed in and lived for. With Thompson, if so, he came close to the ideal. Even the well-advertised obsession of the industrialist for art was half a hoax, because the works in his possession were at the mercy of a man unclear in mind about the distinction between ownership and authorship. He did not hesitate, for example, to have unscrupulous restorers fill out a Miró he found a bit "empty" or brighten up paintings he considered too "dull." Being proprietor of a foundry, he made unauthorized casts of sculptures in his collection, some of them in steel-stainless, of course. Alberto was enraged, and insisted that Thompson have the casts destroyed. The tycoon apologized profusely, invited Alberto and Annette to the most expensive restaurant in Paris, where he himself ate humble pie and promised to melt down every one. Alberto forgave, and he must have forgotten, because Thompson forgot to keep his promise. As if determined to make injury out of insult, the artist allowed his patron to browbeat him into selling works he had for four decades stubbornly refused to part with. He sold drawings by the several dozen at ten dollars each. He fetched from storage sculptures of the Surrealist years and before, unique works in plaster which nobody had ever seen. To Thompson he sold them for a song.

He even painted Thompson's portrait. Not once but twice. It was enough to make one perplexed, if not suspicious, about his acceptance of the relationship. Perhaps it seemed he had little choice. He could not prevent the collector from acquiring his work, nor could he disregard the fact that Thompson now owned

more of it than anybody else in the world. That placed the two men in a very special situation. There is something profoundly compelling to an artist in the knowledge that a large, representative selection of his work of all periods may be gathered permanently together in a single place, and even in a place so singular as Pittsburgh, Pennsylvania. The idea of that unity sustained beyond the limits of a lifetime is one of the most powerful incentives to creativity. Permanence is what Thompson promised. He insisted that his collections, and especially his Giacometti collection, would never be dispersed, but would one day become the nucleus of an important museum, surrounded by scores of Klees, Picassos, Matisses, Braques, etc.

Alberto was in no position to quibble. He agreed to paint Thompson's portrait, and perhaps it was easier because contact between them was inhibited by the impossibility of verbal communication. The portraits do not seem to have caused difficulty. One is plainly half-finished, but the other is superbly realized, a blunt, head-on view of the tycoon in his shirtsleeves, his expression dour, his large hands with fingers splayed resting on thick thighs. "Look at those huge hands!" Alberto exclaimed as he worked. "You can just see them raking in the money. Money-grubbing hands." Thus, the artist was in no doubt as to the true nature of his model, and such certainty must have contributed an extra dimension of inventiveness to the art of playing so largely into Thompson's hands.

Having encountered no difficulty in portraying somebody he cannot have liked or admired, he encountered none in portraying at the same time a recent acquaintance whom he admired and liked greatly. The new model was Igor Stravinsky. The world-famous composer in his time had known many artists. Picasso had drawn portraits of him in 1920 and designed the decor for one of his ballets. A man of exacting standards both professional and personal, quick to be bored and sharp of tongue, after a lifetime of celebrity and controversy, Stravinsky was not given to seeking out people unlikely to live up to his expectations. He had seen works by Giacometti in American museums and collections, recognized their importance, and decided that it would be worth his while to meet

the artist. They chanced to have a friend in common, a Russian musicologist named Pierre Souvtchinsky, who arranged a meeting over lunch at the composer's hotel. It was an instant success. Both men had good reason to respect each other, but they could not have foreseen how deep a pleasure would come from opportunities to show it. Indeed, it must be delightful for geniuses to feel a spontaneous affinity, because they alone can appreciate its solace in the isolation they share.

Stravinsky was seventy-five when they met, Alberto twentyone years younger. It can only have seemed both natural and right that the junior artist should offer his senior the tribute that would testify most eloquently to sympathy and esteem, and that the senior should welcome it. They agreed that the composer would pose for a series of drawings. Giacometti brought his pencils and portfolio to the hotel. Stravinsky posed with patience. That was the beginning of a ritual homage to art and understanding that continued until death ended it. When Stravinsky was in Paris, he would take time from a busy schedule to pose. Alberto to draw. The composer's visits were brief, occasional. After their meeting in 1957, though, he never failed to see Giacometti when there. A few drawings usually resulted, as well as exuberant dinner parties, sparkling conversations, and eloquent gestures. One evening in the fover of a Parisian concert hall Stravinsky spotted Alberto from a distance, immediately made his way through the crowd, in which he was recognized by everyone, and passed like Moses through the waters, to greet the artist and kiss him on both cheeks. At the end of the evening, when the audience was jostling through the fover to the street, Stravinsky again came through the crowd to bid Alberto good night and again kissed him on both cheeks.

The third Giacometti exhibition at the Galerie Maeght took place in June 1957. Alberto, as usual, was anxious that it should include his most recent work, which, as usual, was but a few hours old. He had been up till dawn, working and reworking figurines and busts. When Diego arrived in his studio at eight o'clock, he found four or five new sculptures waiting, with a note from his brother: "Can you cast these for this afternoon? Otherwise, exhibition use-

less." Diego could, of course, and did. Alberto always felt it fair to show his latest work, wanting to be judged on the basis of complete evidence, unafraid of the judgment because his own would be the most severe. If, however, he was the first to acknowledge failure vis-à-vis the absolute, he had a quick eye for the relative aspects of success. He knew his importance.

Writing with gratification to his mother and Bruno, he said that this was the most successful, important, coherent exhibition he had ever produced, the most sincerely admired by everyone, and, in short, the best exhibition of the season in Paris. Of modern art, at least, he conscientiously added. The catalogue contained a long, laudatory text by Jean Genet. Numerous articles in the press promptly confirmed the artist's own estimate. Alberto sent his mother a photo of himself with a caption describing him as a Parisian celebrity, adding that he expected it would give her pleasure. Without a doubt, it did. As for his own, it lay so deeply buried in his work that he could not find it elsewhere.

In addition to sculptures executed the night before the opening, the exhibition presented most of the important works of the previous few years—sculptures, paintings, drawings: Women of Venice, portraits of Annette, Diego, Yanaihara, figurines and busts made from memory, still lifes in oil and pencil, even a few land-scapes. These created an extraordinarily powerful impression, and its power came from the remarkable unity and intensity of Giacometti's mature style, the superb self-mastery that made of his uncertainties the mainstay of his achievement. The aura of authority which came from the exhibition was the same that people felt in Alberto's presence. He and his art had become a single reality, of which the future lay entirely in his hands. He could afford to enjoy for a moment the silly business of success. Besides, as he assured his mother, it didn't distract him from his work, though she sometimes wished that it could.

If, at the corner of the rue de Téhéran and the Avenue de Messine, jubilation reigned in the offices of the Galerie Maeght, Pierre Matisse brooded glumly on the fourth floor of 41 East 57 Street in New York. He worried lest the Parisian upstart take first place with Giacometti, fretting for fear Maeght would get more

sculptures, paintings, and drawings than he did. He knew that Clayeux and Alberto were convivial, providing opportunity for transactions to which he was not privy. Distance did not lend enchantment. But, when on the spot, he was not helped by his glum temperament. Arriving at the rue Hippolyte-Maindron to have a look at recent work, he would view it in silence, occasionally murmuring, "Hmmm," and then say, "Let's go to lunch." However, he bought everything he was offered. And now that the business in Giacomettis was good, he presented himself not only as a dealer but as a friend. As such, he was helped greatly by Patricia, who sometimes seemed to prefer the gallery's artists to its owner. With Pierre Matisse, the suspicion always lurked that the only person, not to say the only artist, who ever counted for anything with him was his father.

Aimé Maeght was unquestionably the founder, proprietor, and prime mover of the gallery that bore his name. After a single decade of business, it had already earned him a large fortune and much prestige. A doting lover of honors and nurser of his vanity, Aimé did not shilly-shally about taking credit for everything. Thereby, unfortunately, came complication in the person of Clayeux. The director of the Galerie Maeght had undeniably done a lot to guarantee its ascension. Content for years to accept satisfaction behind the scenes and in the studios of artists, while basking in the intimacy of his employer, Clayeux eventually began to find the situation chafing. Familial sentiments that had once been entirely gratifying became less so, or were displaced, perhaps, toward younger men brought in by the director to assist him. Maeght was probably too preoccupied by plans for his grandeur to take note of disaffection. Whatever may have been said about his vainglory and braggadocio, much of it true, the truth also is that he never forgot the source of his success or what he owed to those who had helped him attain it: his artists. And he was getting ready to do everybody proud. Himself, too, of course.

He had in mind something no art dealer before him had ever done: creation of a museum to house works by all the artists who had made his fortune. It would provide space for exhibitions of contemporary art, concerts, theatrical productions, and lectures, with extensive gardens and terraces where large pieces of sculpture could be shown out of doors. He planned to build it on a hilltop near the Riviera town of Saint-Paul-de-Vence, where he already owned a residence. The costs, not to mention the pictures, would all be contributed by him. If the scheme sounded like an exercise in self-aggrandizement, nobody could say that it was the idea of a man who saw things by halves. Still, plenty of people said it was folie de grandeur.

Yanaihara returned to Paris early in July. Everything for everyone began again. It began, however, on a rather different footing. What had seemed casual happenstance in 1956 looked like premeditation in 1957. The intimacy of the Japanese professor with the Giacometti couple became public knowledge, and the presumption of general consent was taken for granted. Of course, the basis advanced for everyone's goodwill was the eventual benefit to Alberto's work.

It did not go well. The difficulty persisted. Yanaihara came to the rue Hippolyte-Maindron every day at one or two, and work continued with only occasional breaks till midnight. The routine was grueling. Alberto was kept going by the conviction that the morrow might bring the consummation he wished. What kept the professor going was a pleasing awareness that his role was a consummation, too. What kept Annette going had little to do with the intellectual relationship between the two men. It was their relation to her that mattered. She would not have noticed a possible relation between the artist's frustration, the husband's satisfaction, and the friend's devotion. Annette lived for feeling, for her own feelings. Their gratification had nothing to do with art or philosophy. For the three persons involved together, the intricacy of their relationship probably prevented dispassionate judgment, but it seems likely that greatest felicity was in the portraits of Yanaihara.

A fool, in any event, could have seen that the ground of the Giacometti ménage was shifting beneath everybody's feet. The person watching most closely was not a fool. It was Diego. He didn't like what he saw. To begin with, he didn't like Yanaihara,

whom he had always considered haughty and who never bothered about friendly gestures toward the younger brother of the great artist. What troubled Diego most, however, was not dislike of the artist's model but disapproval of the artist's wife. To say that what was going on went on under his nose was too close to the mark for comfort. In fact, only a few inches of flimsy wall separated him from the facts. The room adjacent to Alberto's bedroom had lately become vacant and been taken over by the brothers, bringing with it, incidentally, at long last a telephone. The telephone room, as it came to be called, was used for storage by both Alberto and Diego, and both of them were in and out of it all day long. Voices, or silences, in the adjoining bedroom were perfectly audible, and it was there that Annette waited for the all-too-occasional intervals of respite which the artist allowed his model.

Diego was neither a prude nor a prig. At fifty-five, he had behind him a full life of worldly common sense. Nothing done by grown people in private for their pleasure could have surprised or shocked him. However, he was still his mother's son. He knew only too well what would shock her. His view of affairs of the senses was a Latin one, determined by nineteenth-century mores and the conviction that men need not conform to the same code that governed the conduct of women. Invulnerable, in short, to shock. Diego had no guard against moral indignation. His sister-inlaw's behavior seemed scandalous because she was a married woman, because the business was public knowledge, and because, above all, she happened to be married to his brother. As for Alberto's involvement in the matter, his responsibility for it, complicity in it, or acceptance of it, none of that would have seemed to Diego anything of which he need take account, since Alberto was a man and an artist. Diego kept his disapproval to himself, but he could not keep from frowning. No man's frown was ever bleaker or more somber.

In the throes of creative difficulty, Alberto was not the best person to look for causes or consider consequences. Diego's unspoken censure must have distressed him, but decades of fraternal concord could not be undone by a temporary awkwardness. Anyway, Yanaihara had to go back to Japan in September. Otherwise, the summer passed peacefully enough. One day the date of departure had come, and there would be no putting it off this time. On the last morning, Yanaihara posed for an hour and a half before going to the airport. Alberto and Annette went to see him off. Again they promised one another that everything would begin again. Great believers in the promise of the future they were.

The next night the artist and his wife sat alone together in their room, she sewing beneath the light, he at the table, writing to his mother. A truly domestic scene, Alberto thought, such as the two had not known for years. All the past weeks he had worked as never before, he told his mother, and was convinced it had been of great use. The results would be clear in a month. At present he felt more than ever filled with optimism. And after a month or so, he promised, he would come home. It would be the shadow season. Happy, he would work in his father's studio. His mother would fuss over him, calling him to meals at regular hours and trying to do something about his clothes. She, too, would pose. They would go for walks together, joke, and argue. She was eighty-six years old. He had every right to be optimistic.

137

A new era of human history began on October 4, 1957, when Soviet technicians launched an artificial earth satellite called Sputnik I. The Space Age had begun. Already the concept of space and time as separate entities had been abandoned in favor of a frame of reference chosen by the observer for the sake of convenience. Giacometti had always lived with a heightened awareness of situation as related to perception, and like most great minds, his was preoccupied by the relativity of measurement in the boundless continuum within which we exist: "The sensation I have often experienced before living beings, before human heads above all, the feeling of a space-atmosphere which instantly envelops these beings, is already the being himself; the exact limits, the dimensions of that being become indefinable. An arm is as immense as the Milky Way, and in this phrase there is nothing mystic."

A bizarre creation came from the rue Hippolyte-Maindron in 1958 amid portraits of Annette and Diego, figurines, busts, and the first studies for the Chase Manhattan Plaza. It is called *The Leg*, because that is what it is: a bronze leg truncated below the hip. It rather resembles the branch of an old tree, and would look exactly like one were it not planted upon a large and obvious foot. The foot gives identity to the whole. The foot was not only the basis but the idea, and as a representation of a specific part is intended to stand for the whole. That, the sculptor explained, was his purpose. He stated that he had had it in mind to execute this work ever since 1947, the year when he produced *The Nose*, *The Hand*, and *Head on a Rod*, all three made to concentrate in

a single part the whole existence of the individual, and all isolated in space to achieve their effect. These works refer metaphorically to the symbolic resources of a lifetime. The Leg was the last which openly showed its existential origin, and in that sense it may have been a definitive step toward the freedom to confront a reality greater than the artist's own.

Two decades had passed since that night in the Place des Pyramides. The incident, however, had not drifted into the background of the artist's memory, or of his conversation. There was something almost uncanny, as a matter of fact, about the way in which Alberto's most intimate feelings and experiences could become the subject matter of seemingly casual conversations. The details of the accident were common knowledge among his acquaintances, related to journalists, part of Giacomettian history. Everybody had heard that the woman driving had been a prostitute and that Alberto had virtually jumped in front of the onrushing vehicle. Then had followed painful months in the hospital, constantly in danger of amputation of the maimed foot. Years of walking with a cane, and with a happy sense that he had encountered a necessity, not an accident. Because of it, he had been able to make important progress in his work. Consequently, of course, he had never made any effort to receive payment of damages or indemnity. Such money would have been ill-gotten, he explained. Alberto was not a man to trifle with the truth. It meant more to him than he expected to mean to it. That certainly determined his candor.

Yanaihara did not come to Paris in the summer of 1958. He had been expected, had been waited for. Telephone calls to Japan had been lengthy. No pecuniary problem existed. The professor pleaded responsibilities at home. That explanation, of course, was the least likely to sound soothing to one who had waited all winter long for nothing. Yanaihara in Japan was a different proposition from Yanaihara in Paris. Remote, he seemed aloof and uncaring. Disappointment did not go unmixed with resentment, and the combination made for bitter fare in the rue Hippolyte-Maindron.

Alberto, too, was undoubtedly disappointed, having expected to resume work which he felt had brought benefit. But he knew how to wait. He always had enough to do to make the days and nights too short. Annette, on the other hand, grew distraught. Her expectations had nothing to do with work, and she had no idea how to wait. A large part of the trouble was the lack of anything to do, lack of desire to do anything, or to become other than what she was. What she was, however, was the question. She was Madame Alberto Giacometti. But to the former Annette Arm. that fact had long ago become irrelevant. If it was irrelevant, so was she. Her identity came to her from her husband. It seemed that she had nothing but a name, when what was wanted was personal fulfillment. She could never find that in marriage to a man wedded to art. He had always disavowed matrimony, anyway, and never ceased frequenting the hotels, if no longer the houses, of such repute as he had for thirty-five years thought nothing but good. What consolation was it for her that portraits of the artist's wife adorned museums and mansions? Precious little adorned her. She had to go on wearing nondescript clothes and living in a nondescript lodging in a nondescript neighborhood. without modern plumbing, with no sense of personal distinction to console her at night as she lay alone in bed, the inevitable light beside her, waiting for her husband to come from his studio or other place of exertion. With no Yanaihara to console her, either.

After a dozen years of posing for an artist whose dissatisfaction was so chronic it seemed to apply to the model, after tending the coal stoves in bedroom and studio, after living on borrowed money so long, it did seem she deserved a bit more than frustration. She was thirty-five years old. Her husband was fifty-six. By his own well-advertised admission, he had never been skilled in the acts of love. Art was his passion. It did well enough for him but very little for the woman with whom he had agreed to share his life. She wanted to live with a passion all her own. When Yanaihara had come along and become important to her husband's work, it must have seemed a delectable way of eating her cake and having it, too. But now the cake was unattainable. Alone together, hus-

band and wife resumed with a passion their personal polemic. Their marriage began to look like a very frail craft in the sea of ambivalence.

Olivier Larronde and Jean-Pierre Lacloche had kept on living in decadent extravagance. But it started to tell. The poet was the one who showed most signs. A diet of drugs and alcohol had withered the bloom of youth. At thirty, Olivier looked forty, and did not appear to care. He wrote little, published less. Promise was going the way of good looks.

Giacometti was steadfast in friendship. He saw no less of Larronde-or in him-because he had become less attractive. If anything, he saw more. He knew perfectly well that his friendship could add meaning to the lives of his friends, and that this could be of practical advantage, too. During their evenings together he had drawn a couple of dozen portraits of Olivier, which he gave to him, along with other drawings. A wealthy amateur publisher was persuaded to publish a volume of Larronde's poetry on condition it be enriched by reproductions of these drawings, thirty-one in all, the idea being that the artist's fame would give a boost to the poet's. It didn't. Purchasers attracted by the illustrations were disappointed to find that these were reproductions, not valuable lithographs or etchings. The poems, though exceedingly precious, did not seem to make up for that other difference in value. The book found few buyers. Unlike his generous friend, Olivier Larronde had no wherewithal for turning to account the resources of failure. He had only opium, the memory of his dead sister, and the staunch devotion of his lover.

Jean-Pierre did what he could. By an irony almost poetic for being so arbitrary, the diet hurtful to the ill-fated poet did wonders for the lover. Beautiful in youth, he became strikingly handsome as he grew older, appealing especially to women. He fathered a son by one of his female friends. But his enduring loyalty was for Olivier. Though he never wrote poetry, he proved himself in the end a paragon of the inspiration needed.

Avoiding the blandishments of fame, Alberto might have been expected to sidestep the pitfalls, too. He got by a good many, but even for such a gingerly foot as his there were some too well made. No book devoted to Giacometti and his work had yet appeared when a persuasive Swiss publisher and photographer named Ernst Scheidegger prevailed on him to allow publication of a small volume. It would include fifty to sixty photographs of Alberto and his work. As for providing a literary text suited to the illustrations. Scheidegger had a cunning idea. What words, he reasoned, could conceivably come closer than the artist's own to being worth a photograph? It seemed like child's play, since all the necessary words existed already in print in the form of Alberto's previously published writings and interviews. That is how it came about that in 1958 all of Giacometti's most important writings to date were published together, along with photographs of him and his work. So the artist publicly acknowledged, with the emphasis of repetition, the relevance of the writings to his work and life. We did not need the assurance, but it is agreeable to have it. We are entitled to infer that for the artist to give it was even better. The two capital texts of Giacometti's career appear in this little book. The first is "Yesterday, Quicksand," describing his childhood games, the cave, the black rock, evocations of Siberia, and the violent fantasies by which the little boy lulled himself to sleep. The second is "The Dream, the Sphinx, and the Death of T.," dealing with emotions, themes, and symbols which even he could not satisfactorily express but which demanded expression even as they asserted an inability to express.

*

This indispensable book, small in size but great in significance, was published in Zurich, where lived not only Bruno and Odette but a quantity of other relatives, and friends Alberto had known most of his life. Adults all, they could accept without a wince the revelations and implications. One who could never have been expected to do so, however, lived only on the far side of a few mountains. It is impossible that this book can have failed to come into the hands of a mother who watched with such solicitude the doings of her firstborn. If Annetta Giacometti read her son's

writings, we will never know what she thought of them. But we know that despite her stern view of propriety, she had led a vigorous life, mothered four children, and lived close to the earth.

"I know that you don't work for vainglory but for the passion of the work itself," she told Alberto. Knowing that, she knew a lot, and it is true that her son was not the only artist she had known intimately. She could be candid. "I truly regret for your sake," she said, "that with all the handsome results and the fine satisfactions you have, you never find it possible to free yourself from all those things you have on your mind. Try for once to take life more calmly, each thing in its own time, and you will see that you will be better for it." Excellent advice, which the mother must have sensed could not be given too often, for on another occasion she said, "Work hard, have success, but don't overdo it, and bring a little calm also into your personal life." That was easier said than done, and the difficulty would in time grow almost too great to be lived with. But Annetta never knew, for which thanks are due in proportion to the difficulty.

She herself had plentiful reasons, as she approached ninety, to be thankful. She was aware of it and said so. She compared herself to the mother of the Gracchi, who called her sons her jewels and inspired them with a sense of civic duty as well as a desire for glory. "I have thought so often with thankfulness and gratitude." she said, "how happy are the old people who have a long life and an old age like mine." Still, she felt life slipping away. Her old friends were all dead. She grew tired, confused, and heard badly. Having become more and more set in her ways, she resisted any change, even the slightest. When Odette installed an urgently needed new water heater, she refused to speak to her daughter-in-law for four days. At night she lay in bed, rereading old letters from her husband and their sons. She was lonely. She didn't like to complain, but her sons knew, and they visited home as frequently as possible. By living so long, Annetta had proved to them not only the tenacity of her constitution and character but also the strength of her love and their abiding need of it.

A bereavement came to the Giacometti family in 1959. Dr. Francis Berthoud, husband of Annetta's only daughter and father

of her only grandchild, died. Silvio, now twenty-two, handsome and engaging, had inherited from his mother the Giacometti vitality, and he later grew amazingly to resemble the most famous of his uncles. He became a doctor, married the daughter of an evangelist from Geneva, and had three children.

It was also in 1959 that Michel Leiris attempted suicide. Of the friends of the early years, Leiris was the one with whom Alberto remained most friendly. It was Leiris, three decades before, who had published the very first article devoted to the sculpture of Alberto Giacometti, in which he had said that the only moments in life which count are those called crises. Despite occasional irritations and differences, the friendship had gone on uninterrupted. The two were united in their disdain for safe success and their disposition to court the danger inherent in a firm conviction that although all efforts to affirm one's being through self-expression are vain, because they end in death, there is no other course open to the man who would give a noble account of himself. As Michel's literary pursuits were autobiographical, he flirted more overtly than Alberto with the temptation to prove one's existence by ending it.

The flirtation was no doubt made more titillating for Leiris by the contradictions it entailed. Like Sartre, with whom he was also on intimate terms, he detested the bourgeois background that had fostered him. He took stands on issues of social justice, signed manifestos opposing government policy, and paraded in support of the oppressed. Nonetheless, he lived luxuriously in a large apartment overlooking the Seine, waited upon by servants, lacking no convenience money could buy. His sartorial elegance was so conspicuous as to verge upon caricature. At the same time, he was resolved to spare himself no mortification that might stem from weaknesses to which the spirit as well as the flesh is heir. The rites of language served this purpose. But one spring day the writer discovered to his consternation that verbal mortification was not enough.

A love affair gone wrong drove him beyond the endurance of self-expression, and he swallowed a vial of phenobarbital. But he didn't die. Hurried to the hospital, he was saved by a tracheotomy. Recovery, however, was prolonged and painful, requiring
not only convalescence at home, where he was cared for by his
wife, but return into the workaday world, where he found again
the mistress who had brought him to the edge of oblivion. Some
years after the event, Leiris wrote: "I think back on my abortive
suicide as the splendid and adventuresome moment which represents in the course of an existence virtually without agitation the
one major risk I will have dared to take. And it seems to me also
that it was at that moment, mating life with death, intemperance
with insight, ardor with renunciation, that I most tightly clasped
that wondrous thing always to be pursued because never quite
possessed, and which one would believe to have been by design
designated as female in gender: poetry."

During his stay in the hospital and convalescence at home, Leiris wrote a number of poems, which he felt inclined to publish without delay, entitled Living Ashes, Unnamed. Thinking also that it would be a good thing to have the poems accompanied by illustrations, he found by his bedside the one best fitted for the job. Alberto agreed. This time there was no mistake, and the illustrations were original etchings, not reproductions. The artist came repeatedly to the Leiris apartment with his pockets sagging, full of copper plates prepared for the etcher's needle. He drew portraits of the convalescent poet, views of the sickroom, views out the window.

Michel's choice of an illustrator must have seemed essential to the matter involved. Nothing overt was said, but he sensed that Alberto did not approve of what had happened. It was true. Giacometti suspected that the mistress who had led his friend to flirt so intimately with death was, indeed, poetry. He could never have approved of that. Besides, both death and art were to his mind affairs too serious for flirtation.

Suicide was often present in Giacometti's mind, and in his conversation. He was aware that the artist's way of life is a reprieve, and that survival is in another sense the price he must pay for the resources with which he works. He liked to talk about the means of putting an end to oneself. This was not a morbid

fixation. Alberto was a cheerful looker after eternity. Since the age of nineteen, he had been preparing his gaze. And all the while he was preparing, the preparation became the vision. An artist's gift is the power to give everything into the care of nothingness.

Notwithstanding an exceptionally sturdy physique, Giacometti was hardly in the best of health as he approached sixty. For years he had been bothered by minor illnesses, pains, ailments that came and went, none so severe as to interfere with his way of life, but all together constituting a kind of chronic malady. His bloodshot eyes needed glasses now. Irregular meals had ruined his appetite, and he complained of frequent pains in the stomach. He worried about cancer, but when he awoke after too little sleep his only concern was to get to work. Seizures of uncontrollable coughing came ever more frequently. He suffered from neuralgic pain on the left side of his face.

Treatment for all indispositions was the same: a visit to Theodore Fraenkel. They would have an agreeable chat, and after a while Fraenkel would tell his patient that there was nothing wrong, prescribe some pills, and advise him to get on with his work. The treatment fitted the case, and vice versa.

Of all the complaints Alberto suffered from, the most persistent was the most general: fatigue. He was always exhausted, never had enough sleep, rest, relaxation. He often talked about being weary to death. His letters, many of them written in bars late at night, repeatedly speak of exhaustion. However, he made no effort to change. By getting along with so little rest, so little comfort, so little food, Alberto severely reduced his dependence on the needs and wants that inhibit visionary relations with reality. Heightened states of awareness do exist, and they are frequently a derivative of self-mortification. The holy man in his cave does have mystic experiences and rapturous visions, induced in part by undernourishment, discomfort, and solitude. His sole object-like the artist's—is the observance of a private religion in which he is both the faith and the faithful. That is what sets him apart. Similar detachment can come from chronic fatigue, a kind of intoxication, producing an almost ecstatic sense of perception. But like all

intoxicants it bears the danger of addiction. Alberto's fatigue was part of his strength. There seemed no limit to his acceptance of self-punishment. The reward was to see all things in their vastness by fixing his eye with indefatigable determination upon a single one.

There was, however, something more seriously wrong than natural, or unnatural, wear and tear. When necessary—that is, when his work suffered—Alberto was capable of taking steps. The neuralgic pain grew so intense, and inconvenient, that he stopped taking Fraenkel's pills and went to see a specialist, who put a prompt end to his pain. There were things less easy to treat. Alberto knew it, and he was not one to shirk the discomforts of awareness.

"Today I feel weak, without strength, without appetite," he wrote one day in 1960. "I feel empty, maybe because of the neck cramp of these last few days, because of all the pills I've taken. I hope that's what it is and that I recover my vitality. My whole life's a bit up in the air . . . no, longing to work immediately, be calm and content soon, but everything's complicated and other people. But I absolutely want to get myself better even if not for long."

He knew that his body was not the ground for which the important battle would be fought. Still, he had to contend with it, and make it do. It wasn't doing very well. No need for inspired vision to see that. A glance in the mirror was enough. Mirrors, though, were not important equipment in the rue Hippolyte-Maindron. In Alberto's studio there were none, while in the adjoining bedroom a couple of small ones did nominal duty.

Giacometti did not take kindly to comments on the deterioration of his physical appearance. If he knew what he was doing, other people were not entitled to take liberties. An acquaintance who thought he looked terrible told him to consult a doctor and was brusquely rebuffed. Bruno incurred an outburst of wrath by suggesting there might be a little affectation in the artist's uncompromising shabbiness. In the matter of his health, and everything that went with it, Alberto was sincere, innocent of ulterior motive, and committed to the foregone conclusion. That was why he liked to think that he looked his best. When photographers came to take his picture, he would make efforts to get the clay out of his hair, straighten his necktie, and brush off his jacket. He assured his mother that he didn't want his appearance to be too bad. What he really wanted of his appearance was that it should be in his image, and it certainly was.

Isaku Yanaihara, long overdue, returned to Paris in the summer of 1959. But everything was not, after all, as it had been before. The unkindness of the wait would have been too easy to attribute to preference on the part of the one absent. Alberto's friends said that Annette would have liked to marry Yanaihara, or that she wanted to have a child by him. His being a husband and father already, however, did not make such dreams very practical. The Japanese professor at times was inscrutable and aloof. He drank a great deal. The romantic mood seems to have passed.

Annette's humor swung erratically from exhilaration to depression. She, too, like Alberto, had become overly fatigued, though in her case the problem was too little to do rather than too much. She slept badly, smoked and drank more than she should have, ate less, and began taking a lot of pills meant to be calming or stimulating. Things were made worse when it became apparent that the bond between Yanaihara and Alberto was strengthened by Annette's inability to adapt herself to changed feelings. The two men, to be sure, shared an aspect of high passion from which the woman was excluded. That it happened to be aesthetic and philosophical did not mitigate her exclusion. On the contrary. Having done more than her share of posing, she was able to appreciate the emotion involved, to appreciate it all the better for having found that in the long run she was not up to it.

Between the artist and his current model the image of the latter certainly stood as de facto evidence of passion. No wonder a number of their friends thought there might be something between them. Annette shared in it because she shared the two men, or they shared her, but her part was not crucial to the evolution

of the thing. Where passion was concerned, she did not like to play supporting roles. Alberto had accustomed her to center stage. His private divertissements in the nightclubs and hotels of Montparnasse had never seemed to amount to much, and had been acted out at a distance, not in the rue Hippolyte-Maindron. Here she had been a star, and she was in no mood for change when the male protagonist was becoming world famous. The first hint that things might get out of hand came from the character originally cast as her confidant. Not that Yanaihara wanted to redo the scenario. He only wanted to play his own part. And it had become apparent that the hero meant more to him than the leading lady. A difficult denouement was coming.

The difficulty distressed the artist. It compounded the difficulty he was having with his art, and both seemed to be of his making. Annette and Yanaihara were indispensable to him as models. Their intimacy could thus be seen as an artistic convenience, and Giacometti had certainly favored it. He had justified it and extolled it. Chances of the affair turning out badly had not been weighed. It is possible that the balance had been tipped long before, when Alberto first knew Annette in Geneva and let her try to please him by imitating the girls at the Perroquet, though she pondered the wisdom of marriage to a cripple. Even so, the burden of responsibility could not be shifted. The one who bore it did not try to. It contributed to the difficulty, and the difficulty was the price of opportunity.

Yanaihara posed according to the same inflexible schedule as always. Every afternoon and half the night, he sat facing the tireless portraitist. The image, if fine, went from bad to worse. If as good as dead, it came to life in a few brushstrokes. The portraits were paintings. Not till the following year—when even greater difficulties were in the making—did the sculptor undertake a likeness of his friend. An important part of the painter's difficulty arose from the impossibility of producing on a plane surface the real effect of three-dimensional features. His determination to do so drove him to renew image after image, each gaining in intensity as the result failed the requirement. Structure was what he was looking for, he said, something that he could build

on. To the sculptor this came naturally, and the painter was trying to see how he, too, could get at it.

Color began to disappear from Alberto's work, fading as he grew older and the creative difficulty greater. This impetus toward the monochromatic-white, gray, and black-was not an aesthetic choice. It came to the artist from his work rather than the other way round. He would have been well pleased to have things otherwise. As a youth, he had executed paintings awash with color. Accumulating experience, however, he moved in the direction of circumspection. Color takes hold of the senses in an autonomous way, provoking an immediate reaction. It is independent of the tangible, and opens one's eve to ambiguities of expression. Giacometti wanted nothing to do with ambiguity and hoped only to make of something abstract, his vision, as tangible a thing as he could. "I try to paint with colors," he said, "but I can't apply colors without a structure to start with. To build up this structure on the canvas is already an endless undertaking. And to go on from there to color seems next to impossible. I don't know how to do it. I simply can't see it."

It had also grown harder and harder for Alberto to see when a work was finished. Being finished meant that he could do no more with it. If he acknowledged that no more could be done, then, far from finishing a single painting or sculpture, he was admitting that none should have been started. This state of affairs, however, presented no problem to a man for whom the most important part of his work had long since become the part to be done the next day. He could see that part, because he saw that sculptures and paintings were never a likeness of what he saw. What others saw was irrelevant. Whether they saw his work as completed or incomplete, to him it was all the same, because works of art were not basically what he was looking for. For him a fragment was already immense, since a human arm could equal the extent of the Milky Way.

Autumn came. It was once more time for Yanaihara to return to Japan. He would again come back, however. Everyone promised. But it is improbable that anyone expected anything to begin again as before. Yanaihara had been extraordinary, and extraordinarily to the purpose. The difficulty had done a lot of good. But the change was definitive. Anybody with eyes could see that. Even as Alberto, Annette, and Yanaihara were saying goodbye, talking about the future, thinking about the past, the past had made its own arrangements.

One evening in October, having dined late at the Coupole, Alberto went across the boulevard to have a drink Chez Adrien. Business at that hour would no longer have been brisk. The girls who remained would have stood idling at the bar, chatting with the bartender, a garrulous black man named Abel, and trying to entice the occasional male customer to buy a split of champagne. When Alberto came in, the atmosphere would have grown a bit more lively. Chez Adrien, he never lacked for company. Everyone called him by his first name except the bartender, who called him Monsieur Albert, and nobody knew, or cared, much about his daytime life. He was said to be an artist, but that description covered a lot of territory in Montparnasse. People were prudent Chez Adrien about asking or answering personal questions. The more money a man spent, the less likely he was to be asked where it came from, and Alberto spent a good deal. By the etiquette of the place, however, he was not considered rich, because he was far too shabbily dressed and poorly groomed, even for an artist, and his shabbiness looked like the real thing. The girls were attentive to such nuances. So they enjoyed Alberto for himself, for his teasing but warmhearted banter, his utter lack of condescension, and his casual generosity. They saw him somewhat as one of themselves. What he saw they may not have wondered or, better still, cared.

The girls who joined Alberto at his table that October evening were named Dany and Ginette. He knew both well. Conversation came easy. At the bar, several other girls still lingered. One of them looked exceptionally young for a place like that. She was short but well proportioned, very pretty, if not

beautiful, brown-haired and brown-eyed. Alberto had noticed her before, thinking that she was too young but nonetheless intrigued, especially by the eyes. The girl had also noticed Alberto and been intrigued. Both had mentioned the curiosity to Dany, who suggested that the girl join them for a drink. As easily said as done. The girl's name was Caroline. She had on a gray Prince of Wales blazer. She sat down at the table and accepted a drink without a trace of shyness. But there was a certain reserve about her, an aloofness, as if she could surrender her person without yielding her real self. She took part in the conversation but took no initiative.

After a while they decided to go to a place nearby called the O.K., where they could have something to eat. At the O.K. they stayed late. When Dany and Ginette eventually said they would leave, Alberto put a handful of money on a plate—it being understood that the girls' expenditure of time was an investment—and then he was left alone with Caroline. They talked. Alberto knew how to draw people out, because his only motive was to see them as they were. Caroline responded. At six o'clock in the morning they went outside. It was dawn. They walked down the boulevard together. When they came to the square in front of the Montparnasse railway station, they found the café on the corner open.

"Let's go in," said Caroline. "I'll buy you a cup of coffee."
Alberto said, "Why do you want to buy a coffee for someone

like me, old and ugly?"

"I feel like it," she said.

So they went inside together and stayed there till nine o'clock, talking.

Neither Caroline nor Alberto had any idea what they were getting into when they came out of the Dupontparnasse Café that morning. Casual encounters were everyday business for them both. But both in their different ways were shrewd scrutinizers of appearances. So there may have been a faint intimation. After hours of talk, when confidences come easy and defenses are down, it would have seemed plausible. But they had no need to know.

Opportunity to meet again required no planning. It came as if by the law of natural selection. As if by the same law, the rhythm and the purpose of their meetings rapidly drew them closer. When,

Carabine a

and to what extent, they became lovers is expectably obscure. Alberto talked almost too willingly about the elusiveness of sexual satisfaction, whereas Caroline had a vested interest in testifying to the contrary. However it may have been, satisfaction of an essential kind was had. One aspect of it was unquestionably sexual. Within that aspect, as we shall see, were aspects which Alberto himself came to view from an altered perspective.

The cafés, bars, and nightclubs of Montparnasse made up a little microcosm, always shifty and elusive, where it was never easy to distinguish truth from artifice, a realm made to order to test the discernment of anyone in search of the distinction. Alberto, of course, had his eye fixed firmly on it. Preposterous as this may appear in view of subsequent events, so did Caroline. The account she gave of herself will always be open to question, but she persisted in her willingness to answer for what she was. Open to question, too, remains the problem of how much, and how soon, Alberto knew about the facts of Caroline's life. The question of how much about Caroline there was to be discovered in the realm of truth—even by the most diligent searcher—will remain forever unanswerable. It depends on the frame of reference chosen by an observer for the sake of convenience.

Caroline, to begin with, was not her real name, though it was the one she preferred to be called by. It had been chosen by a male acquaintance, a man evidently of esoteric whim, who had a daughter named Caroline. His liking for that name, and her preference for it, might, or might not, have been influenced by knowledge that it means a woman of the common people. Caroline's real name was Yvonne. It does not sound with such a lively chime as the other, perhaps, but is pleasant and has no specific meaning. If Yvonne, however, preferred to be known as Caroline, Caroline is the name by which she deserves to be called. Her surname was even less euphonious than Yvonne and is irrelevant. She was born in the month of May 1938 in a small provincial town not far from the Atlantic coast. That, at least, is certain. The rest, being her own account, will always be subject to revision. She was, it seems, one of many children. Family ties were slack, and the little girl felt unwanted. Sent early to school as a boarder, she learned

little and left soon. Her parents meanwhile had moved to an industrial suburb of Paris. She rejoined them only briefly before going off to live the life which, as she foresaw, nobody but she herself would ever do anything to make easy or free. The readiness of one so young to be free and easy soon got her into trouble. She was sent to reform school, from which release came only after a sincere but abortive attempt at suicide. Her father did better: having failed to prosper as a pimp in the neighborhood of the Bastille, he hanged himself by his leather belt, aged forty-seven. Caroline was drawn to a less disreputable section of the city, though not always to the more reputable persons who thronged there. The fitness of her presence at an early age in the bars of Montparnasse, if it appeared dubious to Giacometti when he first saw her Chez Adrien, had already been viewed with reserve by the authorities. But the problem was not one to which they could easily provide a solution. In the days of the Sphinx, everything had been different. Now it was problematical. A girl who had attained the age of consent had nobody but herself to answer to.

The relationship between the fifty-eight-year-old artist and the twenty-one-year-old prostitute quickly became an affair with a momentum of its own. Acknowledged as important by both, it did not, however-not vet-have any bearing on pursuits considered important by both before their meeting. Alberto kept at work. He had recently started several larger-than-life-size female figures for the Chase Manhattan Plaza. Over eight feet tall, these were worked directly in plaster, the sculptor constantly clambering up a stepladder beside them, scattering plaster all over the place, and all over himself. As for Caroline, when not with Alberto she went on with the life that she meant to make as easy and free as possible. Neither seems to have expected the other to assume any responsibility. They met at night. Alberto had long since established his right to complete freedom after dark so far as his wife, his brother, and his friends were concerned. The intimacy grew. One wonders what they talked about, he as subtle as a doge, cultured as a mandarin, while she had no education, knew nothing about art, and cared less. Alberto's power over words was proven. Caroline felt a fascination for them. She said that truth excited her. The character of her excitement would always be shadowy, but she had a code of personal honor and claimed to be a woman who never cheated. The possibility would have appeared wondrous to a man of Alberto's ethical discrimination. In view of what he eventually found out about Caroline, the wonder is that he saw it through to the end.

Faithful to her code, Caroline made a point of divulging her experiences. Alberto learned that her livelihood did not depend solely on the generosity of men. That was only what met the eve on the surface. Below were byways really shady, leading deep into the underworld. She was the accomplice of gangsters, thieves, fences. Robbery did not bother her. She had done quite a lot of it, she said, both in Paris and in the provinces. Firearms, though, she claimed to avoid, recommending stealthier weapons. She could show the exact place on the throat where a knife thrust would do the best job. Not that she was prone to violence. Needful capers, though, could have unfortunate consequences. Alberto listened to all this with relish. If it was mythmaking, what, in fact, was the difference? The girl, talking, sat before him. He could see her. She was tangible. What she said was her truth. He was fascinated. In contradiction to all probability, they had something in common. He, too, made it a point of honor never to cheat. Technicalities may have consumed some of their conversational energy. Alberto also divulged personal experiences, and Caroline listened gladly. Having known many men, she could see that here was one unlike the others. She saw that he was "somebody," and she impetuously seized an opportunity to test the premise of her importance in his eyes. She dared Alberto to choose between herself and a goddess.

Goddesses don't come along every day. This one, however, was a real one. Her name: Marlene Dietrich. As a deity she was doubly convincing for being wholly a creature of imagination. That her firmament was Hollywood and her temples made of tinsel mattered not at all. She was an ageless femme fatale, a siren, a mythical devourer of men. That image of her had been popularized for thirty years, becoming at last—like the person herself—the object of a cult. Giacometti, an ardent moviegoer, was certainly

Martinoset

aware of it. And he understood, of course, how movies—also—show that a woman may be simultaneously an idol, an objet d'art, a visual creation, and a "real" person.

Marlene Dietrich was a real person. If she had made sacrifices beyond her means upon the altar of artifice, nobody but the public was any the wiser. In her meretricious heaven the movie goddess was lonely, disillusioned, world-weary. She longed for the consolations of true art. "Cézanne," she said, "is my god above all." Watercolors by him hung on the walls of her home. She was a conscientious visitor to galleries and museums. One day at the Museum of Modern Art in New York she saw the sculpture of a dog by Alberto Giacometti. She fell in love with it. This dog is an easy sculpture to fall in love with—a bit melancholy in its graceful evocation of man's best friend—and the fact is that Alberto identified it with himself, seen in his mind's eye walking alone in the rain. Marlene's affection for *The Dog* was such that she determined to make the acquaintance of its creator.

Arriving in Paris on November 20, 1959, the star was accompanied by forty-four pieces of luggage and met by two hundred journalists. Imperious and lofty, she seemed, as usual, an incarnation of the glamour that made the weaker sex invulnerable. She had come for a much-heralded engagement at the Théâtre de l'Etoile. The meeting with Giacometti was arranged by a mutual acquaintance. It was the goddess who wooed the artist. She went to his studio and sat in the dust while he perched atop his stepladder, slathering plaster onto the tall figures or hacking it off again. One wonders how the seasoned enchantress saw those women conjured up before her eyes, or, on the other hand, how she looked to the sculptor as he gazed down at her from aloft.

They were attracted to each other. In the café at the corner of the rue Didot nobody recognized the celebrated actress. They could talk in peace, but never for long. Marlene was always in a hurry. She made appointments, then failed to keep them, sending instead huge bouquets of red roses, telegrams, and scrawled notes saying, "I'm thinking of you. Marlene." Precisely what she thought, however, remained wonderfully obscure. Her feelings were supposedly as sincere and simple as the green grass, but she never

had time to come down from her pedestal and let them flourish. The brouhaha of mass adoration kept her distant and tantalizing. Alberto was fascinated. He praised her personality, her intelligence, and was shyly pleased to let his friends know he knew her. He even felt entitled to tell his mother that they had become "close friends."

Caroline was displeased by the apparition of the celluloid goddess, though she must have known that the likelihood of "anything" between the artist and the actress was next to nil. Her calling, too, involved intimacy with the make-believe, and in her own way she may have been as practiced in it as Marlene. Maybe that was why she worried. At any rate, she objected. She did more. She bade Alberto give her proof that she loomed larger in his view than the actress. It was audacious. It was imaginative. She demanded that Alberto fail to keep an appointment he had made with Marlene. He complied. It was amazing. His compliance was worthy of the demand. Who could have dreamed that by agreeing to it he was not only leaving a goddess alone on her pedestal but also preparing to elevate a fallen woman?

Alberto didn't altogether stop seeing Marlene, however. But the total number of meetings can't have been many, as the friendship itself lasted less than a month. Still, his admiration was genuine. He wanted to provide evidence of it. Her comings and goings were too unpredictable to allow for a portrait. So he gave her one of his sculptures, a small figure in plaster. He carried it to her hotel in the rue de Berri one rainy Sunday afternoon. It was a farewell gift, for the actress was to leave Paris in forty-eight hours. Ten days afterward, Alberto received a cable wishing him a Happy New Year, sent from Las Vegas, Nevada. He never saw Marlene Dietrich again. If she was thinking of him, she gave no further sign, sent no more roses or telegrams. Four weeks later she was back in Paris. Alberto learned of it, but he heard nothing from her. "Fortunately," he remarked.

What Annette may have thought about these new women and emotions in her husband's life we do not know. We don't even know how much she knew. Not, at least, at first. Though Alberto talked freely, as always, one can't be sure how attentively his wife listened. Annette's own concerns so preoccupied her that she had next to no attention left over for the concerns of others. Since Yanaihara's departure she had become so exhausted, she said, that the least little thing cost her an effort. It was nervous exhaustion, of course, since she had nothing to do but keep the bedroom tidy. She couldn't sleep. She couldn't eat. She didn't know what to do with herself. She wanted to get away. Luckily for her, she had somewhere to go, as she had recently made a friend.

Paola Thorel was the daughter of a rich Neapolitan contractor. Her husband, Alain, was even richer. They lived in splendor in the rue de l'Université and owned an estate in the country near Paris. Monsieur Thorel wished to have a portrait of his wife and had considered Balthus for the job. The prospect of posing for the crafty count, however, did not appeal to Paola. She was intelligent and sensitive as well as vivacious and beautiful. She had read an article about Alberto Giacometti and decided that, if she must pose for a portrait, she would like it to be executed by him. Thus, sometime in the autumn of 1957, she presented herself at the rue Hippolyte-Maindron. That was the critical period when Giacometti felt most oppressed by the inconclusiveness of Yanaihara's portraits. He was in no mood to try the portrait of a stranger, however beautiful. He explained that he was incapable of executing a proper portrait. Worse, he was incapable of executing properly even the things that he attempted to execute, which probably meant that they should never have been undertaken in the first place, etc., etc. Paola was not disappointed. The portrait had been her husband's idea, not hers. But she was fascinated by Alberto and occasionally went back to the studio. After a few visits, Alberto, contradictory as ever, told her that nothing would please him more than to do her portrait. It was to be a sculpture, moreover, not a painting, and would require many sessions of posing.

For eight months she posed three times a week. A close friendship sprang up between the model, the artist, and the artist's wife, and the major sympathy was between Paola and Annette. They saw much of each other, went together to the movies, to restaurants, to cafés. They had plenty to talk about, as Paola be-

came familiar with all the intricacies and altercations between Alberto and Annette. She had her own experience to offer by way of empathy, because Alain Thorel was not turning out to be an ideal husband despite the wish to see his wife idealized in a work of art. The latter evolved with less ease than the friendship, and Giacometti eventually set aside the unfinished bust to devote himself entirely to the four tall women, the two large walking men, and the monumental head of Diego that he was sculpting with the Chase Manhattan Plaza in mind. Paola herself, however, remained very present. It was to her that Annette turned for consolation, and to her country estate that she retired in December 1959, wanting repose and forgetfulness.

It is possible that the artist's wife did not know much about the visitation of the Hollywood goddess. Probably she didn't much care. As Alberto became more famous, the special effects of fame had to be taken for granted. Annette was not greatly concerned with what went on in spheres beyond her own. On the very day that Alberto said goodbye to Marlene, he took a train to the little town of Clermont to dine and spend the night with his wife and her hosts. He was pleased to find her improved mentally and physically. He never lost the essential tenderness for her, the responsible concern for her well-being.

Sometime in the winter of 1959–60, Alberto invited Caroline for her first visit to the studio. Nobody seeing that place for the first time ever failed to be astonished. But the reasons were as various as the persons. Caroline was not looking for signs of spiritual wealth. She had her feet on the ground, and was nothing if not earthy. At the time, she herself was living conveniently near Montparnasse at the Hôtel de Sèvres. Though far from luxurious, it provided greater comfort than the rue Hippolyte-Maindron. When she saw the artist's lodgings, she must have asked herself some serious questions. No matter how much money he spent Chez Adrien, it was possible that that was all he had. However, she seems to have sensed from the beginning that he had more than money to offer. A woman of strong feelings who succumbed to sudden impulses, she was addicted to gambling, and said that it

ours? Theret?

didn't matter whether a player won or lost. All that counted was the sensation at the climactic moment.

Diego took one look at Caroline and didn't like what he saw. After thirty-five years in Montparnasse, he thought he could tell what was what. She had started appearing regularly at the studio, driving a large American automobile. Diego felt sure it was stolen. He advised his brother to be careful. Alberto brushed aside the advice, saying the assumption was unfair. In fact, he knew that it had every chance of being exactly right. Caroline regaled him with stories about her shady adventures. Now and then she disappeared unexpectedly for a day or two. Returning, she explained that she had been to some city in the provinces to rob a few stores. Fascinated by revelations of life in the underworld, Alberto never could hear enough and urged the spellbinding adventuress to tell him more. She was happy to.

Annette at first took little notice of Caroline. Unlike Diego. she seems not to have considered the newcomer a danger. Maybe she thought that the young woman would do nicely in the role for which she no longer had any staying power: as a model. Annette was thirty-six, her husband close to sixty. They had been together for almost twenty years. It was folly to suppose a young thing of twenty-one could come between them, especially the kind of young thing encountered any night of the week Chez Adrien. A key part of the problem may thus have been Annette's inability to see Caroline as anything but what the crudest appearances gave out. Annette was good-natured and amenable so long as things went her way. In the beginning, she was friendly. She gave Caroline an occasional present, a few books, a little jewel box. Concerning the latter gift, she should have thought twice. Boxes ask for contents. So Caroline's occasional presence at the studio gradually became a familiar one.

Late in February, Alberto left Paris for a visit to his mother in Stampa. Annette did not go with him, preferring to nurse her nerves in Paris rather than in the sunless valley, in the home of her meticulous mother-in-law. Alberto traveled alone, stopping in Zurich for a few days' visit with Bruno and Odette. He seems to have arranged to meet Caroline there, but she did not turn up at

the designated hour. For one who had demanded the deliberate breaking of an appointment as proof of emotional good faith, Caroline was beginning to prove rather undependable. She often kept Alberto waiting for nothing. But she always had the alibi of responsibilities to anonymous individuals who provided for her livelihood, or else the hit-and-run eventualities of the underworld. Alberto protested but waited. In Zurich he sat in the Café Odéon like a youth in love for the first time, eyeing the door with wild anticipation, seized by a start each time it opened.

True to form, Caroline arrived too late. She went from hotel to hotel, searching for Alberto. In vain. She telephoned Bruno, who gave her a number at which his brother might be reached. He was not there. The shoe of frustration was now on the other foot. She waited four days. Then, leaving a terse note with Bruno, she returned to Paris.

Alberto was safely in Stampa, where he received Caroline's note. Late at night on the first of March 1960, he sat down to write an answer. It did not come easy. He found it very difficult, he said, to write to her from there. From the point of view of Stampa, to be sure, he could hardly have seen Caroline in the light of Parisian enchantments. But he could nonetheless visualize her there, he told her, in her car, in the street, a little everywhere.

Before the end of the month, the artist was restored to Paris, his work, his wife, his brother, and Caroline. The lovers reunited were more united for having been briefly parted.

Then Caroline vanished. As occasional eclipses had been customary, the absence cannot at first have seemed unusual. But the days—the nights, rather—went on and on without a sign of her. Strange, intriguing, tantalizing, this continued absence from familiar haunts became worrying, then alarming. Inquiries were fruitless. At the Hôtel de Sèvres the proprietor and employees knew nothing. Caroline's room and few belongings were just as she had left them sometime in the first week of April. Chez Adrien, the bartender, usually an inexhaustible informant, knew nothing. Dany, Ginette, and the other girls insisted that they knew nothing. A week passed, two weeks, three. The girl's absence was undeniably a disappearance. Alberto did everything he could think of. He

searched everywhere. To no avail. He grew frantic. Caroline seemed to have been spirited into another world, of which the artist could discover no trace. And that, in fact, is just what had happened. It's odd Alberto didn't think of it immediately. She was in prison.

Giacometti could be phenomenally persuasive. His persistence knew no limit if an issue that concerned him was at stake. By perseverance, he found out where Caroline was. The one to tell him was the same who had brought them together: Dany. She had found out via the subterranean circuits available for such information. Caroline had been arrested early in April. For more than three weeks, she had been confined to the municipal house of detention for women, the Prison de la Petite Roquette, an antiquated complex of buildings far from Montparnasse, on the other side of the city. Immediately upon finding out where she was, Alberto wrote her a letter. It was May 2, 1960.

Having searched for her everywhere, he sat writing at the very table where he had seen her for the last time. Six months of life passed before his eyes, through his mind. He implored her to believe that he was her friend and that she could count on him as long as he breathed. She had no idea, he concluded, how much he owed her.

To which he added his full name and address. Not that she might have forgotten it, but as proof of commitment for her eyes and for those of the authorities.

Albeit in prison, Caroline had forfeited none of her self-possession. She replied promptly—and tartly—to his letter. She was displeased by his discovery of her whereabouts, and especially by the evident intimacy with the person who had reported it. In circumstances which call for friendship, Caroline had the spirit to question its sincerity. Acclimatized to a world where cheating is an aspect of survival, Caroline took it for granted, which means she hadn't the faintest idea of the value of Alberto's friendship. Guilty as she may have been of various felonies, in this fault of imagination Caroline was blameless. No power on earth could have given her the vision to see what Alberto had to offer. How much he owed to her, she certainly did not know—Giacometti

was right—but time would give an accounting. For the moment, though, what worried the unrepentant prisoner was less her predicament than her suspicion that Alberto was a cheat. Incarceration quickened suspicion. Alberto made haste to reassure, explain, implore. He wrote letter after letter, some of which he mailed, others not.

It was he, Alberto, who should be blamed, he said. It was he who had plagued Dany in his determination to learn Caroline's whereabouts. As for any other kind of infidelity, the suspicion was absurd. Nothing had happened that could justify jealousy. Nobody could be jealous in relation to him, and she knew very well that his idea of love was far from the usual concept. But he would be able to express it much better when he saw her again.

The Prison de la Petite Roquette has subsequently been demolished, its history for the most part forgotten. But the history has an interest, for even in a city so ancient this was a locality especially haunted by intimations of death and sin. The place where female transgressors of the law were now confined had long ago guarded from man's wickedness women who wished only to obey the law of God. The present-day prison stood upon the site of a former convent. Immediately opposite the main entrance, public executions had taken place until the turn of the century. At the end of the street, not more than three hundred paces distant, was the portal of the Père Lachaise Cemetery, where multitudes of celebrated men and women lay buried. Thus, Caroline was held prisoner behind walls that made a singular appeal to the imagination.

At night, at hours which they had been accustomed to spending together, Alberto went to the rue de la Roquette to walk up and down in front of the prison. Between its gates and the street was a park, with rows of sycamore trees, through the leaves of which the streetlights cast shadows onto the high walls, so that the artist might almost have had a sense of passing through a dense forest as he strode—or limped—back and forth.

The length of Caroline's detention without judicial procedure seems to suggest that she was guilty as charged and had been caught red-handed. Concerning the nature of the crime, as in most things that concerned Caroline, ambiguity prevailed. Official

records describe her offense as theft, while she at various times gave various accounts. She was more audacious when talking about a crime than when committing one. That didn't make it any easier to get her out of prison. Alberto attempted to see her during visiting hours, but only relatives were admitted. Needing help, he turned to his friend Clayeux. The director of the Galerie Maeght had influential connections dating from wartime service at the Prefecture of Police. He arranged for Giacometti to meet the magistrate in charge of Caroline's case, who had heard of the artist, received him with respect, but expressed surprise that anyone of note should be bothered about a person so unworthy. Alberto knew better than to discuss Caroline with a member of the police department. He courteously explained that he had reason to disregard appearances in this case and was resolved to do anything he could to get Caroline out of jail.

Given Giacometti's standing, his friends and their connections, not to mention the adaptability of justice, the prisoner's release was feasible. But the magistrate, a man of long experience, knew that with prisoners like Caroline the cost of disregarding appearances might go higher than one who cares for appearances at all may have the capacity to pay. Thinking Giacometti impressive and likable, but naïve, a dreamer, he felt dutybound to insist on the fact that Caroline and her accomplices were dangerous, destructive, and devoid of scruple. Though amused, Alberto listened politely. Magistrate and artist were not made to see eye to eye. Their divergence of views in this case would have extended to the past of the prison itself. Where one saw only guilt, the other was searching for grace.

On the 20th of May 1960, six weeks and two days after her arrest and without benefit of judicial process, Caroline was released from La Petite Roquette. She went straight to Montparnasse, made herself presentable, and appeared at the Coupole for dinner. She had hardly ordered something to eat when Alberto came in with Pierre Matisse. Amazed to see her, the artist said good night to his dealer, who was left looking irritated and worried as he observed the total absorption of the sculptor and the prostitute in one another.

The intimacy between Alberto and Caroline may thus be seen as an affair with a definite beginning. Before that night in May, it had been potential but not essential. By vanishing from his sight, Caroline gave the artist an opportunity to prove his powers by restoring her to it. It was the chance of a lifetime. For them both. If he could bring her back from oblivion, he could take her with him into eternity. As for her, she had proved to him that she was a true figure of the underworld by enabling him to resurrect her from it. Thus, they might both surpass themselves by being just as they were in relation to one another. It was at this time that Caroline became Alberto's principal model.

Annette was furious, her anger fed by failure to have seen that Caroline might amount to anything until after the thing was paramount. But how could Annette, or anyone else, have foreseen that it would come to this? Alberto's preoccupation with prostitutes, all his talk about their being goddesses, pure and aweinspiring: it had always seemed a sort of craze that somehow served the creative act. Nothing to be carried over into real life. But here was this whore sitting in the studio, and Alberto looking at her as if she were seated on a throne. It was ridiculous. Worse, it was embarrassing. In the mise-en-scène of passion, Annette did not intend to relinquish the lead to a girl of the streets. There were violent scenes and recriminations.

It did not help matters to have Yanaihara on hand to console her. The Japanese professor had come once again to spend the summer—it was 1960—with his friends in Paris. Fancy his surprise when he found that they were three instead of two! His surprise was clearly a pleasant one, and that made it doubly disagreeable for Annette. The important flow of feeling did not take place in the bedroom but in the studio, where Yanaihara accepted and admired everything and everyone. Including Caroline. The philosopher from Osaka found himself fascinated by her. How far his fascination led to intimate appreciation of the new Giacomettian adventure is anybody's guess.

Jealous, resentful, petulant, Annette was not neglected. The men whose attentions she claimed did not cease paying attention to her. They were present day and night. It was the integrity of their attention that worried her. She wanted it undivided. Yanaihara was, if anything, more often alone with her than formerly,

being no longer Giacometti's only model. Caroline posed at night. Those hours were left free for Annette and Yanaihara to enjoy as they pleased. Little enjoyment was possible so long as Annette knew Alberto was face to face with the other woman. And she suspected that later Yanaihara would join them at some bar or nightclub, which, in fact, he frequently did.

She became increasingly irascible. She knew she was working herself into a state and that it would do no good to her or anybody else. But she couldn't help it. The more she realized that she shouldn't complain, the more she went on complaining. She smoked too much, drank too much, and took too many pills. She didn't know what to do, and it was too late to undo anything.

The principal portrait of Yanaihara which Giacometti executed that summer was a sculpture. It, too, suggests a break with the past, a foreshadowing of things to come. The lofty head is shown in full, three-dimensional volume. The person, the personality of the model is present. No remoteness between what the eye has seen and the hand done. The outcome is a copy of a human head, nothing more but absolutely nothing less, into which the artist has compressed forty-five years' experience of making works of art look like what he looked at. Still, he had no illusions about real results. "If I could actually make a head as it is," he said, "that would mean one can dominate reality. It would be total knowledge. Life would stop." But that was the direction he was taking. "It's curious," he added, "that I can't manage to make what I see. To do that, one would have to die of it."

When Yanaihara went back to Japan at the end of the summer, he left behind a situation altered as radically as the one which he himself had altered by his first appearance four years before. Nobody could say that that alteration was his doing, or his fault. A peculiar circumstance, however, attracts attention. Of the many portraits which Giacometti executed of the Japanese professor, whether in paint or in bronze (six or eight casts of the sculpture were made), not one was presented to the model as a remembrance of experiences shared. He received a quantity of drawings, some of which may have been likenesses of him. But he was offered none of the works which caused the artist so much

difficulty and changed his creative point of view. This seems to suggest that some aspect of the difficulty may have proceeded from the model's person, and from his appearance in the artist's life as well as in the artist's eye. Alberto can never have doubted that Yanaihara would happily accept a portrait of himself. The gift would have seemed not only a handsome gesture but a welcome pledge to the greatness of their adventure. When Annette said as much, her husband brusquely dismissed the observation.

In 1960, Giacometti completed the large sculptures which he had conceived to decorate the Chase Manhattan Plaza. His concept had called for a larger-than-life-size woman, a monumental head, and a life-size walking man. Four versions of the female figure were executed; a single head, clearly a likeness of Diego; and two walking men. These last were the most impressive. Six feet tall, they possess a truly heroic dimension and represent the sculptor's climactic expression of male dynamism. Craggy, spindly, but rugged, in their static stride they convey the potential power, elemental activeness, and physical stamina of masculinity. Some of the earlier figures of walking men, those in The City Square, for example, are evocative of uncertainty, of apprehension as to their goal. Not these two. They definitely know where they're going, to what avail and what purpose. Though almost sexless and featureless, they are unmistakably male. They are men with a bold, positive look: in the fixity of their gaze seems to dwell a conviction that seeing is attaining.

The monumental head is just that: a head of massive proportions which needs to be seen from a distance in a grand spatial context, and which suffers thereby when compared to smaller, finer fellows. The likeness to Diego seems more an effect of habit than of intent, while the sculpture as a whole has an air of hurry. The best that could be said of this head is that Giacometti made it and that it is the largest one he ever made.

So also for the four figures of women. These are the largest sculptures of Giacometti's career, and they are among the least accomplished of his creations. The problem is precisely in their size, which was determined not by the artist's involvement with

De dust

4 1 8

an aim of his own but by the requirements of a site he had never seen and could not visualize. All he knew was that in order to stand up against the gigantic backdrop of the skyscraper his sculptures would have to be big. As he made them so, they got out of hand, because he subordinated his customary manner of seeing figures at a situated distance to a "nostalgia for the idea of having a large sculpture out of doors." It is true that large sculpture ideally pleads for unlimited space in which to hold its own. No sense of such space entered Giacometti's studio. It was barely large enough for him to work and breathe in, barely, that is to say, life-size. Clambering up and down his stepladder as he worked on these figures, the sculptor could not possibly have had the same physical relation to them that he had had with all his other works. So long as he had his feet on the ground, it seems he was able to keep his sculpture where he wanted it, but it got away from him when he had to get up in the air to come to grips with it. The four women are not possessed of the same remoteness or surrounded by the same numinous aura as the majority of their smaller sisters, of whom one might almost say that the tiniest are the greatest. These four are excessively present in their presence. The sculptor himself was aware of it. They suffered from a complete confusion of dimensions, he confessed, adding that it was impossible to do anything for a given space without first having seen that space.

Consequently, although the sculptures existed, having been cast in bronze so that the artist could see them with a definitive eye, he refused to submit them to the Chase Manhattan committee. He declared that he would prefer never to make another single sculpture, rather than send these bronzes to New York. Time tempered his feelings. He never spoke highly of the four standing women but did not disown them, either. He was perfectly willing to see one or more of them henceforth in all important exhibitions, where their merits could be measured by observers less passionate than he.

That was the end, or as good as the end, of his concern with the Chase Manhattan Plaza. The nostalgia persisted, however, for the idea of large sculptures placed out of doors. It would come to

fruition a few years later in a site more suitable than the island of Manhattan: on a sunlit hilltop in southern France, at Saint-Paul-de-Vence.

While others pursued other aims, Aimé Maeght had gone right along with his grandiose scheme to build a museum on his estate overlooking the Mediterranean. Plans had been drawn by an architect, Josep Lluis Sert. Land was being cleared. As the flamboyant dealer's resolve shaped up, the attitude of his entourage did likewise. Most of Maeght's associates praised their employer. Even Guiguite, constrained by conjugal self-interest, went along. Not Clayeux. He felt bound by no constraint. The prince pored over plans for his pantheon, and the courtier predicted it would be gimcrack. The rationale of Clayeux's disapproval is perplexing, because Maeght's glorification had been his business for a long time. Perhaps the mere proximity of power can be spoiling. If so, the eventuality of estrangement might tell, especially should it coincide with the apotheosis of the prince. Sad to say, it did.

Old and ugly, Alberto had said of himself, how could a girl young and beautiful like Caroline really care for him? He believed what he said. The mirror, negligible as it may have been, proved that he no longer resembled the radiant young man loved by Flora Mayo in 1927. He had spared himself neither hard times nor hard work, and it showed. But he knew what to make of appearances. People had been fascinated by him all his life, and he knew how to make himself fascinating. To that extent, which was great, he had never grown old. The real beauty of youth is the conviction of limitless possibility, and Alberto had that till the end.

Elusive, deceptive, ambiguous as she was—and she was all of that and more—yet Caroline was never in doubt concerning the sincerity of her feelings for Alberto. And he was far too cunning an appraiser of people not to see that she truly cared for him. What he was looking for in her, however, need not have been readily apparent to anyone. She didn't know what to make of him. Being herself a matrix of cross-purposes, she could not conceive of a personal universe obeying laws and creating reality. Even less could she dream that she might contribute anything to

such a universe. Her understanding, however, was not required. What was wanted was her identity. But that, as luck would have it, was almost impossible to put one's finger on. Alberto's interest puzzled her and sometimes made her fretful. "You are much too screwed up," she told him. "I don't know what to think anymore. I'm very unhappy just the same. You're too complicated. I don't know what you want."

No doubt the artist tried to reassure, to make himself uncomplicated and understandable. How much he could explain will always be debatable. They talked and talked. The semi-literate prostitute and the supremely cultivated artist found that they had great confidences to exchange while she posed night after night, seated on the cheap rattan chair in Giacometti's studio, surrendering herself entirely to his scrutiny. She never complained or grew tired but seemed really to enjoy it. When he gasped and moaned over his inability to paint her as he saw her, she said to herself, "That's his pleasure."

His pleasure was also to give her money. They both had everything to gain by it, especially the assurance that they were pleasing to each other. Caroline's American car got out of order, smashed, stolen, or what-have-you, requiring replacement. She asked for a Ferrari. Lengthy discussions, debates, proposals, counterproposals ensued. Finally, Alberto bought, not a Ferrari, but a scarlet MG convertible roadster, a vehicle perfectly adequate for breathtaking flights in shady places. He never learned to drive, but he liked to go fast, and with Caroline he had a speed demon at the wheel.

One day a couple of men came to the rue Hippolyte-Maindron and told Alberto that he would have to give them some money. It was owing, they said, due to Caroline's excessive expenditure of time in his studio. The artist immediately understood the kind of expense involved, being far better qualified, in fact, to address the issue than his two visitors. He invited them to come along to the nearby café, where they could have it out at leisure. The business was simple. Caroline's person represented capital, and she was expected to convert it into profit. Hours spent posing for a shabby artist in a dingy studio netted no cash. But a man who

could afford to give a girl an automobile should be able to pay for her time at the going rate. Peeved by diminished returns, the pimps made no bones about their grievance. They had come to the right man. He was both able and willing to pay. Nobody as yet knew how much, which was well. However, he realized that a bit of haggling over the price was the least he owed to Caroline's commercial dignity as well as to her exalted status in his own mind. They argued for a while. When the sum had been set, all three parted with the conviction that a profitable arrangement had been concluded. Giacometti's conviction was well deserved, since he considered Caroline's time equal in value to his own. For value received, it certainly seemed right that he should give what most men prized most, and give, perhaps, till it hurt.

While in prison, Caroline had conceived a curious longing. She decided she would like to do something artistic. Her whim hit upon the piano. After her release, she asked Alberto to find her a teacher. He turned to René Leibowitz, of all people, the man for whom Isabel had left him, who was happy to take Alberto's forgiveness for granted by doing him a favor. Leibowitz had a pupil named Lawrence Whiffin, an aspiring young composer from Australia, whom he recommended as a capable teacher.

Caroline began her lessons with Whiffin, two per week, and from the first was an exceptionally unsatisfactory student. She knew nothing about music, had barely heard of Chopin, and had neither aptitude nor the self-discipline needed to develop it. Her teacher considered her shrewd and sensitive but at the same time an intellectual nonentity, without any learning or the least desire for education. She often failed to appear for lessons, usually without bothering to call. Whiffin found it infuriating to be involved with anyone so capricious, undependable, and undistinguished. However, he needed money, and money was the only subject that engaged his pupil's attention. She evidently had plenty of it, and insisted on paying for lessons whether she had received instruction or not. She enjoyed flaunting the large sums she carried in her purse and tempted Whiffin with offers of loans, which he was too proud to accept. She also enjoyed talking about her friendship with a famous artist named Alberto Giacometti. But she

frequently remained mute and aloof. Her supposed desire for musical skill seemed the strangest thing about her. Exasperating, maddening as she was, Whiffin gradually found that in spite of himself he had become fascinated by her.

After some months, though already married, he discovered to his chagrin and amazement that he had fallen in love with his improbable pupil. Knowing little about her, he went to call on Giacometti in expectation of learning more. Alberto received him with courtesy, and listened with sympathy to his story. When asked where a girl of humble origin obtained large amounts of money, the artist replied, "Men give it to her." He added that he himself was one of them, and that the others were admirers of well-established priority. This information does not appear to have troubled Whiffin any more than it troubled Giacometti. Perhaps, indeed, the composer was no less enthralled than the sculptor by Caroline's aura of undefiled purity.

One day she appeared for her lesson, sat down, and after a period of pensive silence abruptly blurted, "I want to be loved." Emboldened, Whiffin declared his feelings and attempted to offer physical proof of them. But his pupil coldly informed him that she had given voice to an abstract ideal, not an invitation. Only once, with languid condescension, did Caroline allow the unhappy young man to try to make love to her. The attempt was unsuccessful, the favor not conferred again.

Unable to be Caroline's lover, Whiffin only loved her more, while the absurdity and vulgarity of his passion magnified its intensity. Beside himself, he couldn't get over what he couldn't have. Caroline came and went with regal nonchalance, punctuated by disdain when Larry's ardor grew too pressing. At length, the desperate Whiffin thought he had had all he could take. He swallowed a bottle of pills and lay down to await the end, taking care, however, at the last moment to telephone his wife to say goodbye. He woke up in the hospital. Forgetting her own flirt with death, Caroline considered the abortive suicide conclusive proof of inadequacy and did not deign to visit the hospital. That was the end of their relationship. Alberto went at once to the young man's bedside. A few words of human sympathy were the least the

artist could offer by way of apology for having introduced the young musician to his nemesis.

1

After being portrayed by Bonnard and Matisse, Guiguite thought it would be pleasing to pose for Giacometti, too. Willing to oblige, Alberto painted three canvases in the early spring of 1961. All show signs of haste, if not impatience. But the artist, as usual, caught a vivid likeness, and we can see the sharp-eyed shrewdness of the woman who had once sold vegetables from a barrow but now rode about in a Rolls-Royce. She had known him a dozen years and assumed she knew him well, yet one day she had a surprise. The door to the studio suddenly burst open while the artist and model sat engaged in their work. Both turned to look and found Caroline standing in the doorway. Guiguite, though acquainted with the young woman, did not feel that it was up to her to speak and kept silent. After a perfunctory glance in her direction, morover, Caroline took no further notice of Madame Maeght. She fixed her attention upon Alberto, who sat turned toward her on his stool, palette and brushes in hand, gazing back at her. Caroline did not come any farther into the studio but stayed in the doorway, motionless, staring at Alberto. He returned her stare. Neither of them moved or made a sound. As it continued in utter silence, the look that they gave each other began to seem a physical contact between them, a mingling and merging of selves in the most intimate way possible. It excluded not only the participation but even the presence of any other person. To such a degree that Guiguite began to feel uncomfortable, as if she were intruding upon something that denied her existence. And this look went on and on, while neither moved or said a word. It lasted ten minutes. Then Caroline turned and departed, closing the door behind her. Alberto gazed after her for a moment before resuming his work. Not a word had been spoken. After a time, conversation resumed between the artist and his model. He said nothing of what had happened. She felt that she had by chance been witness to the most consummate kind of contact that human beings can have.

Seeing and being were so much the same thing for Gia-

cometti that it was natural that from an early age the visual and the sexual had been intimately related. The fact was evident in his early work, particularly in the sculptures of the Surrealist period. As the evidence became less apparent in the artist's work, perhaps it grew more telling in his life, gaining in expressive power thereby. The act of looking, and of looking on, was an expression of the unity between the visual and the sexual. It was no secret to people who knew Alberto well that he sometimes liked a third person present at moments of physical intimacy. Another man or another woman. It didn't seem to matter much which. However, it would be very mistaken to see Giacometti as a mere voveur. There was, in the first place, nothing secretive about his liking for looking. On the contrary. It was as open as open can be. The man who seeks fulfillment by observing the enactment of others' satisfaction is making a ceremony of his failure to act. But that ceremony can become the ritual required to celebrate a more sublime order of success, by which the individual transcends himself, his mortal functions and desires, in order to be joined with an ideal which is also the ultimate design of sexuality.

Between Alberto and Caroline the sexual relationship per se had from the first been perfunctory. She was always willing, which was understandable. Alberto had an extraordinary aura of sexuality. But he repeatedly told Caroline that he couldn't touch her because she was too pure. A virgin, a goddess, she was meant to be adored, not defiled. What happened, however, when others were present was another matter. They often went to an obscure hotel in the rue Jules-Chaplain called the Villa Camellia, where Alberto was able to see whatever he needed to see.

In the domain of the imaginary, there is no frontier between the visible and the tangible. To see is already to touch. Each experience asks its own kind of affirmation. Giacometti knew about Caroline's relations with other men. The evidence of his eyes told him a lot. Her descriptions told the rest. Though he made an issue of his freedom from jealousy, the facts were somewhat otherwise. Not at all clear, but otherwise. He must have been fairly free of the jealousy for which he criticized Annette, but old friends were occasionally astonished to see the artist skulking

behind trees and cars on the Boulevard du Montparnasse to spy on Caroline in the cafés. He never ceased quizzing Abel, the bartender Chez Adrien, to learn the details of her comings and goings, as if the thing about her that he couldn't put his finger on was the most important thing.

He wanted to possess one part of her that would belong to him alone. The rest obviously belonged to the one with the most all-embracing imagination. He wanted to own one piece of her anatomy, this piece by mutual consent to be his sole and inalienable possession. He was prepared to pay. He was, in fact, determined to pay. Only by paying the price could he be sure of the possession, and both knew it. The piece of Caroline he wanted to own was a part of her right foot, a very specific part: just above the heel, where two hollows are formed by the Achilles tendon. Some mythological supposition about that part being the most vulnerable may have quickened the purchaser's desire with a notion that his ownership might confer immortality. Who knows?

Caroline was willing to sell. But neither party was qualified to appraise the real value of the merchandise. Alberto probably sensed that it was priceless. If so, he would have realized that Caroline had best be protected from such a dangerous inkling. But she was only interested in assets that could be spent. So the potential for haggling was even more promising than with the two pimps. The artist and the model enjoyed it. The sum they finally settled on was five hundred thousand francs, a thousand dollars at that time, an amount neither too large nor too small for extravagant outlay of the imagination.

Giacometti said: "One day while I was drawing a young girl something struck me: that is to say, all of a sudden I noticed the only thing that remained alive was the gaze. The rest, the head made into a skull, became equivalent to a death's-head. What made the difference between death and the individual was the gaze. . . In a living person there is no doubt that what makes him alive is his gaze. If the gaze, that is to say life itself, becomes essential, there is no doubt that what is essential is the head." One of the works of art which Alberto most admired was the Resurrec-

tion panel of the Isenheim Altarpiece by Grünewald. In that fantastic picture, it is the gaze of the Saviour which dominates all. The miraculous vitality of His gaze affirms not only His return to life but the promise of life everlasting. Grünewald had seen how to make that promise tangible. Giacometti aspired to do as much, and his aspiration fixed principally upon Caroline as an embodiment of the possibility.

Even as the province of the creative act became increasingly concentrated, however, its consummation became increasingly difficult. It always had been so, but now the difficulty seemed to have become almost the substance of the artistic endeavor, a help rather than a hindrance. And Caroline gave her presence, her gaze, her stories, and her self to the difficulty.

"It becomes always more painful," Alberto said, "for me to finish my works. The older I grow, the more I find myself alone. I foresee that at the last I shall be entirely alone. Even if, after all. what I've done till now counts for nothing (and it is nothing by comparison with what I would like to create), fully aware of having failed till now, and knowing from experience that everything I undertake slips through my fingers, I enjoy my work more than ever. Is there any understanding that? Not for me, but that's how it is. I see my sculptures there before me: each oneeven the most finished in appearance—a fragment, each one a failure. Yes, a failure! But there is in each one a little of what I would like to create one day. This in one, that in another, and in the third something that's missing in the first two. But the sculpture of which I dream incorporates everything that appears isolated and fragmentary in these various works. That gives me a longing, an irresistible longing to pursue my efforts-and perhaps in the end I will attain my goal."

Modet

WP

In the month of May 1961, those two garrulous derelicts, waiting for Godot, again put in their appearance, footsore and disgruntled. Though their predicament remained unchanged, they, and their creator, had become world famous. The scene of their endless wait was no longer a makeshift locale but the stage of the state-supported Odéon Theater. Into this paradoxical production the author, Samuel Beckett, thought to introduce his old friend Alberto Giacometti, one whose aptitude for keeping such company he had never doubted. Giacometti had also become world famous, also throwing his weight into the balance of the absurd. He accepted it as Beckett did, maintaining that fame was a "misunderstanding."

The decor of Waiting for Godot is stark. It consists, in fact, of a single tree. By inviting Alberto to make this tree, Beckett hoped to include his friend in the goings-on of the hoboes. Alberto so resembled them, to tell the truth, as did Beckett, that while wandering occasionally through deserted streets at 3 a.m. they might well have expected to chance upon Godot. The author wrote early in March to the sculptor to make his request, adding hopefully: "It would give us all enormous pleasure." And by "all" he may be assumed to have meant not only himself and the play's producers and performers but also the characters, for whom Giacometti's tree would symbolize both life and death: because the bough from which a man can hang himself also bears leaves emblematic of rebirth.

Beckett's choice was inspired. Though Giacometti had never worked for the theater, he agreed at once. The production would be a fitting consecration of the friendship between author and sculptor. With Diego's assistance, of course, Alberto made a marvelously curvaceous, dendriform creation in plaster. Then he and Beckett, both of them eternally unsatisfied, fiddled and fiddled with it. "All one night," Alberto said, "we tried to make that plaster tree larger or smaller, its branches more slender. It never seemed right, and each of us said to the other: maybe." Being man-made, to be sure, it never would seem right. Beckett and Alberto were made to order to know that. Their "maybe" expresses the perplexity of man's march through the world while waiting for the sole event of which everybody can be sure. One day Diego called for a truck and delivered the tree to the Odéon. There it stood for the run of the play, an eerie presence in the drama of man's isolation and loneliness.

On June 2, the fourth, and last, Giacometti exhibition opened at the Galerie Maeght. From every point of view, it was a triumph. Comment in the press was abundant, intelligent, unanimous. Posters announcing the exhibition hung on masts and in shop windows throughout the city. The gallery was crowded daily with admirers not only from France but from abroad. Maeght, Clayeux, Guiguite were jubilant. Everything was sold overnight. Other artists came to pay their respects and concede, though sometimes with envy, that a great man was in their midst. As for the object of all this attention, he was not indifferent to it, having from the first intended to accomplish and conquer. A man who has learned to take frustration in his stride can also go along with triumph. Alberto knew that fame, though in itself dangerous, is nevertheless the proper setting for genius and its works. To produce them is of little good unless they become known, and if known at all, widely known, the wider known the better, because it is by being known that their existence becomes legitimate and purposeful. Likewise for the artist.

What immediately struck visitors to the exhibition was the fact that the great sculptor happened also to be a great painter. This exhibition was plainly meant to prove it. In the same year Giacometti received an honor: the Carnegie Prize, awarded at the International Exhibition held in Pittsburgh, Pennsylvania, home of G. David Thompson, Alberto's American champion, who must

have been gratified. The Carnegie Prize, however, was awarded for Giacometti's sculpture only, and Alberto felt less gratified than the voracious collector. At the outset of his career, he had produced paintings as well as sculpture. He had created masterpieces in oils before the war and, after it, had gradually returned to the easel. The meeting with Yanaihara brought this evolution to a decisive turn, and during the final decade of his life Giacometti devoted himself as much to painting as to sculpting, with results in the former medium quite as great as in the latter. The importance of Giacometti's paintings was lost on the general public, which likes its perceptions comfortably compartmentalized. But the artist knew exactly what he was doing, and it annoyed him that most people failed to appreciate it. Degas, Matisse, Picasso had all produced significant work in sculpture without any ambiguity about the primacy of their painting. No sculptor since the Renaissance. however, and few even then, had endeavored to create an entirely coherent oeuvre in which both means of expression conveyed with equal power the integrated aesthetic resources of one man. That was what Giacometti set out to do in the last years of his life.

The Maeght exhibition presented forty-six items, of which twenty-four were paintings and twenty-two sculptures. The latter included two of the four large women made for the bank plaza, plus the two walking men and the monumental head. Except for a couple of smaller standing women, all the rest of the sculptures were busts and heads of various sizes in bronze or plaster-most of them likenesses of Diego-and with or without pedestals. None of these represented a departure from the stylistic effect Giacometti had already made characteristically his own. The paintings were the revelation. Three of these were still lifes of apples, one a landscape, the twenty others all portraits. More than half of them had been executed since the start of that year, whereas only eight sculptures in the exhibition dated from 1961. The works on canvas were claiming a major part of the artist's attention, and the claim had commanded renewed powers of expression. The evidence hung on the gallery walls. Six portraits of Yanaihara introduced the series, then one of Annette, two of Madame Maeght, two of Diego, two more of Annette, and six extraordinary visions of a "seated

woman." These were the most powerful works in the show. They revealed a new concentration of scrutiny fused with an intense outburst of feeling and announced a departure toward an artistic destination more exalted and profound than before. It was almost entirely in his model's gaze that the artist situated the prospect of that destination. Most people failed to see it, because the paintings looked unfinished. It was obvious that the work with Yanaihara had taken Giacometti very far, and now the change was going to grow deeper.

Annette did not delight in her husband's triumph. The importance of the "seated woman" was too clearly an image of real-life importance. Annette knew it. What was worse, everybody who knew anything about them knew it, including the "seated woman," whose identity was known to everybody. Annette was beside herself. She raged and wept. She demanded that Alberto put the other woman out of his life, break with her, and abide by his word. As his wife, she maintained, she had the right. Prerogatives of marriage were on her side, responsibilities on his. What had been stipulated, understood, and agreed to a dozen years before made no difference. Alberto considered Annette's demand insofar as possible to the full extent of its ethical implications. He did not take it, or her, lightly. He said that if she insisted upon it, he would never see Caroline again. But if so, he promised, then he would never again see her, Annette, either. It was harsh, but there was no denying Alberto's right, because no doubt existed that he would keep his word. Annette had to vield, but the bitterness of it gnawed. And that was a pity.

The pity was in the opportunity missed. When Annette condemned her husband's affair with another woman, he replied that Caroline was essential to him for his work. There were violent scenes in public places, Annette shrieking recriminations while her husband furiously pounded the table, crying, "It's for my art, it's for my art." Not only to Annette but to other members of his family he tried to explain that carnal relations with Caroline were inconsequential but that she was "essential to me for my work." His lucidity seems all the more marvelous for letting him be blind to the trivial truth about Caroline while keeping faith with

her as a way of striving for a greater one. And that was the measure of Annette's great opportunity: it asked her, too, to be lucid enough to be blind, while keeping faith as a means of serving the truth.

In fairness, though, it must be said that few women would have been equal to the opportunity. Alberto was in the grip of a great emotion, which is as rare as a great idea, and bound to bring the thinking person into conflict with one of ordinary experience. To the artist, idea and emotion are one, consecrating the dedication of the individual to a self-justifying activity. Alberto blamed Annette for failing to see this and act accordingly. She, of course, being a common mortal, was more to be pitied than blamed. And Alberto pitied her, which only made everything worse.

Annette's tantrums became so violent that her weary husband started calling her "The Sound and the Fury." When he gave her that nickname, maybe he did not appreciate its aptness, situating ordinary life midway between idiocy and nonentity as a great man's answer to the prospect of death. Annette, in any event, accepted the nickname almost as her due. When writing to Alberto while away in the country for a brief respite, she even referred to herself as "the s. and the f.," adding that she hoped to be on guard against her uncontrollable self, replete with prudence and circumspection. It was no good. She couldn't become what she had no means to be. She suffered increasingly from physical and psychic complaints, hysterical nervousness, indigestion, itching, pimples, fatigue, and though not yet forty, she was haunted by the idea of growing old.

Alberto was worried. He thought psychoanalysis might help. Annette took to the couch with a will, finding in the all-admissive ear of the analyst a reason for passionate self-preoccupation. Encouraged to talk about herself, she discovered a vocation. Whether it would turn out to be what the doctor ordered remained to be seen. He took note of the fact that wife and mother had the same name—an old story by this time—and hinted at some arcane portent in the patient's maiden name, suggesting that it referred not only to a limb but to a weapon. No help, however, was forthcoming from all this talk. The tumult became if anything, and if

possible, worse. In its acrimony it came to include not only the presence of Caroline but the long-rankling resentment against Alberto's way of life: his refusal to improve the austere lodgings, his defiant indifference to his own well-being, and his fierce disregard for anything that interfered with his work. She stormed and scolded. She said that it was overweening pride. That was true, but so it is, of course, for the hero of every great adventure, and she couldn't see it, being an accessory so very much after the fact.

Annette had been talking for years about her desire for a decent place to live. She knew that Alberto would never give up the rue Hippolyte-Maindron. So it was a place of her own that she wanted. Getting away from Caroline's nightly visits and settling herself in greater convenience and comfort was reason enough for moving. There were others. There was one in particular which for fifteen years had been growing more and more difficult to ignore. It was also a nightly affair: the light burning by the bedside.

With uncanny intuition, the wife had hit upon the one singularity of her husband's existence which might reasonably have explained her eagerness to leave his bed. It was a little like her long-ago hesitation at the prospect of marrying a cripple. To be sure, she did not understand her aversion, for she could have lived with that knowledge far less well than with the light. It had been burning since before her birth, and she knew the supposed reasons. She knew about the journey with van Meurs, the death in the mountains. She knew that the night light was a result, and that it had determined the artist's resolve to live in such relentless austerity. She wanted no more of it. But there was more. Feminine intuition fortunately provided for a sparing of total awareness.

Loving the night but fearing the dark, Alberto seems to have felt most secure in the identification of what he was with what he did during the solitary hours just before dawn. It was a reversion to the security of certain childhood situations. His fear of the dark, as he readily pointed out, was an eminently childish thing. What he failed to point out, however—what may have had to be kept in the dark—was the cause of the child's fear. The true

emotion, it seems, roused in children when they are left in the dark is not dread but desire, an overwhelming and fearful longing for the one who can bring them solace for an apparent loss of self in the absence of the visible world. That person, bringing light, becomes equivalent to the world. The light becomes both a beacon and a being, a summons and a response, illuminating the darkness that is prelude to sleep, which is next door to the next world. Beside Alberto's bed the light had been burning since the accidental death of the elderly traveler. In the chain of chance attached to that event, what was the link of the name of the town where it occurred: Madonna di Campiglio? Sleeping with a light on is known as an effective antidote for bad dreams.

Alberto's mother expressed heartfelt sympathy with her daughter-in-law's desire for a proper place in which to set up housekeeping. "Something she should have demanded long ago," Annetta said, "from the beginning." To be sure, she had no inkling of what it was all about. She seems to have assumed that Alberto would go to live with his wife in the new lodgings. As a matter of fact, she, too, was opposed to the obsessive night light, though not obliged to sleep beside it. In the house at Maloja, the rooms occupied by Alberto and his mother were adjoining. The wall between them had a fissure large enough to let the light beside the son's bed shine through into the room of his mother. She complained. Her complaint-unlike Annette's-had nothing to do with troubled repose. It was an objection to the waste of electricity. When alone, she often sat in the dark to spare expense, and her son's extravagance seemed absurd. She objected, as she had objected years before over his refusal to give up the cane. And she objected to his smoking, because along with the light came the smell of burning cigarettes and sounds of desperate coughing. Her objections did not the slightest good. And the fissure in the wall, unfortunately, worked to more than one effect. Through it the old woman sometimes heard her daughter-in-law furiously berating her son. She didn't like it. For her to criticize Alberto was one thing. For anyone else to presume was very much another. Coolness grew between the proud mother and the defiant wife.

Annetta's health was beginning to cause concern. Her dearest

desire was to live to be the first centenarian of Bregaglia, but she said she felt weary with life. She took her grandson to the cemetery of San Giorgio to see how her name could be added to Giovanni's tombstone. She was cared for by local doctors, one a man from the valley whom she trusted, the other a self-appointed practitioner from Chiavenna. His name was Serafino Corbetta, and what attracted him to the ailing Signora Giacometti was the celebrity of her eldest son. By dint of indefatigable assiduity, he managed to ingratiate himself. He showed up unannounced, usually bringing some kind of a gift. He gave medical advice whether asked for it or not, to the sons as well as to the mother. "Why, he's even interested in Diego!" Annetta marveled. If by some delightful coincidence Alberto happened to be present, he would gladly talk long hours in the artist's studio. As often as not, he was able to take home a drawing or other souvenir. Within a few years, Corbetta had acquired a considerable collection and a semblance of intimacy with the Giacometti family. Neither his existence nor his intrusion would be worth mentioning had they not been the means by which a crucial truth came into the artist's relation with life and death.

On the fifth of August 1961, Annetta Giacometti celebrated her ninetieth birthday. All the family was in Stampa to do her proud. Alberto and Annette, Diego, Bruno and Odette, Silvio and his fiancée, Françoise, all were present, all happy to show her what a happy family owed its existence to her. The party was at the Piz Duan. Caviar, delicacies, champagne had been delivered from the Palace Hotel in Saint Moritz. Alberto painted for his mother a bouquet of flowers, and the promise of their lasting beauty was the loveliest gift she got that day.

Annette felt no need to linger after the fete. Yanaihara waited in Paris, having come again from Japan to enjoy the Giacomettis' friendship. It was to be his last visit, and there seems to have been relatively little posing during that final summer. Alberto was away much of the time. The principal portrait to survive is in the post-Yanaihara, Carolinian style, all attention concentrated upon the head, especially the gaze, the eyes, while the rest of the figure is quickly sketched, the major part of the canvas bare. It is an

image tranquil and serene, quite fitting, if that was its purpose, as a gesture of farewell, though the artist sold it to Pierre Matisse. In Alberto's—and Caroline's—absence Annette had Yanaihara to herself. She seems to have been reasonably happy. Moreover, she had found a place where she could also have herself to herself as much as she wished, whenever, and however, the spirit moved her.

The place was a small apartment at 3 rue Léopold-Robert, three minutes' walk from Montparnasse and its cafés. Alberto bought it for her late in 1960. He had bought for Diego at the same time a pleasant little house with a patch of garden just around the corner from the studio. Not long afterward, though this purchase was probably kept secret, he gave Caroline the money to buy an apartment in Montparnasse appreciably more spacious and comfortable than the lodgings of his brother and his wife. Thus, with more than enough money to buy decent accommodations for ones he loved, he himself remained in the dingy discomfort of his studio.

The apartment in the rue Léopold-Robert was a godsend. It gave Annette at last something to do on her own account. Consisting of an entryway, a living room with two windows, a small kitchen, bath, and bedroom, it was perfectly presentable though at the top of four long flights of stairs. Annette decided to remodel the place entirely. Pressed for opinions and advice, Alberto had little to give. He had provided money, and that was all he wanted to invest. Though he had been a friend and collaborator of the foremost Parisian decorator of the thirties, the practical application of good taste in circumstances that could be considered to affect his own way of living was not only unthinkable but odious.

The work at the rue Léopold-Robert would drag on and on. Annette talked about it incessantly. She now talked incessantly about everything that concerned her. To some of the people to whom she talked, moreover, she airily intimated that the apartment wasn't for her personal use at all but would serve to lodge visiting friends and family. The suggestion, of course, was that she had neither the intention nor the expectation of living any-

where save under her husband's ramshackle but glorious roof. These little flights of hypocrisy infuriated Alberto. He knew the truth only too well for having created so much of it. There were brutal settings-straight of the record. Giacometti was a pitiless measurer of the indulgence of self that could be practiced without serious compromise. Anyway, he went rarely to the rue Léopold-Robert, where Annette never succeeded in making herself at home.

In the autumn, Yanaihara was gone, taking with him a few more drawings and lithographs. All three must have suspected that last day that it was their last goodbye. Yanaihara had brought great change into the lives of the artist and his wife, a change so great that it excluded him. The Parisian adventure of the Japanese professor, however great, had been an adventure only.

One day in October—it was the tenth—Alberto woke up to find that he was sixty years old. Neither a shock nor a surprise, the discovery seems above all to have struck him as odd, because he had never dwelt on the idea that, as he grew older, time was using him up. On the contrary. He felt that he had time very much at his disposal. He was devoted to his past. His past was entirely present in the continuing presence of his mother and brothers, his birthplace, the unchanged places he had known as a child, the friends and relations of a lifetime. They were all present even when they were absent. Baudelaire once said: "Genius is childhood recaptured at will." It is also the power of childhood to work its will. "I don't know who I am," Alberto sometimes said, "or who I was. I know it less than ever. I do and I don't identify myself with myself. Everything is totally contradictory, but maybe I have remained exactly as I was as a small boy of twelve."

ag 63

Caroline, too, could be fallibly human and unpredictable. She proved it in the autumn of 1961 by announcing that she had gotten married. It was preposterous and hilarious, of course. Alberto refused to believe it. But she took perverse delight in flaunting her frailties and confounded her admirer with documentary evidence. He was enraged. As for the man who shared her matrimonial venture, he was a very earthbound ne'er-do-well, a member of the underworld in mediocre standing. Destined to do quite a lot of time in stir, he was eventually left alone there when Caroline got a divorce. Why she had even bothered to marry him in the first place is but another aspect of murk in her mystery.

Alberto had a nickname for her. La Grisaille. Monochromatic painting in shades of gray had, indeed, become more and more characteristic of his work, especially since she had become his principal model, since his ever-increasing concentration on her gaze. This was colorless. The eyes which conveyed it had a hue, but what was conveyed had none. Trying to produce its likeness frequently seemed to Giacometti to be overstepping the bounds of reality, not to mention common sense.

"People tell me I paint only with gray," he said. "My colleagues admonish me, 'Paint with colors!' Isn't gray a color, too? If I see everything in gray, if within that gray I see all the colors that impress me and that I would like to convey, why should I use another color? I've surely tried to do it, for my intention has never been to paint solely with gray and white or, in general, with any specific color. At the start of work I've often put on my palette as many colors as my colleagues. I've tried to paint as they

do. While working, I've had to eliminate one color after another; no: one after another the colors have deserted the party; at the last there remained only: gray! gray! gray! My experience: the color that I feel, that I see, that I want to express, which for me signifies life itself, well, I destroy it, I destroy it utterly if I put in its place any other."

La Grisaille herself, however, was an exceedingly, almost excessively, colorful individual. She splashed color onto herself and her doings with the abandon of a Fauve. Whether or not they were true to life made no difference to the vividness of the effect. Effect was all, and it appeared splendid to Alberto. Neither the fact of marriage nor the falsehood of her tall tales could tarnish it. Though her image be gray, the person need not be. On the contrary: the grayer the image, the more resplendent the person. In Alberto's eye her raison d'être was to shine, and shine she would. If it be at his expense, that was only as things were meant to be. Her wont was to receive tribute; his need, to provide it.

It was not merely, or even essentially, material. The artist's exaltation drove him to exalt his model. He told her that she wrote the most beautiful letters he had ever received. His own, he said, and all others, were flat, flat and empty, compared to hers, for she wrote only as very great people were capable of writing. Though he had marveled from the first, her letters surpassed his imagining. They made him feel small, very small, as he contemplated her stature, they filled him with tenderness, and he could find no words adequate to express his awe. What she was existed, and—for him—there was nothing beyond.

He identified himself with her, saw himself completely via her presence in his thoughts and work. In the art of ancient Egypt the divinities depicted anthropomorphically had always to resemble very closely their offspring, the monarchs of the earth. His thoughts responded so closely to the identification with Caroline that in one letter he told her he had felt that the best possible reply to her letter would have been a word-for-word copy of it. The interaction between a creator and his creation seems almost to catch itself by its own tail. She was uncannily shrewd and seems to have sensed how she could make the most of her situation by allowing it to make the most of her. Long afterward, when it was all over, sometimes she would say, "I was his frenzy."

She loved toads and pearls. Her frenzies, though she clung to Alberto, were also figments of the imagination, and they added to the mien of the sorceress. The number of her pet toads, which she cared for tenderly, was thirteen. She had a dog named Merlin, also a cat, and a pet crow called Becco, which she had ensnared one day in Normandy by climbing a tree and shaking it from its nest. Alberto complained of the stench, but he submitted. As to the passion for pearls, he did likewise. The passion extended to diamonds. He gave her bracelets, rings, a jewel-studded watch. Money, however, was the major tribute. Alberto gave it gladly. It was the most impersonal instrument of intimacy. But a vital condition of the transaction was that in order to be effective it must be private, for its value could only be corrupted by the scrutiny of others. Besides, Caroline seemed to care as little for money per se as Alberto did. At the roulette table, the real stakes were not monetary. "You always win," she said, "because you have the sensation." The sensation of what was but another obscurity within her mystery. She loved pearls, toads, money. She longed to be loved. But she cared not at all for works of art. Her mystery was what seemed to save her even as it imprisoned her: within it she had nothing to fear from it.

Diego was unhappy. Having seen things go bad when Yanaihara came upon the scene, he was obliged to watch them get worse now that Caroline came and went with such regularity. Annette thought that he was pleased by the presence of another woman in his brother's life. She was wrong. His disapproval of her did not entail acceptance of a rival. He detested Caroline. She looked like the kind of common whore and tawdry chiseler he had seen all his life hanging around Montparnasse, nor could he make out any reason for assuming otherwise. "The way she holds her head," he exclaimed, "it's disgusting!" He tried to avoid her, never going into Alberto's studio when he knew she was there. But he couldn't pretend that he was happy. Alberto, having spent a lifetime study-

ing his face, knew only too well how to read what it said. Diego warned him to be careful. But the artist heeded what he saw, not what he heard. He cared only to be enraptured by his model. If she turned out to be a femme fatale, so much the better. Weren't they all?

A situation like an inextricable tangle of twine was snarling the lives of the four protagonists, and each of them could feel that the confusion of the others was responsible for it. Caroline knew that her lover's wife and brother despised her, which she probably thought a convenient obstacle to pointless courtesies, so she gave back as good as she got. Annette hated the other woman, bitterly resented her husband's attachment, and responded to the loss of her brother-in-law's respect with sullen umbrage. Diego disapproved of everything, but he kept it for better or worse to himself, and to his mind it was certainly for the worse. As for Alberto, he was confounded by what had happened. It had happened because it was necessary for his art, and there was nothing to be done about that. The two women were involved in the inevitability, but they were not so inherent to it as Diego. He had been part of it from the beginning. He was indispensable. In view of the present mess, their loyalty to each other, their respect and care for each other, could not falter or fail but had to grow greater and firmer. So they entered upon the clinching irony of their lifelong dilemma, and they had no choice but to make the best of it, as it made the best of them.

For Diego the stress was no doubt greatest, because he was by necessity the most passive actor. All he could do was what he had always done, taking strength from the largeness and insistence of the need, armed by the past. He liked to think of his relationship with his brother and his brother's work as resembling those which had inspired the anonymous builders of medieval cathedrals. He had every right and reason to. So what was his dismay to find the place desecrated by a creature to whom in the dubious old days of his youth he would never have given the right time? The world was gone wrong. Heartsick, he started drinking, and that was an activity for which he also possessed exceptional aptitude. There were nights when he had trouble making

1961

his way home. But in the morning he never failed to be up at the appointed hour to get on with all the requirements of Giacometti's work and Giacometti's career.

In October 1961, ten days after his sixtieth birthday, Alberto traveled to Venice. He had been invited by the officials of the Biennale to exhibit a large group of works in the principal pavilion, and had accepted. He had refused, however, an identical invitation from his native Switzerland, claiming that he hadn't enough works on hand. Some obscure resentment still rankled, for he told his mother that somebody had probably thought this was the best that Switzerland could offer an artist, and that he wouldn't have dared to refuse. Switzerland, as a matter of fact, could do very much better. It was planning to do so before the end of the year, and would ultimately do its very best by providing permanent assurance that Alberto Giacometti was the greatest Swiss artist of his time (and name). Concurrent with the Venetian preparations were preparations for a major retrospective in Zurich. That, it seems, was all to the good, but in Venice he still wanted to be viewed as an international participant. The large amount of space allocated to his work suggested that he was considered a serious contender for the prize, still the most prestigious that a sculptor or a painter could receive. Having inspected the rooms where his exhibition would be installed the following summer, Giacometti returned to Paris.

Half a year was not a minute too long to get ready for two exhibitions intended to show the full stature of a great artist. No matter how many masterpieces may be yet to come, an artist at sixty has created the basis upon which his survival stands or falls. Alberto was ready for the test. Maeght, Clayeux, and Pierre Matisse were pressed to help. The mere quantity of works to be shown in Venice was impressive, numbering forty-two sculptures, forty paintings, and more than a dozen drawings. Almost all were of recent date.

To install so many works in the allotted galleries, however spacious, would for anybody have been a touchy and trying business. It fell mostly, as usual, to Diego. The brothers went together

1

NB

to Venice early in June, well before the opening date of the Biennale. Always finicky about relative proportions and situations, Alberto became maniacally so as he grew older. Diego had to make the accommodation. Sculptures which in the northern light of Paris had had one appearance had another in the southern gleam of the lagoon. Alberto thought them too dark. Diego changed the patinas of some, while the artist went after others with paint and brush, although many were not his property. Pierre Matisse, who had arrived with Patricia and a coterie of friends, observed that collectors might not be pleased to find their possessions transformed. The artist shrugged off the unwelcome observation. Sitting up half the night in Harry's Bar or the Grotto, he arrived every morning exhausted at the exhibition, and changed his mind about decisions made the day before. Fortunately for him, not to mention Diego, the Biennale workmen considered him an Italian and regarded him as one of themselves. They cheerfully put up with his demands and rebuilt pedestals from one day to the next. Diego was concerned. Rarely, he thought, had his brother been so nervous and overwrought.

Giacometti now ranked as an international celebrity. Annovances followed, in Italy principally in the form of ubiquitous photographers. But the artist was too preoccupied to notice them. What particularly, and uncharacteristically, engrossed him was the question of the prize. That he would be awarded the prize for sculpture was accepted as a sure thing. But that did not excite him in the least. What excited him was his insistence that the prize. if any, must be for sculpture and painting. Otherwise, he wanted none at all. He was adamant. He was irascible. He, who had never truckled with fame or its business, took a stand so contrary to his usual one that it showed but more clearly where he really stood. His insistence that any award must be for the entirety of his work was the logic of his life. If he were not himself wholly, then he would be no one. He was sculptor and painter. Let the Venetian jurors heed it. He pounded on the table at Harry's Bar, swearing to be intransigent.

Pierre Matisse, Patricia, Clayeux, and the others tried to make moderation prevail. Never an easy business with Alberto, it seemed next to impossible now, as if the artist feared a public failure of vision might haunt his work when he was no longer able to stand up for it. And he was humble enough himself to make an issue of the artist's pride.

Diego had heard enough. Indispensable in the studio, in the limelight he was irrelevant. Two days before the opening of the exhibition, he left Venice for Stampa. Their mother's health no longer allowed her to go up to Maloja in the summertime. Annetta spent the whole year in the apartment where she had lived for more than half a century, where she had raised her three sons, and where her greatest happiness now came from the occasional testimony of their reverence for her long-lived devotion.

While Giacometti's artistic triumph stood ready for consecration in Venice, the city which for forty years had figured so signally in his personal mythology, a companion of more obscure byways was en route, had she but known it, to a place of comparable significance. Caroline also was in Italy. Though she and Alberto did not see each other, they were together in thought. Traveling alone in the scarlet car given by her admirer, she was bound for Sicily. What concerns took her to that lawless island in the infernal heat of summer, it is probably just as well not to know. Her itinerary, however, had in part, at least, been predetermined. Alberto had insisted that she visit Paestum and Pompeii. He had never again set foot in those places since that day in April 1921, and he never would. But he was determined that Caroline should. He cannot have imagined that she was capable of participating in the mysteries of those sites, her own mystery being so totally self-centered and transient. True to form, she remained unmoved by the works of art she saw. Frescoes relating to the cult of Dionysus, statues of Apollo, of Bacchus, of Pan, assuming even that she noticed them, left her cold. The only thing that caught her eye-predictably responsive to such representation-was a painting in the vestibule of the House of the Vettii showing Priapus with his enormous penis, an image reputed to have talismanic powers. So much for Pompeii. At Paestum she found the Doric temples standing where they had stood for two thousand years, dedicated to gods she'd never heard of. She appreciated none of it. Nor could she have been supposed to. Her mere presence boded appreciation enough. She purchased a postcard and scribbled a few lines: "As you see, followed your advice. Here it's a heap of old rubbish!?!"

Venice, which had opened both heights and depths to Giacometti, did him honor. It was fitting, for this was the last time the artist visited the city which had contributed so much to his imagination. In the principal pavilion, the Giacometti exhibition looked superb. Visitors were greeted by two of the tall women executed for New York, then the two great walking men, the monumental head, The Leg, portrait busts of Diego, paintings of Annette, Yanaihara, Caroline: a comprehensive survey of the Giacomettian world. He was awarded the prize for sculpture. He accepted it without objection, after so much bluster and remonstrance. The prize for painting went to Alfred Manessier, a conventional abstractionist. Giacometti knew how little posterity cared for prizes. All he had wanted in reality was for people to see the extent of his undertaking. Not the full extent, of course. That would have to wait, and he was willing. After the prize-awarding ceremony, Alberto went off with his family and friends, leaving behind him forgotten on a chair the honorary document. "It would really have meant something to me twenty years ago." he said. "Now it's only a pleasure."

More honor came at the end of the year with the full-scale retrospective at the Kunsthaus in Zurich. If Giacometti had wanted the best that Switzerland could offer to an artist, this was very nearly it. The exhibition numbered 249 items: 106 sculptures, 85 paintings, and 103 drawings of all periods. Save for a few wooden sculptures from the Surrealist years, now too fragile to travel, everything important was present. In Zurich, the Venetian survey was greatly surpassed, providing an opportunity to view recent accomplishments in the provocative perspective of works executed four decades before. Alberto was grateful for it, and not only for its importance to the native son but for its practical interest to the artist. The native son's importance and the artist's interest merged in a sense of attainment that could never have been comparable elsewhere. He had gone away from home to do

bush

M

his work, but it was in the most important city of his homeland that he was to see the most all-embracing exhibition of what he had done. The embrace went far, and he went with it. For the first time, it took place on the premises of a great museum, where he could see what he had accomplished in the challenging perspective of masterpieces from the past.

What he chiefly saw, what he had for a long time seen with melancholy clairvoyance, was his solitude. His forebears were with him, or he was with them, trying to make a place for himself not unworthy of their legacy. That effort had impelled him all his life to draw careful copies of the works of his elders: to see them better, to see more effectively what they were about, to see better where he stood with them. Where he stood now, as he saw it clearly but sadly, was alone. His place, Giacometti believed, was at the extreme end of a tradition, one which stretched backward from Cézanne to Rembrandt, to Velázquez, Tintoretto, and Michelangelo, to Giotto, and Cimabue, to the Byzantines, the Greeks, and finally to the Egyptians. In terms of that tradition, whose last heroic exemplar had been Cézanne, Giacometti could not see anyone to keep him company in 1962, or anyone likely to try to follow in his footsteps.

"Nobody works like me," he said, "but in my opinion every-body ought to work as I do: that is, try to see an object as it really is. The artists of today want only to express their own subjective feelings instead of copying nature faithfully. Seeking for originality, they lose it. Seeking the new, they repeat the old. That is true above all for abstract art. Cézanne did not do this. He didn't seek to be original. And yet there is no painter so original as Cézanne."

What was original in Cézanne was not his subject matter, which was as old as the hills, but his character, and not his style, which was merely a vehicle, but his spirit. Giacometti's originality was the same, and he kept the same company. He led a heroic life in an age which epitomized the failure of traditional ideologies to excite or nourish man's hunger for heroism. He made no fuss about it, because he never fell into the error of viewing the artist as a

sess as rupture

god whose human shortcomings are irrelevant to the supremacy of his creations.

Like Cézanne, Giacometti had studied all the creative tendencies and artistic innovations of his time, taken what was good for him, then gone his way alone. But Cézanne, however lonely he felt, foresaw a future for art, Giacometti did not. His view of his situation was tragic for himself, but he could bear it. Whether his contemporaries had comparable strength was another matter. Alberto said that he derived more satisfaction from looking at the tin soldiers in toy-shop windows than from most of modern sculpture. He judged the efforts of the artists of his time with the same severity that he applied to his own. By that pitiless measure, most were found wanting. Speaking of abstract art, he said: "It creates and seeks to create a self-contained object, as self-contained and as finished as a machine, without reference to anything beyond itself. Now the question arises how to define this new kind of creation. One wonders what might become of abstract sculpture and abstract painting. How would a Brancusi statue look if it were chipped and broken, or a Mondrian painting if it were torn or turned dark with age? One wonders whether they belong to the same world as Chaldean sculptures, as Rembrandt and Rodin, or whether they form a world apart, closer to that of machines. I would go further and ask to what extent they may still be defined as sculpture, as painting. How much have they lost of the meaning in these words?" That meaning was what he clung to, though he clung to it somewhat as Prometheus may be said to have clung to his rock. Musing on this, he said: "Painting as we know it? I think it has no future in our civilization. Neither does sculpture. What we might call 'bad painting'—that has a future . . . There will always be people who would like to have a picturesque landscape, or a nude, or a bouquet of flowers hanging on the wall . . . but what we call great painting is finished."

G. David Thompson, the rude millionaire from Pittsburgh, Pennsylvania, owner of the largest Giacometti collection in the world, went a little crazy. He had a son, and this lad, like most American youths of the time, was drafted for military service. Having made friends with a couple of other conscripts, young Thompson thought it would be fun for the trio to have a car, and they found a flashy used one. Of his share of the purchase price, however, he lacked a hundred dollars. So he telephoned to Pittsburgh to ask whether that amount could be advanced. The parental answer was no. Not to be thwarted by lack of adult sympathy, the three boys bought a cheaper automobile. It looked good, but the brakes were bad. Unable to stop on a steep hill, they crashed into the rear of a truck and all three were killed instantly.

Dave Thompson was devastated by his son's death, did not attend the funeral, and no longer entertained the intimations of immortality that had moved him to brag about the creation of a museum to house his huge collection of art. He decided to sell. A bit unhinged, perhaps, yet his mentality was unchanged. He wanted to get the most out of his collection, not only in terms of money but also by way of prestige and self-indulgence. He dangled the hoard before various covetous eyes, then changed his terms and his mind before any deal could be concluded. It was the deal, and not the commodity, that mattered. He sold his Paul Klee collection to Ernst Beyeler, the dealer from Basel whose interest in Giacometti was long established. News of the sale flashed instantly through the art world. The next time Thompson was in Paris and went to the rue Hippolyte-Maindron, Alberto said, "I suppose my things will go next."

Thompson reiterated old promises, swore he would never part with his Giacomettis, and, as if to prove his good faith, urged the artist to sell him more. Alberto was hesitant, Thompson insistent. A few days passed. The millionaire returned to the studio. This time he was met by Diego, who had never forgotten the gifts snatched back from the "wrong" brother, and for once he took it upon himself to speak for the right one. He brusquely told Thompson that Alberto would not see him.

A week later the collector was at the Hôtel Baur au Lac in Zurich, where he summoned Beyeler and said, "How much will you give me for the Giacomettis?"

The question asked for careful reckoning, as the collection consisted of about sixty sculptures, dating from 1925 to 1960, including most of the greatest and many that were unique, plus seven or eight paintings and a score of drawings, more than a hundred works in all. Several potential purchasers other than Beyeler were approached. One was a Zurich businessman named Hans Bechtler, who eventually decided that the proposition was too costly. But he saw the collection as a unique opportunity to do something significant for Switzerland and for Switzerland's greatest living artist. It was Bechtler's vision that played a vital part in the eventual disposition of things. After crafty negotiations, Thompson finally sold his Giacomettis to Beyeler. He, too, saw the opportunity as unique, and it was largely due to his unselfish efforts that the artist's mother country did finally do her very best for the deserving son.

As for Dave Thompson, he died two years later. Of heart failure. Unmourned by any in the art world.

"The Sound and the Fury" had not been soothed by time, pills, or the analyst's couch. So long as Caroline sat in her husband's studio, nothing was likely to appease Annette. Scenes and recriminations grew more strident and bitter. Humiliating things were said. Things were said in front of witnesses which, if they must be said at all, cry out for privacy. Annette sneered at Alberto's old, wrinkled, ugly physique compared to other men's youth. Alberto sighed. Sometimes he lost his temper. But he never allowed

others to make unkind or critical judgments of his wife. If he endured what he endured, the necessity to do so had come in large measure from him. Still, he would have been happy had she found someone able to give her what she wanted. Caught in the cruelties of their situation, they aggravated them. For example, while Alberto was doling out millions of francs, diamond bracelets, and pearls to Caroline, he continued to give Annette little. She must have guessed. She was in a position to know how much money there was. She saw that she was getting little of it, and she cared. She cared violently. Not so much for the money itself. In this, if nothing else, Annette and Caroline were, perhaps, somewhat alike. To both, money was a symbol. The meaning of the symbol, however, in each case was almost diametrically opposed. Annette wanted security, Caroline sensation, Alberto recognized the importance of money, but he fought shy of it for fear of compromising his investment in failure. He was mindful of having benefited all his life from the luxury of living and doing as he pleased, compared to which all the rest is, indeed, de trop. He gave money to Caroline because she was made to be paid. Annette was made to be supported, which happened to be her own estimate of the case. Her husband settled with it in like spirit. But she saw the disparity, and it enraged her.

In search of sympathy, especially since the final departure of her Japanese friend had left her so wanting in that department, Annette found it in the person of Jean-Pierre Lacloche. She found, in fact, his entire person to be sympathetic, and, what's more, responsive. He was young, handsome, sensitive, an admirer of Alberto but attentive to the woes of the artist's wife. Nor did Olivier Larronde object. Moreover, what with all the drinks and drugs, and the minimum of creative accomplishment, Olivier's health, both mental and physical, had declined. The exotic high life at 77 rue de Lille went on nonetheless. Annette was delighted.

She wanted to move out of the rue Hippolyte-Maindron. But then she didn't want to, and she didn't exactly do it. She hated the night light; still, it held her. She went here, she went there, she came back. She went to Switzerland. She stayed in the country with her friend Paola or another friend, another woman mistreated

by an artist, the former "housekeeper" to the Count de Rola. From Switzerland she wrote Giacometti to ask what sort of wallpaper she should have in her apartment. Back in Paris, she lived for a while at the Hôtel l'Aiglon, a comfortable place on the Boulevard Raspail near Sartre's apartment. However, she always returned to the rue Hippolyte-Maindron. Her things were there, few as they were, and she was attached to things. She intermittently tried to get settled in the rue Léopold-Robert, but something hindered her. Though the place was ready, she never lived there. She had insisted on it, and she couldn't endure it. She said that the long flights of stairs were too much for her. She wanted a place that would not require such a terrible climb.

So she set about looking, and before long she found something. It was more distant from the studio, not far from Saint-Germain-des-Prés, in the rue Mazarine, an apartment one flight above a small restaurant. It had a large living room opening onto the street, a smaller bedroom with windows overlooking a rear courtyard, a kitchen and bath. Here she did finally make a sort of home. She brought some, though not all, of her things. Books, records, pictures. It was neither tasteful nor very comfortable. It was disorderly, but it was hers. She lived there more or less, rather more as time passed, but she always lived at the studio, too. That is, she went there almost daily, or very frequently, to assert legitimacy, although she may seldom, if ever, have slept there after 1962. But her place was never questioned. As if to confirm this, even as late as 1962, and later, she posed for the artist, proving her endurance and rights. Alberto did not deny them.

Jean-Pierre Lacloche took to heart the grievances of the woman who wanted sympathy. He was a man of honor, of proven courage. It took a lot of both to berate Alberto for his misdeeds. Jean-Pierre did so. He had known the couple a dozen years, had seen thick and thin on both sides, and was not afraid to call things by their names. No matter, he told Alberto, how sublime Caroline might appear at the moment, she would never have stood by him as Annette had done through the difficult years, of which, as a matter of fact, the most recent were not necessarily the least trying. The artist admitted that it was so. But the test of perse-

verance comes in terms of a lifetime, not segments that suit the convenience of temporary gratification. Giacometti was acquainted with that unsparing reality, and he was prepared to take the consequences. Jean-Pierre had still to learn. When the lesson came, good looks and happiness gone, it must be said that he accepted it with unflinching dignity.

Meanwhile, Annette's insistent claim on his sympathy cast in a somewhat different light his opinion as to the virtue of her perseverance. His first loyalty was to Olivier. And there was the time-consuming eventuality of nirvana to be dealt with. Jean-Pierre's ability to deal well with it, in fact, became a bit too capable to suit the authorities. There was a spot of trouble over a shipment of opium. Alberto was displeased. Trouble associated with opium would not have made for welcome associations. But he advanced funds to help adjust it. As a consequence of all this, and more, the sympathetic ear Annette had happily come to consider her own was no longer entirely, if at all, the same. Again downcast, she found her dissatisfaction more galling than ever and gave herself over to renewed "s. and f."

Isabel was still laughing. The third marriage had not inhibited her exuberance, and her hilarity rang out in the drinking places of London and Paris. Alberto found it quite natural to see her walk in his studio door, sit down, and start talking and laughing exactly as she had done twenty-five years before. He did not intend to set aside any part of experience by reason of having become Alberto Giacometti, the great artist. Eruptions of the past were never interruptions of the present.

Mrs. Rawsthorne's occasional visits brought not only hilarity but the continuity of a casual acquaintance which became Alberto's last friendship with a creative personality of significant stature. It had begun one day when a stranger came to his table in a café to introduce himself, expressing admiration and asking only to declare it in person. The name was Francis Bacon. Such spontaneous sympathy was the kind Giacometti found irresistible. Time would show there were quite a lot of other things about both men made for mutual appeal.

Born in Dublin in 1909, son of an English trainer of racehorses, Bacon came to painting, as to most things, by an unconventional and tortuous route. He had little interest in formal education and got little. By the age of sixteen, he had begun to lead the life of a wanderer, which he would follow one way or another till the end. Good-looking and clever, with a malicious tongue, he was determined to get along, though he had no idea in what direction. Driven by homosexual desires, a love for drink, and a passion for gambling, young Francis drifted through the low life, if not the underworld, of Paris and Berlin at a time when in both cities it was easy to be brilliant and depraved. Artistic innovation was everywhere, but Francis was not especially interested. His talents were directed to interior decoration and the design of furniture. It was not until the war years, when he was found unfit for service because he suffered from asthma, that he began to paint in earnest. He proved his aptitude with appalling authority. By the late forties, he had made himself one of the masters of his generation and a figure of controversy. His style. his subject matter, his adroit manipulation of his career roused the fervor of some, the contempt of others.

About Bacon's prowess as a technician there was never any argument. It was the uses to which he put it that stirred controversy. He concentrated on the human figure, although it was subjected at his hands to dislocations and decompositions of horrendous intensity. Attacked in the era of abstractionism for being figurative, he was also denounced for being morbid, macabre, and self-indulgent. He responded with wit, made a mockery of criticism, and kept on painting, drinking, gambling, and making love to working-class boys. His favorite images were of men screaming, naked male bodies interlocked in throes that looked more like agony than bliss, figures sitting on toilets or vomiting in washbasins, crucifixions wrought out of slaughterhouse refuse, and multitudes of portraits, including profusions of his own, in which both limbs and physiognomies had undergone gruesome metamorphoses. Haunting likenesses nonetheless peered from these grisly effigies.

Bacon's models were usually photographs; seldom, if ever,

live persons. He was one of the first to see how photography might by the very inaccuracy of its visual effects enlarge rather than restrict the extent of painterly possibilities. He also relied greatly on the instrumentality of accident. The difference between the arbitrary and the inevitable dissolved as easily as the features of his friends. It was this facility rather than the horrific subject matter that disturbed some people, who said that the painted scream seemed less like a howl of pain than like a well-composed aria. Power and virtuosity, however, were undeniable, and Bacon's reputation boomed.

Many of his portraits were of Isabel. Even more numerous were the bottles they downed in each other's company. Bacon, too, was an irrepressible laugher, though an undertone of the death rattle was distinctly audible in his hilarity. He was obsessed by death. He said: "Man now realizes that he is an accident, that he is a completely futile being, that he has to play out the game without reason. I think of life as meaningless; we create certain attitudes which give it a meaning while we exist, though they in themselves are meaningless." That conviction might not have seemed made for the sustenance of great friendships, and Bacon readily said of himself that he was treacherous. He was also wildly bizarre, charming, crafty, and witty. He once remarked: "I serve champagne to my real friends and real pain to my sham friends." Of both sorts there were plenty. Isabel got only champagne, but the portraits of her appear to have been painted to show the destructive consequences of too much of it. Drink had made her bleary and slovenly, the radiance of youth a ruin. Bacon's charm went with a sympathy for ruin, for disintegration, for extinction. And Isabel, who had seen many men-and women-come and go, could take desolation with gusto. She gulped her wine and went on laughing. Francis loved it.

Alberto was fond of Bacon, and of his boyfriend George Dyer, seeing them often when in London, where he went on a number of occasions in the last years of his life to prepare for the great exhibition of his work at the Tate Gallery in the summer of 1965. Riding about with them one day in a taxi, Alberto patted George on the knee and exclaimed, "When I'm in London, I

Lote

feel homosexual." Francis believed that Alberto might have found contentment in homosexual relations. Who knows? On the evidence of his life and work, Francis never seemed to. He once said to Alberto, "Do you think it's possible for a homosexual to be a great artist?" But he had smashing answers to his doubts.

One evening in 1962, when Isabel had arranged a dinner at a London restaurant, Francis arrived late, nervous, and drunk. He and Alberto launched into a discussion of painting. It started well but then, as Bacon became progressively drunker, developed into one of those maundering monologues about life, death, and the gravity of it all to which Francis was prone when plastered. Alberto, who never drank to excess, listened patiently to all this and eventually responded with a shrug of his shoulders, murmuring, "Who knows?" Taken aback, Francis without a word began to raise the edge of the table higher and higher until all the plates, glasses, and silverware crashed to the floor. Alberto was delighted by that kind of answer to the riddle of the universe and shouted with glee.

Personal compatibility was one thing, professional concord quite another. Concerning aesthetic objectives, the two artists did not see eye to eye. In private, Alberto expressed dislike of the chance effects and crafty sleights of technique so beloved by Francis, while the latter, who is known never to have made a single drawing, allowed that as a draftsman Giacometti was without peer, leaving, of course, treacherously vague the mastery of other terrain. But nothing marred the friendship. After the older man's death the younger said, "He was for me the most marvelous of human beings."

While all this was going on, while he was being honored in Venice, in Zurich, while Thompson went mad and Annette to extremes, Giacometti kept working and living at the same unsparing pace, sleeping and eating less, smoking more, and laboring in the studio day and night. It affected his health. The sturdiest physique on earth could not have taken punishment like that forever. Alberto looked terrible. His skin was ashen. His eyes were sunken, the whites bloodshot. Fits of coughing, increasingly fre-

quent, seemed to stop just short of suffocation. He was vomiting bile. For years he had suffered from stomachaches and lack of appetite. Abdominal pains became acute. He went to see his old crony, Dr. Fraenkel, who prescribed medicines and said not to worry. Alberto returned to work and kept on suffering. However, he worried. For years he had had the impression when going to sleep at night that he might not wake up the next morning. He dreamed of having cancer and thought that if he must have some disease, that was the one he wanted. Being so serious, it had an "absolute" quality which made it the most interesting. In the meantime, he had work to do. The portraits of Caroline continued and he had started an extraordinary series of busts of Annette.

At the Broussais Hospital in the rue Didot, a young man from Maloja named Reto Ratti was just then studying to become a doctor. Having known the Giacometti family all his life, enjoying both the advantage and the pleasure of that connection with Bregaglia, he fell into the habit of dropping by the rue Hippolyte-Maindron. Quick-witted, high-spirited, and handsome, Reto was appreciated by both brothers. Alberto gave him several drawings and Diego allowed him on occasion to sleep in the studio. It didn't take the medical student long to see that Giacometti was in serious need of care, and Reto admonished Alberto to consult a competent physician. Heeding the advice and increasing pain, Alberto returned to the Avenue Junot to see Theodore Fraenkel. This time, prompted by heaven knows what sense of responsibility, instead of telling his patient to take some makeshift medicine, Fraenkel sent him to a surgeon.

He was none other than Dr. Raymond Leibovici, still practicing in the clinic in the rue Rémy-de-Gourmont, where he had treated Giacometti's broken foot twenty-four years before. If a coincidence, it was a happy one, for the patient had confidence in the doctor and was ready to abide by his recommendation. Leibovici ordered X-ray examination of the stomach and intestinal tract. As soon as he looked at the results, he knew that his patient had cancer, a large malignant tumor of the stomach, which had in likelihood begun as a gastric ulcer ten years before. He was astonished to think how much pain the artist had endured. Im-

March

mediate surgery was the only course. Knowing that so radical an operation was never without risk, he decided not to tell his patient the truth. That was his policy. Because he knew that most people fear cancer, he thought there was no good in worrying patients and believed that for some of them a brutal truth might have the effect of self-fulfilling prophecy: aware of danger, the patient might lose the will to resist it.

Dr. Leibovici called the sculptor to his clinic. With X-rays in hand, he delivered his diagnosis. As he held up the X-rays to explain the case and describe the surgical measures necessary. he saw that Giacometti watched his face with searching scrutiny. The doctor said that a gastric ulcer had developed and surgery was required. Alberto accepted the diagnosis without apparent emotion. He did not ask Leibovici whether he had cancer. However, he went straight to Fraenkel and asked him. Having been pledged to secrecy by Leibovici, Fraenkel replied that the trouble was an ulcer, nothing more. Alberto was not satisfied. He demanded that Fraenkel swear by the love of his wife and mother that he spoke the truth. Fraenkel swore. Then Alberto was satisfied. more or less, for he also asked an opinion from Reto Ratti, who was evasive. But Alberto accepted the diagnosis. It was almost as if he'd been disappointed, for he went about saying, "If it were cancer, I'd be willing, because that's an experience worth having. But this is a trifle, so it's a nuisance."

Dr. Serafino Corbetta, the pushy medical man from Chiavenna who had appointed himself official physician to the Giacometti family, happened to be in Paris at this time and presented himself to Dr. Leibovici. The two doctors discussed the case, though the Italian had nothing to add but the presumption of his self-importance.

The patient's general condition being less than mediocre, Leibovici recommended that he enter the clinic several days before the operation in order to prepare his body for the experience. So Alberto found himself again on the premises where he had lain a quarter of a century before, recuperating from a first brush with danger. The coincidence cannot have failed to intrigue his notion of the possible worked upon by the inevitable, and it is

intriguing, because that first brush had since undergone such drastic reevaluation in the interests of truth that the second one may also appear subject to the contrivances of creative necessity. To be sure, this time the artist did not know what stakes he was playing for, and he would be furious when he found out that he had been cheated. But that other time he had had no idea, either. Nobody, of course, is ever entirely up to that game.

Having failed to tell Alberto the truth, Fraenkel failed to keep it to himself. He told Diego, who immediately told Annette, Bruno, Pierre Matisse, Maeght, and a number of other friends. But he did not question the surgeon's right to keep his patient in the dark. The only one to do so, oddly enough, was Annette. Whatever her feelings of estrangement, jealousy, and bitterness, she had been with Alberto nearly twenty years. She knew him well and had a sense of duty toward that knowledge. She felt that his lifelong intimacy with death entitled him to be told if it was near, and that he would resent being dealt with falsely. Alberto Giacometti deserved the truth, because he lived for it. Annette said as much to Dr. Leibovici, who dismissed her protest and forbade any disclosure. She reluctantly complied, but it does her honor that despite the inconsistencies of her nature and her marriage she made an issue of Alberto's right to the truth.

The operation, performed on the morning of February 6, 1963, was a subtotal gastrectomy, requiring removal of four-fifths of the patient's stomach in order to exsect insofar as possible all cancerous tissue. It was an operation almost exactly like the one performed on Henri Matisse twenty years before. Giacometti lay on the operating table for three hours, and Dr. Leibovici was aware as he worked that in such cases one patient out of four could die. But Alberto responded very favorably. The sturdy physique bequeathed by his forebears stood him in good stead that day. Diego and Annette, waiting nervously downstairs, were reassured. By evening, it was clear that present danger had been averted. The next day Alberto was out of bed for a few minutes. With the malignancy gone, improvement was rapid and visible. His color was better, the whites of his eyes cleared. For the first time in

14/2

years, he felt the stirrings of appetite. He had brought with him in a wooden box a small figurine, wrapped in damp rags, and occasionally while recuperating he took it out and fingered the clay. Its responsiveness under those circumstances must have seemed a demonstration of his ability to triumph over them. His humor was excellent. To visitors he displayed his fine woolen bathrobe, asserting it was the first he had ever owned. Many came, including Caroline. All were impressed by the visible improvement. Fourteen days after the operation, Alberto was able to leave the clinic.

He did not, however, return to the rue Hippolyte-Maindron but went to the Hôtel l'Aiglon, where convalescence would be more comfortable. Besides, he had made up his mind that as soon as possible he would go to Stampa, where his mother would help restore him to health. He looked forward to drawing portraits of her. But Dr. Leibovici said that convalescence must be conscientious. In cases such as Giacometti's there was the risk of recurrence, though he took care not to name the danger, and he insisted that the patient henceforth lead an existence disciplined by common sense. That meant regular hours, a well-balanced diet, moderate work, avoidance of fatigue and anxiety, no smoking. If the patient failed to obey orders, the doctor would not answer for the future. Alberto listened politely to this advice. Then he consulted his old friend Fraenkel, who had been kept abreast of the case. Fraenkel said, "Keep on smoking." That was what Alberto wanted to hear and anyway was determined to do. Fraenkel told Leibovici that it was no good to try to reason with Giacometti or urge him to lead a sensible life, since he would live as he meant to, no matter what anybody advised. There is something to be said for that argument, though it was hardly consistent with Hippocratic integrity to hold such a fatalistic view of a friend's survival.

After three weeks of boring convalescence at the Hôtel l'Aiglon, Giacometti was able to travel. Dr. Leibovici was pleased, impressed by the artist's capacity to regain strength and self-confidence after major surgery. Alberto decided to take the southern route home. With Annette he would go by night train to Milan, thence by taxi to Lecco, Chiavenna, and Stampa. And

since they would be arriving in Chiavenna about lunchtime, why not have it with Dr. Corbetta, who would be only too glad to receive them? They could go on to Stampa in the early afternoon.

Diego didn't like that itinerary. He argued in favor of the northern route, via Zurich, Saint Moritz, Maloja. But Alberto's mind was made up. He and Annette left Paris late in March.

Exuberant at the prospect of playing host to the famous artist, Dr. Corbetta greeted Alberto and Annette with effusion. During lunch he grew eloquent over the pleasure of seeing his friend once more in Chiavenna. "After all our worrying," he exclaimed, "you don't know how glad I am to see you here!"

"What worrying?" said Alberto. "It was nothing."

"Oh, you'll never know how worried we were," Corbetta insisted.

"What about?" asked Alberto.

"Oh, nothing, nothing," mumbled the doctor. "We were just worried."

But it was too late. "What were you worried about?" Alberto demanded. "If you were worried, it was about something, something about me that was worth worrying about. If you're so glad to see me again after so much worrying," he pursued, "then the thing you were worried about must have been the possibility that you might not see me again. Was that it?"

The doctor, a portly man, twisted and turned in his self-made awkwardness. It was no good. He was hooked on his own fatuity. If the doctor had worried for fear he might not see his patient again, no reason but danger of death can have been persuasive, non é vero? Corbetta tried to prevaricate, whereupon Alberto exclaimed, "If you don't tell me the truth, I'll leave here now and you'll never see me again."

So the doctor was compelled to admit that there had, yes, in fact, been a danger. Then Alberto saw the truth: the danger, having existed, had to exist still, because it could be none other than the one he had dreamed of. Corbetta had to admit it: yes, cancer had been the trouble. Having betrayed the trust of his profession as well as the supposition of his dignity, the doctor gave way completely. He produced a letter from Dr. Leibovici.

The Parisian surgeon had written to his provincial colleague, describing the operation and its outcome, commenting upon the fortitude of the patient and concluding with the observation that, although the artist might have a normal existence for a few years, danger of recurrence would always remain.

When he left Chiavenna after lunch, Alberto was exhilarated and infuriated. Fury, for the time being, was uppermost. It was directed against a single person, Dr. Theodore Fraenkel. He had frequently failed as a doctor, but Alberto had never held that against him, had, indeed, seemed almost gladly to take for granted the failing of the medical man but by the same token to assume that the friend must be infallible. It was from the friend that he had asked for an oath of truth. Alberto had believed it, and one of the great moments of his life had been belittled by a lie. He had proved that for him life's meaning was not governed by the rule of the physical, but a friend of three decades' standing had falsified the truth. It was unforgivable, and he would never forgive it.

Arriving in Stampa, Alberto had to control himself for fear of alarming his mother, the one person whose wont to worry over him he cherished. He kept the truth to himself. She knew he had undergone serious surgery and was overjoyed to find him lively and well. He was almost too lively. Annetta was startled by his agitation. Hardly had the time of leisurely homecoming elapsed before Alberto started making lengthy telephone calls abroad. He had to be cautious in his choice of words, because his mother was listening. But he couldn't wait to let others know that he knew what they knew. This was not from a desire to show the stoutness of his spirit. What he wanted was to put himself back into a rightful relation with the truth. If a danger existed, it would not diminish his life but enhance it, making every instant valuable and memorable. That was his exhilaration. It would grow and have a life of its own.

For the moment, however, there was Dr. Fraenkel to be dealt with. Fearful of his anger, Alberto waited twenty-four hours before telephoning. When accused, the doctor stuttered and tergiversated. To no avail. Giacometti's condemnation was total. No

plea or apology could move him. Betrayal of trust he could not, would never, forgive. To one who lives for truth, the wanton lie of a trusted friend is almost equivalent to that friend's suicide. The Theodore Fraenkel whose company Giacometti had enjoyed, whose need for sympathy and understanding he had welcomed for thirty years, had ceased to exist. Worse, he seemed never to have existed in the first place. The two men were never reconciled, and it seemed that the loss of Giacometti's friendship took out of Fraenkel's life some zest without which he found himself ill-prepared to cope with survival. Nor did he survive for long. Less than a year later, he lay dead of a cerebral hemorrhage. Unforgiving to the end, Alberto, when he heard the news, said, "I'm glad he died before I did."

As to his own zest for survival, Alberto was in no doubt. He wanted to live. Knowing death had come near, he appreciated life with a new excitement. Having survived danger, he could be indifferent to danger and live with the exaltation of throwing all caution to the winds.

"Maybe I'll be dead in a month," he said. "I have an even chance of pulling through. I'd be glad if I lived for three more years. One year, anyway. And yet if somebody told me I've got two months, that would interest me: to live for two months with the knowledge that one's going to die is surely worth twenty years of unawareness."

"And what would you do with those two months?" inquired his interlocutor.

"I'd probably do exactly what I'm doing. Between here and the inn on the other side of the road, you see, there are three trees. Well, that's more than enough to keep me busy until the end."

A suggestive coincidence, the artist pointing out those three trees to evoke the perseverance of the creative urge. One is put in mind of another artist, whose *Three Trees* stand among his most wonderful creations: Rembrandt. During that summer, while regaining strength, Giacometti drew a series of portraits of his mother. In their depth of feeling and serene representation of old age they recall Rembrandt, undiminished by the comparison. The vivacity of his mother's gaze is conveyed with breathtaking im-

N

mediacy: the same gaze that united parent to child with such extraordinary intensity in the photograph taken during a family picnic in 1909. In the studio where his father's last works had been executed more than thirty years before, Alberto worked again. He painted views from the window and did some busts of Diego from memory, likenesses which went very far by way of distortion to emphasize the most striking features of his brother's face.

Annette, having seen her husband well on the way to recovery, had no need to stay on. Stampa had never given her its wholehearted acceptance, and strident marital recriminations had done nothing to make her better liked. Alberto, on the other hand, though regarded as eccentric, had become as legendary a figure in his native valley as in the world beyond. He was prodigally generous, giving large sums of money to persons he knew were in need, but never boastful or self-important. People at the Piz Duan were proud to be asked to sit at his table, where he would stay talking with all comers till long past closing time. So Annette could leave her husband without qualm to the ministrations of his mother and the adulation of his birthplace. She returned to Paris, where her perennial need for a sympathetic ear again got her the attentions of a friend and admirer of her husband: a young poet named André du Bouchet.

Caroline bided her time all this while in the certainty that, whatever happened, she had had her sensation, her great man, and would have him still should the wheel of fortune turn so. Should she be able to jiggle the wheel ever so slightly to her advantage, she would not hesitate to try. She and Alberto communicated constantly by telephone and letter. Though inconvenienced by sickness and separation, their dialogue had never been interrupted. Both took it for granted that the visual rapport between artist and model would be resumed as soon as circumstances allowed. When the wait of the model sometimes seemed too long, she impulsively took to the wheel of the automobile offered by her adorer and drove to within striking distance. Not to Stampa itself, of course. He would never have accepted her presence there. But she could come near. Under cover of darkness. On more than one occasion, Caroline appeared at night in the neighbor-

ing village of Promontogno, where Alberto met her and they sat for hours on a bridge, talking and talking. Then she would get into the scarlet roadster and drive back to Paris. Alberto took her visits to be grand demonstrations of selflessness, proof that his adoration was not misplaced.

Never forgetting that death strikes without surcease, every day and everywhere, ferocious, blind, fatal, Alberto was aware that a recurrence of the cancer remained possible. Paris had been discredited as a place where he could hope to receive honest diagnosis. He recalled the medical student from Maloja, Reto Ratti, remembered his reticence at the time of the crucial question, and learned that he was continuing study at the cantonal hospital in Chur, conveniently on the road from Saint Moritz to Zurich. After inquiry, he found that he could be examined at the cantonal hospital and have the results without fear of fraud. So he presented himself there in October of that year for two days of examination. The results showed no trace of cancer. The prognosis was as reassuring as the sense of renewal which the artist felt and beheld in himself and his work.

Encouraged to resume the way of life which he had, in any event, hardly forsaken, Alberto took the train for Paris. There he found his studio, as always, kept safe by Diego. His brother had not changed. Annette and Caroline, too, were for better or worse the same. His work, his habits, his haunts, his friends, all were the same. Save Fraenkel. And one other. A second betrayal of trust had occurred. This one was rather different, more difficult to understand, but no less important.

lean-Paul Sartre and Simone de Beauvoir went off in June 1962 for a jaunt to the Soviet Union, where they were pleased to be made much of by party regulars who had baited and broken the recently deceased Boris Pasternak. Hatred of the bourgeois thus temporarily appeased, they then retired to a hotel suite in Rome, where Sartre considered what he might do next. He had spent a lifetime writing, had made a self-justifying cause of the writer's vocation, and had come to terms with reality both inward and outward as a vindication of his ability to write about it. He had written at great length about writing and other writers. Now he thought he could not do better than write about himself and his lifelong infatuation with words. So he produced an autobiographical volume describing his childhood, his aptitude for learning to read by pretending that he could when he couldn't and then for writing stories by plagiarizing the stories of other writers, a process that led him to retreat from life into the inviolable world of words. Words became for him "the quintessence of things," more real than the objects they denoted. Made of words, his autobiography, he said, was yet directed to the heart as well as to the intellect, while meaning to explore and evaluate the significance of language in human experience. Its title: The Words. Though devoted in principle to the years of childhood, the book is a dissection of the child by the mature man and an analysis of the effect upon the man of the child's blind adoration of books. He questioned the goodness of that effect, observing that culture cannot "save" anything or anyone, but acknowledged that his devotion to the just and purposeful use of words kept its power to sustain him. As an autobiographer contemplating the

circumstances of his childhood, Sartre demonstrated his belief that everything in an individual's existence has a meaning, that nothing in life is truly accidental, and that what may appear to be a happening is in reality an act.

The Words was an instant success, soaring overnight onto bestseller lists, sought immediately for translation into a dozen other languages, and adding vastly to the author's prestige, renown, and income. Hailed at once as a masterpiece, The Words was quickly talked about as a persuasive argument for the award of the Nobel Prize. Certainly it is an impressive literary edifice, constructed by a master builder working with materials which were, as he was the first to assert, the foundation of his existence. Built into the glory of it, however, may be an inherent flaw, inasmuch as the written word has an ambiguous relation to action: it implies a remove from direct experience and effective responsibility, insinuating that an author's passion for putting words together rises from the need to erect a barrier between his vulnerable self and a world indifferent, hence hostile, to the resources of his vocabulary.

When Anne-Marie Sartre had finished reading her son's autobiography, she remarked that he had understood nothing about his childhood, an observation, it would seem, designed to accord with the philosopher's conviction that words are quite as fallible as humans, maybe more so.

Giacometti, when he came to read the analysis by his old friend of how art takes hold of an artist's life and molds it to suit the needs which it itself creates, must have been impressed by the ingenuity and spontaneity with which the author was prepared to exemplify the meaning of his own words. But on page 193 Alberto received a rude shock, for there the sculptor found that the writer had summoned *him*, Giacometti, to become an incredible part of the verbal architecture. This is what he read:

"More than twenty years ago, one evening while crossing the Place d'Italie, Giacometti was run down by a car. Wounded, his leg wrenched, fallen into a lucid swoon, he at first felt a kind of joy: 'At last something is happening to me.' I know his radicalism: he expected the worst; this life he loved so well that he would not have wanted any other was suddenly overturned,

shattered perhaps, by the stupid violence of chance: 'Consequently,' he said to himself, 'I was not made to be a sculptor, nor even to survive; I was not made for anything at all.' What thrilled him was the menacing order of forces abruptly unmasked, and the petrifying gaze of a cataclysm fixed upon the lights of the city, upon other men, upon his own body flattened in the mud: for a sculptor, the dominion of stone is ever close at hand. I admire such a will to welcome all things. If one likes surprises, one must like them to that degree, to the point of such rare bursts of brilliance as reveal to the illumined that the earth is not made for them.

"At the age of ten," Sartre continued, "I presumed to like these only. Each link of my life had to be unexpected, to smell of fresh paint." And so on for another twenty pages.

Giacometti was thunderstruck, as if a cataclysm had unmasked the appearance of things. But he was not thrilled. He was appalled. He was infuriated. The writer's words struck him as unwarranted and unspeakable, struck him as a personal wound. and struck him in the part of his life that he would least have liked to see made public and made wrong. He himself, it is true, had repeatedly talked about the accident. None of his friends was unfamiliar with the story. That was all very well, since it was his experience and his life. But here was Sartre, a man whose friendship dated from the time of the accident itself, taking the story without so much as a by-your-leave and falsifying it for purposes purely his own. Everybody knew that the incident had occurred in the Place des Pyramides, not the Place d'Italie, and nobody who knew Alberto could have supposed that his reaction to it might have led him to say to himself: "I was not made to be a sculptor, nor even to survive: I was not made for anything at all." In fact, his reaction had been exactly the reverse, and the accident had generated one of the galvanic convulsions of his creative and personal life. Sartre presumed to shed light where none had been asked for. It seemed an outrage, a failure of good faith, all the more outrageous because the prophet of Existentialist responsibility had elevated his creed upon the basis of good faith. How could a man of good faith deliberately distort the vital facts of another's existence? How could good faith flaunt another

man's truth as a living lie? How could good faith find words to speak another's mind with thoughts as foreign to it as the planet Mars? Those were some of the questions that came to Giacometti as he pondered the provocative paragraph of the autobiographer.

Alberto had not needed Sartre to refashion the facts of his experience. The sculptor himself had long since molded them as he saw fit, as time in its own interests asked him to. Life is meaning, not fact, and Alberto knew better than most people that yesterday's facts do not necessarily make tomorrow's truth. And it was truth that he was looking for. His lies were his own to tell, not for Sartre to tamper with, and the more he thought about itand he thought about it constantly—the angrier he became, so that he eventually felt he had no choice but to end the friendship. News of Giacometti's indignation got back quickly to Sartre, who was surprised. He telephoned the rue Hippolyte-Maindron, but Alberto refused to speak to him. Intervention of mutual friends was unavailing. "It's as if he had never known me!" Alberto exclaimed. "What's the good of knowing someone for twenty-five years if he hasn't understood the first thing about you?" He was adamant. Already he had been irritated by inaccuracies in the autobiography of the Beaver, and by her flippant dismissal of his objections. Now Sartre was guilty of the same failing. He wanted nothing more to do with them. The two men were never reconciled. They ran into each other once or twice, but the friendship was over.

Sartre didn't understand. Long ago the Beaver had facetiously remarked that he associated only with people who associated with him, and now one of those with whom his association had been most enriching and entertaining refused to associate with him. For what reason? A trifling error, a single paragraph. Regrettable, admittedly. But irreparable? The advocate of reason was at a loss. He had tried to make the first step toward reconciliation, but Giacometti kept obstinately aloof. So how else could the penitent, puzzled philosopher construe the whole business than as a peculiar failure of understanding on the part of the sculptor? To be in error, after all, was not the same thing as to be in the wrong, was

it? And yet he knew the insidious intents that hide behind accidents. Nonetheless, he blamed the break on Giacometti. He said that Alberto had turned against him. That was the flaw in the edifice of intellect. By getting them all wrong, he had shown how mean are mere facts unless illumined by comprehensive truth. When asked, after Alberto's death, how it was possible that he had situated in the Place d'Italie an event so famous for having occurred elsewhere, he shrugged and said, "Maybe it's because I've always felt a special fondness for the Place d'Italie."

When Sartre was awarded the Nobel Prize in 1964, it was widely assumed that *The Words* had counted for much in the decision of the Swedish Academy. But Sartre would have none of it. He had already announced, as rumors of the impending honor began to swarm, that he would refuse it should it be offered. True to his word, he did.

Alberto had once sought out and enjoyed the company of illustrious, creative men. Now he seemed more at ease with obscure, common people, prostitutes, drifters, anonymous inhabitants of late-night bars. The eminent came and went, but he never gave the impression that they were necessary. Less than a year after his operation, he had completely resumed his previous way of life, keeping irregular, very late hours, sleeping not enough, smoking four packs of cigarettes a day, eating at haphazard times, drinking countless cups of coffee and rather more alcohol-at Caroline's behest—than before. He was exhausted, overwrought, nervous. "I'm so nervous," he used to say, "I could jump up and down." He sometimes did. If fatigue was an access to visionary perception, he had excess of it. Annette complained that he took no proper care of himself, and it was true. Despite incessant quarreling, she wanted him to come and live with her in decent comfort in the rue Mazarine. He angrily refused. She appealed to Diego for help to persuade his stubborn brother, but he brushed aside her suggestion, saying, "Where Alberto lives is his affair." Annette felt more rejected and put upon than ever. Happily she had the sympathetic ear, and the personal sympathy, of the young poet.

André du Bouchet, a year younger than Annette, was the son of a Frenchman and a Russian doctor. His father early went insane and died in an asylum. A reticent, haughty youth, André aspired to be a poet. His idol among contemporary poets of the older generation was René Char, whom he worshipfully cultivated. So his pique must have been considerable when the idol made off with the worshipper's wife. André sought solace in verse but found little, for he believed poetic consummation to be impossible, though he still endeavored to harvest sparse fragments "until within me mute breath itself concurs." A bleak view of creative redemption, it had much in common with Alberto's. Still seeking figures to idolize, du Bouchet became friendly with Giacometti, who was, as usual, responsive to those who wanted him to be so. Alberto did illustrations for a couple of slender volumes of du Bouchet's verse, and encouraged him to help calm, if he could, "the sound and the fury." His efforts to do that were made with feeling, though it seemed to some that the young man's devotion to his idol was the more significant sentiment, while attentions to the lady may have been only a means of confirming his homage. It was reminiscent of the confusion of feelings in the affair of the Japanese professor. Not a pleasing thing for the lady, who grew increasingly prone to fits of hysterical weeping and rage against the hard hearts of artists. André du Bouchet seems to have done little to show that his was soft.

The matriarch of Bregaglia had begun to weaken. Nobody could remember when she had not been there, a living link with a past nearer to the Middle Ages than to the present day. Known to everyone in the valley, respected by all, she had seemed to guarantee the happy duration of things as they were. But then her strength began to fail. She took to her plain, narrow bed. Above it hung the painting of flowers her eldest son had given her for her ninetieth birthday, three years before. The family gathered round. There were moments of vagueness, when she said, "My bed was moved during the night," or, "That door wasn't in the same place yesterday. Where does it lead to?" When told, she would say, "Well, I know that." She asked for the pastor. He

came and read passages from the Gospel according to St. John. That was in the first week of January 1964, and everyone expected her to die then. She herself expected it. But she didn't. She lingered, and the family mournfully waited.

Caring for the bedridden old lady was not easy in a house where there was no modern plumbing. She could be captious and recalcitrant. Almost all of this taxing work fell to Bruno's kindhearted wife, Odette, as it was impossible in the valley to have professional nursing, such needs being still subject to the custom of Annetta's own time. Tending to family death was the duty of the family. Annette, though present, did not volunteer to help care for her dying mother-in-law, and her husband scornfully exclaimed, "You don't know how to do a thing. Aren't you ashamed?" The three sons sat and waited in the living room where they had sat as children. Alberto spent the time drawing.

Very early one morning, Annetta came to herself for a moment, saw her family gathered around her, and exclaimed, "What are you all doing here?" When they didn't answer, she said, "Skeptics!" After that, it was all vagueness and vigil. Intestinal grippe set in, at the age of ninety-three fatal. It was the month of January, the time of year when the valley lay deepest in the shadow. The end came peacefully at six o'clock in the evening of January 25, 1964.

When it was over, Alberto went to his studio. His studio had all his life been his sanctuary and hiding place. So long as his mother lived, he had never been completely alone there. He could not understand, could not condone, could not accept her loss. He called out to her, and the voice in which he called to her was her own, calling himself. "Alberto, come eat!" he cried. "Alberto, come eat! Alberto, come eat!

Hearing his calls, Annette, his wife, went to the studio door and listened. But she did not go in. She hurried back and told the others, fearing that her husband, unhinged by his mother's death, was going insane. She need not have worried. He had never been saner. By calling himself to eat in his mother's voice, he was only summoning reality to give him the nourishment she had provided from the day of his birth.

Annetta was borne in the depths of winter to the tomb where Giovanni had lain waiting for thirty years beneath the stone designed by her favorite son.

Alberto had aged, inwardly and outwardly. Estrangement from two of his oldest friends, the shock of the operation, the loss of the one who had counted for most in his life: it told on him and made a mark. At sixty-two, he was old. He bore it with dignity. His strength of character had become as granitic as the mountains of Bregaglia. He had entered the company of men of genius grown old before their time but who find at the end renewed resources of expression. One thinks of Balzac, dead at fifty-one; of Beethoven, dead at fifty-seven; Rembrandt, dead at sixty-three.

The works of the last years are not always the artist's most attractive. A human appearance stripped to raw essentials does not make for easy looking. The bronzes of Annette and Diego have the same "unfinished" look as the painted portraits of Caroline. This frankly unfinished appearance is both an affirmation of artifice and a refusal to submit to the superficial satisfactions of art. The part played in the paintings by bare canvas is taken in the bronzes by the metallic mass from which heads surge upward. The head is all, and the head is the look, the gaze. The presence of the artist is inside, an explosive energy, galvanizing what appears to be absent so that it, too, has life. The seemingly arbitrary brushstrokes or blobs of bronze pulse with Giacometti's determination to seize what he saw. He pretended to deny the imperative of personality, but his models are immensely present in their own right. They, too, seem to have aged, to have shed the triviality of organic existence.

Dating from those years is an extraordinary series of busts of Annette, all molded from the same clay, nine or ten in all. Grim evocations of distraught femininity, they reveal the phases of frantic estrangement between the artist and his model-wife. How much, or how often, Annette actually posed we do not know. It makes no difference. Her face, like Diego's, had become an aspect of her husband's style, and he did not need material reminders in order to see what he was doing. "A head that has unreal-looking proportions seems more alive than when the pro-

portions *look* real," Alberto said. If Annette appears beside herself, Diego, of whom numerous busts were done at the same time, wears an air of tolerance and resignation.

Among the major undertakings of the final years was one especially close to the artist's heart. It united him with an old friend and with the city that had helped him to become Alberto Giacometti. Paris was a pole of his existence and he wanted to make a monument to it. This was to be a volume of one hundred and fifty original lithographs, printed and published by his friend Tériade, editor of Verve. The title: Paris without End. For Tériade it would also be a milestone, the last great publication he would see through the press. The two men had maintained a close friendship ever since the Surrealist years. Alberto had painted two portraits of the Greek publisher and visited more than once at his villa on the Mediterranean. Tériade had published volumes of lithographs or etchings by almost all the great artists of the time. Giacometti was not one of them, because the urgency of other work always kept him from committing himself to an undertaking that would make its own demands. Urged by Tériade, however, and by time, he finally consented to create a volume if he alone could decide its contents and title. Paris without End appeared posthumously. It stands as a kind of testament: artist, man, and city brought together to witness an act of love.

The one hundred and fifty lithographs are a profoundly interpenetrating view of Giacometti's experience of Paris. He selected the plates to be printed and determined the order of their relationship, numbering each one. The frontispiece shows a nude figure of a woman plunging forward, as though diving into space, and is immediately followed by a quantity of views of city streets, then of interiors familiar to the artist. We come upon views of his studio, of the cafés he frequented, of Annette's apartment in the rue Mazarine and Caroline's in the Avenue du Maine. We see Diego, Caroline, Annette, the girls Chez Adrien, strangers at café tables, passersby, parked automobiles, the towers of Saint-Sulpice, bridges across the Seine, the Eiffel Tower. At the end of the book, four quick sketches openly acknowledge the artist's desire to look on during the most intimate expressions of human feeling. To ac-

company the hundred and fifty plates, a text of twenty pages was planned, but the artist never got further than a few rough drafts. True, he was a devotee of words. Paris without End, however, said too much to the eye to be in need of other symbols.

Now that Alberto was famous, he was often interviewed. He spoke willingly with critics and journalists, though what he said tended to be essentially the same, as such a grand unity embraced his life and work.

"For me," he said, "reality remains exactly as virginal and unexplored as the first time anyone tried to represent it. That is, all representations of it made until now have been only partial. The external world, be it a head or a tree, I don't see it quite as the representation made of it up until today. Partly yes, but there is still something I see that's missing from the paintings or sculptures of the past. This dates from the time when I commenced seeing, for before then I saw as through a screen, through the art of the past, that is, and then little by little I saw beyond that screen and the known became the unknown, the absolute unknown. Then I could marvel at it but at the same time became unable to portray it.

"Art interests me very much, but truth interests me infinitely more. The more I work, the more I see things differently, that is, everything gains in grandeur every day, becomes more and more unknown, more and more beautiful. The closer I come, the grander it is, the more remote it is. For me it would be worthwhile to work even if there were no outcome for others, simply for my own vision, my vision of the external world, of people. But to succeed in portraying that, in portraying a head . . . When I see the face, I don't see the nape of the neck, because it is almost impossible to have any notion of depth from that viewpoint, and when I see the nape of the neck, I forget the face! Sometimes I think I can catch an appearance, then I lose it and so I have to start all over again. That's what makes me hurry onward.

"I believe I progress every day. Oh, I believe that even if it's barely perceptible. And more and more I believe that I progress not merely day by day but absolutely each hour. That's what makes me run faster and faster, that's why I work more than

ever. I am certain to do what I've never done before and what will make obsolete the sculpture I did last night or this very morning. I worked on this sculpture here till eight o'clock this morning, and I'm working on it now. Even if it's nothing at all, for me it is something more than it was and it always will be. It never goes backward, never again will I do what I did last night. It's a long march. So everything becomes a kind of exhilarating frenzy for me. Exactly like the most extraordinary adventure: if I embarked on a ship for unexplored countries and came upon islands and inhabitants more and more unexpected, it would be exactly like what I'm doing now.

"That adventure is really and truly mine. So, whether there is any outcome or not, what difference can it possibly make? Whether in an exhibition there are things that succeed or fail, to me it's all the same. Since for me, in any case, everything fails, I would find it quite natural that nobody should pay the slightest attention. All I ask is to press wildly onward."

"Sound and fury" continued, and grew worse. In her own apartment, with her life all to herself, Annette found that this was not what she wanted either. What she wanted was Alberto as he had been twenty years before: all her own. Before Yanaihara. Before Caroline. And she could never have that.

She went to the studio almost every day. She swept, dusted, washed, made the bed, took clothes to the cleaner, and did such household chores as would have justified the belief that a household existed. She even posed on the rare occasion. People thought it strange that husband and wife stayed together, when common sense would long since have seemed to dictate separation. Alberto said, "A man of feeling will not force a woman from his life, but the woman should know when it is time to go." Annette, for her part, evidently felt less and less inclined to give up what she had, while time showed how little she could call her own. Divorce was discussed, but nothing happened.

The diabolical business of money continually contributed to the conflict. Despite the ever-increasing taxes to be paid, there seemed to be no stemming the tide of cash or preventing the steady increase in value of the works of art that stood about in the dusty studio. All his life, Alberto had tried to evade the responsibility imposed on each member of an organized society by the material factors upon which his sustenance depends. That was one of the things he ran away from. He tried to come to terms with money on the basis of his compulsion to make life a matter of bare survival and find the resources for it in a near-accommodation with failure. In that, at least, he did fail. The money poured in. He hated having the Midas touch, but he couldn't change it. Banks

bothered him, so he hid his money in the studio or bedroom. Bundles of bank notes and bars of gold were secreted where an experienced burglar would have looked first. What nobody could hide was the accumulation, or the fact that increasingly large amounts were being devoted to the enjoyment of someone other than the artist, his brother, or his wife. In this further twist of their marital muddle, Annette found further cause for fury. However, she was concerned about what others might think, and sometimes said, "Will people assume that I'm staying with Alberto only because of the money?" The obvious answer was: "Only you can tell whether or not that is true."

Fame and money came together. If the prospect of being married to a world-famous artist had ever appealed to Annette, the reality didn't. Her husband's fame seemed to take him from her no less than his passion for Caroline. The studio, when Annette appeared there, was likely to be occupied by an admirer, critic, dealer, curator, or collector, to all of whom, as usual, the artist was unfailingly polite. His wife waited in the adjacent bedroom and often had to go away again without having spent an instant alone with her husband. What was it to her that great retrospective exhibitions of Giacometti's work were being planned to take place simultaneously in 1965 at the Tate Gallery in London and at the Museum of Modern Art in New York? She wanted him to come to her apartment, where she could talk to her heart's content about her lampshades. But he had no time. She complained and criticized. She said that he was bloated with pride and thought of nothing but his work, cared for nothing and nobody but his work. He shrugged and said that she was an idiot. Proof of his insane pride and lack of consideration for others, she insisted, was his neglect of his own health. If anything, he was living even more carelessly since the operation than he had before, and it was unforgivable.

"There are many men who have been sick and who do far more than I do," he said.

"Who?" demanded Annette.

"General de Gaulle," Alberto replied.

Annette slept badly. At night she took soporifies to counter-

act the effects of stimulants taken during the daytime. She plugged her ears with little balls of wax. Still, her dreams were often troubled. One night she awoke with the obscure apprehension that an intruder had entered her room. Before her drugged and drowsy eyes, it seemed that someone stood gesticulating in the shadows. To her consternation, it appeared that this shadowy intruder was none other than Caroline. Quickly resorting to the bedside light, Annette saw that it was Caroline.

Squeezing the balls of wax from her ears, Annette demanded to know the meaning of this inexplicable visit. Whereupon Caroline started to harangue her, having come, she said, on Alberto's behalf to show his wife the error of her ways. Aghast at the lunatic temerity of it, Annette asked how in hell Caroline came to be in her bedroom. To which the uninvited visitor airily replied that she had come through the window via the conveniently adjacent roof of a small shed in the courtyard below. A good deal of abusive and spiteful shouting ensued. Eventually Annette managed to get her guest out by the door, return to bed, and wait again for sleep.

The next afternoon, she made violent protest to her husband. Having spent her moral outrage to no avail on the violation of privacy, she finally said that the nocturnal invasion had been not only obnoxious but might have been dangerous. Clambering across the roof of that shed in the faint light from the nearby staircase, Caroline could have fallen and injured herself. To which Alberto wryly replied, "There was no danger. If she had fallen, I'd have caught her."

So he had been a witness to his wife's mortification. The apparition had come at the artist's behest, as his surrogate in the nightmare of a marriage made all the more horrendous by such a mockery. The provocation seemed too unmerciful to bear. It was, and there would be worse. Though Alberto endeavored to be equitable, the pith of his ethics lay in what he made as well as in what he did, and the making required a manner of being in which the maker had no choice but to do or die, and even that semblance of choice, as a matter of fact, was a swindle. "If I go on like this," he said, "I'm sure to croak before long."

Annette had neither the strength nor the imagination to share in the mirth of the gods. The joke seemed to be entirely on her, and she couldn't bear it. She could only blame her husband, who took the blame anyway, though he took no step to transform the strange terrain over which art alone seemed to enjoy dominion. Wifely frustration fueled tantrums, and tantrums, failing of result, led to acts of desperation. One day while at the studio, enraged beyond control by Alberto's composure in the face of connubial recrimination, Annette wrenched from her finger the gold ring symbolizing the bond she had so insistently claimed, and with a handy blunt instrument she furiously pounded the circlet of precious metal till it had become shapeless. If this was a kind of ritual self-destruction, the supposition seems unavoidable that she had found in herself a flair for it.

Thanks to Alberto, Caroline felt freer than air. That was undoubtedly an element of the ensuing trouble. Having begun by freeing her from prison, Alberto had given her the means to live completely free from material cares. Being free was what she had always hoped for, but it was too easy. She and her cronies were slow to figure out the arithmetic of art: that its wealth, being inexhaustible, can pay infinite returns on an investment of next to nothing. When they glimpsed the opportunity, however, their calculation was prompt. Alberto had told Caroline repeatedly that she was godlike, and had always denied that she was a mere prostitute. He knew that goddesses come high, having himself set the price as high as it could go. When she started asking for more money, he paid. She grew more pressing. Money was no longer tribute. It became an exaction, and things began to spoil, because the sums were so large that the secret got out. Alberto was unhappy to be exposed to the sordid inferences of others. Caroline, sure of her "sensation," didn't care.

She professed to be an innocent pawn at the mercy of forces beyond her control. The situation, in any event, was not of her making. Giacometti had put her precisely where she was. But his view of her was never supposed to be subject to the vulgar interference of accident. One day, when a young artist had come to call on Alberto, suddenly the studio door flew open and Caroline came in. Behind her were two nasty-looking men, who stood together scowling in the doorway. "I need money," she said. "Give me all you have."

Giacometti had to dig about in his hiding places to fetch the bundles of bank notes he had on hand, while the caricatures in the doorway glowered and the young artist was unable either to leave or to pretend not to notice. Caroline surveyed the scene with composure, giving no sign of embarrassment. Alberto, on the other hand, was clearly discountenanced. When he put the money into Caroline's hands, she turned on her heel and without a word of thanks left the studio, followed by the attendant figures. Giacometti's discomposure remained apparent. It was the witness who had made the transaction embarrassing, because he had had the opportunity to misconstrue something he could not comprehend. All the world was welcome to see that Alberto made Caroline essential to his art, though few could be expected to understand why. But nobody was meant to see how the transfiguration took place.

If she was a pawn, she was pushed by pawns, and the lengths to which they were ready to go say a lot about their respect for the game, not to mention its rules. One afternoon Alberto came into his studio and to his astonishment found a mess. Statues, stands, and stools were overturned, drawers wrenched open and contents scattered, paintings, drawings lying helterskelter, and books, papers, palettes, brushes every which way. He discovered, however, as he started putting things to rights, that nothing seemed to be missing. Moreover, there was no sign of forced entry. In short, an appearance of vandalism had been created for its own sake. Alberto knew that Caroline had a key, for he had given it to her. And everybody knew that the studio was vulnerable. A schoolboy could have broken into it with a can opener. But this was not the work of children. The implications were so mortifying that Alberto couldn't bring himself to tell his brother what had happened. Diego, of course, found out, and his dismay only confirmed the unhappy sense of things going

so far wrong that nobody saw how they could ever again come right.

Alberto spoke to Clayeux, trusting entirely in his good judgment. Though mortified, the artist was defiant. "Let them break everything!" he exclaimed. "It will save me the trouble, because there's nothing worth saving anyway." If unafraid for himself, he was fearful for his brother, being aware that Caroline detested Diego no less than he her. Clayeux suggested discreet protection. A police patrol could arrange to pass at irregular intervals and look in to make sure everything was all right. Alberto would have none of it. He was too proud. Besides, he knew that his brother would have been incensed by the implication that he had anything to fear from the likes of Caroline.

Alberto would not condemn her. He could hardly have done so without condemning himself. He went on praising her, blaming Annette, and contemplating the predicament into which his destiny had led him to stumble. It was a fact that Caroline was dangerous. It was also a fabrication. Both of them knew both of her faces, and the knowledge can only have added to the art with which they sustained their appreciation of one another.

Caroline was not the only girl in Alberto's life, though she occupied the principal place. A number of others ran after him. Their exertions didn't get them far or on the whole to happy endings, but Alberto did not discourage the efforts.

A Swiss girl, an aspiring sculptress, appeared uninvited at the studio and solicited special attention with such insistence that she slept night after night on the ground outside Alberto's door. She followed him to Stampa, took a room at the Piz Duan, and when his response to her presence seemed inadequately demonstrative, created a variety of scenes which culminated in her breaking open the linen closet of the inn and heaving its entire contents outside onto the roadway. Home in Geneva, she was later committed to a mental hospital, whereupon her mother wrote Giacometti reproachful letters, saying that he had incurred a moral obligation and must allow the girl to come to Paris and work with him.

A beautiful ballerina from Berlin met Alberto at a party in Zurich. She told him that she kept by her bedside a photograph of him clipped from a magazine. Alberto said, "Is the reality all right?" They had a romance that lasted twenty-four hours, walking about in the old town of Zurich hand in hand for half a day in the rain. But the bedside talisman did not bring lasting light into her life, for less than a year later, in a fit of depression, she leapt to her death from the flies above the stage of the Hamburg Opera House.

Others were less unhappy, and Alberto was glad to repay their interest. His gladness may have been enhanced by the fact that attention paid to his attainment—he was no fool when it came to distinguishing between himself and his success—had the added advantage of testing Caroline's mettle. Having himself been tested to an extreme, he was willing to let her do some proving of herself. In the end, she was very possessive in her own devious way, allowing the artist to see that he held her fast because his hold was essential to her belief in herself. She was satisfied to have it so and only wanted it more and more so. She wanted to possess him and be possessed by him more than any other woman. She was feminine enough to hope for that.

She wanted to bear his child. He explained that nature had made paternity impossible. She reacted with characteristic disregard for law and insisted that a means must be found. They consulted a doctor, who said that some sort of operation might be attempted. That was pure quackery, of course. Nothing came of it but Alberto's securer certainty that Caroline was bound to him by means infinitely superior to the physical.

Among the drifters on the shady tide of Montparnasse night life was the photographer Elie Lotar. The decades had not done well by him, nor had he done much to take advantage of passing time. Because he was companionable and talented, however, people tried to help. Tériade offered him work. Cartier-Bresson gave him a camera and use of a darkroom. It was no good. He didn't want work. He pawned the camera and spent the money on liquor and girls. All he wanted was to waste his life in the bar of the Dôme, or Chez Adrien. There he found his old crony Alberto.

Quick to turn coincidence to advantage, Lotar got Alberto to give him money. Nothing could have been more providential. since the artist didn't know how to get rid of it. Lotar easily and lazily fell into the habit of coming to the studio, where he put on a vague show of making himself useful. He ran occasional errands, buying cigarettes and newspapers or bringing supplies from the art shop. Above all, he told tales of everything that had gone on either before or after Alberto's arrival or departure from the places he had visited the previous night with Caroline. Lotar and Caroline were well acquainted. If her world was not his, he had sunk nearly to it. He was able to tell Alberto what she did, where she went, with whom, when, and, perhaps, for how much. He became a go-between, a fixture, a familiar spirit who presided over the nocturnal ceremony of their affair. He was often present while Caroline sat for the artist. Later he would accompany them to the usual haunts.

Lotar's presence having gradually become inevitable, Giacometti saw that it could also be made invaluable by transforming the hanger-on into a model. As Lotar shared in the life of the studio, his likeness became an embodiment of its last and greatest hours. The indigent photographer and alcoholic drifter, the misbegotten son of a great poet from a foreign land, saved himself from nonentity by giving his sad gaze to Giacometti's final masterpieces.

Alberto was kind to old friends. Now that he was famous, fellow classmates from the Grande-Chaumière sometimes turned up, wanting a little favor or vicarious tastes of achievement. None went away disappointed. Except Flora Mayo, perhaps. In her foolish Chekhovian way, Flora had come back to Paris after thirty years of drudgery and disappointment in America, hoping again to find a "new" life. She found mainly that everything cost more than she could afford and that the only novelty she could be sure of was a lonely and impoverished old age. She wrote to Alberto. He called her. She came to the studio. It had not changed. But they had. He gave her a copy of a book recently published by the Galerie Maeght containing many photographs of his works, with

a long, laudatory text, and inscribed it for her. He invited her to dinner. The feast of reminiscence turned out to be paltry. By trying to be kind, Alberto only made fate a little more cruel. He had suffered for her long ago, and now she was a poor old woman to whom he could offer only the proof that *bis* life had not been for nothing. They did not see each other again, and Flora before long went back to California, where she ended her days in demented solitude.

Aimé Maeght had gone on building his museum. Set amid dramatic terraces, lawns, and groves of pines, it was spacious and imposing. The dealer decided that the central courtyard of the Maeght Foundation, immediately facing the main entrance, should be given over entirely and permanently to a group of sculptures by Giacometti, selected and set in place by the artist himself, while a large interior gallery would show drawings, paintings, and sculptures from all periods of his career. Whatever Alberto may have thought of Maeght's motives, he was not indifferent to the opportunity for viewing an important group of his works under conditions close to ideal. He went gladly to Saint-Paul and selected the positions in the courtyard for several of the large figures created for the Chase Manhattan project as well as a little crowd of Women of Venice. Throughout the grounds were sculptures by Calder, Miró, and Arp. Braque and Chagall designed mosaics for pools and walls. The galleries were filled with works by Matisse, Bonnard, Kandinsky, etc.

If Aimé had set out to be a modern Medici, he had taken an impressive step in that direction as the inaugural day for the Foundation approached. Visitors arrived from all over France, and from many countries abroad, to honor the dealer and his philanthropy.

Alberto had come from Stampa to supervise—with Diego's help, of course—the final installation of his "things." Annette joined him. Caroline kept out of sight, but the wife's humor was no better for it. And while they waited for the great event, a message reached Giacometti from a former friend, old but unforgotten, who had no part in the present festivities and wished

for none, keeping a disdainful distance from the mise-en-scène of all glory save his own.

Picasso sent word that he would be glad to receive a visit from Alberto, and the message sounded more like a plea than the taunting "invitation" of a dozen years before. Aged and alone, the perverse potentate had become the prisoner of abuses of his own power. The line at the "box office" was endless now, but few of those waiting interested the famous conjurer. In a tortuous way, his life and work had come full circle. At the beginning of his career, he had liked to depict and frequent circus folk, equilibrists and harlequins, and now his works once more abounded in circus imagery, while the world press was filled with photographs of the eighty-year-old artist in extravagant disguises, wearing masks, playing the clown. His private life had, in fact, become a public circus, described in detail in a recent volume of memoirs by a former mistress, mother of two of his children, a publication Picasso had attempted to suppress by lawsuit. An artist who goes to court in an effort to uphold his good name must have sunk fairly low in self-esteem.

Throughout his career, Picasso had returned continually to the theme of artist and model, but whereas once he had portrayed the creator as a serene Olympian figure, now he was shown to be grotesque and misshapen, a creature of ridicule and scorn. The vengeance of fate was the acuteness of Picasso's intelligence, which enabled him to see that he had failed to create his salvation. But that awareness brought to the capers and grimaces of the frantic old acrobat such little dignity as they had. It must have been a bitter perspective in which he considered his own carryingson, having long ago observed: "It's not what the artist does that counts but what he is!"

What Giacometti was, Picasso knew. He had never ceased observing with respect, and with secret envy, perhaps, how Giacometti showed what he was. For his part, Giacometti never regarded Picasso with indifference. "He amazes me," Alberto said. "He amazes me as a monster would, and I think he knows as well as we do that he's a monster." But it was far too late in the afternoon for the recollection of sincere esteem to do any good. Con-

cerned to be kind, Alberto hesitated. Though he cannot have failed to understand the cruel irony of Picasso's solitude, he had too keen a sense of honor to be swayed by pity. He sent word that he could not make the visit, and he never saw Picasso again.

The great night of the inauguration fell upon a Tuesday, July 28, 1964. The sky was clear and fragrant, agleam with stars. A hundred and fifty guests had gathered for a sumptuous banquet. The chief dignitary was André Malraux, Minister of State for Cultural Affairs. When much expensive food and wine had been consumed by all the guests, the host stood up to make a speech. a formal statement of his munificence, adding thanks to all the artists, friends, associates, and employees who had contributed their talent, goodwill, time, and energy to the successful outcome of this extraordinary undertaking. He named them one after another, and throughout the crowd there was a sense of merit recognized and repaid. But then it seemed that the philanthropist had neglected to mention one name. And it seemed odd, for the man unmentioned was the one who had been nearly as instrumental as Maeght himself in engineering the dealer's triumph: Louis Clayeux. A number of people noticed the omission, and some of them thought it impolite, but nobody noticed it with a more stinging sense of indignity than Clayeux himself.

Maeght having concluded his address, Malraux got up and launched into one of those grand cultural orations that were his forte. Thanking the donors for a benefaction which he described as without parallel in modern times, he went on to situate the occasion in a perspective including the art of prehistoric man, of the pharaohs, of Byzantium and the court of the Sun King, while admonishing his listeners to be mindful that the form of human activity we call art proceeds from a realm which always has been, and always must be, the dominion of the supernatural. Such a concept was made to order to appeal to Giacometti, who murmured, "He talks like a bull."

Clayeux felt that a wanton and unwarranted humiliation had been inflicted upon him by the man whose climb to glory he had worked so lovingly and hard to facilitate. Seeking out his employer, he angrily complained of the insulting omission. Maeght shrugged and said it was a regrettable oversight, nothing more, no offense meant. Clayeux was not a man to be content with regrettable oversights. Further infuriated by this nonchalance, he voiced outrage to his friends. It is true that he had never favored the Foundation, and so may have been imprudent to expect thanks for its creation. But the Foundation's existence owed everything to the gallery, which in turn owed a very great deal to Louis Clayeux. And if proper expressions of appreciation were not forthcoming at the moment of triumph, why should the maker of triumph continue his good offices?

The following day, Alberto and Annette went to Cap-Ferrat to the luxurious villa of Pierre and Patricia Matisse. Much discussion of the previous evening took place. Alberto was categorical. "If Clayeux leaves," he said, "I leave." Pierre's disdain for the parvenu of Saint-Paul was nobody's secret. Annette urged her husband to leave Maeght. She had heard the dealer bragging to visitors that he had "made" Giacometti. A great lot of talking went on into very late hours, and not all of it had to do with Aimé Maeght. Annette's nerves also claimed consideration. Shrieks of wifely discontent disturbed the sweet quiet of seaside gardens.

Clayeux, in the meantime, went off to Greece. Alberto said he was going back to Stampa. The Matisses prepared to leave for a cruise on their yacht. Annette asked to remain behind alone, saying that a solitary stay in the sun would help restore her nerves. Pierre put a polite face onto the fait accompli, weighed anchor, and sailed off with his own irascible wife. Alberto got on the train and went to Stampa.

Swaddled in the luxury of the Villa La Punta, Annette found herself quite quickly restored to excellent humor. Besides, she was alone only insofar as she cared to be. Close by lived someone who could be counted on to provide comforting attentions if necessary. This person's name was Frank Perls, an art dealer from Hollywood, on vacation at a hotel almost next door to the Matisse villa. A longtime friend and confidant of Patricia and Pierre, he had agreed to look in occasionally on Madame Giacometti to see whether her nerves and their villa were all right. Frank was a hefty but easy-

going man of the world. Having been through three marital misadventures, he was well prepared to look in on the wistful wife of the famous sculptor. During the day he could see her skimming across the bay in Patricia's Chris-Craft. He began to look in on her more often, finding that he was himself a bit lonely. The more he looked in on her, the more he felt inclined, and invited, to pay attention to her. And that was all in the world Annette wanted: someone to pay attention to her, listen to her, offer her the sympathy that artists had neither time nor talent for. Here was Frank Perls, avuncular, worldly-wise, willing to listen.

It was like the movies: thrown together alone, a lonely man and a lonely woman discover that they may find in each other's company a little consolation for the world's indifference to their solitude. To be sure, Frank's home base was far from Montparnasse, though business brought him regularly to Europe and he maintained a small apartment in Paris. Besides, a little absence might have the famed effect. When Annette came back from the Riviera, her nerves had not seemed so effectively soothed for years, while Frank returned to Hollywood in a mood that might have been manufactured there.

Clayeux made up his mind while in Greece. He was finished with Maeght and "his" gallery. If it turned out as a side effect that the gallery should be finished, too, then so much the better. If any colleagues and friends whose careers he had helped make wanted to follow his lead, they would be welcome. Solidarity, in a word, seems to have been the rule he expected to prevail. It didn't. Probity may have been Clayeux's province, but Maeght was master of the marketplace. That was the realm into which the artists of the gallery had thrown their lot. All but one. Alberto had said that he would go if Louis went. Louis went. Alberto followed.

He wrote a long letter to Maeght, announcing his decision. Diego at this moment was in Zurich, where he had contracted to embellish the bar of the city's finest restaurant. Alberto consulted him on the telephone about the letter. Ever circumspect and practical, the younger brother said, "I'll be back in Paris tomorrow.

Wait till I get back before sending your letter, so we can talk it over." Returning the next day, he went straight to Alberto's room. His brother smiled sheepishly and said, "I've sent the letter. I knew that if I talked it over with you I'd never send it."

Aimé and Guiguite were thunderstruck. It seemed a preposterous tempest in a totally unrealistic teapot. Guiguite wept. Aimé tried to reason. Subordinates were sent to implore, to lament. It did no good. Alberto was adamant. He had said he would leave the Galerie Maeght, and he did. The rest was noise and annoyance.

The point of principle upon which Giacometti staked a position of consequence is intriguing. It draws attention to the possibility that something more important than itself stood beyond it or beneath it. Maeght had never in any sense been a friend as Fraenkel and Sartre were. The significant break was with the gallery, not with its proprietor, who was important only as a personality, not a real person. The gallery represented the artist's relations with the world at large and had played a vital part in Giacometti's career. To break with the gallery was not only to deny the continuing relevance of this part but to suggest that, vital as it may have been, its good was done.

Pierre Matisse need never have worried that the upstart of the rue de Téhéran might outstrip him. He had had Alberto first and would have him to the last. But the sculptor had never set foot in Pierre's gallery and knew him only from a great distance as a maker of careers and money. Maeght, however, he had known firsthand as a callous manipulator of the marketplace and it was from this knowledge that he was determined to break away. He had nothing to lose but a lot of excess cash and the intrusions of fame, which he would be happy to put behind him in order to get on with his work untroubled.

The determination to be untroubled while getting on with his work suggests a new urgency, an uncertainty, perhaps, as to just how much work he would have time left to get on with. In that context, rather than in the perspective of friendship, it may be more accurate to situate the break with Maeght. Even the fraternal appeal for prudence had gone unheeded, and Alberto did not lightly disregard Diego's advice. As for Clayeux, he seemed happy in retirement, devoting himself to scholarly research and the collecting of rare manuscripts.

In the autumn and early winter of 1964, Alberto did a bit of traveling. He went first to London to view the rooms at the Tate Gallery in which a large retrospective exhibition of his work was to take place the following summer, simultaneous with the one being prepared in New York by the Museum of Modern Art. He saw Isabel, Francis Bacon, and was entertained by wealthy collectors. Early in November, he went to Stampa, arriving just as the shadow came over the valley. The essential presence was no longer there in person, but her memory prevailed. In mid-December, he returned to the cantonal hospital in Chur for his annual examination. No recurrence of cancer was found. The bill of health rendered, however, was not impeccable. Dr. Reto Ratti was still at Chur. He thought Alberto looked terrible and said so, an observation never received with goodwill by the artist. He needed nobody to tell him that his health was bad. For years he had kept track of its deterioration. He knew perfectly well that he lived on the far frontier of fatigue, and beyond it. He smoked eighty cigarettes a day. He drank countless cups of coffee and more alcohol than anybody should. How it would all end, he willingly, one could almost say eagerly, prophesied.

In anticipation of the inevitable, it is not unnatural to expect that a man who possesses much, especially one who has himself created all that he possesses, shall make some provision for the disposition of his belongings when he can no longer see to their destiny. In short, a will. Alberto did not lack for people who told him that the time had come to put his affairs in order. Nor can he have doubted that he was in a position to appraise the deserts, whether just or unjust, of all those to whose future the past placed him under obligation. But he would not make a will. He dismissed any reference to the matter and would not hear well-meaning reminders. It is true that both his parents had died intestate and that division of their property had been made with-

out discord. His own situation was very different. He had a wife, a brother, another brother, a nephew, and a mistress, all of whom could legitimately presume to haxe "expectations."

After Alberto's death, his property, and above all the "moral" authority to control it, would pass almost entirely to his widow, leaving a measly eighteen percent to be divided between the two brothers and the nephew. Alberto knew that artists' widows are famous for making themselves difficult. He also knew his wife. To a friend who maintained that she was at heart generous and forgiving, that even for Caroline she would "later" let bygones be bygones, Alberto replied, "You don't know her. She'd do just the reverse." It was to Annette nonetheless that he allowed the proprietorship and prestige and power represented by his lifework to pass. Diego, whose assistance had contributed to that work a portion beyond imaginable estimate, inherited mainly memories.

If Alberto pondered the matter, he may have weighed in their respective situations the remorse as well as the responsibility he felt toward each, for he recognized the destruction caused in both cases by an irrepressible will to create. He would have realized that Diego was not a Giacometti in name only, and that his spirit would prove as durable and noble as the bronze in which his effigy had so often been cast. He would need no authority, prestige, or property other than his own in order to make his survival a great achievement. Not so Annette. Having been obliged by circumstances to give up more of herself than she possessed, she would need to get back the most she could in order to survive at all. If she had threatened to do away with herself in order to become Madame Giacometti, after Alberto's death she would need all the powers of an artist's widow, however outrageous or vindictive, in order to lay claim to having lived for something worth living for. Being Madame Giacometti while Alberto was alive had been hard. Survival as Madame Giacometti after his death would be even more difficult if she lacked a widow's material and moral resources. They would give her another great opportunity, a last chance to prove that Annette Arm had had a right to stake her life on marriage to Alberto Giacometti. In view of all he had asked of her, he could not deny her that.

Whatever he may have felt or foreseen as regards the final disposition of his "things," one certainty prevailed. They would survive. Fraternal mortification would not. His widow's right would not. The world's indiscreet interest in the matter would pass away, leaving only his work to get on with its rightful business.

As for Caroline and her future, assuming the artist considered it, the future was entirely in the present. Alberto as a dead artist would be no more difficult for her to live with than he was to talk to as she sat before him every night on the rickety rattan chair. She had had her sensation, and had provided greatly for his. To win or lose the material inheritance would not matter. She had given of herself; repayment was immaterial, though she took care at the same time to make it as whopping as possible.

Elie Lotar had no expectations, nothing to look forward to, and very little to look back upon. What stared him in the face was the sober evidence of failure. It did not intimidate him. He returned the stare with unblinking, though alcoholic, fixity. For breakfast he took a Scotch and Coca-Cola, then prepared with a serious sense of futility to wait for evening. His father lived on in Rumania, aged eighty-five, confirming by his long-lived fame the lamentable lack of filial achievement. But Lotar did not whine, Failure having become his lot, he made it the condition of his integrity. This attitude was one that Giacometti could admire. He could see in it aspects of human experience which he had been looking at all his life. Lotar came as close to being the ideal model for Giacometti's final sculptures as any man could. Alberto came even closer to being the ideal artist to portray him. Their mutual fitness lifted the task and its results almost above the realm of the feasible, demonstrating once again that art provides what art requires, leaving nothing to the rude contingency of accident.

Giacometti made three busts of Lotar. The first two were begun sometime late in 1963 or during the first months of 1964. They were worked on simultaneously day after day for close to a year, the clay kept malleable by wet rags during occasional interruptions. The first shows the model's head and torso, with a very approximate indication of arms, whereas the second shows the

head only and a suggestion of shoulders. The two busts are similar in appearance and feeling. A viewer can sense that they were worked on interchangeably, for it is the same visage, the same look brought to life in both works. The expression is serious, grave, intent; it is also serene and forward-looking. These portraits are set before us with an emphatic starkness of sentiment but grandeur of feeling. They have a heroic air, though it be the air of heroism needed to look futility in the face and still see promise in the stars. They have the fullness, the roundness, the repleteness of credible characters, a bit of Leporello, a bit of Sancho Panza, and a bit of Lotar. As sculptural objects they embody a further gauge of the artist's progress, a step forward, because his effort has plainly taken the direction of showing what is known as well as what is seen. Stylistic effect is subordinate to representation of the human head as an embodiment of real existence. Having traveled by the most sophisticated itinerary imaginable, Giacometti had come to grips with a representational imperative like the one he confronted when he made the first bust of his brother Diego at the age of thirteen, different now by virtue of being on the other side of life, thus invested with the entirety of its mystic inherence. Portraiture had become a ritual act, of which the outcome obviously was a symbol of what had gone into it: a passion for making things that embodied the value of being human.

The third, last bust of Lotar stands in a realm apart. The model is shown in somewhat the same position as in the first portrait, the indication of arms, even of hands, however, more fully developed, also the buttocks and upper legs, upon which the hands rest. All similarity ends there. The feeling is utterly different. This is a final affirmation. Its finality emanates solely from itself, not from our awareness that this work was the artist's last. It is a terminal statement, and as such reduces the contrivance of words to ineffectual fumbling. Whereas the first two portraits were serene and forward-looking, this one is somber and inward. All vision, all awareness seems turned in upon itself. The eyes, the cheeks, the mouth are sunken. It is the face of a man grown ageless in the extremity of old age. To the meaning of the ultimate, this image brings inexpressible tolerance and resignation. And an infinite

capacity for endurance, because there it stands. Final, yet it is not finished. It is finished neither as a portrait nor as a symbol. Its survival proclaims in supremely Giacomettian terms that as a work of art it is unfinished and represents the unfinishable essence toward which men strive as redemption from the temporal and as atonement for the impertinence of their effort.

All his life Giacometti had labored to make a sculptural object equivalent to a living experience, aware that it could not be done. In this final effort, as if to demonstrate that it had all been worthwhile, he created a new beginning, a beginning that had its entire significance in finality. Contemplating the last bust of Lotar, the mind's eve irresistibly summons the image of another final work of sculpture, the Rondanini Pietà, upon which Michelangelo was still hammering a few days before his death at age eighty-nine. Neither in purpose nor in appearance are the two works comparable, but both generate similar feelings of finality, of the impossibility of coming to terms with a work of art as a manifestation of human effort. Both works were turned inward upon themselves. The Pietà illustrates the embrace of death. The bust of Lotar exemplifies it. Both offer access to purely visionary experience. Speaking of the Pietà, Giacometti said: "When Michelangelo fashioned his last statue, the Rondanini Pietà, it was a new beginning. Had he worked on a thousand years longer, making Pietà after Pietà, he would never have repeated himself, never fallen backwards, but always swept further ahead." The same should be said of the speaker. Separated by four centuries, both men seem to assert that, having done so much and come to this, the artist had nothing left to do but die, bequeathing to the history of mankind his final vision.

The very best that Switzerland could do for an artist came in Giacometti's case during the summer of 1963, when Ernst Beyeler exhibited at his gallery in Basel the former collection of G. David Thompson. The opportunity was for Switzerland's best to be done by means of what it did best: amassing money, in order to keep this unique collection intact in the artist's homeland forever. The other great Swiss artist of the century, Paul Klee, was already represented on home ground by the Klee Foundation in Bern. The creation of a Giacometti Foundation in Zurich, to be subsidized by public and private contribution, looked like a logical, creditable undertaking. The collection included fifty-nine sculptures, seven paintings, and twenty-one drawings. Its price: three million Swiss francs, or \$700,000 of that time. Reasonable then, today an incomparable bargain.

Alberto himself, of course, kept aloof from the whole business, which was as well, because some protest and fuss arose over the money-raising. It was all rather ridiculous, and, for a country with so limited a cultural heritage to nurture, most unbecoming. But the Alberto Giacometti Foundation did come into existence, so Thompson's effrontery was not for nothing, after all. The works are divided among Zurich, Basel, and Winterthur. Before his death, Alberto donated two sculptures, nine paintings, and seven drawings.

Like the London exhibition of 1955, the retrospective presented in that city exactly a decade later was sponsored by the Arts Council of Great Britain. Though not quite so extensive as the recent show in Zurich, it also took place in one of the world's great museums, the Tate Gallery. Thus, Giacometti could once more consider his achievements in relation to those of great predecessors

and contemporaries. The works shown began with the first bust of Diego and included one of the most recent of Lotar, ninety-five sculptures in all, sixty paintings, and forty-five drawings. The effect was conclusive. To those with any pretense of understanding contemporary culture it was evident that Giacometti had created a body of work profoundly and broadly representative of his era. It was difficult, austere, and sometimes forbidding work, but none could deny the power of its presence, nor the often tender and lyrical beauty of its invention.

Alberto went to London well before the inaugural date in order to supervise in person, with Diego's help, the installation. He improvised in the basement of the museum a makeshift studio where he could touch up plasters or paint bronzes at the last minute. Pierre and Patricia Matisse came along to celebrate and help, also Clayeux and a number of other friends from Paris, while already on hand in London were Isabel, Bacon, and other enthusiastic admirers. It was very jolly and convivial and there was a lot of exhilarating conversation in the back room of Wheeler's Restaurant in Old Compton Street. The Giacomettis were lodged at a hotel near Victoria Station named St. Ermin's.

It was at St. Ermin's Hotel one day, unannounced, uninvited, and unexpected, that Caroline suddenly showed up in the corridor outside Alberto's room. How she had come there, and for what reason, nobody knew. Alberto was not the only one to see her, unfortunately. It seemed obvious to Diego that his brother was taken aback, almost alarmed, by her abrupt appearance. They went together into his room and remained alone there for some time. Then Caroline disappeared, returning whence she had come without having gone near the Tate Gallery, where eight magnificent portraits testified to the artist's admiration. He was clearly embarrassed by her visit. Its reason remained undisclosed, but his embarrassment implied that the violation of their compact had begun, if not to dismay him, to undermine the basis upon which it had for so long rested secure. Still, he accepted whatever he had to, because acceptance was the rule of his relationship with Caroline.

The inauguration in London was a triumph. Undoubtedly, the artist had a good sense of satisfaction from it. No sooner was

it over, though, than he returned to Paris and thence to Stampa. But before the end of August he was back again in London to look at the exhibition a last time, considering each work with pensive concentration. For a man who had never had a moment to spare for travel except between Paris and his birthplace, it seemed that Alberto was suddenly spurred to voyage afar.

In New York, the retrospective at the Museum of Modern Art was in every way comparable to its British twin. One hundred and forty sculptures, paintings, drawings representative of every step of the artist's progress had been assembled. Nobody had expected Giacometti to cross the ocean simply to see the exhibition, so surprise was considerable when he announced in midsummer that he would arrive sometime early in October. As he refused ever to go up in an airplane, he would travel by ship. Annette was to come with him, and he optimistically foresaw the sojourn at sea as an opportunity to compose differences and try to reach some kind of tolerable modus vivendi. Pierre Matisse made the arrangements. He and Patricia would accompany Alberto and Annette on the outward voyage, aboard the Queen Elizabeth, arriving in New York on October 6, while the artist and his wife would sail homeward alone together eight days later on the France.

Annette assumed that Alberto had brought her along only because he felt that Caroline was not presentable. In this she was mistaken, for Caroline, in Alberto's view, was never meant to be "presentable." She was all she had to be by being as she was. After her appearance at St. Ermin's Hotel, it is possible that what she was began to seem a little too much. It was very nearly beside the point by that time, anyway. Annette, with the threatening model out of reach, began to feel more agreeably herself. Besides, in the United States the attentions of Frank Perls would be at hand. While there, she behaved on the whole like the good-natured Annette of gladder days. Alberto, on the contrary, having set foot upon the farthest shore he had ever seen or could very well have looked forward to, appeared profoundly changed. In New York, though present, recognizable, unmistakable, he seemed other and elsewhere. Nobody knew that three months later he would be dead.

New York was the place where Giacometti's genius had first been recognized. American critics, curators, and collectors had been well ahead of Europeans in appreciating his originality. He cannot have failed to be mindful of this when he stepped off the ship in Manhattan, but he never appeared impressed by it. At the Museum of Modern Art, the director and curators greeted him with respect but also with a sort of bemused awe. A reception was given at the museum in his honor, the invited guests being principally eminent American artists-Rothko, de Kooning. Motherwell, and Rauschenberg were among those present-and all of them approached Giacometti with the same sort of awe. none appearing to sense that what he represented was the last vestige of a tradition which they had thought to repudiate and that his presence in a museum dedicated to their achievements represented ipso facto a repudiation of the ground upon which they presumed to stand.

As for his own exhibition, Alberto visited it twice with care. It had been a great success, admired by crowds and praised by the critics. However, the exhibition did not appear to excite him, only to rouse his curiosity, as though he were studying objects brought into existence by a dream. A waking dream, in fact, was principally what the New York visit appeared to be. He went to the great museums but hurried through them, hardly glancing at the assembled masterpieces. "I'm on bad terms with Rembrandt for the moment," he murmured, and he acted like a man in a frantic race against the hour of closing. He said, "I'm done with museums."

The only thing that seemed to excite him was the Chase Manhattan Bank Plaza, where as yet no sculpture had been selected to stand before the sheer precipice of the skyscraper. He was gripped by the possibility that he might still manage to produce something capable of holding its own before that overwhelming façade. He visited the plaza several times, both by daylight and after dark, striding back and forth, gazing up and down to appraise the site. As soon as he got back to Paris, he said, he would make a large figure, larger than any he had ever made

before, and maybe it would do. As soon as he returned, it's true, he asked Diego to weld an extraordinarily tall armature. But the sculpture that might have grown around it remained in his mind. It was too much for him, and the assumption seems reasonable that it would also have been too much for us.

After a week the hostesses, artists, and intellectuals of New York had gotten as much from Giacometti as he could give. Looking, if possible, a little grayer and more haggard than eight days before, Alberto took his suitcase and Annette aboard the France for the voyage home. He had always been intimidated by large bodies of water, had never learned to swim, and was not keen about getting into a bathtub. During the outward voyage he had been distracted and entertained by the Matisses, but on the return, alone with Annette, he saw the ocean as it was, and he was afraid. It is only in modern times that man has ceased to look upon the sea as an enemy and to fear it. But Alberto had sources of feeling that came intact from antiquity. Having been asked before leaving Paris to write introductory notes for a volume of reproductions of his copies, of which the first had been Dürer's Knight, Death, and the Devil, he sat down in mid-ocean to try. The wanted words wouldn't come. As usual, he could express only what he saw.

"I have hardly looked at the ocean since the moment, two days ago, when I saw the distant point of New York dissolve, disappear—delicate, fragile, and ephemeral—on the horizon, and it was as though I were witnessing the beginning and end of the world. My chest is tight with anguish. I can only feel the sea around me, but there is also the dome, the immense vault of a human head.

"Impossible to concentrate on anything, the ocean encroaches upon it all, it has no name for me, although today it is called the Atlantic. For millions of years it had no name and one day it will again be without name, without end, blind, wild, as it appears to me today. How can one talk here about copies of works of art, frail and ephemeral works of art that exist here and there on continents, works of art that decay, disintegrate, that wither away day after day, and many of which—among them those that I

prefer—have already once been buried, hidden beneath sand, earth, and stones? And they all follow the same path."

Hardly had Giacometti returned to Paris from the longest voyage of his life than he set out for another distant destination. This time it was Copenhagen. A considerable portion of the exhibition from the Tate Gallery had been reassembled in a handsome new museum twenty miles north of that city. In three months Giacometti had made three lengthy journeys to look at large exhibitions of his work. He had never been a haunter of his own shows or a runner after opportunities to take stock of relative achievements. Now he had gone to great lengths to see, and-precisely in the perspective of great distances traversed—to consider his accumulated accomplishments, to look at them all with eyes made keen by the unfamiliarity of surroundings, by travels undertaken, and by his awareness of what had gone into their creation. He was looking at the work of a lifetime, looking at it in the full knowledge that it had required a lifetime and in the consciousness of what a lifetime it had required. He was looking at it for the last time, and one can hardly avoid the surmise that his look took in everything it had to and saw that this was enough.

Sound and fury promptly resumed in Paris when Alberto's life there resumed as before. Caroline sat in the studio on the rattan chair, waiting to be portrayed and paid. The question of money was like a gangrene. It began to poison the atmosphere. Annette was not for nothing a daughter of Calvinist Switzerland. To her, the loss of cash was a loss of grace. She shouted and swore. She said it was outright blackmail. Nor was Caroline the only cause for fury. There was Lotar, too. Bundles of bank notes regularly went his way as well. Alberto paid for his lodging, his clothes, his food, and even, which God knew was too much, for his drink. Annette claimed it was outrageous. Alberto said, "How many sculptures have I made of Lotar? How many drawings? What would one sculpture be worth? One drawing?" He made a column of figures on a scrap of paper, adding up the total. "You see what it comes to. What I've been able to do thanks to Lotar is worth a hundred times more than I've ever given him. In the end, it's I who am exploiting him, not the other way round. I'm exploiting him unmercifully."

The work of the last months, the last weeks, was devoted to the final bust of Lotar and one or two painted portraits of Caroline. The paintings are not charged with the same sense of finality as the bust, nor do they claim to the same extent such eminence in the history of human feeling. Still, their power is incomparable. They, too, bear witness to an unflinching struggle with visual experience. Difficult to meet, their gaze is impossible to fathom. It shows, however, that Giacometti, not Caroline, was the one who had everything to gain. Sometime in October or early November he scribbled on the cover of a magazine one of his innumerable memos to himself. By the morrow, he said, he wanted definitive confirmation: sculpture painting drawing everything . . . But everything was done already. The confirmation lay in the future, of course, as it had to, but what was definitive was the past.

So it was also for Alberto's friend, the poet Olivier Larronde. He had become a pathetic travesty. Bloated and unkempt, looking like a drunken tramp, he wandered the Boulevard Saint-Germain at two o'clock in the afternoon, muttering incoherently under his breath. It seemed a blessing on All Saints' Day of 1965 when he was found dead in the rue de Lille apartment, aged thirty-eight.

That was Jean-Pierre's opportunity to show that he, too, had poetic inspiration. Aware that the idol of his dead friend had been Stéphane Mallarmé, he also recalled that the Symbolist poet's grave was in the cemetery of a small village near Fontainebleau, and he seemed to remember that the adjacent plot was vacant. It was, and Jean-Pierre bought it for Olivier. "The greatest bargain of my lifetime." he said.

Few mourners were present in the quiet cemetery on the banks of the Seine when Larronde was carried there, but Alberto and Annette were among them. The service at graveside was brief. When it was over, the coffin lowered, those present walked down the gentle slope toward the gate. As they came to it, however, suddenly Alberto turned back and walked up across the gravel to the brink of the grave. He stood there for a time, gazing down,

alone, pensive, nodding his head ever so slightly, as the gravediggers started shoveling earth onto the coffin. It was only a minute or two. Then he turned away to rejoin the others. He said nothing, and they all got into the waiting cars to drive back to Paris.

That autumn was exceptionally busy, bringing after the fatigue of those long voyages a lot of the inconvenient obligations of fame. A pair of conscientious Swiss filmmakers, for example, had undertaken a documentary film in color, providing a living, speaking, working record of the artist going about his daily tasks. Alberto felt compelled to cooperate. That was a happy thing, because the film brings sound, motion, and sight to a legendary figure, making him almost believable for a moment even to those who imagined that they knew him. In mid-November, Giacometti was awarded the Grand Prize for Art by the French government. The French national museums had finally gotten around to acquiring a bit of his work for their collections. On top of French honors and attentions, there came another from Switzerland. The sculptor had been approached the previous summer by his friend Eberhard Kornfeld, an art dealer from Bern, who inquired whether an honorary doctorate from the University of Bern would be acceptable. Alberto reluctantly agreed.

Ten years before, he had remarked, "It's curious that I should be the object of so much attention when I'm only a beginner. For if I ever achieve anything, it's only at present that I'm beginning to glimpse what it might be. But then maybe it's better to get honors out of the way at the beginning so as to be able to work in peace afterward."

The ceremony in Bern was to take place on a Saturday morning, November 27, 1965. Alberto planned to leave Paris by the night train on Friday. But he felt unwell. He didn't like the idea of traveling alone. Annette came to the studio late and irritable, having spent the afternoon with a friend visiting the Père Lachaise Cemetery, where they had found themselves locked in after closing time and had some difficulty to get out. She was in no mood to coddle her husband. If he would live in a way contrary to good sense, then let the bother be his. He could go to Bern alone. Alberto called Bruno in Zurich, who advised him to stay where he

grant.

1965

was. Ever contradictory, the artist insisted he had a responsibility toward those who wished to honor him and that he must honor it. Bruno could not attend the ceremony, having an urgent professional commitment, but he promised that Odette would be there. Whereupon Alberto put a few things in his suitcase and went to the station.

In Bern, he expected to be met by Ebi Kornfeld. When he got off the train in the early morning, he did not find his friend on the platform. It was pouring rain. Suitcase in hand, Alberto was going along with the other passengers into the station when he was stopped short by a pain like the blow of a hammer in the center of his chest and he found himself struggling for breath. Dropping the suitcase, he sat down on it, gasping, stunned. No one came to his aid. A minute passed, and then the seizure, too, seemed to have passed. He could breathe. He was able to get to his feet.

Kornfeld had been in the station all the time. But the train had not come in on the scheduled track, and when he hurried around to the other one, Alberto had already gone into the station. There Ebi found him, leaning on a railing, gasping for breath. They went together to Kornfeld's apartment, where Alberto was able to have some breakfast and rest for a few hours before the ceremony.

Odette Giacometti was seated in the university auditorium when the procession of dignitaries began to file in. The instant she saw her brother-in-law, she realized that something was seriously wrong. She made a sign. Seeing her, Alberto left the procession and hurried to kiss her, saying how happy he was that someone from the family was present. He added, "I'm not well. I'm not well." Nonetheless, he rejoined the other dignitaries and took his place for the ceremony. It was prolonged. When Alberto's turn came, he accepted his encomium and honorary scroll with composure. Odette was not reassured. She happened to know an eminent physician who was also being honored, and spoke to him at the end of the ceremony. He recommended that Alberto be put to bed at once. But a formal banquet was planned. Having accepted the honor, Alberto insisted that it would be impolite to

Paris Without End

miss the banquet. Afterward he returned to Kornfeld's apartment, where he was able to rest. He even felt up to making a few drawings. The last of them was of a group of Diego's furniture. "Look," Alberto exclaimed, "I'm copying Diego!"

Back in Paris, he worried over the seizure in the railway station. Fearing a recurrence of cancer, he decided to leave as soon as possible for his annual visit to the cantonal hospital in Chur, where a complete examination could be made. Diego, Annette, friends urged him to consult a doctor in Paris immediately. He protested, made light of it all, but obeyed when delivered direct to the doctor's doorstep in the rue du Bac. The next day, sitting on the edge of his unmade bed, smoking a cigarette, he said that the doctor had found no cause for worry. He suffered from chronic bronchitis, but that was news to no one. It appeared there was an abnormal enlargement of the heart. Nothing to worry about, he insisted. Then, having fallen silent for a moment, 'he added, "It would bother me a lot to die right now."

"It's absurd to talk that way," protested the friend who had delivered him to the doctor's door.

"Why?" said Alberto. "It's not absurd at all. It would bother me a lot. I still have everything to get done."

For weeks he had been trying to write a text for *Paris without End*. He jotted down various notes at various times, though none seemed definitive. In time, however, being his final writings, they would be.

"It is after three in the morning, a little while ago at the Coupole, dinner finished and wanting to read, already I was dropping asleep, dreams deforming and transforming what I tried to read, a line, two lines of the newspaper, and my eyes were closing, the cold outside, the cold and drowsiness chasing me home to go to bed and in spite of my terror to sink into sleep . . .

"The quiet, I am here alone, outside the night, all is motionless and sleep comes over me. I know neither who I am nor what I'm doing nor what I desire, I know not whether I'm old or young, I have perhaps a few hundred thousand years still to live until my death, my past disappears into a gray chasm, I was a serpent and I see myself a crocodile, with gaping jaws; I was the crawling crocodile, jaws agape. Scream and howl so the air trembles at it, and the burnt matches here and there on the floor like warships upon the gray sea."

After his visit to the doctor in the rue du Bac, only three days remained till the date of Alberto's departure for Chur. He spent them working, saw some friends, had Caroline pose for him once or twice, and stayed up very late in Montparnasse. On the last Saturday afternoon, he went again to the shop which had always supplied his materials, purchased a few things, and returned by taxi to the studio. En route, he passed along the street that cuts across the Montparnasse Cemetery. He pounded his knee with his fist. "It seems impossible to do it!" he cried.

"What?" inquired a friend accompanying him.

"To make a head as I see it. It seems impossible to do that. Between now and tomorrow, though, I've got to manage."

That night Alberto spent, as usual, with Caroline, Lotar, one or two other friends. They were not as talkative as usual. Nobody seemed to have anything of moment to say. The topic of departure brooded over the conversation and the late night seemed strangely sad. They parted at four in the morning.

The final day in Paris was a Sunday, December 5, 1965. Alberto worked a little during the afternoon on the bust of Lotar. Diego suggested that it be cast in plaster as it stood. If left in winter in the unheated studio, the clay might freeze, the head would burst, and the work would be destroyed. But Alberto said, "No. I'm not done with it yet."

At ten o'clock in the evening, he got on the train at the Gare de l'Est to go back the way he had come forty-three years and eleven months before. He was finished with Paris. It might be without end, but he wasn't.

Renato Stampa was surprised, when he came home for lunch that Monday, to find Alberto Giacometti seated in his living room. He was also delighted, as the cousins had been lifelong friends. The artist had called from the station, asking Alice Stampa to invite him for lunch. It was clear he wanted to see familiar, affectionate faces.

However, he did not seem alarmed at the prospect of a stay in the hospital. "Finally," he said, "I'll be able to get a few days of rest."

The cantonal hospital in Chur is a large, concrete building standing on a hilltop outside the town. Giacometti occupied a single room on the top floor. It opened upon a narrow balcony with a view across the barren trees and low rooftops of Chur toward mountains in the middle distance. The room itself was severely institutional, containing only the patient's bed, a washbasin, a chair upholstered in white plastic, a table of adjustable height on a wheeled base, a bedside stand, and two cupboards. On the wall facing the bed hung the framed reproduction of an oil painting. A banal Alpine vista, it was just the sort of academic work that Alberto loved to praise, saying, "If only I could do something like that!"

The chief physician of the cantonal hospital was a doctor well known in Switzerland, named N. G. Markoff. Acquainted with the Giacometti family, as his brother had been at school with Bruno, he was aware of the distinction conferred by the fame of his patient. Having examined Alberto on previous visits, Dr. Markoff had a basis for comparison when he came to inspect the patient on the afternoon of his arrival. He was shocked. He found

a man exhausted, wasted, breathing with difficulty, presenting clear signs of cardiac weakness and circulatory trouble. He prescribed immediate oxygen, followed by treatment with digitalis and other stimulant and restorative drugs. Improvement came promptly.

"Is it cancer?" Alberto asked.

Examination showed that there had been no recurrence. After the first few days of hospitalization, the prognosis appeared promising. Reassured, the patient telephoned cheerily to his brothers, his wife, his friends, saying that there was nothing to worry about. He was allowed to get up and walk around the corridors of the hospital, where, as it happened, his young friend Dr. Reto Ratti was not only a member of the staff but also a patient, having had to undergo an operation on, of all things, his big toe. He occupied a room along the same corridor as Alberto, and they were able to visit back and forth.

The presence of a world-famous artist brought a sense of unusual importance to the cantonal hospital. From the day of his arrival, Giacometti was treated as a person of consequence, someone physically no different from other patients, perhaps, but a person set apart by a status beyond the physical. Doctors, nurses, and other patients were aware of it. Visitors were frequent. Bruno and Odette came from Zurich. Renato Stampa was at hand in Chur. Diego came from Paris, spent a day, felt reassured, and returned to the rue Hippolyte-Maindron. Caroline came, too, for a couple of days. Annette at first stayed away, not wanting to encounter her rival. But when, after a week or so, Dr. Markoff still did not deem his patient sufficiently fit to be discharged, Annette irritably packed her suitcases and traveled to Chur. She was of no mind, however, to spend one minute longer than necessarv in that dull Swiss town and planned to go on to Vienna, where du Bouchet and his sympathetic attentions awaited. Meanwhile, she dutifully visited the hospital, and quiet chats alternated with tirades.

During his stay in the hospital, Alberto did almost no work. He made a few sketches, copies, and occasionally fingered a group

of four tiny figurines standing together which he had brought with him in a box. It was symbolic activity.

A few days before Christmas, the patient's condition abruptly worsened. The circulatory trouble became more pronounced. The heart muscle functioned with increasing difficulty, causing serious congestion of the pleura and liver. As yet, however, there seemed no cause for alarm. Alberto kept on telephoning Bruno, Diego, Caroline, Pierre and Patricia Matisse, and others, all of whom were reassured by the familiar, throaty voice saying that they had no reason to worry.

As he lay in the hospital room, however, aware that his condition was serious, if not fatal. Alberto cannot have failed to contemplate a future in which the person known as Alberto Giacometti would have ceased to exist. A few years previously, he had said. "I am convinced that nobody in the world believes he must die. Only an instant before death, he doesn't believe in it. How could he? He lives, which is a fact, and everything in him lives, and still a fraction of a second before death he lives, and in no way can he be conscious of death." The possibility, though, has a claim on the consciousness which the consciousness can never entirely acknowledge. Alberto had done his utmost to acknowledge it, and now he was close to success. He said to Reto Ratti just before Christmas. "Can one die from the lack of a will to live?"

Annette was bored and restless in Chur. Between visits to the hospital, which were often unpleasant, there was nothing to do. She quickly tired of reading. The town offered little by way of entertainment. There were only two cinemas, and the films were in German, which she could not understand. It was freezing cold. Her hotel room was small, sparsely furnished. She spent hours sitting in bars and cafés. Alberto learned of this and warned her to be discreet. "It's a Swiss town, not Montparnasse," he said, "and they don't understand." Acrimony ensued. There was shouting and slamming of doors, conduct shocking to the staff and patients of the hospital. Dr. Markoff observed with stern disapproval the behavior of the artist's wife. Annette resented being stuck in Chur when all she wanted was to be in Vienna. Remembering, perhaps, how capably her sister-in-law had coped with the last days of Alberto's mother, she told Bruno that Odette should come to Chur and do a stint by the bedside of the ailing artist. But Odette did not want to be drawn into the contention between Alberto and his wife, and was tired of hearing her sister-in-law say, "I'm fed up with the Giacomettis." So Annette had to stay. It made her more irascible than ever.

Diego came again by the night train to spend a day with his brother. When he saw him, he was alarmed and began to fear the worst. Nonetheless, he returned to Paris. His fear became apparent to others, who wondered whether the artist's lively talk on the telephone was all that it seemed. One of these was Patricia Matisse, alone in Paris for the holidays. She called her husband, still in America, not expected in France till January 7, and told him he would do well to hurry.

On December 31, Dr. Markoff left Chur for six days' vacation. Neither he nor his assistants considered Giacometti in danger. Hardly had the doctor departed, however, when his patient's condition again took a turn for the worse. It was not a classical or conventional turn, because nothing about Alberto's physical state could explain why it worsened just then. The doctors were perplexed. They hesitated to call back their superior from his vacation or to ask without his permission the assistance of a specialist from Zurich. Reto Ratti, though present, had no authority to intervene. But he was worried. Suspecting, after their conversations, that some reason other than the physical might be in part responsible for this change, the young man spoke to Alberto. He said that the doctors could not restore his health unless they had his cooperation. The artist said, "I can no longer give my cooperation."

In the first days of the new year, Caroline came again to Chur. She, too, was alarmed. Her friend looked terribly wasted and weakened. The skin hung loosely on his bones; his pallor was extreme. He had lost twenty pounds since entering the hospital only a month before. "You look very tired," Caroline said.

"No," Alberto protested, "I'm not tired. I'm not at all tired."

"Well, if you're not tired, then get out of bed," she replied.

He did get out of bed. But he was tired. After a few minutes, he was obliged to lie down again. Caroline stayed with him most of that day. They talked and even laughed. By the end of her visit, Alberto seemed less fatigued. She went back to Paris believing that he could still recover. No matter how worn out he might look, or be, after all, he was only sixty-four.

Annette was infuriated by Caroline's visit. Irksome and tedious as she may herself have found the stay in Chur, she did not want the other woman hovering over her sick husband. God knew how she might try to take advantage of an ailing man's

weakness.

Alberto started to think about his work, his things and affairs, realizing that no steps had been taken to determine how everything should be settled in the event of his inability to do so. True, he had been asked to take steps when there was still time. Now time had taken the initiative. He telephoned his brother Bruno, asking help to put his affairs in order, though he never explained into what order he meant to put them. He was anxious that Pierre Matisse should come as soon as possible to discuss business. He wanted to return to Paris. "If only for a week," he said repeatedly, "just to put things in order."

When Dr. Markoff returned from his vacation on January 6, a Thursday, he saw at once that his patient's condition was serious. Giacometti was breathing with increased difficulty. The heart muscle had weakened. This was the result of a lifetime of chronic bronchitis, all those decades of coughing. Immediate surgical intervention was necessary to drain away the liquid that had accumulated in the left side of the thoracic cavity. A puncture was made, and two liters of liquid were removed. Alberto immediately asked whether there was any sign of cancer. When told there was not, he seemed reassured. The recurrence of cancer was his constant worry, but there was no sign of it. As late as Friday, January 7, there was hope that the patient might recover.

Bruno and Odette had come to stay at a hotel in Chur. Diego planned to take the train from Paris on Monday for his weekly

64

visit. Alberto dozed much of the time. Now and then, and repeatedly over the following days, he murmured, "What a lot of trouble I've made for myself all of my life for nothing. What a lot of trouble I've made for myself all of my life for nothing!"

Indeed, the trouble he had made for himself had truly been a lot. It had been lifelong, and to the extent that he had done nothing either to seek it or to deserve it, surely, it had been for nothing. That, of course, was its glory.

"Well, I've certainly done everything I could to end up where I am now," he said to a friend over the telephone.

To one of the nurses he said, "I'm going mad, I don't know myself anymore, I no longer have any desire to work."

On Saturday, he called Caroline in Paris. His voice seemed to come from afar, faint, strained, foreign. She was alarmed. The next day, when she tried to call, she was told that the patient's telephone had been removed. She decided to take the night train to Chur on Monday.

Alberto continued to worry about his affairs, to ask for Pierre Matisse, who by this time had arrived at his villa in the South of France. The artist told his doctor that he must absolutely be made well enough to travel to Paris, if only for a week, a few days only. Dr. Markoff, who foresaw the outcome, tried to impress upon his patient that the situation was too serious to allow for travel. Alberto accepted his judgment with calm. His breathing became more and more labored. He had a feeling of suffocation. Twice again, on Sunday and Monday, liquid was drained from the thoracic cavity, and both times Alberto asked if there was any trace of cancer. There was none, and as before he seemed reassured.

Late in the afternoon of Monday, January 10, 1966, while alone with Markoff in his room, Alberto murmured to the doctor, "Soon again I'll see my mother."

Just two years previously, Annetta had lain dying in Stampa. Now his own death was imminent. To see his mother again—he for whom seeing had always been equivalent to being—to see her again would be the confirmation and consummation of all he had done, all he had been. His first vision had been of her. Throughout

his life, his vision of her had repeatedly been the affirmation of reality. To be united with her in the sight of eternity was his dying wish.

Bruno sat up the whole night in the chair beside his brother's bed. They alternately dozed or chatted, speaking in Bargaiot, the local dialect of their childhood. Alberto did not seem in danger, and was able to get up by himself to go to the toilet. When morning came, he was composed and cheerful. Diego presently arrived, as expected, from the railway station, and he did not think Alberto looked a bit well. The latter, however, hotly maintained that he felt fine and urged both his brothers to go off together to Maloja, where Odette, having spent a night or two alone, was waiting to be brought back to Chur. In the face of such spirited insistence, Diego agreed to keep his younger brother company in the drive over the mountains and they took to the road in Bruno's car.

Pierre Matisse, meanwhile, heedful at last of pressing messages, and urged by his worried wife, was boarding an airplane in Nice to fly to Zurich, where he planned to dine with a business acquaintance before proceeding to Chur on Wednesday morning.

Diego and Bruno had not been gone very long when Annette arrived at the hospital and found that her husband—once again, inexplicably—had taken a desperate turn for the worse. Tubes were quickly inserted through the patient's nostrils to give him oxygen, and intravenous glucose came from a bottle suspended above the bedside. The hospital room, which after a month had gradually taken on Giacometti's patina in the disorderly profusion of books, magazines, letters, newspapers, was suddenly transfigured by the emergency apparatus, and the gaunt figure in the bed was no more than a man who lay on the verge of death.

In midmorning, Annette went out of Alberto's room and along the corridor. At the head of the stairway, to her dismay, she found herself face to face with Caroline, who had traveled to Chur by the same train as Diego but, instead of coming directly to the hospital, had first taken a room at a hotel. The two women confronted each other in silence. It must have been a moment which truly left them speechless in the knowledge of what they were to

each other and why both were present there that morning. At last, Annette said, "Alberto's going to die. You have to know it, but you mustn't make a scene or let him know that you know."

Caroline started screaming. "It's you who've killed him," she shrieked. "You're the one who's killing him."

Annette was so shocked by this outburst, though it seemed even to her undeniably sincere, that she hit Caroline in the face, seized her by the arms, and shook her. There was a brief but violent struggle in the hospital corridor. Then they composed themselves, because they had to. It took a few minutes. Afterward they went together to Alberto's room.

Caroline was horrified at what she saw: all the paraphernalia of death, the nasal tubes, intravenous drips, and the rest.

"Caroline," Alberto murmured when he saw her, "Caroline." He took her hand. Then he told Annette to leave them alone together. He wanted to be left alone with Caroline, he said. Annette was reluctant, fearful that even at this extremity, taking advantage of the artist's final weakness, Caroline might prevail on him to sign some compromising document. But Alberto's insistence was also final. Leaving the two together, Annette went down into the town to entertain herself for the afternoon as best she could, which would be poorly. Not even the prospect of going on to Vienna could now distract her, as du Bouchet had meanwhile returned to Paris. The afternoon was bitter cold and it felt like snow.

Alberto and Caroline remained alone together. She sat by his bedside. They spoke little. He could see her. She could surrender her appearance, as so often in the past, to his gaze. From time to time he dozed, then would waken and see her again. He held her hand. Nothing is more easeful to the dying than the touch of a beloved, bringing with it till the end the feel of life.

Diego and Bruno arrived in Maloja, where they found Odette waiting. They had some lunch. As they set out to drive back across the mountains beyond Saint Moritz, snow started to fall. It came down slowly at first, large flakes floating gently in the pale light. Then it started falling harder and faster as they drove on, and they were anxious to reach Chur before nightfall.

Annette returned to the hospital at dusk. She joined Caroline in the sickroom. Beyond the window, darkness began to gather in the swirling storm. Diego, Bruno, and Odette, having completed their journey, also came to the room. They saw at once that a dire change had overtaken the patient since morning. Alberto looked from his bed at the five people standing around it, and he said, "You're all here. That means I'm going to die." No one answered.

Dr. Markoff sent for the family and told them that it could be only a few hours until the end.

Back in the room, Alberto said to Diego, "Look at the fix I've got myself into."

Diego went into the corridor and strode up and down, murmuring, "It's not possible. It's not possible that he's just going to die in there like a dog." Knowing that it was possible, however, he called Patricia Matisse in the South of France to tell her.

Bruno, fatigued from a night with little sleep and a long day's drive, returned with Odette to their hotel for a rest.

Diego announced that it was he, this night, who would keep the vigil by his brother's bedside. It seemed the natural thing, having all his life kept watch by his brother's side.

But Alberto said he did not want to be watched over. His voice was cracked, faint, remote, and yet his will remained strong. An argument ensued, neither bitter nor violent, but final. Diego demurred, and left the room. Just across the corridor was a small salon for the convenience of the families and friends of patients. He went in there to wait. Caroline was in the corridor.

Annette remained alone with Alberto. He was tired, wished to rest, to be left in peace. So she turned to go, and Alberto said, "Till tomorrow." Those were his last words. He had always felt that the morrow held infinite promise.

About seven o'clock, the patient fell into a coma. Bruno and Odette returned from their hotel. With Diego, Annette, and Caroline, they stood around the bed upon which lay the figure, faintly breathing, who was still, while they watched over him, their brother or husband or lover, and one of the great artists of his time.

In Zurich, meanwhile, at the Hôtel Baur au Lac, Pierre Matisse was preparing to sit down to dinner with Eugene Thaw, a fellow art dealer from New York, when he was called to the telephone. It was Patricia, who told him that if he didn't hurry he would be too late. A limousine and chauffeur were ordered at once, and despite the steadily deepening snow, Pierre set out for Chur, seventy-five miles away, through the storm.

In the hospital room, Diego, Bruno, Odette, Annette, and Caroline waited. They went across the corridor to the salon. They went back and forth. Neither the moment nor the state of relations between them made for conversation.

Toward ten o'clock, Caroline went down to the lobby of the hospital to make a telephone call. In her absence, Diego, Bruno, Odette, and Annette stayed in Alberto's room. At ten minutes after ten, the artist's body was seized by a spasm. He sat bolt upright for an instant, then fell back. His mouth dropped open. He had stopped breathing. The man called Alberto Giacometti, the person known and loved, the artist admired and revered by that name, had ceased to exist. Where he had been remained only a body, an object, a thing in itself of negligible value. In the first instant of his absence, no one moved, as though paralyzed by a fact that seemed to dismiss the importance of their presence. Then Annette made as if to go to the body, to touch it. But Diego took hold of her and would not let her approach. After a brief struggle, she left the room.

Caroline was just then returning along the corridor, having made her telephone call. When told that Alberto was dead, she rushed toward the room, threw open the door, and like Annette went toward the bed, her hand outstretched toward the artist's hand. This time it was Annette who tried to prevent the symbolic touch. There was another struggle. Caroline prevailed. She managed to grasp the fingers of the dead man. After a little while, the others went out, leaving her alone with Alberto. It occurred to her that he looked like nothing in the world so much as one of his own sculptures, the head of a man with mouth agape and set on a rod, which Giacometti had executed in 1947 in memory of the dead Tonio Pototsching. She gently closed the dead artist's

mouth. A nurse came to put a gauze bandage around his head and under the chin so that the mouth would remain shut as rigor mortis set in.

Pierre Matisse, having come safely but slowly through the storm, arrived after eleven. He found Caroline now pacing the corridor, the others standing silently around the dead man's bed. From time to time, one of them would go near, bending down, as if expecting that Alberto might still have something to say, or else looking to make sure there was no mistake. There wasn't, and there was nothing further to be said or done by anybody. They gathered their coats and gloves and left the hospital.

Snow was still falling. It was general all over that part of Switzerland that night. Returning to Chur, Bruno, Odette, and Pierre Matisse rode in Bruno's car. Diego, Annette, Caroline followed in a taxi, leaving Caroline en route at her hotel. When she stepped out into the storm, Annette told her that the best thing she could do would be to return at once to Paris, remain there, and keep her peace. The artist's funeral could not take place for several days. It was a ceremony, the widow added, at which she, Caroline, would not be welcome.

The following day, the news of Giacometti's death was broadcast to the world. It caused a stir. The obituaries were long, paying tribute in detail to the accomplishments and phases of Giacometti's career, emphasizing the uniqueness of his style, extolling the perseverance and self-effacement with which he had pursued his aims. Legendary already during his lifetime, Alberto proved the authenticity of his legend by dying. By dying, he also proved that an artist's greatest creation is the one in which he himself is submerged as a drop of water is submerged in the sea. He proved that genius is an abstraction which comes to life when its possessor dies. Then his creations start to live, assuming that they have any life at all, for they occupy the place where he stood when he looked at the world, and they offer to those who know how to see it a vision of what he saw, what he stood for, and what he created for others to look at.

The homage of the survivors was profound. During the weeks and months to come, hundreds of pages of tribute would be printed, testifying to the respect and bereavement of persons both celebrated and obscure. Alberto's life had passed into the lives of his admirers. Their survival and esteem became his forgiveness, such as he needed, and it would extend as well to those whom he had wronged or who had wronged him, all-embracing in its continuity. Alberto had said that it was by means of style that works of art attain truth, and added that, while art was interesting, truth alone was of enduring consequence. He had, by main force and long-drawn-out labor, forged a style instantly recognizable as his, and his alone, owing nothing to anyone, and through it he had attained his own truth, now bequeathed to us all. It was his entire bequest, because he would have no "influence," no followers, only a few imitators.

An autopsy was performed. What it revealed was what could have been predicted, what Alberto himself had foreseen when he was scribbling all those admonitions to himself on odd scraps of paper, warnings that he should sleep more, smoke less, take better care of his health. The cause of death was heart failure. But it was not a classic or conventional case, not an embolism or a thrombosis, but inflamed fibrosis of the heart muscle caused by chronic bronchitis.

The day after Alberto's death, Diego again got onto the night train from Chur to Paris. He had something important to do there. When he came out of the railway station that Thursday morning, got into a taxi, and stated his destination, the driver said, "Isn't that Giacometti's place?" He had frequently driven Alberto home late at night, and he remembered. It's true that Alberto was not easy to forget.

When Diego arrived at the studio, he found it freezing cold, having stood unheated since the previous Sunday. The rags wrapped around the last bust of Lotar were frozen. Diego built a fire in the stove, a slow fire at first, taking care not to heat the place too quickly. His work had to be done with utmost patience and skill. It was the very last time he would be called on to perform such work. When the rags were thawed enough to be unwrapped, he saw that the clay had not burst. Alberto's final work remained intact.

Diego's hands had served his brother and his brother's work for a lifetime. They did not fail on either score in the end. When the sad business of settling Alberto's estate was finished, Diego fell heir to a bronze cast of this final work, which he had saved for posterity, and placed it upon his brother's tomb, where it stands today beside a small bronze bird made by Diego himself.

The funeral was held on the following Saturday, January 15, in the artist's birthplace. The day dawned exceptionally beautiful but bitterly cold. It was the time of year when the valley lay deep in shadow, the season Alberto had always liked best. If, as Diego sometimes said, the valley was a sort of purgatory, then it seemed especially so that day, its sunless depths in gloom, while the snow-covered peaks gleamed above and the sky was icy blue.

The artist's coffin lay in the studio in Stampa. In this studio the young Alberto had had his first inklings of what art might be, of what it might do, of how it could conquer the world and fulfill dreams that most men never dream. It had been the studio of his father, Giovanni Giacometti. The earthly remains of Giovanni Alberto Giacometti—for we should not forget that both artists bore the same name—had been set here for a last leave-taking before being carried to the grave. The coffin was elaborate. Of oak, with palm leaves carved into the sides, and bronze feet, it was the most elegant place of rest Alberto had ever known. In the lid a small rectangle of wood could be opened over a glass pane, through which was visible the face within.

"Look!" said Diego. "He's much better here than at the hospital."

Those, however, whose care it had been to prepare the artist for his final confrontation with the public had forgotten how meticulous he was, even in his shabbiness, to respect the formalities of correct attire. It was without a necktie that he went to join his forebears. Rita Stoppani, the old family maidservant, whose portrait the artist had often painted and drawn, kept saying, "But I've never seen Alberto without a necktie."

The little village of Stampa was crowded with "foreigners." People had come from all over Europe to pay last respects. All the family was present, including Silvio and a crowd of cousins.

The Arms had come from Geneva. Michel Leiris, André du Bouchet, Jean-Pierre Lacloche were there. Pierre Matisse, of course, as well as Maeght, Clayeux, Kornfeld, Beyeler. But no artist of any renown. Caroline had come despite Annette's admonition. She was dressed entirely in black. The French and Swiss governments had sent representatives. Officials from museums in Italy, Switzerland, and France were present. Wreaths and bouquets, many with broad ribbons bearing the names of the donors, were lavish.

At two o'clock in the afternoon, the coffin was carried out of the studio by six men and placed on a horse-drawn cart for the procession to the church. Family and mourners followed on foot. There were many journalists and photographers. Their presence offended some, but it was only another aspect of everything Alberto had set out to do from the beginning. The procession made its way through the snow-covered landscape toward the church in Borgonovo, a half mile distant, and a choir of men sang as it moved slowly up the slope.

San Giorgio is austere, its whitewashed walls bare, with plain benches of scrubbed pine. The coffin was carried inside and set down on the stone floor. People filed in after it, so filling the church that many had to stand. Despite Alberto's lack of religious conviction, it had seemed natural that there should be a funeral service with a church ceremony. The people of the valley would have been shocked if it had been done differently. Funerals are important affairs in Bregaglia, and Alberto had been much loved. However, Diego and Bruno had suggested beforehand to the local pastor that a long sermon would be inappropriate. He politely agreed.

The first speaker was a representative of the Swiss museums, who addressed the crowd in German. Then came a member of the Swiss government, who spoke in Italian, and a representative of the cultural association of Bregaglia, a young fellow of twenty-eight, speaking also in Italian. He was followed by the emissary of André Malraux, who spoke in French, praising the great things achieved in France by the deceased genius. Rodolfo Giacometti,

a cousin of Alberto, next spoke with feeling in the name and language of the valley.

Having heard five men extol the accomplishments and character of the one who lay in the coffin before him, the pastor of San Giorgio stood up to pronounce his funeral oration. A radical change of mind had come over him, however, as he sat listening to the fine phrases lavished on the dead artist. He now saw no reason not to have his own say, no matter what he had promised the family. He was an individual for whom the vanity of vanities had acquired peculiarly personal significance, and this gave him added incentive to evoke the emptiness and vainglory of man's doings. Aged about forty, he was a handsome figure in his black robe, with a strong face and ringing voice. Unawed by the dignitaries seated on the benches of his cold church, he delivered a long sermon denouncing the falseness of glory here below and the sinful error of human ways. He told his listeners to put aside the deceptive amenities of this life, so tormented, so short, and to strive for salvation in the knowledge that death strikes without surcease, every day and everywhere, ferocious, blind, fatal. Or words to that effect, and a great many of them.

Alberto would have been the first to agree. The pastor could never have guessed how much more appropriate was his protracted exhortation than the encomiums preceding it. Nor could he have imagined with what an enjoyable sense of fitness the dead artist would have heard it had he known what manner of man was speaking. The pastor had a past, rather shady and troubled. Originally Catholic, it is said, from Sicily, he had clashed with ecclesiastical authorities from his first days in the seminary and was obliged to pursue his vocation in several different establishments. Ordained a priest nonetheless, he was assigned to a poor village in Reggio Calabria, where he found nothing better to do than get one of the girls of his flock with child. Fleeing north from the furious villagers, he sought asylum not only in Switzerland but in conversion to a less strict, though no less God-fearing, faith. How amused Giacometti would have been to know that the man called upon to introduce him to the hereafter was a

person whose credentials for the mission were so far from impeccable! Alberto had never set great store by his own.

When the sermon was finished, the coffin was carried from the church into the adjoining cemetery. In spite of the bitter cold and fresh snow, a deep hole had been dug. Family, friends, admirers, the dignitaries, the pastor, all stood round while the coffin was lowered. Close by lay the artist's father and mother.

As a child, Alberto had dreamed of scooping out for himself in the snow a hole just large enough to hold him, where he could stay in happy security all winter in the dark, his hiding place unknown to all. Though repeatedly begun, the game—if that is what it was—had never met with success. "Probably because external conditions were bad," he explained later. They were all right now. Nor would he ever again have to worry about going home for nourishment.

When the gravediggers started shoveling earth down onto the coffin, a few of those present went forward to the brink of the hole for a last look. Annette was one, and Odette, a few others, but not Diego.

There was nothing further to be done in the cemetery, and the crowd began to disperse. The family, the closest friends, the most eminent admirers went back down to Stampa, where food and drink had been prepared at the Piz Duan. There was a moment of awkwardness, because Caroline had followed along and the rest shunned her. The only one who might at last have made her welcome in his birthplace now lay six feet underground. Jean-Pierre Lacloche, gallant as ever, resolved this awkwardness by giving the unwanted woman a ride in his taxi to Saint Moritz. As for the others, all those who had journeyed to Bregaglia especially for the funeral of Alberto Giacometti, they, too, presently departed. Then it had come time to consider what dimension of human significance had been contributed by the deceased to the natural grandeur of the earth.

Acknowledgments

Notes on Sources

Bibliography

Index

Index of Works

Acknowledgments

Alberto Giacometti, who transformed my life by giving me occasional glimpses of his, naturally comes first in the long list of those to whom his biography owes everything, and no kind of thanks can ever be commensurate. After Alberto, though inevitably right next to him, and thus also beyond the reach of theoretical gratitude, comes his wonderful brother Diego. Without his entire sympathy and support, my undertaking would have had no mainstay.

Bruno Giacometti, the third gifted brother, and his gracious wife, Odette, also gave me unstinting assistance, friendly advice, and hospitality.

Mercil

Through the years, I have been sustained by the confidence and encouragement of my mother, Louise B. Lord, and happily take this opportunity to acknowledge a lifelong debt which no gratitude can ever adequately repay. My friends Hilton Kramer, Erich Eichman, and Gilles Roy have also greatly encouraged and counseled me, as have my patient publisher, Roger Straus, and my generous colleagues Michael Brenson, Reinhold Hohl, Ernst Scheidegger, and David Sylvester—to all of whom I humbly offer inadequate thanks. Michael di Capua, my editor, has expertly presided over the preparation of a publishable text, and I hope that my appreciation may be matched by his satisfaction. The John Simon Guggenheim Memorial Foundation granted me, for the purpose of pursuing my work, a fellowship, for which I am most grateful.

Although I would like to, I can hardly try to specify all the kinds of help I received from the many, many people who deserve my thanks. Some of them are no longer living. Some, indeed, were dead before I began my book, or even, like Braque, for instance, were gone before Alberto was. But I feel it appropriate to include their names because their views and beliefs concerning Giacometti contributed to the formation of my own. Moreover, I mean to suggest that in a very basic sense this book is the outcome of a prolonged and vital collaboration. For their extremely varied and quite indispensable participation in it, I offer my gratitude to the following persons, institutions, and organizations:

Lady Iya Abdy, Sir Harold Acton, Pierre Alechinsky, Paul Alexandre, Georges Altschuler, Annie Anargyros, Michel Anthonioz, Louis Aragon, Alexander Ardacheff, Avigdor Arikha, Henri and Germaine Arm, Dominique Arnhulf-Duhot, Dr. Dana Atchley, André Aulagnier, Georges and Nora

Auric, Ivan von Auw, Jr., Cecilia Ayala, Administration Générale de l'Assistance Publique de Paris, Archives de la Ville de Nice

Francis Bacon, Marc and Olga Barbezat, François and Carmen Baron, Alfred H. Barr, Jr., Many Barthod, Laurence Bataille, Olivier Béard du Dézert, Patricia de Beauvais, Simone de Beauvoir, Hans Bechtler, Samuel Beckett, Maurice Béjart, Denise Bellon, Loleh Bellon, Simon Bérard, Gaston and Bettina Bergery, Heinz Berggruen, Jeffery Bernard, Georges Bernier, Christoph and Alice Bernoulli, Dr. Silvio Berthoud, Jacques Bestock, Ernst Beyeler, Paul Bianchini, Carmelo Binelli, Emmanuel Blanc, Olivier Blanc, Ronald Blunden, Dominique Boischot, Yolé Bolognesi, Yves Bonnefoy, Georges Borgeaud, Pierre Boudreau, Bo Boustedt, Georges Braque, Elisa Breton, P. Brochet, Frederick Brown, Corinne Browne, Pierre Bruguière, Camille Bryen, Bernard Buffet, Gordon Bunshaft, Dr. Robert and Ruth Conne Buol, Jean Burguburu, Constantin Byzantios, Bibliothèque Doucet (Paris), Bibliothèque Nationale (Paris)

Gabrielle Cabrini, Paule Cailac, Alexander Çalder, Mary Callery, Bixio Candolfi, Paola Caròla, Henri and Martine Cartier-Bresson, Nicole Cartier-Bresson, Leo Castelli, Roger Cazes, Marko and Vreni Celebonovitch, William Chattaway, André Civet, Max Clarac, Barbara Clark, Lord Clark, Jean Clay, Louis Clayeux, Jean Cocteau, Estelle Cohn, Louis Conne, Jean Constantin, Dr. Serafino Corbetta, Thomas Cordell, Dominique Cornwell, Marguerite Cossaceanu, Gilberte Cournand, Robert Craft, John Craxton,

Dr. Jacques Cresciucci, Elisabeth Cunnick

Michel David-Weill, Edmonde Charles-Roux Defferre, Lise Deharme, Jean Denoel, Jean-Loup Despras, Christiane Desroches-Noblecourt, Jane Diel, Marlene Dietrich, Nelly van Doesberg, Sina Giacometti Dolfi, Charles Dormoy, Vera Drascek, Walter Dräyer, Jean-Marie Drôt, Jacques Dubourg, Alexina Duchamp, A. Duchenne, Charles and Clara Ducloz, Guy Dumur, Jacques Dupin, Georgette Dupont, Marguerite Duthuit

Christoph Egli, Hedwig Egli, Efstratios and Alice Eleftheriades (Tériade), Abdelkader Elifilali, Robert Elkon, Nina Engel, Edwin Engel-

berts, Max and Dorothea Ernst, Jo Excoffier

Louis Fernández, Jacques Fieschi, Leonor Fini, Wynne Fooshee, Jean

Fournier, Dr. Michel Fraenkel, Leon Friedman

Bianca Giacometti Galante, F. Gantenbein, Paul Gardner, Maurice Garnier, Arnold and Elisabeth Geissbuhler, Jean Genet, Annette Giacometti, Guido Giacometti, Tullio Giacometti, Thomas Gibson, Diego Giovanoli, E. H. Gombrich, André and Henriette Gomès, Carmen Gomezplata, J. Wilder Green, Randall Green, Georges Gruber, Philippe Grunchec, Peggy Guggenheim, Baron de Gunzburg, Dr. Paul Gut, Goethe Institut (Paris)

Larry Hager, Ulrich Hagmann, Claude Bernard Haim, Nadine Haim, Gyula Halász (Brassaï), Gisèle Halimi, Janine Hao, Jacques Hartmann, Jean Hélion, John Hewett, H. P. Horst, Georges Hugnet, Jean Hugues,

Huguette, Bruce Hunter, Jacqueline Hyde

Dr. Gabriel Illouz, Institut Suisse de Météorologie

Pierre Jacob (Tal Coat), André and Léni Jaecklin, H. P. Jaeger,

T. G. H. James, Sidney Janis, Dorris Janowitz, Maurice Jardot, K. A.

Jelenski, Pierre Josse, Pierre-Jean Jouve, Dr. Albert Jung

Ellsworth Kelly, Wilhelm Kirchner, Michel Balthasar Klossowski (Balthus), Pierre and Denise Klossowski, Marie-Thérèse Kobayashi-Moreau, Rainer Köchermann, Harold Kollmeier, E. W. Kornfeld, Catharine Kroger, David Kronig, Koninklijke Bibliotheek (The Hague)

Dr. Jacques and Sylvia Bataille Lacan, Mariette Lachaud, Jean-Pierre Lacloche, Jean Lagrolet, Jacqueline Lamba, Dr. Robert Lander, Marguerite Lang, Monique Lange, Claude Laurens, Jean Laurent, Léna Leclercq, Maurice Lefebvre-Foinet, Dr. Raymond Leibovici, René Leibowitz, Michel Leiris, Daniel Lelong, Julien Levy, Jean Leymarie, Pierre and Elizabeth Leyris, Alexander Liberman, William S. Lieberman, Aline Lignières, Richard Lindner, Jacques Lipchitz, Mary Littauer, Antoine Livio, Albert Loeb, Edouard Loeb, Pierre Loeb, Bennett Lord, Elie and Elisabeth Lotar, Jeanne Louis-Dreyfus, William and Phyllis Louis-Dreyfus, Herbert Lust

Lillian McClintock, Robert McCrum, Hedli MacNeice, Malcolm MacPherson, Aimé and Marguerite Maeght, Olivier de Magny, Andrée Mallet-Stevens, Joyce Mansour, Jean Marais, Jean-Patrice Marandel, Dr. N. G. Markoff, Theodora Markovic (Dora Maar), Charles Marks, Raymond Mason, Sylvaine Massart-Weit, André and Rose Masson, Gregory and Shirley Masurovsky, Peter Matisse, Pierre and Patricia Matisse, Hans von Matt, Serge Matta, Herbert and Mercedes Matter, Hélène Maurice-Bokanowski, William Maxwell, Flora L. Mayo, Bruni Mayor, G. Mazeau, H. Mélandri, James R. Mellow, Dr. Franz Meyer, Gerda Michaelis, Peggy Miller, Bernard Minoret, Joan Miró, Joan Mitchell, Roger Montandon, Henry Moore, David Morton, Dr. Werner Muensterberger, Ministerie van Buitenlandse Zaken (The Hague)

Claude Nabokoff, Maurice Nadeau, Nelda Negrini, Yannis Nicolettos, Viscount and Viscountess de Noailles, National Tourist Office of Switzerland, the New York Public Library

Dorothy Olding, Meret Oppenheim, Sonia Orwell, Arthur Ott

Giuliano Pedretti, Sir Roland and Lady Penrose, Emmanuel Péreire, Jacques Perez y Jorba, John Perkins, Frank Perls, Alessandro Perrone, Cesare Peverelli, Claude Picasso, Pablo Picasso, Paul and Christine Picasso, Gaëtan and Geneviève Picon, Georges Pierre, Henry Pillsbury, Georges Plénel, Jacques Pligot, Jacques Prévert, André Puig, Police Department of Chur (Switzerland), Police Department of Paris (France)

Mercedes Quesada-Brujas

Pierini and Erica Ratti, Dr. Reto Ratti, Charles Ratton, Alan and Isabel Rawsthorne, Man Ray, Gérard Régnier, Madeleine Repond, John and Alice Rewald, A. E. M. Ribberink, Michel Richard, David Rieff, Jean-Paul Riopelle, Georges-Henri Rivière, H. K. Roethel, Gilles Roignant, Henri Rol-Tanguy, Count de Rola, Alexander Rosenberg, Béatrice Rosenberg, Stephen and Grazia Rosenberg, Jean-Régis Roustan, Gaston-Louis and Pauline Roux, Claude Roy, Angelica Rudenstine, Georges Rudier, Véra Russell, Georg Rutishauser, Philip Rylands

Ruta Sadoul, Sir Robert and Lady Sainsbury, Dr. Jonas and Françoise Gilot Salk, Gualtieri di San Lazzaro, Jean-Paul Sartre, Henri Sauguet, Hal Scharlatt, Elsa Schiaparelli, Pierre Schneider, Jacqueline Schuman, Henry and Akiko Scott Stokes, Sherban Sidéry, Jonathan Silver, Barbara Simpson, Barbara Skelton, Albert Skira, Giorgio Soavi, P. C. Soeters, Maté Souverbie, Pierre Souvtchinsky, Ginette Spanier, Sir Stephen Spender, Darthea Speyer, Simon Spierer, Francis Steegmuller, Christian Stiébel, Rita Stoppani, Marianne Strauss, Samuel Szafran; Secretariat of the City Hall of Etampes (France), of the City Hall of the 14th arrondissement (Paris), of the City Hall of the 16th arrondissement (Paris), of the Commune of Stampa (Switzerland), of the Evangelische Mittelschule (Schiers, Switzerland), of the Galerie Maeght (Paris), of the Grand Hôtel des Alpes (Madonna di Campiglio, Italy), of the Grand Hotel Universo (Naples, Italy), of the Hôpital Bichat (Paris), of the Italian Embassy (Paris), of the French Line (Paris), of the Marguerite and Aimé Maeght Foundation (Saint-Paul-de-Vence, France), of the Musée Bourdelle (Paris), of Nice-Matin, of the Palais de Justice (Paris), of the Parish Office of Pinzolo-Madonna di Campiglio (Italy), of the Rémy de Gourmont Clinic (Paris), of the Town Hall of Pinzolo-Madonna di Campiglio (Italy), of the Town Hall of Somloire (France); Service Météorologique Métropolitain de Paris, Services des Recherches d'Etat Civil de la Ville de Paris, Soprintendenza alle Anthichita delle Provincie di Napoli e Caserta (Italy), Syndicat d'Initiative du Haut-Morvan (France)

Francis Tailleux, Yvonne Tamagno, Craig Tenney, Eugene Victor Thaw, André Thirion, G. David and Helene Thompson, Frédérique Tison, Jean-Max Toubeau, Yvon and Monique Toussaint, Antonio Trincali, Televisione della Svizzera Italiana (Lugano, Switzerland)

Alfred Urfer

Sinbad Vail, Claude Venard, Michèle Vian, G. Vimard, Countess Madina Visconti, Ruth Vollmer, Jean Vuilleumier

Patrick Waldberg, Philippe Walther, Rudi Walther, Silvio Walther, Michael Ward, Lynn Warshow, Ruth Washburn, Peter Watson, Antoinette de Watteville, William Weaver, Charlotte Weidler, Sabine Weiss, Michael Werner, Robert and Marion Wernick, Herta Wescher, Lawrence and Margot Whiffin, S. John Woods

Panayotis and Helen Xenos

Isaku Yanaihara, Jacqueline Yudelowitz

Ilya Zdanevitch (Iliazd), Christian Zervos, François de Ziegler, Gustav Zumsteg

Grateful acknowledgment is made to the following for permission to reprint previously published texts:

Marc Barbezat: excerpt from L'atelier d'Alberto Giacometti by Jean Genet (Paris: L'Arbalète, 1963)

Editions Gallimard: excerpt from Les Mots by Jean-Paul Sartre, © 1964 by Editions Gallimard

The Paris Review: excerpt from "Giacometti at the Salon d'Auto" ("La voiture demystifiée") by Alberto Giacometti, published in The Paris Review, No. 18 (Spring 1958)

Ernst Scheidegger: excerpts from "Hier, sables mouvants" and "Le rêve, le Sphinx et la mort de T." by Alberto Giacometti, published in *Schriften*, *Fotos*, *Zeichnungen*, edited by Ernst Scheidegger (Zurich: Verlag der Arche, 1958)

Pierre Schneider: excerpts from his interviews "'Ma Longue Marche' par Alberto Giacometti," published in L'Express, No. 521 (June 8, 1961), and "Au Louvre avec Giacometti," published in Preuves, No. 139 (September 1962)

Alice Tériade: excerpts from Paris sans Fin (Paris: Tériade, 1969) and "Mai 1920," published in Verve 7 (January 15, 1953), both by Alberto Giacometti

Grateful acknowledgment is made to the following for permission to reproduce the photographs that follow page 176 and page 304:

The Giacometti family in 1909: the Giacometti family; the studio and residence in Stampa: Ernst Scheidegger; Giacometti in Rome: the Giacometti family; Giacometti in 1922: photographer unknown; Giacometti and Flora Mayo: Flora Mayo; Giacometti's studio: Sabine Weiss; Isabel Nicholas: Isabel Rawsthorne; Diego Giacometti in 1934: photographer unknown; the passageway outside Giacometti's studio: Jean-Régis Roustan, L'Express; Alberto, Annette and Diego in the studio c. 1952: Alexander Liberman; Alberto and Annette c. 1954: Alexander Liberman; Alberto and Annette in the café at the corner of the rue Didot c. 1960: Henri Cartier-Bresson, Magnum; Alberto and his mother at Stampa 1961: Henri Cartier-Bresson, Magnum; Alberto and Caroline with her dog Merlin c. 1963: photographer unknown; Alberto and Georges Braque c. 1952: Mariette Lachaud; Alberto in his studio c. 1956: André Ostier; Giacometti with Samuel Beckett: Georges Pierre; James Lord and Giacometti 1965: James Mathews; Alberto in 1961: Jean-Régis Roustan, L'Express; Alberto's tomb in the graveyard at Borgonovo, with the final bust of Lotar: Michael Brenson.

and the state of the second second

tana di Kalamatan d Kalamatan di Kalama Kalamatan di Kalama

The second of th

Notes on Sources

The information, the factual matter contained in the biography, came from a great many sources, the majority of which I will identify in these notes. If I don't identify all, it is because I can't expect everyone who shared confidences with me to assume the responsibility or liability of publication. Thus, certain revelations or observations which might be displeasing to persons still alive but which seem essential to a valid account of Giacometti's life will be registered here according to the recorded number of my conversation with that particular informant. Some documents, too, will have to be classified by number only. None of this anonymity will be permanent, however, as everyone and everything is clearly and exhaustively identified in the allinclusive mass of material which will ultimately be available to anyone interested.

My most important, willing, and able informants were, of course, the artist himself and his brother, referred to hereafter as AG and DG. Bruno and Odette Giacometti are referred to as BG and OG. In the interests of saving space, all other informants are identified as briefly as possible. Published sources are acknowledged by their bibliographical number (Bibl. 1, Bibl. 2, etc.), and in this context I want to point out that in approximately a dozen instances I have quoted verbatim from the works of other authors a phrase or two, even a sentence or two, without any acknowledgment in the text. This occasional dalliance with plagiarism was pursued out of a desire to provide not only more persuasive reading but also ideas more original and more perspicaciously expressed than those I could devise. Though unabashed by these borrowings, I have endeavored to be punctilious about disclosing them in the notes.

As a general rule, I have limited the documentation of sources to separate paragraphs or quotations, giving the first few words of each. When necessary, I also identify the sources of specific sentences. Where there is no acknowledgment, it may be assumed that the material derives from my own knowledge.

1

"It's a sort . . . DG, Jan. 14 and June 27, 1970; Sept. 21, 1979. Life in . . . DG, Oct. 15, 1971. Whatever may . . . DG, Jan. 21, 1970. Stampa commune records. Giovanni Giacometti was . . . DG, Jan.

14, 1970. BG and OG, June 25, 1970. Bibl. 46.

The start of . . . DG, Jan. 14, 1970. B. Galante, Aug. 9, 1970. BG, Nov. 5, 1979. Bibl. 46.

The Stampas were . . . DG, May 22, 1970. BG, Oct. 23, 1970. Giovanoli, Sept. 12, 1971. Guido Giacometti, Sept. 12, 1971.

Giovanni may have . . . DG, Oct. 29, 1970. Letter R. Hohl to author, May 30, 1972.

On the 15th of . . . DG, Oct. 25, 1971. The very earliest ... Bibl. 8. Alberto could not . . . Bibl. 130. On the day . . . DG, Jan. 21, 1970. S. Berthoud, June 24, 1971. He was a shy . . . DG, April 30, 1970. Bibl. 5. "From the first . . . Bibl. 5. For two years . . . Idem. Once, while . . . Idem. A time came . . . Idem.

3

Discord seems . . . DG, Feb. 6, 1970. C. Bernoulli, July 2, 1970. S. Dolfi, Sept. 13, 1971. Bibl. 43; 297. The children . . . DG, Feb. 6, 1970. Bibl. 58. On August 24 . . . DG, May 4, 1970. The children also . . . DG, Oct. 3, 1970; Jan. 30, 1972. Bibl. 84. Siberia was . . . Bibl. 5. He was no longer . . . Bibl. 130. During these early . . . BG, June 24, 1970. DG, Sept. 26, 1971; Jan. 25, 1972. For the rest . . . Idem. Bibl. 5. Giovanni Giacometti occasionally . R. Stoppani, statement, Sept. 1971. Bibl. 28.

Diego, to . . . Idem. Diego's calm and . . . Idem. DG, July

6, 1981. One summer's day . . . DG, July 6,

1981.

Lifting his . . . Idem. A year later . . . DG, March 16, 1972. Letter BG to author, March 31, 1972. Annetta Giacometti was . . . Bibl. 297.

"I began to draw . . . Bibl. 167. "There was no ... Idem.

During his boyhood . . . Bibl. 11; 43.

In addition to . . . Bibl. 46; 84. Giovanni had . . . Idem.

This engraving . . . Bibl. 152. In 1914, he . . . Bibl. 27. It was also . . . Bibl. 25; 193. He drew everything . . . AG, Aug. 6, 1964. Idem.

5

On the 30th . . . Letter H. P. Jaeger to author, June 26, 1970. Bibl. 172. Alberto was not . . . Letter Pierini and Erica Ratti to author, July 2, 1971. Bibl. 240. Alberto loved the . . . C. Bernoulli, July 2, 1970. Giovanni and Annetta . . . Letter Arthur Ott to author, June 3, 1971. Document 6. Much as Alberto . . . DG, Feb. 16, 1970. Auguste Rodin . . . Idem. At midnight . . . Idem.

Alberto was a ... Bibl. 43; 46.

He contracted . . . AG, Sept. 20, 1964. Annette Giacometti, March 24, 1970. BG, June 30, 1970. C. Bernoulli, July 2, 1970. Alberto liked . . . Document 7. On the 27th . . . S. Bérard, Oct. 20, 1970. C. Bernoulli, April 10, 1972. The friendship . . . Idem. Life at Schiers . . . AG, Sept. 5, 1964. He went to ... Idem. The stratagem . . . Idem. It was on . . . Idem.

In Stampa, it . . . AG, Sept. 18, 1964.

One day in ... Bibl. 81. Some occupation . . . DG, Jan. 21 and March 20, 1970. The three months' . . . Bibl. 240. "A painter or . . . Idem. Annetta was anxious . . . E. Kornfeld, June 21, 1970. OG, Sept. 26, 1974. A room was . . . DG, Feb. 16, 1970. S. Berthoud, July 3, 1971. Alberto transferred . . . Bibl. 14. During the entire . . . Letter Giovanni Giacometti to Cuno Amiet, March 14, 1920. Letter AG to H. von Matt, Jan. 25, 1921. Bibl. 46. He was lonely . . . J. Vuilleumier, March 23, 1970. Bibl. 46. One day in . . . Bibl. 199.

The teacher of . . . J. Vuilleumier, March 23, 1970. Girls were . . . Idem.

8

Alberto was thrilled ... Bibl. 20.

"The last day ... Idem.

"The same evening ... Idem.

During the late . . . Letter AG to H. von Matt, Jan. 25, 1921.

In mid-November . . Idem.

Florence was freezing . . . Idem. Document 12.

Antonio Giacometti . . . B. Galante, Aug. 12, 1970.

The Roman Giacomettis . . . B. Galante, Aug. 7, 1970.

Though he may . . . Letter AG to parents, Feb. 4, 1921.

Having hoped . . . Idem.

Bianca was . . . Letter B. Galante to author, July 28, 1970. Everyone in . . . Idem. Alberto became . . . Idem. Evelina Giacometti . . . B. Galante, Aug. 8 and 9, 1970. During the first . . . Letter AG to parents, Feb. 18, 1921. If he had hoped . . . B. Galante, Aug. 8 and 9, 1970. At the same time . . . Bibl. 13. Alberto felt trepidation . . . AG, Sept. 18, 1964. "I took a . . . P. Schneider, July 30, 1970. Bibl. 28. "The cigarette is . . . Drawing reproduced in Bibl. 83. While in Italy . . . Letter AG to parents, April 1, 1921. From Naples . . . Letter AG to parents, April 8, 1921. Bibl. 194. After one night ... Idem. The city of Pompeii . . . Idem.

10

Bianca continued . . . B. Galante, Aug. 8 and 15, 1970. Bibl. 27.
In the bust . . . Idem.
There was an . . . Idem.
Throughout the rest . . . Bibl. 13; 25; 27; 49.
Bianca had been . . . Letter B. Galante to author, June 6, 1971.
There was some . . . B. Galante, Aug. 8, 1970.

"I want to ... Idem.
Thinking the request ... Idem.
In the morning ... Idem.
"Then I'll ... Idem.

11

A mysterious advertisement . . . Bibl. 46; 193. Alberto was surprised . . . Idem. A reply presently . . . Letter P. Soeters to author, Nov. 27, 1970. Bibl. 143. It was, to . . . Idem. The idea of . . . DG, Jan. 26, 1970. Bibl. 193. Alberto protested . . . Idem. J.-P. Lacloche, July 30, 1970. J. Clay, Oct. 6, 1971. Before leaving Maloja . . . Idem. "If things turn . . . Idem. The travelers set . . . Letter C. Binelli to author, Sept. 25, 1970. The following day . . . Bibl. 12. Alberto remained . . . Idem. Speaking of Flaubert . . . Bibl. 149. Outside the window . . . Bibl. 193. Alberto took paper ... Idem. Toward the end . . . Idem. In that instant . . . Bibl. 30; 193. "When I saw . . . Idem. Alberto did not . . . Idem. His first impulse . . . Idem. It seemed there . . . Idem. Examination disclosed . . . Idem. During this second . . . Idem, and postcard AG to parents, Sept. 7, 1921. One evening . . . Bibl. 12.

12

"That trip I ... Bibl. 12.
At the time ... BG, July 1, 1970.
"I began to ... Bibl. 30.
Giovanni suggested ... Bibl. 46.
On the 28th ... DG, May 20, 1971.
Letter AG to parents, Jan. 1, 1922.
Formalities delayed ... Letter AG to parents, Jan. 7, 1922.
On the evening ... Document 575.

13

"There's nothing more . . . Bibl. 30.
Among those unfriendly . . . Patricia
Matisse, Sept. 30, 1971; Feb. 7 and
Oct. 4, 1972.
Alberto's first friends . . . M. Cossaceanu, Feb. 19, 1970. M. Celebonovitch, April 13, 1970. A. and E.

Geissbuhler, March 30, 1971. L. Conne, Feb. 11, 1972. Bibl. 30; 46. "One has to be ... Document 143. Bianca, too, was . . . Letter B. Galante to author, July 28, 1970. His letters were . . . Idem. Of other girls . . . AG, Sept. 20, 1964. BG and OG, June 26, 1970. B. Galante, Aug. 8, 1970. Alberto never learned . . . BG, June 25, 1970. The dances held . . . Idem, and Nov.

17, 1975.

From August to . . . DG, Feb. 24 and June 1, 1970. Letter R. Hohl to author, June 1, 1972. Bibl. 46; 59.

14

"He will either . . . M. Cossaceanu, Feb. 19, 1970. M. Celebonovitch, April 5, 1970. A. and E. Geissbuhler. April 1, 1971. The master and ... Idem. Alberto was never . . . Idem. If Alberto's classmates . . . Idem. "It takes a long ... Document 25. Many of the . . . A. and E. Geissbuhler, March 31, 1971. "From the beginning . . . Bibl. 30. Alberto was not . . . Bibl. 43; 194. "I always felt ... Idem. "Whores are the . . . Letter S. Brignoni to M. Brenson, July 26, 1971. "It was for me . . . Bibl. 12. "You'd never win . . . AG quote from Swiss-Italian TV interview. Bibl. 33.

15

Of the three . . . M. Celebonovitch, April 8 and 13, 1970. He received a . . . BG, Oct. 20, 1978. Document 575. Almost every Sunday . . . Letter AG to parents, Dec. 6, 1922. Bibl. 49. There were moments . . . W. Fooshee, April 21, 1971. Alberto's purpose in . . . DG, June 1, 1970; Oct. 17, 1971; Feb. 8, 1973. BG, June 26, 1970; April 2, 1974. Alberto fretted . . . Idem. In the summer of . . . AG, Sept. 26 and 27, 1964. Bibl. 27; 36; 58. "If you want to jump . . . Bibl. 58. Bianca and Alberto . . . BG and OG, June 24 and 25, 1970. "B. Galante, Aug. 8 and 9, 1970. Annetta disapproved . . . Idem.

On the 16th . . . F. Mayo, March 2 and 3, 1971. Flora's father . . . Idem. Having become a ... Idem. She took a ... Idem. Mayo got a ... Idem. Paris thrilled . . . Idem. Alberto met her . . . Idem. While Alberto was . . . BG and OG. June 24, 1970; Sept. 27, 1974. Diego arrived . . . DG, April 15, 1970; Jan. 31 and Feb. 8, 1973. Some time before . . . Idem. Diego was introduced . . . AG, Aug. 6, 1964. DG, Jan. 26, 1970; Jan. 31, 1973. He bought a ... Idem. "Where? ... Idem. "To Venice . . . Idem. Among the new . . . BG, June 26, 1970. DG. Jan. 30, March 5 and 25, June 22, 1972. L. Conne, Feb. 11, 1972. Once Tolotti . . . Idem. If Alberto . . . Idem. A. and E. Geissbuhler, March 31, 1971.

17

simply as Large Woman . . . Bibl. 89. Alberto and Flora . . . F. Mayo, March 2, 1971. Alberto sculpted her . . . Idem. Flora could neither . . . Idem. Besides, Bianca was . . . BG, June 24, 1970. B. Galante, Aug. 7, 8, 9, 1971. The families of ... Idem.

18

Lipchitz was a . . . AG, Aug. 6, 1964. DG, May 4 and 18, 1970. Henri Laurens . . . Bibl. 10. Giacometti's studio . . . L. Conne, Feb. 11, 1972. On a sizable . . . DG, April 15, 1970. Letter M. Brenson to author, Jan. 30, "I planned on moving . . . Bibl. 36. Life in the . . . DG, Feb. 16 and 18, "I was working in . . . Bibl. 58. At this juncture . . . Bibl. 194. At first, he . . . Idem. "It was always . . . Bibl. 15. On several occasions . . . Letter C. de Noailles to author, June 11, 1970. Within a week . . . DG, Oct. 13, 1972. Bibl. 194.

19

Flora Mayo . . . F. Mayo, March 2, 1971. Excerpts E. Geissbuhler's unpublished diary. On the frequent . . . Idem. Her unfaithfulness . . . Idem. He was wounded . . . Idem. Alberto replied . . . Idem. "Something is . . . Idem. It was. They ... Idem. In 1929, for . . . Bibl. 58.

20

Jeanne Bucher, though . . . A. Masson, Jan. 16, 1970. A week or so ... Idem. He sensed at . . . Idem. "I am . . . Idem. The Surrealists aspired . . . M. Leiris, Nov. 15, 1978. Bibl. 151. The self-appointed . . . Idem. A. Masson, March 2, 1970. Most of Giacometti's . . . Idem. a vocabulary of expressive . . . Bibl. 40. Of Alberto's recently made . . . Bibl. Early in 1930 . . . DG, Feb. 6, 1970; Jan. 23, 1973. L. Clayeux, June 23, 1971. In the spring . . . Bibl. 46. The sculptor assured . . . Document 551. Bibl. 229. Alberto fell ill . . . DG, Feb. 6, 1970;

Jan. 7, 1975. R. Mason, May 19, 1970.

The pains did . . . Idem.

In the fashionable . . . DG, Jan. 14, March 30, May 4, 1970. Because he admired . . . Idem. Man Ray, Jan. 14, 1970. Alberto created . . . Idem. Bibl. 27. The evolution of . . . BG, Sept. 24, 1974. So long as . . . DG, March 30, 1970; Oct. 26, 1975. It must have . . . Idem. The worlds of art . . . Letter C. de Noailles to AG, Feb. 24, 1930. Homosexuality was . . . L. Aragon, Nov. 18, 1970. The intimacy of . . . AG, Sept. 18, 1964. G.-L. Roux, Feb. 28, 1970. J. Genet, May 14, 1970. A. Geissbuhler, March 31, 1971. Of the women . . . DG, Jan. 20, 1975. BG, Nov. 10, 1975.

We know that . . . M. Oppenheim, June 21, 1970. Dédé le Raisin . . . Caroline, June 30, 1971. Speaking of ... Bibl. 8. "There was clearly . . . Bibl. 58. Giovanni Giacometti did . . . A. Geissbuhler, March 3, 1971. DG, Dec. 9, 1975.

22

"neither Cubist like . . . Letter C. de Noailles to M. Brenson, Feb. 14, 1972. An acceptable model . . . Letter AG to C. de Noailles, Dec. 31, 1930. Diego was promptly . . . DG, Jan. 14 and March 27, 1970; Dec. 15, 1975. The Figure for . . . Letter AG to C. de Noailles, June 1, 1932; to parents, June 19, 1932. The precise place . . . C. de Noailles, Dec. 21, 1975. The professional agreement . . . DG, Jan. 21, Feb. 6, Oct. 6, 1970; Oct. 22, 1971; May 4, 1973. Letter AG to C. de Noailles, Dec. 31, 1930. Not once in his . . . DG, Nov. 15, 1978. "I think that . . . Document 42.

23

Diego always . . . DG, May 15, 1976.

It had come . . . DG, June 17, 1970.

One evening early . . . AG, Sept. 18, 1964. DG, Jan. 21, 1970. G. Bernier, May 22, June 5 and 7, Nov. 4, 1970; Oct. 7, 1971. D. Bellon, June 27, 1971. C. Ducloz, July 4, 1970; June 25, 1971. L. Penrose, Jan. 22, 1976. Document 442. He left the . . . Idem. At the Dôme . . . Idem. Denise Bellon . . . Idem. Toward morning . . . Idem. Once again . . . Idem. He could not . . . Idem. Jacques Cottance . . . Idem. The police . . . Idem. The formalities at ... Idem.

24

When Diego arrived . . . Idem.

Bianca had long ... BG, Nov. 10, 1975. Letter B. Galante to AG, undated. The reputation of . . . S. Berthoud, June 24, 1971. DG, March 24, 1972. We are told . . . DG, May 31, 1975. Bibl. 8.

Alberto was "undependable" . . . J. Lamba, June 2, 1970. "It is two . . . Bibl. 7. "I seek, groping . . . Bibl. 2. "It gives life . . . Idem. Giovanni Giacometti . . . BG, Nov. 9 and 17, 1975. On the 23rd . . . Idem. Rain was falling . . . Letter Institut Suisse de Météorologie to author, Nov. 17, 1975. Alberto felt unwell . . . Letter AG to C. de Noailles, July 3, 1933. Bruno was at ... BG, Nov. 9, 1975. Alberto soon announced . . . Idem. More practical and . . . Idem.

25

While Alberto remained . . . Idem.

The following day . . . Idem.

The continuity of days . . . Letter AG to C. de Noailles, July 3, 1933. One year after . . . DG, Oct. 17, 1971; May 10 and 22, 1974. Giacometti experienced . . . DG, Jan. 26, 1970. Bibl. 59. "In my room . . . Bibl. 192. He grew impatient of . . . AG, Sept. 27, 1964. In the autumn of . . . J. Levy, Jan. 27, 1971. "For five minutes . . . Bibl. 242. "I knew . . . Bibl. 25. "After a week . . . Idem. "He must be . . . Bibl. 40. Max Ernst sadly . . . M. Ernst, Jan. 31, "Everybody knows . . . Bibl. 122. Sometime in the . . . M. Jean, Oct. 22, 1971. Y. Bonnefoy, Dec. 24, 1972. G. Hugnet, June 18, 1973. Giacometti was not . . . Idem. "Everything I've done . . . M. Jean, Oct. 22, 1971. "We'll have to ... Idem. "Don't bother . . . Idem. From one day . . . AG, Sept. 27, 1964. Speaking of his . . . Bibl. 40.

26

On the 10th . . . I. Rawsthorne, March 12 and 13, 1970; June 30, 1972; Feb. 9, 1975; June 15, 1979. Document 557. Young Isabel . . . Idem.
She attracted . . . Idem.
Mrs. Jacob Epstein . . . Conversations 857; 965; 966.

That chance meeting . . . Idem. Alberto observed her . . . I. Rawsthorne, March 13, 1970. "I can't repudiate . . . Bibl. 58. "The more I . . . Bibl. 27. "I just wanted . . . AG interview, Swiss-Italian TV. Bibl. 33. "The truer a work . . . Bibl. 27. A number of the men . . . AG, Aug. 27, 1964. R. Montandon, May 5, 1970. R. Leibowitz, June 2, 1970. Balthus, July 23, 1970. "always something that . . . AG, Sept. 15, 1964. It was not all . . . E. Defferre, Feb. 5, 1972. "When I was young . Matisse, Oct 24, 1972. "I want to live . . . Conversation with author. "I have a ... Idem. "Alberto could look . . . Balthus, July 22, 1970. "If only one . . . Document 139. Art, it seemed . . . Bibl. 249.

Late in September . . . Bibl. 134.

27

Diego met her . . . DG, Oct. 4, 1970; March 16, 1972; May 4, 1973; June 14, 1976. G. Gruber, May 26, 1970. BG, June 25 and Oct. 22, 1970. She was not . . . Idem. After the pseudo- . . . Idem. No such step . . . Idem. Annette Giacometti, Jan. 29 and May 24, 1970. toward Isabel Delmer . . . DG, June 22, 1972. Bibl. 134. Isabel was pleased . . . Idem. For his part . . . Letter AG to I. Rawsthorne, c. 1937. One evening in 1937 . . . Bibl. 46. Since he had . . . Bibl. 13; 29. Bewildered, alarmed . . . Idem. "I always have . . . Bibl. 30.

28

"So he sees that ... Document 47.

"They recharge my . . . Conversation with author, 1954.
"Sometimes," he once . . . Idem.
"I know very well . . . Recorded statement by artist.
"There was more . . . DG, June 17, 1977.
But no man can . . . Bibl. 137.

The summer of 1937 . . . BG and OG, June 27, 1970. As the time . . . Idem.

29

"I have little . . . Bibl. 119. The first several . . . Idem. While walking . . . Idem. Letters S. Beckett to author, Nov. 7, 1977; Oct. 28, 1978. Beckett's art reveals . . . Bibl. 248. Giacometti and Beckett . . . S. Beckett, April 21, 1970. "It's your luck . . . Huguette, Feb. 18, 1970. Efstratios Eleftheriades . . . E. Tériade, Feb. 11, 1970; Sept. 3, 1971. A. Skira, July 6, 1970. DG, May 24, 1971. Giacometti had attracted . . . Idem. There were several . . . DG, Jan. 14, 1970. H. Cartier-Bresson, May 18, 1970; Sept. 18, 1976; Nov. 28, 1977. S. Sidéry, Sept. 17, 1979. As events in . . . Bibl. 134.

30 That afternoon was . . . Bibl. 46. Document 554. That evening Alberto . . . Idem. Document 48. To walk from . . . Idem. The rue Saint-Roch . . . Idem. Suddenly an automobile . . . Idem. DG, March 27, 1970. People came running . . . Idem. B. Galante, Aug. 8, 1970. It drove very . . . Idem. BG, June 26, 1970. Caroline, July 3, 1971. When they arrived ... Idem. Diego arrived in . . . DG, Feb. 3, 1970. The metatarsal arch . . . Dr. Leibovici, May 14 and Sept. 22, 1970. Isabel came to . . . I. Rawsthorne, March 13, 1970. When not laughing . . . DG, May 22, 1970. When the swelling . . . Dr. Leibovici, May 14, 1970. DG, Meanwhile, consequences . . . March 27, 1970; Feb. 24, 1972.

31

Walking with crutches . . . DG, Jan. 21, 1978. Dr. Leibovici, May 14, 1970. Autumn passed . . . DG, Oct. 10, 1971. It seemed that . . . J. Genet, May 14, 1970. Bibl. 46.

what matters to an artist . . . Bibl. 137. One night Alberto . . . H. Wescher, Feb. 18, 1970. Four years younger ... Bibl. 147. Of those who . . . J.-P. Sartre, Jan. 12, 1979. So the friendship between . . . Idem. Bibl. 46. Giacometti's work . . . Idem. At the time of ... DG, Oct. 10, 1971. Bruno saw an . . . BG, June 25, 1970; March 3, 1978. DG, May 1, 1974. The artist arrived . . . Idem. Alberto insisted . . . Idem. Picasso, however, in . . . F. Gilot, Jan. 28, 1970. Dora Maar, March 5, 1970. He asked Alberto . . . Pablo Picasso, April 22, 1954. AG, Sept. 21, 1964. Picasso was neither . . . Idem. If such sarcasms . . . Idem. A. de

Watteville, Oct. 25, 1971. F. Gilot, June 20, 1973.
Picasso probably . . . Idem. DG, Nov. 4, 1971.
Alberto and Isabel . . . I. Rawsthorne,

Nov. 15, 1972. "Women devour you . . . Bibl. 145. 32 In August, 1939 . . . Letter AG to I. Rawsthorne, Aug. 1939. After a week . . . Idem, and letter to same, Sept. 2, 1939. Returning alone . . . Idem, and letter to same, Oct. 19, 1939. Diego was entitled . . . DG, May 8, 1978. Never one to . . . DG, April 12, 1970; Jan. 19, 1972; July 25, 1972; March 25, 1974. E. Schiaparelli, April 13, 1970. Jean-Michel Frank . . . DG, Aug. 27, Alberto took a . . . DG, March 20, 1970. Isabel was still . . . I. Rawsthorne, Oct. 27, 1971. And it was then . . . Conversation 6. Alberto and Diego . . . AG, Aug. 31, 1964. DG, Jan. 14 and 26, 1970; May 24 and 30, June 28, Oct. 17, 1971; May 30 and Aug. 27, 1972. Diego had no ... Idem. Alberto did . . . Idem. It was a ... Idem. In the morning ... Idem. Beyond Etampes . . . Idem. The exodus went . . . Idem. Alberto said . . . Idem.

They set out . . . Idem. Those ten days . . . Letter AG to mother, Sept. 13, 1940.

The war had made . . . DG, Feb. 16, 1970; March 1, 1972. Diego enrolled . . . Idem. Annetta worried . . . Idem. But there was . . . Idem. "of less ridiculous . . . Bibl. 58.

34

The reunion of ... Letter AG to BG, Jan. 1942. Annetta was not . . . S. Berthoud, July 4, 1970. Dr. Francis Berthoud . . . Idem. Of the several . . . Annette Giacometti, April 12, 1970. Y. Bolognesi, July 3 and 5, 1970. Giacometti's arrival . . . C. Ducloz, July 4 and 5, 1970. R. Montandon, Oct. 18, 1970. D. Kronig, Feb. 20, 1972. No time was . . . BG, June 25, 1970. Y. Bolognesi, July 3, 1970. A. Skira, July 6, 1970. Days were spent . . . Idem. S. Berthoud, Dec. 11, 1974. BG, Oct. 20, 1978. The artist's daily . . . Idem. Between the Place . . . C. Ducloz, July 4, 1970. Man's inclination to . . . Idem. "Not that one . . . DG, Sept. 14, 1973. Even Annetta Giacometti . . . BG and OG, Sept. 26, 1974. "You don't know . . . Idem. It was a bad . . . Idem. OG, Oct. 23,

35

1970. D. Kronig, Feb. 20, 1972. R.

Montandon, March 6, 1972.

Annetta Giacometti kept ... Idem.

The only person . . . Idem.

It was an unhappy . . . Idem.

Alberto fell prey ... Idem.

Isabel had stood . . . Bibl. 46. The nude is ... Bibl. 132. "When I am . . . Bibl. 44. And he later said . . . A. Masson, Jan. 16, 1970.

36

Sometime in the . . . Annette Giacometti, April 12, 1970. C. Ducloz, June 25, 1971.

Isabel, meanwhile . . . Bibl. 134. Diego, on the other . . . DG, June 28, 1970; Oct. 22, 1971; Feb. 6, 1972; Feb. 6, 1979. Diego often . . . Idem. Every day ... Idem. One spring morning . . . Idem. In the meantime . . . C. Ducloz, Oct. 19, 1970. R. Montandon, March 6, 1970. Annette Giacometti, March 24, Annette was the . . . Idem. H. and G. Arm, June 25, 1971. Bibl. 60. Conversation 1092. Compared with such . . . Idem. Conversation 1392. Alberto seems to . . . Idem. Annette no doubt ... Idem. The Arms were . . . Idem. Learning of the ... Idem. The meeting was . . . Idem. BG, June 25, 1970. The Arms henceforth . . . Idem. She idolized . . . C. Ducloz, June 25, 1971. He called her . . . Idem. Y. Bolognesi, July 5, 1970. Annette Giacometti, March 24, 1970. Having finished . . . A. de Watteville,

Oct. 25, 1971. C. Laurens, Jan. 4. 1972. F. Gilot, June 20, 1973.

Annette was not . . . Idem. Conversation 311.

37

One of these was . . . DG, Jan. 26, 1970; March 4, 1976; Feb. 6, May 2, June 1, 1979. On August 24 . . . Idem. "That fool is . . . R. Montandon, March 6, 1970. Isabel had sent . . . Letter AG to I. Rawsthorne, May 14, 1945. Whatever the ambiguities . . . C. Ducloz, Nov. 2, 1979. Annette was not . . . Annette Giacometti, April 19, 1970.

One of Diego's . . . DG, March 28, 1970; June 12 and Nov. 19, 1972; Sept. 21, 1979. R. Wernick, April 29,

Alberto several times . . . DG, Sept. 24 and Oct. 10, 1979.

He burned most . . . Y. Bolognesi, June 25, 1971.

Instead of turning . . . Annette Giacometti, April 19, 1970. September 17, 1945 . . . Document 575.

It was an . . . DG, Jan. 27, 1977; Sept. 24 and Oct. 10, 1979.

Pleased, surprised . . . Idem. AG, Sept. 24, 1964.

When evening came ... Idem.

He was unhappy . . . Idem. R. Wernick, April 29, 1970.

Isabel had arrived . . . I. Rawsthorne, Nov. 15, 1972.

Their first meeting . . . Idem.

The inconclusiveness . . . Idem. DG, Jan. 6, 1975.

Isabel was not . . . H. Cartier-Bresson, Jan. 13, 1979.

Thus, the friend . . . DG, Oct. 11, 1979. G. Plénel, Nov. 18, 1979. Bibl. 123.

"Everything that I am . . . C. Ducloz, June 25, 1971.

Diego was worried . . . E. Tériade, Feb. 11, 1970.

They had no . . . N. de Gunzburg, March 15, 1971. H. P. Horst, Jan. 3, 1980.

Times were hard . . . AG, Sept. 24, 1964.

Alberto was only . . . Idem.

On Christmas Day . . . G. Gruber, April 9, 1970. F. Tailleux, May 11, 1970. R. Montandon, Feb. 3, 1972.

"Well, what about . . . In French: "Ça alors!"

Isabel did not . . . Idem. R. Leibowitz, June 2, 1970.

The young man . . . Idem. Alberto was not . . . Idem.

39

A day came . . . M. Leiris, May 13, 1970. Bibl. 105.

In Geneva, Annette . . . Conversation 856. Bibl. 60.

Alberto replied . . . Idem. M. Repond, July 5, 1970. D. Kronig, Feb. 20, 1972.

He asked her to do . . . R. Montandon, Feb. 3 and March 25, 1972.

It was a ... Idem.

Having followed ... Idem.

"The true revelation . . . Selection and reorganization of statements by AG to author. Also Bibl. 15; 25; 46; 193.

"From that day ... Idem.
"I began to see ... Idem.

As usual, Alberto . . . E. Tériade, Feb. 11, 1970. F. Gilot, July 8, 1971. DG,

Oct. 17, 1971. Document 463. Bibl. 50; 56; 193.

40

At Easter, 1946 . . . Annette Giacometti, March 24 and May 8, 1970. Document 575.

The point of ... Idem.

One good measure . . . Idem.

Back in Paris . . . Patricia Matisse, April 24, 1970.

Alberto's friends in . . . Idem.

One spring day . . . DG, Jan. 26, 1970; May 2 and June 28, 1971; June 19, 1979.

If the question . . . DG, Jan. 21, 1970; Oct. 17, 1971; March 11, 1974.

The only Parisian . . . Idem.

Other possible dealers . . . L. Clayeux, June 23, 1971.

When he came to France . . . Pierre Matisse, April 21, 1971. DG, Oct. 17, 1971; May 25, 1980.

He had sworn not ... Bibl. 13. "Perhaps I'm more ... Bibl. 46.

41

Annette Arm left Geneva . . . Annette Giacometti, Feb. 25, 1971. Document 575.

Alberto was at . . . Balthus, July 23, 1970.

She thought him . . . Annette Giacometti, May 24, 1970.

He found her . . . DG, Sept. 26, 1971. Alberto took her . . . Balthus, July 23, 1970.

Tonio Pototsching had . . . DG, Jan. 26, 1970; June 28 and 29, 1971. Bibl. 12.

"No corpse . . . Bibl. 12.

"I helped to . . . Idem.
"When I went . . . Idem.

the dead reveal . . . Bibl. 125.

Times continued hard . . . E. Tériade, Feb. 11, 1970. H. Wescher, Feb. 18, 1970. Patricia Matisse, April 24, 1970. R. Sadoul, May 26, 1980.

"Well, I'm going . . . B. Galante, Aug. 8, 1970.

"You can't just . . . Idem.

To Bianca . . . Idem.

everyone who knew . . . D. Sylvester, June 8, 1971. I. Rawsthorne, June 9, 1971.

People thought . . . G. Gruber, April 9, 1970. B. Galante, Aug. 8, 1970. L. Bataille, Sept. 25, 1970.

One October Saturday . . . Bibl. 12. At six o'clock . . . Idem. Assuming that he . . . Idem. That same night . . . Idem. Presently, with . . . Idem. "Terrified, I saw . . . Idem. "At that moment ... Idem. Awake, he looked . . . Idem. The dream obsessed . . . Idem. After lunch, Alberto . . . Idem. Leaving Fraenkel's ... Idem. On his way . . . Idem. It is generally . . . W. Muensterberger. April 30, 1971, Bibl. 130. When attempting ... Idem. Nightmares frequently . . . Idem. Giacometti's sculptures . . . Bibl. 47. "What is important . . . Bibl. 27.

The winter of . . . Letter AG to I. Rawsthorne, Feb. 2, 1947. Patricia Matta and . . . Pierre Matisse, Feb. 4, 1971. Devoted to Alberto . . . DG, Sept. 24, an informal arrangement . . . DG, Oct. 17, 1971. In ancient Egypt . . . Bibl. 137. It has been said . . . Bibl. 46. The first of these . . . DG, Oct. 29, a few scrawled phrases . . . Document Pierre Matisse was . . . Letter AG to Pierre Matisse, Nov. or Dec. 1947. but the dealer remained . . . DG, June 29, 1977. He compared Paris . . . Notes made by R. Vollmer, July 1951. Practical preparations . . . DG, April 15, 1977. Letter AG to Pierre Matisse, Nov. or Dec. 1947.

Annette did not . . . Letter AG to I. Rawsthorne, 1948. Alberto does not . . . Conversation 113. Their relationship was . . . Conversations 105; 173; 200; 616; 1180. Her position was . . . Conversation 1190. Annette suggested . . . Annette Giacometti, Jan. 29, 1970. The shadow months . . . Documents 264: 272: 312: 414. People were sometimes . . . E. Korn-

feld, June 21, 1970; Oct. 31, 1980.

Diego made a ... Documents 248: 256. Sometime in 1948 . . . DG, July 25, In the rue . . . DG, Feb. 1, 1970; Oct.

10, 1971.

Francis Gruber . . . G. Gruber, April 9, 1970.

Loss of one . . . Y. Bonnefoy, May 21, 1970. J.-P. Lacloche, July 28, Oct. 7 and 16, 1970. L. Bataille, Sept. 25. 1970. J. Lagrolet, July 29, 1972. F. Gilot, Feb. 19, 1973. S. Massart-Weit, Feb. 25, 1981.

Not long afterward . . . Idem. The two young men . . . Idem. Prospects at first . . . Idem. Whether or not Isabel . . . R. Leibo-

witz, June 2, 1970. "In a burning building . . . Bibl. 46. "What I am looking . . . Bibl. 30. Annette wanted to . . . DG, July 5, "The easiest thing . . . Conversation 244. Annetta had come . . . Conversations 300; 809. An explanation of sorts . . . Conversations 504: 1050: 1403. However, he wanted it . . . Conversations 62; 487. he insisted that the . . . DG, Nov. 9, 1971. Needless to say, . . . DG, June 29, 1970. A honeymoon would . . . R. Hohl, June 23, 1970. "In every work . . . Bibl. 11. Partly at the . . . A. Thirion, June 29, 1971. He began with a . . . DG, May 17, 1971; Jan. 11, 1978; March 15, 1981. The men from the 19th . . . A. Thirion, June 29, 1971. "The Chariot could . . . Bibl. 90. "Art interests me . . . Bibl. 25. "The motor that . . . Bibl. 30. he is reported to ... Bibl. 241. the story of painful . . . D. Sylvester, June 8, 1971. I. Rawsthorne, June 9, 1971. Caroline, July 3, 1971. R. Hohl, May 28, 1972. Bibl. 97; 262. "While working I . . . Bibl. 46.

When Madame Maeght . . . Patricia Matisse, Nov. 22, 1969. In school at . . . A. Maeght, Oct. 28,

1969. Y. Bonnefoy, June 18, 1970. G.

Picon, Oct. 10, 1970. DG, May 19, 1972. L. Clayeux, Feb. 7, 1980. Many Jews ... Idem.

Maeght went . . . Idem.

The pleasure proved ... Idem. With good provisions . . . Idem.

Like so many . . . J. Dupin, April 3, 1970. L. Clayeux, Oct. 22, 1970; June 4, 1978.

The young director . . . Idem. A. Maeght, May 29, 1970.

It was also the presence . . . AG, Sept. 23, 1964.

Giacometti's prestige and . . . BG, Oct. 20, 1978.

What Giacometti refused . . . Bibl. 218. The second Giacometti . . . Pierre Matisse, Dec. 8, 1980.

At 7 a.m. sometimes . . . DG, Jan. 30, 1972.

"Picasso used to be . . . G. Braque in conversation with author, 1960.

Giacometti's visits . . . F. Gilot, July 8, 1971. DG, June 28, Dec. 17, 1973; June 17, 1977; Oct. 11, 1979; May 25, 1980.

One day when . . . L. Clayeux, June 4, 1978. DG, Oct. 11, 1979.

In November of . . . F. Gilot, July 8, 1971. E. Tériade, Sept. 3, 1971. Letter AG to mother, Nov. 26, 1951.

Then Picasso performed . . . AG, Sept. 20, 1964.

"Picasso altogether bad . . . Bibl. 265. The sculptor and the painter . . . Y. Bonnefoy, May 21, 1970. M. Leiris, Nov. 16, 1979.

47

The wildest dreams . . . Conversations 245; 1180.

The matter was . . . AG, Aug. 6, 1964. However, if the . . . Conversation 1180. Alberto's willingness for . . . Conversations 6; 33; 37; 200; 829; 883; 995; 1018; 1180; 1245.

Diego, too, was . . . DG, Jan. 31, 1973; Feb. 21, 1975; Dec. 13, 1978.

"Oh, he's impossible . . . DG, Oct. 21, 1970.

He desired it to be . . . H. Wescher. Feb. 18, 1970. D. Sylvester, March 8,

It was at Alberto's insistence . . . M. Maeght, Feb. 7, 1972.

G. David Thompson . . . DG, Jan. 26,

1970; Oct. 17, 1971. C. Weidler, Feb. 24, 1971. R. Washburn, May 13, 1971. There were times . . . Conversation 263.

"Alberto was my . . . DG, May 15,

Sometime during these . . . DG, July 6, 1981.

Alberto's meticulous care . . . Letter AG to Pierre Matisse, 1951.

48

The war years . . . Bibl. 119.

Beckett came near . . . Idem.

As soon as possible . . . Idem. Henri Laurens was . . . C. Laurens, July 10, 1981.

The Galerie Maeght . . . Pierre Matisse, April 21, 1971.

Clayeux was content . . . L. Clayeux, June 23, 1971.

It was Clayeux . . . Idem.

The direct relation . . . Idem.

Henri Matisse was . . . M. Duthuit, April 27, 1978.

Old age, however . . . M. Duthuit, Oct. 6. 1976. Letter AG to mother, June 28, 1954. Bibl. 46.

Two months later . . . Idem.

André Derain enjoyed . . . E. Defferre, Feb. 5, 1972.

Léna Leclercq was . . . Balthus, Oct. 21, 1970. A. de Watteville, Oct. 25, 1971.

Léna was a little . . . Idem.

After a while . . . Conversation 1272.

One day Giacometti . . . R. Wernick, April 29, 1970. J. Genet, May 14, 1970. "Every work of art . . . Bibl. 44.

"His sculptures . . . Idem. "Confronted by his . . . Idem.

"As for the ... Idem.

"Giacometti is not . . . Idem.

The understanding between . . . J. Genet, May 14, 1970.

The writer decided ... Bibl. 49.

Giacometti kept his . . . Y. Bonnefoy, May 21, 1970. Document 191.

One day an old . . . G. Plénel, July 3, 1973.

50

In his letter of . . . Letter AG to R. Cogniat, Dec. 5, 1955.

"When you think of ... Bibl. 49. When a spectator's attention . . . Bibl.

Comparable to the . . . Bibl. 252.

"I don't know . . . D. Kronig, Feb. 20, 1972.

"Strange feet or . . . Bibl. 44.

Early in June . . . Letter AG to Pierre Matisse, 1956.

The mood of the . . . Conversation 862. Monsieur and Madame Arm had . . . Annette Giacometti, Aug. 27, 1964.

Annette, however . . . P. Bruguière, Feb. 23, 1970. Patricia Matisse, April 24, 1970.

One day Alberto . . . A. Geissbuhler, March 30, 1971.

"Like me . . . Idem.

"What about . . . Idem.

"Oh, you ... Idem.

"Hair is a . . . P. Schneider, July 29,

One day he . . . J. Hartmann, June 20,

Diego watched what . . . DG, Jan. 31, 1973.

Isaku Yanaihara . . Letter H. Scott Stokes to author, Dec. 16, 1981. Isaku received . . . Idem. The post-war climate . . . Idem. He found life . . . Idem. Bibl. 59. One day he . . . I. Yanaihara, Feb. 7, 1982. The winter passed . . . Idem. The visit to ... Idem. Bibl. 60. Weeks passed . . . Idem. Diego did not . . . DG, Oct 2, 1973; Feb. 21, 1984. Annette was amused . . . Bibl. 60. Yanaihara's homeward . . . I. Yanaihara, Feb. 7, 1982. One afternoon . . . Bibl. 60. The next day ... Idem. That evening . . . Idem. Alberto claimed ... Idem. "It had seemed . . . Bibl. 49. Annette was happy . . . Bibl. 60. Her happiness was ... Idem. Alberto was also . . . Idem. He seemed indispensable . . . Idem.

52

The Chase Manhattan . . . G. Bunshaft, March 18, 1971. Alberto wrote to . . . Letter AG to mother, Jan. 1, 1957. Thompson was the . . . C. Weidler, Feb. 24, 1971. "Look at those . . . H. Roethel, May

25, 1977.

Having encountered no . . . P. Souvtchinsky, Nov. 4, 1971. Letter AG to mother, Oct. 11, 1957. Letter R. Craft to author, Oct. 26, 1971.

Stravinsky was . . . Idem.

The third Giacometti . . . June 28, 1973; Nov. 26, 1978.

Writing with . . . Letter AG to mother, June 2, 1957.

If, at the corner . . . DG, Dec. 17 and March 9, 1972; Jan. 5, 1975. Letter AG to Pierre Matisse, May 16, 1958.

Clayeux was one . . . AG, Sept. 23, 1964. Conversations 588; 804; 806. A fool, in . . . DG, May 11, 1970. the business was public . . . Bibl. 288. The next night . . . Letter AG to

mother, Sept. 29, 1957.

"The sensation I . . . Bibl. 10. the sculptor explained . . . Letter AG to Pierre Matisse, April 24, 1958. Letter AG to unknown recipient, Feb. 13, 1960.

he had never made any effort . . . Bibl.

Yanaihara did not come . . . Letter H. Scott Stokes to author, Dec. 16, 1981. "I know that ... Document 281.

"I truly regret . . . Document 269.

"Work hard, have . . . Document 280. She herself had ... Idem.

"I think back on . . . Bibl. 144. During his stay . . . M. Leiris, Nov. 10, 1971.

Suicide was often . . . Bibl. 49. "Today I feel weak . . . AG in con-

versation, March 1960. Giacometti did not take . . . Bibl. 84.

Alberto's friends said . . . Conversations 136; 504; 829.

Annette's humor swung . . . Documents 201; 208.

Between the artist . . . L. Clayeux, May 27, 1970. Bibl. 46.

The difficulty distressed . . . Idem. Structure was what . . . Bibl. 36. Color began to ... Bibl. 46.

It had also grown . . . Idem.

54

One evening in . . . Caroline, June 30, July 3, Oct. 5, 1971. The girls who ... Idem. After a while ... Idem. "Let's go in . . . Idem.

Alberto said . . . Idem. "I feel like . . . Idem. So they went ... Idem. Caroline, to begin . . . AG. Sept. 25. 1964. Caroline, July 3, and Sept. 24. The relationship between . . . Idem. Faithful to her ... Idem. Marlene Dietrich was . . . Letter M. Dietrich to author, Jan. 29, 1982. Arriving in Paris . . . Idem. DG, Oct. 4, 1970. They were attracted . . . AG, Sept. 12, 1964. BG, Sept. 27, 1974. Caroline was displeased . . . Caroline, Sept. 24, 1971. "Fortunately," he . . . Document 160. Annette's own concerns . . . Document Paola Thorel . . . P. Caròla, Feb. 17, 1979. For eight months . . . Idem. Sometime in the . . . Caroline, Sept. 29, 1971. Letter AG to Caroline, March 1, 1960. Diego took one . . . DG, Sept. 6, 1973. Alberto brushed aside . . . AG, Sept. 13. Annette at first . . . Caroline, Oct. 5. 1971. Late in February . . . Letter AG to Caroline, undated, from Zurich. True to form . . . Letter AG to Caroline, March 1, 1960. Document 352. Alberto was safely . . . Idem. Then Caroline vanished . . . Letter AG to Caroline, May 2, 1960. Giacometti could be . . . Letters AG to Caroline, May 2, 5, and 6, 1960. Having searched for ... Idem. To which he . . . Idem. Albeit in prison . . . Idem. It was he ... Idem. At night, at . . . Caroline, July 3. Sept. 24 and 29, 1971. Needing help, he . . . L. Clayeux, May 27, 1970. Giacometti to meet . . . AG, Sept. 12,

55

Given Giacometti's . . . Idem.

On the 20th ... Document 472.

1964.

It did not help . . . Caroline, Sept. 29, 1971.

Jealous, resentful . . . AG, Aug. 6, 1964.

She became increasingly . . . Idem. "If I could actually ... Bibl. 46. "nostalgia for the . . . Bibl. 58. never to make another . . . Letter AG to Pierre Matisse, April 29, 1960. Not Clayeux. He felt . . . AG, Sept. 23, 1964. Elusive, deceptive, ambiguous . . . Caroline, July 3 and Sept. 24, 1971. Document 353. His pleasure was ... Bibl. 57. One day a couple . . . A. Maeght, Oct. 28, 1969. While in prison . . . R. Leibowitz, June 2, 1970. L. Whiffin, Aug. 9, 1970. Caroline began her . . . Idem. After some months . . . Idem. One day she . . . Idem. Unable to be ... Idem. After being portrayed . . . A. Maeght, May 29, 1970. It was no secret . . . Conversations 45; 75; 94; 200; 1180. Between Alberto and . . . Caroline, Sept. 24, 1971. old friends were occasionally . . . L. Fernández, June 9, 1973. He wanted to possess . . . Caroline, July 3, 1971. Caroline was willing . . . Idem.

56

Giacometti said: "One . . . Bibl. 46.

"It becomes always . . . Idem.

"It would give us all . . . Letter S. Beckett to AG, March 3, 1961. "All one night . . . Bibl. 57. during the final decade . . . DG, June 28, 1982. She demanded that Alberto . . . Caroline, June 30, 1971. There were violent scenes . . . G. Masurovsky, Jan. 8, 1972. Not only to Annette . . . OG, Oct. 21, 1978. a great emotion, which ... Bibl. 121. Annette's tantrums became . . . Document 208. Alberto was worried . . . J.-P. Lacloche, Jan. 24, 1972. the light burning by . . . Document 201. His fear of the dark . . . Bibl. 30. The true emotion . . . Bibl. 130. Alberto's mother . . . Document 267. In the house at Maloja . . . OG, July 2, 1982. Annetta's health . . . DG, Sept. 11, 1979.

On the fifth . . . BG, June 30, 1970. S. Berthoud, May 2, 1982.

To some of the people . . . Conversation 482.

"I don't know who . . . Document 164.

57

Caroline, too . . . Caroline, Sept. 29, 1971.

"People tell me . . . Bibl. 46.

It was not merely . . . Letter AG to Caroline, July 10, 1961.

He identified himself ... Idem. "I was his ... Caroline, July 3, 1971.

She loved toads . . . Caroline, June 30, 1971.

Diego was unhappy . . . DG, Jan. 14, 1970.

Annette thought . . . Annette Giacometti, May 24, 1970.

he told his mother . . . Letter AG to mother, Jan. 31, 1960.

To install so many . . DG, Oct. 10, 1971; June 22, 1972; June 8, 1973; June 28, 1982.

Giacometti now ranked ... Idem. Pierre Matisse, Patricia ... Idem.

Diego had heard . . . Idem.

While Giacometti's . . . Caroline, Sept. 24, 1971. Documents 324; 331; 332.

After the prize-awarding ... BG, Nov. 10, 1975.

"It would really . . . C. Weidler, Feb. 24, 1971.

"Nobody works like me . . . Bibl. 60.
Alberto said that he derived . . . Bibl. 58.

"It creates and . . . Bibl. 23. "Painting as we . . . Bibl. 36.

58

G. David Thompson . . . C. Weidler, Feb. 24, 1971. R. Washburn, May 13, 1971.

Dave Thompson was . . . Idem.

Thompson reiterated . . . DG, Aug. 8, 1972.

A week later . . . E. Beyeler, June 22, 1970.

The question asked . . . Idem.

"The Sound and . . . Conversations 189; 244; 440; 509; 1018.

In search of . . . Annette Giacometti, March 24, 1970. Conversations 290; 355.

Jean-Pierre Lacloche . . . J.-P. Lacloche, July 28, 1970.

Meanwhile, Annette's . . . Idem.

Mrs. Rawsthorne's occasional . . . I.
Rawsthorne, March 13, 1971.
the painted scream seemed . . . Bibl.

142.

"I serve champagne . . . J. Bernard, June 7, 1973.

Alberto was fond . . . F. Bacon, April 18, 1970.

"Do you think it's . . . AG, Sept. 18, 1964.

One evening in 1962 . . . I. Rawsthorne, June 7, 1973.

In private, Alberto expressed . . . Conversation 24.

For years he had suffered . . . AG, Sept. 30, 1964. R. Ratti, June 30, 1970.

At the Broussais . . . Idem. He was none other . . . R. Leibovici,

May 14 and Sept. 22, 1970.

Dr. Leibovici . . . Idem. R. Ratti, June 30, 1970.

"If it were cancer . . . S. Lacan, May 25, 1970.

Dr. Serafino Corbetta . . . DG, Feb. 6, 1970.

Having failed to . . . Annette Giacometti, March 24, 1970.

Annette said as much . . . R. Leibovici, May 14, 1970.

The operation, performed . . . Idem. He did not, however . . . Idem. E. Kornfeld, Feb. 27, 1975.

Then he consulted . . . Annette Giacometti, March 24, 1970.

After three weeks . . . Idem.

Diego didn't like . . . DG, May 9, 1973. Exuberant at the . . . AG, Sept. 28, 1964. Annette Giacometti, March 24, 1970. DG, May 9, 1973.

"What worrying . . . Idem.

"Oh, you'll . . . Idem.
"What about . . . Idem.

"Oh, nothing . . . Idem.

But it was . . . Idem. The doctor . . . Idem.

So the doctor ... Idem.

When he left ... Idem.

Arriving in Stampa . . . Idem. For the moment . . . Idem.

it seemed that the loss . . . R. Montandon, March 6, 1970. M. Fraenkel, Jan. 13, 1975.

As to his own . . . AG, Sept. 30, 1964.

"Maybe I'll be dead ... Bibl. 193.

"And what would ... Idem.

"I'd probably do ... Idem.

Never forgetting that . . . R. Ratti, June 30, 1970. "More than twenty years ... Bibl. 156.
"At the age of ... Idem.
Giacometti was thunderstruck ... AG,
Sept. 24, 1964.
Alberto had not needed ... Idem.
The two men were never ... J. Leymarie, April 7, 1970. DG, March 1,
1972.
Annette complained that he ... Annette Giacometti, May 24, 1970.

André du Bouchet . . . Annette Giacometti, Aug. 27, 1964. Conversations 17, 289; 651; 1048.

The matriarch of . . . AG, Sept. 30, 1964. DG, Feb. 15, 1973; Feb. 7 and May 15, 1980. BG and OG, July 1, 1970; Sept. 27, 1974; July 9, 1978. Annette Giacometti, May 24, 1970. S. Berthoud, Dec. 11, 1974.

Annette Giacometti, May 24, 19
S. Berthoud, Dec. 11, 1974.
Caring for the . . . Idem.
Very early one . . . Idem.
When it was over . . . Idem.
Hearing his calls . . . Idem.
"A head that has unreal . . . Bibl. 46.
"For me," he said . . . Bibl. 25.
"Art interests me . . . Idem.
"I believe I progress . . . Idem.
"That adventure is . . . Idem.

60 Sound and fury . . . Caroline, June 30, 1971. Conversations 290; 403. She went to . . . Idem. "A man of feeling . . . Conversation 243. Divorce was discussed . . . Conversations 295; 487; 1180. "Will people assume . . . Conversation 263. She wanted him to come . . . AG, Aug. 6, 1964. "There are many . . . AG, Aug. 29, "Who?" demanded . . . Idem. "General de Gaulle . . . Idem. Annette slept badly . . . Conversations 91; 539. Squeezing the balls . . . Idem. The next afternoon . . . Idem. "If I go on . . . Bibl. 49. Annette had neither . . . Annette Gia-

cometti, March 24, 1970.

1964. Caroline, Sept. 29, 1971.

Thanks to Alberto . . . AG, Sept. 13,

She professed to be ... Idem. One day, when . . . J. Hartmann, June 20, 1971. Giacometti had to ... Idem. If she was a pawn . . . AG, Sept. 13, 1964. L. Clayeux, May 27, 1970. DG, Dec. 21, 1972. Alberto spoke to ... Idem. Alberto would not . . . Y. Bonnefoy, May 21, 1970. Caroline was not . . . AG, Sept. 15. 1964. A Swiss girl . . . Idem. A beautiful ballerina . . . BG, June 26, 1970. M. Béjart, Feb. 8, 1971. She wanted to bear . . . Caroline, Oct. 5, 1971. Alberto was kind . . . F. Mayo, March 2, 1971. Letters F. Mayo to author, Dec. 20, 1971; March 26, 1972.

61

Aimé Maeght had gone on . . . AG, Sept. 23 and 28, 1964. DG. Feb. 6. 1970; Jan. 11, 1972; May 9, 1977; Sept. 24, 1981; Aug. 10, 1982. J. Leymarie, Feb. 2, 1970. Patricia Matisse, Feb. 14, 1970. Pierre Matisse, July 8 and 9, 1970; March 8, 1977. D. Lelong, May 8 and 25, 1970; June 23 and Oct. 13. 1971. L. Clayeux, May 27, 1970. G. Picon, Oct. 10, 1970. BG, Nov. 17, 1975. J. Dupin, Feb. 24, 1978. Y. Bonnefoy, Oct. 18, 1978. If Aimé had . . . Idem. Alberto had come . . . Idem. Picasso sent word . . . Idem. "He amazes me . . . Idem. Bibl. 133. The great night of ... Idem. Maeght having concluded ... Idem. Clayeux felt that . . . Idem. The following day . . . Idem. Clayeux, in the . . . Idem. Swaddled in the . . . Idem. It was like ... Idem. Clayeux made up . . . Idem. He wrote a long . . . Idem. Aimé and Guiguite . . . Idem. In anticipation of . . . J.-P. Lacloche, July 28 and 30, 1970. L. Clayeux, June 23, 1971. DG, Jan. 5, 1972. BG and OG, July 9, 1978. To a friend who . . . Idem. Elie Lotar had no . . . M. Quesada-Brujas, Jan. 15, 1979. "When Michelangelo fashioned . . .

Bibl. 23.

It was at St. Ermin's . . . D. Sylvester, June 15, 1970. DG, Sept. 21, 1979. He was clearly embarrassed . . . L. Clayeux, May 27, 1970. In New York, the . . . Letter AG to author, Sept. 1965. Annette assumed . . . Conversation 246. "I have hardly looked . . . Bibl. 45. "Impossible to concentrate . . . Idem. Sound and fury promptly . . . Annette Giacometti, Jan. 29, 1970. Alberto said, "How many . . . H. Cartier-Bresson, May 18, 1970. So it was also . . . J.-P. Lacloche, July 28, 1970. That was Jean-Pierre's . . . Idem. Few mourners were . . . Idem. "It's curious that I . . . Bibl. 46. The ceremony in Bern . . . OG, June 25, 1970. BG, Sept. 26, 1974; Nov. 10, 1975; Oct. 22, 1978. E. Kornfeld, June 21, 1970; July 9, 1978. In Bern, he . . . Idem. Kornfeld had been . . . Idem. Odette Giacometti . . . Idem. Back in Paris . . . Bibl. 263. "It's absurd to ... Idem. "Why?" said . . . Idem. "It is after three . . . Bibl. 38. "The quiet, I am ... Idem. "It seems impossible . . . Bibl. 263. "What?" inquired . . . Idem. "To make ... Idem. That night Alberto . . . Bibl. 46. The final day . . . Idem.

63

Renato Stampa ... Bibl. 46. However, he did not . . . Idem. The chief physician . . . N. Markoff, June 30, 1970. R. Ratti, Sept. 24, 1970. Bibl. 46. "Is it cancer . . . Idem. Examination showed . . . Idem. The presence of a ... Idem. During his stay . . . Idem. A few days . . . Idem. "I am convinced that nobody . . . Bibl. Annette was bored . . . Annette Giacometti, May 24, 1970. Diego came again . . . BG, July 1, 1970. On December 31 . . . R. Ratti, June 30, In the first days . . . Caroline, June 30,

1971.

"Well, if you're not . . . Idem. He did get out . . . Idem. BG, July 10, 1982. Annette was infuriated . . . Conversations 243; 244; 246. When Dr. Markoff . . . N. Markoff, June 30, 1970. "What a lot of trouble . . . BG and OG, June 30 and July 1, 1970. "Well, I've certainly ... Bibl. 57. "I'm going mad . . . N. Markoff, June 30, 1970. On Saturday . . . Caroline, June 30, 1971. Alberto continued . . . N. Markoff, June 30, 1970. "Soon again I'll . . . Idem. Bruno sat up . . . BG, July 1, 1970. Pierre Matisse, meanwhile . . . Letter Patricia Matisse to author, Jan. 16, Diego and Bruno had not . . . Annette Giacometti, May 24, 1970. In midmorning, Annette . . . Idem. Caroline, June 30 and Sept. 29, 1971. Caroline started . . . Idem. Annette was so ... Idem. Caroline was horrified . . . Idem. "Caroline," Alberto . . . Idem. Alberto and Caroline remained . . . Idem. Diego and Bruno arrived . . . BG and OG, July 1, 1970. Annette returned to . . . Idem. Caroline, Sept. 29, 1971. Back in the room . . . Idem. Diego went into . . . Idem. Bruno, fatigued . . . Idem. Diego announced . . . Idem. But Alberto said . . . Idem. Annette remained alone . . . May 24, 1970. About seven o'clock . . . N. Markoff, June 30, 1970. In Zurich, meanwhile . . . Patricia Matisse to author, Jan. 16, In the hospital room ... BG and OG, July 1, 1970. Toward ten o'clock . . . Idem. Annette, May 24, 1970. Caroline, Sept. 29, 1971. Caroline was just . . . Idem. Pierre Matisse, having . . . Letter Pierre Matisse to author, Feb. 14, 1966.

Snow was still . . . Caroline, Sept. 29,

"No." Alberto . . . Idem.

1971.

An autopsy was . . . N. Markoff, June 30, 1970.

The day after . . . DG, Jan. 18, Feb. 3, Sept. 21, 1979; April 13, 1980; Aug. 10, 1982.

When Diego arrived . . . Idem.

The funeral was held . . . DG, Jan. 26, 1970; Feb. 8, 1978; Sept. 21, 1979; Jan. 13, 1981. G. Picon, Oct. 10, 1970. D. Giovanoli, Sept. 12, 1971.

The artist's coffin . . . Idem.

"Look!" said Diego . . . Letter Pierre Matisse to author, Feb. 14, 1966. Those, however, whose . . . BG, July 1, 1970.

The little village . . . DG, Sept. 21, 1979; Jan. 13, 1981.

At two o'clock . . . Idem. San Giorgio is . . . Idem.

The first speaker . . . Idem. Having heard five men . . . Idem.

The pastor had a past ... D. Giovanoli, Sept. 12, 1971.

As a child ... Bibl. 5.

The family, the closest . . . BG and OG, July 1, 1970.

Bibliography

This biography of Alberto Giacometti is addressed to the general reader, but it was composed with the scholar also in mind, and I hope that both will find it worthwhile. Not being myself a scholar, however, I have neither aspired nor endeavored to produce a work commensurate with the exacting criteria of scholarship. Therefore, it has not seemed necessary to append an exhaustive bibliography, which would have added quite a few more pages to a book already very long. There follows, accordingly, a list of all the published material that has seemed essential or necessary, plus a good deal else. Everything, in any case, that has been helpful to me in my work is included. Anyone finding the list inadequate will certainly know how to make it less so with very little trouble.

WRITINGS AND STATEMENTS BY ALBERTO GIACOMETTI

- 1. "Objets mobiles et muets." Le Surréalisme au service de la révolution (Paris), No. 3 (Dec. 1931), pp. 18-19; ill. by Giacometti.
- 2. "Charbon d'herbe." Le Surréalisme au service de la révolution (Paris), No. 5 (May 1933), p. 15; ill. by Giacometti.
- 3. "Poème en 7 espaces." Ibid.
- 4. "Le rideau brun." Ibid.
- 5. "Hier, sables mouvants." Ibid., pp. 44-45.
- 6. [Replies by numerous artists to] "Recherches expérimentales: A. Sur la connaissance irrationnelle de l'objet: Boule de cristal des voyantes; B. Sur la connaissance irrationnelle de l'objet: Un morceau de velours rose; C. Sur les possibilités irrationnelles de pénétration et d'orientation dans un tableau: Georgio [sic] de Chirico: L'Enigme d'une journée; D. Sur les possibilités irrationnelles de vie à une date quelconque; E. Sur certaines possibilités d'embellissement irrationnel d'une vie." Le Surréalisme au service de la révolution (Paris), No. 6 (May 1933), pp. 10-19.
- 7. [Replies by numerous artists to] "Enquête: pouvez-vous dire quelle a été la rencontre capitale de votre vie? Jusqu'à quel point cette rencontre vous a-t-elle donné, vous donne-t-elle l'impression du fortuit? du nécessaire?" by André Breton and Paul Eluard. *Minotaure* (Paris), No. 3-4 (1933), pp. 101-16.
- 8. [Le palais de 4 heures.] Ibid., pp. 46-47.

- 9. "Le Dialogue en 1934" [André Breton and Alberto Giacometti]. Documents (Brussels), Nouvelle série No. 1 (June 1934), p. 25.
- 10. "Un sculpteur vu par un sculpteur: Henri Laurens." Labyrinthe (Geneva), No. 4 (Jan. 15, 1945), p. 3.
- 11. "A propos de Jacques Callot." Labyrinthe (Geneva), No. 7 (April 15, 1945), p. 3.
- 12. "Le rêve, le Sphinx et la mort de T." Labyrinthe (Geneva), No. 22-23 (Dec. 15, 1946), pp. 12-13; ill. by Giacometti.
- Letter to Pierre Matisse reproduced and translated in Alberto Giacometti (exhibition catalogue). New York: Pierre Matisse Gallery, 1948. See Bibl. 89.
- 14. Excerpts from a letter to Pierre Matisse and notes on the significance of titles in relation to the work in *Alberto Giacometti* (exhibition catalogue). New York: Pierre Matisse Gallery, 1950. See Bibl. 90.
- 15. Charbonnier, Georges. "Entretien avec Alberto Giacometti." Paris: ORTF, March 3, 1951. Published as "Entretien avec Alberto Giacometti" in *Le Monologue du Peintre*, Paris: René Julliard, 1959, pp. 159-70.
- 16. "1+1=3." Trans/formation (New York), 1 (No. 3, 1952), pp. 165-67; ill. by Giacometti. Reprinted from Bibl. 6 and Bibl. 11.
- 17. Taillandier, Y[von]. "Samtal med Giacometti." Interview in Konstrevy (Stockholm), 28 (No. 6, 1952), pp. 262-67; ill.
- 18. "Témoignages." [In thematic issue subtitled "Nouvelles conceptions de l'espace."] XXº Siècle (Paris), Nouvelle série No. 2 (Jan. 1952), pp. 71-72. Prose poem illustrated by Giacometti.
- 19. "Gris, brun, noir . . ." [On Georges Braque]. Derrière le miroir (Paris), No. 48-49 (June 1952), pp. 1-2, 5-6.
- 20. "Mai 1920." Verve (Paris), 7 (Jan. 15, 1953), pp. 33-34. Illustrated by Giacometti with drawings after Cimabue and Cézanne.
- "Derain." Derrière le miroir (Paris), No. 94-95 (Feb.-March 1957), pp. 7-8.
- 22. [Replies by numerous artists to] "A chacun sa réalité: Enquête par Pierre Volboudt." XXº Siècle (Paris), Nouvelle série No. 9 (June 1957), p. 35.
- 23. "La voiture demystifiée." Arts (Paris), No. 639 (Oct. 9-15, 1957), pp. 1, 4.
- 24. Watt, Alexander. "Paris Letter: Conversation with Alberto Giacometti." Interview in *Art in America*, 48 (No. 4, 1960), pp. 100-2; ill.
- 25. Schneider, Pierre. "'Ma Longue Marche' par Alberto Giacometti." Interview in L'Express (Paris), No. 521 (June 8, 1961), pp. 48-50 and cover; ill.
- 26. Text from an invitation to the exhibition "Gaston-Louis Roux." Paris: Galerie des Cahiers d'Art, 1962.
- Parinaud, André. "Entretien avec Alberto Giacometti: Pourquoi je suis sculpteur." Interview in Arts (Paris), No. 873 (June 13-19, 1962), pp. 1, 5; ill.
- 28. Schneider, Pierre. "Au Louvre avec Giacometti." Interview in *Preuves* (Paris), No. 139 (Sept. 1962), pp. 23-30; ill.

- 29. Dumayet, Pierre. "La Difficulté de faire une tête: Giacometti." Interview in Le Nouveau Candide (Paris), June 6, 1963.
- 30. Drôt, Jean-Marie. "Alberto Giacometti." Interview for television, Paris: ORTF, Nov. 19, 1963.
- 31. "31 août 1963" [Homage to Georges Braque]. Derrière le miroir (Paris), No. 144-46 (May 1964), pp. 8-9; ill. by Giacometti.
- 32. Maugis, Marie-Thérèse. "Entretien sur l'art actuel: Marie-Thérèse Maugis avec . . . Alberto Giacometti: 'Moi, je suis à contrecourant.'" Interview in Les Lettres Françaises (Paris), Aug. 6-19, 1964, pp. 1, 14; ill.
- 33. Kessler, Ludy. Alberto Giacometti. Interview for television. Lugano: Televisione della Svizzera Italiana, Summer 1964.
- Sylvester, David. Interview for television. London: BBC Third Programme, Sept. 1964.
- 35. Dupin, Jacques. Interview, 1965, for film "Alberto Giacometti." Zurich: Scheidegger-u. Rialto-Verleih, 1966.
- 36. Lake, Carlton. "The Wisdom of Giacometti." Interview in *The Atlantic Monthly* (Boston), 216 (Sept. 1965), pp. 117-26; ill.
- 37. "Tout celà n'est pas grand'chose." L'Ephémère (Paris), No. 1 (1967), p. 102.
- 38. Paris sans Fin. Texts, from Giacometti's notes dated 1963-65, and 150 lithographs by the artist. Paris: Tériade, 1969.

MONOGRAPHS

- 39. Alberto Giacometti, dessins 1914-1965. With poems by André du Bouchet. Paris: Maeght Editeur, 1969.
- 40. Brenson, Michael. "The Early Work of Alberto Giacometti, 1925–1935." Unpublished Ph.D. dissertation. Baltimore, Md.: Johns Hopkins University, 1974. Bibliography.
- 41. Bucarelli, Palma. Giacometti. Rome: Editalia, 1962. Bibliography.
- 42. Coulonges, Henri and Alberto Martini. Giacometti peintures. No. 55 in the series "Chefs-d'oeuvre de l'art: Grands Peintres." Milan: Fabbri; Paris: Hachette, 1967.
- 43. Dupin, Jacques. Alberto Giacometti. Paris: Maeght Editeur, 1962. Bibliography.
- 44. Genet, Jean. L'atelier d'alberto giacometti. Photographs by Ernst Scheidegger. Décines: L'Arbalète, 1963.
- 45. Giacometti: A Sketchbook of Interpretive Drawings. Text by Luigi Carluccio; notes by the artist "on the copy-interpretations." New York: Harry N. Abrams, 1967.
- 46. Hohl, Reinhold. Alberto Giacometti: Sculpture, Painting, Drawing. Stuttgart: Verlag Hatje, 1971. (Lavish illustration and documentary matter; extensive bibliography. The definitive monograph thus far.)
- 47. Huber, Carlo. Alberto Giacometti. Lausanne: Editions Rencontre, 1970. Bibliography.
- 48. Jedlicka, Gotthard. Alberto Giacometti als Zeichner. Olten: Bücherfreunde, 1960.

- Lord, James. a Giacometti portrait. New York: The Museum of Modern Art, 1965.
- 51. Meyer, Franz. Alberto Giacometti: Eine Kunst existentieller Wirklichkeit. Fraunfeld and Stuttgart: Verlag Huber, 1968.
- 52. Moulin, Raoul-Jean. Giacometti: Sculptures. No. 62 in the series "Petite Encyclopédie de l'Art." Paris: Fernand Hazan, 1964.
- Negri, Mario and Antoine Terrasse. Giacometti sculptures. No. 131 in the series "Chefs-d'oeuvre de l'art: Grands Peintres." Milan: Fabbri; Paris: Hachette, 1969.
- 54. Quarantacinque Disegni di Alberto Giacometti. Preface by Jean Leymarie. Turin: Einaudi, 1963.
- 55. Rotzler, Willy and Marianne Adelmann. Alberto Giacometti. Bern: Hallwag, 1970.
- Scheidegger, Ernst, ed. Schriften, Fotos, Zeichnungen. Zurich: Verlag der Arche, 1958.
- Soavi, Giorgio. Il mio Giacometti. Milan: All'Insegna del Pesce d'Oro, 1966.
- 58. Sylvester, David. "Alberto Giacometti." Unpublished monograph. Includes an interview with the artist.
- 59. Yanaihara, Isaku. Alberto Giacometti. Tokyo: Misusu, 1958. Ill.
- 60. Friendship with Giacometti. Tokyo: Chikuma Shobo, 1969.

EXHIBITION CATALOGUES

Amsterdam

61. Stedelijk Museum (Nov. 5-Dec. 19, 1965). alberto giacometti: teken-ingen. Bibliography.

Rasel

- 62. Galerie Beyeler (July-Sept. 1963). Alberto Giacometti: Zeichnungen, Gemälde, Skulpturen. Letter to Pierre Matisse (Bibl. 13) reproduced; excerpts from an interview by André Parinaud (Bibl. 27). Catalogue reissued as a monograph in 1964 with a preface by Michel Leiris.
- 63. Kunsthalle (May 6-June 11, 1950). André Masson, Alberto Giacometti. Text by Giacometti reprinted from Bibl. 13.
- 64. —— (Aug. 30-Oct. 12, 1952). Phantastische Kunst des XX. Jahr-hunderts. Essays by H.P., W.J.M., and St. Bibliography.
- 65. (June 25-Aug. 28, 1966). Giacometti. Introduction by Franz Meyer; essay, "Giacometti als nachbar," by Herta Wescher.

Rarlin

66. Kunstkabinett (1965). Giacometti-Zeichnungen. Catalogue by Lothar Lange.

Bern

- 67. Klipstein & Kornfeld (July 18-Aug. 22, 1959). Alberto Giacometti.
- 68. Kunsthalle (Feb. 14-March 29, 1948). Sculpteurs contemporains de l'Ecole de Paris. Introductions by Jean Cassou and Arnold Rüdlinger.

69. — (June 16-July 22, 1956). Alberto Giacometti. Introduction by Franz Meyer.

Brussels

70. Palais International des Beaux-Arts (April 17-Oct. 19, 1958). Exposition Universelle et Internationale de Bruxelles 1958: 50 Ans d'Art Moderne. Text by Em[ile] Langui.

Chicago

71. The Arts Club of Chicago (Nov. 4-Dec. 1, [1953]). Exhibition announcement with checklist: sculpture and paintings by Giacometti.

Generia

72. Galerie Krugier et Cie. (May 30-July 15, 1963). Alberto Giacometti.

Hanover

73. Kestner-Gesellschaft (Oct. 6-Nov. 6, 1966). Alberto Giacometti: Zeichnungen. Introduction by Wieland Schmied; essays by Wieland Schmied, Christoph Bernoulli, and Jean Genet. Bibliography.

Humlebaek

74. Louisiana Museum (Sept. 18-Oct. 24, 1965). Alberto Giacometti.

Irvine

75. Art Gallery, University of California (May 17-June 12, 1966). Five Europeans: Bacon, Balthus, Dubuffet, Giacometti, Morandi: Paintings and drawings. Introduction by John Coplans.

Kassel

- 76. Orangerie (July 11-Oct. 11, 1959). documenta '59: Kunst nach 1945: Internationale Ausstellung. Essays by various authors, that concerning Giacometti, "Skulptur nach 1945," by Eduard Trier. Cologne: Verlag M. DuMont Schauberg Köln, 1959.
- 77. Alte Galerie (June 27-Oct. 5, 1964). documenta III: Internationale Ausstellung. Cologne: Verlag M. DuMont Schauberg, 1964.

Krefeld

78. Kaiser Wilhelm Museum (May-Oct. 1955). Alberto Giacometti. Essay by Paul Wember. Bibliography. Exhibition traveled to Statischen Kunsthalle Düsseldorf and Staatsgalerie Stuttgart. Bibliography.

London

- 79. The Arts Council Gallery, Arts Council of Great Britain (June 4–July 9, 1955). Introduction, "Perpetuating the Transient," by David Sylvester; two poems by the artist.
- 80. New Burlington Galleries (June 11-July 4, 1936). The International Surrealist Exhibition. Introductions by André Breton and Herbert Read.
- 81. The Tate Gallery (July 17-Aug. 30, 1965). Alberto Giacometti: Sculpture, Paintings, Drawings, 1913-65. Introduction and essay, "The residue of a vision," by David Sylvester. London: The Arts Council of Great Britain, 1965.

Lucerne

82. Kunstmuseum (Feb. 24-March 31, 1935). thèse, antithèse, synthèse. Foreword by Dr. Paul Hilber; brief essays by various authors. Bibliography.

Lugano

83. Museo Civico di Belle Arti (April 7-June 17, 1973). La Svizzera Italiana onora Alberto Giacometti. Introduction by Aurelio Longoni; essays by Giorgio Soavi, Giancarlo Vigorelli, Franco Russoli, Piero Bianconi, and Giuseppe Curonici. Bibliography.

Milwaukee

84. The Milwaukee Art Center (1970). Giacometti: The Complete Graphics and 15 Drawings. Text and catalogue raisonné of the graphics by Herbert C. Lust. Exhibition traveled to Albright-Knox Art Gallery, Buffalo; The High Museum of Art, Atlanta; The Finch College Museum of Art, New York; The Joslyn Art Museum, Omaha; The Museum of Fine Arts, Houston; and the San Francisco Museum of Art. Catalogue reissued as a monograph in 1970 with an introduction by John Lloyd Taylor.

New York

- 85. Albert Loeb & Krugier Gallery (Dec. 1966). Alberto Giacometti & Balthus: drawings. Introduction by James Lord.
- 86. Art of This Century Gallery (Feb. 10-March 10, 1945). Alberto Giacometti. Texts, reprinted from various sources, by André Breton, Georges Hugnet, Julien Levy, and the artist.
- 87. Julien Levy Gallery (Dec. 1934). Exhibition announcement with checklist: Abstract Sculpture by Alberto Giacometti.
- 88. Knoedler Gallery (Dec. 1967). Space and Dream. Text by Robert Goldwater. New York: Walker and Company, in association with M. Knoedler & Co., 1968.
- 89. Pierre Matisse Gallery (Jan. 19-Feb. 14, 1948). Alberto Giacometti. Introduction, "The Search for the Absolute," by Jean-Paul Sartre (see Bibl. 285); letter from the artist (Bibl. 13) reproduced and translated.
- 90. —— (Nov. 1950). Alberto Giacometti. Includes excerpts from a letter from the artist and notes on the significance of titles in relation to his work (Bibl. 14).
- 91. (May 6-31, 1958). Illustrated exhibition announcement: Giacometti: sculpture-paintings-drawings from 1956 to 1958.
- 92. (Dec. 12-30, 1961). Exhibition brochure with checklist: Giacometti. Text by the artist reprinted from XX^e Siècle (Bibl. 22).
- 93. (Nov. 17-Dec. 12, 1964). Alberto Giacometti: Drawings. Text by James Lord.
- 94. The Museum of Modern Art (Dec. 1936-Jan. 1937). Fantastic Art, Dada, Surrealism. Catalogue edited by Alfred H. Barr, Jr. Essays by Georges Hugnet.
- 95. (April 29-Sept. 7, 1953). Sculpture of the Twentieth Century. Catalogue by Andrew Carnduff Ritchie. Statements by the artists re-

- printed from various sources. Bibliography. Exhibition opened at the Philadelphia Museum of Art and traveled to The Art Institute of Chicago.
- 96. —— (Sept. 30-Nov. 29, 1959). New Images of Man. Catalogue by Peter Selz. Statements by the artists. New York: The Museum of Modern Art, in collaboration with The Baltimore Museum of Art, 1959. Bibliography. Exhibition traveled to the above institution.
- 97. (June 9-Oct. 10, 1965). alberto giacometti. Introduction by Peter Selz. Letter to Pierre Matisse reproduced (Bibl. 13); additional notes by the artist. New York: The Museum of Modern Art, in collaboration with The Art Institute of Chicago, Los Angeles County Museum of Art, and The San Francisco Museum of Art, 1965. Bibliography. Exhibition traveled to the above institutions.
- 98. —— (March 27-June 9, 1968). Dada, Surrealism, and Their Heritage. Catalogue by William S. Rubin. Bibliography. Exhibition traveled to the Los Angeles County Museum of Art and The Art Institute of Chicago.
- 99. Sidney Janis Gallery (Nov. 6-30, 1968). Giacometti & Dubuffet.
- 100. The Solomon R. Guggenheim Museum (June 7-July 17, 1955). Exhibition brochure with checklist: Alberto Giacometti.
- 101. (Oct. 3, 1962-Jan. 6, 1963). Modern Sculpture from the Joseph H. Hirshhorn Collection. Bibliography.
- 102. (Jan.-March 1964). Guggenheim International Award 1964. Essay by Lawrence Alloway.
- 103. World House Galleries (Jan. 12-Feb. 6, 1960). Giacometti.

Paris

- 104. Galerie Claude Bernard (May 1968). Alberto Giacometti: Dessins. Text by André du Bouchet.
- 105. Galerie Maeght (June 8-30, 1951). Alberto Giacometti. Text, "Pierres pour un Alberto Giacometti," by Michel Leiris. Paris: Editions Pierre à Feu, 1951.
- 106. —— (May 1954). Giacometti. Text, "Les peintures de Giacometti," by Jean-Paul Sartre. Paris: Editions Pierre à Feu, 1954.
- 107. (June 1957). Alberto Giacometti. Introduction, "L'atelier d'-Alberto Giacometti," by Jean Genet. Paris: Editions Pierre à Feu, 1957.
- 108. (May 1961). Giacometti. Essays, "Alberto Giacometti dégaine," by Olivier Larronde; "Jamais d'espaces imaginaires," by Léna Leclercq; and "Pages de journal," by Isaku Yanaihara.
- 109. Musée de l'Orangerie des Tuileries (Oct. 24, 1969-Jan. 12, 1970). Alberto Giacometti. Introduction by Jean Leymarie. Texts, reprinted from various sources, by André Breton, Jean Genet, J[ean]-P[aul] Sartre, and the artist. Paris: Ministère d'Etat, Affaires Culturelles, Réunion des Musées Nationaux, 1969.

Pittsburgh

110. Department of Fine Arts, Carnegie Institute (Oct. 27, 1961-Jan. 7, 1962). The 1961 Pittsburgh International Exhibition of Contemporary Painting and Sculpture. Introduction by Gordon Bailey Washburn.

+

Providence

111. Museum of Art, Rhode Island School of Design (Spring 1970). Giacometti: Dubuffet. Preface by Daniel Robbins; introduction and biographical note on Giacometti by James Lord. Catalogue published in the Bulletin of Rhode Island School of Design, 56 (March 1970).

Rome

112. Accademia di Francia, Villa Medici (Oct. 24-Dec. 14, 1970). Alberto Giacometti. Introduction by Jean Leymarie reprinted from Bibl. 109; texts by André Breton, Jean Genet, Jean-Paul Sartre, and the artist, reprinted from various sources; essay by Palma Bucarelli reprinted from Bibl. 179.

Tubingen

113. Kunsthalle (April 11-May 31, 1981). Alberto Giacometti: Zeichnungen und Druckgraphik. Essays by Reinhold Hohl and Dieter Koepplin. Stuttgart: Hatje, 1981. Exhibition traveled to Kunstverein Hamburg; Kunstmuseum Basel; Kaiser Wilhelm Museum, Krefeld; and Museum Commanderie van Sint Jan, Nijmegen.

Turin

114. Galleria Galatea (Sept. 29-Oct. 25, 1961). Alberto Giacometti. Text by Luigi Carluccio.

Venice

- 115. (June 16-Oct. 21, 1956). XXVIII Esposizione Biennale Internazionale d'Arte. Essays by various authors, that on French sculpture by Raymond Cogniat. Venice: Alfieri Editore, 1956.
- 116. (June 16-Oct. 7, 1962). Catalogo della XXXI Esposizione Biennale Internazionale d'Arte Venezia. Essays by various authors, that on Giacometti by Palma Bucarelli.

Washington, D.C.

117. The Phillips Collection (Feb. 2-March 4, 1963). Alberto Giacometti: A Loan Exhibition. Introduction by Duncan Phillips.

Zurich

118. Kunsthaus (Dec. 2, 1962-Jan. 20, 1963). Alberto Giacometti. Essays, "Zum Werk Alberto Giacometti," by Eduard Hüttinger; "Les peintures de Giacometti," by Jean-Paul Sartre, reprinted from Bibl. 106; interview with the artist by André Parinaud excerpted from Bibl. 27. Bibliography.

GENERAL WORKS

- 119. Bair, Deirdre. Samuel Beckett: A Biography. New York: Harcourt Brace Jovanovich, 1978.
 - 120. Barr, Alfred H. Jr., ed. Masters of Modern Art. New York: The Museum of Modern Art, 1954.
 - 121. Barzun, Jacques. Berlioz and the Romantic Century. Boston: Little, Brown, 1950.

- 122. Beauvoir, Simone de. La Force de l'âge. Paris: Gallimard, 1960, pp. 499-503.
- 123. La Force des choses. Paris: Gallimard, 1963, pp. 83, 85, 95, 99-100, 106, 108, 143 passim.
- 124. Tout compte fait. Paris: Gallimard, 1972.
- 125. Becker, Ernst. The Denial of Death. New York: Free Press, 1973.
- Beckett, Samuel. Proust and Three Dialogues with Georges Duthuit. London: John Calder, 1965.
- 127. Berger, John. The Moment of Cubism and Other Essays. New York: Pantheon, 1969.
- 128. Breton, André. L'Amour fou. Paris: Gallimard, 1937, pp. 41-57.
- 129. . Le surréalisme et la peinture suivi de Genèse et perspective artistiques du surréalisme et de fragments inédits. New York and Paris: Brentano's, 1945.
- 130. Brill, A. A., ed. The Basic Writings of Sigmund Freud. New York: The Modern Library, 1938.
- 131. Char, René. Recherche de la base et du sommet suivi de Pauvreté et privilège. Paris: Gallimard, 1955, p. 142. English translation in Bibl. 95.
- 132. Clark, Kenneth. The Nude: A Study of Ideal Art. London: John Murray, 1956.
- 133. Craft, Robert. Stravinsky: Chronicle of a Friendship, 1948-1971. New York: Alfred A. Knopf, 1972.
- 134. Delmer, Sefton. Trail Sinister, Black Boomerang. London: Secker and Warburg, 1961.
- 135. Giedion-Welcker, Carola. Contemporary Sculpture: An Evolution in Volume and Space. New York: George Wittenborn, 1955. Bibliography, pp. 96-107.
- 136. Gilot, Françoise and Carlton Lake. Life with Picasso. New York, Toronto, London: McGraw-Hill Book Company, 1964.
- 137. Gombrich, E. H. Art and Illusion: A Study in the Psychology of Pictorial Representation. Princeton, N.J.: Princeton University Press, 1960.
- 139. Guggenheim, Peggy. Confessions of an Art Addict. London: Andre Deutsch, 1960, pp. 73-74, 105, 141.
- 140. Huxley, Aldous. The Doors of Perception and Heaven and Hell. New York: Harper & Row, 1956.
- 141. Kohler, Elisabeth Esther. Leben und Werk von Giovanni Giacometti, 1868-1933. Zurich: Fischer-Druck und Verlag, 1968.
- 142. Kramer, Hilton. The Age of the Avant-Garde: An Art Chronicle of 1956-1972. New York: Farrar, Straus and Giroux, 1973.
- 143. Lasonder, L. Levensbericht van Mr. P.A.N.S. van Meurs. Leiden: E. J. Brill, 1922.
- 144. Leiris, Michel. Fibrilles. Paris: Gallimard, 1966.
- 145. Liberman, Alexander. The Artist in His Studio. New York: Viking, 1960.

- Mack, John E. Nightmares and Human Conflict. Boston: Little, Brown, 1970.
- 147. Madsen, Axel. Hearts and Minds: The Common Journey of Simone de Beauvoir and Jean-Paul Sartre. New York: William Morrow, 1977.
- 148. Man Ray. Self Portrait. Boston and Toronto: Little, Brown, 1963.
- 149. Maupassant, Guy de. "Etudes sur Gustave Flaubert." Introduction to Vol. VII (*Bouvard et Pécuchet*) of the collected works of Gustave Flaubert. Paris: A. Quantin, 1885.
- 150. Merleau-Ponty, Maurice. L'oeil et l'esprit. Paris: Gallimard, 1964, pp. 24, 64.
- 151. Nadeau, Maurice. Histoire du surréalisme. Paris: Seuil, 1945.
- 152. Panofsky, Erwin. The Life and Art of Albrecht Dürer. Princeton, N.J.: Princeton University Press, 1943.
- 153. Read, Herbert. The Art of Sculpture. New York: Pantheon, 1956, pp. 102-3.
- 154. ——. A Concise History of Modern Sculpture. New York: Praeger, 1964, pp. 158-60.
- Sanchez, Leopold Diego. Jean-Michel Frank. Paris: Editions du Regard, 1980.
- 156. Sartre, Jean-Paul. Les Mots. Paris: Gallimard, 1964.
- 157. Selz, Jean. Modern Sculpture: Origins and Evolution. New York: George Braziller, 1963.
- 158. Seuphor, Michel. La sculpture de ce siècle. Neuchâtel: Editions du Griffon, 1959, pp. 116-18, 169, 270-71.
- 159. Soavi, Giorgio. Protagonisti: Giacometti, Sutherland, de Chirico. Milan: Longanesi, 1969.
- Soby, James Thrall. After Picasso. Hartford: Edwin Valentine Mitchell;
 New York: Dodd, Mead, 1935, p. 105.
- 161. ——. Balthus (exhibition catalogue). New York: The Museum of Modern Art, 1956.
- 162. ——. Modern Art and the New Past. Norman, Okla.: University of Oklahoma Press, 1957, pp. 123-26.
- 163. Waddington, C. H. Behind Appearance: A study of the relations between painting and the natural sciences in this century. Cambridge, Mass.: MIT Press, 1969, pp. 228-34.
- 164. Waldberg, Patrick. Mains et merveilles: peintres et sculpteurs de notre temps. Paris: Mercure de France, 1961, pp. 52-69.
- 165. Zervos, Christian. L'Art des Cyclades. Paris: Editions Cahiers d'Art, 1935.

SELECTED ARTICLES

- 166. "Alberto Giacometti: Sculptures et dessins récents." Cahiers d'Art (Paris), 20-21 (1945-46), pp. 253-68; ill. Photographic essay.
- 167. Althaus, P[eter] F. "Zwei Generationen Giacometti." Du (Zurich), 18 (March 1958), pp. 32-39; ill.

- 168. A[lvard], J[ulien]. "Les Expositions: Giacometti." Cimaise (Paris), 4 (July-Aug. 1957), p. 32.
- 169. Ashton, Dore. "Art." Arts & Architecture (Los Angeles), 75 (July 1958), pp. 10, 31.
- 170. ——. "Art: New Images of Man." Arts & Architecture (Los Angeles), 76 (Nov. 1959), pp. 14-15, 40; ill.
- 171. Berger, John. "The death of Alberto Giacometti." New Society (London), 7 (Feb. 3, 1966), p. 23.
- 172. Bernoulli, Christoph. "Alberto Giacometti: Ansprache, gehalten bei Anlass der Ausstellung im Kunsthaus Zürich." Neue Zürcher Zeitung, Dec. 9, 1962. Section 5, p. 1; ill.
- 173. Boissonnas, Edith. "Connaissance: A propos d'Alberto Giacometti." La Nouvelle Revue Française (Paris), 13 (June 1965), pp. 1127-29.
- 174. Boudaille, Georges. "L'interview impossible." Les Lettres Françaises (Paris), Jan. 20-26, 1966, pp. 14-15; ill. See Bibl. 256.
- 175. ——. "Alberto Giacometti à l'Orangerie: La réalité des apparences."

 Les Lettres Françaises (Paris), Oct. 29-Nov. 4, 1969, p. 23 and cover; ill.
- 176. Bouret, Jean. "Alberto Giacometti." Arts (Paris), No. 315 (June 15, 1951), p. 5.
- 177. Boustedt, Bo. "Quand Giacometti plaçait lui-même ses sculptures." XXº Siècle (Paris), No. 33 (Dec. 1969), pp. 21-36; ill.
- 178. Brassaï. "Ma dernière visite à Giacometti." Le Figaro Littéraire (Paris), Jan. 20, 1966, pp. 16, 12; ill.
- 179. Bucarelli, Palma. "The Sculpture of Alberto Giacometti." Cimaise (Paris), 9 (Sept.-Oct. 1962), pp. 60-77; ill.
- 180. Buhrer, Jean-Claude. "A la Kunsthalle de Bâle: Rétrospective Alberto Giacometti." Le Monde (Paris), Aug. 12, 1966, p. 7.
- 181. Cabanne, Pierre. "La vraie sculpture n'est plus dans la rue." Arts (Paris), No. 825 (June 7-13, 1961), p. 1; ill.
- 182. Caglio, Luigi. "Alberto Giacometti a Venezia." Quaderni Grigionitaliana (Poschiavo), 37 (April 1968).
- 183. C[ampbell], L[awrence]. "Giacometti by Giacometti and Giacometti by Herbert Matter." Artnews (New York), 60 (Jan. 1962), pp. 41, 57; ill.
- 184. Carluccio, Luigi. "L'Amico di Giacometti: La collezione di Serafino Corbetta a Chiavenna." *Bolaffiarte* (Turin), 1 (Oct. 1970), pp. 42-46; ill.
- 185. Cartier-Bresson, Henri. "Giacometti: A Touch of Greatness." The Queen (London), 220 (May 1, 1962), pp. 26-31; ill.
- 186. Cassou, Jean. "Variations du dessin." Quadrum (Brussels), No. 10 (1961), pp. 27-42; ill.
- 187. ——. "Giacometti chez Gulliver." Les Nouvelles Littéraires (Paris), Jan. 20, 1966, p. 11; ill.
- 188. Causey, Andrew. "Giacometti: Sculptor with a Tormented Soul." The Illustrated London News, 248 (Jan. 22, 1966), pp. 26-29; ill.
- 189. Chabrun, J.-F. "Paris découvre Giacometti." L'Express (Paris), No. 311 (June 7, 1957), pp. 22-23; ill.

- 190. Chastel, André. "Alberto Giacometti est mort." Le Monde (Paris), Jan. 13, 1966, pp. 1, 9.
- 191. Chevalier, Denys. "Nouvelles conceptions de la sculpture." Connaissance des Arts (Paris), No. 63 (May 1957), pp. 58-65; ill.
- 192. ——. "Giacometti." Equilibre (Paris), July 1966.
- 193. Clay, Jean. "Giacometti's dialogue with death." Réalités (Paris), No. 161 (April 1964), pp. 54-59, 76; ill.
- 194. ——. "Giacometti: un sculpteur à la recherche de la vie." Lectures pour tous (Paris), March 1966.
- 195. ——. "Giacometti à l'Orangerie." Réalités (Paris), No. 285 (Oct. 1969), pp. 124-29; ill.
- 196. Coates, Robert M. "The Art Galleries: Candy and Cupids." The New Yorker, 23 (Jan. 31, 1948), pp. 42-43.
- 197. C[ogniat], R[aymond]. "Mort d'Alberto Giacometti." Le Figaro (Paris), Jan. 13, 1966, p. 21.
- 198. Cooper, Douglas. "Portrait of a Genius But." The New York Review of Books, 5 (Sept. 16, 1965), pp. 10, 12-14; ill.
- 199. Courthion, Pierre. "Alberto Giacometti." Art-Documents (Geneva), No. 10-11 (July-Aug. 1951), p. 7; ill.
- 200. Courtois, Michel. "La figuration magique de Giacometti." Art International (Lugano), 6 (Summer 1962), pp. 38-45; ill.
- C[urjel], H[ans]. "Ausstellung: Zurich: Alberto Giacometti." Werk (Winterthur), 50 (Jan. 1963), pp. 14-15.
- 202. ——. "Offentliche Kunstpflege: Eine Alberto Giacometti-Stiftung." Werk (Winterthur), 51 (April 1964), p. 80.
- 203. Devay, Jean-François. "A l'ombre de Giacometti ce Diego qu'on ignore." *Paris-Presse*, June 9, 1961.
- 204. Dojidai (Tokyo), No. 19 (1965). Special number in homage to Giacometti. Texts by various authors, including an interview by Jiro Koyamada and Noritsugu Horiuchi.
- 205. D[rexler], A[rthur]. "Giacometti: a change of space." Interiors (New York), 109 (Oct. 1949), pp. 102-7; ill.
- 206. Du (Zurich), 22 (Feb. 1962). Special number in homage to Giacometti, edited by Manuel Gasser. Texts by Christoph Bernoulli, Manuel Gasser, C. Giedion-Welcker, Albert Skira, and others.
- 207. Dumayet, Pierre and Patricia de Beauvais. "Les Giacometti." Paris-Match, No. 1079 (Jan. 10, 1970), pp. 39-45; ill.
- 208. Dupin, Jacques. "Giacometti: sculpteur et peintre." Cahiers d'Art (Paris), 29 (Oct. 1954), pp. 41-54; ill.
- 209. Duthuit, Georges. "Skulpturer i Paris 1950 och tidigare." Konstrevy (Stockholm), 27 (No. 1, 1951), pp. 38-43; ill.
- 210. Eager, Gerald. "The Missing and the Mutilated Eye in Contemporary Art." *Journal of Aesthetics and Art Criticism* (Cleveland), 20 (Fall 1961), pp. 49-59; ill.
- 211. L'Ephémère (Paris), 1 (Winter 1967). Special number in homage to Giacometti after his death, edited by Yves Bonnefoy, André du Bouchet,

Louis-René des Forêts, and Gaëton Picon. Texts by Yves Bonnefoy, André du Bouchet, Michel Leiris, Gaëton Picon, and the artist.

212. Esteban, Claude. "L'espace et la Fièvre." La Nouvelle Revue Française (Paris), 15 (Jan. 1967), pp. 119-27.

213. Estienne, Charles. "Giacometti et ses frères." France Observateur (Paris), No. 580 (June 15, 1981), p. 19; ill.

214. Freund, Andreas. "Giacometti Exhibition Opens in Paris." The New York Times, Oct. 24, 1969, p. 44; ill.

215. La Gazette de Lausanne, No. 12 (Jan. 15-16, 1966). Special number in homage to Giacometti after his death, edited by Frank Jotterand and André Kuenzi. Texts by César, Jean Leymarie, Franz Meyer, Jean Paulhan, Gaëton Picon, and others.

216. Genauer, Emily. "The 'Involuntary' Giacometti." New York: The Sunday Herald Tribune Magazine, June 13, 1965, pp. 31-32; ill.

217. Giacometti, Guido. "Introduzione ad Alberto Giacometti." Quaderni Grigionitaliani (Poschiavo), 37 (April 1968), pp. 143-49.

218. Giedion-Welcker, Carola. "Alberto Giacomettis Vision der Realität." Werk (Winterthur), 46 (June 1959), pp. 205-12; ill.

219. ——. "New Roads in Modern Sculpture." Transition (The Hague), No. 23 (July 1935), pp. 198-201.

220. Grafly, Dorothy. "Contemporary Sculpture: 'Form Unlimited.'"

American Artist (New York), 18 (March 1954), pp. 30-35; ill.

221. Grand, Paule-Marie. "Today's Artists: Giacometti." Portfolio and Artnews Annual (New York), No. 3 (1960), pp. 64-79, 138, 140; ill.

222. ——. "Les certitudes imprévues de Giacometti." Le Monde (Paris), Oct. 30, 1969, p. 17.

223. Greenberg, Clement. "Art." The Nation (New York), 166 (Feb. 7, 1948), pp. 163-65.

224. Grenier, Jean. "Sculpture d'aujourd'hui." Preuves (Paris), 10 (July 1961), pp. 66-68.

225. Guéguen, Pierre. "Sculpture d'aujourd'hui." Aujourd'hui (Boulogne), No. 19 (Sept. 1958), pp. 12-31; ill.

226. Gurewitsch, Eleanor. "A Bit of a Ruckus in Zurich." The New York Times, Feb. 21, 1965, p. B21.

227. Habasque, Guy. "La XXXI^e Biennale de Venise." L'Oeil (Paris), No. 93 (Sept. 1962), pp. 32-41, 72-73; ill.

228. H[ess], T[homas] B. "Spotlight on: Giacometti." Artnews (New York), 46 (Feb. 1948), p. 31; ill.

229. ——. "Giacometti: the uses of adversity." Artnews (New York), 57 (May 1958), pp. 34-35, 67 and cover; ill.

230. ——. "Alberto Giacometti, 1901-1966." Artnews (New York), 65 (March 1966), p. 35.

 Hohl, Reinhold. "Zeichnungen von Alberto Giacometti." National-Zeitung (Basel), Aug. 1959.

232. ——. "Alberto Giacometti im 'Du': Werkaufnahmen mit Tiefenunschärfe." Neue Zürcher Zeitung, Feb. 28, 1962, Section 4, p. 1.

x poul

- "Alberto Giacomettis Wirklichkeit." National-Zeitung (Basel), March 1, 1963.
- 234. ——. "Alberto Giacometti: Kunst als die Wissenschaft des Schens." Die Ernte 1963: Schweizerisches Jarhbuch. Basel: Verlag Friedrich Reinhardt + AG, 1963.
- 235. ——. "Auge in Auge: Giacometti-Ausstellung in der Kunsthalle Basel." Neue Zürcher Zeitung, Aug. 5, 1966, Section 4, p. 1.
- 236. . "Was jede Erniedrigung des Menschen überlebt: Zur Giacometti-Ausstellung in der Pariser Orangerie." Frankfurter Allgemeine Zeitung, Nov. 22, 1969, Section "Bilder und Zeiten," p. 1; ill.
- 237. Hunter, Sam. "Modern Extremists." The New York Times, Jan. 25, 1948, p. B8.
- 238. "An Interview with Jean-Paul Sartre." The New York Review of Books, 15 (March 26, 1970), pp. 22-31.
- 239. Jedlicka, Gotthard. "Alberto Giacometti: Zum sechzigsten Geburtstag: 10. Oktober." Neue Zürcher Zeitung, Oct. 10, 1961, Section 4, p. 1.
- 240. ——. "Alberto Giacometti: Fragmente aus Tagebüchern." Neue Zürcher Zeitung, April 5, 1964, Section 4, p. 1.
- 241. ——. "Begegnung mit Alberto Giacometti." Neue Zürcher Zeitung, Jan. 16, 1966, Section 4, p. 2; ill.
- 242. Jewell, Edward Alden. "The Realm of Art: Current Events and Retrospects: One-Man Shows." *The New York Times*, Dec. 9, 1934, Section 10, p. 9.
- 243. Jouffroy, Alain. "Portrait d'un artiste (VIII): Giacometti." Arts (Paris), No. 545 (Dec. 7-13, 1955), p. 9.
- 244. Keller, Heinz. "Über das Betrachten der Plastiken Alberto Giacomettis." Werk (Winterthur), 50 (April 1963), pp. 161-64; ill.
- 245. Kohler, Arnold. "Alberto Giacometti ou l'obsession de l'image." Co-opération (Basel), Jan. 29, 1966, p. 8; ill.
- 246. ——. "Alberto Giacometti à Bâle." Tribune de Genève, July 18, 1966.
- 247. Kramer, Hilton. "Giacometti." Arts Magazine (New York), 38 (Nov. 1963), pp. 52-59; ill.
- 248. ——. "The Anguish and the Comedy of Samuel Beckett." Saturday Review (New York), 53 (Oct. 3, 1970), pp. 27-28, 30, 43.
- 249. ——. "Bourdelle: The Age of Innocence." The New York Times, Nov. 29, 1970, p. B25.
- 250. ——. "The Sculpture of Henri Laurens: The Ripening of Forms." The New York Times, Jan. 24, 1971, p. 21.
- 251. ——. "Pablo Picasso's Audacious 'Guitar.'" The New York Times, March 21, 1971, p. B21.
- 252. ——. "Alberto Giacometti's Moral Heroism." The New York Times,
 Jan. 18, 1976, p. B29; ill.
- 253. Lanes, Jerrold. "Alberto Giacometti." Arts Yearbook (New York), 3 (1959), pp. 152-55; ill.
- 254. Leiris, Michel. "Alberto Giacometti." Documents (Paris), No. 4 (Sept. 1929), pp. 209-14; ill.

- 255. ——. "Alberto Giacometti en timbre-poste ou en médaillon." L'Arc (Marseilles), 5 (Autumn 1962), pp. 10-13 and cover; ill.
- 256. Les Lettres Françaises (Paris), Jan. 20-26, 1966. Special number in homage to Giacometti after his death, edited by Aragon. Texts by Aragon, Georges Boudaille, César, Michel Leiris, Jean Leymarie, Pierre Matisse, Henry Moore, Jacques Prévert, and others.
- 257. Liberman, Alexander. "Giacometti." Vogue (New York), 125 (Jan. 1955), pp. 146-51, 178-79; ill.
- 258. Limbour, Georges. "Giacometti." Magazine of Art (Washington, D.C.), 41 (Nov. 1948), pp. 253-55; ill.
- 259. —. "La Guerre de Giacometti." Le Nouvel Observateur (Paris), Ian. 26, 1966.
- 260. Lord, James. "Giacometti." La Parisienne, No. 18 (June 1954), pp. 713-14.
- "Alberto Giacometti, sculpteur et peintre." L'Oeil (Paris),
 No. 1 (Jan. 15, 1955), pp. 14-20; ill.
- 262. ——. "Le Solitaire Giacometti." Arts (Paris), No. 824 (May 31-June 6, 1961), p. 2.
- 263. ——. "In Memoriam Alberto Giacometti." L'Oeil (Paris), No. 135 (March 1966), pp. 42-46, 67; ill.
- 264. ——. "Diego, sculpteur." Connaissance des Arts (Paris), No. 364 (June 1982), pp. 68-75; ill.
- 265. ——. "Giacometti and Picasso: Chronicle of a Friendship." The New Criterion (New York), 1 (June 1983), pp. 16-24.
- 266. Markoff, Nicola G. "Alberto Giacometti und seine Krankheit." Bunder Jahrbuch (Chur), No. 9 (1967), pp. 65-68.
- 267. Mellow, James R. "Extraordinarily Good, Extraordinarily Limited." The New York Times, Nov. 2, 1969, p. B29; ill.
- 268. Moholy, Lucia. "Current and Forthcoming Exhibitions: Switzerland." The Burlington Magazine (London), 105 (Jan. 1963), p. 38.
- 269. Monnier, Jacques. "Giacometti: A propos d'une sculpture [Groupe de trois hommes, 1948-49]." Pour l'Art (Lausanne & Paris), No. 50-51 (Sept.-Dec. 1956), pp. 12-14; ill.
- 270. Negri, Mario. "Frammenti per Alberto Giacometti." Domus (Milan), No. 320 (July 1956), pp. 40-48; ill.
- 271. Palme, Per. "Nutida Skulptur." Paletten (Göteborg), 20 (No. 3, 1959), pp. 68-81; ill.
- 272. Ponge, Francis. "Joca seria: Notes sur les sculptures d'Alberto Giacometti." Méditations (Paris), No. 7 (Spring 1964), pp. 5-47; ill.
- 273. ——. "Réflections sur les statuettes, figures & peintures d'Alberto Giacometti." *Cahiers d'Art* (Paris), 26 (1951), pp. 74-90 and one-page illustration, unpaginated; ill.
- 274. ——. "Die Szepter-menschen Giacomettis (Les spectres-sceptres de Giacometti)." Augenblick (Stuttgart), 1 (No. 1, 1955), pp. 1-5 and one-page illustration, unpaginated; ill.
- 275. "Portrait of the Artist, No. 167: Giacometti." Artnews and Review (London), 7 (June 25, 1955), p. 1.

X

276. Preston, Stuart. "Giacometti and Others: Recently Opened Shows in Diverse Mediums." The New York Times, Dec. 17, 1950, p. B8; ill.

277. ——. "Giacometti Surveyed." The New York Times, June 13, 1965, p. B25; ill.

278. Prossor, John. "Paris Notes: Giacometti at the Galerie Maeght." Apollo (London), 65 (July 1957), pp. 301-2; ill.

279. Raynal, Maurice. "Dieu-table-cuvette: Les ateliers de Brancusi, Despiau, Giacometti." *Minotaure* (Paris), No. 3-4 (Dec. 1933), p. 47; ill.

280. Régnier, Gérard. "Giacometti à l'Orangerie." La Revue du Louvre (Paris), No. 4-5 (Oct. 1969), pp. 287-94.

281. ——. "A l'Orangerie: Une vision infernale." Les Nouvelles Littéraires (Paris), Oct. 23, 1969, p. 9.

282. Roger-Marx, Claude. "Giacometti et ses fantômes." Le Figaro Littéraire (Paris), Oct. 20-26, 1969, pp. 33-34; ill.

283. Rosenberg, Harold. "The Art World: Reality at Cockcrow." The New Yorker, 10 (June 10, 1974), pp. 70-84.

284. San Lazzaro, [Gualtieri di]. "Giacometti." XXe Siècle (Paris), Supplement to No. 26 (May 1966), unpaginated.

285. Sartre, Jean-Paul. "La recherche de l'absolu." Les Temps Modernes (Paris), 3 (Jan. 1948), pp. 1153-63; ill. English translation is introduction to exhibition catalogue, Bibl. 89.

286. Schneider, P[ierre]. "His Men Look Like Survivors of a Shipwreck." The New York Times Magazine, June 6, 1965, pp. 34-35, 37, 39, 42, 44, 46; ill.

287. ——. "Giacometti est parti sans répondre." *L'Express* (Paris), No. 761 (Jan. 17-23, 1966), pp. 43-44; ill.

288. Scott Stokes, Henry. "A Japanese Model Recalls Giacometti and Paris." The New York Times, March 15, 1982, p. C13.

289. Seuphor, Michel. "Giacometti à la Galerie Maeght." Preuves (Paris), 4 (July 1954), pp. 79-80; ill.

290. ——. "Paris: Giacometti and Sartre." Arts Digest (New York), 29 (Oct. 1, 1954), p. 14.

291. Sibert, Claude-Hélène. "Giacometti." Cimaise (Paris), 1 (July-Aug. 1954), p. 16.

292. "Skeletal Sculpture: Artist Whittles Men to Bone." Life (Chicago), 31 (Nov. 5, 1951), p. 151-53; ill.

293. S[kira], A[lbert]. "Alberto Giacometti: Copies d'après un bas-relief égyptien-Conrad Witz-André Derain-Une figure grecque." Labyrinthe (Geneva), No. 10 (July 15, 1945), p. 2; ill.

294. Soby, James Thrall. "The Fine Arts: Alberto Giacometti." The Saturday Review (New York), 38 (August 6, 1955), pp. 36-37; ill.

295. Staber, Margit. "Schweizer Kunstbrief: Giacometti in Basel und Genf." Art International (Lugano), 7 (Sept. 25, 1963), pp. 102-3; ill.

296. Stahly, François. "Der Bildhauer Alberto Giacometti." Werk (Winterthur), 37 (June 1950), pp. 181-85; ill.

297. Stampa, Renato. "Per il Centenario della nascita di Giovanni Gia-

- cometti." Quaderni Grigionitaliani (Poschiavo), 37 (April 1968), pp. 4-47.
- 298. Strambin. "Alberto Giacometti." Labyrinthe (Geneva), No. 1 (Oct. 15, 1944), p. 3; ill.
- 299. Tardieu, Jean. "Giacometti et la Solitude." XXº Siècle (Paris), No. 18 (Feb. 1962), pp. 13-19; ill.
- 300. Trier, Eduard. "Französische Plastik des 20. Jahrhunderts." Das Kunstwerk (Baden-Baden), 9 (No. 1, 1955-56), pp. 34-40; ill.
- 301. Tummers, Nico. "Alberto Giacometti." Kroniek van kunst en kultuur (Amsterdam), No. 2 (1959), pp. 16-25; ill.
- 302. Vad, Poul. "Giacometti." Signum (Copenhagen), 2 (No. 2, 1962), pp. 28-36; ill.
- 303. Veronesi, Giulia. "Cronache: Parigi: Alberto Giacometti." *Emporium* (Bergamo), 114 (July 1951), pp. 36-37; ill.
- 304. Watt, Alexander and Marianne Adelmann. "Alberto Giacometti: Pursuit of the Unapproachable." *The Studio* (London), 167 (Jan. 1964), pp. 20–27; ill.
- 305. Wehrli, René. "Rede über Alberto Giacometti." Werk (Winterthur), 50 (Feb. 1963), pp. 80-81; ill. Transcript of speech, given Dec. 1, 1962, at the opening of the exhibition "Alberto Giacometti" at the Kunsthaus Zurich.
- 306. Wescher, Herta. "Giacometti: A Profile." Art Digest (Geneva), 28 (Dec. 1, 1953), pp. 17, 28-29; ill.
- 307. Zervos, Christian. "Quelques notes sur les sculptures de Giacometti." Cahiers d'Art (Paris), 7 (No. 8-10, 1932), pp. 337-42; ill.

Index

Abstract Sculpture by Alberto Giaco-Bazaine, Jean, 340 metti, 153 Beauvoir, Simone de (Beaver), 202-3, Alberto Giacometti Foundation, 496 250, 262, 361, 370, 465, 468; bust of, Alda, bust of, 46, 50 260; and clothes for Annette, 270, Alexis, Renée, 232, 240, 249, 264, 268, 361; and Algerian War, 352; autobiography of, 468 Annette, see Arm, Annette Bechtler, Hans, 449 Apple Asleep (Leclerca), 347 Beckett, Samuel, 188-90, 210, 309, 336-7. Aragon, Louis, 67, 113, 304, 323; draw-428-9 ings of, 260 Beethoven, Ludwig van, 472 Being and Nothingness (Sartre), 203 Arghezi, Tudor, 192 Arm, Annette, 230-1, 233-8, 281; and Bellon, Denise, 134-5 Alberto, 230-1, 233-8, 242, 261-4, 267-Bérard, Christian, 124-5, 134 71, 291, 294, 299; and Alberto's cane, Bérard, Simon, 31, 315-16; portraits and 238; and marriage, 238, 299-303; and bust of, 315 Bergery, Gaston, 198 Alberto's return to Paris, 242; lends money to Alberto, 244, 257, 261; Bernoulli, Christoph, 315-16 corresponds with Alberto, 256-7; and Berthoud, Francis, 143, 186, 209, 218, Paris, 256, 261-4, 267-72, 281, 291-2, 236; death of, 392-3 Berthoud, Silvio, 187, 217-18, 221, 393, 294-5, 297; and shoes for Alberto, 257, 261; as model, 261, 297-8, 300; and 435; at Alberto's funeral, 519 Alberto's friends, 268; and Diego, 268, Beyeler, Ernst, 316, 448-9, 496; at Alberto's funeral, 520 292, 294; as secretary, 269-70, 291, 298; clothes for, 270; and Alberto's Bonnard, Pierre, 191, 312, 424, 485 Bourdelle, Antoine, 62, 68-9, 71, 82, 88, disease, 272, 276, 278; and Giacometti family, 292; see also Giacometti, Annette Bouvard et Pécuchet, 56 Brancusi, Constantin, 69, 82, 140, 447 Arm, Henri and Germaine, 233, 235-7, 362-3; Henri's meeting with Alberto. Braque, Georges, 68-9, 114, 168, 249, 236-7; at Alberto's funeral, 520 313, 322, 340, 363, 380, 485 Arp, Hans, 67, 118, 293, 485 Brassaï, 192 Arts Council of Great Britain, and ex-Breton, André, 67-8, 112-14, 118-19, hibits, 354, 496 125, 128, 145, 151, 153-6, 167, 249 Breton, Madame, 155 Bacon, Francis, 338, 452-5, 491, 497 Brochet, Françoise, 435 Baldini, Rodolfo, 18 Bucher, Jeanne, 104-5, 110-11, 114-15, Balthus, 168-72, 179, 194, 197, 210, 249, 264 252, 263, 268, 297, 343, 408, 451; and Bunshaft, Gordon, 377 Château de Chassy, 344-7, 363; and Buñuel, Luis, 192 mistresses, 345-7; success of, 347; in Rome, 347-8 Caesar, 307 Cahiers d'Art, 140, 191, 282 Balzac, Honoré de, 472

Calder, Alexander, 340, 363, 485; and

Chase Manhattan Plaza, 377

Bataille, Georges, 117, 263

Baudelaire, Pierre Charles, 437

Calvin, John, 35 Campigli, Massimo, 104-5 Camus, Albert, 370 Caroline, 473; description and background of, 401-4; Alberto and, 402-5, 407, 410-16, 420-2, 424-7, 431, 438-41, 449-51, 463-4, 469, 477-8, 482-3, 497-98, 506, 509, 512, 514-15; and Dietrich, 405, 407; livelihood and adventures of, 405, 410-11; disappearance and imprisonment of, 411-14; as model, 415-17, 421, 431, 438-9, 441, 445, 456, 463, 472, 483, 497, 501-2, 506; pimps and, 421-2; and Whiffin, 422-3; foot of, 426; apartment for, 436, 473; marriage and divorce of, 438; nickname of, 438; letters of, 439; and money, 440, 477, 479-80; and Sicily, 444-5; and Alberto's illness, 459; and Maeght museum, 485; Alberto, and future of, 493; in London, 497; visits Alberto in hospital, 508, 510-16; and Alberto's death, 516-17; and Alberto's funeral, 517, 520, 522; see also under Giacometti, Annette and Diego Carré, Louis, 264, 313 Carrière, Eugène, statue of, 275 Cartier-Bresson, Henri, 192, 482 Cézanne, Paul, 38-9, 82, 98, 104, 108, 183-5, 229, 298, 446-7; Dietrich and, 406 Chagall, Marc, 191, 313, 340, 485 Chanaux, Adolphe, 196 Char, René, 470 Chase Manhattan Plaza, sculptures for, 377-8, 387, 404, 409, 418-19, 499-500 Chez Adrien, 320, 383, 401, 473 Cimabue, Giovanni, 446 Claveux, Louis, 264, 313-14, 334, 339-41, 360, 383, 429; and Maeght, 383, 489; and Maeght museum, 384, 420, 487-8; and Caroline's imprisonment, 414; and Venice Biennale, 442-3; and vandalism, 481; and retirement, 491; and Tate exhibit, 497; and Alberto's funeral, 520

Cocteau, Jean, 110, 124-5, 134

Cottance, Jacques, 134-6

Courbet, Gustave, 170

Colle, Pierre, 131, 140, 179, 264 Colleone, Bartolomeo, statue of, 59

Communists (ism), 113, 121, 125, 131,

250-1, 322-3; and Surrealists, 156

Corbetta, Dr. Serafino, 435, 457, 460-1

Crevel, René, 125, 153, 156; suicide of,

Cubism, 68-9, 98-100, 108, 121, 129

Colette, 134-5

Dada, 67 Dali, Salvador, 118 Dany, 401-2, 411-13 Degas, Edgar, 430 de Chirico, Giorgio, 114 de Kooning, Willem, 499 Delmer, Isabel, 163-4, 166-7, 175-6. 193-5, 197-8, 207-8, 210, 213, 226, 231, 241-2, 268, 291, 297; portraits and drawings of, 176-7, 213; deteriora-tion of marriage of, 192-3; Picasso portraits of, 207-8; end of first marriage of, 231; and Lambert, 231, 248, 297; rejoins Alberto in Paris, 248-9, 253-4; and Leibowitz, 254, 256; leaves Alberto, 254-6; see also Lambert, Isabel Delmer, Sefton, 163, 192-3, 213, 231 Denise, 125-6, 131, 144, 175 Derain, André, 68, 167-8, 251-2, 275, 339, 343 Diary of Anne Frank, 253 Dietrich, Marlene, 405-7, 409 Dior, Christian, 124 Documents, 117 Dove of Peace (Picasso), 322 Dream, The (café), 275 du Bouchet, André, 463, 470, 520 Dubout, Albert, 325, 325f

Cuevas, Georges de, 296

Cycladic sculptures, 81-2, 94, 104

Ehrenburg, Ilya, 156 Eleftheriades, Efstratios, see Tériade Eluard, Paul, 113, 153, 207, 249, 325 Epstein, Jacob, 162-3, 167 Epstein, Margaret, 162 Ernst, Max, 111, 114, 153-4, 249, 363 Express, London, 163

Duperret, Odette, 142; see also under

Duchamp, Marcel, 67

Dürer, Albrecht, 20-1, 38, 500

Giacometti

Dyer, George, 454

Fauve, 167
Flaubert, Gustave, 56
Fraenkel, Dr. Theodore, 119, 274-5, 322, 395, 456-9, 461-2, 464, 490
Francesca, Piero della, 169
Franco, Francisco, 180
Frank, Anne, 253
Frank, Jean-Michel, 121-5, 133, 140, 155, 196, 211, 223, 329, 331; and America, 210, 212, 214; suicide of, 253

Fremiet, Emmanuel, 195 Freud, Sigmund, 112, 125, 146, 276 Frua de Angeli, Carlo, 323

Galante, Mario, 142 Gauguin, Paul, 49 Genet, Jean, 295, 348-52, 357, 371, 382; portraits and drawings of, 349; and Alberto, 349-52

Giacometti, Alberto (grandfather), 4 Giacometti, Alberto, 15, 18, 48, 73, 244, 295, 318, 355, 391, 503; author meeting with, vii; and drawing, vii, 18-22, 25-6, 29-30, 33, 36, 43-4, 46-8, 50-2, 57, 85, 186, 198, 213, 238-9, 244, 260, 265-6, 280, 283, 285-6, 289, 295, 306, 314, 316, 318, 338, 342-3, 349, 355, 357-8, 366, 379, 381-2, 390, 417, 442, 445, 449, 459, 463, 471, 485, 497-8, 501-2, 505; and painting, vii, 26, 29-30, 32-3, 35-6, 41, 47, 50, 83-5, 183-5, 238, 260, 266, 280, 283, 289, 297-8, 309, 314, 316, 318, 333, 338-9, 349, 355, 358, 371, 378-80, 382, 384, 398-9, 417, 424, 429-31, 438-9, 442-3, 445, 447, 449. 455-6, 467, 472-3, 485, 497-8, 502; and writing (letters, articles, journals), viii, 9-10, 13-15, 25, 28, 56, 58-60, 72, 107, 118, 126-7, 145-6, 208, 256-7, 271-3, 275-8, 306, 308, 338, 378, 386, 391, 395, 411-13, 439, 500, 505-6; description of, ix, 8-9, 13, 19, 21, 25, 28, 30, 43, 62, 76, 78-9, 82-3, 170, 205, 248, 267, 285, 299, 321, 352, 362, 420, 449, 455; beginnings of, as artist, 3, 18-21; and Maloja, 3, 18, 55, 60-1, 72-3, 85, 96, 150, 183, 185-6, 209-10, 223, 228, 303; birth of, 6; childhood of, 8-13, 391; and cave, 9-10, 146, 274, 391; and rock, 10, 146, 391; and Siberia, 13-14, 146, 391; and sexuality, 14, 31-2, 41, 47-8, 77-8, 95, 108, 156, 227, 403, 425; and feet, shoes, and socks, 14, 25, 36, 52, 61, 81, 144-5, 152, 168, 257, 261, 265, 278, 283-4, 356-7, 387, 426; photographs of, 18, 95, 192, 281, 382, 391, 397, 443, 463; as illustrator, 19, 125, 296, 347, 390, 394, 470; and copying, 20-1, 47, 81, 229, 239, 446, 500, 508; destruction of work by, 21, 28, 51, 150, 165-6, 178, 193, 216, 228, 244, 252-3; first sculpture of, 22, 27; and sculpture, 22, 26-7, 31-3, 35-6, 46-7, 50, 62, 70, 75-6, 80-2, 85, 93-5, 98-100, 102-5, 108, 110-11, 115-18, 124, 126-30, 133, 137-40, 143-5, 150-4, 156, 164-6, 176-80, 188, 193, 200-1, 203, 205-6, 221, 223, 227-8, 252, 260, 265-6, 276-9, 281-90, 304-9, 313-14, 316, 318, 320-1, 329-30, 333, 335, 338-9, 350, 355-8, 378-9, 382, 387-8, 393, 398-9, 404, 408, 417-18, 425, 427, 429-30, 442-3, 445, 447, 449, 456, 467, 472-3, 475, 485, 493-5, 497-8, 501-2, see also and figurines (below), and names of in Works index; and working from nature (representation), 22, 84-5, 98, 103, 164-7, 171, 183-4; at boarding school, 24-6, 28-32; and money, 26, 37, 43, 55, 59-60, 80-1, 102, 114-15, 122, 140, 185, 223-5, 234, 236, 244, 253, 257, 261, 264, 269-70, 281, 314-15, 335, 341, 360-1, 388, 409, 440, 450, 476-7, 483, 490; studios of, 26, 44, 46, 80, 90, 100-2, 219-20, 232, 247, 249, 294, 471, 473, 497, 519; and mumps, 29; and homosexuality, 31-3, 54, 56, 76-7, 125, 397, 454-5; friends of, 31, 44, 70-1, 76-7, 111, 114, 116, 122, 124-5, 155, 190-2, 201-3, 205-7, 220-2, 224, 231, 233, 236-7, 249-52, 262-3, 268, 295, 297, 314-16, 322, 334, 337-9, 348, 352-3, 371, 390, 393, 397, 452, 454-5, 458, 461-2, 464, 466-8, 472-3, 483, 493, 505-6, see also names of; influences on, 33, 99-100, 139-40, 184-5, 309; to Geneva, 35-7, 41, 217-20, 261; and truth, 36, 51, 67, 99, 277, 388, 458, 462, 468, 474; to Venice, 38-40, 59-60, 209; to Florence, 41-2; to Rome, 42-8, 50; and cane, 43, 62, 204, 210, 213, 216, 218, 221, 223, 239, 249, 256, 388; and prostitutes, 47-8, 59, 77-8, 107, 125, 222, 227, 271, 293, 301, 308-9, 320, 353, 361, 389, 404, 416, 469; and smoking, 48, 79, 196, 217, 321, 434, 455, 459, 469, 491; and Naples, Paestum, and Pompeii, 48-9, 444; and Peter van Meurs, 55-61, 274, 277, 308, 433; and death, 57-8, 120, 135, 215, 268-9, 308, 394-5, 462, 505, 509, 512-13, see also and Pototsching's death (below); and light at night, 58, 61, 106, 136, 154, 269, 272, 389, 433-4, 450; and Grande-Chaumière, 62, 70, 72, 75-6, 82-3, 89, 98, 483, see also Bourdelle; arrival and first years in Paris, 67-71, 75-7; and women, 72, 76-8, 125-6, 175-6, 193, 267, 277, 363-4, 481-2, see also and prostitutes (above) and names of; and dancing, 73; and military service, 73-4, 209-10; and marriage, 76, 78, 94, 234, 242, 294, 300-1, 360, 364, 389, 431; and Switzerland, 80, 223, 315, 355, 442, 445, 449, 496, 503; first public showing of, 82, Flora's portrait of, Giacometti, Alberto (cont.)

95, 132; and Cubism, 98-9, 108; and heads, 103-4, 153-4, 165-6, 177, 201, 417-18, 472-3, 506; and jealousy, 107, 374, 425-6; and Surrealism, 109, 116, 118-19, 126-8, 139, 144-5, 150-7, 182, 185, 220, 287, 379, 425, 445; and fame and success, 105-6, 111, 115, 140, 289, 334-5, 339, 354, 359, 363, 382, 391, 409, 429, 443, 445, 474, 477, 490, 503; illnesses of, 119-20, 148-9, 321-2, 395-6, 455-62, 464, 491, 503-5, 508-16, see also and mumps (above) and accident (below) and and venereal disease (below); and Communism, 131, 251; and Diego's accident, 139; first oneman exhibition of, 140; and father's death, 147-8, 187; and father's tombstone, 150; New York exhibits of, 153, 282-3, 286-90, 306, 313, 317-18, 354, see also and Museum of Modern Art (below); and figurines, 177-8, 182, 201, 203-5, 208, 210-11, 216-17, 220-1, 223, 225-8, 241, 244, 252-3, 265, 278-9, 335, 382, 387, 459, 509; and accident, 195-200, 204, 239, 270, 286, 308, 388, 466-9: and crutches, 199-200, 204; and Zurich exhibit, 204-5, 442, 445-6; visits mother, 209-10, 217, 219, 261, 292, 383, 392, 410-11, 459-61; and war, 212-15, 240-1; and the fox, 247-8; and "revelation," 257-60, 269, 274; and Pototsching's death, 268-9, 271, 275-6, 285; and venereal disease, 271-2, 275, 277; and spider dream, 272-8; and Bern exhibit and doctorate, 293, 355, 358-9, 503; and Gruber's death, 295; agrees to marry Annette, 301-3; and Venice Biennale, 315-17, 338, 355, 358, 442-5; and Basel exhibit, 316, 496; and children, 327-8; marital relationship of, with Annette, 327-8, 334, 360-6, 375, 386, 389-90, 398, 409, 416-17, 431-3, 437, 449-52, 469, 471-2, 476-9, 501, 509; collectors and, 332, 361, 378-80, 443, 448-9; and Matisse medallion, 342-3; and Balthus, 344-8; and Léna Leclercq, 345-7; daily routine of, 352-3; and British exhibit, 354, see also and Tate exhibit (below); and German exhibits, 354; and Annette's hair, 365-6; and Chase Manhattan Plaza, 377-8, 387, 404, 409, 418-19, 499-500; and suicide, 394-5; and pimps, 421-2, 426; and Caroline's foot, 426; and tree for Beckett, 428-9; receives Carnegie Prize, 429-30; and mother's birthday, 435; sixtieth birthday of, 437; and abstract art, 446-7; and Tate exhibit, 454, 477, 491, 496-8; and Sartre autobiography, 466-8; and mother's death, 471: and Paris lithographs, 473-4: interviews with, 474-5: and Museum of Modern Art exhibit. 477, 491, 498-9; and vandalism, 480-1; and Maeght museum, 485, 487-8; leaves Maeght, 489-90; and will, 491-2; and Foundation, 496; and ocean, 500; and Copenhagen exhibit, 501; and Larronde burial, 502-3; film of, 503; receives Grand Prize for Art. 503; in Chur hospital, 507-16; and arrangement of affairs, 511-12; death of, 516-17; funeral of, 517, 519-22; homage to, after death, 517-18; and Caroline, see Caroline; and Maeght exhibitions, see under Maeght; relations of, with Diego, see Giacometti, Diego; see also Cycladic sculpture; see also under Giacometti. Annetta. Annette, and Diego, under Genet, Yanaihara, and the names of other

friends and associates

Giacometti, Annetta, 21, 24-6, 61, 197, 217, 407; pregnancies of, 5, 7, 8, 12; description and character of, 5, 7, 12-13; relations of, with Alberto, 7-8, 18, 21, 34-5, 72-3, 76, 81, 144, 146, 182, 185-6, 221, 225, 242, 293, 359, 386, 392, 471, 512-13; thirty-eighth birthday of, 17-18; photograph of, 17-18, 463; Alberto's letters to, 25, 378, 382; as model, 27, 50, 83-4, 103, 183, 185, 283, 293, 309, 357, 359, 375, 459, 462-3; visits Alberto in Paris, 81; and Bianca, 85; and Surrealism, 128; and Alberto's writings, 146, 278, 391-2; and Giovanni's illness and death, 147-8; and Nelly, 174-5; and Diego, 174-5, 211, 329, 331, 334, 385, 392, 444; and Alberto's figurines, 182, 221, 223, 225; after Giovanni's death, 185-7; health of, 217, 392, 434-5, 444, 470-1; and Alberto's cane, 218, 225, 434; and money, 224-5, 361; and Annette, 292, 300, 303, 358, 434, 463, 471; and Bern exhibition, 293, 359; and Diego and Alberto, 329, 331; and Maeght exhibit, 382; and night light, 434; ninetieth birthday of, 435; and Alberto's illness, 461; death of, 471-2; see also Giacometti, Alberto and Diego

Giacometti, Annette, vii-viii, 320, 324, 334, 352-3, 358, 363, 379, 464, 471, 473; and mother-in-law, 303, 358, 410, 434-5, 459-60, 463, 471; as model,

309, 338, 357, 365, 371, 376, 378, 382, 387, 389, 397-8, 410, 430, 445, 450, 456, 472-3, 476; and money, 315, 360-1. 450, 476-7, 501; material desires of. 315, 361: with Alberto to South of France, 324: and children, 327-8, 397: and marital difficulties, 328, 360, 362-6, 389-90, 431-3, 449, 463, 469, 476-9, 481, 488, 501, 509-10; and Diego's indispensability, 331; and Léna Leclercq, 346; and Balthus, 346-7; and Lacloche and Larronde, 352, 450-2; and Bern, 359-60, 503; and Yanaihara. 371, 373-6, 384-5, 389, 397-8, 400, 408, 416-18, 435-7; and Dietrich, 407, 409; and Caroline, 407, 410, 416, 431-3, 441, 449, 477-81, 492, 498, 511, 513, 517; and Paola Thorel, 408-9; apartments of, 433-4, 436-7, 451, 473, 476-7; and Alberto's illness, 458, 505, 508-11, 513-16; and du Bouchet, 463, 470; and Maeght, 485, 488; stays at Matisse villa, 488; and Perls, 488-9, 508, 514; inherits Alberto's estate, 492; to N.Y. with Alberto, 498; and Lotar, 501; Alberto's death, 516-17: at Alberto's funeral, 522; see also Arm. Annette

Giacometti, Antonio, 42, 53

Giacometti, Bianca, and Alberto, 45-7, 50-2, 72, 83-5, 96-7; marriage of, 142;

visits Alberto in Paris, 270

Giacometti, Bruno, 61, 315, 382, 391, 396, 410-11, 509-10; birth of, 12; photograph of, 17; bust of, 50; and dancing, 73; and architecture, 89, 91, 142; marriage of, 142; and father's illness and death, 147-8; and National Exhibition, 204; and Annette, 292; and mother's birthday, 435; and Alberto's cancer, 458; and mother's death, 471; and Bern, 503-4; and Alberto's last illness, 508, 511, 513, 515-16; and Alberto's death, 516-17 Giacometti, Diego, vii, ix, 3, 7-8, 12, 101-2, 143, 211, 363, 464, 473, 492, 509; and Bregaglia Valley, 3; first memory

101-2, 143, 211, 363, 464, 473, 492, 509; and Bregaglia Valley, 3; first memory of, 8; relationship of, with Alberto, 13, 15, 22, 30, 54, 83, 89-92, 122-4, 133-4, 136-7, 164, 211-12, 216, 242, 247-8, 252-3, 293-4, 299, 321, 328-35, 441-2; and his hands, 15-17, 139, 331, 334; photograph of, 17; as model, 22, 27, 50, 164-5, 177, 260, 283, 294, 309, 333, 338, 357-8, 376, 378, 382, 389, 409, 418, 430, 445, 463, 472-3, 494, 497; at boarding school, 30-2; friends of, 30, 34, 90-2, 123, 133, 295; Alberto's

friends and, 30, 93, 133-4; travels, jobs, and activities of, 34-5, 62-3, 83, 90-2; parents and, 34, 83, 217; and van Meurs, 54: in Basel, 62-3: and dancing, 73; lack of purpose of, 83, 89, 122-3: with Alberto in Paris, 89-91. 100-2, 119; as Alberto's assistant, 123-4, 129-30, 133, 164, 223, 293-4, 329-31, 500; and Saint-Bernard sculpture, 129-30; and money, 130, 315, 335, 361, 477; and father's death, 147-8; and father's tombstone, 150; and Annerta, 174-5, 211, 329, 331, 334, 385, 392, 435, 444; and Alberto's accident, 196; to Venice, 209; and military service, 209-11; and sculpture, 212, 330, 333; and war, 213-15, 231-2, 240; and sculpture course, 216; and Picasso drawing, 231-2; and spider web, 232-3; and fox, 242-3, 247-8; and Annette, 268, 292, 294, 301, 303, 331, 366, 384-5, 440-1, 469; and Les Tamaris, 295; and Maeght, 314, 489-91; difficulties in domestic life of, 328, see also Nelly; and bronze furniture, 331-2, 535; Thompson and, 332-3, 449; and Yanaihara, 371, 373, 384-5, 440; and Maeght exhibition, 381-2; and Caroline. 410, 440-1, 481, 497; and tree, 429; house bought for, 436; and drinking, 441-2; and Venice Biennale, 442-4; and Ratti, 456; and Alberto's cancer, 458; and mother's death, 471; and Maeght museum, 485; and Tate exhibit, 497; and Alberto's last illness, 505, 508, 510-13, 515-16; and Lotar bust, 506, 518-19; and Alberto's death, 516-17; at Alberto's funeral, 522

Giacometti, Evelina, 43, 45-6, 50

Giacometti, Giovanni, 236; as artist, 5, 8, 12-13, 15, 18-19, 24, 33-5, 38, 128, 142, 146-8; studios of, 8, 18, 33, 519; and Alberto, 15, 33-5, 104, 128, 146, 150; photograph of, 17; and Alberto's school, 24-5; Alberto's portraits of, 27, 103; and Alberto's work, 33-5, 62, 104, 128, 146; and Surrealism, 128, 146; death and funeral of, 147-9; tombstone of, 150, 435, 472

Giacometti, Odette, 292, 391-2, 410; and mother-in-law, 435, 471; and Bern, 504; and Alberto's last illness, 508, 510-11, 513, 515-16; and Alberto's death, 516-17; at Alberto's funeral,

522

Giacometti, Ottilia, 73, 89; birth of, 8; photograph of, 17; and father's illness and death, 147-8; engagement of, Giacometti, Ottilia (cont.)
143; pregnancy and death of, 186; child of, see Berthoud, Silvio
Giacometti, Rodolfo, 520-1
Giacometti Portrait, A, vii
Gilot, Françoise, 251
Ginette, 401-2, 411
Giotto, 38-40, 446
Grisaille, La, see Caroline
Gruber, Francis, 171-2, 197, 217, 252; death of, 295
Grünewald, Matthias, 427
Guernica (Picasso), 180-2, 207, 322
Guggenheim Museum, exhibit in, 354

Halasz, Gyula, see Brassaï Hélion, Jean, 171-2 Hirschfeld, Alice, 72 Hitler, Adolf, 172, 193 Hodler, Ferdinand, 12 Hugnet, George, 155

Isabel (Epstein), 163 Isenheim Altarpiece, 427

Joan of Arc, statue of, 195 Jourdan, Maurice, 136 Jourdan, Robert, 134-6 Journal (Cocteau), 110

Kahnweiler, D.-H., 265, 326 Kandinsky, Vassily, 340, 485 Kierkegaard, Sören, 370 Klee, Paul, 332, 380, 448; Foundation of, 496 Klossowski, Michel Balthasar, see Balthus Klossowski, Pierre, 346 Knight, Death, and the Devil (Dürer), 20-1, 500 Kornfeld, Eberhard, 503-5; and Alberto's funeral, 520

Labyrinthe, 271, 275-6, 278, 338
Lacan, Jacques, 263
Lacloche, François, 296
Lacloche, Jean-Pierre, 296, 352, 390; and Yanaihara, 371; and Annette, 450-2; and Larronde grave, 502; at Alberto's funeral, 520; and Caroline, 522
La Greca, Murillo, 44
Lambert, Constant, 231, 248, 297
Lambert, Isabel, 308; marries Alan Rawsthorne; see also Delmer, Isabel and Rawsthorne, Isabel

Larronde, Myriam, 295, 297, 390 Larronde, Olivier, 295-6, 348, 352, 390, 450, 452; and sister, 295, 297, 390; and Yanaihara, 371; and Alberto drawings, 390; death of, 502 Laurens, Henri, 69, 99-100, 129, 139-40, 191, 249, 293, 316-17, 338 Leclerca, Léna, 345-7 LeCorbusier, 191 Léger, Fernand, 191 Leibovici, Dr. Raymond, 197-8, 200, Leibowitz, René, 254, 256, 297, 422 Leiris, Michel, 111, 116-17, 249, 339, 352, 393-4; attempted suicide of, 393-4: at Alberto's funeral, 520 Leonardo da Vinci, 360 Levy, Julien, 153, 179 Lichtenhan, Lucas, 315-16 Lipchitz, Jacques, 69, 82, 99, 129, 139-40 Living Ashes, Unnamed (Leiris), 394 Loeb, Pierre, 114-15, 117, 124, 130, 168, 179, 191, 264 Lotar, Elie, 192, 482-3, 493, 506; and Caroline, 483; as model and busts of, 493-5, 497, 501-2, 506, 518-19; and money, 501 Maar, Dora, 181, 207, 251 Macé, Jean, statue of, 304-5 Maeght, Aimé, 311-14, 317, 332, 334, 339-41, 360, 363, 378, 442, 489-90; and Giacometti exhibitions, 318-19, 338-9, 381-2, 429-31; and museum, 383-4, 420, 485, 487-8; and Clayeux, 383,

489; and Alberto's cancer, 458; at Alberto's funeral, 520 Maeght, Marguerite (Guiguite), 311-13, 317, 429; and museum, 420; as model, 424, 430; and Alberto, 490 Maillol, Aristide, 69 Mallarmé, Stéphane, 296, 502 Mallet-Stevens, Robert, 129 Malraux, André, 347; and Maeght museum, 487; emissary of, 520 Manessier, Alfred, 445 Markoff, Dr. N. G., 507-12, 515 Massacre in Korea (Picasso), 322 Masson, André, 111, 249, 363; and joint exhibition, 316 Matisse, Henri, 68-9, 71, 114, 167, 191, 206, 249, 312-13, 317, 324, 341-3, 380, 383, 424, 430, 485; operation on, 341, 458; Alberto's drawings and medallion of, 342-3

Matisse, Patricia, 361, 383, 443, 488; and Tate exhibit, 497; and MOMA exhibit, 498; and Alberto's illness, 509-10, 515-16

Matisse, Pierre, 70-1, 179-80, 265, 312-13, 360, 362, 378, 380, 383; and Alberto, 179-80, 265, 282-3, 286-90, 306, 314, 317, 332, 334, 340-1; and Patricia Matta, 281-2; and Maeghts, 317, 382-3, 488, 490; and Caroline, 414; and Yanaihara portrait, 436; and Venice Biennale, 442-3; and Alberto's cancer, 458; and Tate exhibit, 497; and MOMA exhibit, 498; and Alberto's illness, 509-10, 513, 516; and Alberto's affairs, 511-12; and Alberto's death, 517; at Alberto's funeral, 520

Matt, Hans von, 44

Matta, Patricia, 263, 270, 281; and Alberto, 281-2, 289; marries Pierre Matisse, 290; see also Matisse, Patricia Matta, Roberto, 263, 281

Maupassant, Guy de, 56-7

Mayo, Flora Lewis, 87-9, 94-6, 106-8, 126, 131-2, 254, 420, 483-4

Meurs, Peter van, 53-9, 274, 277, 285-6, 433

Meyer, Franz, 359 Meyer, Ida Chagall, 359 Michelangelo, 446, 495 Minotaure, 191

Miró, Joan, 111, 114, 118, 153, 179, 191, 211, 249, 313, 317, 340, 379, 485

Miss Rose, 242-3, 247-8

Moll Flanders, 197 Mondrian, Piet, 447

Montandon, Roger, 257, 274

Motherwell, Robert, 499 Müller, Joseph, portraits of, 102

Museum of Modern Art, exhibit at, 477, 491, 498-9

Mussolini, Benito, 204

Mysterious Barricades, The (Larronde), 296

Napoleon, 307

Nazis, 204, 210, 212, 336, see also Hitler Nelly, 173-5, 211, 231, 292, 294, 328; and war, 213-15

Nelson, Ms., 196, 198

New York Times, The, 153

Newman, Barnett, 318

Nicholas, Isabel, 161-3; see also Delmer,

Nicholas, Warwick, 161

Noailles, Charles and Marie-Laure de, 110, 124, 129-30, 140, 169; bust of Marie-Laure, 260

Nothing There Is Order (Larronde),

O'Connell, Patricia, see Matta, Patricia "One Condemned to Death, The" (Genet), 349

Passage du Commerce-Saint-André, Le (Balthus), 346

Pasternak, Boris, 465 Péret, Benjamin, 154-5

Perls, Frank, 488-9, 508, 514

Pevsner, Antoine, 293 Picabia, Francis, 67

Picasso, Pablo, 68-70, 114, 180-2, 191, 207, 210, 249-51, 262, 265, 318, 322-3, 339, 350, 363, 380, 430, 486-7; and Alberto, 140, 180-2, 205-7, 251, 268, 323-6; as parent, 206-7; gives drawing to Alberto, 207; bust of, 260, 288-9; exhibition of paintings of, 289; and portrait of Stalin, 323

Picasso, Paulo, 206-7, 238, 363 Pietà (Michelangelo), 495

Pototsching, Tonio, 232, 240, 249, 263-4, 516; death of, 268-9, 271, 275-6, 285

Prévert, Jacques, 111 Prison de la Petite Roquette, 412-13

Raisin, Dédé le, 126

Ratti, Dr. Reto, 456-7, 464, 491, 508, 510

Rauschenberg, Robert, 499 Rawsthorne, Alan, 338

Rawsthorne, Isabel, 491, 497; visits Alberto, 452; and Francis Bacon, 454-5

Ray, Man, 122, 192

Rembrandt van Rijn, 21, 343, 446-7, 462, 472, 499

Repond, Madeleine, 256

Rita, 164-5, 177

Rockefeller, John D., granddaughter of,

Rodin, Auguste, 26, 68-9, 104, 447

Rola, Count Balthasar Klossowski de, see Balthus

Rothko, Mark, 499

Rouault, Georges, 68

Rousseau, Jean-Jacques, 35

Sachot, Manon, 256

Sadoul, Georges, 269 St. Genet, Actor and Martyr (Sartre),

Santi, Ottilia, 4

Sartre, Anne-Marie, and son's autobiography, 466

Sartre, Jean-Paul, 201-3, 210, 249-50, 262, 309, 339, 348, 350, 361, 370, 393, 465, 468-9, 490; drawings of, 260; and Alberto exhibits, 288, 339; and Algerian War, 352; autobiography of, 465-9; and Nobel Prize, 466, 469 Scheidegger, Ernst, 391 The" "Search for the Absolute. (Sartre), 288 Sert, Josep Lluis, 420 Seurat, Georges, 170 Severini, Gino, 104 Skira, Albert, 191, 220-1, 223, 257, 271, 275.363 Souvtchinsky, Pierre, 381 Sphinx (brothel), 78, 271, 275, 308, 404 Stalin, Joseph, portrait of, by Picasso, Stampa, Alice, 507 Stampa, Annetta, see Giacometti. Annetta Stampa, Renato, 507-8 Stoppani, Rita, 519 Stranger, The (Camus), 370 Stravinsky, Igor, drawings and por-

Studio of Alberto Giacometti, The (Genet), 350-1 Surrealism, 67-8, 109, 111-14, 116, 118-19, 121, 124-8, 131, 134, 139-40, 145-6, 150-7, 168-9, 192, 263, 311, 313, 316; and war. 210

trait of, 380-1

Surrealism at the Service of the Revolution, 118, 145 Surrealist Revolution, The, 113

Tailleux, Francis, 171-2, 252; party of, 254
Tal Coat, Pierre, 171-2, 252
Tamaris, Les, 294-5
Tanguy, Yves, 153-5, 179, 249
Tate Gallery, exhibit at, 477, 491, 496-8, 501
Tériade, E., 190-1, 324, 473, 482; portraits of, 260, 473
Thaw, Eugene, 516
Thirion, André, 304

Thompson, G. David, 332-3, 361-2, 378-80, 429, 448-9; portraits of, 379-80; death of son of, 448; and sale of collection, 448-9; exhibit of collection of, 496
Thorel, Alain, 408-9
Thorel, Paola, 408-9, 450; sculpted portrait of, 408-9
Three Trees (Rembrandt), 462
Tintoretto, Jacopo, 38-40, 42, 82, 446
Tison, Frédérique, 346-7
Titian, 342
Tolotti, Gustavo, 91
Tzara, Tristan, 67, 134-5, 197

Unvanquished Poems (Leclercq), 346 Utrillo, Maurice, 68

Velázquez, Diego, 169-70, 371, 446 Verrocchio, Andrea del, 59 Verve, 191-2 Vlaminck, Maurice de, 68, 167

Waiting for Godot (Beckett), 336, 428-9
Walter, Marie-Thérèse, 181
Weinstein, Georges, 134
Welti, Arthur, 44
What We Owe to Stalin, 323
Whiffin, Lawrence, and Caroline, 422-3; Alberto and, 423-4
Words, The (Sartre), 465-6, 469
Wuthering Heights, 169

Yanaihara, Isaku, 369-70, 384, 388-9, 397-400, 408, 416, 435, 437, 470; Alberto and, 370-1, 373-6, 389, 397-8, 400, 437; portraits of, 371-6, 382, 384, 398, 408, 417-18, 430-1, 435-6, 445; and Caroline, 416-17; sculpture of, 417; receives drawings and lithographs, 417, 437; and Annette, see under Giacometti, Annette

Zadkine, Ossip, 129, 317 Zervos, Christian, 140, 191, 323-4 Zimmerli, Jacob, 24, 32

Index of Works

Apple on a Sideboard, 183-5, 289

"Brown Curtain, The," 145

Cage, The, 127, 156, 335, 357 Chariot, The, 228, 335, 357 Chariot, The, or Pharmacy Cart, The, 305-8, 314 City Square, The, 308, 314, 329, 357, 418 Composition, 98 Construction, 98 Couple, The, 94

Dog, The, 406
"Dream, the Sphinx, and the Death of T., The," 276, 278, 391

Egyptian, The, 176 "Ember of Grass," 145

Figure, 104, 130 Forest, The, 308, 314, 329, 335, 357 Four Figurines on a High Base, 335

Gazing Head (Tête Qui Regard), 110, 153 Glade, The, 308, 314, 329, 335

Hand, The, 286, 289, 387-8 Hand Caught by the Fingers, 139 Hands Holding the Void, 151-3 Head, 104 Head on a Rod, 285, 387-8

Invisible Object, The, 151-3

Knight, Death, and the Devil (Dürer), copy of, 20-1, 500

Large Woman, 93-4 Leg, The, 387-8, 445

Man Pointing (Man with Finger), 284-5, 289, 314 Man and Woman, 108, 115 Man, Woman, 98

Night, 260 No More Play (On ne Joue Plus), 137 Nose, The, 286, 289, 387-8

Palace at 4 a.m., The, 143-4
Paris without End, 473-4, 505
Personages, 98
"Poem in Seven Spaces," 145
Point to the Eye, 137-8, 156
Portrait of the Artist's Mother, 185, 289

Reclining Woman, 115

Snow White (Bianca Neve), death scene from, 19 Spoon Woman, The, 93 Suspended Ball, The, 117-18, 127, 156

Tormented Woman in Her Room at Night, The, 139, 277 Torso, 287

Walking Woman (two), 144-5, 151, 179-80, 265
Woman Dreaming, 185
Woman in the Form of a Spider, 138-9, 276-7
Woman with Her Throat Cut, 138-9, 156, 277
Women of Venice, 355-8, 382, 485

"Yesterday, Quicksand," 9-10, 13-15, 145-6, 276, 278, 391